D1058642

EMPIRE

✝✝✝✝✝✝✝✝✝✝✝✝✝✝✝✝✝✝✝

HOW SPAIN
BECAME A
WORLD POWER
1492–1763

✝✝✝✝✝✝✝✝✝✝✝✝✝✝✝✝✝✝✝

HENRY KAMEN

 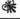

HarperCollinsPublishers

HarperCollins books may be purchased for educational, business, or sales promotional use. For information, please write: Special Markets Department, HarperCollins Publishers Inc., 10 East 53rd Street, New York, NY 10022.

First published in Great Britain in 2002 by Penguin Books Ltd.

FIRST AMERICAN EDITION

Printed on acid-free paper

Library of Congress Cataloging-in-Publication Data
Kamen, Henry Arthur Francis.
[Spain's road to empire]
Empire : how Spain became a world power, 1492–1763 /
Henry Kamen.—1st American ed.
p. cm.
Originally published: Spain's road to empire. London :
Penguin, 2002.
Includes bibliographical references and index.
ISBN 0-06-019476-6 (alk. paper)
1. Spain—History—Ferdinand and Isabella, 1479–1516.
2. Spain—History—House of Austria, 1516–1700. 3. Spain—
History—Bourbons, 1700– 4. Spain—Colonies—History.
5. Spain—Relations—Foreign countries. 6. Imperialism—
History. I. Title.

03 04 05 06 07 UK/RRD 10 9 8 7 6 5 4 3 2 1

Contents

List of Illustrations

Black and white chapter illustrations and engravings

and Good Government, 1613–15 (photo: The Fotomas Index)

Colour plates

List of Maps

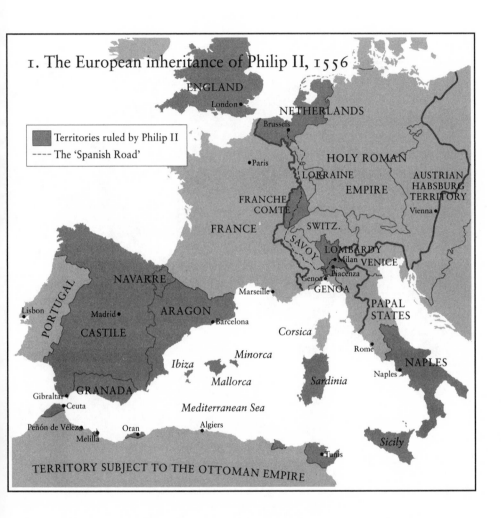

1. The European inheritance of Philip II, 1556

ENGLAND
London

NETHERLANDS
Brussels

Territories ruled by Philip II
---- The 'Spanish Road'

HOLY ROMAN

Paris

LORRAINE

EMPIRE

AUSTRIAN
HABSBURG
TERRITORY

FRANCHE
COMTE

Vienna

FRANCE

SWITZ.

SAVOY

LOMBARDY
Milan VENICE

Piacenza

NAVARRE

Genoa

Marseille

GENOA

PORTUGAL

PAPAL
STATES

Lisbon

Madrid

ARAGON

Barcelona

Corsica

CASTILE

Rome

NAPLES

Minorca

Naples

Ibiza

Sardinia

Mallorca

Gibraltar
Ceuta

GRANADA

Peñón de Vélez

Mediterranean Sea

Oran

Algiers

Melilla

Sicily

Tunis

TERRITORY SUBJECT TO THE OTTOMAN EMPIRE

xi

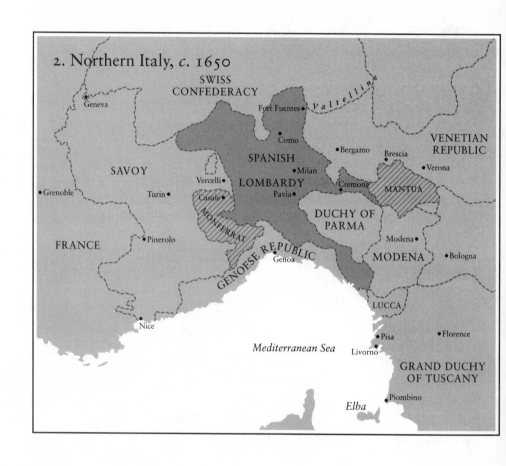

2. Northern Italy, *c.* 1650

SWISS CONFEDERACY

Geneva

Fort Fuentes • *Valtelline*

Como

VENETIAN REPUBLIC

Bergamo • Brescia

Verona

SAVOY

SPANISH

Milan

Vercelli • LOMBARDY

Grenoble

Turin •

Casale •

Pavia •

Cremona

MANTUA

MONFERRAT

Pinerolo •

DUCHY OF PARMA

Modena •

FRANCE

GENOESE REPUBLIC

Genoa

MODENA

Bologna

Nice

LUCCA

Mediterranean Sea

Pisa

Florence

Livorno

GRAND DUCHY OF TUSCANY

Piombino

Elba

3. Southeast Asia

JAPAN

Nagasaki

CHINA

Canton
Macao

Taiwan

PACIFIC
OCEAN

ANNAM

SIAM

CAMBODIA

Phnom Penh

Luzon

PHILIPPINES
Manila

from
Acapulco

to Acapulco

SOUTH CHINA
SEA

Mindanao

MALAYA

Melaka

Borneo

Tidore

Maluku
Archipelago

Celebes

Sumatra

Macassar

Bantam Batavia THE EAST INDIES

Java

Timor

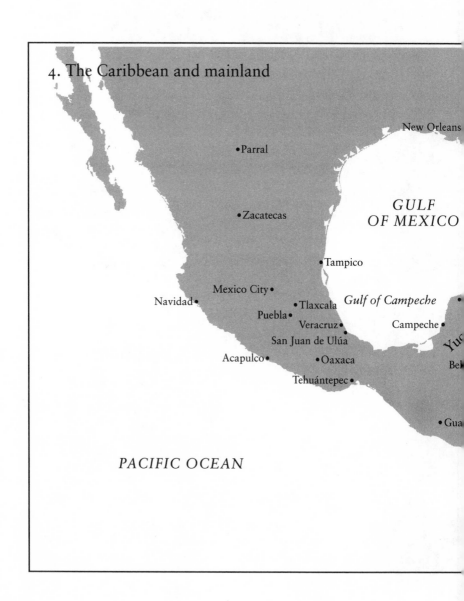

4. The Caribbean and mainland

New Orleans

•Parral

GULF
OF MEXICO

•Zacatecas

•Tampico

Mexico City•
Navidad• •Tlaxcala *Gulf of Campeche*
 Puebla•
 Veracruz• Campeche•
 San Juan de Ulúa
 Acapulco• •Oaxaca Be
 Tehuántepec•

•Gua

PACIFIC OCEAN

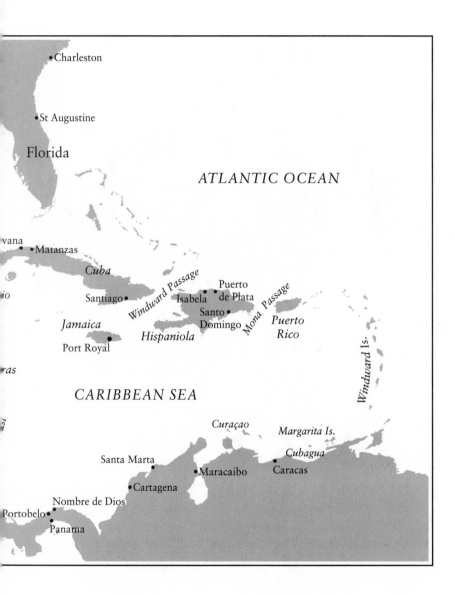

•Charleston

•St Augustine

Florida

ATLANTIC OCEAN

vana
• •Matanzas

Cuba

Santiago•

Jamaica

Port Royal

o

ras

Windward Passage

Isabela

Puerto
de Plata

Santo •
Domingo

Hispaniola

Mona Passage

Puerto
Rico

Windward Is.

CARIBBEAN SEA

Curaçao

Margarita Is.

Santa Marta

•Maracaibo

Cubagua

Caracas

•Cartagena

Nombre de Dios

Portobelo•

Panama

5. The viceroyalty of Peru, c. 1650

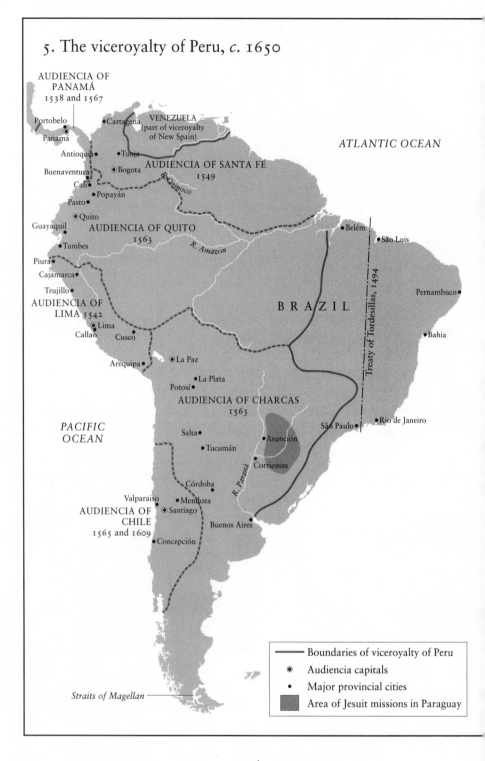

AUDIENCIA OF
PANAMÁ
1538 and 1567

Portobelo
Panamá
Cartagena

VENEZUELA
(part of viceroyalty
of New Spain)

ATLANTIC OCEAN

Antioquia
Buenaventura
Cali
Pasto
Tunja
Bogota
Popayán

AUDIENCIA OF SANTA FÉ
1549

R. Orinoco

Quito
Guayaquil
Tumbes

AUDIENCIA OF QUITO
1563

R. Amazon

Belém
São Luis

Piura
Cajamarca
Trujillo

AUDIENCIA OF
LIMA 1542
Lima
Callao
Cusco

B R A Z I L

Pernambuco

Bahia

Treaty of Tordesillas, 1494

Arequipa
La Paz

Potosí
La Plata

AUDIENCIA OF CHARCAS
1563

PACIFIC
OCEAN

Salta
Tucumán

Asunción

São Paulo
Rio de Janeiro

Córdoba

R. Paraná

Corrientes

Valparaiso
Mendoza
AUDIENCIA OF
CHILE
1565 and 1609
Santiago
Buenos Aires
Concepción

Straits of Magellan

——— Boundaries of viceroyalty of Peru
◉ Audiencia capitals
• Major provincial cities
▨ Area of Jesuit missions in Paraguay

xvi

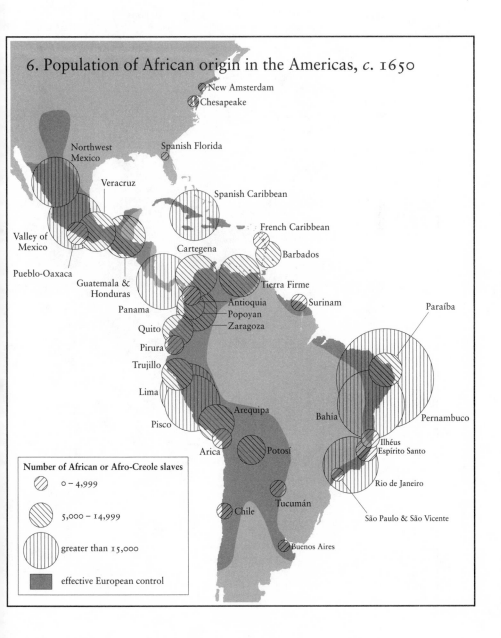

6. Population of African origin in the Americas, *c.* 1650

New Amsterdam
Chesapeake

Northwest
Mexico

Spanish Florida

Veracruz

Spanish Caribbean

French Caribbean

Valley of
Mexico

Cartegena

Barbados

Pueblo-Oaxaca

Tierra Firme

Guatemala &
Honduras

Antioquia

Surinam

Paraíba

Panama

Popoyan

Quito

Zaragoza

Pirura

Trujillo

Lima

Arequipa

Bahia

Pernambuco

Pisco

Ilhéus
Espírito Santo

Arica

Potosí

Rio de Janeiro

Tucumán

São Paulo & São Vicente

Chile

Buenos Aires

Number of African or Afro-Creole slaves

0 – 4,999

5,000 – 14,999

greater than 15,000

effective European control

xvii

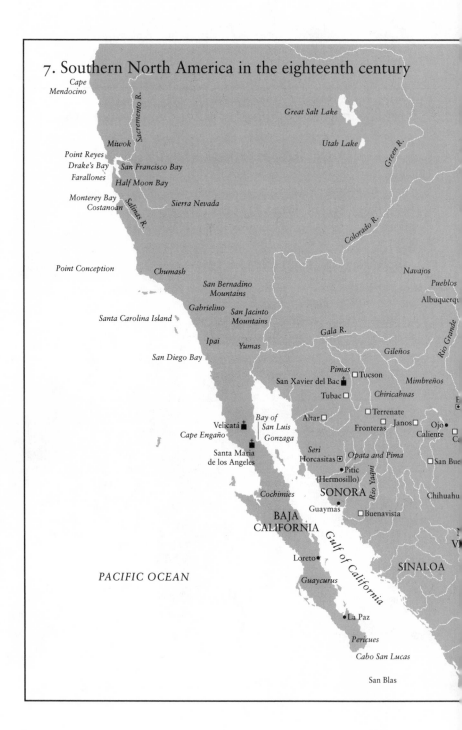

7. Southern North America in the eighteenth century

Cape Mendocino

Great Salt Lake

Utah Lake

Sacremento R.

Green R.

Miwok

Point Reyes
Drake's Bay San Francisco Bay
Farallones Half Moon Bay

Monterey Bay
Costanoan Sierra Nevada

Salinas R.

Colorado R.

Point Conception Chumash Navajos

Pueblos

San Bernadino
Mountains Albuquerqu

Gabrielino San Jacinto
Santa Carolina Island Mountains

Gala R.

Ipai Yumas Gileños

San Diego Bay

Rio Grande

Pimas □ Tucson Mimbreños
San Xavier del Bac ▓ Chiricahuas

Tubac □

E
□
□ Terrenate

Bay of Altar □ □ Janos □ Ojo •
Velicatá ▓ San Luis Fronteras Caliente C
Cape Engaño Gonzaga

Santa Maria Seri Opata and Pima □ San Bue
de los Angeles Horcasitas ▣
 • Pitic
 (Hermosillo)

Cochimies SONORA Chihuahu

BAJA Guaymas □ Buenavista
CALIFORNIA

Rio Yaqui

PACIFIC OCEAN Loreto • Gulf of California SINALOA

Guaycurus

• La Paz

Pericues

Cabo San Lucas

San Blas

xviii

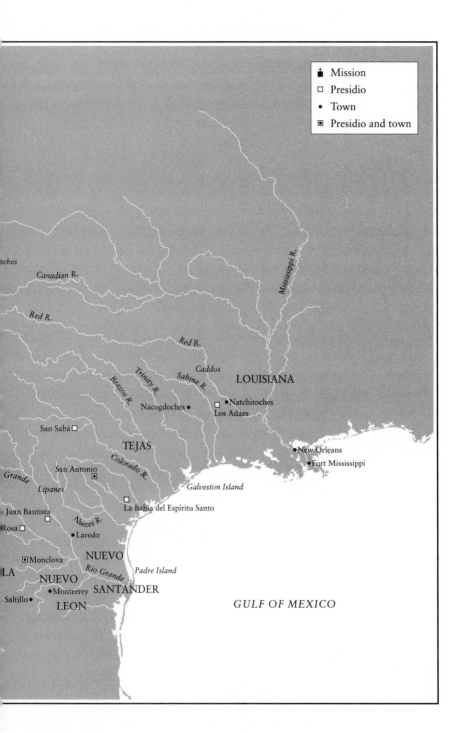

Mission
Presidio
Town
Presidio and town

ches

Canadian R.

Red R.

Red R.

Mississippi R.

Caddos

Brazos R.

Trinity R.

Sabine R.

LOUISIANA

Nacogdoches • □ •Natchitoches
Los Adaes

San Sabá □

TEJAS

Colorado R.

San Antonio
◉

Grande

Lipanes

•New Orleans
•Fort Mississippi

Galveston Island

Juan Bautista
□

Rosa □

Nueces R.

•Laredo

La Bahia del Espíritu Santo

◉Monclova

NUEVO

Rio Grande

Padre Island

LA

NUEVO

SANTANDER

Saltillo •

•Monterrey

LEON

GULF OF MEXICO

Preface

The young Alexander conquered India.
All by himself?
Caesar beat the Gauls.
Didn't he even have a cook with him?
 Bertolt Brecht, 'Fragen eines lesenden Arbeiters'

What would the whites do without the Indians?
 A Guajiro Indian, New Granada, eighteenth century

When we contemplate the magnitude of Spain's hegemony,
and compare it with the poverty from which it arose, we should
not let ourselves give way to pride.
 Ramón Carande (1969)

This book was born, in a way, on the battlefield at St Quentin, a small
French town close to the border with Belgium, where in the year 1557
the king of Spain, Philip II, scored a notable victory over the army of the
king of France. In my study *Philip of Spain* (1997) I gave a short account
of the battle, based both on documents and on recent research. A
distinguished historian, in reviewing the book, suggested that my
account was 'not anti-Spanish, but nevertheless surprising' because it
stated that the Spanish contingent in the battle had constituted only
one-tenth of the troops, thereby undermining the classic view that
St Quentin was a Spanish victory. The Spanish troops may have been
few, he pointed out, but they were more effective than the rest, making
it a Spanish victory. In any case, he added, the victory belongs to him
who paid for the battle, and that was Spain. One way or the other it
must have been, and therefore was, a Spanish triumph: 'the battle was
won by the Spanish contingent'. These objections seemed perfectly

reasonable, and set off in my mind a series of questions that have resulted in the present book. Who did what? Who paid for what? They are queries to which answers are not always offered. Did Cortés conquer Mexico? The surprise of Bernal Díaz del Castillo at reports by an official historian, Gómara, suggesting that Cortés had almost single-handedly overthrown the mighty Aztec empire, was no greater than mine at finding similar claims being made by scholars about the creation of the Spanish empire.

This study, then, pursues a few questions – and only a few – related to the rise of Spain as a world power. It is the fruit of a meditation not only on the battle of St Quentin but also on the evolution of Spain's history, and in that sense follows the direction of much of my research in the past thirty years. Some years ago I published, by way of homage to the people and land in which I now live, an examination of the family life, society and culture of the people of Catalonia in the age of the Counter-Reformation. The present study repays other long-standing debts: to the peoples of Spain, who over the years have allowed me to know, to appreciate and to question the complex characteristics of their culture and their history.

Many notable works, from R. B. Merriman's four-volume survey, *The Rise of the Spanish Empire*, to Salvador de Madariaga's well-known volumes on the same theme, take Spain as the central point around which their presentation has been created. In this view, a small nation startled the world by its incredible imperial prowess, and then relapsed into an inevitable 'decline'. The emphasis on the role of Spain – and more particularly Castile – in the creation of empire has a very long pedigree. This essentially imperialist and Eurocentric perspective has dominated traditional history writing. Castilians were from the first proud of their part in the empire (which they usually referred to not as an 'empire' but as a 'monarchy') and therefore tended quite fairly to glorify and exaggerate their part in it. It became normal to believe, as a leading Spanish scholar of recent times did, that 'the Spaniard occupied Italy, and marched victoriously through the heart of Europe and over the heights of the Andes'.[1] Castile ('Spain') was seen as the universal colossus, the conqueror of peoples, the winner of battles. The nations with whom it came into conflict, such as the Portuguese, Mexicans, Italians and Catalans, also preferred to overstate the case in order to demonstrate their own ability to resist, against overwhelming odds, the

might of Spain. The English did it magnificently in their folklore about the Spanish Armada of 1588.[2] The Dutch were even better. A well-known burgomaster of Amsterdam, Cornelis Hooft, stated around the year 1600 that 'in comparison with the king of Spain we were like a mouse against an elephant'.[3] For both Castilians and non-Castilians, the image of a mighty Spanish empire was a convenient one that they carefully cultivated in their folklore and their history books. On closer examination, however, it is difficult to perceive the elephant. Indeed, perhaps the most pertinent observation of all on this matter comes from the faraway Philippine Islands, where the Sultan of Jolo pointed out to a local Spanish official that 'although it is true that we may be likened to a dog, and the Spaniards to an elephant, yet the elephant may one day find the dog on top of it'.[4] It is hard to beat oriental perspicacity.

Much of our view of the past is permeated by myths and, as with those among us who still cling to the view that the earth is flat, there is no reason why we should not be allowed to go on cultivating them if they are harmless. The story of Spain's empire, however, is not harmless. The past, for Spaniards of today, is not a faraway country, it is an intimate part of the polemics that constitute their present and continues to be central to their political and cultural aspirations. The great age of empire is a crucial battleground in this area of myth and controversy. To the general reader the word 'empire' implies conquest and the extension of national power. Sixteenth-century Spaniards were quite conscious that in applying the word 'conquistador' to the adventurers of the American frontier they were claiming imperial status for the enterprise. The notion of power passed into general use, and with it the use of terms such as 'the Spanish conquest of America'. More recently, however, historians studying imperial history have begun to call in doubt the 'nationalist' interpretation that views expansion as a simple projection of the power of one country. They have preferred to ask questions about the nature of that power.[5]

'Power' does not necessarily mean just the capacity to apply force. More exactly, it can be applied to the underlying structures that made empire possible, factors such as the ability to supply finance and services.[6] In other words, who gave the men, who supplied the credit, who arranged the transactions, who built the ships, who made the guns? For example, few nations in the early modern period – as we know from the example of seventeenth-century Sweden – had the resources to launch a

policy of conquest in Europe without the help of allies. In the same way, Spaniards alone never had the resources to subjugate the continent of America. They drew on the help of others, both Europeans and natives of the Americas. 'Conquest' and power turned out frequently to be of less importance than 'business', or the ability to marshal resources, and at various stages the Spanish world enterprise took on many of the aspects of a 'business empire'.

The present book is essentially a very simple outline of some of the factors that contributed to the rise of Spain's empire. Little is said about Spain itself, because its historians have told the story many times and very effectively. My narrative is directed towards the untold story, viewing Spaniards not as the unique 'movers and shakers' who 'fashion an empire's glory' (in the words of the poet[7]), but as joint participants in an extensive enterprise that was made possible only by the collaboration of many people from many nations. The creators of empire, as presented here, were not only the conquerors from Spain. They were also the selfsame conquered populations, the immigrants, the women, the deportees, the rejected. Nor were they only the Spaniards: they were also the Italians, the Belgians, the Germans and the Chinese. Many Spaniards preferred and still prefer to consider the empire as a unique achievement of their own; these pages offer material towards an alternative view.

In a brilliant study published in 1939 the American historian William L. Schurz outlined a phenomenon that can serve most appropriately as an image of the Spanish empire. He described the fortunes of the Manila galleon, a lonely vessel that ploughed the waters of the Pacific between Asia and Acapulco for over two centuries, carrying in its hold the fortunes and hopes of Spaniards, Mexicans, Chinese, Japanese and Portuguese, a veritable symbol of the international scope of Iberian interests. The empire, like the relentless galleon, survived for centuries and served many peoples. Many of them were inevitably Spaniards, but they came also from every corner of the globe. I have attempted to narrate an imperial history rather than merely the history of one nation in an imperial role. My book presents the empire not as a creation of one people but as a relationship between very many peoples, the end product of a number of historical contingencies among which the Spanish contribution was not always the most significant. Historians of a previous generation preferred to focus only on the Spanish side of the

story, and consequently ended up ensnared in imaginary and now wholly superseded problems such as the so-called 'decline of Spain'.[8] When the mechanisms of empire are defined clearly, 'decline' as a concept ceases to have any meaningful place in the picture.

Only by considering the role of all the participants can we begin to understand the unprecedented scenario that was beginning to develop. It may be helpful to begin at the end, by offering some conclusions. The first main conclusion is fundamental: we are accustomed to the idea that Spain created its empire, but it is more useful to work with the idea that the empire created Spain. At the outset of our historical period 'Spain' did not exist, it had not formed politically or economically, nor did its component cultures have the resources for expansion. The collaboration of the peoples of the peninsula in the task of empire, however, gave them a common cause that brought them together and enhanced, however imperfectly, peninsular unity.

The second conclusion is equally important: the empire was made possible not by Spain alone, but by the combined resources of the Western European and Asian nations, who participated fully and legally in an enterprise that is normally thought of, even by professional historians, as being 'Spanish'. This book therefore attempts to deconstruct the role of Spain, in order to understand who really contributed to what. Fernand Braudel once described the empire of Philip II as being 'un total de faiblesses',[9] literally a total of weaknesses, and I have deliberately looked at this side of the picture. In the process, the role of other Europeans is emphasized, for empire was always a joint enterprise. A scholar has recently reminded us that 'European expansion, and more particularly the overseas imperial systems that followed upon it, were functions of general improvements in technology and Europe's resulting ability to produce goods and services more efficiently than the rest of the world'.[10] The technology was, as we know, normally European rather than Spanish.

Two generations ago Américo Castro, in attempting to assess the Spanish contribution to civilization, affirmed with good reason that 'no significant innovation ever originated in Spain'.[11] Religious ideas, humanism, technology, science, ideology, all came (he said) from outside. His views echoed those of the great neurologist Santiago Ramón y Cajal, who also recognized that 'science, industry, agriculture, commerce, all aspects of thought and work in the epoch of Charles V, were

wholly inferior to those of Europe'.[12] Yet it was this passive Iberian culture that had the ability to produce world power. Spain developed thanks to what it received from outside, but at the same time Spaniards made use of their own essential character in elaborating the path that led them to imperial status. My presentation, it should be noted, explicitly rejects the fashionable view that Europeans were the basis of power, and that some sort of miracle in Europe gave it world supremacy.[13] Neither do I accept the view, elegantly argued by some historians, that Europe's role in the world was based on the 'absolute superiority of western weaponry over all others'.[14] The reader will see that for me the Spanish empire was created no less by native Americans, Africans and Asians, than by Europeans.

The chronology adopted here needs a brief explanation. Though its origins were earlier, I place the creation of empire only in the mid-sixteenth century, when the Castilian state began to seize the initiative from the many explorers, adventurers, missionaries and entrepreneurs who had made the whole venture possible. Unlike other empires both before and after, there was little conquest and expansion, for the Crown already claimed that it possessed, by God-given right, most of America and a good part of Asia, in addition to its associated territories in Europe. The task was to consolidate what it already in theory possessed. The subsequent two centuries (with which this book is principally concerned) were a challenging and unprecedented exercise in coming to terms with the problems of imperial power. Despite the rude shock represented by the Treaty of Utrecht (1713), Spain went on to affirm its right to empire until the historic Treaty of Paris (1763), which recognized its claims and confirmed the extent of its control. All the factors that produced the fragmentation of the empire were already in place by this date, making it a logical point at which to round off the narrative.

It is hardly necessary to say that only a fraction of the story is told here, and, for example, the fascinating new advances made in the history of the North American Indian have barely been touched on in my pages. This may not be enough for more demanding readers, or for those seeking a fine array of impressive bibliographical references. To them I may point out that an adequate survey of the entire theme would have been impossible to contain within the dimensions of one volume. 'The writer rash enough to make the attempt', commented Steven Runciman

about a similar survey of his own, 'should not be criticized for his ambition, however much he may deserve censure for the inadequacy of his equipment or the inanity of his results'.

It is important to stress what this book is not. It is not a narrative of the Atlantic empire, like J. H. Parry's masterly study (1966), nor is it an account of Spanish foreign policy in Europe (a much neglected subject). Neither is it intended to be in any way a work of controversy; the Spanish empire disappeared hundreds of years ago and it would be inane to polemicise about it now. I have been sparing in the use of names, technical terms, dates and statistics. Specialized terms and monetary values are explained in the glossary. The capitalized words Empire and Imperial are used here to refer only to the Holy Roman Empire of Germany; the non-capitalized words empire and imperial are used for the Spanish dominions and for other contexts. Citizens of the peninsular kingdoms are often identified by their places of origin in order not to sow confusion by imprecise use of the adjective 'Spanish'. For ease of expression, I have retained the words 'Indian' for natives of the New World, 'African' for natives of Africa. Place names are given as we now know them, e.g. 'Mississippi' rather than the old Spanish name of 'Espíritu Santo'. In the complex case of the Netherlands, I have made free use of the various terms used at the time, but tend to refer to 'Belgium' when talking of the Southern Netherlands. Most Spanish names are given in their authentic form; by contrast, I have usually stuck to traditional English usage (e.g. Montezuma) for transliteration of names in other languages such as Quechua, Arabic and Chinese. It is evident that an adequate bibliography would occupy the same length as the book itself; I have therefore restricted footnote references.

The begetters of this volume, who come first in my listing of thanks, are all those scholars of a previous and of my own generation, too numerous to name in this preface, whose painstaking researches are the foundation of my exposition and whose labours are gratefully acknowledged in the footnotes. Without their work this book could not have been written. I must next thank the Higher Council for Scientific Research (CSIC) for its financial support. My special thanks go to the personnel of the library of the Institució Milà i Fontanals (CSIC) in Barcelona, for their help in diligently obtaining for me the loan of essential books. As always, I have profited from the intellectual alertness and valuable criticism of my wife Eulàlia.

This modest work will, I trust, enable the reader to appreciate the contribution across time of the many individuals and nations who created, collaborated with and suffered under the first globalized enterprise of modern times, the 'Spanish' 'empire'.

Barcelona 2002

EMPIRE

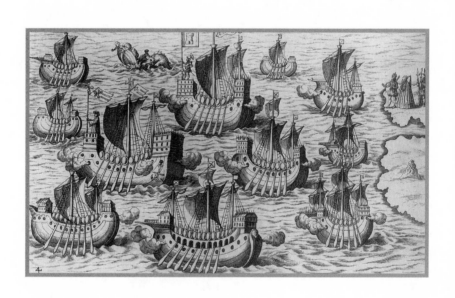

I

Foundations

The money from our realms alone would not be sufficient to
maintain so big an army and fleet against so powerful an enemy.
Ferdinand the Catholic, July 1509

In a small ceremony in the year 1492 at the university city of Salamanca,
in north central Spain, Queen Isabella of Castile was presented with
the first copy, just off the press, of the humanist Antonio de Nebrija's
Grammar of the Castilian language. She was slightly puzzled, and asked
to know for what it served. Five years before, she had been presented
with a copy of the same author's textbook of Latin grammar, and had
found that to be undeniably useful; it had certainly helped her with her
own earnest and not always successful efforts to learn Latin. But a
grammar of one's everyday spoken tongue, as distinct from the formal
study of a language used by professional people and lawyers, was some-
thing different. No other European country had yet got round to produc-
ing such a thing. Before Nebrija could reply, the queen's confessor, Fray
Hernando de Talavera, bishop of Avila, broke in and spoke on his behalf.
'After Your Highness has subjected barbarous peoples and nations of
varied tongues,' he explained, 'with conquest will come the need for
them to accept the laws that the conqueror imposes on the conquered,
and among them will be our language.' It was a reply that the queen
could understand, for in the preceding months she had been actively
engaged in military operations in the lands to the south of Castile, and
the idea of conquest was uppermost in her mind.

In the preface that he subsequently wrote for the *Grammar*. Nebrija
followed through Talavera's line of thought and claimed that 'I have
found one conclusion to be very true, that language always accompanies
empire, both have always commenced, grown and flourished together.'

3

The sentiment was, by then, a commonplace; Nebrija copied the phrase from the Italian humanist Lorenzo Valla. The meaning of the reference was also no novelty, and reflected in good measure Nebrija's concern to advance his career by keeping on good terms with the government of the day. 'Language', in this context, was not limited to vocabulary and grammar. It implied, rather, the imposition of culture, customs and above all religion on subjected peoples. Language was power. Victors, as the Piedmontese humanist Giovanni Botero was to write a century later, 'would do well to introduce their own tongues into the countries they have conquered, as the Romans did'. Over the next few generations, as Castilians came into contact with other peoples, they found that the problem of communication was a fundamental challenge. Talavera himself was to discover, from his experiences in the formerly Islamic territory of Granada, that conquest could not easily be followed by changes in laws or language. The task of understanding, and being understood, had to be resolved before power could be successfully imposed.

It was not an assignment that the Castilians could take on alone. Nebrija's *Grammar*, like everything he and his humanist colleagues in Castile did, leaned heavily on foreign influences and expertise. Since the 1470s Spain had begun receiving the new invention of the printing press, brought in by Germans. The entire printing industry in Spain until the early years of the next century was almost exclusively a foreign enterprise,[1] with Germans predominating but with an occasional French and Italian printer as well. It helped to connect the Spanish peninsula to the cultural activity of the Renaissance in Europe. But it also had an important political role, for among the first pieces of work produced by the presses for distribution to the public in Castile were the texts of royal decrees. Isabella from the beginning extended her patronage to the presses, financed their work and protected them with special privileges. Spaniards, however, were slow to develop the new invention. Scholars found it hard to get native printers with the expertise to print their works. 'Alas,' lamented a Castilian humanist in 1514, 'that we have not yet been visited either by the prudence of an Aldus or the proficiency of a Froben!'[2] The complaint was a reflection on one of the problems that came to affect Spain's political future profoundly: its technological inexperience. A single small example will serve. Though Castilians were the first to have contact with the natives of the New World, the first

4

drawing from life of an American Indian was done not by a Castilian but by a German, Christoph Weiditz, who encountered one in Spain in 1529.[3] The first books to be published in the New World were also the work of a German, Hans Cromberger of Seville, whose agent, the Italian Giovanni Paoli, issued the first printed book in Mexico in 1539.[4] In other respects as well, Castilians were slow to respond to the challenges of the age. Among the few pioneering Castilian printers was Miguel de Eguía, who complained a few years later that Spaniards depended on foreigners for printing and that authors had to wait for their books as if they were gifts from America.[5] Though native printers eventually set up successful businesses, over the next two generations those who wished their books to be well printed took them abroad personally to France, Flanders and Italy.[6]

Foreign expertise was crucial. Fostered in its early stages by German printers, Renaissance learning in the Iberian peninsula owed its success in part to the training that Spanish scholars had received in Italy, in part to the numbers of Italian and Sicilian scholars who came to teach and sometimes to settle.[7] The humanist Peter Martyr d'Anghiera, the papal diplomat Baldassare Castiglione, and the Sicilian scholar Luca di Marinis (known in Castile as Lucio Marineo Siculo) figured prominently among the Italian visitors. In addition to the strong native influences in peninsular culture, for the next half-century scholars from all parts of Spain looked to and accepted the literature and learning that came from abroad. When in 1534 the Catalan poet Joan Boscà published a Castilian translation of Castiglione's book *The Courtier*, his fellow poet and friend Garcilaso de la Vega declared it to be 'perhaps the first work written in Spanish worthy of a learned man's attention'. Significantly, it was translated from Italian. The creative impulse became closely tied to the development of international learning, and Castile began to develop its capacities in the light of its experience with other peoples.

The Spain in which Nebrija lived was, in many senses, on the periphery of the continent of Europe. The Romans had always considered Hispania to be the edge of the world. The passage between the Pillars of Hercules – what we know as the straits of Gibraltar – led out, their poets explained, to an impassable sea of darkness. The Iberian peninsula therefore became the final destination of all the great expansionist civilizations. Celts, Phoenicians and Romans made it their home and settled among the

native peoples. In the eighth century after Christ, Muslim invaders from north Africa swept up through the straits of Gibraltar and began a conquest that gave them three-quarters of the peninsula. By the tenth century the caliphate of Córdoba was a sophisticated, thriving empire, and the Arabs left a permanent imprint on the country. The small indigenous Jewish minority managed to survive under the Muslims, as it later did under the Christians who many generations later reoccupied the greater part of the territory and left the Muslims in control of only the south, known as al-Andalus. Hispania conserved a rich and complex heritage of political forms, languages and creeds that made it impossible for any unity to emerge within the peninsula. It is not surprising that contemporaries looked hopefully for signs of this unity. It would, they thought, bring them peace and a sense of purpose. In the event, co-operation came about only with dedication to great common enterprises beyond their own frontiers.

The territory known as Spain consisted of two main political units, the Crown of Castile and that of Aragon. Their rise to empire is, by common agreement, traced to the political accords that put an end to the long decades of civil war during the fifteenth century. The claimant to the throne of Castile, Princess Isabella, had the support of a group of powerful nobles, who during ten years of conflict backed her claim to succeed to the crown after her half-brother Henry IV. Various projects to marry the princess to powerful nobles ended when in January 1469 she agreed by treaty to marry the son of King Juan II of Aragon, the seventeen-year-old titular king of Sicily, Ferdinand. She herself was aged eighteen. Ferdinand travelled across the peninsula in disguise, with only a few attendants, until he reached the safety of the territory controlled by Isabella. The marriage was celebrated on 18 October 1469, in a simple ceremony at Valladolid. For some time to come, Ferdinand had little effective political power, since the realms he subsequently inherited in Catalonia were also involved in a civil war (1462–72). Isabella was recognized as queen of Castile in 1474, but the military struggles continued up to 1479. In this year Juan II of Aragon died and Ferdinand succeeded him on the throne. The young monarchs were at last able to set about pacifying their realms.

The lands they ruled were by no means a promising inheritance. Civil war had ended, but the kingdoms continued to be beset by instability. The countryside was effectively in the hands of the nobles, warlords who

controlled the rural economy and enjoyed the allegiance of thousands of vassals. In order to survive, the crown had to make alliances. With firmness, the monarchs began to develop institutions and mechanisms that would enable them to collaborate with the nobles, the cities, the Church and the commercial sectors. They enjoyed few economic resources, however. Spain was a poor region that suffered from extremes of climate, bad land distribution, poor communications, and inadequate raw materials. The main industry was the wool trade, with Spanish wool going principally to northern Europe. In return the peninsula imported many of its basic necessities, especially textiles, grain, armaments, paper and small manufactures.[8] In addition to internal tensions in their states, the new rulers were faced with military threats from neighbouring France and Portugal, as well as from the emirate of al-Andalus, which had its capital at Granada and commanded the greater part of the coastline facing Africa. With a total population of perhaps 5.5 million people around the year 1500, Castile and Aragon appeared destined to remain as two more small states marginal to the life of Europe. Yet Ferdinand and Isabella, with few means at their disposal, were able to bring peace to their kingdoms and initiate overseas enterprises.[9] Castile, with eighty per cent of the country's population and two-thirds of its territory, inevitably became the basis of their power.

When the civil conflicts ended in Spain, the monarchs brought peace by the brilliant strategy of organizing rather than eliminating violence. In parts of northern Castile, they backed the formation of urban vigilantes, known as Hermandades (brotherhoods), whose task was to execute rough and ready justice on delinquents and who became famous for their brutality. They soon also set the entire south of Spain on a war footing, actively encouraged citizens to keep arms, and took steps to raise local militia, partly for peacekeeping and partly to offset a new threat from the Muslim rulers of al-Andalus. Commentators quickly recognized them to be efficient rulers. They took care to be present at all times wherever they were required, and in their ubiquity lay the unique contribution they made to the strengthening of royal authority. They moved around their realms tirelessly, certainly the most-travelled rulers of their time in Europe. In 1481 Isabella accompanied her husband to visit the Crown of Aragon (which comprised the provinces of Aragon, Catalonia and Valencia) and was confirmed as co-ruler. They did not return for six years. During their absence viceroys ruled the provinces

in their name. Ferdinand spent most of his time in Castile, where he was in charge of the wars against Granada, and where the Cortes had promised support only on condition that he resided there. In a total reign of thirty-seven years he spent less than three in Aragon proper, only three in Catalonia and a mere six months in Valencia. Isabella, for her part, was almost permanently resident in Castile. During her reign she visited every corner of the kingdom, covering in some years well over two thousand kilometres of terrain. Few residents of Castile did not see her directly at some time in their lives. The judges of the royal council travelled with her and she dispensed justice personally, even in small towns and villages. Ferdinand continued to handle all business of Aragon through his team of travelling secretaries. Both rulers used their presence to impose their authority and pacify the country. The policy undoubtedly worked: 'everyone trembled at the name of the queen', a foreign visitor reported in 1484. However, it was a personal monarchy based not on fear but on collaboration. The rulers used their presence to build up alliances, and nobles who had warred against each other were encouraged to sink their differences in a common cause. The élite came to recognize the achievement of their king and queen. One of the grandees, the admiral of Castile, reminisced years later in 1522 that 'they were rulers of our realm, of our speech, born and bred among us. They knew everybody, gave honours to those who merited them, travelled through their realms, were known by great and small alike, and could be reached by all.'

At every level, their subjects were made to feel that the crown was with them. This was particularly important in the case of the minority communities, for the kingdoms of the Iberian peninsula were the only ones in Western Europe to recognize the legal existence of three religions: Christianity, Judaism and Islam. The many small Islamic communities in Castile and Aragon, remnants of a great medieval culture, were usually under noble rather than royal control. By contrast the small Jewish community was normally under royal jurisdiction. With the help of their advisers, Ferdinand and Isabella put into effect an impressive series of alliances that achieved political stability without altering the traditional structures of power. They made laws, but only through the traditional Cortes; they raised taxes, but always with the consent of the taxpayers; they punished crime, but only through the machinery that existed in the towns. The achievements of the Spanish rulers soon became legendary.

Through collaboration between their respective crowns, they laid the basis for the emergence of a political community that chroniclers termed 'Spain' or 'the Spains'. They brought an end to the civil dissension that had torn the peninsula apart, and diverted the militant spirit of the nobles into foreign wars. Above all, they laid the foundations of expansion overseas. The aspiration had already existed in the imagination of their supporters, usually clergymen, one of whom foretold that the rulers 'will possess universal monarchy'.[10]

The expansion of Spanish influence was an achievement that impressed contemporaries and gave rise to exaggerated propaganda in Castile. Looking back on his successes years later in 1514, the king claimed that 'the crown of Spain has not for over seven hundred years been as great or as resplendent as it now is'. Nebrija, a persistent spokesman for kingly power, wrote that 'though the title of Empire is in Germany, in reality the power is held by the Spanish monarchs who, masters of a large part of Italy and the Mediterranean, carry the war to Africa and send out their ships, following the course of the stars, to the isles of the Indies and the New World'. The king, never one to minimize his own achievements, had a solid confidence in his destiny. He was also stimulated by the reassurance from a visionary nun that 'he was not to die until he had won Jerusalem'.

Military success opened up seemingly endless possibilities. The views won favour in the king's circle, and became even more firmly established a century later, when it became clear that the partnership of the Spanish kingdoms had been achieved during his reign. The opinion prevailed that Ferdinand and Isabella had made Spain great and established the foundations of the universal empire. It is reported by Baltasar Gracián, the seventeenth-century writer, that Philip II one day stopped before a portrait of Ferdinand and commented, 'We owe everything to him.' In the century after Ferdinand's death, through their writings the historians Jerónimo de Zurita and Juan de Mariana firmly asserted the claim that he had been the creator of Spanish imperial power. A generation after them, Fernández de Navarrete confirmed that the king 'not only set up our government, he extended the empire to Italy and the New World, thereby beginning the greatness of this immense monarchy'. 'King Ferdinand', agreed Pedro Portocarrero in 1700, 'was the one who established the empire.' The imperial idea took root firmly in Spain's history, side by side with an imperishable legend about the greatness of the monarchs.[11] It

seemed, from the Castilian point of view, to be a unique achievement, unequalled by any other nation in Europe.

What were the roots of the 'imperial' aspiration that Spain embraced? The word 'empire' (*imperium*) in the early sixteenth century still retained its old Latin sense of autonomous 'power' rather than its later sense of territorial 'dominion'. In Castile in 1135 King Alfonso VII had been crowned as 'emperor' and had been known as 'emperor of Spain', a title that reflected his pretensions but not the reality of his power. In the time of Ferdinand the Catholic, the notion of 'imperium' continued to fascinate European rulers. The most commonly recognized 'emperor' in Europe was the ruler of the Holy Roman Empire of the German Nation, a position normally reserved for Germans. The post was elective, so that other European rulers also yearned after the title and could offer their candidature. By the time of the Reformation, an adviser of the king of England, Henry VIII, was able to assure his master that England too was an 'imperium' in its own right. As we have seen, Nebrija, like other Castilians, felt that Spain did not need any empty titles of empire, for it already had the substance of 'imperium'.

The reality of power in Spain was very much less comforting than royal propaganda claimed. Ferdinand of Aragon's authority was more that of a constitutional ruler than of an imperial conqueror. In the peninsula the three provinces of the Crown of Aragon over which he ruled were wholly autonomous states, each with its own laws, taxes and parliament. He was also king of Sicily and Sardinia, and had hereditary claims to the crown of Naples, which he came to rule after 1504. Since all these realms were independent of each other, the king had no way of creating a common government, administration or army. His marriage to Isabella of Castile did not resolve the problem. Castile and Aragon remained as independent entities in every way. The notion of 'Spain', found commonly in speeches and writings and used habitually since medieval times, referred to the association of the peoples in the peninsula; it had no concrete political meaning, any more than the words 'Germany' or 'Italy' had for the people of those parts. The Aragonese writer Diego de Valera, in a work dedicated to Isabella in 1481, wrote that 'Our Lord has given you the monarchy of all the Spains', a term in which he also included Portugal. The rulers constantly used the word 'Spain' but because of its imprecision never put it in their formal title,

calling themselves instead 'King and Queen of Castile, León, Aragon, Sicily' and so on. The union between these realms was always precarious. When Isabella died in 1504, Ferdinand had to resign his position as ruler of Castile to his daughter Juana, and then left the peninsula for his Italian realms. He returned only in 1507, and agreed to resume governing Castile because of Juana's mental health.

Because there was no overall 'Spanish' government, Ferdinand was forced to operate through a network of personnel and alliances that made it more possible for him to rule over his diverse territories. He thereby helped bring into existence the entire web of relationships that came to characterize Spanish power. It was a web, moreover, in which non-Spaniards frequently played a decisive role, because the Spanish realms were not in a position to supply all the needs of the monarchy. Castilian commentators at the time paid little attention to the existence of the network, limiting their accounts mainly to acclaim of the exploits of their own people. In this way they successfully created a highly distorted image of what was happening. The truth was that, despite the crucial role of the Castilians, empire was never a purely Castilian enterprise. A case in point was the rivalry with Portugal.

Both in the Atlantic and later in Eastern Asia the Castilians arrived after the Portuguese, benefited from their expertise and ended up collaborating closely with them. The Portuguese had intervened directly in Castilian affairs during the civil wars of the fifteenth century, in an attempt to place their candidate on the throne. They had also been active at sea, occupying the Atlantic islands of Madeira and the Azores. No sooner was she recognized as queen in 1478 than Isabella agreed to help Castilian nobles and adventurers who wished to challenge Portugal's expansion down the coast of Africa. Over half a century before, French and Castilian nobles had made a tentative occupation of some of the Canary Islands. The four smaller islands (Lanzarote and Fuerteventura, with Ferro and Gomera) were confirmed in the ownership of the noble Herrera family by a legal decision of the Castilian royal council in 1477, and remained in their control till the end of the eighteenth century, but the three larger islands (Grand Canary, Palma and Tenerife) were eventually yielded to the Castilian crown. From 1478 a few Castilian nobles, financing themselves but enjoying crown support, joined in the enterprise of recruiting mercenaries to take possession of the archipelago.

There was strong resistance from the few natives, an isolated people who were hunters rather than farmers and still lived in caves. Even with the few weapons available to them, they managed to hold the invaders off for several years. The biggest island, Grand Canary, was not subdued until 1483. The hero of the conquest was Alonso de Lugo, a man of considerable wealth and military experience, who first went out to the islands in 1479 and in 1491 secured from the king the supreme command of royal expeditions. He was largely responsible for securing Palma, where he landed in September 1491. He succeeded in controlling it by the summer of 1492, after collaboration from many of the natives, who were deeply split by internal tribal quarrels. The next year he landed in Tenerife with a large number of soldiers and a few horsemen, supplemented by native auxiliaries. But the force was wiped out and the island not brought under control until 1496. When Lugo finally returned to Castile in 1497 he was treated as a hero, created adelantado and granted the governorship of La Palma and Tenerife. After further campaigns in the islands he retired to spend his last days in Tenerife, where he died in 1525, the first and least known of the conquistadors who created the Spanish empire.

Occupation of the islands had a disastrous impact on the indigenous population, whose numbers were significantly reduced by the war. In search of labour to work the difficult volcanic terrain, the invaders began enslaving the local communities of Canarians, Gomerans and Guanches.[12] After protests by the natives, the Castilian crown issued orders to restrict the practice of slavery. The orders were not observed, and there are records of six hundred slaves from the Canaries being sold in Valencia alone between 1489 and 1502.[13] The total population loss in the islands was in excess of ninety per cent. Natives collaborated actively in the task of conquest, and Spaniards depended on them in expeditions against natives of other islands. Some were even recruited in 1510 to go to Italy to fight in the wars there. By the mid-sixteenth century an inquisitor calculated the total number of original natives left in the islands did not exceed 1,200 families, but there was also a growing mestizo population 'since very few women came with the conquistadors'. A generation after the conquest the social and economic circumstances of the natives had greatly changed. The colonization also had a negative effect on the environment: trees were used up for building and navigation, and water became difficult to find.[14] It was a foretaste of the

problems that would ensue when other tropical islands came to be occupied by the Spaniards.

The occupation of the Canaries offered a glimpse of the way in which the Spanish empire would evolve. Though Castilians pioneered the enterprise, the Portuguese, Italians, Catalans, Basques, Jews and Africans played a very substantial role; and Moriscos and northern Europeans also took part.[15] Funds for expeditions were made available through contracts between adventurers and bankers, because expansion was always a question of business, with attendant risks. The Canaries undertaking was made possible by financing from Genoese bankers, principally the Ripparolio, with the close collaboration of the Seville merchant Juan de Lugo. Francesco Ripparolio financed the conquest of Tenerife and of Palma,[16] and his firm set up the first sugar mill in Grand Canary. The Genoese directed the economy of the islands. 'Without me', one of them claimed, speaking of Tenerife, 'this island would not be as well peopled as it is.'[17] In Grand Canary, the queen noted in 1499, over half the land used for sugar production was in Genoese hands. In the early sixteenth century various Genoese settlers were members of town councils and took part in the government of the islands, even though they were, as foreigners, formally excluded from such posts. Without the capital investment of the Genoese, and the manpower of Portuguese immigrants, the islands would have remained a barren conquest. The Portuguese, effectively, were the largest non-Castilian community in the islands.[18] Their labour, supplemented by that of natives and imported black slaves, was essential to the success of Spain's first colonial venture, and continued to be important in the decades that followed, for immigration from Spain began to fall off in the 1520s, as adventurers looked instead to distant and potentially more exciting horizons opening up in the New World.

The incessant activity of the king and queen reflected that of their society. The Iberian peninsula, like other parts of Europe, was opening itself gradually to experiences of the outside world. There had always been a high degree of movement and migration among Spain's population.[19] Some of the movement was seasonal and temporal: young people went to the towns to learn a profession, family men went to earn money helping with the harvest in other areas. Typical was the Extremadura village where it was reported that 'most of the people are poor, and

they go to Andalusia to earn enough to eat and are gone most of the year'. But there was also a substantial permanent migration: villagers moved to other villages in search of a livelihood or a life partner, country dwellers moved to the expanding towns. Few moved beyond the peninsula, yet that would soon change. The new reign began to offer unprecedented opportunities for movement and enterprise.

The famous year 1492 stands out as one in which the foundations of Spain's international reputation were laid. On 2 January the army under King Ferdinand and Queen Isabella entered the Muslim city of Granada, which was now integrated into the Crown of Castile. The military triumph inspired among Spaniards a wave of messianic optimism, which the rulers exploited in order to decree on 30 March the expulsion of the Jews of their realms. A few days later, in mid-April, they issued a commission to a Genoese sailor, Christopher Columbus, who had been present at the surrender of Granada because he was hoping to win the support of the crown for what many royal councillors thought to be a chimeral enterprise. However, the queen gladly gave her support to his plan for exploration across the western seas. By late summer, when the expulsion of a proportion of the Jews had been completed, the Christian rulers were bursting with confidence. In recognition of their achievement at Granada, and not least in order to obtain their military aid in Italy, the grateful pope Alexander VI in 1494 awarded them the title, which all rulers of Spain subsequently used, of 'the Catholic Monarchs'. Ferdinand and Isabella spent the latter part of 1492 and most of 1493 in the Crown of Aragon, mainly in Barcelona, where in spring 1493 they received an excited Columbus, who reported that he had just returned from his voyage and had discovered a new way to the Orient.

In their different ways, the ten-year-long Granada campaign and the pioneering voyages of Columbus were the first significant steps in the move towards an imperial enterprise. The voyages, however, elicited little or no reaction for very many years. By contrast, the wars had a resounding impact and propelled Castile to the forefront of international attention. An enthusiastic Castilian writer, Fray Iñigo de Mendoza, imagined that King Ferdinand would not stop with the conquest of Granada but would extend his successes to conquering Africa, defeating the Turks and dominating the world.

Last remnant of the Muslim power that had once covered three-quarters of the Iberian peninsula, the emirate of al-Andalus in the 1480s

had a population of some half-a-million people, immersed in small conflicts with neighbouring Christians and rent by its own political and clan divisions. In 1482 a border quarrel led to Christians seizing the Muslim town of Alhama. The action escalated tensions and initiated a campaign which the crown adopted as its own and subsequently transformed into a drive to conquer the whole territory. For a decade the struggle harnessed the energies of the population of southern Spain in providing soldiers and producing food and supplies. The medieval wars against the Muslims had come to an end over two hundred years before, but the old antagonism now took on new life.

By themselves the Castilians were not equipped to achieve the conquest of Granada: they had insufficient money, men and weapons. As in other European states the armed forces were not permanent but recruited only for a campaign or for a season. The forces confronting al-Andalus were made up of independent units – supplied by the crown, the nobles, the Church, and the towns of the Hermandades of Castile – that served for limited periods and disbanded after each phase of the campaign. Most surprising of all, the Castilians did not possess adequate naval power, and never launched concerted attacks on the vulnerable seacoast; all their campaigns were land-based.[20] A number of Genoese vessels were contracted to reconnoitre the coastline, in case of intervention from Muslim Africa. The only substantial naval support appears to have been supplied by Ferdinand's subjects, the Catalans, with support from the Neapolitans.[21] The fleet of galleys was commanded by Galcerà de Requesens, who enjoyed the Neapolitan title of count of Trivento. Their presence was especially notable at the siege of Málaga. 'The royal fleet', recorded a chronicler of this time, the curate of Los Palacios near Seville, 'laid siege to Málaga with a host of galleys and vessels and caravels, carrying many soldiers and arms. It was a wonderful sight to see the royal army before Málaga by land, while at sea the great armada kept up a continuous siege.'[22] The war was by no means a continuous one, but rather – like most medieval wars – a long-drawn-out series of clashes and encounters, with extended intervals when nothing happened or when quite simply the soldiers went home to rest or to escape the heat of the summer. There were no pitched battles;[23] attention centred on capturing specific towns, and the conflict took the form of skirmishes, raids and sieges. Periods of hostility alternated with periods of normal, peaceful contact.

Success was assured by international support, for the war also excited the imagination of Christian Europe. The crown's prestige was enormously enhanced by the campaign, which took on the status of a European crusade, blessed by the papacy and with funds from all over the continent. Ferdinand was intelligent enough deliberately to exploit the religious motive. In 1481 he declared that his aim was 'to expel from all Spain the enemies of the Catholic faith, and dedicate Spain to the service of God'. In 1485 he claimed that 'we have not been moved to this war by any desire to enlarge our realms, nor by greed for greater revenues'. The popes from 1482 onwards granted generous funds (through a levy known as the cruzada or 'crusade', conceding special graces to those who contributed to or took part in the campaign). 'Without such subsidies', reported the Florentine diplomat Francesco Guicciardini, who was resident in Castile shortly after, 'this king could not have taken Granada.' A recent historian has confirmed that three-quarters of the crown's costs in the war were covered by Church taxes conceded by the papacy.[24] Extra funds also came from the financiers in the Jewish community of Castile. Italian financiers, already resident and active in Seville, paid for entire campaigns: the crucial siege of the city of Baza, for example, was financed by forty Genoese from Seville and over twenty from Cadiz.[25]

With the help of Italian financiers the king contracted Swiss mercenaries, the most respected infantrymen in Europe, whose battle tactics won the admiration of Castilian military commanders. Foreign volunteers arrived from all over Europe to serve in the holy war. 'Many foreigners', reported a sixteenth-century soldier, 'came to Spain from France, Italy, Germany and England',[26] seeking their glory in Spain. Among the foreign detachments was an English one of some three hundred archers, commanded by Sir Edward Woodville, brother of the queen of England.[27] Perhaps the most decisive foreign help came in the form of heavy artillery, imported from Italy and Flanders and operated mainly by Milanese and German technicians. Used regularly from 1487, so that by 1491 the army had over two hundred units, the cannon were able to demolish medieval fortifications and eventually ensured victory over the Muslims. In the early years of the struggle the latter had no similar weapons but subsequently obtained and also used them to great effect.[28]

The war created a common purpose that brought the peoples of Iberia

together. It was, after the medieval anti-Muslim wars known to us as the 'Reconquest', the first great military enterprise on peninsular soil in two hundred years. The conflict encouraged the several nations of 'Spain' to forget their differences and accept the leadership of the crown, whose prestige was enhanced with the aid of suitable propaganda. Catalans, Valencians and Aragonese volunteered to take part in a struggle that was in theory the responsibility of Castile. Money came from the Crown of Aragon, both from the Cortes and from sale of the cruzada bull. In 1488, for example, the Cortes of Aragon in Saragossa voted sums 'for the war against the Muslims'.[29] 'Who would have thought', remarked Peter Martyr d'Anghiera when he observed the Christian army, 'that the Galician, the proud Asturian and the rude inhabitant of the Pyrenees, would be mixing freely with Toledans, people of La Mancha, and Andalusians, living together in harmony and obedience, like members of one family, speaking the same language and subject to one common discipline?'[30] The collaboration among Spaniards – and the significant reliance on a common language, Castilian – set an important precedent for subsequent co-operation in wars, explorations, and settlements. Spaniards fought side by side in the struggle for Granada, and would continue to fight together in Italy and later in America. Writers of the time were quick to accept the feeling of a common identity, among them Diego de Valera, who dedicated his *Chronicle of Spain* to 'the lady Ysabel, queen of Spain'.

The increasing sense of unity among embattled Spaniards was accompanied, at the same time, by an increased distancing from the peoples they were fighting to subdue. The notion of a 'crusade', backed up by the papacy, helped to convince them that their cause alone was just, and that the enemy 'infidels' deserved no quarter. From 1488 many of the Spanish soldiers wore crusader crosses on their uniform, and a huge silver cross (sent to Ferdinand by the pope) was carried before the troops. In a way that had occurred under the classic civilizations of Greece and Rome, the victors during the Granada campaign also castigated some of the defeated by reducing them to slavery. Enslavement was a long-known practice in Mediterranean warfare between Muslims and Christians, and normally meant the temporary loss of liberty rather than a permanent change of status. It became a significant addition to the very small degree of domestic slavery (mainly of blacks from sub-Saharan Africa) that had existed in late medieval Spain.

The decisive factor that ensured the defeat of Granada was the collaboration of the Muslims in their own downfall. It was a story that would be repeated time and again, in various forms, during the long saga of Spain's empire. Since the 1460s there had been a serious split in the ruling Nasrid dynasty between the ruler, Abu'l-Hasan Ali, and his son Muhammad (whom the Castilians knew as Boabdil). The latter had seized Granada in 1482, leaving his father to rule the kingdom from Málaga; both, however, continued to defend themselves against attacks launched from Christian territory. In 1483 Boabdil was captured by the Christians during a daring incursion his men made towards Lucena. From this event, a Muslim chronicler commented later, 'stemmed the ruin of our homeland'.[31] The reason was that Boabdil accepted the opportunity to ally himself secretly with Ferdinand in order to overthrow the opposition to him in Granada, led now by Abu'l-Hasan's brother and successor Muhammad, known as al-Zagal. For many Muslims, there was no problem in collaborating with Christians; it had been part of the medieval pattern of coexistence in Spain. Ferdinand, indeed, continued the pattern by promising to 'preserve the law of Muhammad' in the towns that surrendered to the Christians during the 1480s. From 1485 Boabdil, now free, established himself in the Albaicín sector of Granada, and led an internal struggle against al-Zagal's supporters in the rest of the city. Whether or not he remained a secret ally of the Christians was of little importance. The civil conflict that he provoked made it almost impossible for al-Zagal to conduct an adequate defence of the other cities of al-Andalus. The most lamentable loss on the Muslim side was the city of Málaga, which surrendered in August 1487 after a bloody four-month siege, an immense loss of lives and the sale into slavery of virtually all the surviving population, including women and children.[32]

The city of Baza surrendered in 1489 after its leaders had obtained favourable conditions for themselves (not, of course, for all the inhabitants) and the guarantee of their lands and property. This now became the pattern for what little remained of independent al-Andalus. In December al-Zagal handed over Almeria and Guadix on similar terms. Many Muslim leaders remained in the country and accepted conversion as the best guarantee of possession of their estates. In this way, as the Muslim chronicler reported, in the year 1489 'the land of al-Andalus finally fell into the hands of the ruler of Castile and entered into obedi-

ence to him. The only district remaining in Muslim hands was the city of Granada and the villages in its vicinity.'[33] By that year the war was, for all practical purposes, over. The sudden collapse of the Muslim cause had a ready explanation. Seeing that little was to be gained by further resistance, the angry al-Zagal wished to save what could be saved but at the same time he wished to punish Boabdil. 'He wanted to cut Granada off, so as to destroy it in the way the rest of the country had been destroyed',[34] reported the Muslim chronicler. Immediately afterwards, al-Zagal and his followers took ship for North Africa.

Granada was already ripe for plucking, torn by dissension between the supporters and the enemies of Boabdil. There had already been contacts between Boabdil and Ferdinand's negotiators, led by one of his commanders, Gonzalo Fernández de Córdoba. In the winter of 1490–91 the Christians began constructing a new settlement, significantly named Santa Fe ('Holy Faith'), in the plains six miles to the west of the city. It was here that the final conditions were discussed for the journey to be made across the Atlantic by the Genoese sailor Columbus. In October 1491 negotiations began for a possible surrender of Granada. The talks, held secretly at night in the besieged city, were led on the Christian side by Gonzalo de Córdoba. The rulers of the city were evidently in favour of a settlement, but could not be rushed because of fears of a negative reaction from the people. Boabdil, above all, wished to survive as a king, albeit under Christian rule.

Eventually both sides ratified the conditions in Santa Fe in November 1491. As had been traditional in medieval wars between Christians and Muslims, the submission took the form of 'capitulations', or surrender on agreed terms.[35] In return for delivering the city, the inhabitants were guaranteed their customs, property, laws and religion. The last of these was to be guaranteed 'for ever more'. The notion of 'conquest' was wholly absent: the Muslims were even allowed to keep all weapons except firearms. It was agreed to allow Christian troops to enter secretly on the night of 1 January and occupy key points. The date for the formal handing over was fixed for the following day, 2 January 1492, when in a glittering ceremony the king and queen, attired in Moorish dress and at the head of their assembled host, accepted the keys of the Alhambra from its last Muslim king. Four days later the new rulers of Granada officially entered their city.

The end of al-Andalus and of Muslim power in the peninsula was

celebrated with joy throughout Christian Europe. But it also created important new problems of imperial control. The vulnerable Muslim population soon found that defeat brings its own consequences, as changes were made in the economy and politics of the region, in clear violation of the capitulations. Many of the élite found life under Christian rule intolerable and passed over into North Africa. Reorganization of the territory was entrusted to Iñigo López de Mendoza, second count of Tendilla and later first marquis of Mondéjar. Hernando de Talavera, the confessor of Queen Isabella, was appointed first archbishop. He encouraged conversions by means of charitable persuasion, respect for Mudéjar language and culture, and the use of Arabic during religious services. A Morisco leader, who in his youth was page to Talavera, recalled how the archbishop went through the mountains of Granada to preach and say mass. Since there was no organ for music he made the natives play the zambra (a traditional dance), and during mass always said the greeting 'The Lord be with you' in Arabic. 'I remember this', the Morisco reminisced, 'as if it were yesterday.'[36]

The most confrontational changes occurred in religion, when in the period after 1500 many clergy began to impose Christianity by coercion. The policy of mass baptisms was encouraged by the head of the Castilian Church, Cardinal Cisneros. It provoked a brief revolt in December 1499 in the Albaicín, the Muslim quarter of Granada, which was appeased only through the good offices of Tendilla and Talavera. There were further scattered revolts in other parts of the south, through most of 1500 and into the early weeks of 1501. They presented the government with a serious policy problem. Some, including Tendilla and Cisneros, favoured harsh measures. Cisneros's view was that by rebellion the Mudéjars had forfeited all rights granted by the terms of capitulation and they should be offered a clear choice between baptism and expulsion. His personal preference was 'that they be converted and enslaved, for as slaves they will be better Christians and the land will be pacified for ever'.[37] Ferdinand, by contrast, favoured moderation. 'If your horse trips up', he told his councillors, 'you don't seize your sword to kill him, instead you give him a smack on his flanks. So my view and that of the queen is that these Moors be baptised. And if they don't become Christians, their children and grandchildren will.'[38]

Over the next few months the Muslims of Granada were systematically baptized; a few were allowed to emigrate. By 1501 it was officially

assumed that the kingdom had become one of Christian Muslims – the Moriscos. They were granted legal equality with Christians, but were forbidden to carry arms and were subjected to pressure to abandon their culture. A huge bonfire of Arabic books, ordered by a royal decree of October 1501,[39] was held in Granada. It was the end of the capitulations and of Muslim al-Andalus. 'If the king of the conquest does not keep faith,' lamented a contemporary Arab leader and scholar, Yuce Venegas, at that time resident on his estates near Granada, 'what can we expect from his successors?'[40] Gradually the minority Muslims found themselves being deprived of their identity, culture and religion; they were the earliest victims of the new imperial attitude. Thanks to these pressures, from about 1501 Granada ceased to exist as a free Muslim society and was converted into a conquered realm.

The Granada war, with its histories of suffering and heroism, was – even more than the expedition to the Canary Islands – the prototype of Castile's imperial experience. It brought Castilians into continuous conflict with their traditional enemy and encouraged them to pursue the practice of military adventure. It created a confrontation of cultures whereby Castilians disdained the customs and beliefs of the conquered. It stimulated a substantial migration: between 1485 and 1498 some forty thousand Christian Spaniards, mostly from other parts of southern Spain, entered and settled in the former emirate of Granada. Above all, it fortified the leadership of the monarchy, and convinced the nobility that they had to collaborate with their rulers. Finally, it gave Spaniards of all regions and classes a pride in the emerging nation to which they belonged. The crushing of Muslim Granada invigorated the concept of a Christian Spain.

There was a small but significant corollary to the war. The acquisition of Muslim Granada stimulated the religious authorities to reconsider the question of the Jews in southern Spain. Since 1480 the Inquisition (founded that year) had been accumulating information about the religious practices of Spaniards of Jewish origin, who were known as conversos. After several years of persecution of conversos, and the execution of scores on the charge of heresy,[41] the inquisitors appear to have felt that the fall of Granada would be a fitting moment for the crown to bring about the conversion of the Jews.

According to medieval tradition in Europe, the conversion would be the signal for the Second Coming of Christ. There were by this time few

Jews in Spain. In the Crown of Aragon, by 1492 there remained only one-quarter of the Jews of a century before. Very many had converted to Christianity because of persecution: others had simply emigrated. The rich Jewish communities of Barcelona, Valencia and Mallorca, the biggest cities in these realms, had disappeared altogether; in smaller towns they either disappeared or were reduced to tiny numbers. The famous community of Girona was, with only twenty-four taxpayers left, now a shadow of its former self. In the realms of Castile, there was a mixture of survival and attrition. Seville had around five hundred Jewish families prior to 1390; a half-century later it had only fifty. By the time Isabella succeeded to the throne, Jews in Castile totalled less than eighty thousand. In 1492 Ferdinand accepted the advice of the Inquisitor General, Torquemada, and on 31 March, while they were in Granada, they issued the edict of expulsion, giving the Jews of both Castile and Aragon until 31 July to accept baptism or leave the country.[42]

In reality, the 'expulsion' was incomplete, for well over half the Jews of Spain chose the alternative of conversion. 'Many remained in Spain who had not the strength to emigrate and whose hearts were not filled with God', lamented one Jewish contemporary. 'In those terrible days', reported another, 'thousands and tens of thousands of Jews converted.'[43] The total of Jews who left Spain for ever was relatively small, possibly no more than forty thousand, but the conversion and expulsion had significant repercussions. It reinforced the vision of the king as champion of Christendom, who would extend further the battle against Muslims and Jews and eventually liberate Jerusalem from its oppressors.

After these ideological successes, Isabella was not inclined to tolerate Muslims in the rest of her realms of Castile. In February 1502 they were offered the choice between baptism and exile. Virtually all of them, subjects of the crown since the Middle Ages, chose baptism, since emigration was rendered almost impossible by stringent conditions. With their conversion Islam vanished from Castilian territory, and continued to be tolerated only in the Crown of Aragon. The different policy adopted in the two realms demonstrated clearly that unity of religion was not an immediate priority of the Spanish crowns.[44]

It was a veritable period of policy successes for the king of Aragon, now at forty years in the prime of his life. Close to his heart was the wish to recover the Catalan counties of Cerdanya and Rosselló from France, which had occupied them thirty years before during the Catalan

civil wars. Profiting from a diplomatic alliance with England in 1489 (the Treaty of Medina del Campo), Ferdinand enlisted English military support in his favour. Fortunately the French king, Charles VIII, had his eyes set on a projected campaign into Italy, and was willing to part with the counties, which were ceded peacefully to Aragon by the Treaty of Barcelona in January 1493. The Spanish crowns from that time reigned undisputedly over all the territory between the straits of Gibraltar and the Pyrenees. The French would emerge in future years as the principal enemy of Spain, and there would be continuous conflict at the frontier in the Pyrenees, but the main field of contention would be in Italy, to which we now turn.

In order to carry out the wars in Andalusia adequately, the crown looked for new military resources. Though Castile had a long history of familiarity with the sea, it was by no means a prominent seafaring nation.[45] The unquestionable pioneers on the ocean were the Portuguese, who since the early fifteenth century had prepared the way for trade to Africa and then to Asia, establishing for themselves a key role in the spice trade.[46] Among Spaniards, only the Basques and Cantabrians, on the north coast, and the Catalans on the east, had been outstanding in their centuries-old dedication to the sea.[47] The heartland of Castile before the acquisition of Seville in the mid-fifteenth century had no direct access to major ports. The masters of maritime navigation had been the Muslims, who used this to dominate the Mediterranean and threaten the coasts of Christian Europe. The fall of Granada, however, gave the crown an opportunity to remedy its basic weakness in sea power. In 1492 the queen seized from the marquis of Cadiz his title city, which thereafter became the base for Castile's expeditions into the Atlantic. In 1502 and 1503 she seized Gibraltar and Cartagena from their respective noble owners, giving the crown for the first time a firm access to the southern Mediterranean.

The fall of Granada left thousands of soldiers without ready employment, but there were conflicts enough awaiting them in the Mediterranean. The outbreak of war in Italy soon offered them scope for action. Spain was concerned with bringing order into its own affairs and had little interest in acquiring other territories, yet events conspired to drag it into adventures just beyond its borders, principally in Italy. The Crown of Aragon had traditional dynastic interests in the western

Mediterranean. At the death of King Alfonso the Magnanimous of Aragon in 1458, his extensive domains were divided in two: the kingdom of Naples went to his illegitimate son Ferrante, and the Catalan-Aragonese crown went to Ferdinand's father Juan. In 1476 Ferrante married Ferdinand's sister Juana, a union that continued the close association between the two branches of the family. In subsequent years Ferdinand, who had his hands full with Spanish politics, found himself involved repeatedly in Italian affairs, and always on behalf of his family in Naples.

Like the territories that came to be called Spain and France, 'Italy' was a conglomerate of small states with few interests in common, divided by the lack of a shared culture, language or traditions. It was repeatedly involved in local conflicts that tended to involve outsiders, since the northern regions of the peninsula (notably the duchy of Milan, a state that extended over one third of northern Italy) were politically distinct, forming in theory part of the Holy Roman Empire. The most powerful (and wholly independent) Italian state was the Republic of Venice. All the others, even the extensive territories of the Holy See, were usually at the mercy of predators both internal and external. Outsiders through the centuries had traditionally invaded Italy from the north, by way of the Alps, and normally withdrew after leaving a trail of ruin in their wake. In the late fifteenth century a yet more pressing threat materialized from the sea, in the shape of the Ottoman empire and its North African allies, which raided the coasts of the Adriatic and the western Mediterranean. But it was France that ignited the flames of an enduring war. Its young king, Charles VIII, barely twenty-two years old and his head full of strange millennial fantasies, laid claim to the throne of Naples. In August 1494, at the head of an army twenty-two thousand strong, he crossed the Alps and invaded Italy. He had assured his alliances, especially with the duke of Milan, and in December was in Rome, where the pope was powerless to resist. In February 1495 he entered Naples to the cheers of the crowds and the helplessness of the reigning king, Ferrante II.

Since the year 1494 Ferdinand of Aragon had been trying to form an international diplomatic alliance against France. The rapid advance of the French into territory that had belonged to his family singled him out as a possible defender of the Italian states. Fruit of these negotiations was the League signed at Venice in March 1495 between the pope, the emperor, Venice, Milan and Spain 'for the peace and tranquillity of

Italy'. Meanwhile in December Ferdinand had sent ships and soldiers, under Admiral Galcerà de Requesens, to his kingdom of Sicily, and in spring 1495 sent a further detachment of two thousand men under Gonzalo de Córdoba. By June the Spanish troops had transferred to Calabria, where their mission was to help Ferrante against the French. The king of France had by now withdrawn to the north, leaving ten thousand French to defend his claims in Naples. In the subsequent campaigns against the French the Castilian troops were at their best, and Gonzalo de Córdoba's exploits earned him the name among his men of 'the Great Captain'. By the end of 1496 the Neapolitans and Castilians had together succeeded in expelling the French forces, but Ferrante died at this juncture and was succeeded by his uncle Federigo. He was the fifth monarch to occupy the throne within three years, and did little to justify hopes of a stable government in the kingdom, which was relentlessly falling into chaos. In early 1497 a truce was agreed between the two foreign belligerents, France and Spain, and confirmed formally in November by ambassadors at the Castilian town of Alcalá de Henares. By then the first hint had arisen of a plan by which the two states would occupy and divide Naples.

Charles VIII died of an unexpected accident at Amboise in France in April 1498.[48] His successor, Louis XII, did not lose sight of the claim to Naples but set himself a new objective: possession of the duchy of Milan, which he claimed through his grandmother. In 1499 the French invaded Milan, but the Spaniards kept out of the conflict. Instead they took part in a small force sent late in 1500 to help the Venetians against the Turks who were attacking Cephalonia. The expedition, consisting of eight thousand men-at-arms and three hundred cavalry in four ships and numerous transport vessels, was commanded by Gonzalo de Córdoba and sailed from Messina in September 1500, heading for the eastern Mediterranean.[49] At Zante it was joined by a French ship, and then by the main Venetian fleet carrying ten thousand men. The main body of Turks hastily withdrew, but the Christian forces laid siege to Cephalonia, where their main achievement was the capture of the poorly defended fortress of St George. By that date an important new step had been taken in Spanish policy.

On 11 November 1500, in the Treaty of Granada, agents of France and Spain agreed (as they had informally done three years before) to divide Naples between the two countries. It was the inevitable consequence

both of political instability in that realm, and of the contending dynastic claims of the two signatories. The agreement was accepted the following year by the pope, whose permission was necessary since he was formally feudal lord of Naples. Subsequent Italian writers were, with good reason, bitterly critical of the decision. The Great Captain was unhappy about it, and Spanish diplomats at foreign courts were hard put to defend its reasons. All the same, French troops from Milan under d'Aubigny invaded Naples from the north in July 1501, and Spanish troops under Gonzalo de Córdoba invaded from the south. The city of Naples surrendered without a fight, and King Federigo was sent off to exile in France. His son, Ferrante the duke of Calabria, who gallantly defended the city of Otranto against the Spaniards, surrendered in March 1502 and was sent off to exile in the kingdom of Valencia, where he was treated with the honour befitting his rank.[50]

Inevitably, the victors soon fell out among themselves, and the projected occupation turned into a direct war between the French and the Spaniards in Naples. The next two years were historic ones for the evolution of Spain's empire. For the first time ever, full-scale battles were fought by Castilian troops outside the Iberian peninsula. There were moments of pure medieval pageantry, as in the famous mounted combat of eleven French against eleven Spanish knights outside the walls of the city of Trani in 1502–3. A crowd of thousands watched the tournament, and Venetian observers were appointed to judge the result. The leading knight on the French side was the famous Chevalier Bayard, *le chevalier sans peur et sans reproche*, and on the Spanish side Diego García de Paredes. At the end of the combat, the participants embraced each other. It was still an age when firearms were not widely used, and the gallantry of medieval chivalry continued to occupy an important place in warfare.

The more substantial and bloody side of the war was fought in pitched battles, in which the French during the first months had a clear advantage. In December 1502 d'Aubigny's forces defeated the Castilians at Terranova in Calabria. But a few months later, on 28 April 1503, the troops of the Great Captain won a victory at Cerignola, and in May they entered the city of Naples in triumph. The French held out at Gaeta, and from Milan sent a force under La Trémoille to recover Naples. The final months of 1503 were occupied in a series of engagements between the French army and the Spaniards along the river Garigliano, ending in

the withdrawal of the former after a decisive encounter on 28 December. Years later the French soldier Brantôme visited the site, where his father had died. 'It was evening', he wrote, 'towards sunset, when the shadows appear more ghostly than at other hours of the day, and it seemed to me that the gallant souls of our brave Frenchmen who died there rose up from the earth to speak to me.'[51] The French were unable to hold on and finally, their garrison at Gaeta surrendered in January 1504. In March, France made a formal treaty recognizing the sovereignty of Ferdinand of Aragon over the whole of Naples.

The Italian experience laid the foundations of Castile's military repu-tation, which received high praise from an otherwise hostile Machiavelli in his *Art of War*. In turn, a soldier of the Great Captain, Diego de Salazar, copied and imitated Machiavelli's text in order to produce his *Treatise on Warfare*, the first modern Castilian treatise on the subject. The impressive series of battles with the French in Italy inspired a spate of treatises by Castilians about their own heroic exploits, gave dignity to the profession of war, and established an enduring legend about Castilian military superiority.[52] The legend was, of course, based on experience of the continuing conflict in Italy between French and Spani-ards. A case in point was the bloody battle at Ravenna in April 1512. The French suffered severe losses, but it was in effect their victory and cost the lives of five thousand Spaniards together with the capture of Ferdinand's generals Pedro Navarro[53] and the Neapolitan marquis of Pescara. The king comforted himself with the opinion, which he obtained from reliable witnesses, that 'in this battle the French have learned to fear the Spaniards'.[54] The Castilians had certainly improved their military reputation,[55] and continued to do so in subsequent engagements. When the parliament (Cortes) of Catalonia expressed satisfaction about the annexation of Naples to the Crown of Aragon, King Ferdinand reminded them firmly that they had contributed almost nothing to it and that all the glory redounded to the soldiers of the Crown of Castile.

Because of its superior manpower resources the Crown of Castile occupied incontestably the principal role in the military enterprises of Spain. But the Castilian achievement would have been impossible with-out the help of other Spaniards. The contribution of Catalans, for example, cannot be overlooked. While the campaigns continued in Naples, Ferdinand returned to Barcelona in April 1503 after an eight-year absence in the realms of Castile. He then put himself at the head of

a small army that went north to relieve the fortress of Salses, under siege by the French. The force was largely Catalan in composition,[56] but heavily reinforced by troops from Castile. The victory that they gained when they drove the French back from Salses in October was undoubtedly in part also a Catalan victory.

The Castilians built on the work of their predecessors in order to establish their military expertise.[57] The chief innovations in European warfare of the fifteenth century were in the technique of fortification, and in the infantry reforms pioneered by the Swiss. The superb work of Swiss mercenaries hired by the crown in the Granada wars seems to have inspired Ferdinand to reform his infantry by imitating them. Decrees in 1495 and 1496 laid the foundations for improvements in technique. The civilian population was encouraged to maintain public order: in 1495 it was directed that 'all our subjects, of whatever rank, should possess suitable offensive and defensive weapons'. During the spring of 1497 the use of the pike was adopted in the army, and troops were formed into 'tercios', infantry units with specific roles that were defined over the next few years in the light of their practical experience in Italy.[58] At the same time the troops began to be armed with muskets (arquebuses), an increasingly essential aspect of their new role in battle. The experience of Granada, moreover, encouraged the Castilians in Italy to make use of heavy cannon, which the French were also using to great effect. But there were few major changes in the methods of war within the Iberian peninsula, and it is difficult to identify any military revolution taking place in Spain.[59]

If the Granada wars were Spain's first step towards empire, the Italian wars were the first step towards international expansion. Spaniards dominated Italy for the next three hundred years, with profound consequences for the history of that peninsula. But, despite the treaty of Granada of 1500, they did not come as imperial conquerors. Spanish chroniclers of the sixteenth century wrote proudly of a 'conquest' of Naples. An exhilarated poet in 1506 claimed that

> Not only do we dominate
> The lands we have conquered,
> We also sail across
> Unnavigable seas.
> We are almost invincible.[60]

The propagandists conveniently forgot that it was the Neapolitans who had invited the Spaniards in the first place, and who made the Spanish victories possible. Castilian soldiers helped their Neapolitan allies against France, and the major battles of the campaign were fought not against Italians but against French forces. Many years later, in 1531, the parliament of Naples reminded their then ruler, the emperor Charles V, 'that without their help the French army would never have been thrown out and defeated'.[61] Ferdinand was reluctant to extend his activities further into Italy. When in March 1504 his ambassador in Rome wrote to him suggesting that the troops in Naples march northwards 'with the aim of liberating Italy' from French occupation, Ferdinand admitted that it was a good idea but that it would not help a rapid peace agreement.[62] That same month, France recognized Ferdinand's sovereignty over a Naples that had proved to be politically unstable and incapable of governing itself. Thereafter the kingdom became a dynastic possession of the king.[63] It was governed by his viceroys, but belonged to him and by no means to 'Spain'. It did not even belong to the Crown of Aragon, and remained, like the Kingdom of Sicily, an autonomous realm under his direct rule.[64]

The year after the fall of Granada, the king sent an agent to North Africa to examine the military situation there. Chroniclers judged with hindsight that Ferdinand was anxious to extend his empire into the Muslim lands across the sea. A contemporary, Peter Martyr, commented that 'for him the conquest of Africa is an obsession'. He may have had ideas in that direction, but several years passed after the fall of Granada and the king still made no aggressive move towards Africa. He continued to be concerned about the Muslim threat from across the straits, and intentions to go on crusade appeared in letters to his ambassadors and to other rulers, but they were never translated into action. Queen Isabella, more pious and more influenced by her clergy, was on the other hand very keen on the notion of a crusade. In her testament she begged her heirs to 'devote themselves unremittingly to the conquest of Africa and the war for the faith against the Muslims'. The means for it, however, were not available. At the time of her death in 1504, her government had made no moves towards Africa. In the period immediately after the fall of Granada, some coastal towns of North Africa were in fact interested in establishing good relations with the victorious Spaniards. Both

in Mers-el-Kebir and the neighbouring town of Oran, there were Muslim leaders who would have accepted Spanish sovereignty.[65]

When the war in Naples ended, those who had their eyes fixed on Africa saw their opportunity.[66] The Portuguese had been established for a century on the coast of North Africa (they had been in Ceuta since 1415), and Castile was therefore precluded by treaty from making incursions in that direction. There were good incentives, however, for attempting to penetrate into the Mediterranean coastline. Protection of trade against corsairs, and the lure of gold brought across the Sahara, were convincing reasons. In 1495 Pope Alexander VI, continuing his policy of distributing the kingdoms of the non-Christian world among the sea-going Catholic powers, confirmed Spanish rights to the territories east of Morocco. A first step to Castilian expansion in North Africa was the occupation of the small, half-abandoned town of Melilla in 1497 by the duke of Medina-Sidonia, with the approval of the crown. Ferdinand subsequently agreed to finance a small force to defend the occupied town. He also gave his backing to small expeditions to North Africa led by the adelantado of the Canaries, Alonso de Lugo.

The foremost advocate of a holy war against the infidel in Africa was the archbishop of Toledo and Primate of Castile, Francisco Jiménez de Cisneros. This austere Franciscan reformer had been confessor of the queen. When he was appointed archbishop in 1495, he immediately set about reforming the lives of his clergy, and devoting his energies to the struggle against the infidel. He employed a Venetian sea captain, Geronimo Vianelli, to make a reconnaissance of the North African coast. Using troops recruited from Spain as well as some who were sent back from Naples, in August 1505 he personally directed an assault across the straits from the port of Málaga, on the small African town of Mers-el-Kebir. Some ten thousand troops were apparently used in the expedition, but they had little work to do. The Berber settlements of the coast changed their loyalty according to the current political situation, and at Mers-el-Kebir the commander had decided in September to hand the town over to the evidently superior force of Spaniards.[67] 'Africa, Africa for the king of Spain, our sovereign lord!' the soldiers are said to have cried as they charged into the population. Mers-el-Kebir was quickly occupied, but proved virtually impossible to retain, since it was isolated, far from Christian bases, and subject to regular attack from the Berbers of nearby Oran. The capture did not fail to excite emotions in

Castile. The Andalusian soldier and chronicler Gonzalo de Ayora felt that it was only the beginning: 'if this continues, the whole of Africa could be conquered with little resistance, thanks to the great rivalry among the Muslims'.[68]

Ferdinand could not finance another expedition, but he backed a much smaller venture, which led to the seizure of the settlement of Vélez de la Gómera in July 1508. Cisneros, meanwhile, offered to put the full resources of his diocese, the richest in all Christendom after that of Rome, at the disposal of the crown. When Ferdinand heard of it, he said 'that he would be pleased and would consider it a great service', commenting at the same time to his ambassador in Rome that 'it can truly be said of the Cardinal that he has a very strong desire to wage war against the infidel'.[69] The cardinal's efforts to mount a serious crusade bore fruit in the impressive expedition, both financed and commanded by him, which began crossing the straits in mid-May 1509.

Up to twenty thousand men were ferried across on several hundred transports. Within forty-eight hours the entire army had put ashore close to Mers-el-Kebir. It was commanded by a veteran of the Italian wars, the Navarrese soldier Pedro Vereterra, count of Oliveto, known to the Castilians as Pedro Navarro. The seventy-three-year-old cardinal accompanied the force. Preceded by the great silver cross of his see, he rode on his mule along the ranks of assembled soldiers and exhorted them to fight or die for the faith. Their objective was the key town of Oran, with upwards of twelve thousand inhabitants and 'all white like a dove' (according to a witness) with its white-painted houses stretching along the coastline, 'a paradise of gardens and fields and hillsides'.[70] As had happened in the Granada wars, capture was facilitated by the defection to the Christians of two of the town's officials, who opened the gates to Cisneros.[71] By nightfall on 17 May the Spanish troops had taken the town by assault, to the accompaniment of a mass slaughter of the defenceless civil population. The Spaniards' own figures (which, in the light of the advantage they enjoyed, may be believed) were that they had lost thirty of their own soldiers and killed four thousand of the enemy. Cisneros was prevailed upon not to continue with his idea of proceeding to take the neighbouring town of Tlemcen, and he returned within the week to Spain.

A further capture was effected in January 1510 when the king commissioned Pedro Navarro to lead an expedition against the small town

of Bougie. Navarro, with a force of four thousand men, took the town on 5 January. He went on that same month to 'persuade' the ruler of Algiers (a city of some twenty thousand inhabitants) to accept Spanish protection. To make sure the agreement would be observed, he placed a small Spanish force on the island facing Algiers, the Peñón of Algiers. On 25 July in the same year 1510, Navarro also succeeded in capturing the town of Tripoli, which lay considerably further east on the coastline, with a very high loss of life among the defenders. It was logically integrated into Ferdinand's kingdom of Sicily, whose security was more directly affected. The series of successes was soon cut short at the end of August, when an attempt under Navarro and the naval commander Garcia de Toledo to capture the island of Djerba, which boasted only one small town, ended in calamity. The soldiers failed to take enough drinking water with them, and fell victim to the scorching summer sun. Those who did not die of thirst were killed by the Muslim population. Some managed to escape, though the greater part of them drowned when four of the ships capsized in a storm. In total, over four thousand men perished.[72]

In practical terms, it made little sense to establish a Spanish presence on the north coast of Africa. The capture of towns satisfied the crusading urges of the archbishop of Toledo, but few Spanish settlers followed in the wake of the troops, despite Ferdinand's express wish that some of the towns be settled exclusively by Christians from the peninsula. The soldiers stationed in the African townships, moreover, were always in a vulnerable position. In 1515, for example, Ferdinand had to find three thousand troops from Mallorca to defend Bougie against attacks by four redoubtable Turkish seafaring brothers, headed by 'Aruj and Khayr al-Din (the latter was nicknamed 'Barbarossa' or 'Redbeard' by the Christians). Khayr al-Din established his base in Algiers and later extended his authority to the main cities of the Mediterranean coast.

Chroniclers were proud to consider Oran and the other garrisons as proof of the power of Spain and the reality of its empire. The possession of a few scattered outposts on the southern shores of the Mediterranean satisfied a historic yearning to turn the tables on a culture that had dominated the Iberian peninsula and menaced Christian Europe for so many centuries. It also demonstrated for the first time in Castile's history that effective use could be made of the sea in order to establish lines of defence beyond national territory. 'Africa', a concept that till then had

played little role in the Spanish mentality, now took on the shape of a new frontier that challenged and fascinated Castilians. The African dream entered into the vocabulary of Spain's empire.[73] But it was still only a dream, giving little more than the smell and illusion of power. The Spanish garrisons possessed an authority that never extended outside the limits of the Muslim-populated towns they occupied. They could not rely on the surrounding countryside for support nor even for food supplies, and the desire to spread the gospel remained in the realm of the unattainable. Nor, for lack of ships, were they able to command the seas that washed the shores of Africa.

While Ferdinand was absorbed with events in Italy, he was also profoundly occupied with the preservation of his power in the peninsula. In January 1502 his daughter Juana arrived from the Netherlands in the company of her husband the archduke Philip of Habsburg (whom she had married at Lille in 1496). In Toledo and Saragossa they attended the Cortes and were sworn in as heirs to the thrones of Spain. They returned to the Netherlands in the spring of 1504. A few months later, however, Queen Isabella died, and the dynastic link with Aragon lapsed. No sooner, then, was Ferdinand ruler of Naples than he ceased to be ruler of Castile. Not to be outdone, he began negotiations to wed the niece of the French king, Germaine de Foix, whom he married in a ceremony near Valladolid in March 1506. Six weeks later Juana and Philip arrived in the peninsula, as rulers of Castile. In September Ferdinand and Germaine departed for Naples, where a few weeks after his arrival the king received news of the sudden death of Philip. The royal couple made preparations to leave Naples, from which they sailed in June 1507.

Their first stop was the town of Savona, near Genoa, where an historic four-day meeting with the king of France, Louis XII, had been arranged. Ferdinand was accompanied by the Great Captain, and Louis by d'Aubigny. The great protagonists of the war in Naples were able to negotiate together in conditions of peace. When he eventually arrived in Castile in August, Ferdinand could see for himself how the mental condition of his daughter Juana, grief-stricken by the death of her husband, had deteriorated. In October 1510 the Cortes of Castile recognized him as governor of the realm in his daughter's name. It was a difficult period for the king, made more difficult by the failure of his

new wife to bear him a son. Germaine's most solid contribution lay in another direction, concerning her home country of Navarre, a small principality nestling in the forested western Pyrenees between France and Spain.

Ferdinand had a direct claim to the throne of Navarre through his father's first wife, Blanche of Navarre. After his father's death in 1479, the kingdom passed to Ferdinand's half-sister Eleanor, wife of the French magnate Gaston de Foix, and through her heirs into the hands of the powerful Albret family. Both the Foix family (from which Ferdinand's wife Germaine came) and the Albrets therefore had direct claims to the throne. When Gaston de Foix was killed in the battle of Ravenna in Italy in 1512, Ferdinand immediately laid claim to the throne on behalf both of himself and his wife. Though the rulers of Navarre were French in culture rather than Spanish, the kingdom since the late fifteenth century had been within the Castilian sphere of influence. France, however, needed the security of Navarre at this period, in order to defend the frontier against invasion by Ferdinand. Indeed, following an agreement of the latter with England, up to ten thousand English troops commanded by the earl of Dorset arrived at the port of Los Pasajes in June 1512 in order to participate in an invasion. The action had been a long time in the planning. The young English king, Henry VIII, had been Ferdinand's son-in-law since 1509 when he married Catherine of Aragon, widow of his brother Prince Arthur. From 1511 Ferdinand had been busy with what he termed preparations for war against the Saracen. 'The Saracen in question is myself', Louis XII of France commented sardonically.[74] In July 1512 the English troops were waiting at Renteria in the Basque country for the signal to advance. However, Ferdinand changed his priorities and decided that the question of the succession to the throne of Navarre could not wait.

In June the king assembled in Guipúzcoa a small army of a thousand knights, drawn from the Castilian nobility; they were accompanied by 2,500 cavalry, six thousand infantry and twenty pieces of artillery.[75] A further three thousand infantry and four hundred cavalry were supplied by the towns of Castile. The joint forces were put under the overall command of the duke of Alba, Fadrique de Toledo.[76] Meanwhile the humanist Nebrija, always a faithful servant of the crown, followed in the rear with the mission of writing up the exploits of the army. Ferdinand hoped that the English would join him. But when the earl of

Dorset realized that the exercise was not being directed against his intended objective of southern France but against Navarre, he refused to budge and prepared to return home. Fortunately for Ferdinand, by their very presence the English tied the French down in that region and made his campaign easier. On the pretext that the Navarrese had refused to let his troops cross their territory and had allied with France, he ordered his army to move into Navarre. The troops crossed the frontier on 21 July. There was almost no opposition from the small and virtually defenceless mountain kingdom. The royal family, the Albrets, fled into France, and on 24 July the capital, Pamplona, surrendered. The campaign was not exclusively Castilian, for the archbishop of Saragossa raised an army in Aragon of three thousand infantry and four hundred horse with which on 14 August he laid siege to Tudela, which surrendered a month later.

In theory the conflict had arisen because of a dynastic dispute, and Ferdinand was at first concerned to negotiate terms. But when he saw that this was not possible, he declared a 'conquest' and assumed the title of king of Navarre. On 28 August a section of the notables of Navarre met in Pamplona and took an oath of loyalty to him. In November the French claimant, Jean d'Albret, entered the territory with French troops but failed to dislodge the Castilians. The rump of the estates of Navarre, in the absence of those members who were partisans of the Albrets, accepted the inevitable and in March 1513 took an oath of allegiance to the king of Aragon. To make sure of his hold on the kingdom, in 1514 Ferdinand sent the army through the Pyrenees and occupied the small region of French Navarre (which was relinquished after the king's death). In June 1515 at the Cortes of Burgos Ferdinand joined Navarre to the Crown of Castile, after rejecting the alternative of uniting it to Aragon. The political consequences for Navarre were minimal. It was in reality neither 'conquered' nor 'annexed', for it retained its full autonomy in all respects. The only relevant change took place in its ruling dynasty. In subsequent generations the Navarrese managed to remain for all practical purposes independent, and even the taxes raised within their borders went largely to their ruling élites rather than to the Castilian state.[77]

There continued to be problems in Navarre, from nobles and communities who opposed the regime. A small Castilian force was garrisoned in Pamplona, to defend the city against future invasions from France.

When Ferdinand died in 1516, Navarrese exiles attempted to recover the kingdom but the plan misfired and the regent of Castile, Cardinal Cisneros, took firm action against the rebels. Castles of opponents were dismantled, among them the castle of the Xavier family. A scion of the family, Francisco, who was just ten years old at the time of these events, looked on as workmen tore down half the ancestral home.[78] Some of his brothers were in exile in France, and five years later in 1521 took part in an invasion of Navarre. When they besieged Pamplona one of the knights in the defending force was a young Basque noble, Ignatius Loyola, who was wounded in the action and forced to abandon his career as a soldier. Ignatius spent the next few years travelling and in 1528 enrolled himself as a student at the University of Paris. The year after, he moved into living quarters there with other students, among them young Francisco Xavier, who had been studying at the university since 1525. It was the beginning of a friendship that a few years later led to the foundation in Paris of the Society of Jesus, and was to have epoch-making consequences for the development of the Portuguese and Spanish empires.

By the time of his death in 1516 the Catholic King appeared to have laid the basis for Spain's future greatness. Subsequent historians of Castile were never in any doubt about it. Ferdinand, wrote the priest Claudio Clemente in his *Dissertatio christiano-politica* (1636), 'laid the foundations of the immense structure of this Spanish empire'.[79] He had determined the broad lines of future international policy: containment of French interests (both in Italy and in the Pyrenees), domination of the western Mediterranean, checking Islamic power. By the addition of Rosselló and Navarre he gave Spain security on its northern frontier for a century and a half. In the Mediterranean, where the rulers of Aragon had held Sardinia and Sicily since 1409, possession of Naples made Spain into the arbiter of southern Europe.

None of these gains came about because of superior Spanish power, or through a lust for expansion. Both in Naples and in Navarre, the operative factor was a hereditary right to the throne, and the ruling classes of the realms accepted Ferdinand's claims with little demur. It is sometimes claimed that the secret of success was the emergence of 'Spain' as a nation. The potential for overseas expansion, however, was never dictated by its potential as a 'nation state'.[80] The peninsular territories

known collectively as 'Spain' did not begin to develop as a nation before the eighteenth century. Nor were they capable of producing by themselves the impetus necessary for imperial growth. Expansion was always a multiple enterprise, attainable only through the joint use of resources. In a Europe without nation states, colonial enterprise in the sixteenth century was a challenge taken up by all who had the means to do so, the product of international co-operation rather than of national capacity.

Ferdinand, it must be recognized, made original and important contributions to the way in which Spain's new responsibilities could be accepted by his neighbours in the international community. Two merit special comment.

First, like the Habsburgs of Vienna he resorted systematically to marriage alliances as a way of pursuing policy aims. The marriages arranged by Ferdinand were of incalculable importance in the future accumulation of territories by Spain's empire. As the Jesuit historian Juan de Mariana recognized a century afterwards: 'Empires grow and extend themselves through marriages. It is well known that if Spain has come to be such a vast empire, she owes it both to the valour of her arms and to the marriages of her rulers, marriages which have brought with them the addition of many provinces and even of very extensive states.'[81] Alliances were made with the Tudors of England: the Treaty of Medina del Campo in March 1489 specified the marriage of the infanta Catherine to Prince Arthur, son of Henry VII. Attempts were made to ally with Portugal: the infanta Isabel married Prince Alfonso in 1490, but the groom died shortly after and the princess married Prince Manoel in 1497. Links were sealed with the Habsburg dynasty: as we have seen, in October 1496 the infanta Juana married the archduke, Philip ('the Fair') of Burgundy, son of the Holy Roman emperor Maximilian I, at Lille in the Netherlands. In April the infante Juan married the archduchess Margaret, Philip's sister, at Burgos. These complex arrangements were all destined to come to grief, because of a series of premature deaths, the most important being that of Prince Juan, who died in October 1497 with no living issue. With his passing the king and queen were deprived of any direct heirs in the male line. The infanta Isabel then died, in childbirth, in 1498; and her infant son, who if he had survived would have inherited the thrones of all the Iberian kingdoms, died two years later. The link with Portugal continued to be pursued,

for Manoel married Ferdinand and Isabella's fourth child María, in 1500. She too died prematurely, in 1517, after giving birth to a son, the next king of Portugal. Manoel then married the infanta Juana's eldest daughter, Eleanor. The succession in Spain seemed to have gained nothing by the elaborate series of unions. However, the network of marriages eventually helped to produce a male heir for the Spanish thrones, in the shape of Juana's son Charles of Ghent. It also became the basis of an important and successful Spanish claim to the throne of Portugal in the last decades of the sixteenth century.

Second, Ferdinand was one of the earliest European rulers to make use of regular diplomatic links. When the death of Henry IV of Castile in 1474 had left Isabella as the principal heir to the throne, the subsequent wars with Portugal forced Ferdinand and Isabella to keep in touch with a broad range of possible allies. This could only be done by acting through agents who travelled through Europe and sometimes resided in the places to which they were assigned.[82] Though usually great nobles or high clergy, they might also be men of letters, as were the chroniclers Alonso de Palencia and Hernando del Pulgar, or the poet Gómez Manrique. Ferdinand was one of the pioneers of the European diplomatic system.[83] He extended the practice of resident ambassadors, till then common only among the Italian city-states, to form part of the normal relationship between national states. By the 1490s the crown had resident diplomats in London, Brussels, and the Holy Roman Empire (Germany), as well as in papal Rome and various Italian cities, notably Venice, Milan and Genoa. Always conscious of the need for support, Ferdinand used propaganda and diplomacy to further his policies. During the Granada campaign he made sure that other states were aware of the conflict, and accepted with alacrity the sending of ammunition and soldiers by the Emperor. The queen even took French ambassadors for tours round the outside of the besieged city.[84] The diplomatic contact with other nations was an essential part of projecting the monarchy's image not only around Europe but also among the Muslim states of the Mediterranean. Since Ferdinand was ruler over various states, he employed relevant nobles from all the states as agents of the crown. Castilians, Andalusians, Galicians, Basques, Catalans, Aragonese, Valencians, Sardinians, Sicilians and Neapolitans all featured as diplomats in his service.[85] By the broad range of their culture, and the diversity of their languages, the different ambassadors were able to overcome the

obstacle of communication, above all if (as often became necessary in the German lands) they were able to converse in Latin. They were an international group, but their loyalty was not (unless they were Spaniards) to Spain or to Spanish interests. They represented only the king and queen.

The marriages and the diplomatic agents, in other words, were by no means a sign that Spain, and exclusively Spain, was on the road to imperial power. The reality of the power of Ferdinand and Isabella was always dynastic, involving the authority of their persons but not necessarily that of their states. After the battle of Ravenna in Italy in 1512, Ferdinand, who was at the time in Burgos in Spain, wrote to his ambassador in Rome expressing thanks for 'his' victory.[86] It was no expression of presumption. The victory, assuming always that it was one,[87] had not been won by Naples or Sicily or Aragon or Castile. It had been won by Ferdinand alone, using soldiers from his different states. To get anything important done, the rulers had to do it in a personal capacity. Ferdinand's presence in Italy was therefore essential to the affirmation of his authority there. In the same way, great decisions at the time had to be decided face to face, as in the interview held between the two kings at Savona. Ferdinand insisted continually to his agents that they must keep him informed, for only he was in a position to act. In 1507 he protested to his ambassadors in Rome that 'I am very surprised that, even though you are there, the matters I should learn about directly through you, come to my knowledge first through other channels.'[88] But these were the early days of European diplomacy. The routes were slow and insecure, the mail irregular, and the bureaucracy small. Communication of every sort was unreliable, and the king was seldom sure that he had the information necessary to make the right decisions.

Co-operation among the élites and dominions of the crown was essential, above all in the field of finance. 'The money from our realms alone', Ferdinand explained in 1509, 'would not be sufficient to maintain so big an army and fleet against so powerful an enemy.'[89] The Hispanic realms, as we have seen, had a deficient economy. In consequence, they also lacked the financial resources for imperial expansion. Who could pay for the guns, the soldiers, and the ships? Ferdinand and Isabella certainly could not. The civil wars had left them deeply in debt, and the deficit continued to grow.[90] They had, moreover, no central treasury to run their finances and no reliable tax income. Like all medieval rulers,

they opted for the solution of making individual contracts for each project, and invited the collaboration of financiers if they themselves lacked the means. In this way Italian financiers fortunately made it possible to launch imperial enterprises. The expedition to conquer the island of La Palma in the Canaries, for example, was organized as a business enterprise financed by a Genoese and a Florentine financier.[91] The wars in Italy, above all, were made possible only by Italian finance. In 1503 the treasurer of the Great Captain's army complained from Naples that 'there are great problems in finding money, of which there is very little even with the taxes from Castile, and it is absolutely essential to get from elsewhere the greater part of what is needed for the many payments we have to make'.[92] The solution came in the form of bills of exchange extended by financiers in Venice and Rome. The contact with Italian financiers was to prove of mutual benefit in following years both to financiers and to the Spanish Crown. Without the services of Italian bankers, the crown would have been unable to pay the diplomatic agents it maintained throughout Europe.[93]

Italian, Flemish, French and English traders had been interested since medieval times in the produce of the peninsula, particularly raw wool. In the south of the peninsula they helped to finance the war against the Muslims. Genoese financiers around the year 1500 – among them the Doria, Grimaldi, Spinola, Centurione and Sopranis – were the chief buyers of the rich olive oil and wine of the Seville region.[94] No less than 437 merchants of Genoa appear in the notarial documents of Seville in the period 1489–1515.[95] Many of them extended their activities to other goods, above all the purchase of raw wool and silk, which they exported abroad and also sold to Castilian manufacturers. When Málaga was captured from the Muslims in 1487 it immediately became the chief port available to the monarchy on that coast, its commerce principally in the hands of the Centurione family.[96]

The Genoese were in a good position to take advantage of the early trade links with the newly discovered lands of the Caribbean. 'In Cadiz', reported an Italian traveller in 1516, 'there are more foreigners than native inhabitants, but the majority are Genoese.'[97] They had to compete, of course, with the local Andalusian traders, the second largest group of merchants in the area of Seville and Cadiz. These were followed closely, in number and importance, by the merchants of Burgos, and then by English merchants.[98] The king and queen were only too pleased that

others could take on the costs of the operation. 'Almost never', the historian Fernández de Oviedo wrote later, 'do Their Majesties put their income and cash into these new discoveries, all is paper and fine words.'[99]

At the same time the resources of each realm could be called upon to aid a common enterprise. Early in 1508, when Ferdinand declared that he was preparing an expedition into Africa, he explained that 'we have asked for a large amount of wheat and biscuit and other supplies from Naples and Sicily, of which a part is already on its way, and as for the provinces of these our realms of Spain we have sent out our captains to raise as many infantry and soldiers as they can'.[100] Over two years later, in the Christmas of 1510, he wrote to Hugo de Moncada, the viceroy of Sicily, explaining to him that roughly half the supplies and men to be used for a projected expedition to Africa would be from his realms of Italy. The African dream, which Italians no less than Castilians would nurture in subsequent centuries right down to the epoch of Franco and Mussolini, was already, with Ferdinand, part of an undertaking that the two Mediterranean communities were meant to share.

They were, as it happened, already engaged together in another great dream, far away across the western ocean.

Christopher Columbus, born in 1451 in Genoa, spent his early career as an agent of the Genoese banking house of Centurione, and from his base in Lisbon made short voyages during which he became convinced that the ocean route to the west would lead to Asia. His attempts to find backing for an expedition were unsuccessful until he obtained in 1492 the contract at Santa Fe, made possible by the financial support of the Aragonese converso Luis de Santangel. Both then and later, there were financiers willing to risk their money on the enterprise: Genoese and Florentines turned out to be the majority backers.[101] The Santa Fe contract promised him, in the event of success, noble status, the title of Admiral of the Ocean Sea, and extensive privileges over the territories he might discover. His three little ships, with a total crew of ninety, sailed from Palos, near Cadiz, on 3 August 1492. After a four-week stop in the Canaries they set out over the western sea and arrived on 12 October in the Bahamas, making landfall at an island that received the name of San Salvador (now identified with Watling Island). Further travel took them to Cuba at the end of the month, and early in December they touched on Hispaniola, destined to be the focus of Spanish

settlement over the following decades. In January 1493 Columbus began the return voyage, was forced by the weather to put into Lisbon and arrived at Palos on 15 March. He set out at once to report to the sovereigns, then in Barcelona. Ferdinand and Isabella lodged Castile's claim to the new territories with Pope Alexander VI, who issued a number of bulls, one of them the famous *Inter caetera* (1493), confirming the title. The wording of the bull was too vague and too much of a threat to Portuguese discoveries to be acceptable. The rulers therefore negotiated directly with Portugal and by the Treaty of Tordesillas (June 1494) agreed to set a line of demarcation 370 leagues west of the Cape Verde Islands. All discoveries to the west of the line would go to Castile, all those to the east to Portugal. In the event, the line passed through enough of the American mainland to give Portugal its title to Brazil.

The news of Columbus's return had at first little impact on Spaniards. Like any novelty it was seized upon by a few writers – notably, in Spain, by Peter Martyr – and given diffusion among the curious in Europe. Columbus's first report (or 'letter') on his voyage was printed nine times in 1493, and eleven more times by 1500. In the discoverer's mind there was an inevitable confusion between what he had encountered and what he had hoped to find. 'The means of communicating with the natives were poor', an historian has pointed out, 'and he supplied what he did not understand from his imagination.'[102] The gold samples he brought back spoke, however, for themselves, and stimulated the sending of a second, more serious, expedition, which left Cadiz in September 1493. This time there were seventeen vessels with twelve hundred men including twelve priests but no women. The purpose was to settle Hispaniola, but the vessels also made an exploration around other islands of the Caribbean. The admiral returned home in June 1496, taking with him some inhabitants of Hispaniola as slaves. He made two more voyages to America. In 1498–1500 he reached Trinidad and the mainland (or Tierra Firme) of South America, and in 1502–1504 he scouted the coast of Honduras and the Isthmus of Panama. But after the first of these he and members of his family were sent home in irons, as a consequence of serious disputes among the settlers of Hispaniola. And the final sailing was conspicuous by its failure to discover anything significantly new.

Columbus died rich but disappointed in 1506. The new lands seemed to offer no quick route to Asia, as he had hoped; and the available wealth included gold and a few slaves but no spices. This was a small

return for one who had expected to discover 'the new heaven and earth foretold by Our Lord in the Apocalypse'. Peter Martyr referred to the western lands as a *novus orbis*, a New World, and Spaniards generally called them 'the Indies', an echo of the illusion that they were part of Asia. For most Europeans the name that stuck was 'America', derived from a popular account of his voyages by the Florentine navigator Amerigo Vespucci. The name first appeared on the map of the world published in 1507 by the Swiss mapmaker Martin Waldseemüller.

The little information available about the new lands was enough to stimulate curiosity. The discovery of gold during the first voyage, by Martín Alonso Pinzón and the men of his ship the *Pinta*, became a dominant obsession. In the *Journal* that he kept, Columbus was conscious of some of the possibilities offered by the discoveries. He found the natives of Hispaniola to be peaceable and obedient. 'They are without arms, all naked, and without skill at arms, a thousand running away from three [Spaniards], and thus they are good to be ordered about, to be made to work, plant and do whatever is wanted, to build towns and be taught to go clothed and accept our customs.' From the beginning, and without any attempt to assess the cultural level of the natives, he thought that they could be easily enslaved: 'all can be carried to Castile or held as captives on the island'.[103]

The logical consequence of Columbus's observations was that the Spaniards did not need to use force against the Arawaks of the northern Caribbean. There was, literally, no conquest of the islands.[104] The natives accepted the coming of the strangers, and made way for them, as they continued to do when the strangers reached the mainland. Later on they offered resistance, but that was after the strangers had begun to seize their lands and women. In the early days the Caribbean offered all the advantages of a peaceful, tranquil society where there was no shortage of native food, no war, no pestilence, and curiously no use of alcohol. In 1498 Columbus could still write from Hispaniola that 'this land abounds in everything, especially in bread and meat. There is no lack of anything except wine and clothing. Of our people here, each has two or three Indians to serve him and dogs to hunt for him and, though perhaps it should not be said, women so handsome as to be a wonder.'[105] During the second voyage, in 1494, there were risings of local Indians protesting against mistreatment by Spaniards. This motivated the seizure and transportation to Spain of around five hundred slaves, of whom half

died shortly before arriving in Spain early in 1495 and were thrown into the sea. The resort to violence and coercion, with the corresponding response from the native population and the beginning of serious rivalry among the Spanish settlers, set the pattern for a deterioration in the life of the Caribbean community.

It is common to think of the Caribbean as a paradise to which the Europeans flocked. There was certainly a great deal of interest in the exciting novelties brought back by Columbus. Peter Martyr recorded the king's delight on tasting his first pineapple, 'a fruit which has become his favourite'.[106] In reality, there was no rush to go to the new lands, for the voyage across was long and hazardous and the conditions of life in the New World uncertain.[107] For as long as a quarter of a century after the Columbian voyages, it continued to be difficult to attract Spaniards to the new lands. A high proportion of the early settlers died because of the climate, lack of food and clashes with natives. Already in 1497 plans were being made to deport criminals to the islands since there were few volunteers willing to emigrate. The prospects were by no means inviting. Hispaniola offered no opportunity for wealth (the early signs of gold vanished, and the Spaniards had not yet begun mining), and there was not even any acceptable food available. Settlers on the island survived simply because the Indians fed them. Many returned home to Europe as soon as they could, and those who stayed simply died: it has been estimated that of the twelve hundred who came in Columbus's second fleet in 1493 barely two hundred survived in the Indies twenty-five years later.[108] At the end of 1498 Columbus actually helped three hundred colonists (among them the father of Las Casas) to return to Spain, because they saw no future in the islands. His optimistic letters to the government, painting a rosy picture of the opportunities, failed to convince. The admiral's years of control in the islands ended in failure for everybody. The report he made of his last voyage, in 1502, was a confused account. His reiterated insistence that he had reached Asia and his apocalyptic fantasies about the import of his discoveries, represent the negative side of his achievement. On the other hand, his positive contribution to the expansion of the European and Iberian horizons was immense, and his achievement in navigation was pioneering. Through his voyages, Spaniards were for the first time inspired to risk their lives and fortunes in exploration and conquest across the ocean.

*

The end of the fifteenth century was in Europe a time peculiarly pro-pitious to imaginative movements seeking a golden age, a millennium, located in the future. Prophetic and mystical ideas, with their roots in the Middle Ages, found receptive minds all over the continent and no less in Renaissance Italy, where the monk Savonarola earned the hostility of both Church and State by his fiery denunciations of corruption. Visionary impulses guided both rich and poor. They served to inspire the famous prophetic *Centuries*, published a generation later in France by the seer Nostradamus. The impulses also influenced the young king of France, Charles VIII, when he led his armies across the Alps into Italy in 1494,[109] and was greeted by his Italian supporters – among them Savonarola – with enthusiasm. The Iberian peninsula was not exempt from these millennial influences, which for some contemporaries seemed to reach their fulfilment with the events of the year 1492.

Christopher Columbus was in the front line of visionary inspirations. In his *Book of Prophecies* (1501) he saw himself as a kind of pioneering liberator, a 'bearer of Christ' ('Christo-ferens' in Latin) to the lands of Asia.[110] It is possible that even a pragmatic person such as King Ferdinand allowed himself to make decisions based on prophetic visions, for he paid attention to the statements of a holy woman known as the Beata de Piedrahita. Virtually all Europeans lived in a social environment that was profoundly imbued with religious ideas, aspirations and dreams. The mentality carried over into political attitudes. Men claimed to be defending their religious hopes when they went into battle, and above all when they fought against the traditional foe of Christian Europe, the Muslims. When Ignatius Loyola was wounded at the siege of Pamplona and became incapacitated for further service in the war, he quickly turned his martial thoughts towards the Muslims and the Holy Land as objectives of his aspirations. Clergy looked beyond the world around them, to visionary expectations and the advancement of spiritual frontiers. Prominent among them was the cardinal archbishop of Toledo, Cisneros. A Franciscan friar with a profound knowledge of the spiritual literature of his time, he was a devotee of mysticism and in particular of the ideas of Savonarola, whose works he published in Castile.

The aspirations and visions of Ferdinand, of Columbus, of Cisneros and of Ignatius were real and powerful motives that shaped their per-sonal lives and public achievements. Those who could read, a tiny minority, were readily influenced by the learned literature at their

disposal. Scholars could point to the writings of a Spaniard of Roman times, the philosopher Seneca, who had stated prophetically that 'in the last ages of the world there shall come a time when the ocean sea will loosen its bonds and a great land will appear and a navigator like him that guided Jason will discover a new world, and then the isle of Thule will no longer be the final limit of the earth'.[111] But the dreams of a few were acted out against a background of the many who did not read, had no learned culture, knew no society beyond their own region, and had no profound contact with the religious beliefs of the Church. It is still all too commonly believed that the offensive of Spaniards against their Muslims and Jews reflected a confident religious spirit that inspired them to carry the banner of the true faith out to the world. The real condition of religion in the Spain of Ferdinand and Isabella, however, was substantially different.

Long before the outbreak of the Reformation or the expansion of Europe into overseas territories, Church leaders in Spain were profoundly aware of the defects in their own religious culture, and the need to bring true religion to their own people.[112] In the first decade of the sixteenth century Dominican missionaries were active among the mountains of the northwest of Spain. Councils of bishops and clergy, led by one held in Seville in 1512, emphasized the need to teach the gospel and encourage people to go to church. Far from being confident and militant, they were concerned to remedy their own shortcomings. Ferdinand and Isabella attempted some reform of the religious orders of Castile, but it was an almost complete failure. In the epoch of Columbus and his successors, Spain still had one of the most backward and unreformed Churches of Christendom, with an inadequate and ignorant priesthood and laity.[113] Nevertheless there were a few clergy in this Church who, full of zeal but as yet unequipped to improve the religion of their own people or to attempt the conversion of the Muslims of Granada, greeted the new frontiers opening up before them with enthusiasm.

Clergy, intellectuals and nobles in Renaissance times shared the challenging vision of spiritual advancement. They wished to destroy the enemies of the faith (not yet perceived as 'heretics', for the Reformation had not taken place), liberate the Holy Land, and achieve the fulfilment of perennial prophecies. Such were the ideas that influenced a Catalan poet to acclaim Ferdinand as the king who would convert the 'realms of

Spain' into a universal monarchy, and the Valencian doctor who saw him eliminating Islam and Judaism in Spain and conquering Africa, the Middle East and Jerusalem.[114] They were visions that influenced the thinking of those Spanish leaders, among them the king and queen, who felt that the struggle against the Granada Muslims, the French, and the savages of other lands was simply a preparation for the great and prophetic imperial mission of liberating the Holy Land itself. Columbus always insisted firmly to the king and queen that 'the matter of France and of Italy' was of little or no importance compared to the grand design being offered them by destiny. In 1510 the Grand Master of the Knights of Rhodes wrote to assure Ferdinand that he was chosen by providence, that he could achieve the recovery of Jerusalem with little effort and the conquest of all Africa up to Egypt. Others claimed that the king would soon liberate Constantinople. At the dawn of the sixteenth century, it seemed, political and military events in Spain were beginning to fit into a messianic and imperial scheme of unforeseeable dimensions.[115]

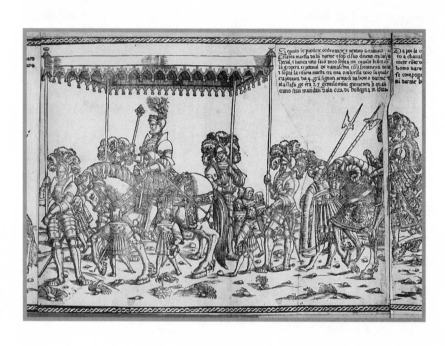

2

The Early Western Empire

The discoveries and conquests were necessary in order to extend
and augment states, which have in consequence become great
and their rulers have become powerful and gained respect.

Bernardo de Vargas Machuca,
Militia and description of the Indies (1599)[1]

In the second decade of the new century, when Ferdinand of Aragon
died, the open Atlantic was virtually a virgin sea, barely touched by
the handful of vessels that had ventured into it. The pioneers were in
principle the Portuguese, who established the first European overseas
empire,[2] but the active participants in naval enterprise came from all
nations, and included Italians, Basques, Catalans and French. From the
fifteenth century the chief attraction of the sea-route southwards was
the possibility of obtaining gold from Africa. By the end of that century
sailors had struck out westwards across the ocean to Madeira and the
Azores, and had obtained a fair knowledge of the winds and currents in
the area. Columbus's voyage in 1492, and that of Vasco da Gama round
the south of Africa six years later, gave Europeans a decisive initiative
in the western and south Atlantic.

On Ferdinand's death in 1516 the thrones of Castile and Aragon
passed to his grandson the archduke Charles of Habsburg, son of Juana
and of Philip the Fair. Born in 1500 in Ghent and brought up in the
Netherlands by his aunt, Charles was an archetypal Renaissance prince,
cultured, pious and trained in the arts of warfare. He was proclaimed in
Brussels in 1516 as joint ruler of the Spanish realms (his mother, still
legally queen of Castile, was treated as such down to her death). Charles
sailed for his inheritance in the fall of 1517. A foreign ruler with
little knowledge of the Castilian language, he came surrounded by his

advisers, most of them from the Netherlands. Misunderstandings with his new subjects provoked a range of grievances that soon, in Castile, flared up into rebellion. By then, in 1520, the new king had left Spain on his way to Germany, where he had been elected Holy Roman emperor and was crowned as such at Aachen in October.

Charles's title as emperor made Spain a partner in his universal destiny. He now united in himself a greater number of realms than had ever before been accumulated by any European ruler: the entire Burgundian inheritance, centred on the Netherlands; the immense hereditary Habsburg lands, including Austria within the Empire and Hungary outside it; the whole of peninsular Spain as well as the Italian territories of Naples and Sicily; and the continent of America. His duties took him everywhere: at his abdication in Brussels in 1555 he recalled that he had made expeditions by land and sea to every state in Western Europe as well as to Africa; and that he had made eleven voyages by sea. He spent one out of every four days of his reign travelling: 'my life', he said later, 'has been one long journey'.

Charles's empire, however, was not Spain's, and Spaniards were well aware of it. Castilians in particular made their attitude felt clearly during the revolt of the Comuneros (1520). They had recently had a foreign king, Philip the Fair, so their objection was not to Charles as an alien. Rather, they objected to what they saw as excessive privileges given to foreigners. Above all, after the omnipresence of Ferdinand and Isabella they objected to the travels of the king in foreign parts. A ruler, they insisted, should reside in his territories: the theme recurs in every Cortes of Castile during the reign. 'Your Majesty's protracted absence from your Spanish dominions', wrote the admiral of Castile in 1531, 'is a thing to which your subjects can hardly reconcile themselves.' With time, Castilians and Spaniards began to accept their international destiny, and Charles himself became in some measure Hispanized (he selected only Spaniards as confessors, for example). Spaniards were introduced to the political and cultural world of Europe. They became eligible for foreign honours: from 1516 ten places in the famous Burgundian Order of the Golden Fleece were reserved for them. The king made the important gesture of learning Castilian, which soon became his second language after his native French.

For most of Charles's reign, the Spanish realms continued with the limited Mediterranean role that they had inherited from Ferdinand the

Catholic, and refused to get drawn into an Imperial role in northern Europe, which they did not understand and for which they were not equipped. After his visit to Germany to become emperor, Charles returned to the peninsula in July 1522 and remained there for seven years, the longest of his stays with his Spanish subjects. In Seville in April 1526 he married his cousin, the beautiful Princess Isabella of Portugal, who in May 1527 gave birth at Valladolid to her only male child, Prince Philip.

During the emperor's absences Isabella assumed, in six of the ten years before her early death in 1538, the daily tasks of government. Her correspondence with Charles reveals clearly the horizons that still defined the world-view perceived from Castile.[3] The Netherlands are almost entirely absent from her letters, and the New World is barely alluded to. The lands of the Crown of Castile are referred to as 'these realms', and those of the Crown of Aragon as 'those realms'. The world outside is perceived almost exclusively in terms of the Mediterranean, its ports, shipping, and defences. There are no references to the world of the northern peninsula: Spanish Cantabria or the Basque country or the seas towards northern Europe. And the only insistent theme is the empress's concern for her husband, his absences, his safety, his wars and – inevitably – the paucity of his letters. She asks him (in 1531) to 'please take care in future not to let so much time pass without writing to me, so that I hear from Your Majesty at least once every three weeks'.

Charles's principal administrator in the peninsula, Francisco de los Cobos, was resolutely opposed to the emperor's expensive commitments in Germany, and tacitly supported the constant refusals of the Castilian Cortes to give financial aid.[4] Long after the defeat of the Comuneros and more than a generation after the voyages of Columbus, most Spaniards seemed to have little interest in the new horizons that were opening up in Europe and across the Atlantic. Only a few humanists, those in the service of the crown (such as the Catalan adviser Mir or Charles's confessor Pedro de Soto), grasped eagerly at the new opportunities for international contact. Despite the prevailing indifference, the emperor's reign was of decisive importance to Castile, for it created all the mechanisms that later enabled his son Philip II to define the outlines of specifically Spanish imperial power. It also served to give primacy within the peninsula to Castile, which became, as state documents of the time affirm, the 'head of these realms', a place where

the emperor's administrators resided, and on which the crown depended for money and for troops. Castile's enhanced role made it somewhat more amenable to the broader international activity of Charles V. There was, moreover, a development that quickly gave it an importance it had never expected: the regular import of precious metals from the New World, the territories known in official terms as 'the Indies of Castile'.

Charles drew his title of emperor only from Germany; in the rest of his realms he ruled according to the power accorded him in each realm. The factor binding all his territories together was (as had been the case with Ferdinand before him) dynastic right; it was by the same right that he was able at the end of his reign to apportion his territories out to members of his family. As he found when he came to negotiate with the various Cortes of his peninsular realms in 1517, Spain had few financial resources, and none to help him with his international enterprises. From the first he had to rely on European rather than peninsular businessmen. The big centres of European banking were in the Netherlands, central Germany and northern Italy, and it was to these places that Charles looked in order to raise loans, which he could repay later from the tax income of each of his realms. Although he had just commenced his reign, he quickly accumulated debts, particularly in Germany where he was attempting to smooth the way to his election as emperor in 1519. He also obtained help from leading Flemish nobles, who gave him sums in exchange for privileges in the New World. Members of his court obtained speculative rights in the New World and in trading concerns. Within a few months of Charles's accession, Castile's horizons began to expand to unforeseen limits thanks to the help of international finance.

Very slowly, Spaniards began to identify themselves with a broader destiny. Some, like his officials, bishops and historians, did so because they were paid to serve the emperor. Charles's Latin secretary, Alfonso de Valdés, presented his master as the fulfilment of the aspiration for peace and unity among peoples: 'that there be one flock and one shepherd', he wrote. Others in the streets gave vein to a genuine popular enthusiasm in the same sense. When the emperor visited the city of Seville for his marriage to Isabel, a triumphal arch proclaimed that 'the campaign which brought you here will also lead you to Jerusalem'. As the years passed, publicists addressed to Charles the very same appeals they had addressed to Ferdinand. The town of Gibraltar in 1538 affirmed

that it was the king's destiny to liberate Jerusalem, 'as holy men have foretold'.[5]

Castilians came to see Charles as their own emperor, one who spoke in their tongue, which he learnt quickly and well. However, though they accepted the emperor they had serious doubts about the idea of an 'empire'. The reality was that Charles himself never had a grandiose image of what his territories might signify, and left the formulation of 'imperialist' theory to his advisers, notably lawyers like his Chancellor, the Piedmontese noble Mercurino Gattinara. For Gattinara, an admirer of the achievements of the Romans, the word 'empire' meant the capacity to exercise sovereign power without limits. But it never had any connotations of international expansion. Indeed, Gattinara appears not to have considered the New World a relevant part of his master's 'empire'.[6] In their turn, Castilian writers followed the precedent set by Nebrija and energetically rejected the pretensions of the 'German' empire. It was a way of claiming autonomy for Spain within the universal monarchy of Charles. Many members of the Dominican order in Spain continued for a long time to oppose the concept of universal monarchy if it threatened the integrity of their homeland.[7]

Contemplating in 1525 the magnitude of the task facing him, the young Charles was conscious that he must not fail himself. 'I am well aware that time is passing, and ourselves with it, and I have no wish to let it go by without leaving some mark of my reputation. With all this in mind, I see nothing that stands in the way of my achieving something great, if the grace of God allows me to enjoy peace and tranquillity'.[8]

He did not take seriously the idea of a group of administrators who might oversee general policy; the Council of State, which might have played such a role, was purely honorific. On the other hand, he was deeply concerned with the efficient management of transactions *between* his states. He had three fundamental priorities: for money to be obtainable when and where necessary, for reliable communication of his orders and correspondence, and for fighting men to be made available. All this required the creation of an international network, without which imperial power could not function. The limited resources available to Ferdinand the Catholic were not enough, and Castile alone could not carry out the task. There was even less likelihood of Germany, a sprawling territory of thousands of little princes with no central administration, helping him. The emperor's attention to necessary tasks of government

was not merely pioneering, it represented an enormous step forward in the organization of European society, and made it possible for his very limited resources to cope with the seemingly impossible task of controlling territories that stretched over the surface of half the known world.

The first of his innovations was to make capital mobile on an international basis.[9] The supply of money, which will concern us in more detail later on (see Chapter 7), was obviously fundamental. The emperor brought his own bankers with him when he came to Spain, so for the moment there was no undue pressure on peninsular resources. Castilians soon discovered, however, that they had to contend with powerful financial interests among the courtiers. Ferdinand the Catholic had managed his affairs with a small team of bankers who followed him around everywhere and made sure the cash could be found when he wanted it. With Charles the bankers and their business took on an entirely new dimension. The case of Spain under the Habsburgs is the fullest and clearest example of the imposition of foreign, international, capital and capitalists on the government.[10] Charles's initial contacts were with the Germany-based banking houses of Fugger and Welser. Later, from around 1560, the bankers of Genoa entered powerfully into the picture.

The second major innovation was concerned with the problem of communications. Vital decisions on war, politics, and commerce were, in the pre-modern world, delayed and frustrated by the problems of making information arrive in good time. Water, horse or coach were the three means of transport, and their efficiency varied. All were slow, but even worse they were uncertain. In Brussels the government from the 1490s had employed as postmaster a remarkable man, François de Tassis, member of a most remarkable family, the Tasso, who came originally from near Bergamo, in northern Italy. In the fifteenth century members of the family were established in both the Netherlands (where their surname was spelt Tassis) and Germany (where it was spelt Taxis). Around 1450 they had organized for the emperor mail links from Vienna to Italy and Brussels. By around 1500 their success in financing postal communications had earned them wealth and noble rank. On succeeding to the throne of Spain in 1516 Charles confirmed Tassis and his business associates (who were members of his family drawn directly from Italy) as postmasters general for all the territories he governed. It was an immense monopoly. The Cortes of Valladolid in 1518 protested strongly

against conceding the service in Castile to foreigners, and objected that 'foreigners should not be granted employment, posts, high office, governorships or naturalization papers'.[11] There were similar protests against the Tassis in Aragon. The family continued undisturbed in their privileges, maintaining a huge postal network that linked Vienna, Brussels, Rome and the Spanish dominions all the way down to Naples. In Castile they became distinguished members of the aristocracy. The Spanish were learning that an international enterprise such as communications required more expertise and resources than they alone possessed. The tasks of empire were global, and called for global solutions. Though the Tassis never lost their prominent position, they were soon joined by Spanish postal agents,[12] who took part with officials of other nations in the common enterprise of transmitting news and information from one part of Europe to the other.

At the same time it was essential to develop and expand contacts with other states, through ambassadors who could speak for the emperor and keep him informed. Charles's diplomatic service was centred on the Netherlands, but his agents were drawn from every section of his territories. The Spaniards, inevitably, played only a small part in the Europe-wide network. Charles took over those who had served Ferdinand,[13] but his principal agents during the reign tended to be from Burgundy (that is, what are now the territories of the Netherlands, Belgium, Luxembourg, the Franche-Comté and several areas that form part of France and Germany) or from Italy. Until Philip II created the structure of a specifically Spanish empire, Castilian diplomats (who seldom spoke any contemporary language other than their own) played a secondary role in international affairs.[14] The emperor's military and administrative élite tended to be at first exclusively from the north of Europe, leading a Spanish army officer in Naples to complain to the marquis of Pescara that 'the emperor only promotes Netherlanders, and grants the leading posts only to them, so that Spaniards and Italians need not expect great favours from him'.[15] But Spaniards and Italians soon proved their value, and rose to the highest posts in the military hierarchy.

The third major area of government innovation lay in the spreading of business risk, by offering the resources of the state as a guarantee to traders and financiers. However, it was the financiers themselves who, by accepting the conditions and high credit rates, were able to put money to work in a way that had been unknown in the medieval world. It was

already becoming common in commercial circles for shipowners to be able to pay premiums to cover their risks at sea. Financiers likewise needed to protect themselves against governments that did not honour their debts. Charles was in the perhaps unique position of being able to offer them the security of not one government alone, but many. In his later years he came to rely more and more on the money that came from America, but in the early decades of his reign the non-Spanish realms contributed heavily to costs and therefore to spreading the risk. As his viceroy in Naples, Lannoy, reminded him, 'since you left Spain [in 1520] you have drawn silver only from here and from Flanders'.[16]

Once the crown's commitments took on global dimensions, it became a priority to defend them. The small, local and temporary armed forces employed by Ferdinand the Catholic became hopelessly inadequate for the task of international policing. Fortunately, the European territories of the monarchy were normally able to cope with their own defence; they raised men and money as required, and allowed the crown considerable scope in using both. Castilians were proud and happy to participate in the emperor's enterprises. The soldiers and nobles who had served in the Italian wars now made themselves available for campaigns elsewhere. This did not mean that Spaniards were pushed into a military role. Quite the reverse, the reign of the emperor was for Spaniards one of unexpected tranquillity. It is a fact all too easily forgotten. Apart from occasional clashes with North African corsairs, there were no wars. The end (1504) of the first phase of the Italian struggle brought to both Castile and Aragon a long period of domestic peace. During the entire half-century that followed, no serious military threat emerged to peninsular Spain, leaving the state to pursue specific commitments without being dragged into a general conflict. The dynastic conflict in Europe between the Habsburg family and the Valois dynasty of France implicated Spanish troops but barely touched the peninsula and produced only a few border skirmishes in the Pyrenees, mainly around Perpignan. In Castile the Cortes was willing (as in 1527) to finance war against the Turks, because they were at Spain's back door. On the other hand it refused (as in 1538) to finance war against the Turks when these were far away, in Vienna.

The absence of war meant that there was little need for a substantial military establishment within Spain. Instead, Castile maintained a military presence in Europe without any need to be at war. This was done through the famous tercios. We have seen that these units had come into

existence under King Ferdinand. Charles V needed troops and garrisons in Italy and the tercios supplied them. They were subsequently given a set of regulations that determined their organization and discipline (Chapter 4). Spanish troops would continue throughout the reign of Charles V to be a small but essential component of the Habsburg army. They were not necessarily better than other troops, but they had the advantage of continuity of service and better discipline, which meant that they had considerably more experience. Not without reason were they referred to in later years as 'veterans', a description they wore with pride. They constituted less than a fifth of the army that sacked Rome in 1527, and less than a sixth of the troops serving Charles in Germany in 1547. At the siege of Metz, which was directed in part by a Spanish general, the duke of Alba, the Spanish detachments made up barely nine per cent of the infantry and just over three per cent of the cavalry.[17] Beyond these campaigns there were armed detachments in specific locations, principally the African forts, and from the year 1536 there were troops in Milan. Spain's effective contribution was always small.

The long years of peace in Spain undoubtedly bored those nobles who retained an interest in warfare, the perennial basis of the noble ethic. Most empires are based on active co-operation with the nobility, who normally supply the investment and services required for imperial power. The nobles also pioneer colonization and command the armies.[18] In the case of Spain, which was not directly involved in war at any moment of the emperor's reign, the nobles were limited to a defensive role on the frontier against the French and on the coasts against Barbarossa and the Turks. The more enterprising therefore took up with enthusiasm the possibility of serving outside the peninsula. A good example of a nobleman who made war his career was Antonio de Leyva, prince of Ascoli, whom Charles appointed as his governor of Milan in 1525. Leyva paid his own way, but kept his bills which he later presented to the emperor for reimbursement.[19] In 1532, when the Turks penetrated deep into Habsburg territory on the Danube, so many Castilian nobles solicited permission to go to Germany that the empress was seriously concerned. 'With so many leaving the kingdom and taking so many horses and so much money', she reported, Castile would be deprived of its defences. The emperor was, of course, delighted: 'I would be glad if they all came', he wrote.[20]

*

The emperor's reign presented Spaniards with a challenge to which, like the Comunero rebels, they reacted in a highly equivocal way. Their disagreements and doubts were expressed openly at every level, both in the Cortes and in the countryside. The Castilian Cortes complained incessantly of the emperor's absence. The people complained of the money he took away for his wars. The historian Sandoval reported that once, while hunting in the Montes region of Toledo, Charles got lost and fell into conversation with a peasant who did not recognize him. The old man said that he had lived to see five kings in Castile. When Charles asked him which of these was the best and which the worst, he replied that Ferdinand the Catholic was certainly the best and the present king the worst. Pressed to explain, he said that the king had abandoned his wife for foreign parts, had carried off with him the treasure of the kingdom, and that he was ruining the peasants with taxes.

A generation after the emperor's reign, Castilians had overcome the distrust of the Comunero period and came to take pride in his achievements. But they were highly selective in their support. They approved the emperor when he was in conflict with those who appeared to be also Spain's enemies: the Turks, the French, heretics. Actions against these could be regarded as defensive, and acceptable. By contrast, they remained indifferent to the aspects of the Habsburg inheritance that they did not understand. As a result, they consistently refused to grant money for foreign enterprises, including Italy. 'In Spain', Charles wrote from Bologna to his brother Ferdinand in 1530, 'they dislike my spending any of their money in Italy.'[21]

In subsequent decades, Castilian historians reconciled themselves to the Habsburg dynasty so completely that they presented in their writings a Castile which had become, in the words of the emperor to the Cortes of Valladolid in 1523, 'the head of all the rest' (he meant the rest of the peninsular realms). An image came to be created of a worldwide and trans-oceanic monarchy that Charles V, with the help of Castilian armies and the Castilian navy, had brought into existence. The sober reality, however, was that this Hispanic empire did not come into existence until some time after the emperor's death. Spain was an important but also a limited resource for the needs of Imperial policy. Certainly, Castile was the only realm in the peninsula that contributed generously to crown finances. The English ambassador to the emperor observed in 1520 that 'nervus belli est pecunia, which he will not have without Spain'.[22] And

the Castilians, despite repeated criticisms, continued on the whole to be generous. But Charles never gave them any special place in the organization of his various territories, which he continued to treat on an equal basis. He explained to the 1523 Cortes that 'we intend, as is reasonable, to be served conjointly by all the nations of our realms and dominions, preserving to each of them its laws and its customs'.

Spaniards made an important contribution to the defence of their own frontiers against the French and the Turks, but they had little experience of a broader military role, except in Italy. And it was in Italy that the Spaniards and their tercios continued to consolidate the military reputation they had begun to gain under Ferdinand the Catholic. For over half a century after 1494, Spain and France continued to struggle for supremacy in the Italian peninsula and in the process earned the unmitigated hostility of its peoples.

Ferdinand's motives had been dynastic rather than imperialist. He aimed to preserve his rights rather than extend his territory, and he demanded no more than security for his realm of Naples, in whose internal affairs he made little attempt to interfere. By contrast, Charles V urgently needed financial help for his policies in other parts of Europe, and sought it not only in Naples but all over Italy. The states of northern Italy had traditionally formed part of the Holy Roman Empire, and the emperor logically considered them to be within his zone of influence. His first military intervention in Italy was against the French, possessors of the duchy of Milan, which was a feudal dependency of the Holy Roman Empire.

In the summer of 1521 an army of over twenty thousand troops under the command of Prospero Colonna, the pope's leading general, marched on the emperor's behalf against the French. Though the soldiers were mainly Italian and German, a small Spanish contingent of two thousand men from Naples accompanied them, under the command of the Neapolitan general Ferran d'Avalos, marquis of Pescara, and the Spaniard Antonio de Leyva. It was an important step forward for the Spaniards, who for the first time made their presence felt in an area outside the traditional zone of Aragonese influence. The war also introduced Milan as an objective of possible interest to the Spaniards. After the death of Colonna in December 1523, Charles appointed as his commander the Flemish Viceroy of Naples, Charles de Lannoy, who reinforced the army with more troops from Naples. Lannoy was himself subject to the orders

of the constable of France, Charles de Bourbon, who was nominally the head of the armies of France but in 1523, as a result of a quarrel with his king had formally transferred his allegiance to the emperor. The Spanish troops under Pescara and his nephew Alfonso d'Avalos, marquis di Vasto, became a key element in the international army serving the emperor.

The Imperial troops under Bourbon invaded France and penetrated as far as Marseille. They were unable to make further headway and retired to Lombardy at the end of September 1524, in a disastrous retreat during which, according to the memoirs of the Franche-Comtois soldier Féry de Guyon, they fed off the orchards of Provence, 'for a whole week, with the enemy always on our tail and attacking us constantly'.[23] It was now the turn of the new French king, Francis I, to make a dramatic move. In October 1524, when it was clear that the Imperialists were no longer a threat to France, he personally led his army through the Alpine passes into the plains of Lombardy and occupied the city of Milan without much opposition. Bourbon's forces withdrew to the city of Lodi, while the king moved his army forwards and laid siege to the city of Pavia, defended by German troops under Leyva. After three months of siege, at the end of January 1525 Bourbon and Lannoy brought their men back in an attempt to shift the French. At the end of February they decided that the stalemate should be resolved by a battle, despite the undeniable superiority of the French in cavalry and artillery.

The Imperial army, of over twenty-four thousand men, included fourteen thousand Germans, some five thousand Italians, and five thousand Spanish infantry under the command of Pescara.[24] An attack on the French positions began in the evening of 23 February 1525, and by dawn next day the Imperial victory was complete. On the field of battle a group of soldiers from the tercio of Naples – three Castilians and a Franche-Comtois – captured the king,[25] who surrendered formally to Lannoy. The victory was due, in the opinion of witnesses, to the efficacy with which the German infantry, the *landsknechten*, attacked the Swiss infantry serving France, and to the mortal firepower of the arquebuses of the Castilian soldiers from Naples.[26] 'I can testify to what the Spaniards did', wrote a Castilian participant in the battle, 'for I saw it with my own eyes.' It was a historic episode in the emergence of the Spaniards as a military force. A generation later, when Brantôme discussed the French defeat with the duke of Guise, one of France's leading com-

manders, the latter agreed that the Castilian arquebuses had probably been an important element in the Imperial victory.[27]

The battle of Pavia was won for the absent Charles on his twenty-fifth birthday, 24 February, and had profound consequences for Spain's emerging role in European politics. Castilians seem to have had little interest in the campaign. Not a single soldier went from the peninsula to take part in it, and as a consequence there were no public celebrations when the news became known. It was not every day, however, that the most powerful king in Europe was taken prisoner in battle. Francis I was brought to Madrid, where he arrived in August 1525 and was treated with full honours but kept under guard. The two monarchs met alone and often for long periods, yet for Francis the entire stay was an unpleasant and humiliating experience. He was eventually released in March 1526 and his place taken by his two sons, both subsequently ransomed by the terms of the Peace of Cambrai of 1529. The prestige gained by Spain rapidly vanished in the general European reaction against Charles's absolute victory over France. No sooner had the French king regained his liberty than he engineered in May 1526 at Cognac an alliance with the pope to 'put an end to the wars devastating Christendom', in other words, to curtail Charles's successes in Italy. The new coalition failed to achieve anything in the shape of military action, and early in 1527 the Imperial detachments, commanded by Bourbon and by the German general, Georg von Frundsberg, joined forces at Piacenza and began to move south towards France's ally Rome.

In March the pope relented to the extent of agreeing with the Imperial ambassador to accept a truce, but it was already too late. The army could not be stopped, and at the end of the first week in May burst into the Eternal City, looting, killing and burning.[28] Spaniards took part equally with Germans and Italians in the destruction. When Charles received the news he was horrified, but the rest of Christian Europe laid the blame squarely on him. His adherents, and in particular the Spaniards, were quick to blame Bourbon (who conveniently for them had died of wounds at the beginning of the attack) and Frundsberg. In private there was considerable satisfaction in many quarters at the outrage perpetrated on the papacy. Political opponents felt that the pope deserved to reap the fruits of his policies, while religious reformers and humanists felt that corruption in the Church was at last being castigated. Charles's Latin secretary, the Spaniard Alfonso de Valdés, drew up a

literary essay, titled *Dialogue on the recent events in Rome,* which circulated in manuscript among officials and received general approval. France, meanwhile, took advantage of the situation to send another army into Italy, under Lautrec. It subjected most of Lombardy except for Milan, then advanced south to Naples and in April 1528 laid siege to the capital, which was at the same time blockaded from the sea by ships under Filipino Doria, nephew of the great Genoese seafarer Andrea Doria.

The Mediterranean sea was, as it had always been, a preserve of the Italians rather than of the Spanish. All the significant naval forces were Italian, and if the emperor undertook military campaigns he did so with a view to protecting the security of Italy. Spanish naval contingents were limited to their own coastal vessels, and to the 'galleys of Spain', a small fleet of around a dozen ships on contract to the crown and under the orders, in the days of the emperor, of Castile's leading sailor, the noble Álvaro de Bazán, founder of a long and distinguished dynasty of naval commanders. The vulnerable position of the emperor in the western Mediterranean was made plain in May 1528 when his fleet, under the command of the Genoese noble, Fabrizio Giustiniano, was defeated by the navy of Doria in the bay of Salerno. The former viceroy of Sicily, Hugo de Moncada, was killed in the action, and other distinguished nobles were taken prisoner to Genoa.

The misfortune turned out to have consequences that were far from unfavourable for the emperor. Andrea Doria was in the process of defecting from his alliance with France, and in the summer he made a historic agreement with Charles's new supreme commander in Italy, the young Franche-Comtois prince of Orange, Philibert of Chalons. By this accord,[29] Doria put his private fleet of twelve galleys at the service of the emperor and received in return a number of important concessions that strengthened his position in the state of Genoa. At the same time a coup led by his family placed the great financial and maritime city firmly in the Habsburg camp. The admiral returned in September to a Genoa that had been hurriedly evacuated by the French. His defection, together with subsequent military reverses suffered by Lautrec's troops, obliged France to make peace with the emperor. From this date the Doria fleet was prominent in all Charles V's expeditions of the Mediterranean.

The Peace of Cambrai in August 1529 marked a crucial moment in the history of Western Europe, for the participating parties each with-

drew from pressing claims that might have led to further war. Francis I was confirmed in control of Burgundy, which the emperor had always claimed; in his turn, he confirmed Charles's domination of Italy. The treaty also marked the end of an epoch in Charles's policy. Till that date his chief preoccupation had been in the Mediterranean. Henceforward, the affairs of northern Europe and, in particular, Germany would demand his attention.

When he left Barcelona for Italy in the summer of 1529, he cut his hair short, in deference to the style now common in western Europe. Those of his entourage who were likewise obliged to cut their hair wept when they did so. The galleys of Andrea Doria were in Barcelona harbour waiting to escort the emperor. The distinguished admiral, now aged sixty-four, his hair long and his beard white, went along with a group of Genoese nobles to have his first personal meeting with the emperor. When he moved to take off his hat Charles stopped him doing so, and instead uncovered his own head.[30] It was a gesture that in Habsburg Spain was coming to signify the granting of the rank of 'grandee' to the noble privileged to keep his hat on in the royal presence. 'Most powerful Prince', Doria said, 'I shall say little but do much more. I can assure Your Majesty that I am prepared to carry out loyally all that will serve your interests.' The young emperor replied: 'I place my trust in you.' The alliance lasted all their lives. Throughout the reigns of Charles and his son Philip II, the Genoese fleets guaranteed the superiority of the Holy Roman Empire and of Spain in the western Mediterranean.

Charles and his court sailed in an imposing fleet consisting of 37 vessels and 130 transports carrying an entire army of cavalry and infantry. The news was impressive enough for the Valencian exile Juan Luis Vives to hear about it in the Netherlands and write excitedly to the humanist Erasmus that 'Spain is in command of everything'.[31] The expedition arrived in Genoa in mid-August. In the course of the six weeks that he remained there, Charles rewarded Doria with the title of prince of Melfi, which carried with it lordship over the Neapolitan city of that name. He was also reminded of the continuing corsair threat from North Africa, when in October six galleys of the Spanish fleet were destroyed by Barbarossa in a naval combat off the island of Formentera, in what a contemporary described as 'the greatest defeat ever suffered by Spain in a combat of galleys'.[32]

The emperor's visit to Italy was occupied principally with meetings

with princes from all over the peninsula. The chief business was, however, in Bologna, where Charles was due to meet the pope. The meeting had been well prepared by ambassadors on both sides, with the intention of securing peace and stability in an Italy now free of the French. The Imperial court advanced slowly southwards and on 5 November 1529 made a ceremonial entrance into Bologna. The city was brilliantly decorated, with the presence of the chief princes of Italy and of Imperial troops under the command of Antonio de Leyva. The Medici pope Clement VII (victim of the horrifying sack of Rome by Charles's troops in 1527) was in poor health, but happy to welcome Charles: there were differences to settle, compromises to make, and political arrangements to secure. The prolonged talks in Bologna, which led to a famous Treaty at the end of December arranging the political complexion of all the Italian states, was the achievement above all of the Piedmontese Chancellor, Gattinara.

The series of acts was brought to a climax early the following year, when a formal coronation of the emperor was celebrated, as completion of the ceremony carried out exactly ten years before in Aachen, when the archbishop of Cologne had crowned Charles. On 22 February 1530, Charles was solemnly invested by the pope in a majestic ceremony when the iron crown of the Lombards was placed on his head. Two days later, in a yet more magnificent ceremony in the cathedral of San Petronio, on a day that was fortuitously his birthday, the golden crown of the Empire was placed on his head.[33] Four weeks later Charles left Bologna, staying in Mantua for a month before returning to Austria, where he arrived at the beginning of May.

In those seven months since his departure from Barcelona, he had through personal contact, intensive negotiation, undoubted pressure, and extensive distribution of incentives, honours, lands and titles, consolidated his hold on Italy and helped also to achieve the security of Spanish interests there. With satisfaction Charles wrote in May from Innsbruck to his wife that 'affairs in Italy are now quite tranquil'.[34] There was only one outstanding problem, that of Florence. The city, a possession of the Medici family and theoretically subject to Clement VII, had rebelled against its masters. After eleven months of siege the defenders, among them the artist Michelangelo, capitulated to the joint Imperial-papal forces in August 1530. A few years later a Venetian ambassador, summing up the political situation in the peninsula, was

able to conclude that Charles was 'master of the greater part of Italy; there are few rulers or states who are exempt from his control, except the Pontiff, Venice and to some degree the duke of Ferrara, all the others are either vassals or dependants and some even servants of His Majesty'.[35]

The Italian territories came to have a much greater significance than Spaniards ever recognized, in the formation of their eventual power in Europe. In a very real sense, there would have been no Spanish empire without Italy. Italians detested the French as 'barbarians' who had attempted to take over their lands, but they soon also learned to detest the Spaniards. Their historians, for whom the decades after the invasions of 1494 were the 'times of calamity', felt that foreign occupation of Italy never lasted long, since it was expensive to maintain foreign troops far away from home. In this case, however, the Spaniards represented a military presence rather than a military occupation. Indeed, the number of Spanish troops based in the Italian peninsula was always (with the special exception of Milan) very small. At any given time in the sixteenth century, there were normally no more than twenty thousand Spanish soldiers in the whole of Italy, most of them based in Milan.[36] The numbers rose considerably only in the seventeenth century. Though Spain in the days of Charles V was periodically involved in military actions in the Italian states, its power there was not based on occupation and oppression but on a strong client network and on economic interest. Since the emperor seems to have decided at an early date that the destinies of his Mediterranean states were linked together, it is important to understand what those links were. Castilians of subsequent generations tended to assume that they had conquered Italy. There was no real basis for the belief.

In the first place, the emperor's power was based on dynastic control of two of the principal territories of Italy. Naples belonged to the dynasty of Aragon after Ferdinand secured it successfully in 1504. Milan, over which France had provoked wars for a generation, remained for all practical purposes in the emperor's control after the battle of Pavia, and on the death of the last Sforza duke in 1535 was integrated into Charles's territories and then passed on to his son Philip. In addition, Charles possessed the hereditary territories of Sicily and Sardinia, and control of the coastal fortresses in Tuscany. Together, these territories represented

about forty per cent of the surface of modern Italy. From the date of the peace of Bologna (1530), when Charles's supremacy was recognized by the Italians and he was formally crowned Holy Roman emperor by the pope, the role of the Habsburg dynasty in Italy was firmly established. But the role was based on dynastic right rather than on military control.

In the second place, outside the territories that were subjected directly to the crown, Habsburg dominance rested on close alliances with the élites of the leading states. In Genoa, one of the most active business and seafaring cities of Europe, the Habsburgs since the 1520s were closely allied with the great Spinola family. From 1528, when the Doria family also drifted to the Habsburgs, these gained a vital alliance that gave security to the possession of Milan. It was the same story in other city-states. We may take the example of Florence, where Charles's support for the Medici family was sealed by the marriage of his half-sister Margaret to the duke in 1536. On the duke's death, Margaret was married to the Farnese duke of Parma. The Italian nobles were happy to collaborate with the powerful Habsburgs, particularly when they could also obtain benefits and security for themselves. They were duly invited to participate in the international empire of Charles: in the chapter of the Burgundian Order of the Golden Fleece held at Tournai in 1531, three Italian nobles were invested as members, the marquis di Vasto, Andrea Doria and Ferrante Gonzaga.[37]

At the same time, Italians and Spaniards were encouraged to enter into political alliances. Intermarriage between Italian and Spanish nobles laid the basis for co-operation between the two nations for nearly two centuries, and created in Italy a recognizable governing élite of soldiers and administrators. In the 1530s the daughter of the viceroy of Naples, Pedro de Toledo, son of the duke of Alba, married the Medici duke of Florence, Cosimo I; Toledo's son married the daughter of Vasto; Vasto's brother-in-law Vespasiano Colonna married the sister of Gonzaga; and Gonzaga's son married the daughter of Doria. In these years Toledo held the post of viceroy of Naples, Vasto that of viceroy of Milan, and Gonzaga that of viceroy of Sicily before he succeeded Vasto in Milan. The closely linked network of blood and influence served to identify the interests of the élite with those of the ruling dynasty. It was an arrangement that suited everybody. In appearance the emperor made the decisions, in practice the decisions were being made for him by the élite that held the reins of power directly.

Thirdly, the Spanish crown employed the services of the leading banking houses of northern Italy, who had pioneered modern financial techniques and now made their expertise and resources available to the emperor. Genoese, Florentine and Venetian financiers were already well placed to control much of the trade of the Iberian peninsula.[38] After 1530 they became the mainstay of Imperial policy both in northern Italy and in Naples. Genoa, where the leading political families and the principal bankers were closely allied to Spain, was a typical example of a free and independent state that in practice functioned as though it formed part of the Spanish empire.

Finally, Italy became the fundamental basis of the naval and military power of the monarchy in the Mediterranean. The forces of Italy and Spain together could dominate the western Mediterranean almost effortlessly. Writing to the empress in February 1530 from Bologna, Charles stressed that Castile was in a position to underwrite his power in two main ways, through ships and money.[39] In practice, however, the bulk of Charles's resources normally came from Italy. Barely two months after the referred letter, he wrote to his wife from Mantua in April 1530, explaining that he had decided to rely almost wholly on Italy for the items he would need for his planned descent on Africa, against Barbarossa.[40] The soldiers he would use would be from those (Germans, Italians and Spaniards) serving in Italy, 'on account of their efficiency and experience'. He preferred not to use any from Spain, because the Spaniards recruited would be 'raw and inexperienced'. For the same reason, 'I have decided that the fleet be prepared here.' He hoped to have fifty galleys available, all of them from Italy and France, though he hoped that vessels currently being constructed in Barcelona would be available. Castile, certainly, must supply some of the money needed, but it should be sent to the Genoese, who would see to the rest. They would make available in Genoa 'artillery, ladders, tools, gunpowder, arquebus fuses and other items'. As for victuals for the expedition, 'I have written to Naples and Sicily and Sardinia for them to prepare over there a quantity of biscuit, meat, wine, vegetables and other provisions for the fleet.' The Castilians of course must also contribute supplies, to be stored in Málaga; he would need 'ten thousand quintales of biscuit, a hundred casks of wine, a thousand barrels of anchovy and sardine, three hundred quintales of gunpowder and five hundred cannonballs'.

Italy, in effect, remained for Spaniards the overriding imperial

experience of the period marked out by the reign of the emperor. Though Charles in his last years was almost wholly preoccupied with German problems, brought on by the convulsions of the Lutheran Reformation, Spaniards had their vision fixed rather on Italy. One of the emperor's faithful soldiers, writing his memoirs during his years of retirement in his home town of Córdoba, looked back on the Italy of those days as a sort of great harlot lusted over by the military power of France, Germany and Spain. Tens of thousands of foreign soldiers had died there in the wars, evidence of the international nature of Charles's power. After leaving Rome in the spring of 1536, the emperor ordered his forces to move north to block any possible entry of the French into Italy. The army was commanded by a Spaniard, Antonio de Leyva, but its composition was, in the emperor's own words, 'fifteen thousand Germans, two thousand Spaniards together with a few Swiss who have come to serve us, and a good quantity of Italians'.[41] In fact, this was only the core of the army, for the emperor hoped to contract up to thirty thousand Germans in order to keep the French at bay. In this way, decade after decade the fighting men of Europe descended on helpless Italy. Our retired soldier, drawing on his own experiences as well as on estimates made by contemporaries, calculated that in the years that he had served there, from 1521 to 1544, the emperor had employed a total of 348,000 soldiers, of whom 44 per cent had been German, 30 per cent Italian, 15 per cent Spanish, and 5 per cent Swiss.[42] The figures are a fair reflection of the contribution made by the respective nations to the maintenance of Imperial hegemony in Italy.

Despite their limited contribution in Italy, Spaniards would rightly remember the Italian experience as the last great age of the traditional type of military hero.[43] Their outstanding commanders included Antonio de Leyva and Fernando de Alarcón, but in the popular mind the names that most stood out were the ordinary soldiers of the tercios, whose feats continued to perpetuate a bygone age of chivalry. Among them was Juan de Urbina, who made himself famous during the wars around Milan, for having risked his life rescuing a fellow soldier from five Italians who were attacking him; and Diego de Paredes, who made himself famous in the duel against Bayard at Trani, and went on to figure in other exploits both in Italy and during the march of the tercios to Vienna. The Navarrese general Pedro Navarro would undoubtedly also have figured among the great heroes of Spain, had his defection to France not earned

him immediate oblivion among the historians. Perhaps the supreme moment of individual achievement in the Italian wars was at the battle of Pavia, when three members of the tercios were among those fortunate enough to seize the person of Francis I of France.

An Italian territory that was directly affected by the international commitments of the emperor was the kingdom of Naples. Ruled directly by the king of Aragon after 1504, Naples continued in theory to be a realm wholly autonomous from Spain, with its own laws and institutions. In practice, it began to be absorbed into Spain's imperial network. The first significant changes in its constitution took place in 1506–1507, when Ferdinand the Catholic visited the realm and relieved the Great Captain of his command. Instead of being the seat of a king, Naples thereafter was to be governed only through the king's representative, his 'viceroy'. It was also to be administered after 1507 by a Collateral Council, which was to take precedence over indigenous tribunals and included Spaniards. The process went through its most crucial phase under the most important of the viceroys appointed by Charles, Pedro de Toledo. During Toledo's period as viceroy, steps were made to turn the territory into one of the great naval construction centres of the Mediterranean.[44] In the late 1530s, the Naples galleys were a key component of the defence forces available to the crown of Spain.

The relationship with Italy was, of course, not simply a military one. Nor was it based only on Spaniards crossing over to Italy. Since at least the fifteenth century, Italians had been active in many aspects of the culture and commerce of the Iberian peninsula. A significant group of Genoese traders and bankers was established in Seville, where the opening of relations with the New World found them well placed to exploit the opportunity.[45] In the early years of trade with America, they were by far the most important group of investors.[46] The Genoese under Charles V became the principal bankers and capitalists of the monarchy, helping to finance the great enterprises of the Crown but also, and through their loans and credit extending their connections all over the western Mediterranean.[47] A historian has acutely observed that 'as the Spanish were conquering the Americas, the Genoese found their America in Spain'.[48] The Venetian ambassador in Spain, Badoer, reported in 1557 that the economic interests of the Genoese 'extend through all kingdoms and states', and that the republic of Genoa 'lends credits to all and waits on everyone'.[49] Their role in making possible the launching of the empire

as big business was crucial. They advanced money to finance emigrants, trade goods, send slaves, and advance sugar production in the New World. 'Everything here goes as the Genoese desire', an agent in Seville wrote in 1563 to one of the chief Castilian bankers of that time.[50] The mechanism used was for the Italian bankers to advance credit (through credit notes known as 'bills of exchange', precursor of the modern cheque) to the crown at the place and time agreed, and to be repaid out of the revenues of the government of Castile. Where possible, the Genoese preferred to realize their returns out of the bullion that the fleets brought from America to Seville. As a consequence, large sums were transferred from Spain to their agents in Antwerp and in Genoa.

While Charles as emperor confronted in the north of Europe the challenge of the Protestant Reformation, Spanish security in the south continued to be threatened by Muslim naval power in Africa and the Mediterranean. The reign of the emperor coincided with the most successful period of expansion in the history of the Ottoman empire, ruled from 1520 to 1566 by Suleiman the Magnificent. Spaniards were by no means exempt from the consequences. Khayr al-Din Barbarossa in 1518 declared himself a vassal of the sultan, and with the assurance that he had the backing of Istanbul continued to prey on Christian shipping in the western Mediterranean. In 1522 he recaptured Vélez de la Gomera, and in 1529 the Peñón of Algiers, where he put to death the small Castilian garrison of 150 men, who had previously refused offers of a safe return to Spain if they surrendered. Barbarossa's fleet of sixty ships had an impact that extended far beyond these minor incidents, for they could count on the support within Spain of the large and discontented Morisco population. The resounding defeat by Barbarossa off the island of Formentera of eight galleys that the emperor sent from Genoa in 1529, alerted Charles to the urgent need for action. But it was a particularly difficult moment, and the options available were few. From April 1530, the major part of his time had to be spent in the Empire, where he was attempting to deal both with the German princes and with the looming Ottoman threat to the city of Vienna. The coasts of Spain remained exposed and unprotected, without adequate ships or fortifications, and in Catalonia where the local population was reluctant to contribute to the defence effort it became necessary to seize French settlers to do the work.[51]

Castilian leaders were willing to assume the costs of defence in the peninsula, but firmly opposed Charles's efforts to raise money in order to face the Turks who threatened Vienna. A member of his royal council, Lorenzo Galíndez de Carvajal, pointed out that 'the expenses of the Empire and of other countries that are not Spain, should not be paid with Spanish money nor discharged on Spain'.[52] In the event Charles did not press the Castilians. But he exercised his right to use the troops based in Italy. The Castilian and Italian tercios, totalling over six thousand troops and commanded by the marquis di Vasto, consequently found themselves stationed on the Danube. They made a historic march from Milan up through the Valtelline to the east, passing through Innsbruck, Passau and Linz and on to Vienna, the first Italo-Spanish army ever to appear in the Holy Roman Empire.[53] A curious detail of their expedition is that many went accompanied by their women, a total of 2,500 ladies of undetermined nation – presumably mostly Italian – or social rank. The march of the tercios into Central Europe was a significant step forward in Spain's response to the international obligations of power. An enthusiastic soldier who took part in the expedition set down in verse his vision of the promise of Spanish glory:

> Spaniards, Spaniards,
> Everyone stands in fear of you![54]

Hundreds of noble adventurers from all over the continent also made their way to Vienna in 1532 to serve against the Turk. Among them were a number of Castilian grandees who wished to demonstrate their loyalty to the emperor. The dukes of Alba and Béjar, the marquises of Villafranca and Cogolludo, the counts of Monterrey and Fuentes, and the scions of the great noble families – the houses of Medina-Sidonia, Nájera, Alburquerque, Mondéjar – were among the many who went northwards. Their appearance was in the event largely symbolic, for on seeing the immense army that the emperor had managed to assemble for the defence of Vienna – some hundred and fifty thousand men and sixty thousand cavalry, described admiringly by the Franche-Comtois Féry de Guyon as 'the biggest and most beautiful army that anyone had seen in half a century' – the Turks decided to strike camp. The tercios arrived on 24 September 1532, when the Turkish withdrawal had already begun, and consequently never saw battle. Francisco de los Cobos, writing from Vienna, reported with pride how the emperor inspected the newly

arrived contingents: 'the day before yesterday he went out to the camp to see the Spanish and Italian contingent, who are the finest anyone ever saw, especially the Spaniards'.[55]

The defence of Vienna was accompanied by a counter-move made in the eastern Mediterranean, in an attempt to draw the Turks away from the siege. In the spring of 1532 Andrea Doria led a fleet of forty-four galleys (of which seventeen were Spanish), carrying over ten thousand German, Italian and Castilian soldiers, towards Greece. Though the Castilians played a minor role, the campaign carried clear echoes of that led a generation before by the Great Captain. On this occasion the expedition resulted in the occupation in September of Coron (where Doria left a Castilian garrison of 2,500 under Gerónimo de Mendoza) and of Patras. The following year, Suleiman sent forces to recover Coron but Doria returned to the Aegean with thirty vessels (including twelve under Álvaro de Bazán) and scattered the Turkish forces. The captured positions were almost impossible to maintain, and were abandoned in 1534 when the Turks returned to the attack. The Imperial treasury could not meet the heavy cost of the campaigns, and when the Spanish tercios reached Messina in 1534 they threatened to mutiny if they were not paid.[56] It was an ominous sign. In previous campaigns in Italy the Germans had often mutinied but the Castilians had usually restrained themselves. After 1534 mutinies were a regular occurrence among the tercios.

No sooner had Doria returned than he faced a completely altered and considerably more dangerous scenario in the western Mediterranean. Barbarossa had journeyed to Istanbul in 1533 and received from the Ottomans a commission as their admiral in the west, together with the help of Turkish ships and troops. With these he proceeded to impose his control on the principalities of the North African coast, and raided and burnt along the coasts of Italy. On his return to Castile in the spring of 1533 Charles was anxious to put into effect his long-considered idea of eliminating the North African corsairs at their root, the cities of the African coast. The Castilian leaders, with Cardinal Tavera at their head and with the support of the empress, expressed their opposition to the choice of Tunis as objective. The desirable objective was, for them, Algiers, whose shipping represented more of a threat to their coasts. In the event, the emperor's advisers opted for Tunis.

The famous expedition to Tunis assembled at its rendezvous in the port of Cagliari, Sardinia, in the early days of June 1535. It was, as all

operations in the western Mediterranean came to be, an international undertaking but with a predominantly Italian complexion, since the defence of the coast of Italy was in question. Genoa, the papacy, Naples, Sicily and the Knights of Malta sent vessels. Charles sailed to join them from Barcelona with the fifteen Spanish galleys, and vessels came from Portugal under the command of the empress Isabella's brother. Ten thousand new recruits from Spain were ferried in transport ships supplied by Vizcaya and Málaga. The cream of the nobility of Italy, Flanders and Castile was present.

The assembled force was an imposing sight, totalling over four hundred vessels.[57] Of the eighty-two galleys equipped for war, eighteen per cent were from Spain, forty per cent from Genoa (mainly the vessels of Andrea Doria), and the remaining forty-two per cent from the other Italian states (including the galleys of Naples under García de Toledo). There were over thirty thousand soldiers on the fleet; they included the Spanish recruits, together with four thousand men from the tercios of Italy, seven thousand Germans and eight thousand Italians, as well as several thousand adventurers who came along at their own expense.[58] The operation was put under the direction of two Italian generals, Doria for the navy and Vasto for the men. The costs of the exercise were met in part by bullion received from America, in part by Genoese bankers (who were also paid in American gold). It was the most imposing military expedition ever to have been mounted by Christian powers in the long history of the western Mediterranean.

The siege of the fortress of La Goletta, at the entrance to the bay of Tunis and defended by a strong Turkish garrison, began on 20 June and lasted for three and a half weeks, during which a number of reinforcements from friendly local Muslim leaders arrived. The fort eventually fell on 14 July, a day of intense heat that afflicted victors and vanquished alike. 'We won the victory despite the terrible heat', Féry de Guyon recalled, 'that day there was no water to be had in wells or rivers, and the battle began after four in the afternoon; the soldiers were so worn out that immediately after winning the battle they just sat or lay down on the ground.'[59] Charles decided to press on to the city of Tunis, which was captured on 21 July and sacked by the triumphant soldiery. Barbarossa escaped, and was replaced as ruler of Tunis by Muley Hassan, who swore allegiance to the emperor, while La Goletta was left with a Spanish garrison. Charles had every reason to be content with a

campaign that brought rejoicing to the Christian Mediterranean. The enormous navy then made its way home to its various destinations. Off the coast of Italy one of the galleys, loaded with German soldiers, capsized and all on board perished;[60] more men died in the accident than during the entire military action at Tunis.

No sooner had Charles achieved his moment of glory in Tunis than a new threat emerged, this time from France. The emperor sailed directly from Tunis to Sicily and Naples, where he spent the winter and dedicated himself to the administration of his kingdoms in southern Italy. In March 1536 he accepted an invitation from the pope to discuss common problems, and on 5 April 1536 was in Rome. Two days earlier, French troops crossed the frontier into Italy, and a state of war existed.

Charles had much business to discuss with the pope, Paul III, who laid on a triumphal entry for the emperor. On 17 April Charles addressed an assembly of cardinals and diplomats in the presence of the pope. He was very angry with France for having broken the peace, and startled the assembly by refusing to speak in his own tongue, French. Instead, he spoke in Castilian. He angrily denounced the threats to peace posed by France, and France's unacceptable alliance with the infidel Barbarossa. Holding up in his hand a sheaf of secret correspondence between Francis I and Barbarossa, he said: 'I myself, with my own hands, seized at La Goletta these letters I am holding.' He challenged Francis I to resolve their differences by a personal duel rather than endanger the lives of so many Christians. At the end of his long peroration, delivered without any notes, he repeated firmly, 'I wish for peace, I wish for peace, I wish for peace!'

The hearers were stunned, many because they had not expected to be addressed in a language little used among diplomats. The bishop of Mâcon, one of France's envoys to the papacy, spoke up and asked the emperor for a text of the discourse, since he did not understand Castilian. Charles replied tersely: 'My lord bishop, let me be clear: do not expect to hear me speak in any language other than Spanish, which is so noble that it deserves to be known and understood by all Christian men.' Charles's own advisers were perplexed by the unexpected vigour of his 'sermon', as they termed it, and by the use of Spanish. The next day, when his ire had cooled, the emperor summoned the two French ambassadors privately and gave them a verbal summary, 'in italiano buonissimo', of what he had said in Castilian. Despite the incident, Charles always gave

precedence to his own language, French, in both private and public life.

The success at Tunis, the empress reminded Charles in September 1535, 'has been particularly pleasing to the kingdoms of Naples and Sicily, and to the whole of Italy'.[61] The Castilians had always insisted on an expedition against Algiers, and had little interest in Tunis, which was on a part of the African coast deemed to be of interest to the Crown of Aragon only. In 1510, indeed, King Ferdinand had stated that 'the conquest of the kingdom of Tunis is the responsibility of the Crown of Aragon'.[62] Castilians therefore continued to insist on the need to take Algiers. The corsairs, in any case, had not been stopped. In a stunning response to Tunis, Barbarossa with thirty galleys launched a lightning attack on the port of Mahon in the Balearic Islands on 1 September. They sacked the town, took a good part of the population prisoner, and left five days later.

The expedition to Algiers, the empress and her advisers hoped, would be an attempt to make up for the incomplete victory at Tunis. But it had to be put off for some time because of the emperor's involvement with the situation in Milan provoked by the death of its duke, Francesco Sforza, in November 1535. Charles, at the time in Naples, wrote to the empress in February 1536, asking her to continue with the idea of the proposed expedition to Algiers, but also to send immediate resources to Genoa to confront the possibility of an outbreak of hostilities with France in northern Italy. All available galleys, the emperor wrote, should be sent to Genoa under Álvaro de Bazán, together with three thousand men for the infantry, available provisions, and money coined from the American gold and silver that had recently arrived in Seville.[63] The nature of the help he required showed that Spain had now moved up in the emperor's list of priorities. From being simply one component of the empire it had become the most crucial. The speech in Spanish proclaimed this reality to the whole world. Writing to his wife the day after his speech, Charles admitted frankly and for the first time, that for his military needs 'there is no way of finding finance anywhere else'[64] than Spain. Since Spain, as we have seen, contributed little through taxation, the emperor's mind was obviously on the precious metals from the New World.

The constant vulnerability of the Christian states was confirmed by a reverse suffered by their naval forces in September 1538 off the island of Prevesa, near Corfu in the eastern Mediterranean. Over 130 Christian vessels, under the command of the viceroy of Sicily, Gonzaga, and

including a Spanish contingent as well as vessels of Doria, Venice and the papacy, confronted a similar concentration of vessels under Barbarossa.[65] The Christian forces failed to achieve anything decisive, except to make it clear that the Turks were still the supreme naval power in the eastern Mediterranean. For the next generation the defence of the sea had to be conducted from the west, where the spate of attacks on Christian territory was unrelenting. Pressure mounted on the emperor, above all from the Spaniards, for an attack on Algiers.

An ill-fated attack on Algiers was eventually launched in 1541. According to the official estimates, Naples and Sicily were to meet sixty per cent of the costs, Castile forty. Similar proportions applied to the galleys, of which the Italians would supply two-thirds and Spain one third.[66] Two-thirds of the soldiers would be Italians (commanded by Colonna) and Germans (commanded by Alba), one third Spanish (under Ferrante Gonzaga). The assembled force sailed from Mallorca in mid-October 1541, picking up on their way the duke of Alba, who was at Cartagena. The total force was estimated at 65 galleys, 450 support vessels and transports, with 12,000 sailors and 24,000 troops. Among the captains was the conqueror of Mexico himself, Hernando Cortés. On 23 October the infantry began to go ashore six miles from the city of Algiers.

That afternoon, a sudden storm hit the coast.[67] 'That day, Tuesday,' Cardinal Tavera later reported, 'such a big storm arose that not only was it impossible to unload the supplies and guns, but many small vessels were overturned and also thirteen to fourteen galleys.' The storm went on unabated for four days, destroying a good part of the ships and many of the men ('thank God', noted Tavera, 'no one of importance was lost, only ordinary men and servants and sailors'). It was impossible to unload the artillery. On the 26th, to the amazement of the besieged Algerians, the emperor began to withdraw his forces. The bad weather continued to hinder an orderly withdrawal and Charles did not reach Mallorca until the end of November. The total losses suffered by his forces were possibly not less than 150 vessels and 12,000 men, without counting cannon and supplies.[68] It was the emperor's first resounding defeat, an unmitigated disaster in every sense, a profound humiliation, and for all the foregoing reasons his last expedition against the forces of Islam.

The defence of Italian and Spanish interests at sea were attended to in the following years mainly by Andrea Doria and his fleet. Land

operations were all but suspended, a situation that vexed the local commander at Oran, the count of Alcaudete, who from his arrival at the post in 1535 made ambitious efforts to extend Spanish authority into the kingdom of Tlemcen, but always with little success. The Ottomans were consolidating their hold on North Africa, and Tlemcen in 1552 was taken over by the Turks. In 1555 the town of Bougie, which had been in Castilian control for forty-five years, was lost to a Muslim force from Algeria. Finally, in 1558 an independent expedition made by Alcaudete, against the advice of the then king, Philip II, was wiped out by the Muslims and its commander killed.

The peoples of Spain and the Netherlands had enjoyed a profound friendship since the Later Middle Ages. Spaniards were unfamiliar with the countries of northern Europe, to which they traded little and whose languages and culture remained for them a mystery. The big exception was the Netherlands, to which they traded directly by sea and which in turn imparted its financial expertise and cultural creativity to the Iberian peninsula. The Netherlands was also the principal foreign market for Castile's chief export, raw wool. The marriage of Juana and Philip the Fair sealed a relationship that seemed to augur a bright future when Philip became king of Castile and even more when Charles of Ghent inherited all the crowns of Spain. With the passage of years, Charles came to the firm decision that Spain and the Netherlands should identify their interests with each other, but he never offered any precise reasons for it. In February 1522, at Brussels, he signed an agreement handing over direction of the territories of the Habsburg family to his brother Ferdinand. This could in perspective be seen as an explicit separation of the Germanic lands from the rest of the inheritance, but he was still too young to have any rigid intentions on the matter.

The collection of autonomous provinces on the northwest coastline of mainland Europe, called the Netherlands because of their low-lying topography, had formed in the Later Middle Ages the core of the state of 'Burgundy', whose other main component was the inland dukedom of that name (divided in the sixteenth century between Franche-Comté and French Burgundy). Lying astride the great rivers Rhine, Meuse and Scheldt, the Netherlands devoted themselves to agriculture, fishing and trading, and in the sixteenth century possessed the biggest centre of capitalist activity in Europe, the port of Antwerp. Mainly Dutch

(Flemish) in language and culture, they were governed by an aristocracy that tended to come from the southern provinces, where the predominant language was French (Walloon). When the provinces passed under the rule of Charles they received the lineaments of a political constitution that bound them together.

A form of central administration was created in Brussels, though each province also had its own government presided over by the stadholders (*stadhouders*, in Dutch). Charles governed his home provinces with a sternness that a father reserves only for his own family. He introduced an Inquisition to repress heresy, and personally directed the crushing of a rebellion in the city of Ghent, his birthplace, in 1539. At the same time, however, he lavished on the Netherlands a care that he gave to none of his other territories, including Spain. And when he went to Spain he took there with him everything that he most cherished: his Flemish culture, his Flemish religion and art and music, his court ceremonial (known as the 'Burgundian' ceremonial) and ritual (the Order of the Golden Fleece), and above all his Flemish officials, whom he appointed to the choicest posts not only in Spain but also in Italy. In time, as the demands of war in the Mediterranean and Germany occupied more of his time, he spent longer periods outside the Netherlands than in it. But it remained for him the homeland that he most cherished.

Everything, in short, demonstrates the prior position occupied by the Netherlands in the minds of the early Habsburg rulers of Spain. The provinces, however, in no way formed part of the Spanish empire and were not subject to Spain. Their only political link with Spain was that they shared a common ruler. We have glanced at the wholly logical link between Spain and Italy. What then were the links between Spain and the Netherlands?[69] Great scholars used to maintain that it was Charles's aim to 'transfer the Netherlands into an outpost of Spanish power in northern Europe'.[70] The idea is highly improbable and unsupported by any evidence. It would almost make more sense to take the reverse view, and think of Spain as an outpost of Netherlandish power – that is, economic and cultural power – in southern Europe. None of the emperor's acts suggests that he wished to subordinate one country to the other. When he crushed the rebellion in Ghent he used only local troops, four thousand Netherlanders and four thousand Germans,[71] rather than soldiers from the Mediterranean.

There were, however, already men from Spain serving in northern

Europe. The extent of Spanish power, it is perhaps not too obvious to mention, can be measured simply and precisely by the presence of Spanish troops. There were only a limited number of such troops active in Europe at the time of the emperor. When Charles was at war with France he brought some to the Netherlands and deployed them on France's northern frontier.[72] In 1527, six thousand Castilian troops took ship at Santander for service in the northern Netherlands. Early in 1540 the emperor also arranged for two thousand troops to be dispatched from Laredo in case he needed back-up just after the Ghent revolt. This was also the period when cultural relations between Flemings and Spaniards were at their best and most positive, thanks in great measure to the vogue in the peninsula for Erasmian humanism. Everything, therefore, conspired to make it a fruitful period for co-operation. As we shall see, Flemish clergy collaborated with Castilians in the first missionary efforts in the New World. Soldiers from the peninsula continued to be transported to the north after 1540. We know that three thousand arrived in the Netherlands in 1543 and five thousand in 1544, a period that coincided also with the first disorders caused by troop indiscipline.

Spanish soldiers also played a fundamental role in Italy, where they were the backbone of control in Naples and began after 1530 to help garrison Milan. In 1532, as we have seen, they made their first appearance on a large scale against the Turks on the Danube, but returned immediately afterwards to Italy. The tercios constituted perhaps half the army of twenty thousand that invaded French Provence from Milan under the command of Leyva in 1536. The attack petered out, Leyva died at Aix, and the forces were withdrawn to Italy in September.[73] Their next appearance on the international scene was in the Holy Roman Empire, on the occasion of the last war between the emperor and France, which broke out in 1542. Charles used up to eight thousand tercios from Italy to serve in the armies that he launched, from his base at Metz, against the French province of Picardy in 1543 and 1544. From that decade, the tercios became a vital help to Charles's crumbling military position in the Germanic lands. Their role was always supplementary and by no means represented an extension of Spanish imperialism to Germany, where they nevertheless helped the emperor to achieve his last great victory.

The problem that most blighted the emperor's health and prematurely

aged him was the spread of the Protestant Reformation through the German lands. Throughout his military campaign in the year 1546 against the Lutheran princes who formed the Schmalkaldic League, the emperor relied heavily on troops brought in from Italy, both Italian and Spanish, together with levies made in the Netherlands. A major encounter between the two opposing forces was put off for several months, with the inevitable result that troops on both sides had to be paid off and sent home. Charles's reduced forces, however, were complemented by those of his brother Ferdinand and of his newly acquired Lutheran ally, Duke Maurice of Saxony. The Imperial army was made up of two main nations – Germans and Spaniards – under the command of the emperor and the duke of Alba. There were five thousand Spaniards constituting a fifth of the total force, and also a number of Italians.[74]

In the morning of 24 April 1547 the army reached the River Elbe opposite the town of Mühlberg, where the League forces under Elector Johann Friedrich of Saxony were gathered.[75] The elector had ordered the only available bridge across the river to be destroyed and was confident that the emperor could not cross. The emperor's men, however, constructed a makeshift bridge, and a convenient ford was also discovered. The forces poured over and inflicted a decisive defeat on the surprised Saxon army. A Saxon nobleman, Thilo von Throta, captured the Elector Johann, who was trying to flee after being wounded in the battle.[76] Among the Castilian nobles who served in the Imperial forces was Luis de Avila y Zúñiga, who did not doubt that the strength of the emperor's army lay in the German troops.[77] He reserved his highest praise for the Hungarian cavalry, 'who with incredible rapidity began to accomplish the victory that they were particularly capable of securing'. The Castilians played an important part in the battle, though by no means the part imagined by the official historian López de Gómara[78] and subsequent Castilian scholars. The Venetian ambassador, who was there, claimed that the Spanish troops were 'brutish, rough and inexperienced, though they are becoming good soldiers; those I have seen in Germany have all been veterans [of other wars]'.[79]

The emperor's victory, certainly the most famous of his entire career, was immortalized in the superb equestrian portrait of Charles by Titian, now in the Prado. Castilian tercios were still in Germany to help him in his last disastrous campaign in 1552, at the unsuccessful siege of Metz,

where they made up less than a tenth of the infantry and under four per cent of the cavalry.[80] The Spanish presence in Western Europe was still in its early days and barely perceptible outside the Italian peninsula. However, it had already begun to attract comment, both favourable and unfavourable. Whereas a Castilian poet, Hernando de Acuña, greeted the possibility of a universal dominion for Charles, with 'one monarch, one empire and one sword', non-Spaniards were distrustful of the implications. 'Spaniards', wrote an English observer at the court of the emperor, 'had now in their hands the seal of the Empire, and in their swing the doing of all things.' Antoine Perrenot, later Cardinal Granvelle, informed Charles in 1551 that reliance on Spanish troops meant that 'he could not remain safely in Germany after the Spaniards had gone'.[81]

Down to the 1550s, there was no discernible anti-Spanish feeling in Europe, outside Italy. Europeans looked on Spaniards with interest and curiosity rather than fear. They distrusted them only because Spaniards appeared to be tools in the scheming hands of the emperor. The goodwill shown to Prince Philip (later Philip II) on his remarkable journey through Western Europe in mid-century, stands out in sharp contrast to the hostility against Spaniards that developed later during the age of religious wars. The emperor after Mühlberg was preparing to unburden himself of his political cares, and summoned his son to join him in Brussels. The prince sailed from Catalonia in November 1548, on a long and historic journey that took him through southern France, northern Italy and the Alps, Bavaria and the Rhineland, and so on to the Netherlands.[82]

The only untoward incident during the journey occurred in Milan, when there were riots against some of the Castilian soldiers accompanying him. For the rest, he was treated with consideration and generosity everywhere. Philip could not have been happier. He wrote from Heidelberg that 'I have been very well received by all these princes and cities of Germany, with great demonstrations of affection.' In the Netherlands he made a successful official visit to every one of the seventeen provinces, and was sworn in at every principal city. The first sign of reaction against him as a Spaniard was in Augsburg, on his way back to Spain. The emperor had gathered the chief members of the Habsburg family, in order to debate the succession to their various thrones. Charles had over the years consolidated control of the

hereditary family lands – mainly Austria and Bohemia – in the hands of his brother Ferdinand. The latter had since 1531 been 'king of the Romans', a title which gave him the right to succeed to the Imperial crown. Charles wished Philip to succeed eventually to all his realms, including Germany. Strongly supported by most German opinion, Ferdinand wished the succession, and the Imperial crown, to pass to his eldest son Maximilian, king of Bohemia and currently standing in for Philip in Spain. The Germans had no wish whatever to be ruled over by a Spaniard. Only a German, the cardinal of Augsburg declared in November, could rule Germany. The princes would prefer the Turk to Philip, reported an ambassador.

For a long time after Columbus's landfall in the Caribbean in 1492, the impact of the newcomers was barely perceptible. Nearly thirty years – an entire generation – would pass before a substantial Spanish presence was established on the mainland of the New World. America remained a half-forgotten reality that disappointed the pioneers, because it failed to produce either immediate wealth or a route to the Spice Islands. Nearly sixty years after the Columbus expedition, an official historian, López de Gómara, asserted that the discovery of the Indies was 'the greatest event since the creation of the world, apart from the birth and death of him who created it'.[83] By that time, however, a generation of Spaniards had grown up and died, the silver mines had been discovered, and were pouring their wealth into Europe. Gómara's claim was made with obvious hindsight. Very few people were thinking in such optimistic tones at the time that Charles V succeeded to the thrones of Spain.

The occupation of key islands in the Caribbean, carried out after the elimination of sporadic native resistance, took a long time to achieve, in some cases nearly twenty years. The chief settlement was the island of Hispaniola, where the first Spanish city in the new continent, Santo Domingo, was founded. By 1500 the immigrant population of the island, exclusively male, numbered up to one thousand people. Hispaniola became centre to a wide variety of activities, nearly all predatory, such as raiding other islands for Indian labour, or fishing for pearls. Some immigrants were happy to work as farmers and till the soil. Las Casas recorded that when he had asked a farmer in Spain why he was sending his sons to live in the Caribbean, he replied that it was so they could

'live in a free world', and till their own land. Corn, rather than conquest, was a dominant aim.[84] But some Spaniards, dissatisfied with farming life in the Caribbean, became restless. One of them, Hernando Cortés, made the famous complaint that 'I came here to get rich, not to till the soil like a peasant.' The most potent early attraction was the discovery of gold, sought eagerly by Columbus and the early settlers.[85] Hispaniola quickly became a producer of impressive quantities of it that were shipped back to Spain. A period of stability was introduced by the regime of the new governor of the Indies, Nicolás de Ovando, who arrived in April 1502 with a large accompaniment of 2,500 newcomers. Some of them were administrators, and others settlers and adventurers (among them Las Casas). It was a timely arrival, for the number of settlers on the island had shrunk to around three hundred, a sorry remnant. Ovando governed for seven years, and introduced all the main features of colonial rule, notably the distribution of the native population among settlers. He also treated the native population brutally, on one occasion massacring eighty-four of the Indian leaders.

The Spanish occupation soon showed its negative side. Natives who were made to work for the settlers (through the system of labour distribution known as the encomienda) succumbed to the onerous conditions, and died in their thousands. After two decades of disruption in their traditional life, the native Arawak population rapidly diminished and disappeared. It became necessary to raid surrounding islands in order to enslave their natives and bring them to Hispaniola to work. One of the consequences was the total depopulation of the Bahamas, from which possibly forty thousand persons were transported to Spanish-occupied areas in the period 1509–1512.

Diminishing prospects of easy wealth, however, soon induced those who had come from Spain to emigrate from Hispaniola. They were encouraged by official permission (granted by Queen Isabella in 1503) to enslave so-called 'cannibals', and by reports of more gold. Settlers moved to other islands: Puerto Rico from 1508; Jamaica and Cuba from about 1511. The latter island was 'pacified' by Diego Velázquez, its first governor, in a campaign of terror against the largely defenceless natives (Las Casas, who was there, described them as 'simple and gentle') that included the murder of one of their chiefs, Hatuey. The Caribbean experience became a motor to Spanish expansion, and drove adventurers

even further outward, first to the islands and then in growing numbers to the mainland. By the second decade of the sixteenth century the small Spanish population had spread out to look for riches elsewhere. In 1510 a group of them seized from local Indians the site of their village in the gulf of Urabá, on the south of the Caribbean, and established the town of Darien.[86]

The depopulation of the Caribbean Islands by whites forced the Spanish government to reconsider its policy, or lack of one. The diminution in native labour was soon made up for by the import, which we shall consider presently, of blacks from Spain and Africa. But what could be done about the constantly mobile whites? Alonso Zuazo, who was sent to the islands by Cardinal Cisneros in 1517, reported that part of the problem was that Spanish immigrants were not married and therefore did not feel settled. 'At present', he wrote, 'two out of three are without wives and have no permanent home.'[87] Zuazo also made a proposal that would have substantially changed the eventual character of the empire. He suggested that immigration be encouraged from all parts of the world, with the condition only that those who went to America should be good Christians. At the same time more ports should be encouraged to have access to the New World. The richness and variety of the crops available in Hispaniola would, he suggested, pave the way to substantial wealth.

Foreign participation was already important in this early phase of settlement. There was no possibility of mounting expeditions without a good dose of investment and a strong measure of risk, and the foreign financiers who had already appeared in Hispaniola were willing to stick their necks out. Their task was made easier by the government's policy of free trade in the New World. Charles V, endemically short of money, was only too glad to receive offers from his German financiers and in 1528 he made an agreement with the Welsers which allowed them to explore, develop and settle in Venezuela on certain conditions. The first colonists sponsored by the Welsers arrived early in 1529, and for the next sixteen years the company remained in full control of developments in the territory, exploiting the local population as slaves and exploring for wealth into the Orinoco valley.[88] In the same period the emperor was considering an offer from the Fuggers to enjoy similar rights in Peru.

The goods shipped back to the Caribbean in exchange for gold were,

as Ovando informed King Ferdinand in 1504, mostly controlled by Genoese and foreigners. After the initial period of gold production the settlers found that with cheap labour available they could also produce sugar, derived from canes brought in from Africa. As had happened in the Canary Islands, foreign capital played a crucial role. The sugar mills (ingenios or obrajes) in Hispaniola, financed mainly by Genoese,[89] came to have profound implications for the New World. Many Genoese went to live in the New World in order to run their businesses directly. The financier Geronimo Grimaldi, who acted on behalf of his colleagues Centurione, Spinola, Doria and Cattaneo, lived in Hispaniola from 1508 to 1515 and directed his firm's business there. Later the Genoese extended their activities to Puerto Rico, Cuba and the mainland.[90] Silesian miners emigrated to Hispaniola in the 1520s, and in 1525–6 the Welsers set up a factory on the island, with the financiers Georg Ehinger and Ambrosius Alfinger as their agents.[91]

Sugar production began in Hispaniola around 1515, and Ovando delivered the first boxes of sugar manufactured in the island to King Ferdinand on his deathbed. The development offered a way out for the foundering economy of the Spaniards in the Caribbean, mainly in Hispaniola and to some extent in Puerto Rico. The ingenios were responsible, however, as the Dominican friars on the island pointed out, for the destruction of the native population through overwork. From 1494 Columbus had begun the enslavement for labour purposes of the Arawaks of the island, with calamitous consequences. There had been at least three hundred thousand of them before the coming of the Spaniards; by 1548 the historian Oviedo doubted whether five hundred remained. This incalculable disaster prompted the first requests for import of substitute labour, namely of African slaves.

While the Spaniards were attempting to develop a viable economy in the Caribbean, a group of dissatisfied adventurers based in Cuba had in 1513 set out and made contact with the coast of Florida. Those who piloted the vessels began to learn how the currents and winds moved in the Caribbean, and how to arrange sailings in the straits and also towards Spain. Others, meanwhile, were pressing inland from the western coast of the Caribbean. Darien (or Santa Mariá la Antigua as the Spaniards at first called it) began in 1510 as a frontier settlement of about three hundred restless (and ruthless) adventurers, led from 1511 by Vasco Núñez de Balboa, who succeeded remarkably well in controlling the

Spaniards as well as living in peace with the surrounding Indians. In the course of searching for a tribe that was reputed to be rich in gold, Balboa gathered enough information to petition the crown in 1513 for further help in the form of men and arms. When the crown refused to help, he set out from Darien on 1 September 1513 with a group of Spaniards and a large number of Indian helpers. The latter guided him through the difficult terrain of mountains, forest and broad rivers, heading always southwards. They never wanted for food, since the friendly native tribes, at each stage of the journey, supplied them with what they wanted. The overland crossing of the isthmus was, moreover, facilitated by the fact that at no stage did they meet with hostility from the peoples living in the area.[92] On the morning of the 27th, Balboa with some of his group climbed a ridge and had his first glimpse of a vast sea to the south, of which he formally claimed possession for the crown. Two days later they reached the shores of a gulf that led out into the same sea. Balboa waded into the water and repeated the ceremony of possession. It is ironic that even while he was exulting in claiming that ocean for Spain, unknown to him the Portuguese were already navigating it and had made contact with the Spice Islands of Maluku. On his way back, northward through the gulf and then across the isthmus, Balboa concentrated his energies on the search for gold. During the march he ordered some chiefs to be tortured and murdered because they insisted that they had no gold. The historian Oviedo stated laconically that on the journey 'the cruelties were not stated, but there were many'.[93]

In order to press forward with the search for riches on the south coast of the Caribbean, the crown in July 1513 nominated Pedrarias Dávila as governor of the area which then and later was referred to as Tierra Firme but which the order of appointment significantly renamed 'Castilla de Oro'. The fifteen hundred men who sailed from Seville with Pedrarias were an important departure from previous immigrants. Zuazo subsequently reported to Charles V that 'all or most of them had been in Italy with the Great Captain'. They were a hardened, ruthless lot; King Ferdinand himself warned Pedrarias that 'they are accustomed to very great vices, so that you will have difficulties'.[94] Possibly half the men died shortly after arriving in Darien, from illnesses contracted on the voyage and from inability to adapt to their new conditions. Serious difficulties soon arose in the new province of Castilla de Oro, not least among them the differences between Pedrarias and Balboa which led to

the governor ordering the arrest and execution of the latter in January 1519.

The case of Pedrarias Dávila highlights one of the gravest problems in the early evolution of the empire: the inability of the crown to control events from a distance. By the time of King Ferdinand's death nothing had been done to remedy problems, even though it was in his reign that the Dominicans began their campaign of protest. The regency of Cardinal Cisneros was too short to be able to implement any changes. It was left to Charles V, the friend of Las Casas, to take matters in hand. However, for him as for his son Philip II the attraction of the wealth of the Indies took priority over all other considerations. The excesses and brutalities of the Spaniards in the Caribbean were very many and only too well known to contemporaries both in the Indies and in Spain. Tens of thousands of the natives of the New World perished in the course of a few years, as the strangers brought European ways and European civilization to them. It was the first stage of the contact between the continents of the Atlantic.

The year 1519, which began with the execution of Balboa, was responsible for two historic events that brought about a quantum leap in the development of Spain's world empire. In February eleven small vessels set sail from the western tip of Cuba, under the leadership of Hernando Cortés, and headed for the Yucatan peninsula. In September four ships under the command of the Portuguese sailor Magellan and under contract to the Castilian crown set out from Sanlucar in Spain, with the aim of entering by a southern route the ocean that Balboa had claimed. The year also marked the foundation on the Pacific of the city of Panama, a direct consequence of the expedition of Balboa, the first European to see the shimmering expanse of the new ocean, or 'South Sea' as it continued to be called for over two centuries more. Thereafter the expeditions in the New World were continuous, spreading out all over the penetrable territory; some had exploration as their objective, others had conquest, all without exception were looking for wealth and adventure. Those who lived to tell their story never ceased to wonder, like the chronicler Bernal Díaz del Castillo, at the enormous obstacles of geography and climate that they had encountered and overcome.

Throughout his reign the emperor suffered from a permanent inability to pay his bills. When he could not cover his costs in one kingdom, he

sought money in another. 'I can barely pay my costs here', he wrote from Brussels in 1531, 'without having to look for help from those realms' of Castile.[95] In the early years he relied heavily on Genoese financiers, who financed for example the victory at Pavia. 'A few days previously', according to a soldier in the Pavia campaign, 'His Majesty sent a large amount of money to the Genoese merchants for them to use when dealing with the suppliers of the army.'[96] Charles managed to get Castile to play a significant role in covering his costs, but government income, already pledged in part to pay the debts accumulated by Ferdinand and Isabella, was insufficient to meet the needs of international policy.

Fortunately the New World came to his rescue. Gold was the first great lure offered: Columbus, Cortés, Pizarro and every subsequent adventurer placed the search for gold at the head of his priorities. The Caribbean, where Columbus had seen natives eat off plates of gold, was the primary producer; the precious metal was in the early days panned from mountain streams. In the first two decades of the sixteenth century the Spaniards probably collected around fourteen tons of gold (14,118 kilos) from the Caribbean.[97] The news of the discovery of gold in Peru led to further exploration, discovery and exploitation. Most of the metal went to Spain, where it excited astonishment. An official of the emperor's treasury wrote from Seville in 1534 that 'the quantity of gold that arrives every day from the Indies and especially from Peru, is quite incredible; I think that if this torrent of gold lasts even ten years, this city will become the richest in the world'.[98] The effects were quickly noticed in the royal treasury of Castile. 'I am extremely pleased', Charles V wrote from Italy in 1536, at a moment when war with France was imminent, 'at the timely arrival of the gold from Peru and other parts, it amounts to nearly eight hundred thousand ducats, a great help for our present needs.'[99] From the 1540s the first silver mines were discovered on the mainland, principally Zacatecas and Guanajuato in Mexico and Potosí in Peru. Their output, however, remained low until the development of the use of mercury in mid-century (see Chapter 7).

Charles used the precious metals, or the promise of their arrival, to set up credit for himself with the only bankers who had adequate international connections: those of Augsburg, Genoa and Antwerp.[100] The bankers, in turn, set up or expanded their operations in Seville and the rest of Castile, in order to have direct access to their profit. This

meant, inevitably, that a high proportion of the gold and silver from America became pledged to foreign bankers, often years in advance. Charles, obviously, used that part of the precious metal he was entitled to, the 'fifth' levied as a tax on all mine production in America. But from 1523, and more frequently from 1535, he also began to 'borrow' (that is, seize as involuntary loans) shipments that came for the Castilian merchants of Seville. The latter complained bitterly in 1536 that this effectively gave the advantage to foreign merchants: 'they control all the money'.[101]

In fact, the foreigners controlled more than money. In order to pay off his debts to foreign bankers, the emperor gave them property rights to key sectors of the Castilian economy. German financiers were permitted to administer institutions and buy property, and were given control of the rich mercury mines at Almadén in southern Spain. The Cortes at Valladolid in 1548 protested that: 'a consequence of Your Majesty's loans in Germany and Italy is that a great number of foreigners have come here. They are not satisfied just with their profits from banking, nor with obtaining property, bishoprics and estates, but are buying up all the wool, silk, iron, leather and other goods.'[102] The foreign bankers' hold over the emperor, and their clear dominance in international finance, could be seen by the size of their loans. During Charles's reign he made over five hundred contracts (known as asientos) with financiers. In total, he borrowed nearly twenty-nine million ducats from bankers in Western Europe. The Genoese lent 11.6 million and the Germans 10.3 million, accounting between them for three-quarters of all loans.[103] Spanish capitalists were able to come forward with only fifteen per cent of the total, even though they had in theory the easiest access to the wealth of the New World.

The picture appears to be one of an empire oppressed and exploited by international finance, but this is not a helpful way to look at what was happening. The bankers literally sustained the existence of Charles's regime through their loans, and the emperor had to do no more than find the money to repay them. At one of the worst moments of his career, in 1552, when the troops of Maurice of Saxony trapped him at the Austrian city of Innsbruck and he was forced to flee through the winter snow to Villach, Charles was saved by his bankers and by American silver. In Villach Charles was able to agree the terms of a vital contract with his banker Anton Fugger, and even as they talked the ships

were leaving Spain for Genoa, laden with silver newly arrived from America.[104] When failures in the money supply happened, they put in peril the entire network of power. In 1555 Prince Philip, then at Brussels, sent the duke of Alba to Italy to take charge of military affairs. The duke was both grieved and angered to find that there was no money available to help him carry out his job. From April 1555 to May 1556 Spain sent no money at all to Italy, and in Genoa the bankers suspended business for lack of cash. In Naples the German troops in Spain's service had not been paid for months and were mutinying. Alba managed to find some money out of the taxes in Naples, but warned Philip of 'what is owed to the armies, and the risks that threaten your states if they are not paid, and the cries and clamour of your subjects saying that they have not been paid'.[105] An empire could not be run without money.

Ironically, in those months of distress in Germany and shortage of money in Spain the emperor reached out to extend his territories by absorbing England, where Mary Tudor had been proclaimed queen in July 1553 after the collapse of rebellions and plots against her succession. It was the masterstroke of his reign, with incalculable consequences for the future of Spain.

Many years before, Charles had been considered as a husband for Mary Tudor. Now, after consulting with Mary, he wrote to Prince Philip, widower of a recent marriage to Princess Maria of Portugal, asking whether he would care to marry the queen. The wedding of Philip and Mary, celebrated in Winchester in July 1553, followed the pattern of previous Spanish royal matches, such as that between Ferdinand and Isabella. There was to be no union of the realms involved (in this case, England and Spain), and indeed Philip in London took great care not to participate in any decisions of the royal council. Charles and his advisers saw the English alliance as vital, in military and commercial terms, to the defence of the Netherlands against French aggression. As always, the Burgundian inheritance was at the centre of his mind. 'At all costs', he wrote to his ambassador in England, the Franche-Comtois Simon Renard, 'it is our desire that England and the Netherlands be paired off together in order to afford one another mutual aid against their enemies'.[106] Charles had already decided over three years before to leave the Burgundian inheritance wholly in the hands of Philip. The addition

of England to Philip's possessions meant that he was on his way to being the most powerful ruler in Western Europe.

The possibility kindled profound misgivings among other Europeans. The English themselves feared domination by Spain. Philip during his stay encountered the first signs of English distrust. The reasons were political, based on fear for the future rather than on anything the Spaniards had done, for there had always been good relations between the two peoples. A member of Philip's retinue complained that 'we are in an excellent land, but among the worst people in the world. These English are very unfriendly to the Spanish nation.' In London there were several incidents in the street, and Spaniards were frequently set upon and robbed. When the nobles complained, they were told 'that it is in the interests of His Majesty's service to cover up all this'. As a person, Philip was accepted, but Spanish power in England was not. The Venetian ambassador commented that the prince was not only popular but also well loved, and would be more so if the Spaniards round him could be got rid of.

Once the marriage was achieved, the emperor felt that he had completed the arrangements for an orderly transfer of power to members of his family. For several years now his problems of health had convinced him that he must give up his extensive responsibilities. Two years before, a confidential report sent to Philip from Brussels described the emperor's condition:

In the opinion of his doctors His Majesty cannot expect to live long, because of the great number of illnesses that afflict him, especially in winter and in times of great cold. He puts on a show of being in better health when he is in fact most lacking in health, since the gout attacks him and frequently racks all his limbs and joints and nerves . . . and the common cold affects him so much that he sometimes appears to be in his last straits, for when he has it he cannot speak nor when he speaks can he be heard . . . and his piles put him in such agony that he cannot move without great pain and tears. All these things, together with his very great mental sufferings, have completely altered the good humour and affability he used to have, and turned him into a melancholic . . . And on many occasions he weeps and sheds tears as copiously as if he were a child.

Aged only just over fifty years but racked by the pain of gout, he prepared his succession with the care that characterized everything he did. On

25 October 1555 in the great City Hall at Brussels, before a packed assembly that included the chief officials of the Netherlands, delegates to the Estates General, members of the Habsburg family, neighbouring princes and the knights of the Golden Fleece, the emperor expressed his decision to abdicate. He summarized his travels on behalf of his realms:

I have been nine times to Germany, six times to Spain, and seven to Italy; I have come here to Flanders ten times, and have been four times to France in war and peace, twice to England, and twice to Africa . . . without mentioning other lesser journeys. I have made eight voyages in the Mediterranean and three in the seas of Spain, and soon I shall make the fourth voyage when I return there to be buried.[107]

While he spoke, the English envoy observed, there was 'not one man in the whole assemblie that poured not oute abundantly teares'. The wave of emotion overtook Charles, who also began to weep. He turned to Prince Philip, who was seated on his right, embraced him and bade him kneel before him. He placed his hands on Philip's head and blessed him. The prince then rose to accept the duties entrusted to him. At the ceremony, and later in 1556 by formally notarized acts, the emperor abdicated from the greater part of his possessions. He left the Habsburg lands of Central Europe in the hands of his brother Ferdinand, but at the latter's request delayed abdicating from the Holy Roman Empire. All the other realms were passed on to his son Philip of Spain, who now became ruler of an immense combination of territories that included England, the Netherlands (with the subsequent addition of Franche-Comté), Castile, Aragon, Milan, Naples and Sicily, the Mediterranean Islands, the forts of North Africa and the colonized areas of the New World. Possession of these territories in addition involved authority over associated states (such as the Italian duchies, or Ireland) as well as claims to territory in the Pacific. Spain was now separated from the Germanic Empire, and struck out on its own. It was an inheritance to stagger the imagination. Philip was subsequently proclaimed as ruler in the appropriate realms. He was declared king of Castile, with suitable ceremony, in the main square of Valladolid in March 1556. Ruler by right of inheritance and not through any conquest, he stepped tranquilly into the place prepared for him by his father. It was the beginning of the most ambitious and creative phase of Spain's encounter with the world outside. Philip's empire, the Elizabethan chronicler William Camden

later recognized, 'extended so farre and wide, above all emperors before him, that he might truly say, *Sol mihi semper lucet*, the sunne always shineth upon me'.[108]

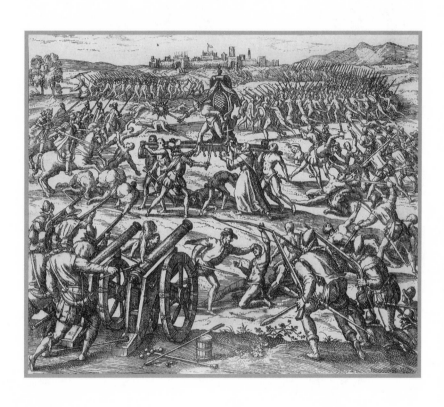

3

A New World

At the time of the conquest there was no Christian God nor king of Spain here, nor was there any justice, and so the Spaniards and the Indians gave themselves up to plundering and robbing, so that there was great hunger and very many people died throughout the kingdom.　　　　　　Felipe Guaman Poma,
New Chronicle and Good Government (1614)

Like all states in the process of expansion, that of Spain resorted to procedures of conquest and occupation. The recovery of Naples for the Crown of Aragon, and the incorporation of Navarre with that of Castile, would not have taken place without the use of an army and all the attendant consequences of death, disruption and destruction. However, the Italian campaigns had demonstrated already that Castile had few resources to spend on an expansionist programme. In the New World, the nature of the enterprise ruled out from the very beginning any use of military force by the crown. Neither Ferdinand nor Charles V perceived the American venture as one of 'conquest'. When the Spaniards extended their energies to the lands beyond the ocean, they did not – despite the proud claims of their chroniclers – conquer them. The occupation and development of the New World was a little more complex than a mere act of subjugation.

Not a single Spanish army was expended on 'conquest'. When Spaniards established their control, they did so through the sporadic efforts of small groups of adventurers whom the crown later attempted to bring under its control. These men, who proudly assumed the description of 'conquistadors', were often not even soldiers. The group of men that seized the Inca emperor at Cajamarca in 1532, was made up of artisans, notaries, traders, seamen, traders, gentry and peasants, a small

cross-section of immigrants to America and in some measure a reflection of peninsular society itself. Similar groups were in action at other points in the New World. Most of them, especially the leaders, were encomenderos (132 of the 150 adventurers who accompanied Valdivia to Chile were encomenderos). This meant that they were engaged on their expedition by virtue of the crown conceding them an encomienda, a contract that gave the recipient rights to demand tribute and labour from the natives, and obliged him to serve and defend the crown and instruct the natives in the Christian faith. The wording of the contract frequently specified a form of feudal service, 'with arms and a horse',[1] making it evidently a military agreement. Thanks to the encomienda, the Crown was able to mount a military operation in the New World without the necessity, which it would in any case not have been able to fulfil, of sending an army there. The almost total dependence of the 'conquest' period on private enterprise was emphasized by the historian Oviedo, who as we have seen commented that 'almost never do Their Majesties put their income and cash into these new discoveries'. It was an all-important aspect that the encomenderos did not forget.

Moreover, the so-called 'conquest' of the Americas was never completed. The encomenderos were at no time in a position to subjugate the native populations systematically or occupy more than a fragment of the lands into which they had intruded. They were too few in number and their efforts too dispersed. Well over two centuries after the period of alleged conquest, and long after cartographers had drawn up maps in which the virtual totality of America was depicted as being 'Spanish', Spaniards in reality controlled only a tiny part of the continent, mainly the fertile coastal areas of the Caribbean and the Pacific. The fact is fundamental to understanding the nature of Spain's role in America. The overseas empire was a fragile enterprise that produced many significant benefits – mainly from the gold and silver mines – but that Spaniards by no means succeeded in controlling entirely.

Finally, the early Spaniards in the New World insisted that they had won what they had won through the traditional right, recognized in Old World societies, of 'conquest', but they were very soon disabused of this notion. The clergy who advised the Crown stated that Spaniards had no right to burst in like robbers, seize what they liked, and proclaim that they had 'conquered' it. On the Sunday before Christmas 1511 a

Dominican friar, Antonio de Montesinos, went into the pulpit of the church in Santo Domingo, Hispaniola, and denounced those Spaniards who had encomiendas of Indians. Other clergy, foremost among them another Dominican friar, Bartolomé de las Casas, subsequently joined in the campaign. In 1512 King Ferdinand sanctioned the issue of the Laws of Burgos, which attempted to regulate the activity of colonizers and the condition of the Indians. No one in the nascent colony took any notice of the laws, but out of them arose a special document drawn up by a member of the royal council, Juan López de Palacios Rubios, and known as the requerimiento (requirement), which based Spanish claims to authority not on simple conquest but on the donation of the new lands to Spain by the pope.

The document was meant to be read out publicly to Indians who would not accept the Spanish claims. Employed on numerous occasions by Spanish expeditions, it claimed that God had given the world to the papacy, that the pope in turn had given 'these isles and mainland' to the rulers of Spain, and that if the natives did not accept the Spanish obedience and the Christian religion they would be treated as rebels, dispossessed of their property and enslaved. Las Casas commented that when he first read the document he did not know 'whether to laugh or cry', and certainly many Spaniards thought the requerimiento ridiculous.[2] The author of the text himself realized that it was farcical. Fernández de Oviedo reported that Palacios Rubios 'could not stop laughing when I told him what some commanders had done with it'. In fact Oviedo had personally criticized one specific case, that of Pedrarias Dávila, first governor of Castilla del Oro (Tierra Firme), one of whose captains read out the document to a group of uncomprehending Indians. 'It seems to me', Oviedo told Dávila, 'that these Indians have no wish to listen to the theology of this Requirement, nor do you have any obligation to make them try and understand it; keep it for when we have some of these Indians in a cage, then they can study it at leisure.'[3] A report made by Alonso Zuazo to Charles V explained how the reading was done: 'the requerimiento was read in Spanish, of which the Indians did not understand a word. Moreover it was read at such a distance that had they understood the language they could not have heard what was being said.'[4] Where feasible the document was translated for the benefit of the listeners. Since the interpreters themselves did not understand what the document said, the final result was little short of grotesque.

It is tempting to consider the coming of the Europeans in terms of their ultimate success. Traditional accounts have therefore, with good reason, emphasized the factors that seemed to give them superiority. Spaniards are supposed to have had an advanced political civilization, a uniquely vital religious mentality, and a burning urge to battle against the heathen. Their feats have been explained by their superior technology, and their single-minded pursuit of gold. Some of these factors were no doubt present, but they did not necessarily culminate in success, for the history of the Spaniards was also one of immense failures. In perspective, of course, many of the participants in the conquest refused to admit any failure. Old, blind and living modestly in retirement on his lands in Guatemala, the historian and conquistador Bernal Díaz could reminisce: 'I often pause to consider the heroic actions of that time. I seem to see them present before my eyes, and I believe that we performed them not of our own volition but by the guidance of God.'[5] The Spaniards' own chroniclers combined to foster a myth of a successful God-given conquest. The reality was more complex: there were specific 'successes', but the general picture was one of a need to adapt to circumstances that were not always favourable. Between success and failure, the Spanish enterprise in the New World, the first of its type to be undertaken by any European nation, took on characteristics of its own.

From the Caribbean the Spaniards made sporadic ventures to the north and south. In the south from 1509 onwards they made contact with the indigenous population of the mainland (called Tierra Firme) and began to find evidence of the use of precious metals. In the north they settled further islands (Cuba in 1511) and also made contact with the mainland of Mexico. Governor Velázquez sent out expeditions from Cuba northwards to the Gulf coast and to the Yucatan (which Ponce de Léon reached in 1513). In this area of the Caribbean the decisive event was the success of Cortés in discovering and subduing (1519–21) a rich and powerful civilization in the interior of the continent. Mexico fell to the Spaniards a quarter of a century after their discovery of America. The feat sparked off a fever among other restless groups of Spaniards, who dispersed throughout the continent in search of riches. This second phase of the conquistadors, during which some of the most spectacular discoveries of the time were made, occupied another quarter of a century.

Mainland America was home to extensive and highly developed

civilizations that in central Mexico and the Andes took on the form of 'empires', in which local communities made regular payments of tribute to the ultimate overlords, the Mexica in their island city of Tenochtitlan (centre of a Nahua confederation that dominated the peoples of Mexico) and the Incas in the Andes. In these empires the noble class had special privileges, religion had a pervasive ceremonial role, and landed property tended to be controlled by communal bodies (called calpulli in Mexico and ayllu in Peru). Outside these imperial areas the vastness of America was peopled by numerous sedentary and non-sedentary peoples whom the Spaniards barely got to know.

'On Holy Thursday 1519 (April 21)', the companion in arms of Hernando Cortés, Bernal Díaz del Castillo, recorded in his chronicle, 'we arrived with all the fleet at the port of San Juan de Ulúa. The royal standards were raised on the flagship, and within half an hour of our anchoring two large canoes came out to us full of Mexica Indians. They said that their lord, a servant of the great Montezuma, had sent them to find out what kind of men we were and what we were seeking, also to say that if we required anything for ourselves or our ships, we were to tell them and they would supply it.'[6] On this courteous note the Mexicas welcomed the small expedition that had sailed from Cuba a few months before and worked its way up the Yucatan coast. In February the expedition chanced to encounter a Spaniard, Jerónimo de Aguilar, who had been shipwrecked in the Yucatan but had settled in the area and married a Maya wife. Shortly after, a local Maya chief had presented the Spaniards with twenty female slaves. One of them, renamed Marina, was a Mexica whose mother tongue was Nahuatl but who had also learned the local Maya dialect during captivity. Aguilar and Marina turned out to be a godsend for Cortés. When dealing with Mayas, Aguilar interpreted from their language for the Spaniards. When contact was made with the Nahuas, Marina – in the period before she began to learn Spanish – interpreted what they said, and Aguilar translated her words to Cortés.

For some time past the Indians had been receiving reliable information of the strangers who had come to their shores. They had many doubts, however, about the way to receive them. Cortés had landed with four hundred soldiers, sixteen horsemen, some artillery and a firm conviction that the land he now trod belonged by right to his sovereign king. The natives overwhelmed Cortés and his men with gifts, priceless gold and ornaments 'and many other things that I cannot remember, since all this

was very long ago', reminisced Bernal Díaz. For Cortés, however, the gifts served merely to confirm him in his principal objective, to get the Mexicas to recognize the rulers of Castile as their overlords. If achieved, the objective would strengthen his own position. Very soon after his arrival, he decided to renounce the authority of Velázquez and rely exclusively on the support of the crown in Spain. So began the fascinating chain of events whereby the Spaniards worked their way through the terrain of Mexico, allying with some tribes and terrorizing others, until eventually in November they entered the mighty city of Tenochtitlan, with its population of at least a quarter of a million people, and faced the great Montezuma.

A respectable historical tradition has presented the Mexicas as over-come with doubt and fear at the coming of the white gods. The native sources, written a generation after the conquest, were anxious to explain, through the medium of symbols and omens, why the collapse of their civilization took place. 'Ten years before the Spaniards came to this land, a wonderful and terrifying thing resembling a flame of fire appeared in the sky.'[7] The Nahuatl account spoke of the appearance of eight omens, for eight was a standard amount in Nahua usage, and the omens were treated as a sort of prologue to the story rather than as symbols of impending doom. The first contact was, as Bernal Díaz has indicated, cordial. During the progress to Tenochtitlan the Spaniards made many friends. At their first stop on the coast, at Cempoala, they won the alliance of the Totonacs by defying the messengers sent by Montezuma. In August 1519 they were at Tlaxcala, a Nahua city that was traditionally hostile to Tenochtitlan and where the leaders resisted the Spaniards by force until they realized that the newcomers were by no means friends of the hated Montezuma. After three weeks of negotiation and contact with the Tlaxcalans, the Spaniards managed to seal an alliance that was to have decisive consequences. The Tlaxcalans were eager to use the strangers to help them in their own wish to overthrow the hegemony of the Mexicas. Unwilling to become simply a tool of the Tlaxcalans, however, Cortés insisted on deciding his own route towards Tenoch-titlan, and his men, accompanied by a large force of five thousand Tlaxcalans, headed for the city of Cholula.

The Cholulans, faithful allies of the Mexicas but enemies of Tlaxcala, had already planned with Montezuma's agents to lay a trap for the Spaniards. Cortés was unaware of any danger, and believed that he

could also win over the Cholulans. But after three days in the city, he began to have suspicions, and told his men that 'we must keep on the alert, for they are up to some mischief'. Fortunately, Cempoalan and Tlaxcalan agents who accompanied him were able to reveal details of secret movements being made by the Cholulans. The next day Cortés and his men made signs of preparing to leave, and summoned the Cholulan warriors into a central courtyard. The Spaniards and their allies then sprang their own trap, and launched a merciless attack on the warriors. 'They attacked them with spears and killed as many as they could, and their allies the Indians possibly killed even more, while the Cholulans carried neither offensive nor defensive weapons and in consequence died miserably.' Thousands of Tlaxcalans poured into the city and executed a bloody revenge on their enemies, until Cortés managed to put a stop to the killing. Possibly over three thousand Cholulans died in five hours of fighting.

The massacre caused a great impression throughout the region. 'All the peoples in Mexico and in all the areas to which the Spaniards went, all of them were distressed and distraught; it was as if the earth shook, all went in fear and terror.' Cortés was concerned to leave behind him a peaceful and friendly Cholula, and succeeded over the next few days not only in consolidating this but also in arranging peace between the Cholulans and the Tlaxcalans. He now had the chief cities of the plain on his side, and made plans to advance to Mexico. He did so, however, using a strategy that could have undone the Spaniards. He chose to approach Tenochtitlan with a relatively small force, his own 450 Spaniards, and a support of probably 1,000 Indians as porters and guides. 'The Spaniards with all the Indians who were their allies came in a great crowd in squadrons, making a great noise and shooting off their guns; their weapons glittered from far off and caused great fear in those who were looking on.' Very many writers, both Nahua and Spanish, have described their entry into the legendary capital, passing through the city of Iztapalapan. Cortés was preceded by five files of his men, last of all the musketeers, who 'when they went into the great palace repeatedly shot off their arquebuses. They exploded, sputtered, thundered. Smoke spread, it grew dark with smoke, every place filled with smoke.'[8] Behind the Spaniards came 'those from the other side of the mountains, the Tlaxcalans, the people of Tliliuhquitepec, of Huexotzinco, came following behind. They came outfitted for war . . . they went crouching, hitting

their mouths with their hands and yelling, singing in Tocuillan style, whistling, shaking their heads. Some dragged the large cannons, which went resting on wooden wheels, making a clamour as they came.'

Montezuma gave a traditional greeting of welcome, which Cortés reported to his emperor as a speech of homage. Montezuma's speech was indeed fulsome enough to permit such an interpretation. 'This is your house and these are your palaces,' he said to Cortés, 'take them and rest in them with all your captains and companions.' In the subsequent six months that they were in the city, the Spaniards effectively controlled Montezuma but were themselves wholly vulnerable. The Mexica leaders, resigned but sullen and indignant, became outraged when Cortés began ordering the destructions of their statues. At this stage Montezuma informed Cortés of the arrival of more Spaniards at Veracruz, eighteen vessels from Cuba under the command of Pánfilo de Narváez, who had been sent by governor Velázquez to arrest Cortés and take charge. Cortés at once decided to leave Tenochtitlan for the coast, taking most of his men with him in order to confront the superior forces of Narváez, and leaving behind Pedro de Alvarado with enough men to protect Montezuma. It was not an easy decision, for Montezuma had warned him that the Mexica leaders were plotting to kill all the Spaniards. Bernal Díaz describes the state of permanent alarm faced by the men. They got used to sleeping fully clothed and fully armed, or even not sleeping at all. Díaz never reverted to sleeping normally again. 'I always lie down fully dressed,' he wrote many years afterwards, 'what is more, I can only sleep for a short time at night, I have to get up and look at the sky and stars and walk around for a bit in the dew.'

Cortés left Tenochtitlan in May 1520 and went out to meet Narváez, whose forces he defeated in a quick action that he had preceded by secret overtures to the incoming Spaniards. Narváez was wounded and lost an eye; five men were killed on his side and four on that of Cortés. Most of the Spaniards agreed to join Cortés, who at this moment received a message brought from Tenochtitlan by two Tlaxcalans, saying that Alvarado and his men were in serious trouble as a result of an attack they had made on the Mexica chiefs during a festival. Cortés hurried back to the capital. 'There were over one thousand three hundred soldiers,' writes Díaz, 'counting Narváez's people and our own, also some ninety-six horses, eighty bowmen and as many musketeers. In addition the Tlaxcalan chiefs gave us two thousand warriors. We arrived

at Mexico on 24 June 1520.' However, they found the city openly in revolt against the Spaniards, and after bitter fighting in the streets were forced to consider withdrawing. The situation became untenable when the Mexica chiefs elected a new emperor, and Montezuma himself was killed during an attack with stones. Assailed by thousands of Mexicas, the Spaniards fled in total disorder. On that fatal night, or 'Noche Triste' as it came to be called, of 10 July,[9] the Spaniards lost around eight hundred men, five Spanish women, and over a thousand Tlaxcalan allies. After the retreat the Indian allies complained to Marina that if the Spaniards withdrew the Mexicas would finish them off. But Cortés told them, 'Don't worry, if I leave I shall be back soon, and I shall destroy the Mexicas.' This greatly solaced the Tlaxcalans. 'When the Spaniards had gone to sleep, far into the night wind instruments were being played, wooden flutes and wooden fifes, and there was drumming, war drumming.'[10] The Spaniards had to take a rest in Tlaxcala, for 'they were too few to go to battle again with the Mexicas'.

The preparations for an attack on Tenochtitlan took some eight months.[11] From his base at Tlaxcala, Cortés gave first priority to replenishing his meagre forces, which he achieved thanks to men and supplies that arrived on the coast in subsequent weeks from Cuba, Jamaica and Spain. 'To Tlaxcala came Spanish soldiers with many horses as well as arms and munitions, and this encouraged the Captain to get ready again to go back and conquer Mexico.' The Tlaxcalans also began a programme of building boats with which to ferry men across the lake of Tenochtitlan. Cortés, with the support of the Tlaxcalans, carried out raids on neighbouring towns. By the end of 1520 a large part of the plain of Anahuac, including the cities of Tlaxcala, Cholula and Huejotzingo, had with Spanish help established an alliance against the Mexica, whose empire was now in a state of collapse. The next step in the campaign was to break up the union between the cities of Tenochtitlan and Texcoco, the basis of power of the Mexica state. Just after Christmas 1520, ten thousand Tlaxcalan warriors escorted Cortés and his men on a march towards Texcoco. The ruler of the city, Ixtlilxochitl, seeing how the tide of power in Anahuac was turning against the Mexica, greeted Cortés warmly and promised his support. All was now set for the attack on Tenochtitlan. In March and April several successful sorties were made against towns adjacent to the capital that were friendly to the Mexica. By the end of April the city of Tenochtitlan stood alone

against its enemies. The brigantines built for the Spaniards were, from their base at Texcoco, in command of the northwest shore of the lake. A formal siege was begun in the second week of May 1521.

The situation had changed dramatically since Cortés's first landing on the coast with four hundred men and the power of the entire Nahua people ranged against him. His band of Spaniards was now not much bigger, just over nine hundred men thanks to recent arrivals. But he had on his side the majority of the cities that had been vassals and allies of the Mexica. The Indian historian of Texcoco, Alva Ixtlilxochitl, reported that just before the siege the ruler of Texcoco reviewed his men, and 'on the same day the Tlaxcalans, Huejotzingoans and Cholulans also reviewed their troops, each lord with his vassals, and in all there were more than three hundred thousand men'.[12] The total Indian forces supporting the Spaniards were a vast army that could be supplemented from the rear whenever necessary, whereas the Mexica in their island city were cut off from outside help. The city, now ruled by Montezuma's nephew Cuauhtemoc, had also been suffering an epidemic of smallpox, apparently brought to the region by one of Narváez's soldiers. As the siege progressed, lakeside towns that had initially supplied the capital came forward to Cortés and offered him their support. Despite their situation, the Mexica resisted their attackers for three and a half months, in a desperate struggle that cost tens of thousands of lives and impelled the attackers to destroy the city systematically as they entered, as the only way of reducing the defenders. Finally, Cuauhtemoc was captured as he attempted to flee. Tenochtitlan perished with thousands of corpses within it, and it took three days for the survivors to be evacuated.

'When the news spread through the provinces that Mexico was destroyed', Bernal Díaz recalled, 'the lords could not believe it, they sent chieftains to congratulate Cortés and yield themselves as subjects to His Majesty and to see if the city, which they had so dreaded, was really razed to the ground.' A Nahua song lamented that

> Nothing but flowers and songs of sorrow
> Are left in Mexico and Tlatelolco
> Where once we saw warriors and wise men.

Cortés and his men achieved immortal fame. They became folk heroes within their own lifetime, not only in Spain but in every European nation. Who were these men? They were for the most part young: Cortés

was aged thirty-four at the time, Bernal Díaz only twenty-four. An examination of nearly two-thirds[13] of the Europeans who took part in the conquest of Tenochtitlan shows that ninety-four per cent were Spaniards and six per cent from other nations, mostly Portuguese and Genoese, with a sprinkling of Greeks and Netherlanders. At least two were black. Of just over five hundred Spaniards whose places of origin are known, one third came from Andalusia, the rest principally from Extremadura, Old Castile and León. A long historical tradition has tended to present the early Spaniards in America as the scum of the earth, but it cannot be credited. By the same token there is no foundation to the legend, common in much Spanish historical writing, that they were hidalgos. The men who made it to the New World, survived the Atlantic crossing, and lived through the travails of hostile tribes and a savage climate, were robust, intelligent and (if they were lucky) survivors. Out of five hundred of the Spaniards who were at Tenochtitlan nearly eighty-five per cent could sign their names, a piece of evidence that often indicates literacy. Much less is known of their professional status. The callings of only thirteen per cent of the five hundred can be identified: they were principally artisans, sailors, soldiers and scribes.[14]

The fame of having helped to overthrow Mexico was the only profit gained by many of the Spaniards. After the fall of the great city, reported Bernal Díaz, 'we were all disappointed when we saw how little gold there was and how poor our shares would be'. They quarrelled among themselves, and most went off to seek treasure elsewhere. 'When we realized', Díaz wrote, 'that there were no gold mines or cotton in the towns around Mexico, we thought of it as a poor land, and went off to colonize other provinces.' The majority of those who took part in the fall of Tenochtitlan ended their days in poverty.[15] Nor were they fortunate enough, like Bernal Díaz, to live long. Up to eight hundred Spaniards died in the Noche Triste, and over half of all the known conquistadors who took part in the campaigns died during wars against the Mexicas.[16] Overthrowing the American empires was an extremely costly undertaking, and did not always bring rewards to those who took part in the enterprise.

Not until ten years later did a further group of Spaniards, based in the isthmus of Panama, begin to pool their resources and send expeditions down the Pacific coast of South America. The newly founded town of Panama became a typical frontier melting pot where all types of

adventurer concentrated in search of a quick profit. Three of them decided to pool their limited resources in order to fund an expedition. They were Francisco Pizarro, the illegitimate and illiterate son of a former soldier from Trujillo in Extremadura; Diego de Almagro; and the priest Hernando de Luque, who could count on a local contact of the Castilian financier Espinosa in Seville as back-up for the required capital. A first expedition southwards along the South American coast in 1524 was a failure, but by contrast a second in 1526–7 made contact with unmistakable signs of wealth. In order to get the highest possible backing for a further journey, Pizarro in 1528 returned to Spain and obtained in the summer of 1529 at Toledo (where he also met and talked to Cortés) the desired grant conceding him rights as governor and adelantado of an immense stretch of territory along the Pacific coast. He also brought back with him his four brothers and a cousin, when he sailed from Sanlucar early in 1530.[17]

In January 1531 an expedition of 3 ships carrying around 180 men and with 30 horses on board left Panama under Francisco's command. They were joined further along the coast by two vessels under Sebastián Benalcázar. Later on Hernando de Soto arrived with two ships, about a hundred men and twenty-five horses. Together they were by no means a force to sneer at, but the Spaniards had to counter bitter resistance from coastal Indians. They spent several months around the bay of Guayaquil, in the vicinity of Tumbez, and began to learn about the territory that they were entering.

The empire of the Incas was one of the most remarkable in human annals, dating from the twelfth century, when the Quechua peoples began to extend their control over a vast area that by the fifteenth century stretched over five thousand kilometres from the south of modern Colombia down to central Chile, and stretching inland across the Andes to the Amazon forest. The ruling tribe were the Incas, who formed an élite that was superimposed on the local élites of the Andean valleys. For a territory that was technologically primitive, without knowledge of the wheel or of writing or of the arch in construction, the empire achieved heights of efficiency and sophistication that have continued to amaze posterity. At the time of the Spaniards' arrival, the land of the four quarters – known as Tawantinsuyu – was divided by a civil conflict between two respective claimants to the title of supreme Inca. The last unquestioned Inca ruler, Huayna Capac, died leaving sons, Atahualpa

and Huascar, who bitterly contested the succession, while other sons were too young to participate in the struggle. Huascar dominated in the south, in the royal capital of Cusco, while Atahualpa became based in the north, in the city of Cajamarca. Atahualpa was obviously interested in making contact with the strangers, who in the autumn of 1532 prepared to strike inland and cross the Andes, a small band of sixty horsemen and one hundred on foot.

Atahualpa envisaged no threat from the small number of strangers, and sent envoys to greet them as they made their descent into the fertile valley of Cajamarca. He was in a position of strength, for his general Quisquis had just succeeded in defeating the forces of Huascar and capturing the rival Inca. Atahualpa hoped to lure the Spaniards into his territory and deal with them there.[18] The latter were almost paralysed by fear, more so when they learned that the emperor was camped with a huge army outside his capital city. Pizarro had to speak to his men to encourage them. In the afternoon of 15 November 1532 the Spaniards entered a half-deserted Cajamarca. The emperor had been kept fully informed of the men's movements. Pizarro sent a delegation under Soto to Atahualpa inviting him to meet the Spaniards on his scheduled return the following day. As the hour for the emperor's return late in the afternoon of Saturday 16 November approached, Pizarro carefully disposed his own trap. Atahualpa entered the ceremonial square of Cajamarca, carried aloft on his palanquin by eighty nobles and accompanied by a redoubtable host of several thousands of his people. Seated in majesty in the centre of the huge square, he contemplated the small handful of men who had managed to penetrate his domains. The Indian interpreter Felipillo began to translate for the Inca's benefit the words of the requerimiento, read by Pizarro. Then the Dominican friar Valverde began to exhort the Inca to accept the true God. Atahualpa rejected the breviary offered by him and threw it on the ground. Valverde was outraged and ran back to Pizarro, who 'raised a cloth as a signal to act against the Indians'.[19] A single cannon, strategically placed, was now exposed and fired directly into the crowd of Indians, causing indescribable terror. The soldiers and horsemen, till now hidden in the buildings on the sides of the square, charged out to cries of 'Santiago!' and directed their arquebuses on the massed ranks of people with the deliberate aim of killing as many as possible. At the same time Pizarro and his aides flung themselves on the Inca and made him prisoner. The panic-stricken

and wholly defenceless people[20] trampled each other to death and demolished an entire wall with the force of their bodies as they attempted to escape from the square. 'They howled out loud in terror, asking themselves if these things were really happening or if it was a dream; possibly more than two thousand of them perished.'[21] Not a single Spaniard died ('apart from a black man on our side', states a soldier who took part in the massacre). Night had now fallen, and the many thousands of Andeans who had been waiting outside, unable to enter the city, were in their turn seized by the panic of those fleeing desperately from the terror in the square. The whole valley of Cajamarca, as far as the eye could see in the failing light, was filled with fleeing Indians.[22]

The capture of Atahualpa was a unique event in the history of the Spanish empire. For the first and last time, a small band made up almost exclusively of Spaniards, and without any help from native allies, managed to carry out an incredible feat against overwhelming odds, and with no guarantee of continuing success. Until the very last minute before the action in the square, they were filled with dread. 'We thought our lives were finished', a young Basque soldier wrote shortly afterwards to his father, 'because there was such a horde of them, and even the women were making fun of us and saying they were sorry for us because we were going to get killed.'[23] It was an accomplishment that far outdid in audacity the action of Cortés and his men at Tenochtitlan.

The hundred and sixty men who captured Atahualpa had no immediate plans other than to make themselves rich. They were by no means professional soldiers, though like most Spaniards on the American frontier they were familiar with the use of arms. They represented a fair segment of the peninsular population, with artisans, notaries and traders preponderant; three-quarters were of plebeian origin.[24] Adventurous and young – ninety per cent of them were aged between twenty and thirty-four, and only Pizarro exceeded fifty – they accomplished an exploit that ranked (in the opinion of Europeans) among the most fabulous of all time. Atahualpa was kept as an honoured prisoner at Cajamarca, and eventually agreed to pay an unprecedented ransom for his freedom: he would fill the dimensions of the room in which he was kept, twenty-two feet long, seventeen feet broad and nine feet high, with gold and treasure from his subjects in the Inca empire.

The amassing of the Inca's treasure was one of the most emblematic acts in the history of all empires. It displayed to perfection the obsession

of Europeans with the wealth associated with precious metals. Above all, it displayed their complete indifference to the destruction of the cultures with which they came into contact. As the ornaments were rounded up by the Inca's messengers from the four corners of his part of the empire – plates, cups, jewellery, tiles from temples, artefacts – they were systematically melted down under Spanish supervision, and reduced to ingots. Over those four months from March to June 1533, bit by bit the artistic heritage not simply of the Incas but of a great part of Andean civilization disappeared into the flames. For two thousand years the craftsmen of the Andes had applied their techniques to working and decorating with gold. This became no more than a memory. At Cajamarca alone the Spaniards managed to reduce the ornaments to 13,420 pounds of gold and 26,000 pounds of silver. In subsequent weeks, they came across equally fabulous treasures, which were likewise consigned to the furnaces.

Francisco Pizarro's promise to liberate the emperor was not kept. On the excuse that he was fomenting plots, and had usurped the throne and murdered his half-brother Huascar,[25] Atahualpa was condemned to death at the insistence of Almagro and other Spaniards and strangled and then burnt as a criminal (he was 'mercifully' garrotted because he agreed to accept baptism and die as a Christian) in the square at Cajamarca on 28 June 1533.[26] Pizarro defended himself afterwards by claiming that he was unable to intervene. 'I saw the marquis in tears', reported a witness, 'because he was unable to save his life.' Other Spaniards, including Soto, openly condemned the murder and the fabricated evidence used to justify it. Subsequent Spanish commentators never ceased to view the killing as a crime. José de Acosta judged that 'our people sinned gravely when they killed the ruler'. In the memory of the people of the Andes the strangling of their emperor as though he were a common criminal became transformed into something much nobler, a decapitation, a royal death that would lead at some distant time in the future to his resurrection.

The conquerors made haste to confirm their claims with the Spanish government (and also to set aside for the Crown the obligatory fifth). A portion of the Inca treasure was carried overland to Santo Domingo, and excited wonderment everywhere. In Panama a man who saw it swore that 'it was like a dream'; in Santo Domingo the historian Oviedo assured a friend that 'it is not a myth or fairy tale'.[27] At the end of 1533 the first of four vessels carrying the news and treasure arrived in Seville,

followed within a few days by Hernando Pizarro, who was escorting the royal fifth. The search for similar treasure became immediately the aspiration of all newcomers to the Indies. Francisco Pizarro and his men proceeded to the Inca capital, Cusco, which had formerly been in the hands of Huascar. There in the month of March 1534 they obtained further treasure, possibly around half the quantity obtained in Cajamarca. In the autumn of 1534 Pizarro left Cusco for the coast, where on 6 January 1535 he founded the city of 'the Kings', 'Los Reyes', later to be known as Lima.

The Inca empire was not yet overthrown, only beheaded. Its overthrow would in fact cost another thirty-five years and be achieved only through the collaboration of the Indian population with the Spaniards. The next conquistador to come southwards was Pedro de Alvarado, followed by Sebastián del Benalcázar. Almagro also headed southwards towards Lake Titicaca and Chile. He found no gold, the expedition cost the lives of well over ten thousand Indians who were helping his expedition, and he returned empty-handed. The whole Andean region was plunged into a generation of war that left the once-great Inca empire in ruins. The first leader of the resistance against the Spaniards was Manco, a younger brother of Huascar whom Pizarro had installed in Cusco as supreme Inca. Manco had welcomed the Spaniards when they came, thinking that he could use them against the generals of Atahualpa. After three years of humiliation at their hands, he escaped from Cusco, raised a huge army of fifty thousand men from the four corners of Tawantinsuyu, and laid siege to the capital city, held by a small Spanish force of less than two hundred men under Hernando, Juan and Gonzalo Pizarro, supported by their Indian allies. What should have been an easy task for the Peruvians turned out to be quite the opposite. The siege of Cusco lasted over a year, from March 1536 to April 1537. When they were all but reduced to desperation, a group of Spaniards broke out of the city and galloped at speed directly to the old stone fortress of Sacsahuaman, on the height overlooking Cusco. They occupied and used it as a base from which to turn the tables on their attackers. 'The battle was a bloody affair for both sides', according to the son of Manco Inca, 'because of the many natives who were supporting the Spaniards, among them two of my father's brothers, with many of their followers.'[28] After the success of their sortie, the Spaniards garrisoned Sacsahuaman with fifty soldiers and a large number of Indian auxiliaries. It was one of the great

heroic moments of Spanish valour. The survival of the Spaniards, however, had been made possible only by the constant help they had received during the year from local tribes who had always opposed the Incas.

Manco next attempted to profit from the civil war that was taking place between the forces of Pizarro and those of Almagro. When this failed, he withdrew in 1537 to the mountains, to Vitcos in the province of Vilcabamba. With him went a host of Indians from all corners of the empire. There in the wooded highlands overlooking the River Urubamba, in an area that included the old sacred centres of the religion of the sun and whose exact location remained unknown till the twentieth century,[29] Manco resurrected the Inca state, which survived for a generation until its fall in 1572. Meanwhile the Spaniards quarrelled among themselves, and after a battle between the factions in 1538 Almagro was taken prisoner by Pizarro and executed.

The successes of the Spaniards came less from military superiority than from an ability to adapt to seemingly unfavourable conditions. They were always very few in number, in contingents of between two hundred and five hundred men, faced by unfamiliar terrain, inadequate food supplies, and a far more numerous enemy. In such circumstances they had to use their few resources with the maximum of skill. Cortés's brilliant march to Mexico set a pattern that most subsequent adventurers attempted to emulate. Firearms and (when available) cannon were of strictly limited use: they were insufficient in number, and rendered easily unreliable by lack of powder or tropical rain. Cortés tended to employ them with the specific purpose of inducing fear rather than of killing. The Spaniards enjoyed, in the circumstances, little effective technological superiority, and in any case were often more vulnerable to the arrows of skilled indigenous archers than the latter were to European firearms. The few horses brought from Europe were infinitely more valuable. A larger animal than any known to the Indians, the mounted horse gave advantages of height, mobility and speed that easily demolished opposition. In Pizarro's campaign against the Incas, the bulk of a few charging horses easily crushed the massed ranks of the enemy and always guaranteed victory. Apart from the tools of conquest, however, there were three fundamental factors that no historian can fail to emphasize.

First, the Spaniards soon learnt to use against their enemy all the symbols of the supernatural environment that enveloped friend and foe

alike. Second, they enjoyed a superior mobility by sea that served to isolate and defeat enemies. Finally, and most important of all, the conquerors always worked hand in hand with native peoples who opposed the ruling empire.

The supernatural omens seem to have favoured the Spaniards from the beginning. It is possible, of course, that this version of events in Mexico and Peru developed much later and was a way, exploited by the Spaniards and accepted by native writers, of rationalizing the conquest through hindsight. The songs that survived from the Nahua peoples seem to support the vision of a civilization that had little hope in the future,[30] though many recent scholars have questioned this view. Spanish chroniclers conveyed the idea that Cortés was viewed as a returning god (the Aztec deity Quetzalcoatl) and that the Spaniards as a race were treated as gods. A similar idea may be found in sources relating to the Incas. Other indigenous sources that describe the coming of the Spaniards, however, do not always support the idea and may be interpreted in different ways.

The Europeans came from the sea and owed their success to it. The American peoples were at home in their rivers and lakes, and traded actively along the seacoasts, but never developed an ocean-going capacity. By contrast the Europeans – like the Arabs – had a long familiarity with the sea, which gave them an exceptional mobility. At key moments of their adventure in the New World, they were capable of suddenly bringing in supplies and reinforcements out of nowhere and dramatically changing the course of events.

An enduring legend of the early Atlantic empire was the superhuman capacity of the conquerors. An early chronicler and witness of the great events in Peru, Cieza de León, commented: 'who can tell of the unheard-of exploits of so few Spaniards in so vast a land?'.[31] 'Hernando Cortés with less than a thousand men overthrew a great empire', wrote a veteran of the American frontier, Vargas Machuca, 'Quesada with a hundred and sixty Spaniards conquered the kingdom of New Granada.'[32] An official historian, Gómara, continued in his *History of the Indies* with the same extravagant story, written for the eyes of the emperor: 'never has a king or a people ventured so far or conquered so much in so small a time as our people have done, nor have any others achieved or accomplished what we have done, in feats of arms, in navigations, and in the preaching of the holy gospel'. Virtually all the

chroniclers of the period exercised their imaginations in playing the numbers game. In doing so, they created for their fellow countrymen (and for many historians even today) an ineffaceable image of Spanish valour, prowess and racial superiority. Among the very few conquerors who protested against this was Bernal Díaz, indignant at the exaggerated role given to Cortés by the official historian Gómara.

It is unjust to minimize the astonishing daring of the conquerors. But it is also essential to remember that Spanish military success was made possible only by the help of native Americans.[33] The conquest of some indigenous Americans by others laid the basis of the Spanish empire. The help was of two kinds, on a humble level, from men of service, and on a more elevated level, from military allies. Men of service were the hundreds of natives who carried out indispensable duties of carrying baggage and supplies, searching for food and water, tending animals, preparing meals and attending to all the needs of the Spaniards. Without such support the efforts of the latter would quite simply have been in vain and they would never have attained their objectives. Without Indians to help him, Balboa would never have reached the Pacific. The Indians were often used to performing such services for their own lords, but in the major Spanish expeditions they were more usually forced to help, and over-exploited until they died. After the fall of Tenochtitlan, when Alvarado went southwards he took with him three hundred Spaniards, but the effective bulk of his force consisted of nearly twenty thousand Indians, according to a native chronicler.[34] His journey by sea and land to Ecuador was effected by five hundred Spaniards, but they had with them three thousand Indian slaves from Guatemala. Valdivia's first expedition into Chile, in 1540, consisted of only 150 Spaniards. It would nevertheless have been impossible without the indigenous guides and the one thousand native porters who went along.

The crucial help was, of course, that from military allies. Both against the Mexicas and the Incas the Spaniards were able to count on alliances with native peoples, who exploited the situation for their own purposes. The Inca Huascar expressed his support for Pizarro, and later his brother Manco also took the Spanish side. 'If the Incas had not favoured the Spaniards', commented a witness of the capture of Atahualpa, 'it would have been impossible to win this kingdom.'[35] Allies supplied valuable information, acted as spies and scouts, recruited service helpers, and advised on questions of terrain and climate. A memorial from the people

of Huejotzingo in New Spain to Philip II in 1560 explains in detail how that city helped Cortés:

We took all our nobles and all of our vassals to aid the Spaniards. We helped them not only in warfare but also we gave them everything they needed. We fed and clothed them, we would go carrying in our arms and on our backs those whom they wounded in war or were simply very ill, and we did all the tasks in preparing for war. And it was we who worked so that they could conquer the Mexica with boats; we gave them the wood and pitch with which the Spaniards made the boats.[36]

Above all, the Indian allies fought. Their substantial numbers invariably tipped the balance of a contest in favour of the Spaniards. Cortés made his first recorded use of Indian auxiliaries in the assault on Tlaxcala in September 1519, when in addition to his own men he had the help of four hundred men from Cempoala and three hundred from Ixtacmaxtitlan. By the time that Cortés undertook the siege of Tenochtitlan in 1521, he was as we have seen helped by a vast army that made the fall of the Mexican capital inevitable. Meanwhile, he had gained the aid of an unexpected ally: a smallpox epidemic, which reached the city after having devastated Hispaniola in 1519. Thousands died, enough to affect the Mexica battle capacity. 'When the plague lessened somewhat', the Nahua chronicler reported, 'the Spaniards came back. They had been gone two hundred days. And the people of Xaltocan, Quauhtitlan, Tenanyocan, Azcapotzalco, Tlacopan, and Coyoacan all entered in here.'[37]

At the siege the massed ranks of the Tlaxcalan allies sang; 'Aid our lords, those who dress in iron, they are besieging the city, they are besieging the Mexican nation, let us go forward with courage!'[38] The message that Marina gave to the Mexicas after the great siege of Tenochtitlan had commenced was unequivocal. They should hand over Cuauhtemoc, they should cease fighting. 'Here', she said, pointing to the Indians who accompanied the Spaniards, 'are the rulers of Tlaxcala, Huejotzingo, Cholula, Chalco, Acolhuacan, Cuernavaca, Xochimilco, Mizquic, Cuitlahuac, and Culhuacan.'[39] Should the Mexicas attempt to resist such a powerful alliance of enemies? In later years, the native allies did not fail the Spaniards. We have seen that Tlaxcalan soldiers took part in Alvarado's march to Guatemala in 1524, and six years later they aided Nuño de Guzmán in western Mexico.[40] Almagro's expedition to Chile in 1535 was made possible by the twelve thousand Andean war-

riors he took with him from the area of Cusco and Charcas. Gonzalo Pizarro's venture to the Amazon turned out to be ill-fated, but its preparation had been made possible by ten thousand natives who accompanied him from Quito. In one combat in Chile in 1576 two thousand natives aided the thirty Spaniards; in another in 1578 one thousand natives supported the Spaniards.[41] Three thousand Tlaxcalans joined Cortés's expedition to Honduras in 1524.

The Spanish campaigns, it is clear, were made possible only by massive help from native Americans, who were rightly proud of their contribution. Like the original Spaniards, the Tlaxcalan lords after the conquest enjoyed the right to title themselves 'conquistador'. But conquest was always incomplete. There were obviously territories, principally in the Caribbean, that were taken over wholly by the newcomers because the indigenous population ceased to exist. Throughout the mainland, by contrast, Spaniards rarely 'conquered' more than a limited area where they could survive, usually on the coasts or in a focal centre, such as the Nahua and Inca cities. Beyond these areas they found it difficult to subjugate the natives, and continued for generations in an uneasy relationship with vast unconquered areas of America. Many regions remained free of Spanish control simply because the Spaniards had had no reason to intrude. For example, when Pizarro's envoys were making their way from Cajamarca to Cusco there were tribes that did not consider it necessary to impede them, so they were left alone; 'and so', as the tribes stated later, 'nobody came to this region to conquer it, because no resistance was ever offered'.[42] Literally and legally, they were never conquered; they did not feel, therefore, that they should be treated as a conquered people.

The indigenous role in the conquest of America was also to be seen in the Yucatan peninsula, home of Maya civilization. Spaniards had touched on the Yucatan coast since 1502 but over the next two decades most encounters with the Mayas were sporadic and brief. After 1527 more serious attempts were made to penetrate the territory, a phase that culminated with the foundation in 1542 of the Spanish settlement of Mérida. A large force of Nahua warriors accompanied the Spanish group that entered the territory in 1541. A Maya leader recorded the occasion years later in his chronicle:

I was then just a boy, following my father, who was in office; meanwhile it was all clearly observed and I now relate it. It took place here beside a well where

there stood a great tree . . . When the strangers arrived, there was on the horizon a sliver of sun as it dawned in the east. When they reached the entrance to this community of Calkini they fired their guns once; when they arrived where the savannahs begin they also fired their guns once; and when they arrived at the houses they then fired their guns a third time.[43]

The Nahuas were not the only people to help the Spaniards in the Yucatan. As in Mexico and in Peru, there were indigenous leaders among the Mayas who seized the opportunity to use the Spaniards against their enemies. The leaders of families such as the Pech and the Xiu instructed their clans to help the invaders. The Pech rulers told their *cah* (community) 'that nobody would wage war but that they would commit themselves to going and helping the Spaniards in their conquests and to travelling together with the strangers'.[44] These Maya were proud of their part in the creation of the Spanish empire, seeing the defeat of their people as in fact a victory that they had won over their Maya enemies. A leading member of the Pech family went so far as to describe himself as 'the first of the hidalgo conquistadors' ('*hidalgos concixtador en*').[45] The collaboration between some indigenous tribes and the strangers continued for generations, for there was a permanent frontier to the Spanish presence. As late as 1583 the Maya chronicles offer 'an account of how we, the Mactun people, who live in Tixchel, went and campaigned to make Christians of the unconverted'.[46]

The survival of an unconquered America is often described as 'revolts' or 'rebellions', terms which suggest mistakenly that the natives were somehow reneging on an accepted allegiance. The major Indian actions against Spaniards were in fact always 'wars', legitimate acts from their own free sovereign territory against incursions by strangers from outside. The Mixtón wars (see Chapter 6) in 1541 were one example. In Chile, from the end of the sixteenth century, the indigenous population also began an extensive struggle against the Spanish presence. During this war, which lasted a generation and led to the Spanish abandoning the entire south of Chile beyond the River Bío-Bío, seven Spanish towns were wiped out and the Araucanian Indians improved their techniques with use of the horse and guns. In the campaigns subsequently mounted by Spanish settlers against the so-called 'rebellion', the thousands of native auxiliaries pressed into service played a crucial part. The Indians in Chile, says an official report of 1594, 'are those who have most contributed with

their persons and their goods to the provisions of the war'.[47] The Arau-
canian wars, in effect, demonstrated the capacity of undeveloped tribal
societies to resist the European presence. By 1599, in the opinion of a
Spanish priest, the Araucanians had developed a good infantry and a
highly proficient cavalry based on horses taken from the Spaniards.

No less impressive than the achievements of the conquerors, whether
Spanish or Indian, were those of the handful of adventurers who pene-
trated the unknown interior of the new continent. Settlement was only
one dimension of empire. Equally powerful was the urge to extend its
fringes, a task that kept Spaniards constantly on the move. 'In this land',
reported one, 'a man is never fixed but always moving from one place
to another.'[48] The histories of Cortés and Pizarro are ample confirmation
that the primary aim of the adventurers was gold, whose existence was
confirmed by their own experience but above all by the persistent myths,
current among the indigenous population, of peoples and lands where
gold was a commonplace item of everyday use. In his *Chronicle*, Guaman
Poma commented bitingly on the motives that had driven Columbus
and his men:

They did not wish to linger a single day in the ports. Every day they did nothing
else but think about gold and silver and the riches of the Indies of Peru. They
were like a man in desperation, crazy, mad, out of their minds with greed for
gold and silver.

Through questioning natives and following up stories they heard, the
Spaniards soon built up a corpus of stories – what we may call myths –
about possible locations of gold. The finding of gold in part of Tierra
Firme caused the area to be renamed 'Castilla del Oro' (Golden Castile)
in 1514, and from the 1530s Spaniards reported finding gold in burial
grounds in the Sinu area inland from Cartagena. The myth of 'El Dorado'
(The Golden Man) began to appear from this date, in the lands associated
with the Chibcha peoples. When Quesada was governor of Santa Marta,
he heard for the first time of the story of El Dorado and of the ceremonies
at the sacred lake of Guatavita. Shortly after, Benalcázar, who was
coming up from Peru, encountered near Quito an Indian who told him
of 'a certain king who went naked aboard a raft to make offerings,
smeared all over with powdered gold from head to foot, gleaming like a
ray of the sun'.[49] Thereafter the search for the fabled site, where gold

was so commonplace that it could be used to decorate the body, became a part of the mythology of exploration and conquest. Fifty years later, a brother of St Teresa of Avila reported from Quito that he was hoping to form an expedition to look for 'the Golden Man, in whose search a thousand captains and men have so often been lost'.[50]

After the fall of Tenochtitlan the Spaniards went their separate ways, pursuing the continuous reports that reached them of peoples as wealthy as the Mexica. One of the first to venture north, in search of the fabled Seven Cities of Cibola, was Nuño de Guzmán, who in 1529 led an expedition into the region of Culiacan. The most famous of the ventures into North America (see Chapter 6) belonged to this period: that of Hernando de Soto in 1539–42, which set out from Cuba, and that of Coronado in 1540–2, with its base in Mexico. The spin-offs from the Pizarro expeditions to the Andes also had important consequences. Perhaps the most notable hero was Pedro de Alvarado, who had played a leading role in the campaign of Mexico and after it departed southwards with a large force of auxiliaries to the region of Guatemala. When he heard of the events in Peru, Alvarado in 1534 took ship down the Pacific coast and made for Quito, where he arrived shortly after Almagro and Benalcázar, and narrowly avoided a battle with them. Benalcázar in his turn took men with him to the lands further north, where he founded the town of Popayán (1536) and even further north, in 1538, came into contact with another Spaniard, Gonzalo Jiménez de Quesada, a native of Andalusia.

The most important of the non-Spanish expeditions also entered at the same time into the same area. The contract granted to the Welser family in Venezuela allowed them to penetrate the interior of the continent. Expeditions were made by Ambrosius Alfinger in 1531 and Georg Hohermuth in 1535–8, but the best known is that of Nicolaus Federmann, who in 1537 set off into the mountains and made his way towards El Dorado. 'I lost', he reported later, 'many people and horses; of the three hundred persons with whom I left no more than ninety survived.'[51] The cost in lives was everywhere enormous. When Quesada reached his objective only 166 remained of the nearly 900 with whom he had set out. An early Italian historian of America, Benzoni, reported that 'of those who went to Peru, eighty died out of every hundred'. The intrepidity of the early pioneers became legendary, and the chroniclers never ceased to insist on it. 'As for the hardships and hunger they have faced,'

wrote the chronicler Cieza de León, 'no other nation in the world could have endured it.' In the chroniclers' hands, the legend quickly became racially exclusive, and the intrepidity was converted into something possessed only by Castilians and by nobody else. The endurance of the thousands of Indians who made the expeditions possible was effaced from historical memory. 'What other race', asked Cieza de León, 'can be found which can penetrate through such rugged lands, such dense forests, such great mountains and deserts, and over such broad rivers, as the Spaniards have done, *without help from others*, solely by the valour of their persons?'

After the execution of Almagro, Francisco Pizarro felt able to consolidate his authority in the lands to the south. He entered into an agreement with Pedro de Valdivia, a veteran of the Italian wars who had come to Peru in 1536. Early in 1540 Valdivia left Cuzco with an expedition of 150 Spaniards and over 1,000 Indians, which made its way southwards and in February 1541 founded the town of Santiago de Chile. In the following years Valdivia set himself up as governor of the region, and for the first time made contact with the hostile Araucan people. In 1547 he returned to Peru in order to help the new royal viceroy Gasca eliminate the rebellion of the Pizarros. He was rewarded with the governorship of Chile, but returned in 1549 to Santiago to deal with the problem of the Araucanians. The Araucanian wars were a continuous conflict that ended, for Valdivia, with his capture in a battle in January 1554 and his execution by ritual torture. The wars went on, with a pause in the year 1558, when the Araucanians were for a period defeated. A young soldier who served in the Spanish forces, Alonso de Ercilla, narrated their heroic story of resistance; his poem *La Araucana* remains one of the greatest of all epics.

The Atlantic coast was not forgotten. Among the first visitors was the Venetian Sebastian Cabot, who conceived the idea that there was a shorter route to Asia through the American land mass than that taken by Magellan (on the latter, see Chapter 5). He received official support, and set out from Sanlucar in April 1526 with 4 vessels and 210 men, the majority of whom were Germans and Italians.[52] The vessels reconnoitred the South American coast and early in 1528 entered the estuary of a river which Cabot named the 'river of silver', the Río de la Plata, in the hope of coming across more of the precious metal that they had already encountered. The silver had come across the continent from the still undiscovered Inca empire, but Cabot and his men were unable to

continue their expedition and had to return to Spain. Discovery of the Incas five years later unleashed excitement over the possibility of reaching Peru from the Atlantic.

On 14 January 1534 Hernando Pizarro arrived in Seville with part of the Inca treasure. The reaction was swift: a flood of volunteers demanded to go on expedition. In May 1534 a royal contract with the Andalusian soldier Pedro de Mendoza authorized him to explore the Río de la Plata, gave him the rank of adelantado, and conceded a vast territory for him to govern and pacify. The expedition set out in August 1535 in fourteen large ships, with at least fifteen hundred Spaniards and around a hundred Belgians, Germans and Portuguese. According to the historian Gómara, it was the largest fleet to have sailed to the Indies till that date. The chronicler of the enterprise, the German Huldrich Schmidt, describes how the main body of the men under Mendoza suffered extreme hardships and Indian attacks in the Plata estuary (where they began the settlement of Buenos Aires) and were soon reduced to a fifth of their number. He himself went with a group up the Paraná under their leader Juan de Ayolas; in August 1539 they founded the town of Asunción, Mendoza returned to Spain but died *en route*. In 1540 Charles V passed on Mendoza's privileges to Alvar Núñez Cabeza de Vaca, veteran of extraordinary explorations (see Chapter 6) in the North American continent. Cabeza de Vaca's experiences were put to good use, and his small but efficient expedition pushed up towards the River Iguaçu in December 1541, spending a relaxed Christmas among friendly Indians. In January they discovered the spectacular Iguaçu Falls, and shortly afterwards changed direction, moving back downstream by the Paraná towards Asunción.

Of the many, varied and always significant expeditions pioneered by Castilians, two stand out as exceptional because they were different in concept and consequence. The first was the highly individual quest of Francisco de Orellana, who was serving as an official in Guayaquil under the command of Gonzalo Pizarro, at the time governor of Quito. In 1540 Orellana accompanied Pizarro on a long and fruitless expedition into the interior of the continent. Pizarro returned empty-handed two years later; meanwhile he had sent Orellana and a small group ahead to look for food. The group was carried swiftly downstream by the current, with little hope of turning back. Surviving by wit and effort, the Spaniards made rafts and lodged when possible with friendly Indians. At the end of August 1542 they emerged out into the Atlantic, having spent eight

months descending the river, which they named the Amazon from the accounts they picked up about women warriors in that region. They then made their way by sea up the coast till they reached a port near Trinidad.

Another attempt was made on the Amazon in 1558, from the direction of Peru. The expedition, led by the Navarrese Pedro de Ursúa, planned to make its way to the great river from its tributary the Marañón. Unfortunately, Ursúa had recruited a number of undesirable elements, including the soldier Lope de Aguirre. He also made the mistake of bringing along as his companion a beautiful widow, Inés. Shortly after they began descending the Marañón, Aguirre led a coup, murdered Ursúa (December 1560), seized Inés and later murdered her also. He went on to murder other possible rivals, and proclaimed himself king and in rebellion against the king of Spain. His bloody journey and career was short; at its end he was seized and executed.

Neither of these expeditions advanced the process of empire. But they helped to stamp the Spanish presence, however cursorily, on extensive and almost inaccessible expanses of the continent. The mere act of exploration became in some measure an act of conquest. In the strange European way of thinking, simply to be there confirmed possession of those territories. The Amazon as a consequence now became subject to the king of Spain, in the same way that centuries later other rivers, waterfalls and lakes in Africa and Asia would be claimed for European nations because an explorer happened to come upon them. The Falls of Iguaçu, whose thunder echoed through the ears of Cabeza de Vaca during the five miles that he and his group had to trek through the forest in order to avoid them, became in this way part of the cultural heritage of the Spanish empire.

By around 1570, three-quarters of a century after Columbus, Spaniards were to be found in every corner of the Atlantic world. Their presence, however, was so thin as to make them virtually invisible. After struggling against great odds for two generations, they managed to make their presence more acceptable to native Americans. But their small numbers and the immensity of the New World landscape made it impossible for them to carry out a European-style occupation. There was never in any real sense a 'conquest' of America, for the Spaniards never had the men or resources to conquer it. All their settlements were tiny and vulnerable. The whole of Cuba had only 322 households in 1550; 20 years later the

town of Havana had only 60. In 1570 the city of Cartagena had only three hundred. Around 1570, according to the king's official geographer López de Velasco, the total number of Spaniards in all the settlements of the New World came to 25,000 households.[53] The entire Spanish population of America, in other words, could have fitted easily into a moderately large European town, such as Seville. There were few colonists outside the major towns. Their main concern always was to occupy a useful coastal strip, then make the zone round it secure, as they did around 1545 with their settlements in the Yucatan at Mérida and Campeche.

For Spanish power in America to become viable, it was essential to work out a system based on collaboration rather than 'conquest'. Wherever they claimed authority, one of the first acts of the Spaniards was to distribute encomiendas, which gave them 'rights' over the labour of the natives. To do this they had to reach some agreement with local chiefs. Where possible, they opted to retain existing patterns of authority among the native Americans, placing themselves at the top in the place previously occupied by the Aztecs and Incas. The old system of tribute was continued, this time with local Indian leaders helping to extract payment from the population. The process can be seen in the Peruvian area of Huamanga, where the Spaniards founded a town in 1539. Many of the local communities allied willingly with the Spaniards, hoping in that way to gain freedom from Inca rule and a position of advantage for themselves.[54] It proved to be valuable help in establishing Spanish power. For many decades after the beginning of Spanish rule, and especially in remoter areas such as the valleys of Peru, native Indian societies continued their traditional way of life, unhindered by the changes that were certainly taking place elsewhere in the New World. In the central zones of Spanish settlement, two parallel societies developed: a Spanish world, where everything was organized in response to the demands of colonists, and an Indian world, with its own culture and ruling élite. The two often remained autonomous for generations, though in time they began to converge. In Huamanga by the 1550s the Indians, guided by their curacas, were helping to make the local economy function to serve the needs of Spaniards. Even this system was breaking down a decade or so later, as the number of Indians declined.

As soon as the Spaniards had consolidated their impact, their first concern was always to set up a township, the basic unit of life in the

Iberia from which they came. By the mid-sixteenth century there were small towns, often with names taken directly from Spain (Trujillo, León, Santiago), dotted over the landscape. Having made sure that they had access to the sea and to local sources of wealth, they set about organizing their labour force. This involved making agreements with the local native chieftains (the caciques in Mexico, the curacas in Peru), for men to be supplied for work in the encomienda, the fundamental economic institution of the early colonial period. Indian labour, and also by now some black labour, made possible the survival of Spaniards as the new governing class in America. 'Through my services in war', a proud young conqueror wrote home from Chile in 1552 to his father in Medina del Campo, 'I have obtained a repartimiento of Indians, and am owner of a valley on the sea coast which has over a thousand Indians. I built a fortified house where I live, with horsemen serving me, and I have subjected the whole province, burning houses and hanging Indians.'[55] Labour services had been traditional in the imperial scheme of both Mexicas and Incas, as defenders of the encomienda did not fail to point out. For a high proportion of the early settlers, it was their mainstay. 'I am aiming to obtain some Indians', explained one newly arrived Spaniard in 1578, 'because here in these parts the man who has no Indians has no way of making a living.'[56]

Confronted by the enormous extent of the New World and their own exiguous numbers and limited capacity for conquest, the Spaniards never achieved adequate control over the native population. In areas where it was possible to implement the encomienda and make use of native labour, the Spaniards used Indians to build houses, plant crops, tend the fields and irrigate them, spin and weave textiles for domestic use, and transport goods. This type of basic economy functioned adequately for the first generation of the colony. But when more Spaniards came to live in the New World, the resources of native labour became inadequate. Spaniards required items with which they were familiar and with which the natives could not supply them, such as wheat, olives, sugar, wine, weapons, and quality cloth. The emphasis moved, for them, from local production to import of essential items. Inevitably, many Indians on the fringe of this scheme of things returned to their own way of life. The Spanish market system remained important for many natives, but for the majority it became secondary, for they had their own parallel society and parallel markets. Where, above all, there was

no mining industry, the Indian managed to survive in his own society.

The principal question round which the Spanish presence in the Atlantic revolved, was that of the survival of the native population, or, to present the other face of the same problem, the use of Indian labour. Spaniards, like many of the early French and English in the New World, came in search of quick wealth, not with the intention of settling and working. Ever on the move, the early European population relied entirely on the settled indigenous population for food and survival. In every essential respect, the natives of the New World constructed the economy and society of the empire controlled there by Spain. Production in America rose and fell according to the productive labour supplied by the natives. 'All our Spaniards', runs an unequivocal report from Chile in 1600, 'are sustained by the labour of the Indians and the work of their hands and are maintained thanks to their sweat.'[57] It was well known, chroniclers reported time and again, that Spaniards from the peninsula did not go to America to work, but to live off the exploitation of native labour.

The Spanish presence, in consequence, involved the enslavement of large numbers of the indigenous population of America.[58] In medieval Europe slavery had normally been practised as a consequence of war, but no war had taken place when in February 1495 Columbus seized and sent to Spain as slaves five hundred young people from the Caribbean, followed by three hundred more in June the same year. Queen Isabella forbade any further slavery in October 1503 and in December decreed that natives of the New World should be considered 'free and not to be enslaved'. After her death, however, slavery continued to be widely practised on the indigenous population, especially in the Caribbean, and was expressly permitted if the subjects were defined as cannibals or rebels. King Ferdinand admitted to Columbus in 1511 that the practice was 'something that weighs on my conscience', but did nothing to restrict it. The first serious attempt by the crown to stop slaving was an order by Charles V in 1530. He had life-long scruples about the issue. Though obliged for practical reasons to withdraw his ban shortly after, he grappled firmly with the problem in 1542 by a decree that was incorporated in November into the famous New Laws. It was a historic step. Thereafter the Spanish crown formally permitted slavery on only one occasion, when in 1608 it allowed Araucanian 'rebels' in Chile to be enslaved (the law was revoked only in 1674).

Rules and regulations issued by Spain were, however, in practice ignored on the other side of the Atlantic. Slavery, and the slave trade in Indians, continued to have a fundamental impact on the indigenous population long after it had theoretically ceased to exist legally. The entire history of the first century of contact between Europeans and native Americans is tied up with it. There were areas, often forgotten if we look only at the main centres of colonial activity, where the impact was deadly. When the Spaniards settled in Panama, and later after 1530 extended their interest to Peru, they desperately needed assistance from native labour. As a consequence, the Pacific coast of Nicaragua became one of the biggest centres of slaving. It has been suggested that in the decade 1532–1542, when demand for slaves was highest, as many as two hundred thousand natives were seized from this coastline and shipped off into slavery.[59] Already in 1535 an official was reporting that a third of the population in the Nicaragua area had been disposed of for purposes of slavery.

The scant details demonstrate beyond any possibility of controversy, that the indigenous peoples of the New World were those who, with their labour and with their lives, contributed principally to making possible the establishment of a European presence. The undoubted heroism of the conquistadors pales into insignificance before the involuntary heroism of the native Americans, who in their hundreds of thousands participated in and attempted to survive the new order of things.

Almost unconsciously, Spain became the channel through which the agrarian and social life-cycle of the Atlantic world was transformed. The first Castilians in the New World were faced by an environment that did not supply the foods they normally consumed, the liquids they drank, the clothes they wore, the tools they used, or the animals that helped them to perform their labour or to move about. New World food provoked some of the gravest illnesses they suffered, and was possibly the chief cause of mortality among early European immigrants. Spaniards therefore brought with them everything they needed. In so doing they set in motion (see Chapter 6) profound changes in the biological processes of the continent.

Few historical issues have provoked so much contention as the impact of the European presence on the demography of the New World. Bartolomé de las Casas began the debate by offering in his polemical

writings the spectacle of a native population that was virtually exterminated. He estimated that twenty million Indians were wiped out by Spanish cruelty. There can never be any doubt over the disaster that took place. In the thirty years after the arrival of Columbus, the indigenous population in parts of the Caribbean and sections of the mainland were completely extinguished. Like Las Casas, many subsequent commentators blamed the cruelty of the Europeans for what happened. A jurist, Tomás López Medel, sent out to Guatemala in 1542 to assess the need for the New Laws that had just been decreed, came to a conclusion that may have been exaggerated in its calculations but was inspired by the facts as presented to him:

Our Old World has been responsible in the New World of the Indies for the deaths of five or six million men and women who have been wiped out in the wars and conquests waged over there, as well as through mistreatment and mortal cruelty and other causes of the same character, intolerable conditions of work in the mines, forced labour, personal service and very many other ways in which the insatiable greed of our men from over here has inflicted itself on those wretched people in America.

The cruelty of the Spaniards was incontrovertible. It was pitiless, barbaric, and never brought under control by the colonial regime. The Spaniards of course had no interest whatever in destroying the natives; to do so would evidently have hurt their primary institution, the encomienda. Yet to establish themselves in the land with security they had no hesitation in employing extreme violence. Mistreatment by colonial settlers, widespread and always pernicious, was sufficiently terrible for the Franciscan friar Toribio de Motolinía, in his *History of the Indians of New Spain* (1541), to list it among the Ten Plagues that had destroyed the Nahua people. The examples of cruelty were endless. During the war against Manco Capac in 1536 the Spaniards in the Jauja district, according to one who took part in the action, 'captured a hundred Indians alive; they cut off the arms of some and the noses of others, and the breasts of the women, and then they sent them back to the enemy'.[60] When the Spaniards were settling into the Mérida area in Yucatan, the Maya in 1546 attacked them and killed fifteen to twenty colonists. In retaliation the encomenderos killed hundreds of Maya, enslaved an estimated two thousand, burned six of their native priests, and hanged the women.[61]

Such incidents were repeated throughout the New World. All the contemporary reports speak, like a Maya chronicler in the sixteenth century, of 'how much suffering we went through with the Spaniards'.[62] The reports give relatively little importance to the loss of lives in hand-to-hand fighting, but narrate what their authors witnessed and experienced directly from day to day: the consequences of enslavement, of over-work, of ill-treatment, of under-nourishment and famine. Contemporary chroniclers, both native and Spanish, offer impressive figures for the deaths caused among the Indians. The image of Spanish cruelty was rapidly transmitted to Europe and became engraved on the minds of Europeans. When Michel de Montaigne was writing in France, the cruelty of Spaniards was already proverbial. Some European commentators eventually settled on the figure of twenty million Indians for a total of those killed by Spain.[63]

Yet the cruelty inflicted on the inhabitants of the New World was responsible for only a small part of the subsequent disaster. There were never enough Spaniards in America to kill the vast number of natives who perished. Without any doubt, the main reason for the catastrophic drop in the population of the Americas was infectious disease brought by the Europeans. Natives of the Atlantic world were free neither from illness nor epidemic.[64] But the European invasion brought new and cruel forms of death. Bacterial organisms carried by Spaniards hit the Caribbean area soon after the landfall of Columbus, and reached the mainland even before Cortés. The first major pandemic (of smallpox) broke out in Hispaniola at the end of 1518, reached Mexico in 1520, and seems to have travelled well into North America and possibly also into the Inca empire. The Europeans brought with them from their continent and from Africa a hideous range of killer infections, including smallpox, typhus, measles, diphtheria, influenza, typhoid, the plague, scarlet fever, yellow fever, mumps, colds, pneumonia and gonorrhoea.[65] Syphilis also became known in America, though it may have been simply a mutation of an existing disease; logically its appearance in Europe at this time made many attribute it to the contact with America. The direct impact of disease was devastating and was recorded by the Indians in their chronicles. There were other causes of mass mortality, but they were all indirect or long-term.

The fall in the indigenous population of the New World is amply documented. Statistics have normally been arrived at on the basis of

reports drawn up at the time, and of subsequent censuses made by administrators and clergy. Controversy has arisen, however, on the fundamental and unresolved question of the size of the pre-contact population:[66] how many people were there in the Caribbean and the mainland before the epidemics hit? Demographers have made learned guesses, with a tendency always[67] to settle on the highest figures for the pre-disease population. The high figures offered by historians of distinction have logically led to stark conclusions when compared with the very low figures of population censuses effected by authorities in America from the mid-sixteenth century onwards. All that is certain is that extensive depopulation took place. The island of Hispaniola within half a century of the arrival of Columbus had been totally denuded of its original inhabitants. Within a generation the outer fringes of the Spanish-occupied territories were affected. In northwestern New Spain the Totorame and Tahue peoples of Nayarit and Sinaloa had by 1590 been reduced by around ninety per cent, though other tribes suffered less.[68]

The epidemics, moreover, often preceded contact with the invaders, whose pathogens were carried in advance of their arrival, by the air, by insects, by animals and by natives. 'While the Spaniards were in Tlaxcala [after the Noche Triste]', a Nahua text reports, 'a great plague broke out here in Tenochtitlan.' The last undisputed Inca, Huayna Capac, died of a pestilence just before 1528, a few years before the Spaniards arrived in Tawantinsuyu.[69] In this way smallpox prepared the way for the fall of the American empires. Bacterial infection appears almost as an immense, impersonal and continent-wide punishment inflicted on the New World by its contact with the Old. The coming of the European, no matter what barbarities he may subsequently have committed, appears to have had a small role in the epic of cosmic disaster. However, pre-contact ravages had limits both in space and time: they did not maraud freely[70] and were controlled by local conditions.[71] In the post-contact period, by contrast, disease spread more rapidly. The epidemic of 1545–8 was probably the most disastrous ever to affect central Mexico.[72] In another in 1576 a settler wrote: 'the epidemic here in Mexico is terrible; the Indians represented all our wealth, and since so many of them have died everything is at a standstill'.[73] But already with the colonial period came the contribution made by contact, and it was deadly. The total number of people affected can never be reliably

calculated, but it is not unreasonable to suggest that over ninety per cent of the deaths among the indigenous peoples of the New World were caused by infection[74] rather than by cruelty.

The birth of an Atlantic world in the sixteenth century, it has been pointed out, involved a gigantic international migration of people.[75] The Spaniards occupied a primary place in it.

Not a single Castilian accompanied Columbus on his first voyage; most of the sailors were Andalusians or from the Cantabrian coast, men who had more knowledge of the sea. Within the next decade, however, Castilians – the majority population of the peninsula – formed the greater part of the adventurers who went out to the Caribbean and then to the mainland. Men from Castile, Andalusia and Extremadura made up four-fifths of the 380 who left Cuba with Cortés on their way to Mexico; the same 3 regions answered for the majority of identified conquistadors. The places of origin of emigrants varied in subsequent years, depending on the economic circumstances that impelled them. Many, obviously, were fleeing from poverty, from a country of 'so much misery and suffering that there is no future for anybody there',[76] towards new horizons. 'I am determined', a settler in Mexico confessed, 'to raise my sons in a country where they are not oppressed by so much misery' as in Spain; in New Granada another wished to 'raise my sons in a good country where they are able to eat'.[77]

The new lands attracted dispossessed Spaniards of all conditions, many of them soldiers and sailors unemployed after the wars in Granada and Italy had come to an end, others young and hardy men of limited means, including many hidalgos (like Cortés) and illiterate labourers (like Pizarro) who looked to America to better their fortunes. Emigration was the way to improvement: 'you must understand', a new arrival in Panama wrote back to his son in Spain, 'that those who want to better themselves cannot continue living where they were born'.[78] The procedure, as explained by a settler in Puebla to his brother-in-law in Extremadura, was: 'if you need to come to these parts the first thing you must do is go to Madrid to get a licence to emigrate, then when you have the licence sell whatever you have to raise as much money as possible, then go to Seville and arrange for your passage at the lowest price possible'.[79]

The total figures for emigration from the peninsula did not by any

means amount to a flood. Emigrants had to register at the House of Trade in Seville, and about fifty-six thousand persons did so in the course of the sixteenth century. An historian has suggested that this may represent only about a fifth of the real total, since very many managed to emigrate without passing through the system of control. If this reasoning is accepted, many more went to the New World than the surviving records say. A recent estimate is that in the peak period 1500–1650 perhaps 437,000 Spaniards went to the New World, and over the two centuries 1500–1700 perhaps 100,000 Portuguese.[80] In reality, all such figures are arithmetical projections based on the (improbable) supposition that a continuous torrent of people went across the Atlantic. There is no firm evidence that this was the case. Unregistered emigration obviously took place, but it is likely, as has recently been argued,[81] that the numbers were significantly lower. The Spanish population of the chief cities of America was always small, and was fed by fairly modest levels of immigration from the peninsula. As we can see from the correspondence of those who were successful in the New World and wished to attract their families over, it was not easy to convince Spaniards of the benefits of emigration.

Success in the New World depended, in the view of Spaniards themselves, on their own personal effort. 'Someone who comes here from Spain as poor as I was', stated an immigrant in Guatemala, 'has to go through a great deal to find a living.'[82] Others were frankly pessimistic about their chances: 'America is not the place for people who come here poor; a man is hard put to earn enough to feed and dress himself.'[83] However, there was no lack of optimism, either: 'those who apply themselves to work hard in this land can make more in one year than over there in a lifetime'. 'The man who has a will to work will not go short,' another wrote from central Mexico, 'the opportunities here are better than in Spain.'[84] There were of course very many immigrants who made their way merely through the labour of their hands, such as the farmer in Puebla who around 1550 'was a farm labourer for one year together with another labourer, and later I obtained lands and bought four teams of oxen, and sold my wheat for making flour in Mexico city.'[85] The attraction was obviously enormous of a 'land where there is no hunger and those who want to apply themselves become rich in a short time', the reference being to Peru in 1559.[86]

Reports from successful immigrants tended of course to leave out of

consideration the crucial contribution of the native population and of imported blacks, without whose help (as Las Casas pointed out) the Spaniards would have achieved little. A settler in Mexico explained succinctly that 'in this country hunger is unknown and we have all the produce of Castile as well as much more from this land, with the result that Spain is not missed; so that even if you are poor you are better off here than in Spain, because here *you are always in charge and do not have to work personally*, and you are always on horseback'.[87] A settler in Lima explained that 'the property I have is a farm with vineyards, a lot of land, and cattle that are worth many ducats; and its value is such that I have a dozen blacks working, without counting the Indians who bring much profit to the property'.[88] He was rich but also old, and pleaded with his son in Madrid to come out and take over the inheritance: 'if you had come out here, son, each year you would have been earning more than four thousand pesos'. The continuing promise of America, based less on 'work' and more on opportunity, encouraged further emigration from Spain.

It is easy to forget that the terrors of a sea voyage deterred very many Spaniards from emigrating. The crossing to America was frequently a long and painful purgatory. During all voyages the mortality rate could be enormously high, but an even greater peril were the storms at sea that lasted for days and tore the small vessels apart. The sufferings of the passengers on the vessel (part of a convoy of twenty-seven ships) in which Bartolomé de las Casas set out from Seville in July 1544, are described vividly by one of his fellow passengers, Padre de la Torre.

The ship is a narrow, tight, prison from which nobody can escape even though there are no bars or chains, and so merciless that it makes no distinction between its prisoners. The feeling of being crushed, and of suffocation and heat, is intense; bed is usually the floor, some bring pillows, ours were poor, small and hard, stuffed with dog's hair, and we had miserable goat's hair blankets. There is a lot of vomit in the ship, and a great deal of bad temper, which makes many people lose control completely, some for a longer time than others, and some unceasingly. The thirst you suffer is unbelievable, made worse by the food, which is biscuit and salted things. The drink is a litre of water a day, you have wine only if you bring it. There is an endless number of fleas that eat you alive, and clothes cannot be washed. The smell is awful, especially in the hold, though it is insufferable everywhere in the ship . . . These and other travails are quite

normal in the ship, but we feel them particularly badly because it is not what we are used to.[89]

Once they had arrived in the New World, new colonists were all too aware of the immense space between them and their home country. A colonist in Mexico in the 1590s lamented to his nephew in Spain that he would probably never see him again, the distances being such that 'it's not like me going to your house and you coming to mine, as we used to do'.[90]

Those who emigrated were always highly selective about where they wanted to go. The government tried to encourage them to settle everywhere, but people had firm preferences. The failure of early endeavours in the Río de la Plata meant that nobody wished to go there. In 1558, when the authorities were trying to enlist colonists for a sailing to the Plata, they explicitly lifted the normal ban on foreigners, Jews and Muslims. It was still not enough, complained an organizer of the expedition. Even allowing in all the prohibited categories, as well as Moriscos, 'despite everything, in the whole of Spain people could not be found to come'.[91] The expedition finally sailed, but mainly with soldiers, which had not been the intention of the council of the Indies.

In time the discovery of the mines of Mexico and Peru would give yet more boost to the attractions of coming over. Certain professions were evidently in short supply and offered quick gains to newcomers. A baker in Mexico commented that 'you earn more here than in Spain'; another resident of the same province confirmed that 'for poor people this country is much better than Spain'.[92] Even for priests, whose numbers were reputed to be excessive in Spain, there were advantages: 'for the clergy', a settler reported from New Granada, 'America is a very good place'.[93] The most disliked of all the professions were the lawyers, whom the early conquerors tried to keep out of America. Their services, however, were soon seen to be essential, since they helped to protect disputed property rights. 'Over here even the donkeys earn their living', a priest wrote ironically from Quito, 'and the lawyers much more so.'[94]

Many immigrants hoped to profit from opportunity and return home with their wealth: 'in three or four years we'll earn, God willing, more than thirty thousand pesos, then we'll come back to Castile'.[95] 'Those of us who live far out here', an old and infirm settler wrote from Trujillo to his family in Spain, 'live with no other wish than to end our days at

home, in our country.'[96] Many did go home, but only to live off what they had gained: a resident of New Spain commented in 1574 on a friend who 'now that he is rich wants to see the back of the Indies; he told me when he left to catch his ship that he never wanted to return to America, he was fed up with it'.[97] The poor, however, could not return: 'those who come out to this country cannot return to Castile without money, for everyone would laugh at them'.[98] In practice for a variety of reasons only a small proportion did so. The majority were too settled, too successful, or too old ('now that I am old, I shall stay here'[99]) to return. Though they yearned to live again among their families and show off their newly acquired riches, they feared the old world that they remembered only too well. 'We did think of going back shortly to Spain', two brothers wrote home from Potosí, which by that date (1576) was awash with silver, 'but looking at the misery there and at what we have over here, we have no wish to go but will stay here in this country, which is rich and good.'[100]

From the beginning, non-Spaniards played a significant role in the creation of the empire not only in Europe but also in the New World and Asia. Official chroniclers, however, tended to gloss over the fact. They often passed over in silence the detail that Columbus was Italian and Magellan Portuguese. A decree of 1499, repeated in another of 1501, prohibited the entry of any foreigner into the Americas, but the bans were never observed, and in any case it was easy for immigrants to claim that they came from some other part of the Habsburg territories. It was common for Germans and French to pass themselves off as citizens of the Netherlands. Foreigners were numerous in towns that had strong trading links. Seven of the group of men that founded the town of Panama in 1519 were foreigners; in the same half-century one tenth of the households in the town was foreign.[101] The irregular situation of many 'foreigners' was set right by an order of Charles V on 17 November 1526 allowing any of the subjects in his realms to go to America. From that date immigration was virtually uncontrolled.

Non-Spaniards, of course, owned a good part of the New World, if the concessions made by Charles V to his Flemish courtiers were to be taken seriously. In the 1530s many Netherlanders received official permission to settle in the Caribbean, New Granada and the Río de la Plata. Castilians in the peninsula continued to harbour resentment

against the privileges granted in America to foreigners. The concession in 1528 of the territory of Venezuela to the German banking firm of the Welsers caused the greatest indignation, for it opened the door wide to foreign infiltration. When Welser's agent Hieronymus Köhler went to Venezuela in 1534, it was reported that those in his ship represented 'many tongues, many from Scotland, England and the Netherlands, but mostly Basques, Spaniards and Italians, around thirty persons who even if pushed to it could not understand each other'.[102]

Despite attempts to control their presence, non-Spaniards, especially Portuguese and Italians, could be found everywhere. The situation elicited a comment from the historian Oviedo on 'so many different peoples and nations, of varied and diverse condition, who have come to America and pass through it'. In particular, he said, in the city of Santo Domingo 'every language can be heard, from every part of Christendom, from Italy, Germany, Scotland, and England, with Frenchmen, Hungarians, Poles, Greeks, Portuguese and all the other nations of Asia and Africa and Europe'.[103] America was too vast a continent to be closed off, and the non-Spanish element continued to be important throughout the colonial period. In the generation after Columbus it proved – as we have commented – very difficult to attract Spaniards to the Caribbean, and the government made intense efforts to bring in Spanish settlers from the Canary Islands.[104] In the end, the authorities had to be content with allowing Portuguese settlers into Hispaniola, where they flourished, contributed greatly to sugar production, and converted parts of the island into a 'little Portugal'.[105] In 1535 on the island there were 'over two hundred Portuguese who run the sugar mills, and others who are farmers, as well as many carpenters and masons and smiths and all the trades; there is a great number of them in all the settlements and they are very productive'.[106] In 1588 the city council of Santo Domingo complained to the government that the Portuguese 'in this town are more numerous than the Spanish, they trade publicly and thereby appropriate the wealth of the country'. In many areas of America the Portuguese continued to play a significant role. Five per cent of the population of Buenos Aires in the early seventeenth century, for example, was Portuguese; and by mid-century there was one Portuguese family for every three Castilian.[107] Since Portuguese controlled the slave trade in the same period, they used it as the channel for entry. An official of Cartagena de Indias reported in 1618 that 'the biggest problem is that

most of these slaving ships are Portuguese; each one transacts his business in blacks and then stays on to live in Cartagena'. Not surprisingly the officials at Seville complained that 'the Portuguese do so much business in the Indies that it appears the Indies belong to the Crown of Portugal rather than to Castile'.[108]

The Italian presence was also pervasive. Italians participated in the early explorations, as we have seen, both in person and through agents. But they were also to be found everywhere in the New World in the first century of settlement, especially in Mexico.[109] Italians, mainly from Genoa, took part in all the expeditions of conquest: they could be found with Cortés in Mexico, with those who seized the Inca at Cajamarca, and among the companions of Valdivia in Chile. A native of Lombardy introduced printing into Mexico, a Sicilian was with Balboa when he sighted the Pacific. Italians were, in the 1530s, among the first to colonize the mouth of the Plata. The expedition to this area, led by Pedro de Mendoza in 1535, also brought from Nuremberg a shipload of German merchants and adventurers, some of whom helped in the colonization of Paraguay. The foreigners in early Spanish America were by no means an élite, apart from the few commercial agents of Genoese and Germans. In Hispaniola and Cuba the majority were, like the Spaniards, ordinary people seeking their fortune: they included sailors, farmers, traders and artisans.[110]

Meanwhile an equally significant, but wholly involuntary, immigration was taking place. Almost from the beginning of trade relations between Europeans and the African kingdoms, the former had purchased, in addition to the prime commodity of gold, quantities of slaves. Slavery had existed in medieval Western Europe, and warfare between Christians and Muslims in the Mediterranean continued to give life to the practice. Slaves also existed as part of the economic life of all African states, which made use of them at all levels and were only too willing to trade them for European commodities.[111]

The taking of black slaves to the New World had always been permitted by the government, and Las Casas had suggested in addition that import of black labour might ease the lot of Indian labourers. The first import of blacks is normally dated to 1510, when King Ferdinand licensed the House of Trade in Seville to send to Hispaniola two hundred and fifty Christian blacks acquired in Lisbon. More and more blacks

were imported, commented Las Casas later, but 'it never led to any help or freedom for the Indians'. Blacks from the Iberian peninsula had the legal status of slaves, that is, they had originally been captured in aggressive raids on the African coast. But the need arose for many more than the peninsula could supply.[112] Since Spain had no access to them in her African territories, recourse was had to the Portuguese, who held outposts in tropical Africa.

Spain's direct participation in the trade of Africans to America, which dates from the first import of Africans to Hispaniola, established a model that became the standard one for all the enterprises, both civil and military, that contributed to the evolution of the colonies. The state did not have direct access to the resources or expertise necessary to carry out the trade. It advanced the money and made the rules, but left all other matters in the hands of the entrepreneurs. This had already happened in the case of the Portuguese. In the late fifteenth century the money for their slave trade to Africa was put up principally by the Florentine financier Bartolomeo Marchione and by Genoese colleagues.[113] Throughout its long history, therefore, the African slave trade to the Spanish empire was dominated by international finance. The early permissions took the form of limited 'licences', later on a system of long-term contracts or 'asientos' was adopted. The first licence for importing slaves in quantity from Africa was granted in 1518 to the Franche-Comtois noble Laurent de Gorrevod, who in turn sub-contracted the licence to others. In 1528 the first asiento went to Heinrich Ehinger, agent of the German financiers the Welser.[114] Slaves were transported mainly from the area known as Upper Guinea, stretching from the Senegal southwards to Sierra Leone, and from the Congo; the trade was managed by Portuguese merchants in the Cape Verde Islands and in São Thomé off Biafra.

The new Portuguese trade very soon aroused a storm of protest among Spanish officials and churchmen, because of its brutality. The outcry was such that Philip II for a while suspended it. Among the most outspoken critics was the Dominican friar Tomás de Mercado, who had lived in Mexico in the 1550s and seen it in action. He termed it 'barbarism' and 'injustice', describing the blacks as 'cheated, violated, assaulted and despoiled'; the death rate on the Atlantic crossing could be, he testified, four-fifths of the blacks transported.[115] A few later Spanish writers, such as the Jesuit Alonso de Sandoval, whose *On the salvation*

of Africans (De instaurando Aethiopum salute) was published at Seville in 1627, also bitterly criticized the barbarity of the Middle Passage, as the long trip from Africa to the Caribbean came to be known. Sandoval concluded that 'slavery is the beginning of all offences and travails, it is a perpetual death, a living death in which people die even while they are alive'.

It is impossible to estimate satisfactorily the number of Africans who were transported across the Atlantic, and the problem has consequently always aroused controversy among scholars. A recent calculation[116] suggests that around the year 1500 the number of slaves transported annually from the West African coast was 5,000, rising to 8,000 a year around 1550, then 13,800 a year around 1650 and 36,100 a year around 1700. Only a proportion of these went to the Spanish plantations (after 1650 the demands of other Europeans in the Americas boosted the trade). But imports from Africa to Spanish America were high: the main port of entry, Cartagena, received a possible annual average of four thousand a year in the early seventeenth century.[117]

There is no wholly satisfactory way to arrive at figures for the involuntary immigration of Africans into the New World before the eighteenth century. The documentation is inexact, fraud was extensive, and the high death rate on the Atlantic crossing cut deeply into the presumed number of persons on each voyage. On balance, a general perspective is perhaps more illuminating than any attempt to count the uncountable. Reputable scholars have suggested that between 1450 and 1600 the Americas may have received around 290,000 Africans and between 1600 and 1700, when the slave trade was at its peak, around 1,490,000.[118] The proportion that went to the Spanish colonies remains highly problematic. A recent opinion is that up to the year 1600 Spanish America received around 75,000 and between 1600 and 1700 around 455,000,[119] but the figures serve largely to help us view the question in global terms and cannot be accepted as reliable.

The very large number of blacks imported very soon had the consequence that blacks came to outnumber whites in the New World. 'Because of the sugar mills', the historian Oviedo reported from Hispaniola, 'there are so many of them on this island that it seems to be a veritable Ethiopia.' This is astonishing, when we consider the unremitting mortality rates imposed on African immigrants. It was estimated, even in the sixteenth century, that on the Atlantic crossing around one

quarter on average of the captives died of disease or because of the harsh conditions. There must have been many cases like that of the ship which (in 1717) reached Buenos Aires with only 98 survivors from its original shipment of 594 slaves.[120] That was, of course, after an already high death rate caused by the conditions of the slave trade on the African continent itself. Once in the New World the slaves had to journey yet again to their destination, which involved further suffering and mortality. When they finally arrived they were put to work in conditions that quickly cut their lives short. Despite all this, they endured and survived. Their ability to survive in the intolerable conditions to which they were subjected, earned them a reputation as a labour force. But the reality was that they died in their thousands, and generally failed to reproduce themselves,[121] so that the need to import more slaves became a permanent one.

Though black slaves had initially been imported to meet the demands of labour in the Caribbean, they were quickly seen to be essential in all aspects of production, and the numbers in Spanish-occupied parts of the mainland rapidly rose. In Hispaniola they were the only labour in the sugar mills and in agriculture; 'only blacks till the soil', the city council of Santo Domingo stated in 1556.[122] In 1553 the viceroy of New Spain informed the government that 'this land is so full of blacks and mestizos that they outnumber the Spaniards greatly. You Majesty should order that they do not send blacks, because there are in New Spain more than twenty thousand and they are increasing.'[123] In central New Spain in the 1590s they were the largest ethnic group after the native Indians, and outnumbered white Spaniards by two to one. In Peru the situation was the same. From the last decade of the sixteenth century, Lima was a city whose population was half African, a situation that prevailed until the middle of the seventeenth century.[124] In Chile in 1590 the European population of nine thousand was greatly outnumbered by the black population of twenty thousand.[125] In the isthmus of Panama the non-native population was overwhelmingly black. In 1575 the town of Panama had 500 Spanish households, but the area had 5,600 black slaves. By 1607 nearly seventy per cent of the town's population was black.[126]

Africans played an appreciable role in the creation and defence of the empire, and took part in the campaigns of the early conquistadors. Blacks were with Balboa when he claimed the Pacific, with Pedrarias

Dávila when he colonized Panama, with Cortés when he marched to Tenochtitlan, with Alvarado when he entered Guatemala.[127] Almagro apparently had twice as many blacks as Spaniards serving with him, and Gonzalo Pizarro at the time of his rebellion had up to four hundred blacks in his forces.[128] The most famous black of the early frontier was Juan Valiente, a hero of the conquest of Chile, who served with Alvarado, Almagro and Valdivia, became an encomendero in 1550 and died in battle against the Araucanians in 1553. The prowess of blacks as soldiers became legendary, and blacks were in the front line of the defence of the American territories.

Throughout its first two centuries as an imperial power Spain was completely unable to send enough men to its colonies to serve in the armed forces. Blacks became the main component of the militias that fought the Indians, patrolled the frontiers, put down rebellions and fought foreign pirates.[129] Time and again the efficient black defences repulsed European invaders in the Caribbean. In Havana in 1600 the governor had at his disposal a coloured militia of free mulattos (the 'Compañía de Pardos Libres'). By the end of the seventeenth century blacks could be found as junior officers in the colonial militia. The alternative face of the picture was that runaway (cimmaron) and rebel blacks also acted as a powerful aid to European military expeditions in their efforts to take over territories in the Caribbean. The first and most menacing sign was in the daring expedition of Francis Drake across the isthmus of Panama in 1572, a feat made possible only by the help given him by a group of thirty cimarrons.

The principal role of black Africans in the Spanish empire was as mainstay of the economy.[130] Production in the islands and mainland of the New World would, quite simply, have collapsed without their contribution. From the time that Spanish missionaries and authorities decided that the indigenous population could not put up with the intensive labour required in certain activities, African slaves became the substitute. They came to be the main workforce in the sugar mills, in mining, in agriculture. From the beginning of its introduction into the New World, sugar cane came to be identified with the mass importation of black slaves. Blacks produced the sugar of the Caribbean. They became crucial contributors to the mining industry, in the silver mines of Mexico and the gold deposits of Colombia and Peru. Their role supplanting the Indians in the gold mines of Colombia is cogently

echoed in the myth prevalent among the black miners of Güelmambi, at Barbacoas in Colombia:

Before we blacks arrived the Indians lived here, in this same place. When we arrived the Indians fled, under the earth towards the mountains where the rivers have their sources. But before fleeing they took all the gold, and broke everything up with their hands and feet, turning it all into gold dust. And now we, the blacks, must break our bodies to find the gold dust and keep ourselves alive in the places where the Indians used to live before.[131]

In the famous mines of Potosí, on the other hand, their role was only ancillary, for it was considered that they could not resist the altitude as well as the Indians. Above all, blacks served and slaved everywhere in Spanish America in the haciendas and the great ranches, helping to produce the crops and tend the animals on which Hispanic society depended.

They were also the basis of domestic service. Europeans had been familiar with blacks in the Old World, and may for that reason have found them more acceptable for positions of trust in New World society. Blacks, moreover, were an uprooted people, and showed an amazing ability to blend into their host societies. In Peru, they were used extensively in domestic service, and a large population of free blacks developed as owners granted certificates of liberty to those who had served them well. By around 1650 possibly one-tenth of Peru's black population was legally free.[132] Outside the domestic household, blacks occupied the service trades, as blacksmiths, cobblers, carpenters and tailors. The small shipbuilding industry in Peru – mainly in Guayaquil – was manned principally by blacks of different racial grades.[133] Because they were mostly untrained and illiterate their success in the shipyards was relative; their efficiency was admirable, but the quality of vessels produced left much to be desired. In the long run, though there was a continuing process of manumission (that is, liberty granted on an individual basis) the blacks found it difficult to achieve a generalized legal freedom. It was a problem common to colonial societies. Indian slavery, which had been prohibited in the mid-sixteenth century, continued to be practised openly and illegally long afterwards. But at least the Indians had the protection of a law, even if it was not observed. Africans did not even have a law to protect them.[134]

In no small measure, the black man created the empire that Spain

directed in the New World.[135] It is a role that, until recently, was wholly neglected by Spanish historians,[136] unlike Portuguese scholars who were always conscious of the part played by blacks in the origins of Brazilian civilization.

For the government in Spain, an even bigger problem than controlling Indians was that of controlling the settler class. In reality, the crown never managed to impose its will adequately on the colonial élite, which demonstrated from the time of the Pizarro revolt in Peru that it could dictate the rules of the game.

The Spaniards in America were convinced that the continent was theirs because they had gained it through their own sweat and blood. 'I shall declare', wrote Vargas Machuca in 1599, 'how much is owed to the discoverers and settlers of the Indies, since with the valour of their swords they have acquired for their prince notable realms, that have been discovered, conquered and populated.'[137] The claim was absolutely true. Since the time of the occupation of the Canary Islands, the crown had no cash, men or weapons to carry out its aspirations to empire, but it used freely the system of granting military commands (adelantamientos) and authority over natives (repartimientos) in order to satisfy the adventurers. The extension of the Spanish presence was by no means a haphazard process involving random marauders. In an unknown world filled with menace, men came together only with those they trusted, and made agreements carefully stipulating the contribution each would make. The classic agreement made at Panama by the Pizarros was typical. Trust was extended to those who came from the same family, town or province. Men from Extremadura formed a closely knit group that supported the Trujillo conquistador Pizarro during the campaigns of Peru; they split up only after the defeat of the rebellion of Gonzalo Pizarro.[138] The men who pioneered the opening of Florida were a network drawn from families of Asturias who were linked by kinship. They came from the towns of Avilés, Gijón, Santander, Castro Urdiales and Laredo. The Asturian creator of Spanish Florida, Pedro Menéndez, specifically recommended that the crown choose its agents in that area from Asturians and Basques, 'who are the people best fitted to work in Florida, some because of their nature and some because of kinship and friendship'.[139]

Royal government was installed relatively late. It consisted mainly of a viceroy (in New Spain from 1535, in Peru from 1542) who in theory

controlled the administration, supervised the treasury and dispensed royal patronage.[140] He was meant to work together with the supreme administrative body, the Audiencia, consisting of senior officials sent from Spain. The first Audiencias were set up in Santo Domingo and Mexico City; by 1661 there were twelve in the Indies, and one in Manila (1583). The fact that all viceroys and judges (oídores) of the Audiencias were sent from Spain is significant. No autonomous organs of government were set up by the Spaniards, and no laws were made in America (other than administrative measures); all legislation was decided in Spain by the council of the Indies, and then sent to America to be implemented. In effect, the council of the Indies, set up formally by Charles V in 1524 and consisting of half-a-dozen experts in law, made all decisions for America. Questions of law and order, town-planning, disposition of the labour force, and other matters affecting the daily life of the settlers, could be decided only in Spain.

This impressive picture of control from the peninsula seldom accorded with what really happened.[141] The colonial system as it operated in practice bore little relation to the intentions of legislators. Government in America, as could be seen by Viceroy Mendoza's suspension of the New Laws in Mexico in order to avoid a rebellion, could not function without the help of the settlers. Philip II realized this and was obliged to capitulate to demands for the encomienda to be continued. Because of the great distances involved, and the complete lack of necessary resources, Spain could not control America through conquest or coercion. Messages and messengers were sent out but then got lost in the vast expanse of mountain, forest and sea. 'I am off to the kingdoms of Peru', a trader wrote from Cartagena de Indias in 1575, 'and shall be a whole year travelling there, for by land it is a thousand leagues away.'[142]

The only possible way to exercise control was through a series of understandings and compromises. The world's greatest empire of the sixteenth century, consequently, owed its survival to the virtual absence of direct control. There were outstanding viceroys – the most famous was Francisco de Toledo, viceroy of Peru from 1569 to 1581 – who brought a semblance of order into the internal government of the overseas territories. But the reins of control from the mother country were never tightened, and only became looser as the decades advanced. By the late sixteenth century, effective political and economic power in America was firmly in the hands of the settlers rather than the crown.

The case of the town of Tlaxcala, in central Mexico, was typical.[143] The original policy of the government there had been to exclude white civilian colonists, so as to facilitate orderly administration by the Indians themselves. But the area abounded in fertile undeveloped land and a large supply of resident labour, a combination that Spanish settlers found irresistible. From around 1540 they managed to obtain grants of land within territory officially designated as belonging to Indians. Though the viceroy made some effort to cancel the grants, by the 1560s unauthorized intrusion by whites was widespread, and towards the end of the century extensive cattle ranches had taken over much of the fertile plains.

The weakness of imperial control was most glaring of all in the area of commerce. From the beginning foreigners were prohibited from going to America. They went there. After a limited period of free commerce, they were prohibited from trading to the New World. They traded, regardless. They were forbidden to extract gold and silver and other items. They did so, but with the added advantage that they paid no taxes since they did so illegally. In every respect, the edifice of legal controls was evaded and ignored.[144]

The pioneers of the European enterprise overseas were almost without exception laymen; even Columbus had no priest with him on his first voyage. Yet all had the words of the gospel on their lips, and in default of an ideology all proclaimed that their purpose was to advance the faith of Christ. Cortés during the march to Mexico insisted always on the importance of religion, preached the sermons himself, and was the first to cast down the statues of the Indians. Since their early days in the Caribbean, Spanish clergy did not cease to wonder at the unprecedented opportunity that had been granted to them, to evangelize barbarians who had been untouched by the corruptions of Western civilization. The ideology that they took out with them to the New World was by no means an exclusive product of Castile. Since the fifteenth century the ideas of literate clergy in Spain – especially in the three principal mendicant orders, the Dominicans, Franciscans and Jeronimites – had been open to Italian influences and the precepts of the Netherlands movement of piety known as the *devotio moderna*. Members of the Dominican order at the University of Salamanca were powerfully influenced by a revival of the philosophy of Thomas Aquinas. The ideals of the *devotio moderna* penetrated most deeply into the thinking of the Franciscan

order, which sent out twelve of their number – the 'twelve apostles' – to New Spain in 1524 to preach the gospel there. Among the Franciscans who arrived in this period were three Netherlanders: Pieter van der Moere (known in Spain as 'Peter of Ghent', a kinsman of the emperor); Jan van der Auwera (known as 'Juan de Ayora'); and Johan Dekkers (known as 'Juan Tecto').[145] With them the prophetic spirituality of Netherlands Catholicism arrived in the New World.

In early New Spain, the friars literally battled for control.[146] The Franciscans arrived first, in May 1524; the Dominicans, also twelve in number, arrived in 1526, and were followed seven years later by the Augustinians. In the Atlantic world the missionaries faced a challenge with which they were only in part familiar. They had encountered in the peninsula the phenomenon of Islam, as well as evidence of ignorance and unbelief, but no systematic heresy. At all events, their training in the theology of a dual universe, in which God and the devil, good and evil, justice and retribution, played their appointed parts, ill prepared them for the culture of the non-sedentary peoples of the New World, in which belief in a Supreme Being appeared not to exist and religion was often defined by 'animism', the magical character of elements of daily life.

Their remarkable efforts in America can to some extent be seen as a spiritual parallel to the secular conquest. Like the conquistadors, they had no doubts about their purpose; like them, they were responsible for the destruction of much of the cultural heritage of the region – buildings, art, statues – and had no hesitation about using violence against individual Indians. Within a generation of their arrival in New Spain the Franciscans had founded eighty houses of religious, the Dominicans forty. By the end of the century there were around three hundred monasteries in New Spain, with fifteen hundred friars in them. From mid-century they and the other mendicant orders were joined by the newly founded Jesuits, who first arrived in South America through the port of Bahia in Brazil in 1550.

The clergy did not by any means bring with them the traditional faith of the Iberian peninsula. Theirs was a much purer version of Catholicism. Heirs to the epoch of humanism, they had a more idealized concept of religion; heirs to the medieval tradition, they had a more theocratic, pre-Reformation, vision of priestly power; heirs to the millenarian vision, they laboured in the conviction that the conversion of the Indians heralded the fulfilment of prophecies about the imminent end of the

world. The great argument that the friars offered to their own and to future generations, was that they aimed to comply with the simplicity of the gospel, and save the souls of the native population of America. In the long period that stretched from the famous sermon of Montesinos in 1511 in Santo Domingo, to the end of the century, the majority of the friars never ceased to criticize the Spanish settlers and proclaim themselves as the true defenders of the Indian. The view of the mystical school of Franciscans, as represented by one of their historians Gerónimo de Mendieta, was that conversion of the Indians formed part of a divine plan for the world. Inspired by the apocalyptic vision that many members of the order shared, they saw the conversion of America as the final prerequisite for the Second Coming of Christ. History was drawing to an end: 'the day of the world is already reaching the eleventh hour', the twelve friars bound for Mexico were informed by their superior as he took leave of them at the quayside in Hispaniola.[147]

It was a heady dream. Going out into territory untouched by Christians, they envisaged creating again in America the early Christian Church of the apostles, with the opportunity this time of rectifying the mistakes made by the official Church in the fifteen centuries of its turbulent history. The problem was that the vision they brought with them operated as a filter that both distorted what they saw and modified the impact of what they did.

Their first great obstacle was the fundamental issue of communication. The problem was posed starkly in the open square of Cajamarca, as Atahualpa and his warriors faced the poised Spaniards. When the interpreter Felipillo translated the requerimiento for the Inca (we are told by the historian Garcilaso) he came to the phrase 'God, three in One' and rendered it 'Dios tres y uno, son cuatro', by which Atahualpa was made to understand that the Spaniards were offering him four gods. Then almost as though in imitation of the gesture of Nebrija offering his grammar to the queen of Spain, the friar Valverde approached the Inca and offered him a breviary, explaining through the interpreter that it 'spoke' the word of God. Guaman Poma depicts the scene in the following words:

'Give it to me', said Atahualpa, 'so that the book may speak to me.' He took it in his hands and began to turn over the pages of the book. 'Why does it not speak to me? The book does not speak to me!' Speaking with great majesty, seated on his throne, Atahualpa Inca threw the book from him.[148]

It was the provocation the Spaniards were waiting for, and they took advantage of it.[149] The failure of either side to understand the other at Cajamarca signalled the end of the old order in Peru and the triumph of the Christian God. But the lack of communication was never overcome. Half a century later, when Guaman Poma prepared his commentary on the Spanish experience in Peru, the distance between the languages of the conquered and the conquerors remained as evidence of the unbridged gap of comprehension.[150] It is an issue to which we shall return.[151]

The friars came to a continent rich with exotic tongues, whose mastery was their first major challenge. Peter of Ghent and the Flemings soon learnt Nahuatl, the language of the Mexica empire, but in some areas the predominant language might be different – Zapotec or Totonac or Otomi – and difficult to master. Peter of Ghent helped to draw up the first instruction manual in Nahuatl, which was published in Antwerp and then reprinted in Mexico. In Peru the missionary Domingo de Santo Tomás compiled the first lexicon and grammar of the Quechua language, and a few years later in 1590 the Franciscan Jerónimo Oré drew up the first catechism in Quechua. Both authors were optimistic about the ability of Indians to grasp the concepts of European philosophy and felt that Quechua was an adequate vehicle for transmitting the gospel message.[152] The intellectual labour of some of the early clergy in philology and natural sciences was impressive, and they were actively supported both by their bishops and by the Spanish crown. But others were not so certain that conquerors and conquered were speaking the same language or communicating the same concepts.

There were serious obstacles.[153] In early Mexico, reported Mendieta, 'there were not enough friars who could preach in the languages of the Indians, so we preached through interpreters'.[154] Around 1580 in Peru, half a century after the capture of Atahualpa, the majority of clergy was still ignorant of the language of the natives. When they preached the text had to be translated by interpreters, and 'we do not know what they are saying', admitted one friar.[155] The problem of the great multiplicity of languages in Peru – what the Jesuit José de Acosta called 'a forest of tongues' – was solved in a way that the Incas themselves had practised: by imposing only one, Quechua, the Inca tongue, as the general language. But for many Andeans the Quechua tongue was and would continue to be a foreign language, and one may doubt whether the missionaries attained an adequate knowledge of it. Clergy who attempted preaching

in Quechua would often make a complete hash of what they thought they were saying.[156] The major problem in instruction was the absence of words in the indigenous languages to express European concepts. All the basic vocabulary of Catholic belief, words such as Trinity, Grace, Sacrament, Heaven and Hell, were absent from native languages. In the end many Spanish words, most significantly of all the word 'Dios' for the single true God, were introduced bodily into common Indian speech. It takes little imagination to conclude that for very many natives the entity referred to as 'Dios' became one more god in their traditional pantheon.

The attempt to penetrate the languages of the indigenous population formed one part of the programme that the European missionaries set themselves. They set about accumulating knowledge of the New World, for knowledge was power.[157] They wished to know about the land, the people, the customs, the rites and religions. Systematically, they drew up reports, analyses and studies. The consequence was a remarkable output of publications, mainly by Castilian clergy but also by some royal officials, about the ethnography of America. It was a literature that has few equals in the history of empires, either then or since. Those who wrote were conscious not only that they were collecting knowledge, but also that the world around them was changing rapidly and that they must seize the information before it disappeared.

The crown made its own contribution by encouraging the collection of information about native cultures. Philip II was notoriously fascinated by all aspects of American civilization, patronizing both the botanic researches of Francisco Hernández and the ethnographic studies of José de Acosta. Having spent six years in Mexico, Hernández informed the king that 'I completed ten books of paintings and five of writings about the plants, animals and antiquities of this land.'[158] At some point in the 1570s, however, official support for such work was suspended. In 1577 a royal decree prohibited further studies on native history and religion. The prohibition is a puzzle that remains to be explored, for the king had no motive for hostility to such matters. Whatever the real reason, the ban seems to have affected only one group of writers, those from the Franciscan order. The two most notably affected were Bernardino de Sahagún and Gerónimo de Mendieta.

One of the earliest and still the most awesome attempt to bridge the cultural gap between Spaniard and Indian was that made by Sahagún,

whose monumental *History of the Things of New Spain*, sometimes known as the Florentine Codex, was drawn up with the help of Nahua aides, who produced a text that the friar later translated into Castilian.[159] Under Sahagún's direction the Nahua scribes from around the year 1547 recorded an immense amount of practical information and folk memory, including folk memory about the nature of the Spanish conquest. Only twenty years later did Sahagún begin to organize and translate the Nahuatl texts. Though he claimed and felt that he had written the account himself, it was in essence a direct product of the Nahua memory. The friar's great contribution was to have presided over one of the first authentic accounts (albeit written a generation later) of the contact between Spaniards and the people of the New World. It fell foul of the ban on writings about the natives, and remained unpublished in its full form until the twentieth century.

The brilliant work of some of the early missionaries represented, however, only one face of the conquest. The other face of the conquest was its inevitable violence. A few Indian leaders accepted Christianity because they saw it as politically beneficial, but their peoples always had to be coaxed into the new religion by coercion. The system of teaching employed by the friars relied exclusively on the use of discipline, and any failure to observe discipline was met with the appropriate punishment, which was invariably physical. Mendieta was inflexible on this point: 'it is a mistake to think that teaching the faith to Indians can be done in any other way. God was talking of them when he said to his servant, Compel them to come in.'[160]

The most striking case of the use of violence among the early missionaries was that of Fray Diego de Landa, who accompanied his conversion campaigns in the Yucatan peninsula with a veritable reign of terror. He declared in 1562 that only punishment would make the Indians accept Christianity. 'Though they seem to be a simple people,' he stated, 'they are up to all sort of mischief, and are obstinately attached to the rites and ceremonies of their forefathers. The whole land is certainly damned, and without compulsion they will never speak the truth.' During his stay in the area over four thousand Mayas were ill-treated and tortured, and around two hundred of them were put to death for religious reasons. There could be no talk of accommodating native culture. It had to be uprooted and destroyed. The indigenous priests of the Maya in Yucatan were among the few in America who, unlike the Andeans, had access to

a written culture. Their writings were wherever possible kept secret from the Spaniards, and only in the twentieth century were several texts discovered, deciphered, and given the collective name of *The Books of Chilam Balam*. In his campaign of repression Landa did not spare what books he could find. 'These people', he reported, 'make use of certain characters or letters, with which they wrote in their books their ancient matters and their sciences. We found a large number of these books and we burned them all.'[161]

Many colonists and clergy were strongly opposed to these violent methods. One consequence was that gradually power was taken out of the hands of the mendicant orders and transferred to the authorities. Among the friars, early optimism gave way to a measured pessimism. Mendieta looked backwards on an epoch which to him seemed like 'a golden age'. For his part, Sahagún was already by the 1550s beginning to feel that the spiritual conquest of America had been a failure.[162] He shifted his gaze beyond the New World, and saw new horizons for the empire of Christ among the peoples of the Pacific.

At the peak of the Franciscan effort in mid-sixteenth-century Mexico, the best-known and most intransigent of the friars, Motolinía, expressed firmly to the emperor his hopes for a convergence of religious and secular power in Mexico, and the establishment of a theocracy, as foretold in the book of the Apocalypse: 'what I plead for is that Your Majesty place all your efforts in bringing to fulfilment the Fifth Monarchy of Jesus Christ, which is to expand and embrace the whole earth and of which Your Majesty is to be the leader and captain'.[163] The great Franciscan dream, expressed in distinctive ways by Motolinía himself in his *History of the Indians of New Spain*, and by Sahagún and Mendieta, for the establishment of an empire founded on the reign of Christ, was certainly one of the most powerful ever to have been conceived in the early stages of an imperial enterprise. Motolinia's appeal came too late. Already the emperor, weary in body and spirit, had decided to give up the reins of power and seek the security of another, more eternal, kingdom. The universal Christian monarchy for which the clergy yearned would achieve fulfilment only under his son, who had been governing in the peninsula since the year 1543 and was destined, in the half-century that he exercised power, to bring into existence the greatest world empire that Europe had ever known.

HAERLEM.

4

Creating a World Power

Although our Spain abounds in valiant men who are well fitted
for employment in war, it is lacking in armaments and in the
practice of arms. Jerónimo Castillo de Bobadilla,
Political guide for corregidors (1597)[1]

The king of Spain in 1556, when he took the throne over from his father,
was aged twenty-eight, a man of few words, of medium build, with fair
hair and blue eyes. A devotee of hunting and jousting, cultured, serious
and deeply religious, he had spent nearly five years travelling through
the principal countries of Europe. Regent of Spain since 1543, when he
was aged sixteen, he had accumulated ample experience of the problems
of government.[2] After several months in England with his wife Mary
Tudor, he crossed over to Brussels to receive from his father in 1555 the
territories that from then on constituted his inheritance. Charles did
not abdicate from Sicily, Naples and Milan, for these realms already
belonged to Philip, who had been given the right of succession to the
dukedom of Milan as early as 1540 and was invested as its duke three
years later. He also received the crown of Sicily and Naples the day
before his wedding to Mary Tudor in 1554. It only remained to give the
prince the Netherlands, the Crown of Castile (which included
the New World), and that of Aragon together with Sardinia. Philip's
right to rule remained the same as that of his father: it was dynastic,
that is, based purely on the principle of inheritance in the family.
His title in all his European territories continued to be dynastic.
But under him a fundamental difference began to operate for the
first time. Because the territories he controlled were centred on the Med-
iterranean, very quickly their political focus moved to Spain, since the
king chose Spain as his centre. He stayed on four more years in the

Netherlands, where a new war with France, provoked principally by events in Italy, demanded his attention. But it was Spain, and the men of Spain, that from now on began to make the decisions and wield the power.

While a French army invaded Italy to attack Milan, another invaded the Netherlands. By July 1557 Philip in Brussels had assembled a defensive army of thirty-five thousand men, commanded by Emanuele Filiberto, the duke of Savoy, and William of Nassau, Prince of Orange, with cavalry under the orders of Lamoral, Earl of Egmont. Of Philip's total available forces (not all of whom took part in the battle) only twelve per cent were Spaniards. Fifty-three per cent were Germans, twenty-three per cent Netherlanders, and twelve per cent English. All the chief commanders were non-Spaniards. The king threw himself with energy into the campaign.[3] In the last week of July he was busily arranging for the scattered Italian and German troops under his command to rendezvous at St Quentin. His duties made it impossible for him to go to the front, but he insisted to Savoy that (the emphasis is that of the king himself in his letter) *'you must avoid engaging in battle until I arrive'*. On 10 August, the feast of St Lawrence, the Constable of France at the head of some twenty-two thousand infantry and cavalry advanced upon Savoy's positions before St Quentin. The town was of crucial importance to the Netherlanders, both for blocking the French advance and for clearing the way to a possible march on Paris. Unable to avoid an engagement, Savoy counter-attacked.

In a short but bloody action the army of Flanders[4] routed and destroyed the French forces, which lost over five thousand men, with thousands more taken prisoner. Possibly no more than five hundred of Savoy's army lost their lives. It was one of the most brilliant military victories of the age. Philip's friend and adviser Ruy Gómez remarked that the victory had evidently been of God, since it had been won 'without experience, without troops, and without money'. Though Spaniards played only a small part in it, the glory redounded to the new king of Spain, and Philip saw it as God's blessing on his reign.[5] The French were forced into peace negotiations, and peace talks, which began late in 1558, ended with the signing of a treaty in April 1559 at Cateau-Cambrésis.

Philip returned home to Castile in September 1559, confident that the peace he had just made with the French would be a lasting one. 'It is

totally impossible for me to sustain the war', he had written earlier that year. There were serious financial problems that needed to be resolved. In 1556 – omen of much graver events to come – a Spanish regiment in Flanders had mutinied when not paid. 'I am extremely sorry', Philip wrote to the duke of Savoy, 'not to be able to send you the money for paying off this army, but I simply do not have it. You can see that the only possibility is to negotiate with the Fuggers.' The costs of war, not only in the Netherlands but also in Italy, were already insupportable.

Cateau-Cambrésis promised a pause. It was the end of the long dynastic conflict between the houses of Valois and Habsburg, and was sealed by Philip's marriage to the daughter of Henry II of France, Elizabeth. Seeing the vast territories he controlled, however, other powers feared the king's intentions. The Venetian ambassador at his court took a more hopeful view. Philip's aim, he reported, was 'not to wage war so that he can add to his kingdoms, but to wage peace so that he can keep the lands he has'. Throughout his reign, the king never veered from this idea. 'I have no claims to the territory of others', he wrote once to his father. 'But I would also like it to be understood that I must defend that which Your Majesty has granted to me.'[6] He stated frequently and firmly to diplomats that he had no expansionist intentions. He employed officials who made clear their opposition to policies of aggression.[7] On the other hand, the realities of political life made it inevitable that he should almost continuously be drawn into war situations, both defensive and aggressive. There were also serious problems to be dealt with, above all the debts accumulated by his father. The financial arrears in Flanders were very bad, he admitted to his chief minister there, Cardinal Granvelle,[8] but 'I promise you that I have found things here worse than over there. I confess that I never thought it would be like this.'[9]

The nature of the 'Spanish empire' that came into being under Philip was unique, and calls for some explanation. The chief novelty was Spanish control. From now on the administrative decisions would emanate from a ruler resident in Spain, rather than from one who moved around his possessions. There was, however, little or no novelty in terms of the territory controlled: Philip simply took over from his father a number of states that he had already been responsible for since the 1540s. Portugal and its possessions, ruled by the Spanish king between 1580 and 1640, always retained their own autonomy and were not

formally under Spanish administration. A few more territories would be added, such as the Philippines and a couple of fortresses in Italy, but the 'empire' was substantially complete from the moment it was born. It did not, like most other empires in history, continue to grow as the result of military adventures. Uniquely, therefore, the Spanish monarchy was not the consequence of empire building nor of an aggressive imperialism. It emerged as a fully adult being, but with serious defects of which the king was fully aware. Within two decades of succeeding to the throne, Philip took fundamental steps to restrict and define more closely the frontiers of imperial activity.

For the first time in nearly half a century, Spain had a resident king, one who was determined to give his full attention to the state of the monarchy. It was none too soon, for the governments of the states he inherited were on the brink of bankruptcy. The Castilian treasury was in serious deficit, and Philip had already in June 1557, while in London, consolidated part of the debt into government bonds (juros). He made another arrangement of debt payments in November 1560. 'Apart from nearly all my revenues being sold or mortgaged', he reported in 1565, 'I owe very large sums of money and have need of very much more for the maintenance of my realms.'[10]

One of the first things he did on returning home was to reorganize the accounting system of the treasury (known as the Hacienda). He had to attend to serious problems involving the threat from Muslim power and the discovery of groups of possible Protestants in Castile. But there were promising factors as well. In the middle years of the sixteenth century Spain was basking in the warm sunshine of success.[11] Thanks to the link with America and to its key position in the European political system, Castile was enjoying an unprecedented expansion. Between 1530 and 1580 the population levels in Castile in both town and country rose by some fifty per cent; Seville, exceptionally, tripled its population between 1534 and 1561. Production rose. To the demand created by expanding population was added the demand from America for food and manufactured goods. Treasure when it arrived gave merchants more cash to invest in trade, manufacturers more money to invest in production. Agriculture expanded: 'even the wilderness disappeared', the chronicler Florián de Ocampo observed in 1551, 'as everything in Castile was dug up for sowing'. The woollen industry at Segovia and other Castilian towns, the silk industry in Granada, expanded and flourished. Foreign finance (the

Genoese, for example, handled the valuable export of silks to Italy) played a key part in expansion. Half a century of internal peace – we have seen that Spain took little direct part in any of the wars of the emperor – helped to consolidate the gains made by the economy.

There were, certainly, negative aspects. Contemporaries were worried about the rapid increase in prices, which they found hard to understand and usually blamed on profiteers. 'Thirty years ago', Tomás de Mercado wrote in 1568, 'a thousand *maravedis* of money was something, today it is nothing.' They were concerned about the activity of foreign merchants, whom they blamed for taking silver and gold out of the country in exchange for imports. 'Foreigners who bring merchandise to these realms must give a surety to take back merchandise and not money', demanded an irate member of the Castilian Cortes in 1548. 'Spain has become an Indies for the foreigner', claimed another in the same session. The reactions were typical of an attitude that found it difficult to adjust to the complex realities of imperial expansion. By contrast, Philip II attempted to concentrate on the positive aspects of Castile's capacities, in order to stabilize and strengthen the government.

No sooner had peace been made with France than Spain had to turn its attention to the pressing threat from the Muslim powers of the Mediterranean. At approximately the same time that Philip's envoys were negotiating the peace of Cateau-Cambrésis, the emperor Ferdinand was concluding a truce with the Turkish army before Vienna. In the eastern Mediterranean the Turkish navies continued their relentless push westwards. From 1558 to 1566 Philip II was concerned principally with the Muslim allies of the Turks, based at Tripoli and Algiers, the bases from which North African forces under the corsair Dragut preyed on Christian shipping.

In 1558, while he was away in Brussels and therefore unable to make all the decisions, the regency government under his sister sanctioned an ill-prepared expedition to the coast of Oran, led by the count of Alcaudete. It was, as we have seen, wiped out by the troops of Algiers. In June 1559, still in Brussels, he gave his approval to a largely Italian expeditionary force designed to capture Tripoli, an idea of the duke of Medinaceli, viceroy of Sicily, and Jean de La Valette, grand master of the knights of Malta. The huge force was made up of some ninety vessels, under admiral Gian Andrea Doria, with twelve thousand men under the

viceroy. They left the rendezvous, Syracuse, in early December 1559, but bad weather forced them back and it was not until March 1560 that they set sail and occupied the strategic island of Djerba, off the Tripoli coast. The delay enabled the Turks in Istanbul to put together a relief fleet, which attacked Djerba in May. Half the Christian fleet was sunk and the soldiers, led by their officers, fled in panic. Doria and Medinaceli managed to escape, but the Turkish ships trapped the remnant of the force. Over ten thousand men surrendered in July and were led in triumph through the streets of Istanbul.[12]

It was the biggest disaster ever suffered by Spain and its allies. 'You would not believe', reported the French ambassador from Toledo, 'how much this court, and Spain, have felt the loss and how ashamed they are of it.' Djerba brought home to Philip the need to reform the disposition of Spain in the Mediterranean. In 1561 Dragut destroyed seven more of Spain's galleys. Then in 1562 a freak storm wrecked another twenty-five off the Málaga coast. Spain's limited naval power in the western Mediterranean was crumbling rapidly. While the king tried to keep himself informed about Turkish intentions, he put in hand a major programme of shipbuilding, still with an eye on Africa. In August 1564 the newly appointed commander of the Mediterranean fleet, García de Toledo, managed to put together a force that captured the rocky fortress (Peñon) of Vélez de la Gomera on the North African coast.

The capture of the port of Vélez was a small but symbolic achievement. It demonstrated Spain's amazing capacity to stay on top in the Mediterranean, despite all reverses. The French noble Pierre de Brantôme took part in the siege, which left him all his life with an undisguised admiration for the Spaniards. On his return to France he mentioned to the young King Charles IX how impressive Spain's massed ships had been. 'And what would I do with so many ships?', the king said. 'Don't I have enough at the moment, so long as I do not have to go to war abroad?' 'That is true, Sire,' Brantôme replied, 'but if you had them you would be as powerful at sea as you are on land, and if the kings before you had paid attention to the navy you would still have Genoa, Milan and Naples.' 'Sire,' another noble chipped in, 'Brantôme is quite right.'[13] Significantly, the anecdote appears in Brantôme's account of the achievements of Andrea Doria, an unmistakable tribute to the contribution of Italians to Spain's imperial role.

When a Turkish fleet was sighted off the south of Italy in April 1565

the first impression was that it was headed for the fortress of La Goletta. In May 1565, however, it attacked the island of Malta, which was defended principally by the knights of St John, commanded by Jean de La Valette. The knights had only 2,500 men to defend their 3 main fortresses, against the fleet with its 40,000 soldiers. The first fortress, St Elmo, capitulated rapidly, but the Turks were forced to besiege the other two. Casualties were high on both sides, among the knights, their soldiers and the civil population of Malta, as well as among the Turkish besiegers. Early in September a relief force under García de Toledo arrived from Sicily with eleven thousand men, and forced the Turks to raise the siege.[14] The success brought jubilation to Christian Europe and glory to the Spanish empire, which had demonstrated that it should be taken seriously as a naval power in the Mediterranean. But there was no cause for complacency: Italy and Spain were still menaced, Spain's military strength was at a low level, and the treasury was empty. A major effort had to be made to overhaul the defences of the Christian powers.

Spain's inability to cope with the pressures of military conflict on the monarchy derived from a situation that had no ready solution: the lack of a centralized administration and treasury, both in the peninsula and outside it.[15] Down to 1700, the government relied principally on private contractors to supply both soldiers and ships. This meant that Spain's military potential was not determined by the state, but dependent on the efficiency of persons outside its control. The problem was insoluble, because the machinery of state had effective jurisdiction only in the Crown of Castile; in every other territory of the monarchy, even in the colonies, for practical or constitutional reasons power lay in the hands of local authorities. It was not a new problem, and therefore cannot be seen as a breakdown of control. The problem was there at the inception of empire, inherent in the structure of relationships between Castile and its associated territories. Because Castile was unable, despite the radical policies of statesmen later on in the seventeenth century, to change the nature of administrative control, the issue of imperial efficiency was never tackled adequately. At a time when every major European power – England, Brandenburg, Sweden, France – was moving towards State and Crown control of the army and navy, in Castile the state was impotent to harness the joint resources of a multinational community that could have become the greatest power on earth.[16]

The capacity of Castile to function as an imperial power depended heavily, as we have seen, on the contribution of its allies. Historians at one time took an entirely opposing view, and held that Castile was in itself a great power. This can now be seen as an illusion. Castile had little to offer. By contrast, the creation of the world monarchy would not have been possible without the bullion of America, and the manpower, expertise and finance of other Europeans. War expenditure, moreover, made deep inroads into the availability of finance. Well before 1560, the Castilian government was deeply in debt and unable to cover its commitments. After 1560, Philip II made serious efforts to liquidate his costs but the need to augment his forces, first in the Mediterranean and then in northern Europe, upset all calculations. The king reorganized his accounting department after 1560, but never managed to create an efficient treasury. Perhaps most alarming of all, there was no state bank to handle the business of payments.[17] A scheme for a network of banks throughout Spain's territories was put forward to the king in 1576 by a Flemish financial expert, but was never attempted.

The challenge of time and distance represented a fundamental barrier to efficiency. A world empire like that of Spain could never be controlled satisfactorily so long as the distances remained insuperable, the information inadequate or out-of-date, and the officials out of reach and uncontrollable. In order to keep contact with every corner of its associated territories, 'Spain waged an unremitting struggle against the obstacle of distance.'[18] In the best conditions, letters to Madrid took just under two weeks from Brussels, over three months from Mexico. Between sending a letter and receiving a reply, an official in a faraway colony might have to wait two years before knowing what action to take in a particular matter. The situation in Europe was not necessarily better.[19] Commenting on the delays in letters, Granvelle in 1562 complained that in Brussels they had less contact with Madrid than Americans did. Later, when viceroy of Naples, he quoted a previous viceroy as saying that 'if one had to wait for death he would like it to come from Spain, for then it would never come'. Between inefficiency and delays, the evolution of events in the empire escaped the control of those in charge.

Philip II attempted also to overcome the enormous gap in information. Europeans who moved outside their own cultural zone found themselves up against the problem of communicating with other people,[20]

and Spaniards were no exception. Castilian imperialism found itself disadvantaged by the language in which it attempted to exercise power. The words, ideas and knowledge which had sustained Castilians at home failed to respond adequately to the challenge posed by contact with the complex human universe outside their borders.[21] Both in Europe and in America, many Castilians readily opened their minds to the possibilities of an open discourse with other cultures, but others clung to their ancestral heritage. The clash between supporters and opponents of Erasmus, which came to a head in Castile in the 1520s, was a crucial moment in the process. The young Philip II experienced in his own person the problems of extending the horizons of Castile, and very quickly opted to break down the frontiers between his people and the rest of the world. His tour of Europe in 1548, when he was only twenty-one but already regent of Spain, had revealed to him the wonders of Renaissance Italy, and its evident superiority in art, shipping, architecture, fortification and printing. There was everything to be learned, and he was eager to do it. When he became king he incessantly imported experts in each of these fields from Italy. The journey to the Netherlands was, if anything, even more revealing. Philip never displayed any affection for England, where he spent several months, but his passion for the Netherlands was profound and lasting, and when he returned to Spain he carried with him as much of the Netherlands as he could: paintings, fashions, ideas, books, as well as the requisite personnel of artists, gardeners and technicians.

He also brought back knowledge, and began the task of collecting data on the empire. Before leaving the Netherlands in 1559, he commissioned the cartographer Jacob van Deventer to 'visit, measure and describe all the towns throughout our territory'.[22] The project took fourteen years to complete. In 1566 Philip told the viceroy of Naples that 'since every day there arise matters in which for greater clarity it is necessary to know the distances of the places in that realm, and the rivers and frontiers it has', a detailed map should be sent to him. In 1575 the viceroy was asked for 'a survey of that realm, for business that arises here'. The same procedure seems to have been followed in all realms. In 1566 Philip ordered the preparation of a completely new geographic survey of Spain. Now preserved in the Escorial, it was the most impressive survey of its kind undertaken in any European state of the sixteenth century.[23] In 1570 he commissioned a Portuguese cosmographer,

Francisco Domíngues, to carry out a geographical survey of all New Spain. The following year he appointed an official 'cosmographer-historian' for America, Juan López de Velasco. The king was acutely conscious of the lack of orderly information on the geography and history of his realms, a situation which made it extremely difficult to plan policy. When in 1566 he was asked to make a decision concerning Legazpi's voyage to the Philippines, he was unsure what to do since he could find no maps of the area. 'I think I have some maps', he wrote to his secretary, 'and I tried to find them when I was in Madrid the other day. When I go back there I shall look again.'[24]

His constant interest in maps was not based on the curiosity of an amateur. He collected few of them. They were, rather, essential instruments of state. But it is a comment on the general backwardness of cartography in Spain that the king's interest did not stimulate the science among Spaniards. There were not even any reliable maps of the Iberian peninsula available. The best mapmakers of the time were foreigners, mostly Italians, and they devoted more care to Spain's coastline (for shipping) than to its interior. Philip was therefore highly satisfied to greet the publication at Antwerp in 1570 of Abraham Ortelius's *Theatrum*, a volume of maps dedicated to him. Other Netherlanders also made a crucial contribution to knowledge of the peninsula. Shortly after his return, Philip invited Anton van den Wyngaerde to come to Spain and make a survey of its cities.[25] For lack of Castilian expertise, all the major advances made in the mapping of the Spanish dominions were the work of foreigners.[26] The first street map of Madrid was done by a Fleming and published not in Spain but in the Netherlands. The results of Soto's expedition in North America were not seen on a map until Ortelius published them in 1584, and the first full atlas devoted to the Americas was produced by Cornelis van Wytfliet at Louvain in 1597.[27]

From 1575 the councils began preparing the most ambitious of all the survey schemes. In May 1576 Philip issued a detailed list of forty-nine questions which were to be answered by all officials in America. The questionnaire covered every conceivable topic from botany and geography to economy and religion. The answers, the famous 'geographic relations', began to come in from 1577 and trickled through for ten years more.[28] A similar survey was ordered for Castile. Behind all these projects, which occupy the 1560s and 1570s, it is possible to see clearly

the king's desire to produce a large and encyclopedic corpus of information on his realms. No other monarch of that time sponsored, as Philip did, a general history, a general geography, a general topographical survey and a general map of his domains. As in all the projects, he wanted research to be based on the methodical use of original data. His purpose was not to impress, but to learn and to achieve. He never became, like some other rulers, a great scholar. But he was without any doubt the most creative sponsor of schemes among the monarchs of Europe.

The other great concern, after information, was to find reliable officials. There was no imperial bureaucracy, and the king had to fend for himself in each country. Appointment to administrative posts was usually made from among the local élite, a practice which brought stability and bound local élites to the crown. But after the 1550s radical changes occurred. Later critics of Spanish power insisted often on the way in which Philip II Castilianized the monarchy and centred decision-making in Madrid. Unlike the monarchy of Charles V, that of Philip became truly Spanish, and above all Castilian. The choice of Madrid as his seat of government from 1561 was a Castilian decision. The move has been often misunderstood. It did not convert the city into the capital of Spain (that did not happen until 1714), but it gave an administrative centre to the nascent empire. When he became king in 1556, Philip made every effort to place Castilians of confidence in key posts, in order to have direct links with administration everywhere. Without such links, control would be impaired and information rendered unreliable. The policy injured sensibilities, especially in entirely autonomous states such as the Netherlands, and in the long run created serious problems. In the Italian territories the king made changes that effectively placed power in the hands of Spanish officials. In 1568 he ordered the viceroy of Naples: 'in future, when posts fall vacant, inform us if there are any Spaniards who might be appointed'. Posts involving military security were almost invariably reserved for Spaniards.[29] The changes were affirmed by the appointment of Castilian viceroys, and by inspections in 1559 to make sure the new system was functioning.

The king, however, was not spitting into the wind, and it would be unwise to suppose that he did so. Though he tried to focus important decisions on Spain, he intervened as little as possible in the internal government of the states of the monarchy. As his father had done before

him, he presided over the formation of networks that bound together the élites of other states. He also offered them employment in every corner of the empire. They served as administrators, financiers, diplomats and generals. Of course, only the more cosmopolitan (or the more influential) took up these posts. For the most part, provincial élites (as in Catalonia)[30] were far happier living in their provinces, where they knew the people, spoke the language and exercised their authority, complaining all the while of the omnipresence of the foreign Castilians. At one and the same time, then, Castilian predominance was real but so too was the active participation of many of the élites of the empire. Non-Spanish writers such as Botero and Campanella, who applauded the policy of drawing all nations into the government of the empire, were not proposing anything unconventional; they were merely recording a situation that already, in part, existed.

An excellent example is the career of one of Philip II's closest collaborators, the Belgian noble Jean-Baptiste de Tassis. Born in Brussels in 1530, he was the youngest of six sons of the head of the emperor's postal services, who had the same name. He did not enter into the postal administration but chose his career in the army, serving the Habsburgs both in the Holy Roman Empire and the Spanish empire, but above all in the Netherlands, where he held posts successively under the duke of Alba, Don Juan and Farnese. Alba recognized his many talents and employed him on several diplomatic missions. In this way, combining his diplomatic with his military career, Tassis ended by travelling throughout Europe, and undertook important diplomatic assignments in Savoy, Denmark, Scotland and England, as well as in Portugal and the Mediterranean. Along the way, he became fluent in four languages (German, Latin, Castilian and Italian) other than his native Flemish and French.[31] A firm patriot of the cause of the united Netherlands, his views coincided in part with those of Cardinal Granvelle, who may be considered his mentor. But Tassis was more open-minded and flexible than Granvelle, which explains his immense popularity with people of all shades of opinion, and his great success in diplomatic initiatives. When he was on one of his periodic missions to Madrid in 1574 the newly appointed governor of the Netherlands, Requesens, pleaded that he be sent back to Brussels, for 'he is very well liked by the people of this country and also by our people, so I beg you to order him back here at once'.[32] Perhaps his last great service was as ambassador of Philip II

to the Estates General of France in the closing years of the French civil wars.

Since the time of the Great Captain Gonzalo de Córdoba, Castilian soldiers serving in Italy were grouped into infantry regiments, each numbering around two thousand men and later known as 'tercios'. They were created during the wars of Granada and developed by the Great Captain and his commanders in the Italian wars as a response to the powerful infantry of France. Both the French and the Castilians imitated Swiss models, but the Great Captain modified the model in creating smaller, more mobile detachments.[33] The 'tercios' did not receive a formal organization until the Ordinance decreed by Charles V in Genoa in 1536, when four specific units were created. They quickly gained fame for their efficiency in battle, since they were not conscripts but paid volunteers who chose war as a profession. Destined for continuous service in the Italian territories, they were the first permanent army units in Europe. They also tended to be of good social class. In the case of the tercios serving in Flanders in 1567,[34] at least half were of noble status, the overwhelming majority from Castile and Andalusia. As a social and military élite they were treated with due respect by their officers: 'honourable sirs', begins a letter from the duke of Alba to the tercios who had revolted in Haarlem during one of their periodic protests over non-payment of wages.

Tercios were not, as a rule, employed within Spain,[35] unless other forces could not be raised. Though well organized they were not numerous, and formed only a small proportion of the total forces available to the crown. During the wars in Flanders, the Spanish tercios seldom exceeded ten per cent of the total number of troops serving there in the army. Many Italian tercios also existed, recruited principally in Milan and in the kingdom of Naples, but they did not enjoy the same reputation as the Spaniards. When not paid within a reasonable time, as happened more often than not, the tercios were capable of staging mutinies. Brantôme describes how after the taking of the Peñon de Vélez in 1564 a group of four hundred soldiers from one of the tercios refused to embark at Málaga on the ships taking them to Italy, and marched instead to Madrid to demand their arrears. 'They strolled in fours through the streets, as brave and proud as princes, bearing their swords high, their mustachios trimmed, defying and threatening everybody, in fear of

neither justice nor Inquisition.'[36] The king refused to take any action against the soldiers, but asked Alba to speak directly to them and explain that their salaries were waiting for them in Italy.

The tercios, however, were only a small solution to the problem created by imperial expansion. With its small population of just over five million people, no match for the much greater populations of France, Italy and Germany, Castile was at no time in a condition to produce enough manpower to service the needs of war and peace overseas. Writers complained at the time that emigration to the New World took away a good part of the male population, but that was much less significant numerically than the constant demand, from the 1560s onwards, for soldiers. Like other European governments that had no permanent army, the Castilian state could resort only to traditional feudal levies from the nobility (a practice that continued without interruption into the eighteenth century), or to contracting soldiers through voluntary or forced enlistment within its borders. It had no authority to raise troops from Catalonia, Valencia, Aragon or Navarre without the express permission of the authorities there. The export of Castilian soldiers was as a consequence substantial.[37] It has been calculated that between 1567 and 1574 about forty-three thousand soldiers left Spain to fight in Italy and the Netherlands, an average of over five thousand a year.[38] The impact, after many years, on the homes and countryside of Castile may be imagined. The death rate for those who served overseas in the army was impressive. It has been suggested that in the eighteen years from 1582 to 1600 possibly fifteen hundred Spaniards a year died in Flanders.[39] The death rate in the 1580s may have been even higher, around fifty-five Spanish soldiers a week. Those who returned, did so (Philip III was to comment later) 'wounded, without arms, sight or legs, totally useless'.[40]

Neither feudal levies nor forced enlistment could service a world empire. Castile therefore, like other European states, contracted foreign soldiers, who were often despised as 'mercenaries' but were in every sense professionals and therefore always of higher quality than raw recruits. Until well into the seventeenth century 'national' armies were in fact recruited among many nations. The French royal army at the end of the sixteenth century was made up largely of foreign troops.[41] The 'Dutch' army commanded by Maurice of Nassau in 1610 included not only Dutchmen but French, German, Belgian, Frisian, English and Scottish soldiers.[42] Much later, in 1644, a 'Bavarian' regiment active in

Germany included not only Germans but Italians, Poles, Slovenes, Croats, Hungarians, Greeks, Franche-Comtois, French, Czechs, Spaniards, Scots and Irish.[43] In the same way, throughout the great centuries of empire Spaniards always remained a minority in the so-called 'Spanish' armies, which were composed largely of non-Spaniards. None of the military actions of Habsburg Spain would have been possible without the support of foreign officers and men. It was one of the most vulnerable aspects of 'Spanish' power. There were always more Italians and Germans than Castilians in the armies of Spain. Spaniards were seldom more than one-tenth of the total of troops that the government helped to maintain in Flanders,[44] where the army usually consisted of infantry drawn from the Netherlands and Germany. Foreign soldiers were indispensable to maintaining Spanish power, but at the same time the fact that they were not political subjects of their paymaster could weaken military discipline, a problem that remained unsolved from the age of the Great Captain to that of Spinola. The only saving factor was that thanks to the great extent of the Spanish empire a high proportion of 'foreign' troops were also subjects of the king, so that some bond of political loyalty existed.

It is frequently supposed that the separation of the German from the Spanish branch of the Habsburg family, at Charles V's abdication, led to a parting of the ways. This did not happen, nor could it. The Empire was, after Italy, Spain's main recruiting ground for soldiers, and Philip II was always careful to preserve good relations both with Emperor Maximilian II, who was married to his sister María, and with the other German princes. Spain's power in Europe was at all times backed up by German manpower. It was no accident that the duke of Alba preferred German troops over those of any other European nation, including Spain. After he came to the throne Philip's first substantial recruitment of Germans was in 1564, when three thousand Germans were ferried to Africa and made possible the capture of the Peñón de Vélez. In the year 1575 three-quarters of all soldiers recruited by the king were Germans, and in those years many German nobles also served in the armies subject to Spain.[45]

Italian nobles as well as commoners served in the forces of the king. The crown welcomed the collaboration of local élites in military campaigns. 'It would greatly benefit Your Majesty's service', the viceroy of Milan informed Philip II in 1572, 'to employ and have beholden to you these nobles of Milan.'[46] The greatest families of Lombardy, among

them the Gonzaga, Borromeo and d'Este, accordingly served in the campaigns of the Spanish empire, and also contributed with their own private forces. At the end of 1592, for example, the army in Milan included twenty companies of Neapolitan infantry commanded by the marquis di Trevico and ten of Lombard infantry under Barnabò Barbo. The nobles of the kingdom of Naples took part in all the military campaigns of the Habsburgs: they were present at the sack of Rome in 1527, at the defence of Vienna in 1529, and at the siege of Florence in 1530. In 1528 in Italy there were 'many Neapolitan knights, gentlemen and honourable citizens participating in various ventures alongside the Spanish soldiers and German mercenaries'.[47] When the duke of Alba marched against the pope in 1556, the Neapolitan duke of Popoli commanded the cavalry. The great names among the Neapolitans were all present at Lepanto; they also served under Alba in Portugal in 1580. A Neapolitan, the prince of Carafa, defended the city of Amiens against Henry IV of France in 1597. The ordinary soldiers of Naples became in the seventeenth century the principal cannon fodder of Spain's forces. From 1631 to 1636 alone, the kingdom provided the army of Milan with 48,000 soldiers and 5,500 horses.[48]

Another example is that of the Irish. From the sixteenth century, when the English began to devastate their homeland, Irish nobles and soldiers emigrated to the continent and became a small but consistent component of Spanish armies from the 1580s. In the early years of the next century they served under their own captains, principally the sons of Hugh O'Neill, earl of Tyrone.[49] In the wars of the Netherlands about five thousand Irish soldiers were serving each year in the army of Flanders during the period 1586 to 1621, their numbers rising slightly up to the middle years of the seventeenth century.[50] After that period, many of them preferred to serve directly in the Iberian peninsula: some 22,500 Irish emigrated to Spain in the years 1641–1654.[51] 'All the men of this nation', a Spanish official wrote in 1640, 'always serve here with the greatest courage.'[52] They played a key part, for example, in repelling the French army from Fuenterrabía in 1638. In times of manpower shortage, of course, recruits from any quarter were always welcome, though with reservations. 'Only when the supply of Irishmen, Germans, Belgians and Italians fails us should we be forced to consider the Scots', commented a general in 1647.[53]

In the circumstances, it was difficult to enforce a single religious

ideology in the Spanish army. The armies of Charles V outside Spain always contained Protestants. Under Philip II, the army of Flanders recruited Protestant troops from Germany without any problems, and it is likely that Protestants could be found almost everywhere in Spain's forces in Europe. Certainly by the seventeenth century it was no longer considered outrageous to employ heretics. A Spanish official commented to his government in 1647, with respect to recruitment in Germany, that 'the troops to be raised there will be excellent, except that they will be heretics to a man'.[54] Philip IV observed in the same year that 'soldiers of a contrary religion are more tolerated in the armies which serve me outside Spain',[55] but he did not hesitate to accept an offer to employ six thousand Dutch Protestant soldiers in Andalusia. In the event, the offer never materialized. It did not affect the reality that after the middle years of the seventeenth century thousands of Protestant soldiers were in Spanish pay in northern Europe, exactly as they had been in the high tide of empire under Philip II. They did not necessarily have to go into battle for Catholic Spain. The manpower required for maintaining political dominance was, we should remember, seldom used on the battlefield. Though battles might often decide the outcome of war, they were exceptional events. Power was maintained rather through a military presence in the form of small garrisons distributed through key towns, token forces that were meant to deter and seldom had an 'occupying' role. The most typical examples of such garrisons were those on the North coast of Africa and in certain Italian cities.

The fertile peace enjoyed by Spain under Charles V enabled the new Habsburg monarchy to establish itself, but had serious consequences for Spain's military capacity. With no call for a war effort either in the New World or in the peninsula, the country's techniques of recruitment, training and armament deteriorated rapidly. 'As a result of the peace that has reigned here for so many years', the Council of War admitted in 1562, 'the exercise of arms and the habits of war have greatly diminished.'[56] A leading official commented that 'our Spain is badly in need of the practice of arms and warfare', and that 'since our time has been one of universal peace, military discipline is much decayed'.[57] When Philip II had just come to the throne a Castilian writer lamented that 'it is a great shame to see how the Spanish infantry is lacking in practice of the art of war'.[58] Shortly after, the country's vulnerability was made

evident by the complete failure of the expedition sent in 1560 to Djerba. At the end of the reign the same complaints persisted. A military official in 1593 saw too much internal peace and a neglect of military training as the reasons for Spain's incapacity in warfare.

Philip II, in short, inherited an empire without the means to defend itself. 'Not even when the country was conquered by the Moors', an army officer grumbled to the king, 'has Spain been in its present state. There are no horses in the country, nor armour, arquebus or pike, nor any other type of weapon, nor anyone who knows how to handle them.'[59] It was not entirely exaggeration. A major revolt of the Granada Moriscos in 1569–71 exposed the fragility of peninsular defence, and the bulk of supplies for the campaign there had to be imported from abroad, mainly from Italy and from Flanders.[60] The peninsula had many natural resources in terms of raw material for armaments, but they were inadequately or badly exploited. In the 1560s the only effective cannon foundry, at Málaga, functioned because German and Belgian technicians directed it.

Spain was almost totally dependent on imports from abroad for artillery, armour, gunpowder, cannonballs and arquebuses.[61] Logically, the army abroad also drew its supplies largely from foreign sources. The duke of Alba in the 1560s in Flanders received some supplies from Málaga, but the rest came from Milan, Hamburg and even England.[62] Despite attempts at reform, the country was unable to produce the substructure to support its role as a great power. On the eve of the invasion of Portugal in 1580, when Spain was theoretically at the peak of its might, the country still had an unreformed military establishment, no national militia, no equipped armouries, incomplete coastal defences and inadequate supplies of artillery and munitions.[63] In the mid-1580s a Spanish soldier lamented the 'absence in the realms of Spain of a city or town specializing in making and fashioning arms, in the manner of Milan, Brescia, Augsburg, Ulm and Frankfurt. Since Spain lacks these things, certain foreign nations take full advantage of it'.[64]

In the course of Philip's reign the problem of armament supplies received attention. Spain could offer bullion to suppliers; in return they began to export materials to the peninsula. In time the import from the Baltic of timber and pitch for ships, copper for coinage, and grain for food became a standard part of Castilian trade; Hamburg, Gdańsk and Lübeck joined the Iberian trade system. At the same time the king, who

had been deeply impressed by the standard of fortifications in the months that he visited Italy, took care to import the best military engineers from there. The experts included the Bologna engineer Francesco di Marchi, who came to Spain in 1559 and stayed fifteen years, and Gian Battista Antonelli, who came at the same time. At certain periods, the only military engineers to be found in the Iberian peninsula were from abroad. In 1581 an official reported to the king that of the royal engineers available 'all are foreigners. I know of no Spaniard who is equal to them.' The problem of producing armaments continued to be difficult, chiefly because of the lack of Spanish experts. In 1572 the king wrote urgently to Italy for two experts to be sent to Madrid because of 'the great shortage of cannonballs in these realms', and because 'there is no one here who knows how to make them'. In order to make bronze cannon (which would not rust, like iron cannon) Spain had to import virtually all the necessary copper from the Baltic. With time, copper sources were identified in Cuba and also in the peninsula, but no Castilians knew how to fuse copper and iron correctly, so the king in 1594 appointed a German to take control of the problem.[65]

The deplorable situation of military and other supplies logically affected every part of the monarchy. It is tempting to accept the optimistic rhetoric of the writers of that time, about Spain planting the royal banner in every continent of the world. The reality is that a government without reliable military or naval power had never been in a position to conquer any overseas territories or plant its banner anywhere. In the early years of the sixteenth century the problems of defending American territories that had never been 'conquered' in the first place, became apparent. In the 1520s French corsairs attacked Santo Domingo and Havana. It was the beginning of a long and difficult struggle to maintain control not only over American territory, but also over the shipping that crossed the Atlantic from the peninsula.

The sea was both the strength and the weakness of Spain's empire. By developing reliable sea-routes, Spain and its collaborators could penetrate to almost any point of the globe, establishing settlements in and trading to every continent. Defending these scattered territories was, however, the main problem. In the Mediterranean, the Spanish crown possessed a handful of galleys, but relied mainly for naval warfare on the galleys it could contract from Italian nobles in Genoa (the famous Doria family) and in Naples. A further small flotilla, largely in private

hands, operated off the Andalusian coast. In the 1550s, two-thirds of the Mediterranean galleys employed by the crown were contracted from private owners, the majority Italians.[66] The situation in the Atlantic was quite different; there, for the first two-thirds of the sixteenth century, the crown had no vessels at all. Fleets to America consisted exclusively of private vessels sailing under charter. A generation after the accession of Charles V had given birth in theory to the world's biggest empire, the government of Spain had neither an army nor a navy, and was unequipped to fulfil its imperial role.

Under Philip a naval system for the Atlantic came into existence.[67] For reasons of security and in order to exercise more financial control, the government in 1564 decreed measures to regulate the Atlantic crossing. From now on, ships crossing to America could only do so as part of two organized annual convoys from the river at Seville. One sailed in April bound for New Spain, the other in August for the isthmus of Panama. After wintering in America, the fleets would return with their respective cargoes to a common rendezvous at Havana, then return together through the Bahamas channel before the beginning of the hurricane season, and arrive in Spain in the autumn.

The Piedmontese ex-Jesuit Giovanni Botero in 1596 wrote a survey of the states of the world in which he commented favourably on Spain's capacity to use sea power in uniting its different possessions. 'With two armadas', he claimed, 'one in the Mediterranean and one in the Ocean, the Catholic King maintains united all the members of his empire in Europe and in the New World.'[68] In particular, he commented on the contribution made by the Catalans, Basques and Portuguese and Genoese to imperial seamanship. Botero's analysis was both wrong and right. It was wrong because his treatise, coinciding with the stunning defeat of the great Armada sent against England, ignored the fact – quite obvious to councillors of state in Madrid – that Castile was unable to protect the vital sea-routes in northern Europe or in the Caribbean. It was right because it drew attention to the enormous contribution made to imperial sea power by the non-Castilian peoples of the monarchy.

Three obvious cases stand out: the Portuguese, the Basques and the Belgians. Basque ships and sea captains, as we shall have occasion to note again later, dominated the ocean crossings to the New World.[69] It is often forgotten that the Basque sea-going community also successfully exploited an important corner of the empire by establishing a claim to

the cod fisheries of Newfoundland in the 1540s. They were the first west Europeans to venture into the area,[70] but continued to play an important role in the fisheries in the 1570s and 1580s. In 1578 nearly one hundred Basque fishing-boats were active in Newfoundland, and there were up to fifty whalers. It has been estimated that by the late sixteenth century more ships and men were crossing the North Atlantic each year to fish and to hunt whales, than were sailing between Spain and its colonies in the New World.[71] By contrast Castilians did not favour the sea, and Castilian society looked down on the navy. The army was accepted as a route by which one could gain honour and glory, but not the navy. This may have been a fundamental reason why the navy, despite its vital importance for Spain, never developed as it did in other European states.[72]

Navigation across the world's seas could not have been done without a team of international pilots, for Castilians knew the Mediterranean but few had the necessary experience of other oceans. For the world's seas, they necessarily depended on the Portuguese who had preceded them. The first Castilian ship's manual, Pedro de Medina's *Art of Navigation* (1545), drew on Portuguese experience, as did Martin Cortés's *Short summary of the art of navigating* (1551). However, a Spanish official in the 1550s commented on the 'ignorance' of Castilian pilots, and Gian Andrea Doria in the 1580s went so far as to describe them as 'hopeless'.[73] Hopeless or not, they piloted the majority of Spain's ships.[74] There were, of course, outstandingly good pilots, such as Andrés de Urdaneta, who went to the East Indies in 1525 with the fleet of Juan García Jofre de Loaysa, which ended up in the Maluku archipelago having lost most of its ships and men (one of them Sebastián del Cano). Urdaneta, with other survivors, remained for eight years in Maluku, where he picked up valuable knowledge of the islands. He returned to Spain and then lived in Mexico, before being prevailed upon in 1565 to guide Legazpi's expedition to the Philippines. Over subsequent decades the sailings to and from Manila used French, Portuguese, Italian and even English pilots when they could not find suitable Spaniards. When the great Armada sailed against England in 1588, no Castilian or Portuguese pilots could be found with experience of the Channel coasts, and French pilots had to be sought.[75]

The manning of ships was a constant headache, for it was always difficult to find experienced crews among Castilians (see Chapter 9). It was a problem that affected all sea-going nations. The captain of a fleet

preparing to cross the Atlantic in 1555 complained that 'it will be imposs-
ible to find sailing men other than Portuguese, Netherlanders and some
from the Adriatic'.[76] Significantly, the two pilots used by the captain on
this voyage were both Portuguese. In 1558 a royal decree recognized that
foreigners would have to be allowed to enlist as crew for ships going to
America, 'because no others can be found'.[77] In the same way, galleys
were useless without oarsmen. In the history of naval empires too little
attention is given to the men whose labours made possible the survival
of naval power.[78] Galleys in the Mediterranean traditionally drew their
rowers from slaves and convicted criminals. In the sixteenth century the
slaves were usually Muslim, taken in raids on Muslim coastal areas or in
sea battles against Muslim ships. Ironically, therefore, captive Muslims
helped to sustain the naval might of the Christian powers. In early modern
times, they supplied around a quarter of the rowers in ships controlled by
the papacy, Sicily and Genoa, half of the rowers in the ships of Tuscan
ports, and up to three-quarters in ships run by the Knights of Malta.[79] As
time went on, the supply of such slaves and also of convicts dwindled. The
authorities therefore resorted to seizing gypsies for galley service, and also
Christian prisoners of war if all else failed.

Constructing imperial authority in home waters was, for Philip II, a
novelty. Under his father the several states of the monarchy had collabor-
ated together without any major difficulties. There seemed to be no need
for more centralized control; the emperor, with the help of his officials
and a good postal system, had been able to make decisions for Flanders
in Castile, in Castile for Germany, in Germany for America. On returning
to Castile in 1559, the new king saw matters differently. The disaster at
Djerba induced him to make the rebuilding of naval power in the
Mediterranean an urgent priority. The shipbuilders of Naples and
Messina, with help from Barcelona, set their hands to the construction
programme. Between 1560 and 1574 about three hundred galleys were
built, principally in the Italian states controlled by Spain, giving new
strength to naval expeditions in those years.[80] Arrangements were also
made with Italian allies: for example in 1564 Cosimo de' Medici of
Florence, who soon after assumed the novel title of 'Grand Duke' of
Tuscany, contracted ten of his galleys to the king of Spain for a period
of five years. The great test for this resurgence of naval power was the
unavoidable head-on clash with the irresistible Turkish navy.

The close collaboration established between Spaniards and Italians during these years of anxiety in the face of the Turkish threat was of course a continuation of the policy handed down by Ferdinand the Catholic, but it remained a cornerstone of Spain's imperial power for two centuries after the reign of Philip II. In order to facilitate decision-making, the business for Italian states was transferred to a new council of Italy, set up in Spain in 1555 and formally organized four years later. Of its six councillors, three had to be natives of Sicily, Naples and Milan. Italy became, even more than it had been under Charles V, the core of Spain's power.[81] Italian financiers (mainly from Milan and Genoa) directed and organized the credit employed by the crown; Italian generals and soldiers served in its armies throughout Europe, including the Spanish peninsula; Italian vessels were the basis of Spain's naval power. Spain's principal military base in Europe was the duchy of Milan, which by its geographical position blocked French expansion into Italy. The duchy was used as a military centre where units from Naples and the Iberian peninsula could conveniently rendezvous, prior to departing for northern Europe. There were two overland routes to the north: one through the western Alpine passes and Savoy down to the Rhine, a route known as the 'Spanish road', and one eastward through the Swiss Valtelline and thence into the Habsburg lands of central Europe. The duchy was also, with its flourishing armaments industry, a major source of war material; and its fortress was the 'strong-box of the monarchy',[82] a Fort Knox where Spain kept its bullion reserves.

The kingdom of Naples contributed through its military recruits, shipbuilding and taxes to Spain's potential as a great power. Many Italians, quite justifiably, saw this as part of a scheme to exploit their resources in favour of the imperial ambitions of Spain. Those who were able to take a broader view, however, adopted a different perspective. The monarchy, Philip II insisted, did not intend to exploit. 'Except in the most urgent cases,' he observed in 1589, 'it is not the custom to transfer the burdens of one kingdom to another. But since God has entrusted me with so many kingdoms, and since in the defence of one all are preserved, it is just that all should help me.'[83] His views were echoed by an Italian general, Marcantonio Colonna, who felt that all the king's dominions formed one body, whose members must help each other as much as they could.[84] In the event, the continuous menace from Islamic naval power in the middle years of the sixteenth century obliged

Spain to make constant and heavy demands on Naples, Milan and Sicily, with the result that the people of these states continued to feel that the empire was an alien and oppressive institution.

The Italian states, of course, were free and sovereign territories with their own governments, laws, coinage and institutions. Spain had not conquered them, nor ever possessed the means to do so. How then did Spain manage to maintain imperial control? It was a question the Italians often asked themselves, and they did not like the answer. The Republic of Venice, and the papacy, were the two largest non-Spanish states in the peninsula, and their spokesmen affirmed roundly, generation after generation, that the failure of Italians to unite among themselves had given birth to the foreign invasions and the domination of barbarians. Machiavelli was the best-known spokesman of this point of view, but there were very many others.

In administrative terms Spanish control as exercised through the viceroy was efficient largely at the upper level. The local nobility in their regions continued to direct virtually all aspects of law and order.[85] So long as the territories complied with the obligations they had to shoulder within the imperial system, Spain recognized willingly that the Italian aristocracy were those best equipped to guarantee order and stability.[86] But these local élites competed among themselves for the privileges offered by the viceroy, and in that way made it possible for Spanish influence to be exercised through a network of clients that extended through the country. From the time of Charles V, the military leaders of Italy, notably from the families of Gonzaga, Colonna and Medici, took service with the Spanish crown and helped to impose Spanish influence over the Italian states. At the same time, these military leaders strengthened the links of the Crown with local governing élites. The efficiency of the council of Italy lay in the fact that it was linked to a network of influence that spread throughout Italy.[87] The community of interest, therefore, between local nobility and the distant crown, made it possible for a system of 'empire' to develop whereby the ruling circles benefited considerably from the Spanish presence, at the same time as they sought to make that presence less onerous. The crown had two powerful inducements it could use. It could offer posts in the bureaucracy to local nobility and thereby confirm their power; it could also distribute honours, titles, privileges and pensions, and in that way build up a network of eager clients.[88] Even states that were not under Spanish

control collaborated fully. In 1599 the Gonzaga duke of Mantua reminded Madrid that his territory had contributed by its policy to the stability of neighbouring Milan, and that he had made possible the unimpeded recruitment of soldiers in Italy for service in Germany.[89]

The Italian states, as allies in the empire, were normally not under occupation by Spanish troops, who were (as we have seen)[90] too few in number to have any decisive role. The only significant exception was the state of Milan, whose strategic situation made it the ideal place to station and convene troops. Under Philip II the normal number of Spanish soldiers stationed in Milan were the three thousand of the tercio of Lombardy, and a further one thousand or so in fortress garrisons.[91] However, Spain could offer further military support where needed, and also maintained small garrisons in key points at the request of local rulers. From the 1520s, for example, the emperor had agreed to protect the small city state of Piombino, whose port was considered of strategic importance for the naval route between Naples and Genoa. In 1529 a fleet of five Muslim ships had sailed without resistance into the harbour, occupied the port and seized an Imperial vessel. In the time of Philip II its small garrison, all Spaniards, amounted to two hundred men. During the reign Spanish troops carried out possibly their only direct act of annexation in Europe. It occurred in 1570, when the army from Milan marched in and occupied the coastal territory of Finale to prevent its strategic port falling into French hands. Its ruling family eventually ceded the city formally to Spain in 1598.

There were evidently negative aspects to the imperial relationship with Italians. The impact of Spain was felt for the most part in finance, specifically affecting soldiers, ships and exterior trade. In Sicily local taxes had to pay for the upkeep of the Spanish tercio of three thousand men that protected the country from invasion, and for the galleys that guarded the coasts and were periodically incorporated into the Mediterranean fleets of Spain. Spaniards, however, were not the only participants in this imperial scenario. Virtually the entire financial and commercial machinery of Sicily was in the hands of other Italians, mainly Genoese and Venetians. 'Outsiders', reported a contemporary, 'make off every day in this kingdom with the most important and richest goods of those who live here.'[92] Spaniards could not and did not compete with this situation. The island, which was not over-burdened by its imperial rulers, never deteriorated to the status of an imperial colony.

Even its critics had to concede that the Spanish presence in the sixteenth century guaranteed peace and order in Italy. The Castilian historian Antonio de Herrera claimed proudly that in Italy Philip II 'maintained peace and liberty for a longer time than any other prince had ever done'.[93] However, the southern Mediterranean was not an area of natural wealth, and the Spanish presence did not contribute in any way to solve its inherent economic and social problems.[94] Western Europe appreciated the wheat supplies it received from the area. But Naples, for example, was dependent on foreign imports for most of its raw materials and industrial goods, and faced serious problems when bad harvests (as in 1585 and the 1590s) caused a lack of ready cash. Despite this, the Spanish crown asked the kingdom to contribute more and more to war expenses. From around 1560 the burden rose significantly. The minimum war costs of the Crown in Naples, paid for by local taxes, doubled between 1560 and 1604. In the latter year the two biggest military expenses of the crown in Naples were the tercio (twenty-seven companies) of Spanish infantry, and the twenty-six galleys of the kingdom.[95] Next in importance came the upkeep of the twenty companies of Italian infantry and cavalry. The burden of the galleys may be gauged by the estimate, made around 1560, that it cost as much to maintain a galley for one year as it did to build one. In the same period, around four hundred men were employed in the shipbuilding arsenal of the city. The kingdom, clearly, was contributing handsomely to maintaining the power of Spain.

But the cost of war did not necessarily impoverish the Italian states. The Neapolitan writer Antonio Serra in 1613 observed that 'the income of His Catholic Majesty is all spent within the kingdom; he reaps no part of it and often sends millions in cash'.[96] Spain regularly sent silver into the states to cover expenses. In Milan, the Spanish presence not only attracted necessary quantities of bullion from Spain, it stimulated economic activity in the duchy and boosted the armaments industry.[97] The benefits of interior peace and tranquillity enjoyed under Philip II by Spain's Italian allies cannot be minimized.[98] In Naples, none the less, the imperial system had negative effects on financial stability. Large sums of money were periodically sent out of the realm to pay for military expenses.[99] A report on the treasury of Naples in the late 1620s pinpointed a problem that brought serious consequences: 'the certain ruin of everything we have here, is to burden it daily with the special expenses of troops in Germany, Flanders, Milan and Genoa'.[100]

*

The gravest challenge faced by Spain in the great age of empire was the rebellion of the homeland of Charles V, the Netherlands. Prior to 1555, when Charles V included them in the package of territories that he handed down to Philip II, they had not involved any cost to Spain. The seventeen provinces recognized Philip II as their ruler but were in no sense part of Spain's empire and had no constitutional or tax obligations to Spain. Indeed, one of the first requests they made to Philip after recognizing him as sovereign was that he remove from their soil the Spanish troops stationed there. The demand did not affect the close and cordial links that had always existed between the two peoples. Philip had a deep affection for the culture and people of the Netherlands, but during his long years there (1555–9) soon recognized the problems posed by the independent spirit of the provinces and the ambitions of their nobility.

Disputes in the Brussels government, which was directed by Philip's half-sister Margaret of Parma, caused the nobles to oppose the administrators headed by Cardinal Granvelle. In 1564 the king agreed reluctantly to Granvelle's dismissal, but opposition then centred on the proposal to reform the Church in the Netherlands by creating more bishops and strengthening the heresy laws. The count of Egmont made a special visit in 1565 to Madrid, from which he returned with the impression that Philip had agreed to relax the persecution of heretics. But the king had never even entertained the possibility, and wrote to Margaret confirming the need to continue with the death penalty for heresy. His letter arrived in Brussels, where all the higher nobility were gathered to celebrate the wedding of Margaret's son Alessandro, and sparked off indignation. As he left a meeting of the council of state the prince of Orange whispered to a friend: 'We shall soon see the beginning of a fine tragedy!'[101] Early in 1566 the aristocracy went on strike by resigning their offices, and a group of lower nobility demanded religious freedom and the suppression of the Netherlands Inquisition (set up by the pope in 1522 at the request of Charles V). In August 1566 mobs of Calvinists ranged through the major cities of the Netherlands, desecrating churches and smashing images.

A military solution to this chaos became inevitable, particularly when the king learned that Calvinist nobles were making military alliances with German Lutherans. Philip appointed the duke of Alba to lead an expeditionary force to take charge of the situation. Alba left Spain in

April 1567 to join the army in Italy. His force of ten thousand men set out from Milan, took the Alpine passes down into the Rhine valley, and then marched through the corridor known as the Spanish Road, arriving in Brussels on 22 August. Brantôme reported that 'I saw them as they passed through Lorraine', where he greeted several officers he had known from the days of the Peñón de Vélez. Most of the soldiers were Castilians, from the tercios of Naples, Sicily, Sardinia and Lombardy; 'and with them went four hundred courtesans on horse, as fair and gallant as princesses, as well as eight hundred on foot'.[102] As they had done on the expedition to Vienna in 1532 and would continue to do for at least another half-century,[103] the tercios still took their women with them.

In retrospect it may seem easier to understand why the king acted as he did, but at the time it was a wholly unprecedented decision to send an army into a friendly state in time of peace. The Netherlanders had always prided themselves on being free subjects of the king, unlike the Neapolitans who (they felt) had been occupied by force. The reference came up frequently in later years. The emperor Maximilian II, Philip's brother-in-law, himself reminded Philip that 'anyone who thinks he can control and govern Flanders like Italy is very much deceived'.[104] The Netherlanders did not understand now what an army might achieve. The country already belonged to the king, so why send an army there? 'What can an army do?', Egmont asked Margaret scornfully, 'kill two hundred thousand Netherlanders?' Spanish intentions soon became clear. The duke of Alba was there to restore order, arrest dissidents and check the growth of heresy. It was the first time that heresy in another country had ever appeared as a concern of the Spanish crown. But Philip II met the problem head-on. 'If possible', he stated, 'I shall attempt to settle affairs of religion in those states without the use of arms, because I know that it would be their total destruction to resort to them. But if matters cannot be settled as I wish without using arms, then I am determined to resort to them.'

Alba carried out his programme with efficiency. He made it clear that 'in this question of Flanders the issue is not one of taking steps against their religion but simply against rebels'. On 9 September he began the great repression by arresting Egmont, Hornes and a number of other Flemish notables. 'With the energy and vigour you are applying to affairs', the king wrote to him, 'I feel that their resolution is in sight.'

'The king has no intention', Alba reassured a correspondent, 'of shedding blood. If he can find another way of resolving this business, he will take it.' The same day he told the king that 'the peace of these states cannot be achieved by cutting off heads'. The statements are important evidence that neither Philip nor Alba intended a systematic repression in the Netherlands. But events quickly flew out of control, into an unending spiral of repression, rebellion and war that left its mark on the history of the Netherlands and of Western Europe.

The momentous and tragic events in the Netherlands lie beyond the range of our story, but it is crucial to recognize that they determined for one hundred years the destinies of Spain. The operation undertaken by Alba in 1567 was intended to be a limited one, but it soon exploded in the face of the Spanish government and turned into a predicament that demanded further intervention and yet further intervention. The special tribunal set up in Brussels, officially called the Council of Troubles but soon nicknamed the Council of Blood, carried out in 1567 a swift programme of arrests, confiscations and executions directed against 'rebels', regardless of religion, whether Calvinist or Catholic. At this stage it was still possible to withdraw after the job was done. Those who had helped to advise Philip, such as Cardinal Granvelle and a friar called Villavicencio, who had lived and taught in the Netherlands, were convinced of it. Villavicencio insisted that Alba's task was now complete. The situation, he insisted to the king, could not be resolved with an army. Nor must force be used against the Netherlanders, for that would unite them all against Spain. They would fight to defend what was theirs. Spaniards could not be allowed to govern in the country, 'for they neither know the language nor understand the laws and customs'. The only solution was for the king to go there at once.[105] It was one of the tragedies of this complex situation, that Philip ignored the policy advice and simply sent the documents on to Alba. And Alba, as the general on the spot, made decisions that Netherlanders and even Spaniards disagreed with and regretted.

Among the leading nobles who escaped Alba's clutches was William of Orange. When news came of Alba's departure from Spain, Orange opportunely took refuge in Germany. In the course of 1568 Orange sponsored invasions by several small forces, which entered from France and from Germany. All were defeated. Captured prisoners gave details of Orange's links with Protestants in several countries. The invasions

could not fail to affect the fate of the distinguished prisoners in Alba's hands. On 5 June 1568 in the public square of Brussels, the counts of Egmont and Hornes, unswerving Catholics who always protested their loyalty to Philip II, were beheaded for high treason. The executions shocked and alienated opinion throughout Europe. They also helped to prepare Netherlanders of all opinions and faiths for the inevitable: a struggle to free themselves from the terror of Alba and the heavy hand of Spain.

Long familiarity with the theme has allowed us to fall into the illusion that the so-called 'Dutch' revolt (it was never limited to the Dutch, but included all Netherlanders) was a revolt against Spain. In constitutional terms, this could not happen, for the Netherlands were a sovereign state and not subject to Spain. Their resistance was directed, more precisely, against their ruler the Spanish king, his ministers and his system of government. There were, however, immensely important consequences for Spaniards, forced by the conflict to increase dramatically their levels of expenditure on war. It became necessary to call for help from the resources of the nascent empire.

The entire year 1568 turned into a nightmare for the king. Since January that year he was suffering severe depression as a result of the imprisonment, which he himself had ordered, of his son and heir Don Carlos. The alarming crisis in Brussels, and the execution of Egmont and Hornes, occurred in the middle of this situation. Just over a month after the executions, in the middle of July Don Carlos was taken ill and died unexpectedly. It was a loss that profoundly shook the king and, possibly even more important, left him without an heir to the throne. The king's personal calamities were not yet over. In September his young wife, Elizabeth Valois, whom he had married in 1559 as part of the peace agreement with France in the treaty of Cateau-Cambrésis, died in childbirth at the age of twenty-two. His grief was profound, 'to suffer so great a loss after that of the prince my son. But I accept to the best of my ability the divine will which ordains as it pleases.' International events, meanwhile, were reaching flash point. There were protests throughout Europe over the death of Egmont, and dark rumours (which circulated even in Madrid) that Philip had murdered his own son. Two incidents brought relations between England and Spain to a virtual rupture. First, in September 1568 there was a clash between ships under John Hawkins and Spanish vessels in the harbour of San Juan de Ulúa

in Mexico (see Chapter 6). Then in November came the provocative seizure by Queen Elizabeth of Spanish pay-ships taking silver to Flanders for the duke of Alba's troops; they took refuge from a storm in the Channel and the English impounded them. The most critical problem occurred on the king's own doorstep, within his kingdoms of Spain, when on Christmas Eve 1568 the Moriscos of Granada rose in rebellion.

Granada was a conquered area since the 1490s but it was still a sensitive frontier, where Muslim vessels from the Mediterranean maintained contact with the resident population and came ashore almost at will. Like the peoples of the New World, the citizens of the former emirate did not accept the Christian empire imposed on them. Since 1492 the rulers of Spain had pursued an equivocal policy of repression and toleration towards the conquered. Decrees of 1500 and 1526, in Castile and Aragon respectively, forced all Muslims to convert to Christianity, making them Moriscos. The Inquisition was established in Granada in 1526, and began to prosecute Moriscos for not observing their new religion. In many parts of the peninsula, above all where Moriscos were subjects of the nobility, there was by contrast an effective tolerance of the practice of Islam. Numbering about three hundred thousand in the 1560s (some four per cent of Spain's population), the Moriscos lived mainly in the southern half of the peninsula. Most cherished Spain as their home but resented their inferior status. The majority remained practising Muslims and looked for help to their co-religionists in Africa and the Ottoman empire. It was an explosive situation that bred constant violence. Disaffected Moriscos in Valencia and Granada were active as bandits. The rebellion that broke out in 1568 drew its support primarily from the villages of the Alpujarra region, rather than from the population of the city of Granada. Numbering only four thousand at the beginning, by the summer of 1569 the rebels amounted to perhaps thirty thousand. With Spain's crack troops away in Flanders, the threat to internal security was serious.

Two independent forces under the marquises of Mondéjar and Los Vélez carried out an energetic repression from January 1569. But support for the rebels among the Moriscos increased. Muslims in North Africa sent arms and volunteers. Because quarrels among the Christian commanders hindered efficiency, in April 1569 the king decided to put the campaign under the overall command of his half-brother Don Juan of

Austria. By now it was no longer a question of mere rebellion. Virtually the entire population of the kingdom of Granada was up in arms, in a ferocious war in which little mercy was shown. There was a real risk that the conflict would also bring in the large Morisco populations of Valencia and Aragon. Just across the straits, in North Africa the Turkish governor of Algiers, Uluj Ali, chose this moment (January 1570) to seize the city of Tunis.[106]

From January 1570 Don Juan succeeded in imposing his strategy on the military campaign. There were massacres on both sides. Particularly notable was the resistance put up in February 1570 by the town of Galera. When it fell, all its 2,500 inhabitants, women and children included, were slaughtered; the town was razed and salt poured over it. Slowly and brutally, the cruel war drew to its close. On 20 May the rebel leader came to the prince's camp and signed a peace agreement. Resistance continued everywhere, above all in the Alpujarra area. But by the summer of 1570 the revolt was effectively over. Help from Muslims abroad – there were four thousand Turks and Berbers fighting with the rebels in spring 1570 – was not enough to keep it going. What turned the tide was the mass import of arms from Italy, a valuable help since the Spanish troops had few of their own. Guns and powder in quantity came from the factories in Milan.[107] By November, reported an official, 'it's all over'.

It had been the most brutal war to be fought on European soil during that century. Luis de Requesens reported having killed thousands during the mopping-up. 'I have become ruthless with these people . . . An infinite number has been put to the sword.' The deaths were not, for all that, the only terrible aspect of the war. In the late summer the king's council, under Cardinal Espinosa, made the decision to expel a part of the Muslim population of Granada to other parts of Spain. The operation began on 1 November 1570. Over the subsequent months a total of probably eighty thousand Moriscos, men, women and children, were forcibly expelled for ever from their homes, and distributed through parts of Castile where their presence was till then unknown. Very many died of their hardships during the march. Don Juan, watching the exiles, could not repress his pity. It was, he wrote to the king's chief minister Ruy Gómez, 'the saddest sight in the world, for at the time they set out there was so much rain, wind and snow that mothers had to abandon their children by the wayside and wives their husbands . . . It cannot be

denied that the saddest sight one can imagine is to see the depopulation of a kingdom.'[108]

The war in Granada was brought to an end in good time to be able to confront a yet more massive threat from the combined forces of the Islamic Mediterranean. Since early 1566 the intelligence services of the West had not ceased to convey alarming news of Turkish naval activity in the Mediterranean and military movements on the Hungarian frontier. It was feared that the aged Ottoman ruler, Suleiman the Magnificent, hoped to make one last great drive against Christian Europe. Spanish energies were concentrated on the problems in the Netherlands and later in Granada, and could not cope with the threat from yet another front. Andrea Doria continued in a state of vigilance. The Turkish navy, meanwhile, carried out extensive attacks in the eastern Mediterranean, in waters over which the republic of Venice could not afford to lose control. In the summer of 1570 the Turks occupied most of the island of Cyprus. Venice, supported by the pope, appealed for a general alliance of Italian states against the apparently unstoppable menace. Such an alliance, however, could not come about without the participation of the state that controlled half Italy, namely Spain.

The Holy League signed between Spain, the papacy and Venice on 20 May 1571 stipulated that the allies would raise and maintain for six months a standing force of around two hundred galleys and over fifty thousand men. Apart from an unspecified amount that the pope would contribute, Spain (and its territories) would pay three-fifths of the costs and Venice two-fifths. When the naval forces eventually assembled at their rendezvous in Messina in the summer of 1571, they totalled 203 galleys, the greatest assembly of ships ever concentrated in the waters of Western Europe.[109] The direct Spanish contribution to this impressive force was limited to fourteen galleys, under Álvaro de Bazán. The other sixty-three galleys sailing under Spanish command were all Italian: they included thirty from Naples, ten from Sicily, eleven Genoese ships under Gian Andrea Doria, and other small contingents including three galleys sent by Savoy and three by Malta. The pope sent twelve galleys, under Marcantonio Colonna, and Venice one hundred and six. The fleet of the Holy League was in every sense an Italian and above all a Venetian fleet, with Spain relying heavily on its Italian allies for support. Naples and Sicily alone contributed over half the galleys and more than a third of

the costs. By contrast, Spain supplied the highest proportion of men. Of the twenty-eight thousand soldiers who accompanied the fleet, Spain contributed just under a third, around 8,500 men in four tercios under their commanders Lope de Figueroa, Pedro de Padilla, Diego Enríquez and Miguel de Moncada. There were in addition around five thousand German troops, and the rest were mostly Italian (including three thousand sent and paid by the pope). Besides the soldiers, the Christian fleet also had 13,000 sailors and 43,500 rowers. The immense fleet took a long time to assemble, and at the end of August the agreed commander, Don Juan of Austria, twenty-four years old and in the prime of his career, arrived in Messina to take up his post.

The armada left Messina on 16 September, heading for Corfu.[110] At sunrise on 7 October it came upon the enemy fleet, at the entrance to the Gulf of Lepanto, off the Greek coast. The vessels of the two combatants covered the sea as far as the eye could see, the broad-bottomed Christian galleys occupying so much space on the water that some had to wait in the rear. The centre of the Christian battle array consisted of sixty-two galleys commanded by Don Juan; each of his two wings was made up of fifty-three galleys.[111] The Ottoman fleet, with an estimated 208 galleys and 25,000 soldiers, was almost evenly matched, though without the superior cannon and arquebuses on the Christian side. It was perhaps the most remarkable land battle ever to have been fought at sea, as the infantry fought from one galley to the next, backed by firepower. The balance of carnage at the end of the day also had few parallels in European history.[112] Both sides recognized immediately that it was a Christian victory, but the casualties gave no reason for rejoicing. The Christians lost fifteen galleys, nearly eight thousand dead and eight thousand wounded. The Turks lost 15 galleys destroyed, a further 190 were captured, and their casualties included 30,000 dead and 8,000 prisoners; in addition, 12,000 Christian rowers were freed from their ships.

Venetians and other Italians never wavered from the belief that the victory had been an Italian one. Their historians went so far as to criticize Spain for its failure at Lepanto: the failure, that is, to exploit the Italian victory by going on to reconquer Greece.[113] Though repeatedly celebrated as Spain's most memorable military feat, more than any other victory of the age of empire Lepanto demonstrated clearly that in war as in peace the power of Spain depended on its allies. Historians have

looked with care at who actually paid for what in this great naval expedition, but have been reluctant to break away from the common assumption that Spain was the great contributor. The stark reality was that Spain could not pay its share, and the Italians came to the rescue. The Italian states made a fundamental contribution in supplying the armaments, equipment and victuals for the expedition. They also paid out of their own resources for the ships and men they supplied. The papacy made the most important contribution of all, by allowing Philip II to raise special Church revenues that helped to defray the expense of the campaign. The total costs that fell on the Castilian exchequer have been calculated at five million ducats. Of this sum, the government sent only sixty thousand ducats in silver. The rest was paid by Genoese bankers, who issued credit (in the form of 'bills of exchange') to cover the money, which they hoped to recoup later with adequate interest charges.[114]

Just as the military and financial contribution to Lepanto was one shared between all the allies, so the victory belonged to all. In Rome, reported a cardinal, 'we are mad with delight, and above all the pope, who we really thought without exaggeration would die of joy, for the old saint has not slept these two nights'.[115] The exultant Pope Pius V offered to crown Philip II as Emperor of the East personally if he could recover Constantinople.[116] The prominent political role of the Spanish monarchy served to concentrate the hopes of the West on Spain. The feverish excitement of those days is clearly reflected in the letters of congratulation that were directed to the Spanish court, to Don Juan of Austria and to the other main participants. When in addition the queen of Spain gave birth, shortly after, to Prince Ferdinand, it seemed as if heaven had deliberately combined the two events. Philip II said expressly to the papal nuncio that he hoped his son would be the new defender of Christendom.[117] The birth fulfilled prophetic hopes that had long existed in Castile, over the mythical role of a liberator who would bear the name Ferdinand.[118] A majestic painting by Titian, done shortly after, combines the two events as one. But the messianic enthusiasm after Lepanto also nurtured pipe dreams. In Portugal the Jesuits encouraged young King Sebastian in his plans to carry the war against Islam into the heart of Africa. When he received a somewhat confused version of the news of the victory, a Jesuit in Cochin China believed that Don Juan had liberated the Holy Land. The Christian victory, it seemed, might

lead to the defeat of Islam in the Mediterranean and the liberation of the Holy Places.

The impetus continued. Don Juan re-conquered Tunis in 1573, with a force of 155 galleys contributed by the Italian states of the empire and by Spain. His force, which consisted of twenty-seven thousand men, two-thirds Italians and Germans, one third Spaniards, sailed from Messina on the exact day 7 October, in a clear attempt to capitalize on the triumph of the preceding year. There was no resistance from the town, which was nevertheless sacked.[119] The victory was short-lived. In September 1574 a massive Turkish fleet of over 230 vessels and 40,000 men recaptured the city. The fortress of La Goletta, which overlooked the city and was manned by a Spanish garrison, had surrendered a fortnight before. The loss was bitterly criticized in both Spain and Italy. 'I cannot but lament', observed Spain's ambassador in Rome, Juan de Zúñiga, 'that all that has been spent this year has been to no avail.' The pope blamed Spanish incompetence. He asked Don Juan, who passed through Rome in November, to express his concern to the king. Zúñiga bluntly blamed 'the way they manage things in the council in Spain'.

Despite the continuing commitment to the Mediterranean, in the 1570s Spain was sucked relentlessly into the maelstrom of the Netherlands. Don Juan wished to maintain a strong Spanish presence in the inland sea, but Philip II thought differently. The king was still unable to go to Brussels in person. 'There's nothing in this life I wish more', he commented, 'than to see my subjects there, but it is not possible for now to absent myself from here, because of the war against the Turk.'[120] Alba continued to have a free hand. His proposal to impose a new tax, the 'tenth penny', aroused universal protest and fortified the opposition of those, both Catholic and Protestant, who wished to set their country free from foreign occupation. In April 1572, Flemish naval freebooters known as the 'Sea Beggars' were turned out from England, where they had taken refuge from Alba, and returned to seize the port of Brill, which became a base for patriotic resistance against Spain. The rapid success of the largely Calvinist Beggars in winning the northern provinces and electing William of Orange as their leader, opened the second and most decisive phase of the revolt of the Netherlands. In France the influential voice of Admiral Coligny, the Huguenot leader who was now

prominent in the royal council, called for French intervention in support of the Netherlands rebels. The massacre of St Bartholomew's eve in August 1572, engineered by the queen mother, Catherine de' Medici, for domestic reasons, conveniently removed Coligny and with him the threat from the French Protestants, thousands of whom were set upon and murdered.

Apart from the terror exercised by the Council of Blood, what Netherlanders most remembered of their struggle against Spain were the excesses of the soldiery and the execution of patriots. In October 1572 Alba allowed his troops to sack and massacre in the city of Mechelen, which had supported Orange. In the next few weeks it was the turn of Zutphen and Naarden. At Haarlem, the Spaniards methodically executed the entire garrison, over two thousand persons, in cold blood.[121] There were strong protests from other Spanish officials, who felt that the policy of repression was leading nowhere. A senior officer reported to the king's secretary 'the abhorrence in which the name of the house of Alba is held'. Another Spaniard urged Philip to realize that repression had failed, despite 'having executed over three thousand people in just over five years'.[122] The failure of Alba's harsh policies in the Netherlands had been for some time apparent to Philip II, who, however, was unable to act because he saw no acceptable alternative. By contrast, the St Bartholomew's massacre for the first time seemed to offer light at the end of the tunnel. The removal of the threat of intervention by Huguenot nobles, who had always been the closest allies of Orange, opened the way to a possible adoption of a less intransigent approach.

In consequence, the year 1573 marked a fundamental change of direction in royal policy that affected not only Europe but the whole empire. The 1573 Ordinance on Discoveries (discussed below in Chapter 6) laid down the line to be followed in future in the New World: conquest was no longer to be an objective. In the Netherlands, as we can see by the remarkable instructions to the new governor, Requesens, Philip was willing to try a policy of extensive concessions. Most of his advisers, both the hard-liners and those who were not so, supported him. From France his ambassador Francés de Álava wrote advising against the further use of force. 'In my poor judgement', he wrote to the king, 'another way must be sought.' From his position in Italy as viceroy of Naples, Cardinal Granvelle also urged the king to adopt a more flexible policy. He reflected in July 1574 that the king's advisers had not the

slightest idea of the affairs of the Netherlands: 'they do not understand nor will understand in very many years'.

The cost to the empire in terms of men and money was in any case insupportable. The spiralling costs were the despair of Philip's financial advisers. Juan de Ovando, president of the council of Finance, drew up an estimate in August 1574 which showed that current annual income of the Castilian treasury was around six million ducats, while obligations came to eighty million. The current debt in Flanders was around four million, or two-thirds of all the available income of the government of Spain. To this one had to add the current costs there, over 600,000 ducats a month, the biggest single burden on the treasury. The monthly expense in Flanders was over ten times the cost of defence in the peninsula, and twenty times the cost of the royal household and government.

Even while Alba complained that he was not receiving enough men or money, the king was complaining that he received too much. In February 1573 the duke wrote to the king's secretary, appealing for a diversion of resources away from the Mediterranean and towards the north. 'I beat my head against the wall when I hear them talk of the cost here! It is not the Turks who are troubling Christendom but the heretics, and these are already within our gates . . . For the love of God, ask for the new supplies that I have detailed to His Majesty, because what is at stake is nothing less than the survival of his states.' Throughout the year, he continued to rage, plead and rail against those in authority in Madrid. 'Until those who serve in his councils are dead or sacked, His Majesty will achieve nothing here.' Philip refused to be browbeaten. 'I shall never have enough money to satisfy your needs', the king wrote, 'but I can easily find you a successor able and faithful enough to bring to an end, through moderation and clemency, a war that you have been unable to end by arms or by severity.' In 1573 he appointed his old friend Luis de Requesens, grand commander of Castile and currently governor of Milan, to the governorship of the Netherlands.[123]

The difference between the attitudes of the old and the new governor were patent from the first day. Alba told Requesens that he had advised the king to 'lay waste in Holland all the country that our people could not occupy'. The grand commander of Castile was horrified at this typical soldier's solution. 'From the very first day', he was to comment later, 'I have had the water up to my teeth.' Apart from having to deal with the rebels, he had to search for solutions to one of the king's main

preoccupations, that of acquiring naval power for Spain in the waters of the north. A substantial naval force being planned by Pedro Menéndez de Avilés in the port of Santander in 1574 never got under way. The death of Menéndez that September, and an outbreak of typhus among the crews, forced cancellation.

During 1575 further attempts were made to send naval help. In September and again in November fleets were sent out from Santander. The first was hit by storms and dispersed along the English coast. The second, crippled by mutiny and bad weather, never made it to sea. At the end of December the king decided to postpone the naval effort. Officials lamely recognized that the Dutch were far superior to them at sea.[124] Outside the Mediterranean, Spain's naval power in Europe was virtually zero. To keep trade going, Philip even tolerated the transport of goods to and from Spain by Dutch rebel ships. From Seville it was reported that 'Flemings, English and Dutch control all the trade'. In 1574 the king was offered the use of a Baltic port, on the Swedish coast, from which to strike against the rebels and cut off their wheat supplies. It was the first of several proposals of this type. The offer could not be taken up. In the north, as a consequence, Spain lost out to the maritime superiority of the Protestant powers. It was a fatal weakness that with time assured the Dutch their freedom, and created continuing problems for Spain.

Though the king recognized in 1574 'that it is not possible to make progress on Flanders through a policy of war',[125] the attempt at a policy of moderation in the Netherlands failed to pay off. When Requesens, who had been unwell for some time, died in March 1576, he was replaced as governor by Don Juan of Austria. The 1575 bankruptcy had by now accelerated the disorder in the Netherlands, where the regiments that had not received their pay were mutinying and deserting. In a long tirade against his own men Requesens declared 'that it is not the prince of Orange who has lost us Flanders, but soldiers born in Valladolid and Toledo whose mutinies have cost us money, confidence and *reputación*!'.[126] Towards the end of 1576 an army that numbered sixty thousand men on paper had sunk in fact to no more than eight thousand.[127] The core of the army under Spanish control mutinied and in November 1576 sacked the great commercial city of Antwerp at a cost of some six thousand lives and a large amount of property.

This bloody 'Spanish Fury' confirmed the resolution of the seventeen provinces of the Netherlands, assembled at Ghent in the States-General,

to decide their own destiny. They negotiated a general peace (the Pacification of Ghent, November 1576), demanding that Philip accept the current religious position and withdraw all Spanish troops as a precondition of settlement. Don Juan was forced to accept. 'There seems little hope of avoiding', he complained in December, 'the situation we are going through, and all at my cost, for I am struggling from seven in the morning to one o'clock at night. These people are so out of their minds, that the only thing they can think of saying is, "The Spaniards must leave, the Spaniards must leave".'[128] In February 1577 he issued a so-called Perpetual Edict and withdrew the army. When the Calvinists failed to respect the religious truce, Don Juan recalled the troops under Alessandro Farnese, prince of Parma, and in 1578 at Gembloux defeated the forces of a Netherlands now wholly united in revolt under William of Orange. Gembloux was both a rout and a massacre: the small army of the States-General, unprepared for an attack, retreated rapidly but lost, in dead and prisoners, six thousand of its seven thousand infantry. When Don Juan died of illness in October his place was taken immediately by his lieutenant Farnese.

The obvious failure of Alba's policies has tended to overshadow his reputation. Though by no means the most successful of all the generals ever to serve the Spanish empire, Fernando Alvarez de Toledo, third duke of Alba, was certainly the most distinguished.[129] A close collaborator of the young Charles V, he gained the emperor's confidence, received the Golden Fleece in 1526, and served him in all his theatres of war, principally in Germany, where he participated in the victory of Mühlberg as well as in the final reverse at Metz. He commanded the armies of Philip II in Italy, and was appointed viceroy of Naples before being chosen for the governorship of the Netherlands in 1567. The campaign there made his reputation as an efficient and ruthless commander, but it also unmade his health and his career, for the king never again put his trust in purely military solutions. Unfortunately, Alba came to represent for contemporaries (as well as for future generations) the unacceptable face of Spanish imperialism, brutal and merciless. A tall, stern and honourable aristocrat, Castilian from the roots of his hair to the tips of his boots, Catholic and cultured, he tended to despise the citizens of the empire who were not as he was. Brantôme, who knew him in his mature years, described him in his last days as still full of energy, 'neither more

nor less than a fine, grand, old tree, still putting out small, green branches to show that it had been in former times the pride of a great forest'.[130]

Alba played a fundamental role both as general and as head of the group of nobles and officials who reflected his political interests. But he was also one of the great constructors of the empire inherited by Philip II. As member of the Council of State, general and viceroy, he travelled to every corner of the territories ruled over by the Habsburg dynasty: he was at ease equally in Vienna, Brussels, London, Rome, Naples and Madrid, and his adequate command of French and Italian, together with an elementary knowledge of German, enabled him to speak on equal terms with leaders of every nation. Travelling between his assignments, he became the lynch pin for major decisions affecting the functioning of the monarchy, a sort of imperial executive with responsibilities in all matters concerning politics, war and finance. 'For the campaign in Milan and Piedmont', he wrote in 1555 from Brussels to a fleet commander in the Mediterranean, 'we need to have a good supply of gunpowder, cannonballs and saltpetre; when you reach Naples in the galleys you will need to send me five hundred quintals of gunpowder'. In the same month, still in Brussels, he assured Charles V, who was in Vienna, that troop recruitment for Italy was going well: 'speaking of the Spanish troops, I have no doubt that Germans will be sufficient for now and will be very good. When I arrive in Italy I shall do what seems necessary, and shall try to raise troops from the appropriate nations and in the number required.'[131]

Early in 1556 the theme was money. 'It is three months since I have heard from Your Majesty', he wrote in a letter from Portofino, 'and I go about begging for news of what is happening at Your Majesty's court. The matter of money is in such straits that I do not know what can be done this summer if Your Majesty does not send to Spain at once for some supply.' 'When I was in Livorno', he wrote to Prince Philip, 'I made two contracts with Niccolò di Grimaldo for 110,000 escudos; I used 70,000 of it to pay off the wages owing to the men in the army of Tuscany and Orvieto up to the end of 1555, and sent the remaining 40,000 to Milan to pay the Germans.'[132] Between supervision of recruitment, wages and supplies, and the very many other matters requiring his attention, Alba made sure that the various realms of the monarchy contributed together to the common effort. The task had never been done adequately before, and now called for serious attention. Historians

have too easily assumed that the duke had only to put himself at the head of the famous Spanish military machine for it to function smoothly. There was in reality very little machine, and it barely functioned. 'I arrived in Italy', he wrote in 1556 to the Regent of Spain, Philip's sister Juana, 'and found the army was due 1,200,000 escudos. What was supposed to come from Spain has never arrived, and I have had to wage war for a whole year with an army that is almost always mutinous and disobedient.' Nor was the shipment of troops to Italy any comfort. Vessels bringing tercios from Sardinia to Naples in February sank at sea, with the loss of one thousand men, a major disaster. At New Year 1557 he had little reason to be satisfied with the new troops sent to him. 'The galleys have arrived with the Germans and the Spaniards, but they are all in such a condition that we cannot expect much from them. Over half the 2,300 Germans are sick, and two-thirds of the 700 Spaniards are moribund. I am here without men and without money.'[133]

Spanish expansion had been made possible by the use of private contracting in every possible sphere. It was the only way a poor nation could exploit the opportunities made available to it. Moreover, public financial enterprise was as yet little known in the peninsula. Certain cities, notably Barcelona, had public banks of limited scope.[134] The crown, by contrast, had no fund of money on which it could draw for its schemes. Experience showed that private contracting was an unreliable instrument, and that it very often exacted a high price. Philip II began the monarchy's attempts to distance itself from conquistadors and adventurers. For the first time, empire became a serious business in which the crown – that is, the public sphere as against the private – decided to extend its initiative.

But what was the role of Spain and its crown in this new international community? Philip II gave priority to two aims: affirming the authority of the crown, and ensuring adequate finances.[135] From the beginning of his reign he pursued both objectives consistently in dealing with the New World. Spanish imperialism was neither more nor less than the power of the crown. By affirming his own authority, Philip rejected the old view that based the Spanish presence in America on papal donation. When he accepted the surrender of the independent Andean state of Vilcabamba, by the agreement imposed on Titu Cusi Yupanqui in 1565, he made it clear that the submission was to his authority. It was not a repetition of what Pizarro had imposed on the Incas, a submission

based on the requerimiento. The formal rejection of the papal donation bore fruit in special meetings of government committees from the year 1567 onwards. In 1568 the king convened an important committee to discuss the government of America; there were members from all the councils, among them Juan de Ovando, president of the council of the Indies, as well as the viceroy-designate of Peru, Francisco de Toledo. Its work was meant to round off the recently completed codification (1567) of the laws of Castile and Léon, known as the 'Nueva Recopilación'. Among the many important results of the 1568 committee, perhaps the most significant was the Ordinance on Discovery and Population of 1573, which we shall consider later (Chapter 6).

The tenure of Francisco de Toledo as viceroy of Peru was in many ways symbolic of the way that Philip II proposed to run the overseas empire. Toledo had been a distinguished diplomat and soldier before he was sent out as viceroy in 1569, armed with elaborate instructions from the king. He was to give priority to the condition of the majority population, in terms of their religion and the nature of their labour obligations. He was also to make sure that order was restored in the production of silver and the collection of the taxes due to the crown. His term of office, a highly successful twelve years, coincided with the ordering of the mining industry in South America, changes in the administration, and the establishment of tribunals of the Spanish Inquisition in the New World. The coming of the Inquisition, which was in operation from the 1570s, had little impact on the colonial world. But it signalled an important change in the sphere of religion, for it was part of a package that included the introduction of reforms decreed in Europe by the Council of Trent, and signified for those friars who had been working in America an end to their dreams of an autonomous American Church under their control.

The most memorable of Toledo's achievements was the capture and execution of the last Inca, Tupac Amaru, youngest son of the Manco Inca of the time of the Pizarros. It was an act that encapsulated both the philosophy and practice of Spanish imperialism, and requires our attention. The neo-Inca state created in the mountain fortress of Vilcabamba by Manco Inca coexisted with the Spanish presence in Peru for decades. Now and then, the Indians would come down from the mountains to make raids against the Spaniards and their allies. But there were deep divisions among them. When the Spaniards set up a

puppet Inca – a brother of Manco – in Cusco, many Indians deserted Vilcabamba and followed the new ruler. Then in 1545 a group of Almagro's followers, who had been befriended in the fortress by Manco, murdered their host. The confusion was not resolved until power passed to a natural son of Manco, Titu Cusi Yupanqui, in 1560. The people of Tawantinsuyu found themselves at the parting of the ways between the old order and the new. What would they do? In 1565 rumours circulated that Titu Cusi aimed to stir up a general rebellion and restore the empire of the Incas. The Spaniards decided to try the way of negotiation and an emissary, accompanied by Spanish soldiers and Cañari Indians hostile to the Incas, went up to have talks with Titu Cusi. The latter accepted baptism and promised to call off the threatened uprising. It seemed that a *modus vivendi* between the Spanish and the Inca states would be reached. Christian missionaries were allowed to preach in the territory controlled by Titu Cusi.

The hope of liberation, once kindled, could not be extinguished. In those same months, quite independently of the Incas a millenarian movement called Taki Onqoy began to take shape in the area around the town of Huamanga (see Chapter 6). In 1571 Titu Cusi fell ill and his men called on a local Spanish missionary to cure him. The cures did not work and the Inca died. Convinced that the priest had poisoned the emperor, the Indians tortured him to death. The murder supplied an excuse for the recently arrived viceroy Toledo to intervene. Titu Cusi's brother Tupac Amaru assumed power but was destined not to exercise it for long, since a deadly epidemic was now sweeping through the forest areas and affected the territory of Vilcabamba: bridges and roads were left unguarded as warriors died. Toledo sent a small force of Spaniards in. They succeeded in capturing Tupac Amaru, who was taken in chains to Cusco. There, after being baptized, the last legitimate Inca emperor was beheaded in 1572. Guaman Poma recorded that 'all the great ladies wept, and the Indians of this kingdom, there was great mourning throughout the city and they tolled all the bells, and all the leading persons and ladies and the principal Indians went to the funeral'.[136]

The execution, like that of Atahualpa a generation before, provoked bitter criticism on all sides. Writing a generation later, the historian Garcilaso de la Vega alleged that when Toledo returned to Spain Philip II criticized him for the act, saying that 'he had not sent him to Peru to kill kings, but to serve them'. Guaman Poma's version was that the king

refused even to receive Toledo.[137] There is no evidence to support either of these stories.

In fact, the execution fitted in opportunely with the perspective of empire that the Spaniards were now adopting.[138] In the colonial territories there was to be no other authority save that of the king: popes, princes, Incas, were no longer to dictate the limits of Spanish power. In the beginning of the conquest period Spain had leaned heavily on papal authorization for its policies; now that was no longer deemed necessary. This did not mean that Spanish power was to be viewed as total or absolute, and no such pretension was ever made. But from now on only the crown decided. In Peru Toledo took great pains to issue publications showing that the Incas had always been usurpers of power in the Andes. This made it easier to present Spanish power as the only legitimate authority. 'As Your Majesty is the real ruler of this kingdom', the viceroy informed his master in 1573, 'and there are no legitimate heirs of the Inca tyrants, all the wealth, land and livestock reserved for the service of the Incas, and which are not private property, justly belong to Your Majesty.' The king's obligation, in turn, was to 'defend the native Indians and devise laws for their conservation'.[139] There was henceforth to be one sole empire, ruled over by one sole authority, the Crown of Castile.

5

The Pearl of the Orient

We are here at the gateway of great kingdoms. Will Your Majesty
aid us so that trade may be introduced and maintained among
these nations?

Guido de Lavezaris, governor of Manila, to Philip II[1]

Spain's first contact with the Pacific is dated traditionally to 1513, when
Vasco Núñez de Balboa and his men crossed the isthmus of Panama.
The first Spanish settlement on the South Sea was the town of Panama,
founded in 1519 by Pedrarias Dávila, who had come out (aged already
over seventy) in 1514 as governor of Darien and soon displayed a
ferocity that the natives came to regard as typical of Spanish methods.
He was responsible for the execution of Balboa, and continued his fierce
and arbitrary course until removed from his position, but was appointed
soon after to the governorship of the adjacent territory of Nicaragua,
where he died, still ferocious but indomitable in 1531 at the venerable
age of ninety.

Tied down by the grim and mortal task of establishing themselves on
the mainland, the Spaniards on the Pacific at first made little use of the
sea, which served primarily as a transport route along the southern
coast. Spain's history in the Pacific, consequently, was pioneered not by
its own nationals but by Portuguese. In the same year that Cortés set
out for the Yucatan peninsula, five ships left Sanlucar in September 1519
under the command of the Portuguese captain Ferdinand Magellan
(Fernão Magalhães). Magellan's expedition had a largely Spanish crew
but included sailors from several nations. Among them was Antonio
Pigafetta, a native of Vicenza, who later wrote a detailed and classic
account of the enterprise. Later on, when he was preparing his account,
Pigafetta explained how he came to be there: 'I was in Spain in the

year 1519, and from books and conversations I learnt that there were wonderful things to see by travelling the ocean, so I determined to discover with my own eyes the truth of all that I had been told.' Thanks to his enthusiasm, the most famous expedition in European naval history was narrated for posterity. It was a long and hazardous voyage. Four months later, in January 1520, they were at the Río de la Plata, and further south in Patagonia the little fleet suffered a serious mutiny. Not until the end of the year did four surviving ships manage to navigate in thirty-eight days through the perilous and windy strait that bears Magellan's name. They emerged into an ocean that seemed by comparison so tranquil that it was named 'the Pacific', but they soon faced the unending expanse of sea, 'so vast that the human mind can barely conceive it', accompanied by thirst and starvation as their supplies ran out. Their first landfall fourteen weeks later in March 1521 was at Guam, where the thieving curiosity of the natives induced the sailors to name the islands the Ladrones. At Cebu a chieftain accepted baptism, but Magellan was killed in a clash with natives on Mactan, in the Philippines.

The survivors in two ships made it to Maluku, where they encountered Portuguese traders at Tidore and managed to take on spices. The voyage home was attempted in both directions. One of the vessels, the *Trinidad*, set out eastwards across the Pacific but was beaten back by winds and a few survivors managed to return to port. The other, the *Victoria*, under Sebastián del Cano, left Tidore on a westwards route in December 1521, striking out directly from Timor towards the coast of Africa. It rounded the Cape of Good Hope and eventually entered the port of Sanlucar on 1 September 1522, three years after departure. Del Cano had left Tidore with a crew of forty-seven Europeans and thirteen Malays; only eighteen of the former (two of them were Germans) and four of the latter made it to Spain. Together with the 13 who later returned from the *Trinidad*, they were the only survivors of the 265 men that had made up Magellan's enterprise. The *Victoria* was the first vessel in history to circumnavigate the globe, a gigantic step forward in human achievement. It also established for the Spaniards direct contact with the Spice Islands, opening up the prospect of competition with the Portuguese and possible empire in Asia. The price obtained for the spices brought back by del Cano more than paid for the entire cost of mounting the expedition. A Genoese had offered the New World to Spain, now a Portuguese and a

Basque (in a voyage documented by an Italian) offered the Old World as well.

The news was brought personally by del Cano to the emperor in Valladolid in September. The return of the *Victoria* revealed for the first time the possibility of direct Spanish access to the riches of the east, and the crown did not wish to let the opportunity slip. But there were problems of measuring distances. The Treaty of Tordesillas in 1494 had agreed to fix a line of demarcation in the Atlantic, but how did this affect the division of lands in the Pacific? After trying in vain to reach agreement in 1524 with Portugal over sharing access to the Maluku archipelago, Charles V in 1525 sent out another expedition from La Coruña. Financed by Castilian and German bankers, it consisted of seven vessels under Juan García Jofre de Loaysa, with instructions to contact the Spaniards stranded in Maluku from Magellan's voyage. The voyage was a disaster: both Loaysa and Sebastián del Cano, who accompanied him as second-in-command, died at sea, and though the remaining ships touched at the Philippines and other islands before reaching Maluku early in 1527, the survivors were forced to take refuge on Tidore. A third expedition, sent out in October 1527 from Mexico by Hernando Cortés, and commanded by his cousin Álvaro de Saavedra, reached the South China Sea the year after, and explored various islands, but disintegrated like its predecessors and Saavedra died during the passage. With Portuguese help, survivors from these last two voyages – one of them was the subsequently famous Andrés de Urdaneta – eventually returned to Spain in 1536.

The continuous failures did not serve to foster optimism. As a consequence, the emperor in 1529 by the Treaty of Saragossa ceded to Portugal (in return for the handsome sum of 350,000 ducats) all his claims to the Spice Islands, and a line of longitude was laid down in the Pacific, 297.5 leagues to the east of Maluku.[2] Spanish ships were not to operate to the west of the line. Interest in expansion towards the Pacific virtually disappeared. But the vagueness of the term Spice Islands continued to attract individual explorers. In normal usage, the term referred to the islands of Amboina, the Bandas, and Ternate and Tidore, in the Maluku archipelago; but in a broader sense it was also applied to all the islands between the Celebes on the west and New Guinea on the east. Where, moreover, did the line of demarcation really run? Since there was at the time no reliable way to measure longitude, reasonable doubt

remained over what the Portuguese could really claim as their own. Occasional Spanish ships ventured into the disputed area. A venture to the islands in 1536 under Hernando de Grijalva collapsed, the commander dying in a mutiny; one ship was wrecked in Maluku, though another made it back to Mexico. Six more years passed before another initiative came from New Spain, when Pedro de Alvarado backed an expedition that sailed from the port of Navidad on 1 November 1542. The ships reached islands which the expedition's leader, Ruy López de Villalobos, named the Philippines in honour of the prince of Spain, later Philip II. The vessels touched on New Guinea, which they also claimed for Spain. Villalobos died of fever on the island of Amboina in 1546, receiving the last rites from a wandering Navarrese missionary who had arrived there, named Francisco Xavier.

The success of the Portuguese in extending their activity through Southeast Asia was due in good measure to their establishment of key trading posts at Goa and in the Indian Ocean. Pioneers of the route to India round the Cape of Good Hope, thanks to Vasco da Gama's epic voyage of 1498, Portuguese traders pushed east towards the Spice Islands. In 1509 they attacked the town of Melaka with a force that included Magellan in its ranks. Two years later, under Viceroy Albuquerque, they captured the town, and held it thereafter for 130 years. In 1512 they touched on the Philippines, and going farther south established their main base in Maluku, at Ternate. Their firm presence in the China Sea may be dated from the settlement of Macao in 1553, a centre that offered excellent access to the whole commerce of the region and from which they soon organized a successful three-way commerce that took in Goa, Macao and Japan. The annual 'great ship' from Macao to Nagasaki became from 1570 an integral part of the trade route from Goa. The Portuguese accomplishment was, of course, not due to themselves alone. It came in great measure from the collaboration of European financiers (mainly Genoese)[3] and from agreements made with the Asian authorities in India, Melaka, China and Japan.

Rivalry with the Portuguese influenced a good part of Spain's enterprises, and must be considered a positive stimulus to the growth of Spain's empire. Portuguese trade was a tiny enterprise in terms of goods and shipping, but of profound consequence for the Western world, which for the first time penetrated deep into Asia. The Portuguese continued for over a century to be the most active of the Western powers

in East Asia, considerably more active than the Spanish, who were obligated by the terms of the papal donation not to enter into territories where the former were active. It was an obligation that continued to be observed, within the limits of possibility, even after the union of the crowns of Portugal and Spain in 1580. The Portuguese pioneered contacts: in 1543 their traders first arrived at the port of Kyushu and brought to Japan the science of firearms, a technology that the regional warlords (daimyo) gradually adapted to their needs and used in their quarrels. No less far-reaching in its consequences was the arrival at Kagoshima in 1549 of the Chinese trading vessel that set ashore Francisco Xavier.

Well over twenty years after the Villalobos voyage, the Spanish government helped to plan and finance a further expedition. Philip II stated expressly that 'the main purpose of this expedition is to establish the return route from the western isles, since it is already known that the route to them is fairly short'.[4] A fleet of five ships under the command of the veteran Basque administrator Miguel López de Legazpi and piloted by Fray Andrés de Urdaneta sailed from New Spain on 21 November 1564. The Legazpi expedition was new in style and concept: it reflected Philip II's resolve to take a direct hand in policy, while at the same time modifying the rules that till now had governed expansion. The king's instructions, which insisted on a wholly peaceful approach, were intended to avoid the excesses committed by New World conquistadors. The expedition touched at several islands (including the Marshalls and the Marianas) which Legazpi dutifully claimed for Spain, before making landfall on the island of Cebu in the Visayas in April 1565, after a five-month voyage.

With just under two thousand people at the time the Spaniards arrived, Cebu was the chief port in the Visaya Islands and a promising place to settle. The Spaniards set up a base, from which they began to trade and to reconnoitre adjacent islands. They had to endure six long years of misery, privation, lack of customary food, subjection to tropical disease and discomfort. Though their instructions were to avoid bloodshed in the course of imposing their presence, that proved to be impossible. In the event, it was fairly easy to overcome native resistance, for society in the islands was based on small kin-based units known as barangays, consisting of from thirty to one hundred families, which

were usually independent of and hostile to each other. The lack of any broad political organization among the natives made it possible for the Spaniards to move in without serious problems. Above all, as in America they could count on support from local allies.

The first important move out from the Visayas was made in May 1570 when an expedition of ninety Spaniards accompanied by three hundred Visayan auxiliaries attempted to seize the settlement at Manila, a thriving *barangay* at the mouth of the River Pasig in Luzon, ruled by a son of the Muslim sultan of Borneo and defended by bronze cannon. They were unable to dislodge the natives and had to settle for an uneasy coexistence. A year later the local leaders (*datus*) came to an agreement accepting Spanish rule, and in June 1571, a year before Legazpi's death, Manila was formally constituted as a Spanish town.[5] It was about the same size as the main town on Cebu and showed signs of Muslim influence, but was seen as more attractive. Manila developed in time into the principal Spanish colony of the entire Philippines.

The policy of settlement adopted by the Spaniards in the South China Sea was similar to that used in the New World. As leader of the official expedition, Legazpi enjoyed the title and rights of adelantado: for later writers he was simply 'el Adelantado'. His principal companions had the status of encomenderos; an official listing of 1576 calculated that the territory of the islands was allotted to 143 encomiendas. However, half a century had now passed since the beginning of the conquests on the American mainland, and the style and philosophy of the imperial enterprise had changed radically. Within the small ambit of the Spanish community in the Philippines, it was possible to take seriously the king's 1573 Ordinance. When he received a request in 1574 for further encomiendas in the islands, Philip II rejected it out of hand. The first formal law to be issued by the Spanish authorities in Manila was a ban, in 1576, on any further grants. The holders no longer enjoyed the status they once had. 'The encomenderos of these islands', the bishop of Manila reported in 1583, 'are all very poor people.'[6]

The need to survive always took precedence over the need to conquer, for conquest was neither a priority nor a possibility in the Philippines. Among the earliest threats to the Spaniards was the Chinese pirate Limahong, who virtually controlled the seas round the islands. In March 1575 Legazpi's son Juan de Salcedo led a major Spanish expedition of two hundred and fifty men, backed up by one thousand

five hundred Filipinos and a Chinese interpreter, which sailed from Manila to Lingayen Bay, at the mouth of the River Agno, and destroyed the Chinese vessels where they lay at rest. But survival also involved elementary concerns such as food. Without slave labour to support them, the colonists found it hard to maintain themselves. The bishop of Manila in 1581 described cases of Spaniards who managed to eat only because they stole from the natives. They would, he reported, 'break in on a native who has just cooked himself a meal and take it away from him. If I reprimand them they say, "What do you expect us to do? Lie down and die?" '[7]

Because of its great distance from Europe, Manila from the first was provisioned directly from the New World and treated as a dependency of the viceroyalty of New Spain. In 1583 it was given an Audiencia to govern its affairs, and an autonomous supreme court in 1595. In practice, because of the distances involved and the time taken to traverse the Pacific, the Philippines quickly struck out on their own and developed as an independent colony. But the Spaniards never developed a viable economy of their own, and always depended down to the nineteenth century on the regular financial assistance they received from the Mexican government in the form of silver. The subsidy, known as the 'real situado' ('royal subsidy'), was brought directly from Acapulco in the galleons in the form of cash. In reality, though it took the form of assistance it was simply a restitution to the islands of the customs duties their ships paid when they had crossed the Pacific to trade in Acapulco.[8]

Both geography and the quality and size of the Spanish community radically restricted the extension of Spanish power. As one official pointed out to the Madrid government, the Philippines consisted of at least forty large islands, without counting the many smaller ones. A modern count of the extent of the territory arrives at a figure of over seven thousand islands, many of them with active volcanoes. The climate was tolerable but by no means hospitable: it was described by one Spaniard as 'cuatro meses de polvo, cuatro meses de lodo, y cuatro meses de todo', or four months of dust, four of mud, and four of everything.[9] The 'todo' included, of course, monsoons, typhoons and earthquakes.

The ban on conquests, and the permanent shortage of manpower,

eliminated all possibility of occupying or dominating territory beyond the confines of the town of Manila. A few small outposts were set up elsewhere on the islands, in order to trade. The Spaniards themselves were based mainly on the largest of the islands, Luzon, populated principally by the Tagalog people. They made almost no attempt to settle on the large southern island of Mindanao. Spaniards visited the large group of islands in the central area, the Visayas, but they happened to be mainly missionaries. No attempt was ever made, or could have been made, to take control of the entire archipelago. The inhabitants of Mindanao, usually Muslim in religion and therefore known to the Spaniards as 'Moros', remained unsubdued for three centuries. Occasional expeditions were sent against them, particularly in the 1630s when they were found to be allying with the Dutch from Indonesia. Successes were scored in terms of engagements won and men killed, but they were all futile because the Spaniards were never in a position to occupy territory beyond that which they controlled around Manila. Even on the island of Luzon they never managed to dominate the mountainous north-eastern provinces, inhabited by natives whom the Spaniards called Ygolotes. In the other islands, meanwhile, the Spanish position was – outside the valiant and isolated missionary communities – hopeless. The natives of the mountainous areas there, perhaps the original inhabitants of the archipelago, were given the collective name 'negritos' or 'blacks', which like the word 'moro' was a meaningless extension to Asia of the vocabulary of the Iberian peninsula.

In the imagination of Spaniards, and even more surely in their maps, the Philippines featured as part of their 'empire'. Those who lived in the islands knew better. A leading judge, administrator and soldier of Manila, Antonio de Morga, reported in the 1590s that Manila 'is a town of small means, founded by persons most of whom have little income', and that 'there are very few men in these islands who know how to manage a musket'.[10] For a variety of reasons that are easy to understand, Spaniards from the peninsula were not attracted there. White immigrants, many of them of mixed race rather than pure Spaniards, came principally from New Spain. 'Every year', reported a Spanish lady from Mexico City in 1574, speaking of the personnel who were sent out to the Philippines, 'they send two or three hundred extra men, they cannot send more because there are not many in this land.'[11]

Fortunately for the Filipinos the impact of the Spanish invasion was

minimal.[12] There was no demographic disaster, for the natives had long had regular contact with all the neighbouring cultures of Asia, and were relatively immune to new diseases. There was no economic shock in the shape of new crops (such as sugar in the Caribbean) or mining (such as silver in Mexico), which would have called for the use of intensive labour. The native population continued to develop the forms of economy it had always possessed. Rice continued to be the basic produce of Luzon, unfortunately for the Spaniards, who had to accept eating it rather than wheat, which would not grow in the moist tropical climate. They managed to bring maize with them from Mexico, but the natives did not take favourably to it.[13] They also brought cattle with them, for they could not do without meat. There had been no cattle in the islands before the coming of the Spaniards, and Filipinos had tended to live rather off fish, with occasional resort to fowl and pigs. The geography of the islands, however, was not conducive to ranching of the type known in Mexico, and cattle-raising never became extensive. Nor did mules or sheep thrive in the climate. Eventually the Spaniards took to importing Asian variants of the animals they knew, and Chinese horses became common. But even horses never had the impact on transport that might have been expected, for the topography, the climate, and the intense rains that made roads impassable all combined to reduce their utility.

Spain's success in establishing its activity in the Philippines led commentators to exaggerate the potential of Manila, regarded by one seventeenth-century Italian traveller as 'so equally situated between the wealthy kingdoms of the east and of the west, that it may be accounted one of the greatest places of trade in the world'.[14] Successive attempts to capture the port by the Chinese, Dutch, Americans and Japanese, are good evidence of the undoubted value of the outpost. But the Spaniards were never in a position to exploit their advantage adequately. 'The Philippines ought to be considered of little importance', Legazpi reported in 1569, 'because at present the only article of profit that we can get from them is cinnamon.'[15] The other much-prized spices, such as cloves, were to be found further away, in Maluku which was deemed to belong to the Portuguese. The Philippine Islands had a primitive economy, with little exploitable wealth. Moreover, the Spaniards were few in number, adventurers rather than settlers or traders.

The poor prospects for trade in the Philippines made it imperative to continue with attempts to subdue nearby territories. The small Spanish numbers were obviously incapable of undertaking an effective 'conquest' of the islands, but succeeded through a judicious combination of force and alliances in dominating the public life of the area. By the 1570s the Spaniards considered that they were masters of the Philippines, and their optimistic spokesmen began to send to Spain serious suggestions that Philip II should consider a conquest of the rest of the Pacific. It was a glaring example of the inability of Europeans to understand the complexity of Asia. Though the Spaniards were relatively secure in Luzon, they had no control over Mindanao (into which they did not venture until about 1635) and other parts of the archipelago. Muslim traders and warships, active in the islands, attacked them constantly. Manila was a highly vulnerable and isolated outpost, wholly outnumbered by native populations, subsisting not only because of its own tenaciousness but even more because of the tolerance of the two major powers in Asia, the Chinese and the Japanese. Rather than being, as it pretended to be, the capital of a colonial territory, it was little more than a small trading outpost, similar to the Portuguese outposts of Goa and Macao. When necessary, the Spanish soldiers could make armed excursions into surrounding territory, but they never effectively controlled the Philippines.

In 1569 Legazpi wrote to New Spain that because of the lack of local items to trade he hoped to 'gain the commerce with China, whence come silks, porcelain, perfumes and other articles'. All the luxury goods in the Philippines came from outside. By good fortune a link with roving Chinese traders was established in 1572, and the next year the galleons to Acapulco were able to take their first rich cargo: 712 rolls of Chinese silk and 22,300 pieces of porcelain. The impact on consumers in New Spain was sensational. 'They have brought from there', observed a lady of Mexico City, 'rich goods better than any to be found in Spain and more finished than anything of its kind in the rest of the world, such as satins, damasks, taffetas, brocades, gold- and silver-cloth, woollen shawls of a thousand kinds; chinaware finer than that of India, quite transparent and gilded in a thousand ways, so that even the most experienced persons here cannot make out how it is made; an abundance of jewels and chains of gold, wax, paper, cinnamon and quantities of rice.'[16] The shipment guaranteed Manila's commercial survival, and

established the basic pattern of the colony's economic life for the next two hundred years.[17]

Relations with the Asian mainland were strengthened in 1574 when the Manila authorities collaborated with officials of the Ming dynasty in order to repulse an attack by Chinese pirates. Thereafter the small settlement in Manila, apparently an outpost of the powerful Spanish empire, became in reality an entrepôt for the Chinese government, which carefully refrained from interfering in its affairs so long as the commercial advantages remained clear. 'The Chinese', reported a Spanish official, 'supply us with many articles, such as sugar, wheat and flour, nuts, raisins, pears and oranges, silks, porcelain and iron, and other things that we lacked before their arrival.'[18] The commerce grew and so did the population of Manila, as Spaniards from Mexico drifted there in search of opportunity. The steady traffic created by the arrival of junks (a term applied in our day to small coastal vessels but used at the time for large masted ships of between a hundred and six hundred tonnes)[19] from mainland China, guaranteed prosperity to the small colony. The few hundred Chinese sailors who came in the three junks that initiated the trade in 1572, swelled to a registered six thousand five hundred and thirty-three visitors who were estimated to have come from Southern China in the year 1605.[20]

The galleon trade also gave an enormous boost to the immigration of Chinese[21] from the nearby mainland, mainly the province of Fukien. The Ming dynasty followed Confucian principles of public conduct, and disapproved of trade with foreign nations, Asian or otherwise. Despite disapproval by their regime, the merchants of south Fukien took an active part in overseas commerce; they began settling in Manila from the 1570s and in the Japanese port of Nagasaki from 1600. When the Spaniards first arrived in Manila there were about a hundred and fifty Chinese in residence. By 1586 the Chinese population of Manila, known to the Spaniards as 'Sangleys', numbered ten thousand, easily dwarfing the Spanish and mestizo population of around eight hundred. They were the first large colony of Chinese ever to be established outside mainland China.[22]

The Spanish authorities were logically alarmed by the flood of immigrants, and in 1582 created a special quarter of the city, known as the Parian (from the local Chinese word for 'marketplace'), to which the Chinese were in theory restricted. It was impossible, however, to avoid

the reality that the immigrants from the mainland monopolized retail trades and dominated the crafts and agriculture. 'The truth is', Antonio de Marga admitted in the 1590s, 'that without these Sangleys it would be impossible to maintain the town, for they operate all the trades.'[23] The fact is seldom reflected in the references made by Spanish historians to their Asian empire. At the same period a Jesuit reported that 'from China come those who supply every sort of service, all dexterous, prompt and cheap, from physicians and barbers to carriers and porters. They are the tailors and the shoemakers, metalworkers, silversmiths, sculptors, locksmiths, painters, masons, weavers and every kind of service.'[24] The growth of Manila was at every stage made possible only by the Chinese merchants, artisans, farmers and general labourers who contributed by their work, investment and imports to the development of one of the most thriving 'European' cities of Asia.[25] It was in practice the *only* city in the Philippines. Many other small settlements grew up, thanks largely to the efforts of Spanish missionaries, until they reached a total of around one thousand by the end of the colonial period, but they were not significant as urban centres.

Though the Spanish presence in the Philippines was a small one, it was maintained thanks to a certain common interest among the races. All the residents united resolutely to defend themselves against attack from outside. In 1597 when Muslim pirates from the islands of Mindanao and Jolo attacked Luzon, the population drove them off successfully. In October 1603 the Spanish mounted an expedition within Luzon against the Sangleys; a common anti-Chinese sentiment united the two hundred Spaniards, three hundred Japanese and fifteen hundred Tagalogs who took part.[26] But tensions between the Manila communities also erupted occasionally into bloody violence. There were massacres of the Chinese by Spaniards, chiefly in 1603, 1639 and 1662, with the active help of the Filipinos, who were always willing to get rid of the Chinese. The brutal treatment of the fundamentally peaceful Chinese population was always counter-productive. After an estimated twenty-three thousand of them had perished in the massacres of 1603, Morga reported that 'the city found itself in distress, for since there were no Sangleys there was nothing to eat and no shoes to wear'. The majority of remaining Sangleys emigrated to the mainland, leaving a community of about five hundred. By 1621, however, their population had again risen, to twenty thousand.[27]

The Spanish population, by contrast, failed to grow. As late as 1637 Manila counted only a hundred and fifty Spanish households within its walls, an incredibly small number after some eighty years of colonization. The lack of European women forced the settlers to marry Asians, and a population of mixed blood rapidly came into existence. As in the New World, Spaniards employed the indigent peoples in tasks for which they were not suited or prepared, with negative consequences for the native economy. The bishop of Manila, Salazar, complained in 1583 of 'the excessive work to which they subject the natives, leaving them no rest nor time to sow their lands, so they sow and harvest less'. In particular, natives were used as manpower for the constant expeditions that were made around the islands, with the result that 'a great number of them have died'.[28] 'They treat the natives worse than dogs or slaves', was the indignant conclusion of a report drawn up in 1598 on the clergy of Luzon.

The demand for labour led to an important new element in the demography of the Philippines. To make up for the general shortfall in manpower, and also to recruit household help, all Spaniards during the sixteenth century imported African slaves, who were traded to East Asia by the Arabs and the Chinese. 'The country is flooded with black slaves', according to an observer at the end of the century.[29] As in the New World, blacks did not long remain slaves, and soon made themselves into a vital component of the labour force. In 1638 the number of free blacks serving in Manila as soldiers, labourers and sailors was estimated at around five hundred.[30] In the end, the city became a thriving commercial centre in which the Spaniards formed only a small part of the population. 'The diversity of the peoples who are seen in Manila and its environs', reported a friar in 1662, 'is the greatest in the world, for these include men from all kingdoms and nations – Spain, France, England, Italy, Flanders, Germany, Denmark, Sweden, Poland, Muscovy; people from all the Indies, both east and west; and Turks, Greeks, Persians, Tatars, Chinese, Japanese, Africans and other Asians.'[31]

The sailing-ships on the Pacific were, like the early vessels on the Atlantic, entirely at the mercy of the winds. They had to contend not only with two quite different wind systems in the north and south Pacific, but also with the seasonal monsoons and regular typhoons in the Asian islands. Early vessels, like those sent out by Cortés to Maluku in 1527, had no

difficulty sailing westwards to their objective, but failed completely to find a way back. Survivors had no option but to return to Europe via the Cape of Good Hope. Villalobos and his ships likewise failed to return. The first vessel to make the eastward journey across the Pacific was one that deserted from Legazpi's expedition in 1565. The first to make a carefully recorded return voyage was another ship from the same fleet, under the command of Legazpi's grandson Felipe de Salcedo but piloted by the veteran Urdaneta. It was sent back to Mexico with a small shipment of cinnamon and reached Acapulco in Mexico in September 1565, after a four-month crossing that took advantage of the favourable winds at a latitude of around 40° north. The achievement was historic: for the next two centuries galleons commuted every year between Manila and Acapulco, sticking closely to the well-tried route and suffering mishap only in the event of bad weather or war. The itinerary remained thereafter the basic one followed by all Spanish vessels coming from Asia.[32]

The establishment of an ocean route did not lead, as it had done in the Atlantic, to imperial expansion. It is true that there were serious doubts, aired in the council of the Indies in 1566, about whether the line of demarcation in the Pacific allowed Spain to operate in the Philippines and the Spice Islands, but in practice these scruples were ignored. Sailors spread stories of fabulous wealth on legendary islands, especially two, known as 'Rica de Oro' (Gold Rich) and 'Rica de Plata' (Silver Rich), which tantalized the appetite of adventurers throughout the sixteenth century.[33] But there were few vessels, whether Asian or European, on the Pacific, and those engaged in long-range trade always gave priority to a safe arrival rather than hazardous exploration. The Spaniards occasionally touched at islands, such as Papua (1528) and Tahiti (1567), that might give them reliable shelter on their long voyage, but never found an adequate stopping-place.

The lack of a halfway port on the Pacific crossing always remained a major obstacle that never ceased to prove fatal. Ships' captains were urged by Spain to keep a lookout for the legendary islands. In 1611 the merchant Sebastián Vizcaino, whom we shall encounter later, crossed to Japan from Acapulco and then on his way eastward made a fruitless search for them, which took several months, declaring decisively on his return to New Spain that 'there are no such islands'. In practice, the Spaniards lacked the means to explore the Pacific, and therefore missed,

among other places, the islands of Hawaii, which lay at a latitude (20° north) midway between the routes and currents normally used by their vessels. Hundreds of galleons crossed both ways across the Pacific during more than two centuries, yet never once chanced on the advanced native civilization of Hawaii.[34]

Attempting to establish alternative routes was a thankless task. Alvaro de Mendaña with two ships (and Pedro Sarmiento de Gamboa as his second-in-command) made a voyage from Peru in 1567 towards Maluku,[35] and came upon an archipelago which he named the Solomon Islands (among the isles that received names were Guadalcanal and San Cristobal). The Spaniards had a brief but bloody encounter with the natives, and returned to Callao via California. Mendaña returned to the area with 4 vessels and some 380 intending colonizers in 1595. Their first landfall was at islands that he named Las Marquesas de Mendoza, after the wife of the then viceroy of Peru. By the time the newcomers left two weeks later, two hundred islanders had been killed. The fleet went on to the Solomons, but after two months struggling against the lack of their accustomed food, the unfamiliar climate, and a spate of deaths including that of Mendaña himself, the colonists withdrew. Sailing past New Guinea, they arrived starving in Manila early in 1596.

In the absence of any other centre of settlement in the whole Pacific, the Manila galleons were the only lifeline between New Spain and the Philippines. With the whole economy of Spanish Manila depending on them, they braved the winds and made the voyage once every year from Acapulco to Manila, and back again to Acapulco. In the last decades of the sixteenth century, as many as three or four ships might sail together. In 1593 the Spanish government, responding to years of protests from traders both in America and in the peninsula, restricted the sailings to two ships a year, with a limit on the amount of goods they could carry. Later, in 1720, a decree established that two ships should be the rule, though it remained normal for only one ship to do the crossing.

The sailings were unique in world history. The first galleon crossed the Pacific in 1565, the last sailed in 1815: for two and a half centuries the ships maintained, almost without a break, their perilous and lonely voyage across the vast ocean. Vessels sailed from Cavite in Manila Bay in June or July, helped by the monsoon winds out of the southwest.

They drifted for five or more months across the Pacific. When they arrived in Acapulco a fair was held at which the goods were traded. At Acapulco they loaded up with silver and passengers, then returned in March to catch the northeast trade winds back across the Pacific.

The trip from Manila was the 'longest continuous navigation in the world',[36] lasting an average of six months, though there were ships that did not make it in less than nine. The voyage was always accompanied by high mortality, without counting the extreme risk from storms. A witness in Mexico reported how one vessel, the *Mora*, 'left China on the first of July 1588 and arrived in Acapulco on the third of February, after forty-three people had died on the voyage'.[37] There were many terrible cases, like the *Santa Margarita* in 1600 which was beaten about by storms and in eight months was only able to reach the Marianas, by which time a mere fifty of the two hundred and sixty on board had survived; of the survivors all were killed by natives save one who escaped to tell the tale. In 1603 the *San Antonio*, which carried the richest cargo known till that date, as well as many of the Spanish élite fleeing from the Chinese uprising in Manila, was simply swallowed up by the sea somewhere out in the Pacific.[38] In 1657 one ship reached Acapulco after more than twelve months at sea: all on board were dead. Laden with fabulous treasure and the coveted prey of all, the vessels succumbed to the enemy only four times and always to the English: in 1587, 1709, 1743 and 1762.[39] Many more, unfortunately, to a total of well over thirty, fell foul of storms or simply disappeared at sea. The return from Acapulco was shorter, an average of four months.

The conditions of life on so long a crossing are fully documented by an Italian apothecary, Francesco Gemelli, who made the voyage in 1697:

There is hunger, thirst, sickness, cold, continual watching, and other sufferings, besides the terrible shocks from side to side caused by the furious beating of the waves. The ship swarms with little vermin bred in the biscuit, so swift that in a short time they not only run over cabins, beds and the very dishes the men eat upon, but fasten upon the body. Abundance of flies fall into the dishes of broth, in which there also swim worms of several sorts. In every mouthful of food there went down an abundance of maggots. On fish days the common diet was rank old fish boiled in water and salt; at noon we had kidney beans, in which there were so many maggots that they swam at the top of the broth.[40]

The galleon trade played a key role in the evolution of links between Europe and Asia.[41] But it was not an isolated commerce. In reality it acted as spinal cord to a large body of commerce that was closely connected to it, and that extended throughout the Pacific, America and as far as the Mediterranean. Manila functioned in the first place as a centre for East Asian trade. Silver coins from Mexico became a fundamental commodity offered by the Spaniards; the Chinese brought their goods to Manila in order to benefit from the silver, which they exported to China. American silver in this way stimulated the Asian economy. In the peak year 1597 the amount of silver sent from Acapulco to Manila totalled twelve million pesos, a figure that exceeded the total annual value of Spain's trade across the Atlantic.[42] In the wake of silver, trade with America brought new foods and crops to China, most notably maize, which in later generations helped the country to stave off threats of famine. In the twentieth century, China became the world's second largest producer of maize, after the United States.[43]

The Philippines were also a traditional part of the Japanese trading system. It was reported from Manila in 1575 that 'every year Japanese ships come loaded with trading goods', and that they also brought 'ever-increasing amounts of silver' from the productive Japanese silver mines.[44] It has been calculated that between 1615 and 1625 an estimated 130–160,000 kilos of silver were exported from Japan, an amount that represented about 40 per cent of the total world output apart from that of Japan.[45] The trade with Japan, however, did not last long. The Spaniards had their own silver from Mexico and though they may have desired it they did not in principle need Japanese silver. Moreover, the traders of Manila recognized the prior interests of the Portuguese at Macao, and did not compete with them. In any case, the problem of religion – as we shall see – soon cut short the links between Spaniards and Japan.

In time, therefore, the little outpost of Manila, whose future had seemed bleak to Legazpi when he first settled it, became the lifeline for the trade of East Asia with Europe. 'From China', commented a Spanish Jesuit in 1694, 'they began to bring their rich silks when they saw our silver, and also provided the islands with cattle and even with ink and paper. From India and Melaka there come to Manila black and white slaves, both men and women, hardworking and industrious, and from

Japan a great amount of wheat, flour, silver, weapons and other things.'[46] The Portuguese in Macao played a key part in the trade. Chinese silks, inevitably, represented a threat to European producers. A director of the Dutch East India Company (the VOC), Van der Hagen, wrote in 1619 that since most of the silk went directly to Europe from America it would be fatal to the silk industry of Holland. The Dutch in Indonesia therefore waged an active campaign against the junks, and in 1622 alone they destroyed eighty off the China coast.[47]

The positive results of a successful external trade, however, were a contrast to the internal impact on the Philippines. Morga reported in 1596 that the settlers had neglected both defence and agriculture: 'this trade is so great and profitable that the Spaniards do not apply themselves to or engage in any other industry'. The colonists invested in the galleons but not in their own lands; around 1600, no more than five or six Spaniards in all Manila were active farmers.[48] In contrast to the extensive development of great estates by both Spaniards and Portuguese in the New World, in Asia the Spaniards ignored agriculture. 'The Manileños have no lands', an eighteenth-century French visitor reported, 'and so no assured income.' The main reason may have been the absence of an easily exploitable fund of slaves, but on the other hand the Spaniards could have made use of paid native labour. Whatever the explanation, the undeniable consequence was that the Spanish population depended heavily on food imports for survival. Only a small number of the junks trading to the islands brought goods for the export market, the majority carried food. Of ten Chinese junks captured by the Dutch in the area in 1617 seven were 'fruit junks' with food for the Spaniards, only three carried silks.[49]

Manila developed into a showcase of the best and the worst that Western colonialism could offer to other peoples. It was at its best as an international mart, at which the most incredible riches changed hands between traders from all parts of the globe. First in importance came the silk cloths, of every type and quality, as well as the superb variety of silk apparel and stockings, all of it from China. Then came the cottons, some from Mughal India but also from China, as well as gold and jewellery, ivory and jade and porcelain, and perfumes such as musk and camphor. The varied and precious spices came from Maluku, but also from Java and Ceylon; only cinnamon came from the Philippine Islands themselves. It rained riches, but solely for the brief season – at most

three months in the year – when the fair was held and the goods prepared for loading on the galleons. After that Manila relapsed into indolence for nine months.

The Spaniards did not work, for they did not need to. As a consequence, not a single aspect of the resources of the islands was ever developed by them. At the beginning their enthusiasm was fired by evidence of gold, and Legazpi reported the natives wearing gold ornaments. An expedition to northern Luzon in 1572 commanded by Salcedo did succeed in returning with fifty pounds of mined gold.[50] But the hostile natives killed Salcedo during a second expedition, and the Spaniards thereafter decided that it was impossible to develop mining, both because of the impenetrable country and because of the lack of a labour force. In later years efforts were made to mine gold, which was exported in limited quantities to New Spain. But there were great difficulties in establishing mines and finding the necessary labour, and the profits from the galleon were much greater. It was an astonishing case of the complete dereliction of a patrimony by its owners. The privileged few lived in a paradise that they never exploited. When the British captured the city in 1762 (Chapter 10) they were profoundly disappointed by the contrast between its reputation and its poverty. The eighteenth-century French navigator La Pérouse commented that 'the Philippines resemble the estates of those great lords whose lands remain uncultivated though they would make the fortune of a great number of families'.[51]

At the end of the eighteenth century the wealthy citizens who controlled the city of Manila made their own unequivocal assessment of the situation.

The Spanish conquerors of these islands did not leave Spain to take up the plough in the Philippines, much less did they undertake so long and unknown a navigation to set up looms and transplant new fruits. That which led those great men to abandon house and country and to face so many dangers was their interest in gold and spices. The natural inclination of men to seek their fortune by the shortest road led them to migrate with the sole aim of freighting the Manila galleon. None but Spaniards of adventurous temper have ever come to the Philippines, and they have not been suited for the development of industry. Since the founding of this community there has not been, nor is there now, any other means of conserving the islands, than the Acapulco ship.[52]

Spaniards appeared in East Asia at a crucial period of its evolution, when the hitherto dominant Ming dynasty of the Chinese empire was in decline and tributary states such as Japan began to assert their autonomy. China was for its rulers the centre of the universe, the 'Middle Kingdom', a superior and self-sufficient civilization that claimed to despise other civilizations. Foreign trade was deemed unnecessary, but because it none the less happened all imports from overseas were classified as 'tribute' and all exports were considered 'gifts'. In effect, foreign trade was banned until the year 1567, when the dynasty permitted two main trading areas: to the west (Southeast Asia) and to the east (Japan and Manila).[53] When the foreign Manchu emperors of the Ching dynasty began their conquest of China in the mid-seventeenth century, the warlords in the south (among them the redoubtable admiral Cheng Chengkung, known to foreigners as 'Coxinga') remained faithful to the Ming and continued the policy of trading. When Ming resistance finally ended in 1683, the Ching rulers adopted a more open trade policy, and lifted all bans in 1684.

In Japan the traditional system of government, in which supreme power was exercised by a 'Shogun' in the name of the emperor, was unable to resist internal dissension. Many of the great *daimyos* and their noble vassals (the *samurai*) enjoyed great autonomy, engaged freely in trade and welcomed the appearance of Portuguese merchants and missionaries. After 1570 power in the Japanese Islands was taken over by two famous leaders, Toyotomi Hideyoshi (1536–98) and, after his death, by Tokugawa Ieyasu. They presided over the gradual unification of the islands and the consolidation of military power under a new Shogunate in 1603, based in the city of Edo. Hideyoshi's dream was to overthrow the Chinese empire and establish Japan's supremacy in the region. To this end he sent an immense army into Korea (1591–1592), at the same time as he sent out threatening missives to Taiwan and the areas of the Pacific, including the Philippines, which had previously been (under their Japanese name Ruson) an important trading area.

The receipt in Manila in 1593 of Hideyoshi's letter profoundly disturbed the small Spanish community, which relied exclusively on Japan for some of its necessities and was in no position to resist an invasion. In 1594 governor Luis Pérez Dasmariñas in response sent a special mission to the imperial Japanese court, bearing gifts of European

clothing together with a conciliatory message. A Franciscan friar who accompanied the mission saw with his own eyes the unbelievable might of the Japanese nation. He expressed his astonishment at the power of the emperor to conjure up for his service tens of thousands of warriors, 'in amazing numbers'. On one occasion he saw over fifty thousand soldiers being employed to construct a new city, and reported that the quantity of men sent to the war in Korea were 'infinite in number'.[54] Manila, he concluded, must be on its guard.

Hideyoshi favoured the extension of trade, and encouraged the growth of silver mining, which helped to finance it. But he wished to control the terms on which commerce was conducted. When he paid a visit to Kyushu in 1587 he discovered that the local lord of Nagasaki had ceded the port to the Portuguese Jesuits seven years before.[55] He thereupon made what was, for Europeans, a momentous decision: to expel the Portuguese Jesuits from Japan, while still continuing good relations with the Portuguese merchants. In practice, he suspended the operation of the decree, and the Jesuits continued their work discreetly. Hideyoshi's decisions were in fact unpredictable. The most serious conflict arose over the fate of the Mexico-bound Manila galleon *San Felipe*, which was wrecked on the coast of Tosa (island of Shikoku) in 1596.

First the local population and then Hideyoshi's agents seized the cargo of the wealthy galleon, despite the protests of the Spaniards. 'The loss of this ship was a very great one', Morga wrote from Manila to Philip II, 'she was worth a million and a half pesos.' But worse was to come. The pilot of the ship boasted to the Shogun's agents of the power of the Spanish empire, and the part to be played in it by the Franciscan friars who were on board. The affair precipitated the first serious persecution of Christians, whom the Shogun considered a threat not only to traditional religion but also to his own control over the administration. He ordered the execution of twenty-six Christians; the number consisted of seventeen Japanese laymen, three Japanese lay brothers, and six foreign Franciscans. They were crucified at Nagasaki on a cold winter's morning in February 1597, after being subjected to public humiliation. In reply to a protest from the governor of the Philippines, Francisco Tello, the Shogun argued that 'if Japanese went to your kingdoms and preached the law of Shinto, disturbing the public peace, would you be pleased? Certainly not, and therefore by this you can

judge what I have done.'[56] 'I will', he decided, 'that there be no more preaching of this law.'[57]

The situation changed in 1600, when the supporters of Hideyoshi's son and heir were routed in battle by Ieyasu (1542–1616), who established his Tokugawa dynasty as shoguns of Japan for the next two and a half centuries. Despite the continuing fragility of the Christian presence in Japan, Ieyasu favoured trade with the Spaniards, and by 1609 the commerce between Nagasaki and Manila had reached proportions that preoccupied the Portuguese, formerly the chief purveyors of goods from Japan. Between 1600 and 1635 more than 350 Japanese ships went to Asian ports with an official permit to trade. Many of the Japanese merchants were in fact Christians who used the trade as a way of keeping in touch with the outside world. Since they did not usually wish for Mexican silver from the Philippines, they took back Chinese silk, Spanish wine and glass, and other items.

Trade with Japan was essential to the life of the Spaniards in the Philippines. There was no metal or weapons industry in the islands and from the 1590s the Spaniards depended on Japan for iron, copper, nails, bullets, gunpowder, and hemp for rope. There was a great fear that the persecutions of 1597 would mean the end of imports, but the Japanese were keen to trade and from 1602 there was a fairly tranquil interchange of goods. Japan, indeed, saw the continuation of the trade as evidence of Manila's good intentions, so that from 1602 the Spaniards took care to send an official ship every year. The captains of the vessels, some of them Portuguese, were veterans of the Asian shipping routes. The instructions issued to the captain of the vessel in July 1606 show clearly the purpose of the voyage. 'The ship you are taking carries merchandise from the citizens of this town, but the only purpose and intention is to maintain good relations with that kingdom of Japan.' The instructions in 1607 were equally specific: 'the only purpose of this ship is that it goes and returns as a way of maintaining the peace with that kingdom'.[58] There was no doubt, however, that the ship was also a lifeline for supplies. The treasurer of Manila in 1607 reported that the Japan ship 'when it comes back brings silver, saltpetre, hemp for rope, flour, nails, iron and copper, all of them essential goods which we cannot do without'.[59] A priest in the Philippines commented with evident satisfaction that 'when the trade with Japan flourished, Manila was the pearl of the Orient'.[60]

The relations with Japan came to an end in the second decade of the seventeenth century, when Ieyasu became convinced that the Christians represented a threat to the state. The Spaniards made a last effort to improve their position with the Japanese. In 1611 Sebastián Vizcaíno was sent by the viceroy of New Spain on a special mission that included the task of discovering the islands Rica de Oro and Rica de Plata, but was directed principally to establishing contacts with the Japanese regime.[61] His ship, which also carried a group of twenty-three Japanese Christians returning to their country after a visit to Europe, left Acapulco at the same time as the Manila galleon did, in March 1611. On his arrival in Japan in July he sent the appropriate messages to officials and was given permission to proceed to the capital, Edo. At the end of the month he and the Japanese were conceded an audience with Ieyasu, who, however, did not show any interest in the Spaniards.[62] Although he spent over two years in Japan, travelling round the country, meeting Christians and taking soundings of the harbours for possible future use, he achieved nothing of consequence. His mission a failure, Vizcaíno returned with his vessel to New Spain, where he arrived in January 1614. It was a year of great consequence for Spanish interests in Japan, where in February a decree 'on the expulsion of the Bateren', i.e. the Jesuits, was issued by the Shogun. Till that decade, the Japanese government had limited its pressure on Christians largely to the foreign clergy and the local samurai who had befriended them and adopted their religion.[63] Now it took a much firmer attitude, directed at all Christians. In October 1614 the decree of expulsion was put into effect in reality, unlike Hideyoshi's edict of 1587. In November a large number of European and Japanese clergy left the islands for Macao and Manila.

The heroism of the galleon route served to maintain Spain's foothold in the Pacific. At every stage, however, the handful of Spaniards depended on the indispensable collaboration of other peoples, foremost among them the Chinese, the real masters of the South Pacific and of Manila. Chinese had been trading to the islands long before the Spanish came. Spaniards relied on them for the building of vessels; the ships were constructed in the yards at Cavite (Luzon), out of trees felled by indigenous labour. Chinese and Malay workmen under the supervision of Spanish experts also constructed most of the ocean-going galleons in the islands.[64] In the early seventeenth century a Philippine official

suggested, however, that it might be better to buy vessels for local use from the Japanese. 'The cost of constructing galleys and ships in the Philippines is intolerable, the little wood that there is costs blood, for the natives suffer great harm having to drag the timber by hand.' Besides, he pointed out, 'the iron has to come from Japan'.[65]

The most important aspect of all, the nature of the trade from the Philippines, was determined principally by the Chinese. With good reason the merchants of New Spain called the Manila galleon the 'nao de China' or China ship. The Portuguese also had some part in the cargoes of the China ship, for from 1608 the traders of Manila were allowed to send one ship a year to Macao to buy supplies. The official restriction was of course never observed. Macao carried on a constant and profitable trade with Manila. The Portuguese ships arrived in the Philippines every June, bringing spices, black slaves, cotton and other items from India, and luxuries from Persia; they returned in January with Mexican silver.[66] Since the trade officially did not exist, it never paid taxes, though the value of imports from Macao was put at an annual million and a half pesos.

Spaniards liked to think of Manila as an outpost of the universal Spanish empire. In reality, it existed only because of the tolerance of the Chinese and Japanese. In the 1580s there were just a few hundred Spaniards in the city; by contrast, there were over ten thousand Chinese in the 1580s and possibly thirty thousand in the 1630s.[67] Morga estimated the number of Japanese around the year 1600 at one thousand five hundred. The indigenous population, obviously, outnumbered both. The restriction of Chinese to the Parian did not avoid occasional bloody clashes. The problem of numbers continually weakened the Spanish position. A formal and comprehensive report sent by officials to the Madrid government in May 1586 pleaded for more settlers to be sent out, with the promise of freedom from taxes.[68] In practice the islands attracted few immigrants from Spain itself. At the end of the eighteenth century some nine-tenths of the resident Hispanics had come from New Spain, a high proportion of them vagrants and criminals whom the authorities had transported. The Spanish governor in 1768 calculated that there had been fourteen sanguinary Chinese insurrections since the founding of the colony, perhaps the most serious of them in 1603, when the Chinese killed nearly half the Spanish population. The Chinese dominated both the internal and the external commerce of Manila. The

bishop of Manila went so far as to claim in 1598 that 'there comes each year from New Spain a million in money, all of which passes on to the heathen of China'.[69]

Though the Spanish in the Philippines were few in number and their impact limited, they like their predecessors the Portuguese were able to capitalize on a small advantage: possession of firearms and especially of ship's cannon. Firearms were of course already known in the east (the Arabs and Chinese had used them), but never formed part of the Asian technology of war. When the Portuguese captured Melaka in 1511 they were surprised to discover a large stock of cannon that the defenders had apparently used only for ceremonial purposes. Subsequently, when they realized the possible advantages, Asian princelings employed Portuguese to make cannon for them. The Japanese quickly learnt from the Portuguese and began to use firearms as well as cannon. One of the most important moments in Asian history was in 1526 when Babur, the founder of the Mughal dynasty in India, used guns and heavy artillery to help him overthrow the sultanate of Delhi at the battle of Panipat.

However, in terms of the alleged military impact of Europe on Asia the employment of firearms was only of marginal value. Europeans never came to dominate the indigenous civilizations of East Asia in the first three hundred years of contact, and the part played by firearms in this picture was (as in the New World) little more than anecdotal. Deadly use of arquebuses and cannon against a relatively defenceless civilian population showed that Spaniards could kill indiscriminately but achieved little else. In the Philippines the natives simply vanished into the bush, which allowed the invaders some breathing space and helped to facilitate settlement. But there were never enough firearms or Spaniards to bring about any real 'conquest' of anything, and Western weapons never played a significant role.[70] Nor in the islands was it practical to launch cavalry charges, as Pizarro had done in Peru, with the few horses imported from New Spain (the first horse came to the Philippines only in 1575).

Europeans in Asia had to contend with the fact that native civilizations always fought back, and always successfully.[71] Contact with firearms did not significantly affect the nature of their land warfare against Europeans. In cases when they took over the use of firearms, the

armaments simply reinforced traditional weapons in established war strategies,[72] and impressive items such as cannon were often kept purely as symbols of power rather than as a means to acquire power. Possibly the only context in which Europeans achieved an important advantage against Asians was when they brought cannon into play from on board a ship.[73] This gave them unquestioned mastery at sea, and quickly condemned unarmed vessels such as the Chinese junk to a defensive role.

The Spaniards in the Philippines, however, were always in a vulnerable position. When they needed firearms they had to import them from Japan. Any technological advantage they may have enjoyed over Asians became purely theoretical. They successfully adapted the Mediterranean galley for use in Asian waters, and were quickly imitated by the Chinese. But the galley had its limits in terms of the waters it could navigate. For rapid manoeuvres the Filipinos who attacked Spanish settlements preferred the *caracoa*, which used eighty to one hundred rowers and was ideal for the coastal waters of the islands.

'Conquest' in any real sense was never achieved through advanced armaments, and became possible only when Europeans were able to recruit indigenous manpower. Auxiliaries from south India, for example, achieved the Portuguese conquest of Melaka; the Portuguese could not have done it alone, with or without firepower.[74] Elsewhere Europeans survived simply because it suited the local authorities to tolerate them. Their numbers were in any case almost negligible. It has been estimated that in any one year between 1600 and 1740 there were not more than fifty thousand Europeans to be found in the whole of Asia,[75] a figure that pales before the scores of millions who peopled the continent and continued their lives quite oblivious of the existence of strangers on their shores. In mainland Asia in 1576, according to an Italian Jesuit who worked along those coasts, there were possibly around three hundred Spaniards, mostly traders within the Portuguese areas of influence. The colony at Manila was a good example of the fragile European presence. One of the higher estimates for the number of Spaniards in the islands was given by Giovanni Botero, who reported in the 1590s that 'the number of Spaniards there amounts today to one thousand six hundred, of whom less than nine hundred are soldiers'.[76] The totals were certainly optimistic. A census of the year 1584 reported that there were only 329 'Spaniards' in Manila available for military service, and no more than

713 in all the Philippines, the term 'Spaniard' being one that also included those of mixed race. Four years later the bishop of Manila stated that there were only eighty Spanish householders in the city.[77] It was a small base on which to construct the domination of the most populated continent on earth.

After two generations of successful settlement in America, however, it was difficult for Spaniards to rid themselves of the 'conquest' mentality when they ventured into the Pacific. The colonization of a tiny corner of the Philippines did not by any means end their ambitions in East Asia. Explorers continued at intervals to penetrate in other directions. We have touched on the expeditions of Mendaña to the Solomon Islands. Shortly after, in 1605, the Portuguese captain Pedro Fernandes de Quirós landed in the New Hebrides, which he claimed for Spain under the name of 'Austrialia del Espíritu Santo' 'Australia [i.e. the "southern lands"] of the Holy Spirit'. The southern islands, however, had no visible wealth to exploit and were inhabited by primitive tribes. Quirós went back to Spain and spent years trying to convince the court to grant him funds to explore the great undiscovered continent to the south of the Pacific, but it was all in vain. Spanish pretensions were set on the more attractive cultures of mainland East Asia, which offered opportunities for trade, possibilities of evangelization and hopes of imperial expansion. A Spanish Australia, which almost lay within the grasp of the Portuguese navigators, never came to form part of the empire.

The most desirable area of expansion was the Spice Islands, theoretically under control of the Portuguese, to whom the Spaniards gave support for most of the sixteenth century. This situation changed when in 1605 the Dutch arrived and expelled the Portuguese from Ternate and Tidore. The Portuguese withdrew to Manila, from where governor Pedro Bravo de Acuña in the following year launched an expedition to drive out the Dutch. Using troops from Manila and a thousand Filipino auxiliaries, he expelled the intruders and set up a Spanish fort – the first of its kind in Maluku – on Ternate. In 1612 the administration of the garrisons was officially put under that of Manila. The Spaniards developed a small town on the island, populated by Moluccans, Chinese, Filipinos, Portuguese and Spaniards, and also maintained bases in Tidore, Gilolo and Pilolo. The coming of the Spaniards was seen, through the vision of the Aragonese historian Argensola far away in his library in Saragossa, Spain, as a triumphant conquest of the archipelago of

Maluku.[78] The reality was that, like other European settlements in Asia, the bases were tolerated by local rulers because they posed no serious threat. The Spanish garrison on Ternate did not exceed two hundred men, and on Tidore one hundred and fifty.[79] The sultan of Ternate, meanwhile, had an army of four thousand men armed with muskets and swords and could afford to ignore the quarrels of Europeans, who benefited his realm by their trade.

The Dutch continued to have a base on Ternate as well as in the other islands. They were now the most formidable European power in Asia, with bases already in Java, Sumatra, Borneo, Malaysia and India. Their large and well-armed ships easily outmatched anything the Portuguese and Spanish could put up against them. The Spaniards hung on grimly in Maluku, resisting Dutch attacks and the dissolution in 1640 of the union with Portugal. Meanwhile they managed to get hold of a good part of the trade in cloves: in 1640 it was estimated that they exported nearly as much as the Dutch did.[80] In practice the whole adventure was a costly mistake. In 1640 the financial cost of supporting the Spanish presence in Maluku was almost equivalent to the value of the annual situado received from New Spain.[81]

It was above all the missionaries, their enthusiasm always running ahead of realities, who felt that their presence in the Pacific was an omen of great events. Early successes at conversion in Japan, and the continuous threat from Muslim princes and pirates in the South China Sea, emboldened them to take more positive steps. It seemed a particularly good idea to capitalize on the traditional hostility between Japan and China, and use Japanese help against the latter. They pressed on Philip II the need to conquer all Asia; one or two of them went, all alone, to the mainland of Southeast Asia, confident of success. When the king got wind of such proposals, he always played them down. 'Touching the conquest of China which you feel should be undertaken at once,' he wrote to the zealous governor of the Philippines in April 1577, 'the opinion here is that the matter should be dropped, and instead you should cultivate good relations with the Chinese and not give aid to the pirates who are their enemies, nor give them any just cause for annoyance with us.'[82]

His caution was lost on the colonists in the Philippines, who felt that their precarious position could only be remedied by a firm occupation of the mainland of Asia. Francisco de Sande, third governor of Manila,

felt that six thousand men would be enough to conquer the whole of China. The successful occupation of Portugal by the Spanish crown in 1580 unleashed the imperialist and messianic imagination of the king's subjects, among them some Portuguese clergy. The Portuguese bishop of Melaka in 1584 urged Philip II to undertake the conquest of the nearby Muslim sultanate of Atjeh, and after that to take over the whole of Southeast Asia. 'All this', the optimistic prelate assured the king, 'can be accomplished with four thousand men.'[83] The Portuguese Jesuit Francisco Cabral, writing from Macao in June 1584, assured the king that the conquest of China would be easy using only three thousand Japanese Christians, for the Japanese (he said) were a warlike race. In the same months the authorities in the Philippines expressed an identical view. The bishop of Manila suggested to the king that Japanese warriors be used, and the governor of the town assured Philip that 'the enterprise of China is the greatest and most profitable and most noble one ever offered to any prince in the world, and also the easiest'.[84]

In the same decade Philip II's own cosmographer, the Neapolitan Giovanni Battista Gesio, whose enthusiasm at the occupation of Portugal inspired him to offer opinions on broad matters of imperial policy, advised the king that Luzon was as strategically important as Flanders or Italy. Gesio had already made the government happy by informing them that the Philippines lay well within the area of the Pacific demarcation line allotted to Spain. He now looked further ahead to the possible conquest of all the lands that had been assigned to Spain, and assured Philip that Luzon should be the base 'for the enterprise of Japan and, much more important, of China'.[85] These were the years, it should be recalled, when 'the enterprise of England' was also on the king's agenda.

Perhaps the most ambitious of the proposals was a petition dated 26 July 1586, signed by all the officials of Manila and taken to the council of the Indies in Madrid by the Jesuit Alonso Sánchez, a resolute supporter of the invasion of China. The move was probably inspired by the visit made earlier that year to Manila by a group of eleven Japanese Christians from Nagasaki. The memorial recognized the immense power of China, described as a high civilization 'superior to us in everything except salvation of the faith'.[86] Notwithstanding, it proposed an invasion force of twelve thousand Spaniards, brought in specially from the New World or even from Spain, plus six thousand Japanese allies (obviously to be

recruited from the many Christians in that country) and an equal number of Filipinos. The dimensions of this army, surpassing anything attempted by Spain in its entire history as an imperial power till that date, was at least evidence that the proposers were aware of the enormous task that would face an invasion. In every other respect the plan was a flight of folly. Sánchez sailed for New Spain, and eventually reached Madrid in January 1588. It was the very worst moment to suggest a military adventure, for the Great Armada against England was just about to sail and the king had neither mind nor money to attend to anything else. The Jesuits in Madrid were appalled by Sánchez's plan and their new superior, José de Acosta, a veteran of the Indies, went to talk to him. Acosta roundly rejected any idea of military intervention in Japan or in China, basing his argument on the high culture and civilized government of the states of Asia, which he contrasted with the 'primitive' societies that the Spaniards were combating in the New World.[87] The Sánchez proposal came to nothing, but it was not the end of such ideas. In March 1588 a Spanish Augustinian friar in Macao suggested to the king that four thousand Japanese Christian warriors under Spanish leadership could easily conquer all China.

There were always adventurous spirits among the Spaniards in Asia. A handful of Spanish mercenaries offered their services to the king of Cambodia in his wars against Thailand, but their protector was defeated and they were taken off as prisoners.[88] They later escaped to Manila, and proposed to the governor in 1595 a military alliance with Cambodia against Thailand. They argued that one thousand Spaniards (or only three hundred, if Cambodia also helped) would be sufficient to conquer all Thailand, a move that would open the doors to the riches of Asia and the 'conquest of the entire mainland'. The young governor Luis Dasmariñas embraced the plan with great enthusiasm. In January 1596 an expedition of three small vessels and a hundred and thirty men set out from Manila for Cambodia. After over seven months of fruitless wandering, the majority of them returned frustrated to Manila, where the outcome of the expedition confirmed the opposition of some Spanish leaders to military adventurism. However, a few Spaniards continued to make their way to Phnom Penh, capital of Cambodia, and took part in power struggles at the royal court in the years 1598–9, but were finally and bloodily eliminated by the Muslim groups that were in the ascendant. The irrepressible Dasmariñas, meanwhile, on his

own initiative had mounted in 1598 an expedition of over a hundred men that was scattered by storms in the South China Sea. Of the three vessels only one, with Dasmariñas on board, made it to mainland Cambodia. The men survived a year and a half before returning to Manila.[89]

Dasmariñas's successor as governor, Francisco Tello de Guzmán, was no less optimistic about the capacity of the Spaniards in Manila to conquer Southeast Asia. 'If there were six hundred spare Spaniards in these islands, and the money, one could conquer the kingdom of Siam', was his view in 1599.[90] He yearned for expansion, as a way of compensating for the evidently weak and exposed position of the Spanish colony, where at any time an alliance between Chinese, Japanese and Filipinos could wipe them out. In the event he managed to achieve a written treaty of friendship with Thailand in 1598, the first formal link ever agreed between Thais and Spaniards, though nothing further came of it. The idea of extending conquests largely as a protective measure seems to have been strong in Manila. A memorandum of 1596 to Philip II from Dasmariñas's son, Luis Pérez Dasmariñas, recommended the occupation of Taiwan as a way of defending the Philippines against a possible threat from the Japanese and the Chinese.

Decades of empty proposals and of failed expeditions, however, may well have served to convince many in Manila that the occupation of Asia was unrealizable. Morga, who served as judge in Manila from 1595 to 1602, was one of those who opposed all schemes for conquest. At the dawn of the seventeenth century the idea of an empire in the east – an idea that had never been seriously entertained in Madrid – had faded, to be replaced by the reality of rivalry with the Dutch and English. By the same date the missionaries had also given up hope of a rapid conversion of the Asian continent. Only the Manila galleon continued to preserve the lifeline between the Spanish empire and East Asia.

The northern Pacific seemed less accessible to Spaniards who had centred their activities largely in the Caribbean, but fairly soon it became an object of serious attention. The search for wealth in this sector did not exclude another goal that the Spaniards kept well within their sights: access to a northwest sea passage connecting the Atlantic and the Pacific. The English and French, as we know, were actively involved in looking for such a passage, but Spaniards did not linger behind. They tended to

call it 'the strait of Anián', a name derived from Italian travel writings. The instructions that Charles V sent to Cortés in 1523 emphasized the importance of finding a passage, and the conqueror dutifully gave support to attempts in 1532 and 1533 but they failed, in each case because natives killed the voyagers. There were legends enough and oral reports from Indians, about fabulous peoples and places towards the northwest. Among the creative influences on the imagination was the chivalric novel *Las Sergas de Esplandián*, published in Madrid in 1510, which carried the following account:

I wish you now to learn of the strangest thing ever written or recorded by man. To the west of the Indies there was an island, called California, very close to the Earthly Paradise, inhabited by black women with no men among them, and who lived as the Amazons did.[91]

The name California came to be applied specifically to the peninsula of Baja California, which was thought to be an island when first located in the 1530s. But it was subsequently used by Spaniards to apply to all the land on the northern Pacific coast, and when explorers reached Alaska in the eighteenth century they gave it the name 'New California'.[92]

In 1539, the year before he finally left for Spain, Cortés sent an expedition northwards up the Pacific coast under Francisco de Ulloa, which had no significant results. A different voyage in 1541 was likewise uneventful. At the same period other groups were moving north through the Gulf of California: Hernando de Alarcón in August 1540 found the mouth of the Colorado river and penetrated inland. The most famous of the early voyages was that of João Rodrigues Cabrilho, a Portuguese in Spanish service, who was sent out by viceroy Mendoza in 1542. He commanded two ships that in September 1542 touched into San Diego bay, which they named San Miguel. Cabrillo Point, as it is called today, affords one of the finest views of the ocean from the outskirts of the modern city. Cabrilho continued northwards and in October went ashore and claimed possession of the land. The vessels spent the winter up north, where Cabrilho died in January 1543 off modern Santa Barbara. His ships pressed on further but turned back when they encountered bad weather, arriving at the port of Navidad, from which they had sailed, in April.

These important but random explorations achieved neither the Northwest Passage nor the wealth of the fabled California nor any

secure hold on territory. The Pacific remained an open sea, into which the English were the first non-Iberians to sail.[93] The English sea captain Francis Drake was active in the isthmus of Panama from 1570. In 1573, with the indispensable help of a group of runaway blacks (cimarrones), he pooled his resources with those of a French Protestant captain, and waylaid the silver convoy from Peru as it made its way to Nombre de Dios. It was on this expedition that Drake, like Balboa half a century before, saw the great expanse of the Pacific, and 'besought Almightie God of his goodnesse to give him life and leave to sayle once in an English ship in that sea'.[94]

His dream was realized a few years later, in a famous voyage which demonstrated clearly that the Spaniards had no real control over any part of the Pacific, either north or south. As the viceroy of Peru observed two decades later, 'the entire defence of the Indies consists more in the ignorance which enemies have of it, and the obstacles posed by land and weather, than the forces which there are to resist them'.[95] The vessels with which Drake set sail at the end of 1577 from Plymouth numbered five, among them his own *Pelican*. They were backed to the hilt by financing from the court and from investors. By the time he reached the Straits of Magellan his fleet was reduced to three ships, and he had renamed his vessel the *Golden Hind*. In the first week of September 1578 they entered the Pacific, and made a slow progress up the coast.

Early in 1579 he learnt that the shipment of silver from Potosi was being taken by sea to Panama, caught up with the Spanish vessel in March, just north of the equator, and without suffering any resistance was able to board the ship and seize its shipment of 450,000 pesos. The total impunity with which he raided and plundered at every major port from Chile northwards was astonishing. By the time he reached the coast of Nicaragua his ship was so heavy with booty that it would have been foolhardy to set out across the ocean without further repairs. The search for a safe harbour took him well past San Francisco bay, towards a cove twenty-eight miles further north that has traditionally and probably justifiably been called 'Drake's Bay'. There, during a stay of thirty-six days required to re-fit his vessel, the commander took possession of all the territory in his queen's name and called it 'Nova Albion'. He then set out across the Pacific, through the Spice Islands and thereafter round the Cape of Good Hope to Plymouth, which he reached in September

1580, the first English captain to circumnavigate the globe, after an absence of two years and ten months at sea.[96]

Drake's raid on the treasure-ship in Peru in 1579 was the first of its kind, and seems to have been the motive for resolutions in Madrid in 1581 to establish a fleet for defence. Typically, the resolutions took years to convert into action, but fortunately for Spain the Pacific was also a long way from Europe and very few vessels were able to repeat Drake's exploits. A force of five small galleons for defence was in operation by 1588.[97] Drake was followed to the South Sea by Thomas Cavendish in 1587 and by Richard Hawkins in 1593. Cavendish, a young English gentleman, was notable as the first foreign sailor ever to seize the famous Manila galleon. He entered the Pacific with three ships in 1587, attacked the port of Paita in Peru and towards Panama seized a ship from whose pilot he gathered enough information to enable him to calculate the possibility of attacking the Manila galleon. In October he was at the southern tip of the peninsula of Baja California and narrowly missed the Manila galleon *Nuestra Senõra de la Esperanza* that passed the coast in November. He was able, however, to catch the *Santa Ana*, which, after two days of fighting and successfully repelling four boarding attempts, surrendered to his vessels on 17 November. Apart from Chinese silk and other luxuries the raiders got perhaps 600,000 pesos in gold, as well as silks, pearls and jewels. The *Santa Ana* was scuttled and burnt, and its unfortunate chaplain hanged from a mast. The English then set out across the Pacific in a repeat of Drake's famous circumnavigation of the globe. Cavendish's own ship, the *Desire*, was the only one of his vessels to arrive safely in Plymouth in September 1588, just after the defeat of the Spanish Armada. Queen Elizabeth is said to have commented, on seeing the riches: 'The king of Spain barks a good deal but he does not bite. We care nothing for Spaniards, their ships loaded with gold and silver come hither after all.' In an attempt to repeat his success four years later, Cavendish perished at sea near Cape Horn.

Among the survivors from the *Santa Ana* were its Portuguese pilot, Sebastião Rodrigues Cermenho, and the Basque merchant Sebastián Vizcaíno, a man of considerable experience in the trade between Manila and Mexico, whom we have already encountered in the context of Japan and who played an important part in exploration of the Pacific coastline. In 1595 Rodrigues Cermenho returned from Manila in the galleon *San*

Agustín, making landfall in November at a point some sixty-five miles south of the California–Oregon boundary. Continuing farther south past Drake's Bay, he found an inlet which he named the Bay of San Francisco.[98] A sudden storm wrecked the galleon, and the crew had to make their way back to Mexico in a boat and without their precious cargo.

The following year Vizcaíno set out from New Spain with the objective of finding a suitable harbour on the Pacific coast, but had to turn back after an abortive attempt to found a settlement on the Baja coast. The failure of this first expedition did not deter him, and he continued to insist to the government that a suitable port be found on the northern coast for the Manila galleons. Permission was given in 1599 for another reconnaissance, and in May 1602 he set sail with three ships (and official financing) from Acapulco. Although the voyage suffered severe tribulations of sea, wind and cold (they reached their northern limits in January 1603), and the death from illness of a quarter of the crew, it was epoch-making for it touched on all the major coastal features of California, to which Vizcaíno gave names that still remain in use. Monterey Bay, which he charted and named after the then viceroy, was deemed so attractive by Vizcaíno that it became the objective of later attempts at settlement. Moreover, exceptional efforts were made to remain on good terms with the natives, who proved both amenable and hospitable.

A Carmelite friar who had been on the voyage, Antonio de la Ascensión, drew some conclusions about the possibility of extending the empire into California.[99] The first point of settlement, he said, should be the point of Baja California, which could be controlled with up to two hundred soldiers, based in a camp with a watch-tower, 'for when in lands of heathen Indians, although they may have declared themselves friendly they must not be trusted'. The camp would serve not simply as the centre for spreading religion, but also for bringing in all necessary animals and cultivating wheat. Indians should be brought in from New Spain to teach the Baja natives their music. Young local Indians should be selected to learn the Spanish language, which would facilitate the work of conversion, which should be entirely under the control of the crown. At the same time, no encomiendas of any sort should be permitted.

Vizcaíno continued to play a fundamental role in Spanish plans for

the Pacific, but not in California, his principal interest. Instead, he was dragged away to search for mythical islands and to make contact with Japan. The expansion of the empire into the northwest was thus delayed by over a century. The Audiencia of Mexico was advised in 1629, for example, that there were no obvious riches along that coast, since no gold ornaments had been found on natives, that looking for a harbour was not a priority since only a few days more would take the Manila vessels directly to New Spain, and that foreigners could not conceivably reach the area since it was such a great distance from Asia or from Cape Horn.[100] No thought was given to what then seemed impossible: that other nations would approach the Pacific from inland, or from across the land mass of the North American continent. By the 1630s officials had ceased to believe in the straits of Anián, and therefore refused to back further initiatives. Interest continued in one form or another, and individuals went pearl fishing, but the north Pacific coast beyond Cape Mendocino remained an unknown land.

In December 1552 the Jesuit missionary Francisco Xavier died of fever virtually alone on the island of Sanchian off the South China coast. Xavier, a noble from Navarre, spent his entire career as a missionary within the orbit of the Portuguese *padroado*, and both wrote and spoke Portuguese during his work. His achievements did not form part of the history of Spain's religious enterprise. Like other orders at this period, however, the Jesuits never restricted their membership by nation, and from the beginning Xavier counted with the close collaboration of Castilians who worked within the scope of the *padroado*. Long before Spanish ships established their base in the Pacific, Spanish Jesuits were beginning to build an empire for Christ in the same seas, thanks to the prior work of the Portuguese. Xavier and two Spaniards founded the Jesuit mission in Japan in 1549. Forty-three years later, when a general meeting of resident Jesuits took place at Nagasaki, five Spaniards held all the principal posts in the order; the other eight fathers attending included four Portuguese and four Italians.[101] The successes of the clergy were rapid and remarkable: the Church in Japan grew to have an estimated 150,000 members in 1584.[102]

In the South China Sea the way ahead was not so easy. The Spaniards found that Islam had arrived before them. They had been brought up in a culture that encouraged hostility to 'Moors' and Moriscos, and were

aware of the wars against the Muslims in Africa. All the missionaries in Asia, and none more than Xavier himself, were on their guard against the ever-menacing power of the crescent, which had penetrated the Mediterranean and now seemed to be sweeping across the Indian Ocean. Islam was still a fairly new religion in South East Asia, disseminated along trade routes by Arab and Chinese Muslims in specific areas only. Muslim merchants seeking spices brought their faith to the southern Philippines and Maluku. Based on his experience in the islands of the area, Legazpi felt that Islam was not so deeply rooted as to constitute a challenge. Though many natives were now Muslim, especially in Jolo, Mindanao and Ternate, their practice of the religion barely extended beyond the use of circumcision and abstinence from pork. In Luzon there was virtually no evidence of Muslim penetration. It seemed logical for Legazpi to conclude that the field was wide open for implanting Spanish religion. The indigenous population in the Philippines seemed to take readily to the new culture offered by the white settlers. The use of images, incense and rosaries, together with colourful ceremonies and attractive temples, was not so different from the public practice of Hinduism and Buddhism. The Christian God could also be identified with the power, wealth and success of those who were his followers, and the natives were not so foolish as to reject sharing in the possible advantages of this situation.[103]

Spanish religious orders arrived in the Philippines soon after Legazpi: the Augustinians were the first in 1565, followed by the Franciscans in 1578 and the Jesuits in 1581; the last were the Dominicans in 1587. Many of them had experienced disappointment with the missionary effort in America, and they now eagerly embraced the challenge to convert all Asia. It was a dream that, as we have seen, also had imperialist aspirations for conquest not simply of souls but of territory. In New Spain the great Franciscan scholar Bernardino de Sahagún, disillusioned already by the gains made for the faith there, expressed his conviction that the way ahead was in Asia. 'It seems to me that Our Lord God is opening the road so that the Catholic faith may enter China. When the Church enters those kingdoms I believe it will last for many years, for in the islands, here in New Spain, and in Peru it has been nothing more than a stopping-place on the way to coming into contact with those people.'[104] The almost mystical urge to move on from America to Asia was also shared by several other eminent missionaries of that generation,

among them Las Casas and the first archbishop of Mexico, Juan de Zumárraga.

Europeans were undoubtedly fascinated by Asia. The Augustinian friar Martín de Rada went to Fukien from Manila and in 1575 published an account of his visit, which was fortunately used by Juan González de Mendoza in his *History of the great realm of China*, published at Rome in 1585. The book went through thirty editions in the principal European languages, and provided for readers a vision of the power and mystery of the unknown east. Spanish writers were in no doubt that China had to be respected as a high civilization. It was, however, Japan that eventually most earned the fear and respect of Spanish intellectuals. The apparent success of the Jesuit mission there stimulated the popularity of Jesuit newsletters which were published in Spain. Philip II himself in 1584 gave audience to a group of young Japanese Christian nobles who were passing through on their way to visit the pope and were persuaded by the king to visit his pet scheme, the monastery-palace of the Escorial. All Asia, with its rich cultures, appeared open to the aspirations of the Catholic missionaries. In 1569 a Portuguese Dominican, Gaspar da Cruz, author of the first European book on China, suggested that the discovery of the whole globe by Spaniards and Portuguese signified that the time for the conversion of all peoples, and thus for the end of time, was at hand. 'The world shows great signs of ending, and the scriptures are about to be fulfilled.'[105]

The drive to evangelize Asia was unfortunately blighted continuously by rivalry among the religious orders. It was a long and unedifying story that brought no credit to any of the parties concerned. The incredible success of the Jesuits in Japan had been achieved through the channel of the padroado conceded to the Portuguese crown. The Portuguese clergy based their activities on the chain of settlements extending from Goa to Melaka and Macao, terminating in Nagasaki. It was also the route taken by the annual Jesuit trading ship. Though other religious orders had made periodic efforts to break into the Portuguese/Jesuit monopoly, Philip II always respected the system that divided Asia into Portuguese and Spanish spheres of influence. As soon as he died, the mendicant orders in 1599 pleaded with Philip III to rule that future missions to Japan should go from Manila and not from Goa and Macao. The pope, Clement VIII, decreed in 1600 that the priority of Goa should be maintained. The decision created uproar among the friars, principally

the Franciscans, and the controversy did not abate until a subsequent pope revoked the decree in 1608.

In the Philippines the Christian clergy had to face first of all the formidable obstacle of language. The natives spoke a bewildering diversity of tongues and dialects,[106] which varied from one island to another. Of the six major languages on Luzon, the most important in the Manila area was Tagalog. With a few distinguished exceptions, priests from Spain were usually unable to cope with the problem, though most managed some form of basic communication with their parishioners. The lack of any social contact between the tiny Spanish-speaking population in Manila, and the dispersed mass of Filipinos throughout the provinces, had the consequence that after more than three centuries of Spanish domination less than ten per cent of the population in 1900 could speak Castilian.[107] And the greater part of that ten per cent had learnt the language only after the end of the eighteenth century, when educational changes made the use of Castilian obligatory.

The task of converting the natives was made worse by the fact that few clergy were willing to come all the way out to the islands from Europe. The total length of a journey from Spain to Manila could be as much as two years, with attendant risks of illness and death; unsurprisingly, many priests sent out to the Philippines refused to go farther than New Spain. Notwithstanding all the obstacles, the Church in the islands regularly claimed to be baptizing hundreds of thousands of Filipinos every year. Soon, by the early seventeenth century, it was claimed that the Philippines were Catholic.

In reality the problems encountered by the Church here were much the same as in America, and the solutions were no more accessible. By the 1620s a leading friar was already expressing clear despair at the limited success achieved by missionaries. In effect, the quality of Catholicism never reached the levels hoped for by the clergy, but on the other hand the number of natives considered to be Christian in the mid-seventeenth century was well over half a million people. By the end of Spanish colonial rule, two types of Christianity could be found in the islands.[108] One was the religion of the Spanish clergy and the small number of colonists of Spanish origin. The other was the 'folk Catholicism' of the people, sharply differentiated from the former by both race and language. Spanish clergy lamented and regretted the division, but in perspective there were many reasons for the Filipinos to be

satisfied with the purely cultural consequences. They received from Iberian Catholicism many rich and colourful elements not to be found in their traditional religion, and at the same time were integrated into a broader social and economic role than they had hitherto experienced. Fray Domingo de Navarrete reported in the seventeenth century that 'the fervour which people used to have in Castile has been passed to the native men and women in Manila. They celebrate feast days very well, in their processions they dance, and play on the guitar.'[109] Catholicism of some sort managed to take root among the native people of Luzon and other islands. By contrast, it failed entirely among other Asians who lived in the archipelago. The Chinese feigned conversion because it helped their trade, but when in 1762 the British occupied Manila they unanimously abandoned the religion of the Spaniards.

The Church was perhaps the only flourishing sector of Spanish society in the islands. It controlled the biggest agricultural estates (though the proportion of land it held, relative to land under cultivation, was always fairly small), and was numerically the most important Spanish presence. In 1722 there were said to be over fifteen hundred religious in the islands, a figure that exceeded the total of the Spanish lay population.[110] And Church influence was always dominant. When they wished, the clergy could provoke riots against Spanish administrators they did not like. In 1719 they incited a mob that burst into the palace of Governor Bustamante and murdered him.

The vast sea that washed the shores of New Spain, California, and Peru on one side, and Maluku and the Philippines on the other, was claimed by Spain in the sixteenth century as 'the Spanish Sea',[111] and Spanish navigators certainly pioneered many of its waters. But the dimensions of the Pacific eluded any attempt to claim it as the *mare clausum* or 'closed sea' of a single nation. The Spanish and Portuguese enjoyed an initial advantage in that, unlike the civilizations of China and Japan, they were active long-distance seafarers and faced little competition from either Asians or Europeans. The natural hazards of the ocean route, particularly its terrifying storms, also deterred those who might try to break into the Spanish monopoly. But this happy situation only lasted half a century. The daring of the English, and the determination of the Dutch, soon exposed the weaknesses of Spain's claims in a virtually limitless space that they were unable to control and that became the

arena, much later, for pioneers such as Cook and Bougainville. The expeditions of Malaspina around the year 1790 came too late to reclaim for Spain a significant role in the evolution of what had once been viewed, with an undeniable but naive optimism, as their sole preserve.

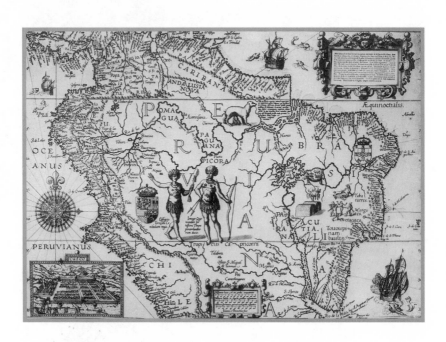

6

The Frontier

Everybody says there is not a man who would not bring his wife and children to this country so as to take them away from the want and poverty in Spain, because a single bad day here is worth more than any good day in Castile.

Alonso Herojo, from New Granada, 1583[1]

The expansion of horizons in the imperial age offered to Spaniards an almost endless range of opportunities to better themselves. They saw before them a constantly evolving frontier, whose essential component always was the hope of freedom.[2] There were enormous obstacles, such as those of distance and climate, to achieving what they sought, but very many were able to adapt to the difficulties and overcome them. The going was not always easy, as they quickly realized. Spaniards in the New World were able to overthrow the regime of the Mexicas and the Incas, but then came up against the very obstacles that had limited those native empires: the unconquered frontier. One example at the confines of the South American lands may serve. The Incas had never been able to extend their control south of the Bío-Bío river in Chile, and the Spaniards in their turn lost out to the indomitable Araucanians who controlled the area and fiercely resisted all outsiders. The conquistador Pedro de Valdivia, who was appointed governor of Chile by Pizarro, successfully penetrated southwards and in 1541 founded the town of Santiago in a land that he named Nueva Extremadura after his native country. But the way forward was blocked by the Araucanians, who captured him during an expedition in 1554, and apparently put him to death by pouring molten gold down his throat.

The frontier towards which the Spaniards pushed was also pioneered by women.[3] They were, in the first place, the women of the new lands.

The Europeans and Africans who came were overwhelmingly male, and immediately accepted the need to take indigenous women as companions. The early conquistadors were delighted to meet acceptable women among the tribes, like those in Colombia who were said to be 'fair of feature, not too dark in complexion, and with more grace than the other women of the New World'. From the beginning, Europeans were impressed by the ability of American women to defend themselves, a phenomenon that gave birth to the pervasive legend of the Amazons, whose existence was mentioned in the letters of Cortés. Even far out in the Pacific, Pigafetta claimed to have heard a report that 'on the island of Ocoloro, south of Java, there live only women, who kill men if they dare to visit the island'.[4] By the 1530s in Colombia a report from Bogotá stated that 'we heard of a nation of women who live apart, without men, for which reason we call them Amazons'.[5] The historian Oviedo mentioned several Spaniards who claimed to have heard of the phenomenon, although by contrast at least one conquistador, Nuño de Guzmán, when he spoke to Oviedo in 1547 referred to the legend as a 'monstrous lie', because he had been in those parts and seen nothing to confirm it.

The chroniclers without exception narrate stories of heroic native warriors, like the girl in the vicinity of Cartagena who killed eight members of a landing party before she was overpowered, or the women of the Urabá region who 'go to battle with their men'. Without the support of the women of the new lands, life for the invaders would have been intolerable. Cortés owed the success of his expedition in large measure to Marina, who had been given to him along with nineteen other women of the Tehuantepec coast, when he was on his way to Mexico. He already had a wife in Cuba, Catalina, and he never married Marina. But she gave him invaluable help as an interpreter, and bore him sons; later she married an encomendero of Xochimilco. 'Without Doña Marina', Bernal Díaz wrote succinctly, 'we would not have understood the language of Mexico.' Many other conquistadors, great and small, took native mistresses or wives, particularly from among the native nobility.[6] The alliance between Tlaxcala and Cortés, for example, was sealed through the marriage of Spaniards with native ladies who were first formally baptized. Ladies of Montezuma's family likewise married Spanish soldiers. One of the most significant of these unions, because it offered (like the relationship of Marina with Cortés) a bridge

between Europeans and the New World, was the marriage in Cusco of the conqueror Garcilaso de la Vega with Isabel, a niece of Atahualpa. Their son, who spent his adult life in Spain, was the Inca Garcilaso de la Vega, the illustrious historian of his own Inca forebears.

Women who went out from the peninsula were truly valiant, considering the enormous distances they had to overcome: first from their home towns to Seville, then the fearful crossing from Seville, and finally the long journeys within the continent of America. A lady in Mexico in 1574, writing to her father in Spain, recalled the terrors of the voyage and hesitated to recommend that he come. 'You have written to say you wish to come here', she commented, 'but the sea voyage is so dreadful that I did not dare send for you, and on every crossing there is an outbreak of sickness; the ships on which we came lost so many people that only one in four survived. Valdelomar [her husband] is fine on land, but he suffered so badly on the crossing he made that he and the children nearly died, and they still have not recovered.'[7] It is easy to understand why the even more extended crossing to Manila deterred both men and women from going to Asia.

Few first-hand accounts communicate more directly the contribution of women to the enterprise of the Indies than the report, written twenty years after the event, of the lady Isabel de Guevara, one of those who participated in the ill-fated expedition of Pedro de Mendoza (Chapter 4, above) to the Río de la Plata in 1536. It merits a lengthy quotation:

On reaching the port of Buenos Aires our expedition contained one thousand five hundred persons, but food was scarce and the hunger was such that within three months one thousand of them died. The men became so weak that all the tasks fell on the poor women, washing the clothes as well as nursing the men, preparing them the little food there was, keeping them clean, standing guard, patrolling the fires, loading the crossbows when the Indians came to do battle, even firing the cannon. Afterwards they decided to ascend the Paraná, in which voyage the women worked the sail, steered the ship, sounded the depth, bailed out the water, took the oar when a soldier was unable to row, and exhorted the soldiers not to be discouraged. And the truth is, no one forced the women to do those things. Thus they arrived at the city of Asunción. And the women had to turn to their tasks anew, making clearings with their own hands, clearing and hoeing and sowing and harvesting the crop with no one's aid until such time as the soldiers recovered from their weakness.[8]

Though the colonists always accepted marriage with native women, they prized highly the possibility of bringing over Spanish ladies. Several women featured among those who took part in Columbus's third voyage to America in 1497. One of those who arrived in Hispaniola in 1509 later married Cortés. In 1539 the new bishop of Cusco, obviously concerned to create the beginnings of a civilized Hispanic society, wrote to the government asking it to send 'genteel young ladies to these lands' who were 'of good blood' and 'peaceable'. But this was the very moment, in May 1539, that Charles V decided to prohibit 'single women from going to the Indies, and married ones may go only in the company of their husbands or if their husbands are already there and they are going to join them'.[9]

Both government and clergy were concerned at the danger to morality, family life and social stability represented by the uncontrolled movement of men and women. In 1541 single women were specifically forbidden to go to America, and in 1549 married men were prohibited from emigrating unless they did so with their wives or unless it was for a short business visit. The rules may often have been applied efficiently, for there is ample evidence of the efforts made by Spaniards to get round them. The degree of prolonged separation of men in America from their wives in the peninsula could often reach alarming proportions. In 1535 the bishop of Mexico reported that in the area under his jurisdiction there were 'absent from their wives' no less than 482 Spaniards.[10] Despite the prohibitions, hundreds of single women emigrated. They made a fundamental contribution to the colony, by giving the restless adventurers a motive to settle down and form stable households and townships. Without them, the creation of a productive and organized colonial empire was literally impossible. Life in the colonies was by no means easy: many women soon became widows, and had to marry again. Some had to transform their life-styles and become administrators of their estates and directors of personnel. Others became pioneers of the religious life in the new lands.

An entire generation of settlers went out alone to make their fortunes and then took measures to bring their wives over. 'Without my wife I am the unhappiest man in the world,' wrote a young settler in Guatemala; 'without you I cannot live', wrote another from Puebla.[11] Men who had begun to make their new life function found that they sorely needed European women to make their existence satisfactory. 'Over here women

of your condition are very much in demand', a father in Lima wrote to his daughters in Seville.[12] 'You can imagine what sort of life the men can manage here without their wives', wrote a man from Santo Domingo to his wife in 1583. Many wives of course went over: 'one thousand bored women have just arrived in search of their husbands', commented a Spaniard from the port of Cartagena (New Granada) in 1587.[13]

There is no reliable figure for women emigrants. The official records, recognized to be deficient, suggest that women were no more than five per cent of emigrants from Seville to America prior to 1519. By the 1550s they were a sixth and in the 1560s their numbers rose dramatically to nearly a third of licensed passengers. Despite their small numbers, they participated in every stage of the creation of empire. They were, like the men, conquistadors.[14] Women came to Mexico with the troops of Pánfilo de Narváez, and were present when Cortés captured Tenochtitlan. They also accompanied the expeditions into North America, where the intention was always to create settlements. Many are memorable for being warriors. An early example was María Estrada, who with other Spaniards fought her way out of the Aztec capital during the Noche Triste, and later fought at Otumba. The conqueror of Chile, Valdivia, had as his companion and comrade-in-arms the Extremaduran Inés Suárez, who distinguished herself in a defence of the town of Santiago against the Indians in 1541.

Males suffered a higher death rate than females, and the latter might sometimes almost equal them in numbers: in Lima in 1610 the European population consisted of some 5,500 males and 4,400 females. Women's contribution to the colonial economy cannot be minimized. The men might write home that there was easy money in the Indies, but in some areas, at least, money could be made only by application. A lady in Mexico City wrote to her sister in Seville in 1572 that 'in these lands money cannot be earned except by hard work, just like over there, for things are no easier in this land than over there'.[15] There were richer women, Spaniards who were proud to be wives of their conquistador husbands. 'I am married to a conquistador and settler of these provinces who has three towns, and I am a lady with vassals. God has blessed me to share in his fortune, and given me such a husband that in all these parts there is no woman better married or better off', a lady of New Granada wrote home in 1565.[16]

*

The first generation of Spanish settlers in the New World established their towns on the seacoast, both in the Caribbean and in the Pacific. It gave them a useful environment for subsistence and trade, and avoided conflict with the inland peoples. Some two decades were to pass before they ventured into the unknown North American continent in search of riches. The lands to the north were a formidable challenge, ranging from tropical forests in Florida to the barren mountains and plains beyond New Spain. The first Spaniard to venture into that area was Juan Ponce de León, who reached Florida in 1513 and died in 1521 after being wounded in an unsuccessful attempt to enter the territory to which he gave its European name. The real expansion did not take place until the 1520s, in two principal waves: towards the Atlantic from the Caribbean islands, and towards northern New Spain from Mexico.

The most astonishing of the early military expeditions was that led by Pánfilo de Narváez, who had been sent by Governor Velázquez from Cuba to arrest Cortés and lost an eye in the encounter. He now took on the Florida assignment left vacant by Ponce de León. He left Cuba and landed in Florida, near Tampa Bay, in 1528, with four hundred men and eighty horses. The party, which had a licence to 'explore, conquer and settle', and therefore included women as well, had as its second-in-command Alvar Núñez Cabeza de Vaca. The Spaniards penetrated fruitlessly into the north of Florida, plundering as they went, then retreated back in confusion to the Gulf of Mexico, where Narváez and many others died, while possibly a hundred survivors, among them Cabeza de Vaca, escaped out across the Gulf then inland through Texas. Eventually only four survivors were left: they moved from tribe to tribe, working as slaves for the Indians and surviving by their wits. After some ten years living among the coastal tribes, Cabeza de Vaca and his three companions worked their way westward to the Río Grande.

In the same year, 1528, that the Narváez expedition took place, Hernando Cortés left New Spain to go home and the council of the Indies set up as government in his place an Audiencia of officials, presided over by Beltrán Nuño de Guzmán. Guzmán was a lawyer who had arrived in the New World after the fall of Tenochtitlan, and had succeeded in securing (from Spain) the governorship of the province of Pánuco. There he made a name for himself by his brutal suppression of Indian rebellions; thousands were rounded up and sold off as slaves to Spaniards in the Caribbean. As president of the Audiencia he continued

with his slaving and profiteering activities, provoking violent opposition from many colonists and fierce denunciations from the clergy, among them Motolinía and the newly appointed bishops of Tlaxcala (Garcés) and Mexico (Zumárraga).

Not content with the profits he was making out of his regime in New Spain, Guzmán led a force to the northern limits of the territory, which came to be known as New Galicia, in search of the fabled riches of the Isle of the Amazons and the Seven Cities of Cibola. He was supported by a strong force of soldiers and fifteen thousand Indian attendants. On his way north through Michoacan he continued his brutal practices in the territory of the Purépecha or Tarascan people, where he seized, tortured and killed the king of the Tarascans, in one of the most savage acts to occur in the entire history of the conquest.

One day in March 1536, while Guzmán's raiders were exploring new territory by the River Sinaloa, they came across a bearded and sunburnt white man, accompanied by a burly black man, in the company of eleven Indians. The newcomers were Cabeza de Vaca and an escaped companion; two more Spaniards arrived a couple of days later. They had a long and fascinating story to tell; Cabeza de Vaca's narrative of having lived 'alone among the Indians and naked like them' became a classic of travel lore. Guzmán gave the new arrivals clothes to wear but, commented Cabeza de Vaca, 'for some time I could not wear any nor could we sleep anywhere but on the ground'. With the linking of the two groups of Spaniards, the Spanish empire suddenly gained a whole new perspective, of a northern continent that stretched ocean to ocean and could conceivably be penetrated and occupied. This was the classic 'frontier' that now challenged the daring of the Spanish explorers.

Among the best known of the early soldiers who came north from Mexico was Francisco Vázquez de Coronado, who succeeded Guzmán as governor of New Galicia. In February 1540 with the official blessing of the viceroy he led a large group of 260 settlers and 60 soldiers in search of the fabled Seven Cities of Cibola, a mythical settlement that formed part of the corpus of legends that persistently inspired the early explorers. They were encouraged by a reconnaissance made the previous year by two friars, who reported having seen 'from afar' a wonderful city even larger than Mexico. In their pursuit of wealth the Spaniards had the advantage of being able to learn from Cortés's famous expedition nearly twenty years before. The Coronado expedition therefore came

well equipped with hundreds of horses, as well as arms, dogs, guides and a force of one thousand native allies.

The impressive army represented the first known contact of the horse with North Americans (who, however, had to wait over a generation before they could acquire them). The journey was fruitless, for Coronado quickly found that the small native tribes living in an area of adobe villages had none of the gold or silver he had been led to expect. After attacking and occupying settlements of the Zuni and later of the Hopi peoples, Coronado sent some members of his expedition towards the west, where they reached the edge of the Grand Canyon and sighted the great River Colorado. With his main force he moved to the territory of the Pueblo Indians by the Río Grande, but provoked hostile reactions when he made constant and aggressive demands for food and clothing. The main contact made was with the Tiwa people, who suffered the brunt of the unending Spanish search for supplies. In one village the Indians refused to co-operate, so thirty of the inhabitants were killed and the village torched. In the space of two years, Coronado's men attacked and destroyed thirteen of the fifteen Tiwa villages in the region.[17] Finally, in 1542, after many frustrations, the group returned to Mexico City, where Coronado died twelve years later. His pioneering journey into the interior of the Great Plains, where they found (in the words of their chronicler) 'nothing but buffalo and sky',[18] and no substance whatever to the fables of golden cities, left the colonists in New Spain with little wish to venture again into the inhospitable and empty north.

The Coronado expedition was paralleled towards the east by the journey of Hernando de Soto, a conqueror who had participated with Pizarro in the ransom of the Inca and still sought adventure. In 1537 he was named governor of Cuba and granted a commission as adelantado of Florida. The next two years were spent preparing a further attempt on the lands where Ponce de León and Narváez had failed to achieve anything of substance. Soto landed on the west coast of Florida at Tampa Bay in 1539, with a company of over six hundred men and good supplies and horses. By 1540 they had penetrated Georgia and reached as far as Carolina, but found little to justify the effort. In May 1541 they came to the immense River Mississippi, which they named Espíritu Santo, crossed it and penetrated deep into the interior of the continent into Arkansas and Texas, attacking and pillaging when necessary,

attracted always by stories of great wealth. Soto died of fever during the journey in May 1542, and his body was consigned to the great river he had discovered. His men, now reduced to barely three hundred and harassed by Indian attacks, began to construct boats in the winter of 1542 and in the summer of 1543 made their way down the Mississippi to the Gulf, the first Europeans known to have done so.

The unsettled nature of the Spanish presence on the northern fringe of New Spain was complicated further by the Indian reaction, of which the most resolute was the so-called Mixton war in the area of New Galicia in the years 1541 and 1542. The Caxcan tribes on this frontier were inspired by a millenarian movement that looked to the return of the god 'Tlatol' who would drive the Spaniards out, destroy the Christian religion and restore an age of riches for the indigenous peoples. Where they could, they burnt churches and killed the clergy. The limited troops available to Viceroy Mendoza were unable to deal with the scale of the uprising. One of the forces sent to deal with the Indians was led by the conquistador Pedro de Alvarado, who was routed, forced to withdraw and died of the wounds he received. Finally, the viceroy himself had to take the field, and he did so wisely with the aid of his Nahua allies. His army consisted of a small core of a hundred and eighty mounted Spaniards, together with artillery; its main body was made up of well over ten thousand Indian auxiliaries with their *caciques*.[19] The rising was put down, but the Spaniards recognized that there were practical limits to the area in which they could effectively operate.

The year 1543, it has been said, 'closed the age of the conquistadors in North America'.[20] The administrators in Cuba and Mexico were keen to extend the territory under their control, but the men they sent out had their vision fixed exclusively on precious metals and had little interest in farming the rich land or taking their religion and culture to the natives. The policy of violent intrusion worked to an extent because of the collaboration of some Indian tribes against others, but could not in the long run succeed. An empire required different methods if it was to succeed at all.

The meagre results of Spanish ventures into North America up to the 1540s were compensated in the same decade by the discovery of dazzling wealth much closer home. Silver was found at Zacatecas in northern New Spain in 1546, and at other nearby sites soon afterwards: Guanajuato,

Aguas Calientes, San Luis Potosí. New Galicia's sudden wealth resulted in a rash of mining settlements and an influx of immigrants in search of a quick kill. This time the explorers came to settle, not merely to maraud. As the population of the area rose, the frontier pushed further north and a new province, New Biscay, was formed in the 1560s, drawing its name from the Basque entrepreneurs who pioneered the mines. Its capital town, Durango, was founded in 1563. The new wealth could only be protected by an active policy of settlement, which in turn implied building houses and defences, finding food, and maintaining Christian clergy. The Spanish presence began to take on a more concrete form. When much later silver was also found in 1631 at Parral, further north, the frontier pushed well beyond New Biscay.

However, there were inevitable obstacles, the most important being the native tribes, which had never been dominated by the Nahua and now refused to be drawn into the Spanish scheme of labour service. After years of fighting off attacks by the hostile Indians, whom the Spaniards labelled Chichimecs no matter what tribe they came from, the authorities arrived at a solution that had functioned half a century before in the Caribbean: they imported labour. Indians from the peaceful areas of Mexico, such as from Tlaxcala, were brought in and settled in the new territory. At the end of the sixteenth century, free Indians made up nearly two-thirds of the total mining force of seven thousand five hundred Indians at Zacatecas. It was another important stage in the native conquest of the New World.

The success of the policy of settlement in the 1560s coincided with an active intervention in imperial policy by the crown. Philip II's new policy of crown control over developments in the overseas empire had been initiated by sponsoring Legazpi's expedition to the Pacific. The king did not neglect the Atlantic. In 1565 he made a historic contract with Menéndez de Avilés. The venture was one of the most important ever sponsored by the Crown in the New World and laid the foundation for Spanish aspirations to power in the Atlantic and North America.

The Asturian soldier and sea-captain Pedro Menéndez de Avilés, born in 1519, had had direct experience of the Caribbean, served at the king's side in the campaign of St Quentin in 1557, and spent a while in prison in Seville in 1563 because of a dispute with the House of Trade. He was commander of three of the fleets that sailed to America, in 1555, 1560 and 1562. On 20 March 1565 he made a contract[21] with the government

by which he was appointed adelantado of Florida, with the right to be civil and military governor of the territory for two lifetimes. He was granted the title of marquis, conceded twenty-five square leagues of land for himself, and given certain trade monopolies. In return he was to mount an expedition at his own risk and expense, and supply five hundred armed men; with these he was to settle Florida, build two towns and advance the Catholic faith. Shortly after the contract was settled, the king received news of a French Huguenot expedition that had settled in Florida. Philip II arranged for three hundred royal soldiers to augment Menéndez's force, and made haste to get the adelantado on his way. It was the first time that the Spanish crown had ever sent troops to the New World, sign of the seriousness of the situation.

The Calvinist leadership in France had for some time encouraged exploration in the Atlantic in search of possible New World settlements. France had never recognized Spain's claim to America based on the papal donation, and its government had regularly encouraged all efforts to trade and settle there. In 1564 an expedition of Calvinists, led by Jean Ribault, founded a settlement on the Atlantic coast of Florida, at the mouth of the St John's river, naming it Fort Caroline. Philip II's government considered the occupation, which was backed by its principal enemy – France – and carried out by heretics, an act of war. In early September 1565 the adelantado and his men came ashore further south, at a spot where they founded a town they named St Augustine. They then immediately set out for Fort Caroline.[22]

Ribault and most of the adult men had gone out in order to head off the newcomers. The Spaniards surprised the colonists in the fort, killed all the males they found ('we cut the throats of a hundred and thirty-two', the adelantado later reported), and took captive the women and children, fifty in number. Menéndez then caught up with Ribault's group, who realized that resistance was hopeless. He refused to promise mercy when the French offered to surrender. The lives of a select few were spared. Most of the rest, possibly 340 in all, had their hands bound behind their backs, were taken apart in groups and systematically had their throats cut in cold blood. Of the total number of prisoners spared in this action, between a hundred and fifty and two hundred, some were ransomed, some freed, and others sent to the galleys. It was the first important clash in the New World between Spaniards and colonists from another European country, and also the most bloody. It was bitterly

denounced in France, and in Madrid the French ambassador, a Catholic, presented an angry protest to Philip II. However, the ferocity served its purpose; for at least a generation no other Europeans attempted settling the areas claimed by Spain. But it could not stop the efficient and firm settlement of French and English in North America and along the Atlantic coast.

The establishment by Menéndez of the town and fortress of St Augustine was one of the most significant decisions of the century. The first Spaniards in the area – from Ponce de León, who had given it the name 'Florida', to explorers such as Cabeza de Vaca and Hernando de Soto – had been in search of quick wealth and saw little reason to remain where there was none. By mid-century, considerations of security, not only against foreign incursions but more cogently to protect the valuable treasure fleets as they made their way across the Atlantic from Cuba, gained the upper hand. Earlier attempts to found a suitable base had failed. By contrast, Menéndez, who had ambitious plans to create a solid Spanish presence in the area, succeeded in setting up several other bases on the coast, notably at Santa Elena. He also hoped to facilitate direct overland links with the Spanish silver mines in New Spain. His dream was to open up a transcontinental route from the Atlantic all the way to Mexico, and give reality to the programme of imperial expansion.[23] After the Fort Caroline operation he went to Cuba, then returned the following year and resumed exploration further up the Atlantic coast. Philip II backed him fully, and in 1566 sent an additional detachment of royal soldiers to Florida to garrison the posts settled by Menéndez. The king also repaid him for the high costs incurred in Florida and gave him the title of governor of Cuba. Colonists were encouraged to come directly from the peninsula, and in 1570 the crown began to pay the salaries of the garrisons directly. The Spanish presence was now an accepted fact.

The obstacles to a successful programme remained formidable. Menéndez, like all the pioneers, had no inkling of the immense distances in America. The Spaniards, moreover, were pitifully few in number and in order to survive they logically had to seek allies among the native Indians. The attempt to find a *modus vivendi* between the two cultures did not succeed here any more than it did elsewhere. The adelantado had good intentions, and repeatedly affirmed his interest in saving Indian souls. In practice, repeated incidents such as the destruction of a fort in

1568 by Indians who had allied with French marauders, and the murder in 1571 of a group of Jesuits further north up the Atlantic coast, made Menéndez adopt the view that only extermination of the natives ('a war of fire and blood') would bring security to the Spanish settlements. In 1573, back once again in Madrid, he petitioned the king to permit enslavement of the Indians, but Philip refused. The adelantado's last great service to his king was to accept command of the armada being prepared for service in Flanders in 1574. Before the fleet could sail he died during an epidemic in Santander, in September that year. In Florida the situation deteriorated rapidly. His family there took over control, but mismanaged affairs. The Indians attacked relentlessly. Very soon only two Spanish settlements remained in Florida: St Augustine and Santa Elena. The latter was abandoned temporarily in 1576, and then permanently ten years later.

The mid-sixteenth-century Spanish expeditions into North America produced some useful, if confused, information about the continent, and advanced the science of cartography, particularly in respect of the location of the great rivers. From the European point of view, something had been achieved. In terms of imperial expansion, however, little was gained apart from acquainting the scattered Indian tribes with the strange ferocity of the white man. The peoples on the northern frontier of New Spain defended their lands tenaciously. A weary Spaniard in 1587 reported that 'from the moment I left Mexico until I reached Zacatecas my horse and I have not let go of our arms one second, and we were armed from head to foot because the countryside is swarming with these devils of Chichimecs; . . . in all the route there was not a single village, and water only every eight leagues, little of it and bad at that; we slept on the ground even though there was a lot of snow, and every night we spent on guard'.[24] In this troubled country, Spaniards were obliged to seek help from some of the local tribes. It was a period when peoples such as the Mexicas, the Tarascans and the Otomíes were interested in expanding their territories. In northern New Spain they were willing to make alliances with Spaniards against their enemies. They provided the bulk of the fighting men available to the newcomers, and fulfilled crucial roles as scouts and interpreters.[25] The Indians conquered other Indians, and in consequence facilitated the task of the white man. If the frontier continued to survive, it was almost

exclusively because of the support given by indigenous peoples to the Spaniards.

The difficulties faced by the empire in expanding significantly into North America were illustrated by the case of New Mexico. In 1595 Juan de Oñate, son of one of the wealthiest citizens of New Spain, presented to the viceroy a proposal to settle the northern limits of the Spanish frontier, in the area of the Rio Grande known since the 1580s as New Mexico, over one thousand miles beyond the recognized area of Spanish settlement. Apart from an undertaking to go with two hundred men, he promised to take a thousand head of cattle and a similar number of sheep, as well as a large quantity of other animals and supplies.[26] The Crown would supply priests and artillery, and granted him the title of governor and adelantado. Typical delays and disputes stopped any action on the proposal until January 1598, when the expedition finally left. Though there were fewer Spaniards than expected, it was still a considerable enterprise, with eighty-three wagons and seven thousand head of animals. In late April, at a site to the south of the Rio Grande and of the subsequent fort of El Paso, the adelantado took part in a formal ceremony in which he laid claim to New Mexico. His small group – barely a hundred and thirty men, including eight Franciscans – had naive ambitions of acquiring 'new worlds, greater than New Spain', and of reaching both the Pacific and the Atlantic oceans. In the summer and fall Oñate led his group round the country of the Pueblo Indians, accepting the 'obedience' of the chiefs and their villages. The nature of this 'obedience' sheds, as we shall see, interesting light on the mis-understandings that always underlay Spanish pretensions to imperial authority.

There were problems at the village of Acoma, a small settlement situated on the roof of a sandstone mesa nearly four hundred feet above the surrounding desert. Virtually inaccessible from the bottom of the cliffs surrounding it, Acoma was a natural stronghold. A small group of thirty-two men from Oñate's expedition reached the area in December 1598, whereupon the Acomas guided them to the top of the mesa and supplied them with water and food. When the soldiers became too insistent, some of the villagers refused further supplies and attacked the Spaniards, killing a dozen of them. On receiving the news Oñate consulted his advisers, who agreed that 'if these Indians were not pun-ished, they could destroy us easily'.[27] A task force of seventy soldiers

was sent against Acoma in January. In a brilliant operation, the Spaniards scaled the cliffs at an uninhabited point of the mesa, and lifted two small cannon with them. The next day the soldiers attacked, with devastating results. They killed some five hundred men and three hundred women and children, and enslaved about five hundred survivors, condemning adult males among them to have a foot severed.[28] No Spaniards died in the action. Surviving children were taken from their parents and put in the care of missionaries for the 'salvation of their souls'. Little was gained by the brutality, nor could any territory be occupied.

Oñate was persistent, and despite failures he repeatedly invested in further expeditions from his isolated base in San Gabriel. In October 1604 he led a group of three dozen Spaniards westward through Hopi country; they managed in 1605 to descend the River Colorado and locate its entry into the Gulf of California. These were the years when Vizcaíno had been mapping the California coastline from the sea. On Oñate's return to Mexico City the viceroy refused to sanction further expeditions by him into what he termed a 'worthless land'. There was nothing there, the viceroy said, but 'naked people, false bits of coral and four pebbles'.[29] Though there was strong pressure to abandon New Mexico, in 1608 the crown decided to back its existence because of the conversions that the Franciscans reported making in the province. In 1609 the capital of the province was re-located from San Gabriel to Santa Fe. In reality the whole idea of New Mexico had been a mistake, an over-optimistic extension of the frontier. It continued to exist almost exclusively because of the missions. Oñate returned to Spain in 1621, all his schemes in ruins. The Spanish presence on the northern frontier remained extremely small. In 1630 Santa Fe had no more than 250 Spaniards in it; the rest of the population consisted of Indians and people of mixed race. In 1660 the tiny settlement at El Paso, further south on the Rio Grande, also began to expand. In this almost empty frontier region, the few settlers survived by relying on the labour of Pueblo Indians.

The Pueblo were a notably peaceful group, with a tradition of hospitality towards outsiders. The establishment and expansion of Spanish settlements was made possible by the normally friendly reception accorded to the newcomers. The Spanish response to this welcome took a curious form that had not changed since the days when Cortés had

confronted Montezuma. The Spaniards interpreted the act of hospitality as an act of homage. The reports made by Oñate on his journey through the Rio Grande area in 1599 leave no doubt about this. In one village of five hundred houses 'the Indians received him very well with maize, water and turkeys, and rendered obedience to His Majesty'. The Zuñi villages 'received us very well with maize, tortillas, beans and quantities of rabbits and hares. They are a very amiable people and all rendered obedience to His Majesty.' Further on, the tribes 'came out to receive us with tortillas, scattering fine flour upon us and upon our horses as a token of peace and friendship, and all those provinces, which are four pueblos, rendered obedience to His Majesty and treated us very well'.[30] The frontier limits of the Spanish empire in North America were in this way defined in the minds of the Spaniards, by the limits of hospitality. The possibility of 'conquest' did not arise, for there were never adequate Spanish men or weapons and in any case it would have been impossible to hold on to areas that had been occupied exclusively by force. The frontier became defined, as events would prove, not by the capacity of the Spaniards but by the goodwill of the Indians.

Oñate capitalized on the friendly reception he received everywhere, and used it as the basis for exacting submission. The terms on which the Indians gave their 'allegiance' were transmitted through the medium of two Mexican interpreters accompanying Oñate. One interpreter translated what the Pueblo leaders said into Nahuatl, the other translated from Nahuatl into Spanish.[31] On the basis of this highly unreliable method of communication, the Pueblo villages unknown to themselves and quite involuntarily accepted the authority of the mighty Spanish empire.

By the first decade of the seventeenth century, it appeared that Spanish efforts to extend their presence into the North American continent had met with little success. Immigrants from the mother country preferred to go to the well-established centres in continental South America. Though there was no territorial expansion the fragile settlements that still existed in New Mexico and Florida managed somehow to survive. For the next hundred and thirty years after Menéndez de Avilés, and until the founding in 1698 of Pensacola on the Gulf coast, St Augustine remained as the only significant Spanish settlement in all Florida. Its isolation was further testimony to the failure of Spain's enterprise on the northern frontier. In 1600 the fort had just over 500 residents,

though the figure increased to around 1,400 in 1700, the peak of its population in Spain's colonial epoch. There was farming country around the fort, but little else was available to attract settlers, and Spaniards were reluctant to make their home there. The white males intermarried with local Timucuan women, and food supplies came from the neighbouring Indian community. Free contact between the communities thus converted the fort into North America's first 'melting pot' of races.[32]

The Florida experience may have been one of the influences on perhaps the most important measure ever taken by Philip II in respect of the overseas empire: his Ordinance on Discovery and Population. The Ordinance, issued on 13 July 1573, reflected in some measure the aspirations of Las Casas, who had died seven years before but whose writings were used in framing its text.[33] Fruit of lengthy deliberations that had begun at least five years earlier, it definitively banned further conquests in America, and emphasized the preaching of religion and the protection of the Indian as primary objectives. The aim was to stop further and fruitless expeditions and consolidate control over areas already settled. From now on, Spain recognized the 'frontier' as an objective in its American domains. The only people authorized to move the frontier forward were the missionaries, aided if necessary by small military escorts for their protection. At the same time, the native peoples in the area under Spanish control, those who were known as 'peace Indians' in contrast to hostile 'war Indians', were guaranteed certain legal rights and protection. The king was applying in the New World what he had already put into practice in the Old. After the Lepanto campaign of 1571 and subsequent truce agreements with the Turks, Philip opted for a defensive rather than an aggressive policy in the western Mediterranean.[34] The Mediterranean frontier was to consist on one hand of a network of small defensive garrisons, on the other of peace agreements with local Muslim rulers in North Africa. A similar policy was meant to be applied in the New World.

It is hardly necessary to say that the Ordinance had little effect on the practical situation of the American native. But its importance for other aspects of the emergent empire was fundamental. The papacy refused to give formal approval to a law that ignored its claim to be able to grant away territories. Philip II in retaliation took directly under his control the supreme authority over the Church in America, using as his excuse

the Patronato. He had already used this authority when granting formal permission in 1568 for the Jesuits to begin work in the New World. The 'frontier' in America now became a reality. The law also took over all mining enterprises for the crown. The king began at the same time to send out questionnaires, both in Castile and in America, calling for information on the geography, culture and economy of the regions he ruled. In Castile a pilot questionnaire was first sent out in 1574, and a list of questions went to all the towns in 1575. In 1576 (see Chapter 4 above) a detailed list of forty-nine questions was sent to all officials in America. Without adequate laws and information, government of the empire would not have been possible, and Philip wished to be kept informed.

Like most laws that preceded and followed it, the 1573 Ordinance erred on the side of optimism and did not always bear in mind what happened in the real world. The 'frontier' was an ill-defined area, both geographically and politically, in which an alien Spanish culture attempted to come to terms with an indigenous culture that showed remarkable resilience in dealing with the invaders.[35] In practice, the Spaniards made a significant impact in a few frontier areas of North and South America but failed to establish themselves securely everywhere. The cases of St Augustine and Santa Fe exemplify the distance, loneliness and fragility of the outer fringes of the empire. Spanish settlements usually had only marginal contact with their dispersed Indian neighbours and only sporadic links with their own people. The entire area surrounding the Spanish settlement at Santa Fe remained unpenetrated by Spaniards for nearly one hundred years.

Part of the problem lay in the limited resources available to the representatives of royal government. The difficult frontier of Chile, for example, could not be defended by only the settlers, who resented the heavy costs incurred by the Araucanian wars. Royal government in the shape of the viceroy therefore had to assume the burden. Philip II's Ordinance had stated expressly that defence was a direct obligation of the settlers only, but he had to make an exception for Chile, where it was calculated that up to 1594 the crown had spent over four million pesos on the war.[36] By the early seventeenth century, Chile became an exceptional case where the crown was in effect maintaining at its own expense a standing army (around two thousand men) to defend the frontier against the natives.[37] In New Spain, tax revenue had to be

spent on coastal defences and the Caribbean, leaving little available for expeditions and exploration. As viceroys of the early seventeenth century repeatedly observed, apart from the defences in existence at the ports of San Juan de Ulúa and Acapulco, there were no arms or soldiers to defend New Spain against a possible attack from the sea by foreigners. In this fragile situation, as the acting viceroy bishop Juan de Palafox reported to the crown in 1642, it was advisable to make no moves to expand northwards: 'with the Indians who live next to the peace Indians, for the moment it is better to leave them alone, not provoke them, and keep up discreet contacts'.[38]

In effect, only the native Indian could maintain the frontier. The 'peace Indians' became the principal line of defence against the so-called 'war Indians'. There was not enough Spanish manpower available for colonization or for military advance, but that did not threaten Spanish control. The viceroy of New Spain, Velasco, explained to the crown in October 1590 that in the absence of Spanish soldiers he could turn to the 'peace Indians' and use their services against hostile tribes.[39] The 'peace Indians' in their turn needed the occasional help of Spanish colonists for supplies of food, particularly maize and beef. This fruitful relationship seemed to benefit both sides and, above all, guaranteed the continuation of the Spanish presence.

No sooner had Spaniards begun to settle in the Caribbean than other European ships also appeared in the area. There are records of French traders on the coasts of Brazil as early as 1503. In official eyes the vessels were illegal pirates and could be dealt with out of hand. The Europeans did not recognize the sweeping Spanish claims to New World territory, and felt that they were equally entitled to take part in trade. Most important of all, they were frequently supported by their governments, which considered their acts to be not piracy but legitimate commercial competition, an expression of the rivalry between European states for control of overseas trade and territory. The European traders inevitably differed among themselves about each other's rights to trade, so that they too came to consider rivals as pirates. The combination of trade and belligerency at sea had already existed in other parts of the world, including the Mediterranean and the Pacific. In the Caribbean, it presented a particularly grave threat to the security of the nascent Spanish empire.

The authorities applied the term 'pirate' to all illegal shipping, but there were in reality many categories of pirate. Some were privateers (in possession of a licence from their governments), some were interlopers (contraband traders), and by the seventeenth century some were habitually based in American waters and were known as freebooters and buccaneers (the words were, respectively, of Dutch and French origin). There was often a world of difference between criminal pirates dedicated only to robbery, and illicit traders concerned only to make a profit, but the Spanish authorities saw little to separate the two. Foreign activity in the earlier decades tended to coincide with a war situation in Europe: the French were particularly active in the half century from 1500 to 1559, the English during the last decades of the sixteenth century, and the Dutch from the 1570s to 1648.

The problem intensified with the epoch of religious wars in Europe after 1560. Non-Spaniards, whose primary motive was clearly trade or settlement, began to cite ideological reasons for their actions. John Hawkins, the notorious English trader, always took care to cite religious motives for his activities. The Spanish government adopted the same tactic and pinned the label heretic on all the foreign traders in the areas that it claimed to control. Though piracy was not therefore a new phenomenon, it took place after 1560 in a context that was particularly conflictive, because the interests of states as well as of religions inflated its significance. Spain's inability to patrol its imperial seas adequately was fully recognized by other European powers, which did not scruple to extend war situations into colonial waters. The most agitated months for naval activity in the Atlantic, and by extension in the Caribbean, were from March to July and from August to November, periods that lay outside the stormy season and allowed reasonable security to trading vessels but also enabled predators to act. For safety reasons but above all to control illicit commerce, the Spanish government officially limited trade to specific ports on either side of the Atlantic, normally Seville in Spain and a range of ports in the Caribbean.

A French vessel carried out the first recorded pirate attack in the Caribbean in 1536, on the north coast of Panama.[40] In 1544 the French actually captured the town of Cartagena. By the 1550s the most notorious of the French captains in the Caribbean was François Le Clerc, known as 'Peg-leg', who in 1554 occupied for a month and left in ruins the town of Santiago de Cuba. Another, the Huguenot Sores, captured

Havana the following year, destroyed it and massacred his prisoners. A resident of Hispaniola reported in 1552 that 'on top of our many problems there is an even bigger one, having as neighbours the French, who every day rob from us all we have. Six months ago they took over this region and burnt the village after looting it, and we were a month wandering through the wilds suffering hunger and illnesses.'[41] 'Along the whole coast of this island there is not a single village that has not been looted by the French', an official of Santo Domingo reported in 1555.[42] From this date there was a growing swarm of unauthorized vessels in the Atlantic and Caribbean, their activities based less on 'piracy' than on profits from trade. The most obvious example is John Hawkins, whose first voyages from England in 1562 and 1564 were an extension of his father's activity in the slave trade.

Defence of the seas and of trading ships was not an obligation of the Spanish government. The bulk of trade on the Atlantic was private, and merchants often preferred to adopt their own methods of security. On the other hand, the government received income from taxing the trade and from its own import of precious metals; it therefore collaborated with defence measures, enforcing, for example, the rule that ships must sail together. From an early period it also dedicated a part of its income from America to defence costs, which rose regularly during the sixteenth century.[43] So did the spate of attacks on ships and coastal towns. It was impossible to organize a naval squadron to patrol the seas, so defence measures over the next generation concentrated on building fortifications in coastal towns. Additionally, from 1562 the authorities in Seville enforced the rule that merchants' ships must sail together, in 'convoy'. At the same time the crown helped to finance the construction at Bilbao of a dozen ships to form a new 'armada' to patrol the coasts both of the Atlantic and the Caribbean, and to escort the convoys. Launched in 1568, the armada over the next dozen years played a valuable role[44] but was obviously unable to guarantee security on both land and sea.

By this time matters of religion and diplomatic changes in Europe were seriously affecting security in the Atlantic. Western European governments began to invest heavily in ideological enterprise. A member of France's royal council, the Calvinist leader Gaspard de Coligny, backed the expedition of Jean Ribault in Florida. Queen Elizabeth of England and members of her council were shareholders in the second slaving voyage of John Hawkins in 1564. The Spaniards considered

Hawkins a pirate, though his activities amounted to illegal trade rather than piracy. On his fourth and last slaving voyage, which was also backed by the queen, he was attacked in 1568 in the harbour of San Juan de Ulúa by the fleet of the newly arrived viceroy, and barely managed to escape home to England after losing three-quarters of his men and three of his six vessels. The incident unleashed an unremitting campaign of revenge against the Spanish. In the period 1570–1577 there were some thirteen illegal, and deliberately piratical, English expeditions to the Caribbean.[45] Some of the English were quite simply foolhardy. John Oxenham in 1576 led a group of fifty men that crossed the isthmus of Panama by land and captured a Spanish ship on the South Sea, the first foreigners ever to do so; but they were subsequently captured by the Spanish and executed.

The most important and daring enemy was Francis Drake, whose campaigns against Spain began in 1570 (see Chapter 5). His attacks in 1585 on Santo Domingo and in the Caribbean were no longer simply acts of piracy but full-blooded war campaigns, backed in his case by the resources of a fleet financed by the queen of England. After a short two-week visit to Galicia in September 1585, Drake set out across the Atlantic with his squadron. It was the most powerful naval force ever seen in American waters: twenty-two ships with two thousand three hundred men and twelve companies of soldiers. Santo Domingo was sacked and made to pay a ransom, Cartagena was occupied and held for six weeks. There was dissension among the English commanders over what to do next, since no news emerged of a silver fleet. Eventually Drake decided not to attempt Panama, sailed off into the Florida Channel without bothering to attack Havana, and instead attacked and destroyed the fort at St Augustine. There were few or no material benefits to the English from this remarkable expedition, which on the other hand exposed the complete vulnerability of the Spanish colonies in the New World. To uphold pride in their own reputación, the Spanish authorities persisted in treating Drake publicly as though he were a pirate, but in the privacy of government meetings the ministers virtually accorded him treatment as a head of state when they discussed what steps might be taken to have him assassinated.

The depredations of Drake in the Atlantic ports of Spain forced the helpless and indebted government, fearful now of losing all control over America, to take some long overdue steps.[46] In 1586 Philip II sent out

to the Caribbean the Roman military engineer Gian Battista Antonelli, whom he had invited to Spain in 1559 and who stayed on to become one of the most active engineers of the crown. Spain had few military engineers of its own, depending almost entirely on experts from Italy (a situation that continued well into the eighteenth century).[47] Antonelli spent several years in the Indies and elaborated an ambitious scheme of defensive forts for Puerto Rico, Santo Domingo, Florida, San Juan de Ulúa and Havana. In practice, decades passed before much was done. Increased defence by land, moreover, might afford excellent protection against attack from the sea, yet could not affect the increase of foreign privateers out at sea. The English alone launched around two hundred privateering voyages to the Caribbean during the war years from 1585 to 1603.[48] The vessels sometimes acted like swarms of bees, hovering over their prize until they were sure how to act. The governor of Cuba reported how in 1592 just offshore from Havana 'in addition to fourteen ships on watch at the entrance to this port, off Cape San Antonio there are three ships and two pinnaces. These remain there day and night. The total number of large ships that have been seen so far is nineteen, with four pinnaces. I suspect that it is a foregathering of thieves.'[49]

Privateers ranged through the entire Caribbean, robbing and sacking virtually at will, but taking care not to inflict damage that would hurt their own commercial interests. Conflict in Europe also encouraged the growth of intervention by French and Dutch shipping. The latter came principally to exploit the great natural saltpans at the western end of the Araya peninsula, in Venezuela, between La Margarita Island and Cumaná. The local authorities had neither ships nor men to stop them. The governor of Cumaná reported that from 1600 to 1605 about one hundred Dutch ships a year came openly to the saltpans and loaded up for free.[50] A punitive expedition was undertaken against them in November 1605, when twenty Dutch salt ships were destroyed. Though they cut back on salt smuggling for over a decade, the Dutch went on to settle parts of the mainland, and by 1616 were firmly based on the River Essequibo, where they formed the nucleus of the foreign colony of Guiana.

Illicit activity by foreign ships was not restricted to the Caribbean, but common to the entire coastlines, which were endless and therefore wholly vulnerable, of the Atlantic and the Pacific. Between 1575 and 1742 at least twenty-five different foreign raiders made their impact felt

on the Pacific coast.[51] Although the Pacific was relatively distant in terms of access, it was no less promising to raiders, for the silver of Potosí was normally taken overland to the coast at Arica and then transported by sea to Callao, from where it was taken by an armed naval escort to the isthmus of Panama. Drake's raid on Peru in 1579 was the first of its kind; he was followed to the South Sea by Thomas Cavendish in 1587, as we have seen, and by Richard Hawkins in 1593. Hawkins was not as fortunate as Cavendish had been. He entered the South Sea with only one ship early in 1594, but managed through making successful raids to capture other vessels in the ports of Valparaíso and Valdivia. In an action against the South Sea defence squadron in June, he was captured and his vessel, the *Dainty*, was taken and incorporated into the Spanish fleet. It was the only success registered by the Spaniards in the entire sixteenth century. The English were not a mere external threat. Their actions on the Pacific coast encouraged a few natives to believe that the English were a hope for liberation from the Spaniards, and some even suggested that the English were the legitimate successors of the Incas, on the assumption that the word 'inglés' derived from the word 'inga'.[52] A century later there was a native rising in the province of Potosí, with the intention of handing the land over to the English, if they came.

From the end of the century English raiders were succeeded by Dutch, typically with the expeditions of Olivier van Noort (1600) and of Joris van Spilbergen (1614–15). Van Noort's intrusion into the Pacific, with four vessels, was financed by three Rotterdam merchants.[53] The Dutch hoped in general to establish a basis for trade (rather than merely rob gold) and secure a place for settlement with the help of Indians hostile to the Spanish. Van Noort achieved nothing on either count, suffering instead great travails from the weather and the loss of many men, but he won fame as the first Dutch circumnavigator of the globe. Spilbergen left Holland with six well-armed ships in 1614, and encountered the first serious attempt at defence. In July 1615 the viceroy of Peru managed to put together two galleons and five merchant vessels to repel the invaders, but they were quickly routed by the Dutch off Cañete and five hundred men killed or drowned.[54] Like van Noort, Spilbergen achieved little of substance, but his military success and the continuing hope of further trade and wealth kept Dutch interest alive. After the expiry of the Twelve Years Truce with Spain, in 1623 the Dutch sent a powerful fleet of eleven warships commanded by Admiral Jacques l'Hermite, with

1,640 men and 294 guns, through the passage round Cape Horn, with the intention of intercepting either the Peru silver convoy or the Manila galleon.[55] It was the biggest naval force ever to have entered the South Sea, but though it wreaked considerable damage at several ports the expedition failed to achieve anything of value, and returned home via the Pacific and the Cape of Good Hope, only a remnant reaching Holland in 1626.

Previous attempts to defend the Caribbean were resumed in 1636 with the formation of the Windward Squadron ('armada de Barlovento'), in theory to be financed by a levy on the trade of New Spain, and based on Veracruz. The armada had an unstable life, being used more frequently for escorting the annual fleet across the Atlantic than for its initial role of defending the seas in America. In the mid-seventeenth century it ceased to exist as a united squadron, but was re-formed again in 1665 as a result of successful aggression in the Caribbean coasts by British and French. In Peru the ability to defend the enormous coastline was even less likely to succeed. Foreign intrusions never developed into a serious threat to territory, but they were also impossible to detect and control. The viceroy in 1600 reported that 'it is not possible to guard Callao and at the same time scour the coast without forsaking the one to attend to the other, and even if this were done what resistance can four ships offer?' The following year an official complained that Lima was 'protected only by its reputation'.[56] In practice the Spaniards were unable to put up any effective resistance to attacks from the sea, but could normally rally the civil population, for the most part unarmed blacks and mulattoes,[57] to offer a good defence against any landing of foreign invaders.

The menace of foreign privateers had in spite of everything two significant benefits for Spain. First, it exposed the haphazard organiz-ation of trade and drove the Spanish authorities to take defensive measures and develop a system of regulated fleets. Second, by their persistent illicit activities – excluding from our consideration the openly military actions – the foreign traders helped to bring some order into the commerce of the region. We know, for example, of Captain Fleury of Dieppe, who between 1618 and 1620 traded (against the opposition of Dutch and English competitors) in the Atlantic and Caribbean areas, bringing supplies to coastal communities that would otherwise have died of starvation.[58]

The situation was not peculiar only to Spanish settlements. The English in seventeenth-century Bermuda were in the same way dependent on supply ships from other nations. No European colony outside Europe could afford to limit its trade only to vessels of its own nation. Common sense suggested that in order to obtain regular supplies so far from home, and also incidentally to avoid the taxes demanded by the home country, informal smuggling should wherever possible be encouraged side by side with the official trade.[59] Spanish officials in the Caribbean complained of the commercial activities of foreigners and claimed that they were ruining the colonies. It was only part of the truth. Foreign traders and smugglers helped to create in the Caribbean a normal system of trade, whereas the restrictions of the official system were in fact condemning the colonies to economic frustration.[60] As in other corners of its vast empire, Spain did not have the means to regulate adequately the trade of the territories it claimed. Had there been no illicit traders, the supply and maintenance of the very many outposts manned by Spaniards would have collapsed. In their own way, the foreign traders were actually making it possible for the empire to survive.

The 1573 Ordinance was based on the fundamental premise that the empire's chief mission was religious. In the months that the document was being prepared, the king had been made well aware that Spain had a special duty to defend and promote the true faith. He supported the programme of reform and renewal in the Catholic Church that the Council of Trent had recently proposed. He was also conscious of the threat to Spain's security posed by Islam in the Mediterranean and by the successes of the Protestant Reformation in northern Europe. Nor did the issue of the missionary effort in the overseas empire escape him. The Spanish crown under Philip came to play a leading role in the evangelization of the New World, as it had an obligation to do through the so-called Patronato Real. This privilege, almost unique[61] in the history of the Church since it gave the crown the right to appoint all prelates as well as enjoy all Church revenues in the New World, inspired direct royal participation in religious affairs. Between 1493 and 1800 the crown financed the sending to America of at least fifteen thousand clergy, of whom a quarter went to New Spain.[62]

Not all these clergy were Spanish. The Flemish priests who featured among the Twelve that arrived in New Spain in 1524 were the fore-

runners of a long line of foreign clergy that went to the colonies out of pioneering zeal, curiosity and self-sacrifice. They had no specific loyalty to Castile or its culture. Toribio de Motolinia, in a famous letter of 1555 that he wrote to Charles V, worked with them and asked the emperor to send more, especially 'the many friars in Flanders and Italy who are servants of God'. Mendieta in his account of the work of the early Franciscans paid tribute to the French, Flemish and Italian priests who spent their careers in Mexico.[63] Both in America and in Asia, the religious orders were a vehicle for utilizing the talents of Catholics from all parts of the kingdom and from foreign countries. Many of them left memoirs that remain an invaluable source for assessing the views and motives of the missionary clergy. An outstanding example is the Franciscan friar Alonso de Benavides, a Portuguese born in 1578 in the Azores, who was in New Spain by 1598. He took part in the pioneering advance of the friars into New Mexico, and returned to Madrid in 1630, where he published an account of the triumphant advance of the faith in the New World. In the same decades, an Englishman, Thomas Gage, lived for fifteen years as a Dominican and parish priest in Guatemala, and after he left his post to return to England (1637) wrote the first full and intimate account by a foreigner of religious and social conditions in the American colonies.

From the later seventeenth century, when the flow of Castilian clergy from the peninsula began to dry up, foreign missionaries increased appreciably in number. A substantial proportion of those who served the Jesuits in this period came from Italy and central Europe,[64] as we know from the examples of Kino and Neumann cited below. A random check on the twenty-six Jesuits who sailed from Cadiz in 1730 and arrived in Havana in February 1731 shows that they included two Swiss, one Austrian, one German and one Moravian priest.[65] On subsequent sailings these nationalities continued to feature, together with one Sardinian and one Hungarian.

The effort and money did not always pay off. Forty years after the arrival of the mendicant missionaries, the evidence for their success was highly ambiguous. The friars claimed to have baptized hundreds of thousands of eager Indians; there is no lack of impressive statistics in the reports they compiled. The real status of the new converts was not so clear. Native peoples showed an amazing capacity for accepting many of the outward forms of Christianity without in any way abandoning

their own cultural habits. The relative failure of conversion efforts led very quickly to a change of focus in the clergy's methods. As early as 1533 in Mexico the Dominican Domingo de Betanzos maintained that Indians were not rational creatures and were therefore incapable of accepting Christianity. The clergy began to adopt an openly aggressive and domineering policy, which differed little in its practical effects from racial discrimination. In Mexico their distrust of those of mixed race was unmitigated; both mestizos and mulattoes tended to be excluded from all possibility of equality with other Christians. The Franciscans, who also came to view the American natives as deficient in natural reason, allotted them a subordinate role in the Church. They were treated as innocent 'children', in need of guidance. 'They are made to be pupils, not teachers; parishioners, not priests', Mendieta maintained.[66]

The decades after the fall of Tenochtitlan coincided with a catastrophic fall in native population levels. The clergy felt that the only practical way to cater to scattered communities of Indians was to bring them together into organized Christian townships. From about 1538, as a result, the so-called 'doctrinas' or Indian villages were created. Indians were often uprooted from their own homes and forced to move to the townships, where they lived under the protection of the friars. The experiment lasted for a long time, over thirty years, but provoked opposition on almost every side. The Indians normally disliked the new townships; the Spanish settlers objected to Indians being removed from the labour pool; and the other clergy criticized the friars for their allegedly tyrannical control of the Indians.

Changes in the religious programme were central to Philip II's 1573 Ordinance, which effectively altered the nature of the missionary effort. From the 1580s the 'doctrinas' so carefully nurtured by the orders were removed from their control and converted into 'parishes', in the charge of resident clergy responsible to a bishop. In practice, as in everything else the changes were not implemented adequately for nearly half a century.[67] The Franciscans denounced the new policy, which they saw as the end of a fruitful period in the planting of the gospel. From this time, in accord with the principles of the 1573 guidelines, they dedicated their efforts to missionary work on the northern frontiers of New Spain. It turned out to be perhaps the most heroic period in the history of their order.

The Franciscans effectively converted the frontier mission into an

instrument of empire. Until the end of Spain's presence in North America, they 'monopolized the missions along the Spanish rim from California to Florida'.[68] They claimed to have founded, by 1629, fifty churches among the Pueblo Indians of New Mexico. In the reports that they later published for dissemination in Europe, the friars claimed to have converted tens of thousands of natives. The first Franciscans, also in 1573, reached the Atlantic coast of Florida, where they were heirs to a previous effort by Jesuits. Within a century they succeeded in establishing a number of mission centres northwards from St Augustine into present South Carolina. They also succeeded in founding a string of missions westward from the Suwanee river into the territory of the Apalachee Indians. The same 'successes' were registered in every corner of the worldwide empire, and books published by the orders in Madrid gave an unequivocal picture of the irresistible spread of the faith.

What was the 'mission'? Even when used by clergy, the word had different meanings. It was a typical product of the 'Counter Reformation', the spiritual movement active in the Catholic Church from the end of the sixteenth century.[69] In Europe the mission was a temporary visit by groups of preachers who aimed to invigorate the spiritual life of the parishes. In the New World the mission became, by contrast, a permanent unit that was in effect the frontier parish and ministered principally to American natives, who were grouped into townships similar to the old 'doctrinas'. It was the most typical institution of the frontier, establishing contact with frontier peoples and imposing on them the religion and culture of the Spanish people.

But it was not a task that the Spaniards could achieve alone. In order to establish a link with the language and customs of the natives, they called upon the help of allies. There were none more reliable than their old friends the Tlaxcalans, who had made the conquest of Mexico possible. In the 1590s a colony of Tlaxcalans was imported to the northeastern frontier and settled at Saltillo, where they helped to teach the natives and also acted as a showcase for the possibilities of cooperation.[70] In this way the Tlaxcalans continued to contribute not only to the native conquest of America but also to its conversion.

Moreover, the friars were not usually so foolish as to go out alone into Indian territory. Learning from the sad experience of idealist priests who had undertaken conversion work without military support and been killed for their pains, in nearly all cases they went accompanied by

soldiers. It was an explicit fulfilment of the 1573 Ordinance that had forbidden further conquests but recognized the need for a military presence in frontier areas. The mission community was a carefully organized settlement,[71] normally taking the form of a compound with the church building in the middle and service huts and Indian residences forming a large circle round it. It was usually accompanied by the other basic feature of the frontier, the Spanish town, which might be as large as a thriving mining town or as small as a presidio, a fort manned by up to fifty soldiers.

Soldiers and the use of force became an integral component of the missions. The soldiers were more than a defence, they kept order and served to pursue runaways and punish wrongdoers. Pious violence had typified much of the early work of conversion in Mexico, and it continued to be employed against the natives at every level, both in religious and in secular matters.[72] The compulsion, which Mendieta had defended when writing about the Franciscans, was accompanied by the systematic use of violence as a way of educating the natives. The clergy never had doubts about the need for it. Whipping became a normal method of disciplining indigenous Christians and breaking their resistance. José de Acosta in 1576 testified that in Peru he had seen priests 'strike Indian penitents with kicks or with their fists; if the penitents are too slow in what they say, or admit some grave fault, then they either flog them or have them flogged in their presence, often until the blood runs. It is a horrible thing to say, but I speak of true and attested facts.'[73]

The communication of the Christian message followed European norms, with an emphasis on education and learning from memory. Everywhere, of course, language presented a grave obstacle. On the whole, Jesuits attempted to learn elements of native tongues. By contrast the Franciscans from the mid-sixteenth century stuck to Spanish alone and used no other language. In New Mexico during the whole seventeenth century only one Franciscan is recorded as being able to speak to the Indians in their own tongue.[74] In Guatemala the clergy continuously attempted to eliminate the use of indigenous tongues and to impose the sole use of Castilian.[75]

Perhaps the most successful weapon the clergy had at their disposal was technology. Captivated by what the priests had to offer – the novelty of their culture, the practical knowledge in agriculture and methods of

defence against enemies – groups of natives collaborated with them and helped to set up mission centres. When they learned that the newcomers did not appear to be a threat, many tribes made positive moves and extended hospitality to them. From that moment the missionaries' work was conditioned entirely by the availability of native labour, the prime support of the Christian enterprise. Three main changes, all of them fundamental, were slowly imposed on the affected natives.

First, they were encouraged to live together, as we have noted, in a community organized for defence, with a church as the social centre. In the heartland of New Spain and Peru these church communities, originally run by Franciscans, continued to be called doctrinas, though the name was being dropped by the end of the sixteenth century. When the Franciscans went into the frontier lands of North America, they took the doctrina with them. Second, the Indians were encouraged to adapt their traditional social and sexual customs to the dictates of Catholic morality. Clergy were proud of the way that converts were taught to live and dress like 'Christians'. The 1573 Ordinance stated expressly that they were to be taught to 'live in a civilized manner, clothed and wearing shoes; given the use of bread and wine and oil and many other essentials of life such as food, silk, linen, horses, cattle, tools and weapons, and all the rest that Spain has; and instructed in trades and skills'.[76] Finally, they were encouraged to change their food production and work methods. Natives had usually got by on a subsistence economy, producing sufficient for their own needs. Now the friars aimed to produce surpluses, which could be taken to nearby Spanish markets to earn income for the missions. The new system called for extra effort on the part of Indians, and they did not like it. It changed their routine of work and leisure, and quickly provoked discontent. The employment of Indians in this way also gave rise to one of the most enduring problems on the frontier: the competition between settlers and clergy for available labour,[77] an issue that never ceased to provoke disputes and armed conflicts among the settlers themselves.

It is evident that the mission settlements affected only a small proportion of the peoples living in the territories that Spaniards claimed to control. But it was an achievement to have converted even a few. The dedication of the Franciscans, who first came to Florida in 1573, was notable. By the 1670s they had a string of Christian settlements through the north of the region, mainly in Apalachee. When the bishop of Cuba

made a lengthy ten-month pastoral visit to the area he found that the Christian Indians in the missions totalled some thirteen thousand.[78] In view of the evident hostility of the majority of the tribes, the willingness of the few calls for an explanation. The missionaries adopted shrewd strategies based on long experience.[79] Friars always came bearing gifts, especially iron tools; it was a fundamental tactic that seldom failed. They brought trinkets, bells, clothing, images, musical instruments and food. The objects did not serve merely to entertain, they established a bond of hospitality that created an obligation to friendship. They concentrated always on winning over and educating the children, who would later serve to win over the adults. Some tribes sought to ally with the friars in order to secure an advantage against other tribes, or even against other Spaniards, particularly soldiers. The nomadic peoples outside the confines of the frontier were a continuous threat to the Christianized villages. A report from the Pueblo villages in 1607 stated that 'the Spaniards and the Christians and peaceful natives of New Mexico are frequently harassed by attacks of the Apache Indians, who destroy and burn their villages, steal their horses and cause other damage'.[80] In some cases, local leaders thought that the missionaries were magical persons who offered solutions they themselves did not have, especially in medical matters. The friars invariably came in the company of European animals – dogs, goats, horses, sheep – that promised to change the Indian way of life.

And changes happened, to a degree that altered irremediably the geography and ecology of the new lands. It is a story that scholars have only recently begun to explore.

Animals imported by Europeans thrived in their new environment and took over the plains of the New World. Every type of European domestic and outdoor animal was brought over, from dogs and horses to chickens, sheep, pigs, goats and cattle, all necessary in order to reproduce for Spaniards the environment they knew. Some vessels crossed the Atlantic as veritable arks of Noah. 'We brought pigs, chickens, dogs and cats', a passenger on Columbus's 1493 voyage reported, 'they reproduce there in a superlative manner.' A few of the animals revolutionized the society and economy of America. The preferred animal of Spaniards, the pig, first introduced to Hispaniola in 1493, was by the 1530s swarming all over Hispaniola, Cuba, Mexico and Peru. Pigs were easy to transport by ship from Spain, and repaid the effort. In 1514 governor

Velázquez in Cuba reported that the pigs he had brought had increased to several thousand.[81] De Soto took thirteen pigs with him to Florida in 1539, and had seven hundred of them by the time of his death three years later.

Cattle were especially good at reproducing themselves: it was reported from Hispaniola in 1518 that thirty or forty cattle left in the wild could increase to three hundred in three or four years. In Mexico they multiplied effortlessly. The French explorer Champlain related that during his visit there at the end of the century he had seen 'great, level plains, stretching endlessly and everywhere covered with an infinite number of cattle'.[82] In 1619 the governor of Buenos Aires reported that eighty thousand cattle a year could be killed in the area round the city for their hides, and a century later a witness estimated that the cattle in the southern pampas numbered around forty-eight million.[83] Horses were certainly the most difficult animal to transport across the Atlantic, and a high proportion died on the voyage. The first of them came to America with Columbus in 1493. They reproduced slowly, but soon became essential to all Spanish activity, given the vast distances in the New World. Pizarro brought the first horses in 1532 to Peru, where they played a crucial role in the subjugation of the Andean peoples. On the pampas of the Río de la Plata horses were in the environment they best loved. When Spanish settlers began the permanent occupation of Buenos Aires in 1580 they found that they had been preceded by hordes of wild horses, and a generation later the horses in Tucuman were reported to be 'in such numbers that they cover the face of the earth'.[84] The only animal to have difficulties in reproduction was the sheep, which also arrived with Columbus in 1493. Timid, and intolerant of the tropical climate, sheep had a hard time in the Caribbean, but in the more hospitable regions of New Spain and in the Andes they came into their own.

The animals changed the life of colonial peoples permanently. Prior to the coming of the white man, the Nahuas had enjoyed a largely vegetarian diet. The availability of animals persuaded very many to become meat-eaters. In the same way, the arrival of the horse revolutionized the quality of Indian life. The change was sometimes slow. In the 1550s in Cusco the natives fled in fear if they met a horse. By the 1580s, however, in the Quito region the richer Indians rode horses when they went out to their fields, and were ploughing with ox-teams. Around

Cusco, 'many of them have mastered horse riding and shooting from horseback'.[85] In North America the Plains Indians first acquired horses after 1600, drawing on the herds of wild horses that by now were roaming the frontier north of Mexico. The Apache and the Navajo, who emerged in time as the principal horsed tribes of the continent, seem not to have had them before the 1630s and the 1680s respectively. The horse became an integral part of their economy and culture. A Navajo song much later represented the horse:

> He stands on the upper circle of the rainbow
> The sunbeam is in his mouth for a bridle
> He circles round all the people of the earth
> Today he is on my side
> And I shall win with him.[86]

The spectacular multiplication of European animals was brought about by two simple factors:[87] the abundance of rich vegetation in the New World, and the complete absence of any competition from tamed indigenous grazing animals. Castilians introduced into the open spaces of the New World a form of life that had sustained a section of their economy for centuries: pastoralism. The grazing animals were allowed to occupy vast spaces and to move on to yet more spaces, eating as they went. It was a type of economy that had immediate consequences on surface vegetation. It also required new forms of land management, to make sure the animals had what they needed. This consequently had social and political implications. The indigenous communities, which relentlessly resisted the advance of the animals that ate their crops and occupied their lands, stood in the way and had to be dealt with.

Not only animals but all forms of Old World life travelled with the Europeans. As we have seen, they brought with them their own plants for food, as well as trees and flowers; weeds also came across, mixed in with the plant life, and so too did pests, such as ship-rats. They all formed an essential ingredient of the invasion, for they went everywhere with the newcomers. In the process, they permanently changed the environment of the colonized world, a process that has been termed 'ecological imperialism'.[88] Above all, as we have seen, they brought diseases, whose lasting consequence was the destruction of part of the indigenous population of the New World and the islands of the Pacific.

Stated briefly, the arrival of outsiders altered the entire eco-system in which the indigenous peoples had existed. In perspective the loss of population was the most striking feature of the extension of Spain's religious frontier. The Spaniards carried infectious diseases with them. The missionary programme in the southwest of the United States had the involuntary consequence of reducing the native population by upwards of ninety per cent prior to 1678.[89] By the early eighteenth century it resulted in cutting the population of the Pueblo Indians by at least half, and depopulating permanently the majority of their settlements.[90] The disaster in its turn had a profound impact on the native cultures, which were often unable to offer themselves a satisfactory explanation of what was happening.

As population numbers shrank, the available labour force declined and patterns of land use changed dramatically. Outside areas inhabited by nomads, agriculture had supported life. This was now fundamentally affected, as encomenderos took over control of land, tricked Indian caciques into selling them farms and villages, or in many cases simply claimed land and drove the resident Indians off it. Communal lands were transformed into private estates, fences were erected, streams were diverted, and above all the normal Indian crops, such as maize and manioc, were suppressed and substituted by wheat, olives, sugar, grapes and whatever else was necessary or profitable to the white man. Spanish officials in America collaborated fully in the expropriation of the natives, and government orders from Madrid to protect the Indian were simply ignored. The process began very soon after the coming of the Spaniards, and took many shapes and forms, all of them exhaustively studied by modern historians.

A careful study of the case of the Valle del Mezquital in central Mexico gives one indication of the consequences on the environment of the New World. By the end of the sixteenth century the native population here had declined ninety per cent from pre-contact levels. By this time the Indians were no longer in possession of the land, and Spaniards had begun to settle and to plant the foods they required: wheat, barley, grapes, pears, peaches, apples, oranges, dates, figs and walnuts.[91] Then the animals came in. By the end of the century nearly two-thirds of the land surface of the Valle was given over to pastoral use.[92] The plains became barren deserts, erosion set in, deforestation advanced. Sheep, directed usually from a rural hacienda, dominated the landscape. What

had been a fertile and productive agricultural region was converted during colonial times into a desert.

The valour of the Catholic missionaries, many of whom lost their lives in the course of their efforts, had few parallels in the history of the Christian Church. The clergy were, however, no mere purveyors of faith. Their own experience taught them that in order to plant the faith with success, they must also re-shape the civilizations of the territories perceived to be within the empire. The entire missionary enterprise of the colonial period must consequently be seen as an extended confrontation between European culture and the distinctive cultures of the non-European world. Early worries that the missionaries may have had in Mexico, about being able to communicate convincingly the fundamental tenets of the faith, were soon replaced by a conviction that the medium of discourse – through social education – was no less important than the gospel message. Education brought with it, as always, the need for discipline. And discipline meant, for Spaniards, the Inquisition.

The Inquisition did not come to the New World with the Spaniards, for its role was concerned only with heresy, a problem that was not considered to exist among the primitive Indians. However, in the same way that he had proposed the introduction of black slaves in order to save the lives of the Indians, so now Fray Bartolomé de las Casas proposed the introduction of the Holy Office in order to save their souls. 'I beg you', he wrote to Cardinal Cisneros in 1516, 'to send the Holy Inquisition to those islands of America.'[93] The cardinal did not see the need for implanting the tribunal in a few poorly populated islands on the edge of the Atlantic, but he was concerned about the emigration of conversos and Moriscos to those lands, so he chose a half-way solution, issuing commissions as inquisitor to select bishops (at this early date three had already been appointed in the Caribbean). The first commission as inquisitor of America was accordingly issued to the bishop of Puerto Rico in 1519.

The inquisitor soon found work to do, for the first known case of an alleged 'Lutheran' in the New World occurred in the 1520s. A royal official from Venezuela, where the Welsers had just been given a monopoly contract, urged Charles V to 'prohibit all Germans from taking part in the conquest, for it has been found that there were some in those

provinces who shared the opinions of the heretic Martin Luther'.[94] In particular a Fleming had been arrested, and details of his case were sent to the inquisitor in Puerto Rico. It is worth recalling that at this date the Lutheran heresy had barely come into existence, and was moreover completely unknown in Spain. Yet Las Casas, his eager eye fixed on all that was not quite right in the America he knew and loved, was alert before the menace of heresy. 'The Germans who have gone there', he wrote in 1535, 'are all heretics and spawn of that wild beast Luther.'[95] In practice, this early Inquisition in America did little of consequence, except pick on a few foreigners and irritate the Spanish settlers.

Shortly after the overthrow of the high civilizations of Anahuac and Tawantinsuyu, the traditional rigour of the Holy Office asserted itself. Fray Juan de Zumárraga, the Franciscan who became first bishop of Mexico in 1530, was appointed inquisitor five years later and distinguished himself as an enemy of heresy.[96] His most famous operation was the trial and execution of the Indian noble of Texcoco, Carlos de Chichimecateotl. It was one of the most cruel and also most unjust acts of inquisitorial severity, and earned the reprimand of the Inquisition in Spain, which informed Zumárraga in 1540 that the Indians should be brought in to the faith 'more through love than through severity', and that the execution of Carlos was quite simply wrong. 'It is not just to employ so much severity in order to frighten the Indians.' One positive consequence of the case was that the Inquisition prohibited any further action for heresy against the Indians, on the basis of the similar policy that it practised in Spain itself towards the Moriscos. Instead the New World tribunal in subsequent years dedicated itself primarily to rooting out Jewish conversos and arresting (and executing) those foreign sailors who fell into its hands.

Despite the outcome of the case involving Carlos, the question of the Indian always remained at the top of the agenda. Other clergy in America decided to act on their own against superstition, bypassing the official Inquisition and its procedures. Las Casas himself proclaimed an 'Inquisition' of his own in his diocese of Chiapas in 1545. Had it ever been allowed to function, it would have turned upside down the lives of all the parishioners, both Spaniard and Indian, with undoubtedly blood-curdling consequences. Another bishop who claimed the privilege of having his own Inquisition, and certainly did achieve blood-curdling results, was the bishop of Yucatan, Fray Diego de Landa. For half a

century, the clergy in America could count on the help of these informal 'Inquisitions', but pressure still mounted for a regular body that could be controlled from Spain. Eventually the same committee (the Junta Magna) in Spain that was preparing the king's Ordinance on Discovery, decided to establish two autonomous tribunals of the Holy Inquisition in America, as part of a general reform of the institution throughout the monarchy. A decree to this effect was issued in 1569, and shortly after there were tribunals functioning, along the lines followed in the peninsula, in Mexico City and in Lima.

In the year 1569 Cristóbal de Albornoz, canon of the cathedral of Cusco, who had been in the viceroyalty of Peru since 1565, was entrusted with a visitation of the parishes in the area of the town of Huamanga, a task in which he was assisted by Guaman Poma de Ayala. His experiences with the religion of the Indians drove him to denounce the existence of a widespread movement of 'idolatry' known as Taki Onqoy (in Quechua, 'the dance sickness'), whose existence had already been known to local clergy since at least 1565. On the basis of information supplied by Albornoz and other clergy, it became apparent that for many years the whole mountainous area of central Peru, focusing on the town of Huamanga but extending from just south of the capital Lima to the northern part of Arequipa province, had been home to a radical cultural movement that challenged all existing religion and society.

The coincidence of dates with the Inca resistance in the mountains at Vilcabamba was fortuitous, for the preachers of Taki Onqoy did not admit the principles of Inca religion either. According to a local priest,

many people followed them, and were told not to believe in Dios[97] or his commandments, nor worship images and crosses nor go into the churches nor confess with the priests, but to confess with them because they had come to preach in the name of the huacas Titicaca and Tiahuanaco and many other huacas; and that these huacas had overthrown the Christian 'Dios', whose time was now over.[98]

The god of the Christians, moreover, was a mute god. The affirmation reminds us immediately of the breviary that Atahualpa had thrown on the ground because it did not speak. The Taki Onqoy preachers, to demonstrate the truth of their claim, would set up the Christian cross in the houses of the Indians and address it; but it would not speak. The huacas they brought with them, on the other hand, did speak to them.

'See', they said, 'how this one speaks to us and is our God, and we have to worship it.'

The huacas were devotional objects of all kinds, both domestic and public, both small and large, that formed part of the everyday life of ancient (and also modern) Peruvian religion; but the meaning of the word was notoriously imprecise. The Andeans gave the name huaca both to an object and to the spirit that was present in the object; it most frequently referred to stones, and the shape and direction of stones tended to have great importance. But huacas could also be rocks, mountain peaks and rivers. The shores of Lake Titicaca, with its ancient temple of Tiahuanaco, were a fertile centre of huaca devotion, and on the island of Titicaca there was a pre-Inca huaca in the form of a crescent-shaped rock that in old times the Indians covered in sheets of gold.[99]

Taki Onqoy was in part a survival of some aspects of pre-Inca religion in the Andes. Its fundamental feature was the *taki*, or ballad,[100] a common feature of social and celebratory gatherings in pre-Hispanic times. It also took distinctive forms that suggest millenarian ecstasy, of the type, for example, practised by the followers of El Mahdi in the nineteenth-century Sudan. Witnesses said that 'they sang in a certain manner, which they called Taki Onqoy', and that 'some danced saying they had the huaca in their body', 'they shook and tumbled on the ground'.[101] The adepts believed that

all the huacas of the kingdom, all those which the Christians had pulled down and destroyed, had now come back to life; all were now going through the air in order of battle against 'Dios' to conquer him, and indeed they had already conquered him. And when the marquis [Pizarro] came to this land 'Dios' conquered the huacas and the Spaniards conquered the Indians. But now the world was turned upside down, and 'Dios' and the Spaniards had been overthrown this time, and all the Spaniards were dead.[102]

The Jesuit counter-attack against the huacas was unremitting. In 1607 the parish priest of San Damián in Huarochiri, Francisco de Avila, a dedicated priest who spoke the Quechua language, claimed that he had discovered the practice of heresies among the Indians. He was appointed in 1610 as 'the first judge for idolatry' in the viceroyalty, to carry out a programme of 'extirpation'. With the assistance of Jesuits he began a systematic enquiry into the worship of huacas in the area. The 'enquiry' was fundamentally an 'inquisition', but without the procedures of the

traditional Spanish Inquisition; for instance the punishment it administered was corporal (whipping, or imprisonment) and it did not have the death penalty. Avila claimed to have destroyed during his missions over eight hundred 'fixed' idols (such as rocks), and over twenty thousand smaller idols (huacas).[103] He led a campaign that imitated the methods of the Inquisition, even to the extent of holding a great ceremony resembling an auto de fe in Lima in December 1609, in the presence of the public, the viceroy and dignitaries.

Subsequent 'extirpators' also helped in the campaign, which was at its most intense during the half century 1610–1660.[104] Some Spanish writers tried to understand and explain the significance of the objects revered by the Andeans, but came down regardless in favour of the use of violence. It was a violence not only of words, through sermons in which revered objects were condemned as idols and native teachers as sorcerers. It was also a physical violence, in which traditional objects were ritually burnt, and suspects publicly whipped. Throughout colonial America, clergy used the ritual of destruction systematically in order to eliminate elements of indigenous culture that they did not understand, 'idols, offerings, masks and other things of the kind which the Indians use in their heathenism', as a friar in New Mexico explained.[105]

The leading role of clergy in the labour of colonization gave them an incomparable importance in the formation of the Spanish empire. Beyond the great ranches, the busy trading ports, and the bustling mining centres, there was very little Spanish settlement. In catering for the spiritual needs of the Indians, the missionaries had to take care to uphold the essentials of Spanish culture, particularly the use of Castilian and of Castilian personal names, respect for peninsular norms of morality, and the wearing of clothing. At the same time, however, they attempted to introduce Spanish social norms, such as the eating of bread and meat. Food of some sort had to be made available, for example, to natives of the great plains of North America who were being dissuaded from their former lives as nomadic hunters. The inevitable consequence was that some missionaries had to run their missions as a practical business in which the means of production was a fundamental priority. The Catholic faith in the Spanish empire also became a business concern.

Perhaps the most famous of all missionary enterprises in the Spanish empire was the experiment conducted by the Jesuit order in the interior

of South America, among the Guaraní people.[106] From around 1540, when the town of Asunción was founded, white settlers were moving from Peru into the territory watered by the Río de la Plata. From 1585 the Jesuits were active locally, and founded a college of the order in Asunción. In the same years the pioneer of preaching among the Guaraní was the Franciscan Luis de Bolaños, who produced the first word-book and prayer-book in their language. Another Franciscan, Francisco Solano, dedicated himself to the same task among the Chaco Indians. Then in 1587 the Jesuits came: two Spanish Jesuits came from Peru, and a Portuguese, an Irishman and an Italian were among the four who came from Bahia. These were early explorations, doomed to failure. Not until a quarter of a century later, in 1610, did they establish their first permanent missionary base in Guairá province. The pioneers were two Italians, fathers Maceta and Cataldino, who established the first 'reduction', a community of Indians that resembled the doctrinas and from which all outsiders were excluded.[107]

Against the opposition of local Spanish settlers, the Jesuits obtained in 1611 and 1618 ordinances that gave them official permission to set up further reductions. The experiment attained enormous success. By the 1700s there were between eighty thousand and a hundred-and-twenty thousand Guaraní in the reductions. At the same date there were two hundred and fifty Jesuits in the province of La Plata (Buenos Aires, which was re-settled in 1580 after the collapse of the first colony a generation earlier), of whom one quarter worked in the reductions. Thirty Guaraní missions were located within a vast area stretching from the River Paraguay and beyond the River Uruguay towards the south Atlantic. The zone became known as 'Paraguay', but in effect covered a huge swathe across mainland Spanish South America.

The enterprise captured the imagination of contemporaries and continued to stir passions long after it had ceased to exist. Starting from the principle of the 'doctrina', officially in practice elsewhere in America, the Jesuits organized each community into a carefully constructed compound, circular in formation for defence purposes and with its social life based on a church constructed in the centre. The community was entirely self-sufficient and also heavily armed against regular attacks by hostile natives, notably the Chaco Indians and the frontiersmen of Brazil, the bandeirantes. No contact with Europeans was permitted. The obviously 'utopian' character of the settlements was of course not original, for

others such as Las Casas and the bishop of Michoacán Vasco de Quiroga had also attempted similar schemes. The difference in this case was that the Jesuit experiment worked, and endured more or less successfully for nearly two hundred years.

The international contribution to this apparently 'Spanish' scheme can be easily overlooked. The utopian idea may have filtered in though various channels, since the Jesuits came from all corners of Europe. As with the early Franciscan mendicants, the Netherlands contingent was always present. A group of Belgian Jesuits came to the reductions in 1616, then another in 1628, and another in 1640. This last group included François du Toit, the first historian of the Jesuits of Paraguay. From the end of the seventeenth century, the entry of Jesuits from central Europe, here as in the northern frontier of New Spain, was notable. In 1691 when Antonius Sepp, a Tyrolean priest, came to Buenos Aires to join the reductions, the Guaraní towns owned 698,300 cows, 44,200 oxen, 11,400 calves, 240,000 sheep, 28,200 horses, 45,600 mares, 3,000 fillies, 770 young mares, 700 young fillies, 15,200 mules, 8,000 asses, 150 stallions and 343 pigs.[108]

Though the Jesuit enterprise was directed to the instruction of the natives, it did so through the medium of a social discourse that aimed to Christianize Guaraní culture by isolating it. The Guaraní towns, which of course were only a small segment of the indigenous population of the area, formed a network of economic production that did not escape the attention of European writers who saw it as a form of idealistic communism. The Jesuits, as we shall see, by working through small units such as the reduction or the hacienda, were able to perfect a type of economic organization that exploited the resources available in the Spanish empire, and at the same time gave support to the empire while preserving its own character and autonomy. This autonomy never failed to attract criticism, especially from the local settlers in Asunción.

Our primary concern, however, is with the role of the Jesuits as frontiersmen in Paraguay. There was no perceptible Spanish presence in the heartland of the South American continent. At the very time the reductions began, the slave-hunting and gold-seeking bandeirantes of Brazil (also called paulistas because many came from São Paulo) were making expeditions inland that took them into territory that theoretically belonged to Spain but was now part of the joint Spanish–Portuguese empire. The only obstacle in their way was the Jesuit reductions. The

bandeirantes, consisting normally of a small number of Portuguese supported by black slaves and thousands of Indian allies, attacked the Jesuit missions, carrying off or murdering the Indians in them. In 1629 their first big expedition succeeded in driving the missions completely out of Guairá; the Jesuits led their Indians out of the area in a long march that took them up the River Paraná in canoes and through the forests. In 1636 further murderous attacks were made on the reductions, the motive being that it was easier to seize settled rather than nomadic natives. The Jesuits eventually responded in a way that turned them into the true defenders of the Spanish American frontier.

Though many settlers objected, the priests set about arming and training their Indians. They received official permission to import weapons, and the reverend fathers became military instructors and generals, teaching the Guaraní how to defend as well as attack. The Indians also became expert horsemen, producing an efficient cavalry that formed the core of the armed forces. By the mid-seventeenth century the Jesuits were in charge of the only available army in the whole of the trans-Atlantic empire. By 1647, when the army numbered seven thousand armed soldiers, the Guaraní had become the empire's only defence, protecting colonists against hostile Indians and the mines of Potosí against the Portuguese threat. Altogether between 1637 and 1745, when the reductions were eventually abolished, the Guaraní armies entered the field at least fifty times on behalf of the king of Spain.[109] In 1697 a force of two thousand drove back the French from Buenos Aires; in 1704 a force of four thousand accompanied by their horses and cattle and a store of weapons came down the Paraná on barges in order to defend the city against the English; and in 1724 they expelled the Portuguese from Montevideo. Without the amazing prowess of the Guaraní soldiers, the power of Spain in South America could have been extinguished.

Like the other great religious orders, the Jesuits also made a fundamental contribution to the economy of the empire. They everywhere attempted to extract a living from the available resources, and seem to have succeeded amazingly. The bishop of Puebla, Juan de Palafox, who entered into a famous controversy with the order in New Spain, was scandalized by their dedication to materialist enterprises. He reported with disgust to the pope in 1647 that the Jesuits ran their estates with black slave labour, herded hundreds of thousands of cattle, ran six large

sugar plantations worth a million pesos each, owned vast haciendas four to six leagues across, as well as factories and shops, and participated in the trade to the Philippines.[110] The Jesuit missions on the northern New Spain frontier, which began from the 1590s, were likewise run as a profitable economic concern.[111] In the valley of the upper reaches of the Sinaloa and Sonora rivers, by the mid-seventeenth century the Jesuits had established thirty-five missions that took in, according to their calculations, thousands of native converts. They had planted wheat and other cereals throughout their lands, and had covered the plains with thousands of cattle that served the Indians for food which they had previously obtained by hunting. The Indians were both Christianized and weaned away from their former nomadic existence. The Jesuits in this way changed the entire economy of the areas they evangelized. At the very end of the seventeenth century Father Kino was one of the great ranchers of his time, transporting hundreds of cattle from one mission point to another, and encouraging the spread of wheat cultivation in the river valleys.

The immense changes made by the Catholic faith to the eco-systems of the New World could be seen also in the extensive series of landed estates that the Jesuits owned along the coast of the viceroyalty of Peru.[112] By around 1700 the Jesuits, who had arrived barely thirty years before, were among the richest landowners of the Andean valleys. At first the Jesuit haciendas produced sugar, then they took to cultivating vines; both were directed to financing the eleven Jesuit colleges in Peru. Winemaking soon became the most profitable industry on the coast, though in theory no wine was to be sold to Indians, 'because they leave their farms and get drunk'.[113] It is possible to imagine the irony of entire estates and valleys being dedicated to growing produce that the indigenous population was forbidden to consume. When there was a shortage of local native labour, as happened by the end of the sixteenth century, the Jesuits made use of imported black slaves, brought in principally through Buenos Aires and Brazil. By the mid-eighteenth century the Jesuits were reckoned to be the biggest slaveholders in South America. They also figured as among the most successful property owners, since they did not pay taxes and even avoided the famous sales tax, the alcabala, on the excuse that their estates produced for subsistence and not for trade.

*

This rapid journey to select points of the Spanish frontier in the New World leads us to some unconventional conclusions. It was obvious throughout the colonial period that Spaniards did not possess the means, the men or the money to establish a secure presence outside a handful of big cities and the hinterland associated with them. The unending forests, the interminable grasslands and plains, the expanses of un-patrolled coastline, escaped their authority completely. Nor was there any way in which they could impose adequate control over those who wished to trade outside the officially approved system. We have often been presented with a picture of a continent that was in substance firmly Spanish, with only its outer fringes vulnerable to the marauding of pirates and the raids of untamed Indians. When we look at the picture more closely, the distinction between what was and was not Spanish, what was the empire and what was merely its frontier, becomes blurred and often vanishes completely.

The incapacity of Spain was the basic situation. Beyond that, the different elements of the vast American landscape were in fact held together by those who have too often been looked upon as its destroyers. The marauders and the untamed were also an integral part of the whole, the informal participants in empire were no less crucial than the formal. The indigenous peoples who never ceased to be hostile to the Spaniards were also those who worked with and alongside the Spanish system, because it was also in their interest to ensure the survival (on their own terms) of the empire rather than its ruin. The Dutch and English bringing blacks and material goods to Central America were backing up Spain just as much as the Guaraní warriors who sailed down the Paraná, singing and armed to the teeth on their way to defend Buenos Aires. There was, in brief, no clear division between an occupied Spanish America and the untamed frontier beyond it. Both internally and exter-nally, all parts of the enterprise in the New World formed a complex frontier, in which both friends and enemies collaborated in order to survive.

7

The Business of World Power

This monarchy of Spain, which embraces all nations and encircles the world, is that of the Messiah, and thus shows itself to be the heir of the universe.

Tommaso Campanella, *Discourses* (1607)[1]

'During this year [1530]', recorded a native Cakchiquel chronicler of Guatemala, 'heavy tribute was imposed. Four hundred men and four hundred women were delivered to be sent to wash gold. All the people extracted the gold. All this, all, we ourselves saw, oh my sons!'[2] The great prize attained by Spain's empire, guarded jealously and coveted by every nation in Europe and in Asia, was the gold and silver of the New World. In the early decades the search had been exclusively for gold, whether in the form of ornaments (as with the Inca treasure) or panned from mountain streams. During the first decades of settlement, both in the Caribbean and in Central America, the Spaniards organized tens of thousands of slave labour gangs to help pan gold. From the middle of the sixteenth century, however, the discovery of rich deposits of silver far south in the American continent at Potosí (Bolivia) in 1545 and at Zacatecas (Mexico) in 1548 opened the way to the preponderance of silver in the economy of the empire. Gold was worth about ten times more than silver, and continued to be mined for centuries. But silver reigned.

Silver output remained low until the development of the use of mercury. The mercury amalgam process involved the isolation of silver from waste by combining it with mercury. The process was developed in 1555 from German ideas,[3] by the Sevillan Bartolomé de Medina, and first extensively used in Mexico, then in Peru from the 1570s. In Peru the Spaniards enjoyed the advantage after 1568 of rich mercury mines at

Huancavelica. Mexico, by contrast, had to rely throughout the colonial period on the importation of mercury, with great difficulty and much cost, from the royal mines in Spain at Almadén, in the province of Ciudad Real. When there were difficulties in supply, the crown resorted to purchasing mercury from the mines at Idria in central Europe. The amalgam process boosted output phenomenally. At Potosí production was seven times higher in 1585 than in 1572, and during the period 1580–1650 output never fell below 7.6 million pesos annually.[4] 'Potosí is more prosperous than it has ever been',[5] a satisfied settler reported in 1577. 'There is so much silver that we want for nothing', wrote another. Thirteen thousand feet up in the cold and barren mountains of central Peru, Potosí with a population in 1547 of fourteen thousand grew to have one of nearly one hundred and sixty thousand in 1650, the largest town in the entire empire, producing four-fifths of the silver of the viceroyalty. A friar in 1630 saw the mine as the hope of Spain's imperial policies: 'Potosí lives in order to serve the imposing aspirations of Spain: it serves to chastise the Turk, humble the Moor, make Flanders tremble and terrify England.'[6]

It would be a truism to say that the men who created this wealth were the indigenous natives. How did they labour to produce it? The familiar image of Spaniards exploiting a vast fund of 'forced paid labour' equivalent to slavery is only partly true. In fact, at Potosí the way the natives served with their labour went through different stages. Until the early 1570s, the conditions of work and marketing were defined largely by the Indians themselves.[7] They produced the silver according to their own rules and conditions, and then made arrangements for handing the requisite quantities over to the Spaniards. From 1573, in the period of Viceroy Toledo, the system of drafting peasant labour, the mita, was used to recruit Indians to work for a small wage in the mines. The consequences were dramatic: output increased fourfold. In the early decades around thirteen thousand Indians a year were recruited, though the figures declined as epidemics and disease took their toll.

From this period, the American mines poured out their riches. Between 1550 and 1800, Mexico and South America produced over eighty per cent of the world's silver and seventy per cent of the world's gold. Between 1540 and 1700 the New World produced around fifty thousand tons of silver, a quantity that doubled the existing stock of silver in Europe, with profound consequences for its economy.[8] Over

seventy per cent of this production came from the famous site at Potosí. There are no reliable figures for the amounts of metal transported across the Atlantic, but the official imports registered at Seville indicate that between 1500 and 1650 over a hundred and eighty tons of gold and sixteen thousand tons of silver were sent from the New World to Spain.

The rapid wealth in its turn stimulated the economy throughout the empire. 'There are many men I know who three years ago possessed not a penny and were three or four thousand pesos in debt, now with the new invention of mercury some of them have forty and fifty thousand pesos.'[9] 'God has given me silver, and in quantity', a satisfied settler wrote from Huamanga in Peru in 1590, 'I now live rich and honoured in this land, who would make me go back to Spain and be poor?'[10] Spaniards of all ranks and conditions saw their lives transformed in America by the riches that poured out: artisans set up businesses, traders purchased ships, merchants opened shops, butchers, tailors and shoemakers found new opportunities in a land where there was effectively no competition for their services. 'This land', it was reported from Lima, 'is silver-mad.'[11]

The crown of Spain was foremost among those who profited, receiving by law one fifth (quinto) of wealth produced. To demonstrate their loyalty to the crown, conquistadors from the time of Cortés and Pizarro always took great care to set aside the royal fifth before dividing the spoils. With time the government also began to levy taxes on everything else connected with the bullion trade. The New World, as we have seen from the situation during the emperor's reign, was transformed into the treasure chest not only of the Spanish state but of all those – settlers, traders and bankers – whose investment in the enterprise was beginning to pay dividends.

The precious metals, rather than conquest, were the key to the development of the monarchy. Though military forces were important for the survival of Spanish power, they played little part in its *creation*. The empire, in reality, was brought into existence by the collaboration of powerful provincial élites and enterprising traders who operated across nations rather than within one nation alone. It was the first globalized economy. The Romans, a sixteenth-century writer pointed out, had become great by conquest; the Spaniards, by dynastic inheritance that united many lands. Writing a year before the death of Philip II, Gregorio

López Madera commented that 'all past empires have come to birth through violence and armed force, only that of Spain has been just in its origins and increase, for the greater part came together through succession, and the rest was conquered through rightful claims'.[12] While not denying Spain's imperial primacy, he saw its empire as the product of collaboration rather than conquest.

It is a point of view that is easy to overlook. Unlike the Portuguese empire, which was a widely dispersed but territorially small venture closely monopolized by the Portuguese themselves, the Spanish monarchy from its inception was a vast entity in which non-Spaniards always had a crucial role. Like any great enterprise, it was highly expensive to run. In times of peace, basic operations such as communications, trade and transport of supplies between the territories of the monarchy required a degree of efficiency that the central government could never guarantee, since it had no personnel who could carry out the task. Virtually all the important operations were therefore contracted out. Even the collection of the crown's own taxes was contracted, since there were no internal revenue officials. As in any large business, it was the ability to arrange transactions and move money that ensured success. To achieve this, the crown resorted to international bankers.

Castile already had a small but active commercial economy, based principally on the wool trade and the merchant community of Burgos.[13] As the principal export of the region, wool was the basis on which a small number of northern Castilian merchants traded and became financiers, both in the peninsula and in the ports of Western Europe.[14] These interests refused to accept the intrusion of outside financiers, and formed a vocal opposition that took part in 1520 in the rebellion of the Comuneros. Castilian manufacturers and traders were always quick to denounce the 'foreign' predators, and yearned for a lost age when the economy had been local, closed and self-sufficient. It was, however, the logic of the imperial system that it brought into being a network of interests in which non-Spaniards had an essential part to play.

After the defeat of the Comuneros, Charles returned to Castile and took in hand the organization of his new territories. In all respects, the methods followed were those pioneered by the Portuguese, whose ships had been the first to penetrate the African coast, the Atlantic and Asia. The Portuguese had tended to draw up agreements with private contractors who were accountable to a specialized government body,

the 'Casa' in Lisbon. From 1506 the Casa had imposed a state monopoly on trade in certain items, principally bullion and spices. Charles now set up a similar controlling body in Seville, the Casa de la Contratación (or House of Trade), and formalized the details of the state monopoly. Government supervision was made firmer by the establishment in 1524 of a new council of the Indies, which from that time began to control all aspects of imperial policy and trade.

One of the chief tasks of the Casa was to impose the new trading monopoly based on Seville. Its first administrator ('factor') was a Genoese.[15] At the same time the merchants of Seville were organized together into a trading-guild or Consulado (1525), based on medieval guilds that had traded from the northern coasts of Spain. Both Casa and Consulado operated a system that excluded outsiders, but this was not their primary intention. The government hoped to use their resources to operate profitably an enterprise for which it had little capital of its own. Money was found from the various commercial enterprises that had been active in Castile since the fifteenth century. Among them was the important firm of the Espinosa, a family that originated in Burgos, had representatives in Antwerp, Seville and Nantes, and helped to finance the ships that sailed in 1525 from La Coruña to Maluku under the command of García de Loaysa.[16] But it soon became apparent that Castilian traders were unable by themselves to exploit the available opportunities. They lacked the money, the ships and the expertise. Charles wasted no time in searching for additional help elsewhere. He found it, as we have seen, largely in the Genoese trading community.

Within two generations, the American trade revolutionized sections of the Spanish economy. 'In the last sixty years', reported Tomás de Mercado in 1569, Seville had acquired 'great riches' and become a 'centre for all the merchants of the world'. But the trade was never in reality a monopoly of Seville. It was so international, Mercado pointed out, that the insurances on traded goods had necessarily to be international. 'To insure what is transported they need to insure in Lisbon, in Burgos, in Lyon and in Flanders, for the quantity of goods carried is so great that neither Seville nor even twenty Sevilles would suffice to do it.'[17] Any big merchant now effectively traded 'in all parts of the world'. 'Everybody depends on everybody else.'[18] Seville had become a centre of the commercial world, but only because the world market dictated its proceedings. A complex international network came into existence,

uniting the trading élite of all countries and attracting the investment of a broad range of social classes.[19]

The attention of this business activity focused exclusively on the shipping lanes between the New World and Europe. In 1561 a royal decree set new rules for the way in which shipping should cross the Atlantic. Vessels were to sail only in official trade fleets that left a single point of departure, Seville, twice a year in January and in August. In the Caribbean the fleet was to split into two squadrons, one bound for Tierra Firme (Cartagena and Panama), the other for New Spain. The system, and the Seville monopoly that went with it, was meant to ensure greater security at sea and to regulate the goods carried and the taxes paid. The rules were modified in 1564, when separate fleets for New Spain (in April) and Tierra Firme (in August) were permitted. On the return journey, fleets from both areas were to rendezvous in Havana and set out together to Seville in March. The system was not always adhered to, but remained in force until the end of the seventeenth century, when Cadiz replaced Seville as the actual port of departure. From the later decades of the eighteenth century the monopoly was modified and then discontinued.

The Atlantic route was the principal lifeline of the empire, but necessarily linked up with other smaller routes. The most important of these was the route to Buenos Aires, which from the end of the sixteenth century was allowed to trade with two annual ships to the peninsula. In the same way, every year the Manila galleon focused the hopes and anxieties of those who traded to Asia. Among those who owned and sailed the ships, provided pilots and managed the cargoes, a clearly dominant place was occupied by the Basques. They had during the sixteenth century an almost exclusive control over the vessels taking part in the sea-going trade of Seville.[20] The merchants who invested in the Atlantic trade were, during the first half of the sixteenth century, logically and principally Spaniards (mainly from Burgos and the Basque country). Their loans to traders in that period exceeded in quantity the loans made by the Genoese.[21]

Spaniards resident in Seville felt that theirs was the most substantial trade in the world. This was not wholly true. In terms of shipping, there were other more substantial trades in Europe than that of Seville. The volume of Spanish tonnage in the Atlantic around the year 1600 was, for example, only a small proportion of the tonnage employed by the

Dutch to trade to the Baltic. And even the Atlantic trade cannot be measured simply in terms of Spanish ships. The vessels of other European seafaring nations on the Atlantic in the years after 1600 exceeded in volume the tonnage controlled by Spain. The same perspective can be applied to the goods traded across the Atlantic. They were always the least significant part of the items taken to or brought from the New World. The most important section of the Atlantic trade was always the silver, which completely overshadowed the value of any other merchandise carried. By the seventeenth century, as we shall see, even the silver was no longer in Spanish hands.

In order to cope with problems created by the different trades within the empire, the Madrid government attempted to impose a system of controls, sometimes in the form of a monopoly, sometimes simply in the form of prohibition. The type of problem provoked by transcontinental trade can be seen through the example of the Manila galleon. As its critics in Spain pointed out, the galleon served as a convenient outlet for Chinese silks, which made their way to the peninsula and put silk producers there out of work. There was a similar problem in Peru, where the Manila imports competed with local produce. Moreover, large amounts of silver were sent directly from Peru to Mexico in order to pay for Asian goods.

From the end of the sixteenth century the government banned the entry of Chinese silks into Spain, in 1582 it prohibited direct trade between Lima and the Philippines, and from 1587 onwards passed decrees (always ignored and therefore continually repeated) restricting trade between Mexico and Peru.[22] The illegal trade continued, as the merchants of Panama complained in 1601: 'the ruin of this province has been the trade between Lima and Mexico, which absorbs all the silver that used to come here. And above all the greatest ruin is caused by the goods brought from China, which are so cheap that they displace the goods from Castile.'[23] An exception was permitted when from 1604 onwards one ship a year was allowed to go from Callao in Peru to pick up merchandise from Acapulco. The prohibitions continued throughout the seventeenth century, with negative consequences for the economy of Manila, Macao and the China coast. In the early eighteenth century the royal council was still dealing with the disputes between Spanish and Manila merchants over the regulation of the trade. It was only one part of a broader problem of attempts to regulate trade between the different

markets of the empire. In 1631, for example, the Spanish government went so far as to prohibit all trade between New Spain and Peru, because of complaints of unfair competition.

With or without controls, the Manila trade was in its day 'probably the most lucrative branch of international trade with the Orient'.[24] The cargo of Chinese silk in the Manila galleon was usually estimated as worth between two and three million pesos on each shipment. The silver ship from Acapulco brought in return about two million pesos in an average year. The consequence of this inflow of Mexican silver was that during the first half of the seventeenth century Spanish coins became the effective international currency of Southeast Asia.[25] The Chinese themselves used Spanish coin when trading in Maluku. Spain was drawn into the Asian economy and became a market for goods from China, where silver was worth twice as much as in New Spain, making Chinese items correspondingly cheaper to purchase.[26] Silver pesos therefore flowed to Manila and thence to China in much greater quantities than appeared in official registers. In the early seventeenth century the New Spain authorities informed Madrid that around five million pesos a year crossed the Pacific to Asia on the Acapulco galleons. A large part of this went straight from Manila to China, causing an official in Manila to comment that 'the king of China could build a palace with the silver bars from Peru which have been carried to his country'.[27]

In the same way, American silver crossed the Atlantic but not necessarily towards Spain. In 1599 the governor of the La Plata region reported that the silver which passed through the area did not go to Spain; 'some may go to Lisbon but it is very little, virtually all goes to Flanders and England; almost all the ships that come to the Brazil coast are Flemish and German, which are sent from Lisbon to take on sugar which they then exchange in Brazil for silver, at prices even lower than those in Lisbon'.[28] He calculated that in the last four years one and a half million pesos had left the area this way.

From the moment the Spanish government began to get involved in military and naval enterprises outside the peninsula, it faced the problem of financing them. In the early sixteenth century there were no public banks, and no generally accepted currency except pure gold or silver. To make payments abroad to financiers, suppliers, and its own troops, governments (like traders) had to use credit notes called 'bills of

The last Muslim ruler of Granada, Boabdil, hands over the keys of the city in
1492 to Ferdinand and Isabella. Granada was not formally conquered, but agreed
to capitulate on terms that respected its religion and its property.

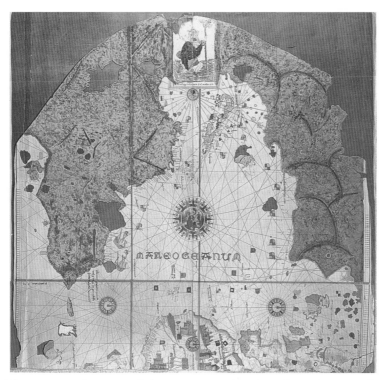

The Basque explorer Juan de la Cosa was employed as pilot and cartographer
to Christopher Columbus, and around 1500 drew up the first map of the western
hemisphere, in which the outlines of the Caribbean islands were clearly given.

Fray Diego Duran's *History of the Indies* (*c.*1580), drawn up with the help of Mexica artists, was a mine of valuable information on the Indian cultures of New Spain. In this illustration from his work, Nahua warriors besiege a force of Spaniards under Pedro de Alvarado, companion of Cortés in the conquest of Tenochtitlan.

A sixteenth-century Mexican illustration depicting the battle for Tenochtitlan, whose capture in 1521 was made possible by Indian allies of the Spaniards. The scene shows a Tlaxcalan ally pulling Cortés out of one of the canals of the city.

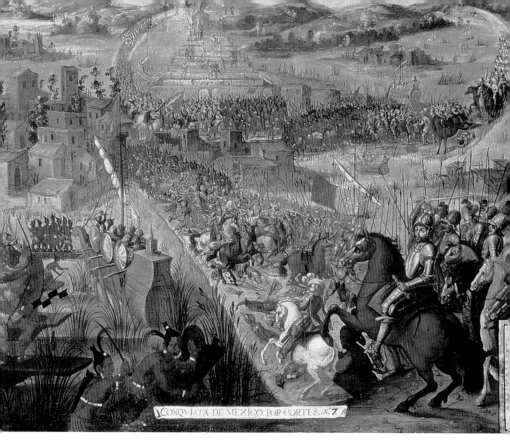

CONQVISTA DE MEXICO POR CORTES. *c.7*

A painting that encapsulates the imperial mythology of the conquest. Ranks of well-armoured Spaniards on beautiful steeds prepare to capture the capital of the Mexica in the face of overwhelming odds. The painter conveniently omits that a massive army of Indian allies supported them.

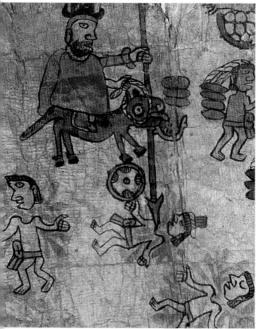

A Nahua chronicler depicts his people dying in battle against the mounted Spanish soldiers. Within a few years the Indians of America also learned to use the horse in their military campaigns.

Contemporary portrait of the conqueror of the Incas, Francisco Pizarro. The capture of the Inca Atahualpa by Pizarro's men was the most daring achievement of the Spanish conquest, but contemporaries were even more impressed by the dazzling treasures secured in Peru.

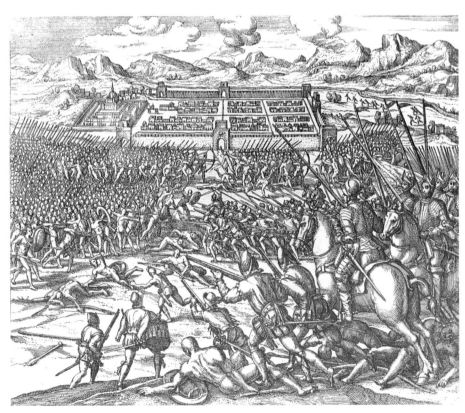

Capture of the Inca capital Cusco by Pizarro and his soldiers in 1533, as imagined by Theodor de Bry. In reality there was no formal battle for the city, and Pizarro's Indian allies facilitated the Spanish takeover and the crowning of a puppet Inca emperor.

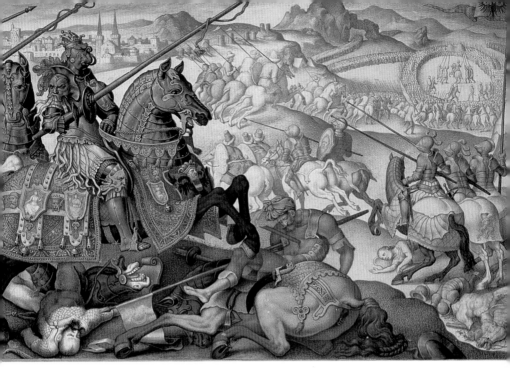

Vienna, besieged for the first time in 1529 by an immense Turkish army, was saved when all Christian Europe, including the Spaniards, rallied to Charles V's appeal for help. Failing to make any headway, the Turks eventually withdrew without engaging in battle.

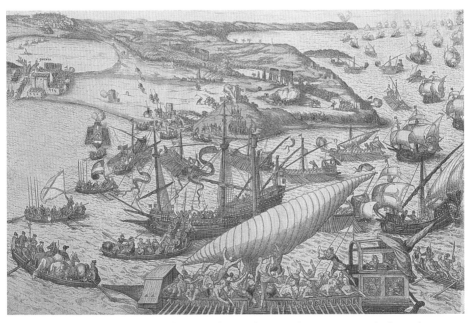

The siege in 1535 of the fortress of La Goletta, at the entrance to the bay of Tunis and defended by a strong Turkish garrison, was one of the great successes of the reign of Charles V, whose international army went on to capture the city of Tunis. The victory confirmed Spain's yearning for an African empire.

(*left*) Charles of Ghent was duke of Burgundy, as portrayed here, when he succeeded at the age of sixteen to the kingdoms of Spain. The union of Burgundy and Spain under one ruler converted the latter realm into the centre of a world monarchy.

(*right*) The famous equestrian portrait of a triumphant Charles V after his victory over the Schmalkaldic League at Mühlberg in 1547 was intended by Titian to promote an image of imperial power.

Magellan's famous voyage of 1519, the first circumnavigation of the globe by a European sea-captain, immediately gave Spain's empire a universal dimension and a claim to dominion in Asia. This Italian map of 1545 showing Magellan's route was once owned by Charles V.

A nineteenth-century painting of the two types of ship on which Spain's maritime power in the sixteenth century rested. On the left is a galleass, a powerful armed version of the galley, the oared vessel used principally in the Mediterranean. On the right is the famous galleon, used by Spaniards across the world's oceans.

The navies of Italy and Spain, commanded by Philip II's half-brother Don Juan of Austria, combined to defeat the Turkish navy in the greatest sea battle of early modern times, off the coast of Greece at Lepanto, in 1571.

The Navarrese Jesuit missionary Francisco Xavier, a subject of the Spanish crown, worked with Portuguese colleagues to bring Christianity to India, Southeast Asia and Japan. He died in 1551 on an island in the South China Sea.

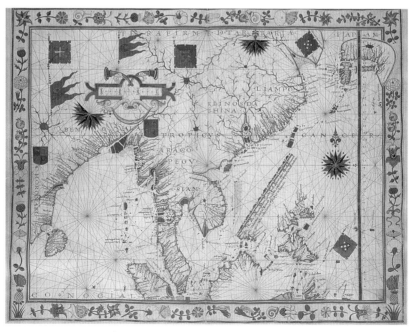

Portuguese mapmakers used their skills to draw up the first systematic maps of Asia. This pioneering portolan map of 1570 by Fernão Vaz Dourado shows the coastline from India through the China Sea towards Japan.

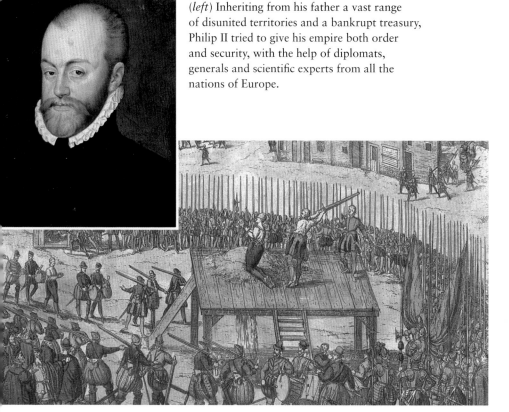

(*left*) Inheriting from his father a vast range of disunited territories and a bankrupt treasury, Philip II tried to give his empire both order and security, with the help of diplomats, generals and scientific experts from all the nations of Europe.

The execution at Brussels in 1568 of the Counts of Egmont and Hornes and other Flemish nobles provoked an outcry against the regime of the Duke of Alba and plunged the Netherlands into eighty years of struggle for independence from Spanish control.

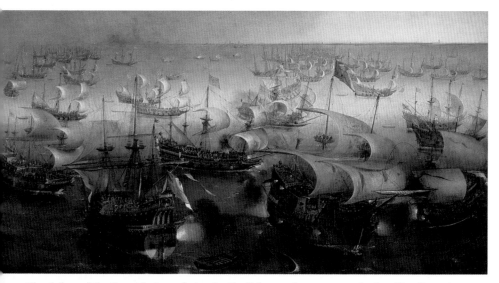

The defeat of the Spanish Armada by the English navy in 1588 was, both militarily and psychologically, the greatest reverse suffered by Spain during its epoch of world power. Fortunately, there were always Europeans who profited from the empire and were willing to support it during periods of crisis.

The legend of the golden man, or El Dorado, fascinated sixteenth-century
Europeans (as we can see in this engraving by Theodore de Bry) and spurred
several Spanish expeditions to search for the territory where gold was seemingly
so abundant that the local king could bathe in it.

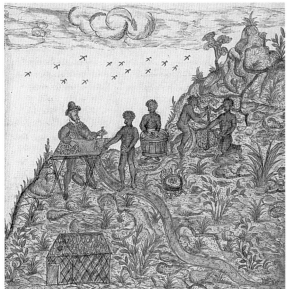

(*left*) Throughout colonial times Colombia remained an important area of gold
mining. The pre-conquest Quimbaya culture of the valley of the river Cauca in
Colombia produced many artefacts of gold, of which this figurine is an example.

(*right*) African labour was essential to mining in all parts of Spanish America,
since the native Indians could not endure the work conditions and quickly died.
African slaves were also the main labour force in other key sectors of the
colonial economy, notably sugar production.

Gold artefacts in a pre-conquest Mexica shop, as shown in the Florentine Codex edited by the sixteenth-century Fray Bernardino de Sahagún on the basis of information and drawings supplied by the Nahuas who helped him. Gold for the Indians was a metal used in ritual, for the Spaniards it was (Cortés claimed) a necessity of life.

(*below*) A late colonial view of the great silver mine at Potosí in the mountains of Bolivia, showing the populous city that grew up round the site. Sustained by Indian and African labour, Potosí for a time dominated world production of silver.

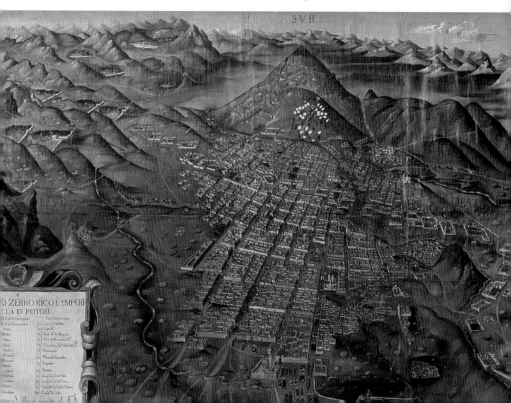

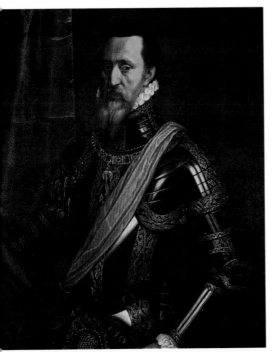

(*top left*) The third Duke of Alba, Fernando Álvarez de Toledo, was Castile's most famous general of the imperial age. His harsh policies failed to produce a solution to the rebellion of the Netherlands, but he later successfully occupied Portugal.

(*top right*) Perhaps the most brilliant military commander ever to serve the empire, Alessandro Farnese, prince then later duke of Parma, achieved significant victories against the rebels in the Netherlands.

(*left*) Chosen to command the army in the Netherlands because of his financial resources, the Genoese noble Ambrogio Spinola went on to become Spain's leading general in the age of the Thirty Years War. This superb portrait was done by his friend Peter Paul Rubens.

Spinola's most memorable achievement was the taking of the fortress of Breda from the Dutch rebels, in 1625. Ten years later Velázquez immortalized the event in a huge canvas that vindicated the majesty of the empire while also respecting the gallantry of the vanquished commander.

Cadiz had been the scene of successful attacks by English naval forces in the preceding century. When they botched it in a raid in 1625, the Spaniards were quick to celebrate the event in a sweeping canvas by Zurbarán.

(*left*) Spanish missionaries were keen to achieve the conversion of native rulers, but they also systematically made use of violent punishment against Indian backsliders, as shown in this colonial chronicle.

(*right*) Antonio de Mendoza, who governed New Spain from 1535 to 1550, was the first viceroy to be appointed in the New World empire, and laid down the lines along which the king's representatives would govern.

The Creole élite of colonial America was anxious to claim some part in the heritage of the Incas. This panel of *c.*1750 shows the succession of the kings of Peru from the Inca Manco Capac to Ferdinand VI of Spain.

(*above*) From the time of the conquest, many of the Spanish élite in America married native women and were proud to identify themselves with the native civilizations, as we can see from this eighteenth-century family portrait.

(*above left*) Idealized portrait of the emperor Montezuma, painted for the Grand Duke of Tuscany in the later seventeenth century and based on a sixteenth-century Mexican illustration. The powerful image is evidence of the renewed appreciation at that time of the culture and achievements of the native civilizations of America.

The decisive victory gained by the forces of the Duke of Berwick at Almansa in 1707 over the army of the Archduke Charles established the Bourbon monarchy in Spain and inaugurated a series of fundamental reforms in the empire.

In the eighteenth century the missions of the religious orders were the front line of Spanish penetration into Indian territory of the North American continent. Settlements and churches were set up in Arizona (as in this painting), California, Texas and Florida.

exchange'. These little bits of paper became the oil that kept the wheels of the empire running. 'One can no more trade without them', a sixteenth-century Antwerp financier commented, 'than sail without water.' The notes could travel rapidly with the mail, making credit available immediately; real payment would come later, when the relevant bullion arrived. As countries spent more money on war and foreign policy, the credit that they demanded stimulated the business of international financiers and traders, who arranged themselves into consortiums to take on the huge loans (or 'asientos') asked for by the Spanish empire.

Spain became caught up in the credit boom. The trade fairs in Spain, of which the best known are the fairs at Medina del Campo,[29] no longer handled cash; most transactions were in international credit. 'People from all nations go to these fairs,' reported Tomás de Mercado, 'you hardly see coin, all is paper.' But credit, of course, had to be backed by traded goods and bullion. Mercado felt that the wealth of Spain, precisely because it was drained away through trade, no longer remained in Spain but was going to foreign countries. 'In Flanders, in Venice and Rome, there is so much money from Seville that the very roofs could be made of escudos, yet in Spain there is a lack of them. All the millions that come from our Indies, are taken by foreigners to their cities.' He complained that the trend now was to 'subject us covertly to the foreigners, giving them the leadership in all our main enterprises'.[30]

When Mercado wrote 'foreigners' he meant above all the Genoese, the financiers who attracted most hostility from Castilians. The Genoese, went the complaint in the Cortes of Madrid in the 1540s, controlled everything, and charged interest at extortionate rates. In 1569, for example, large quantities of bullion from the Indies were being shipped to Genoa, to pay above all for the wars in Granada, which depended heavily on weapons imported by the Genoese from Italy.[31] The Genoese dominated and financed the high tide of Spain's empire. Despite the attempts to weaken their role, from 1557 (with the accession of Philip II) to 1627 they decided the destinies of Spain.[32] An English trader of the time observed that Spaniards did not control their own commerce because of 'the residence of many Genoa merchants among them, whose skill in trade far surpassing the native Spaniard and Portuguese, by means of their wealth and continual practice of exchanges, devour that bread which the inhabitants might be sufficiently fed with'.[33]

The foreign financiers, it has been pointed out by the leading authority on the subject, dominated Spain's business affairs for two centuries.[34] They had been active in the Iberian peninsula since the thirteenth century and were primary backers of the Portuguese overseas programme. Many settled and became citizens of the major commercial centres. However, commentators like Mercado, who presented a picture of greedy foreign financiers feeding on the wealth of Spain, failed to understand that Spain needed their help in order to set up a network of international payments for trade and for war. Though there had for some time been small groups of Castilian financiers in the trade centres of Western Europe – in Bruges, in Antwerp, in Rouen, in Lyon, in Florence – they had neither the means nor the status to handle the transactions ('asientos') required by the crown. Many foreign financiers, by contrast, such as those of Augsburg and Genoa, employed a highly efficient system for their contracts. In return for their loans, the crown began from 1551 onwards, and regularly from 1566, to give permission for something that had till then been prohibited by law: the export of precious metals from the country.

At perhaps the most difficult moment of his reign, in 1575, when it seemed to Philip II that he must break the stranglehold of foreign finance, the king cancelled his asientos with the Genoese and turned instead to Portuguese, Castilian and Florentine financiers. Particularly between 1579 and 1583, the Florentines and their businessman grand duke, Francesco de' Medici, were energetically courted by Spain.[35] They cooperated efficiently but failed to come up to expectations, and the king returned to the Genoese. An important step had been taken, however. The Portuguese financiers now had excellent relations with the crown, and when Philip II became king of Portugal in 1580 they were in a good position to develop their contacts.

The triumph of the Genoese financiers and their central role in the formation of the Spanish empire, was made possible by a simple but fundamental reality: the debility of Castilian capitalism. When Charles V took over power in Castile, foreign financiers were (as we have seen) in a good position to give weighty backing to the enterprises associated with the New World and the empire. They advanced huge sums to the crown in Italy, Germany, France and the Netherlands; in return, they were obliged to accept payment only within Castile, because of the ban on exporting specie. What could they do with their money? For the most part, they bought up property in Castile, and invested in

Castilian industry and commerce; in the process, they operated through Castilian capitalists.[36] The result was a boost for the boom period in the Castilian economy.

But the effort of creating an international network to support Spain's role as a world power meant in real terms that virtually all aspects of the peninsular economy became closely integrated into outside markets and were often dependent on them. A very clear example is supplied by the fortunes of the wool trade, which in the early sixteenth century had been the pride of Castile and the backbone of its merchant élite. From about 1560 the Italians and other foreigners came to dominate Castilian wool exports.[37] Between 1560 and 1612 the proportion of wool shipped by foreigners from the north coast of Spain rose from fourteen to sixty-nine per cent.[38] Castilians always continued to control an important core of the trade, but their role was firmly superseded by that of other European traders and financiers.

After about 1566, when the export of specie from Spain by individuals was permitted, foreign financiers were no longer obliged to make their capital work within the Castilian economy. They withdrew from peninsular trade, dedicating themselves, as the Venetian ambassador reported in 1573, mainly to the international money market. Their Castilian contacts, like Simón Ruiz, were left to face the cold by themselves. Many went out of business, others resorted to buying land to shore up their family fortunes. In the chief seaports of the peninsula, foreign traders began to dominate.[39] The great empire was at the most delicate stage of its formation, but all its nerve centres – trade, finance, the economy – slipped firmly into the hands of outside businessmen who did not intend to let pass the opportunity to control the source of their profits. Without exception, Castilian traders and financiers were relegated to a secondary role. Simón Ruiz, for example, took part in no asientos after 1581. 'The foreigners do with us as they wish', he lamented.[40]

The wealth of the empire became, in the final decades of the sixteenth century, the great prize. Castile had been part of a small local market, living off home produce and exporting a few raw materials. Now it became a vast emporium of the produce of the entire world, only some of it consumed within Spain but all of it serving to enhance the business activities of the planet. The import registers of the great ships that entered Seville, laden with tobacco, hides, dyes, sugar and precious stones, were only a small part of the productivity created by the Spanish

territories. For the first time in history, an international empire integrated the markets of the world, as vessels from the St Lawrence, the Río de la Plata, from Nagasaki, Macao, Manila, Acapulco, Callao, Veracruz, Havana, Antwerp, Genoa and Seville criss-crossed in an interminable commercial chain that exchanged commodities and profits, enriched merchants, and globalized civilization. African slaves went to Mexico, Mexican silver to China, Chinese silks to Madrid.

The immense trade generated by the empire was never in fact controlled by Spain, despite official attempts in that direction.[41] As the precious metals and colonial produce made their way to the peninsula, they became prey to systematic fraud. Since those who really controlled the economy were outsiders, it was to them that the bullion and profits went rather than to Spain. Moreover, throughout the great age of trade the peninsula functioned neither as exporter nor as importer but merely as an entrepôt. This was especially true of the bullion trade. In the 1560s and 1570s the war effort in the Netherlands demanded the export of vast quantities of bullion to northern Europe, so silver destined for Spain ended up there; after about 1578 the main recipient was Italy. Philip II made efforts to check the process, and in 1583 once again prohibited the export of specie. The controls, however, soon collapsed. The officials of the royal treasury calculated in 1594 that huge quantities of silver arrived at Seville annually from America, of which after smuggling and fraud not more than ten million ducats remained. Of this sum, six million left the country immediately to pay for royal and traders' debts, leaving only four millions. Since debts were mainly to Italian financiers, the bullion leaving annually for Italy tended to be in the region of six million ducats.[42] Financiers in Florence in 1584, for example, reported that the fleet which arrived at Genoa from Spain that year, under the command of Gian Andrea Doria, carried four millions in silver for Florentine financiers.

The international dimensions of business may be seen in the career of one of the significant traders of the Atlantic world, the Corsican merchant Gian Antonio Corso Vicentelo, archetype of his profession.[43] His uncle and father-in-law Antonio Corso 'el Viejo' had commenced before him the building of the family's fortunes on the basis of the American trade. Gian Antonio left his native Corsica at the age of thirteen around the year 1530, travelled around the Mediterranean, served in the ill-fated campaign of Algiers under Charles V, then at the instance of his uncle

went to Lima. He made his money during the civil wars in Peru, built up his fortune in association with his countrymen and members of his family, and brought into being a firm that did business in Peru, central America and Seville. In 1575 he successfully established a claim in Seville to noble status. He returned in 1585 to Seville, where he died in 1587. Members of his family rose into the Castilian nobility (his daughter, with a generous dowry, married the count of Gelves), and he amassed a fabulous personal fortune, consisting of galleons, three houses, lands, investments, and silver. Though fully integrated into Sevillan society, Corso remained all his life a Corsican, surrounded by people from his home country and working mainly with them.[44]

By the end of the sixteenth century Spain had become an integral part of a cosmopolitan network, which included the two largest channels of Europe's intercontinental trade, that to the Americas, whose trade in official terms was estimated as at least ten million ducats annually, and that to East Asia, estimated at half that sum.[45] The real figures for the trade, if we take into account all its sectors, are impossible to quantify. This vast commercial enterprise had the outward form of an empire dominated by Spain. Viewed from inside, however, it was a structure in which all the essential arteries were controlled by non-Spaniards. An important role, as we have seen, was played in the sixteenth century by the Genoese, without whose crucial help at every stage the great Spanish empire might never have come into existence.[46] They were the vital link with the kingdom of Naples, where they dominated the shipping industry, the export trade, the supply of food and the machinery of finance.[47]

The international system inevitably linked up with broader trading interests. For example, the crucial links between Spaniards and the business centre of Antwerp in the southern Netherlands, were extended yet further by the links of Antwerp with England, with Germany and with Italy.[48] Belgians carved out for themselves a significant part in the trade of the Iberian peninsula.[49] The links with the New World fell into the hands of traders who, like Corso, were on the spot. Italians, Belgians, Germans and Portuguese New Christians became by the seventeenth century the key agents in a commercial chain that connected Amsterdam, Antwerp, London and Hamburg with La Rochelle, Nantes, Rouen, Livorno, Venice, Genoa and Naples, and beyond them with Africa, Brazil, Goa and the whole of Spanish America.[50] One small bit of

evidence underlines the true relation between foreign traders and Spain. Had Spain really been the centre of wealth, the great banking houses would have moved their head offices there. Instead they stayed where they were, in Antwerp, or Augsburg, or Genoa. Cities such as Lisbon, Seville, and Cartagena de Indias merited only commissioned agents. With good reason did the merchants of Seville protest (in 1626) that 'our people are without sustenance and income, the foreigners are rich; and Spain, instead of being as a mother to her sons has ended up as a foster-mother, enriching outsiders and neglecting her own'.[51]

The relation between 'power' and 'business' in the functioning of the empire was not a smooth one. Those who manipulated the political power were not always those who ran the business side of affairs. The Genoese were well aware of the distinction. 'At present', one of them wrote in the early seventeenth century, 'our Republic and its liberty are founded on its own fortunes and on the protection of Spain, and we must hope to find strength in the arms of this monarch.'[52] The reality was that Spain and the Genoese depended on each other heavily, a position from which both were anxious to escape. Notable attempts were made by Philip II, and later by Philip IV, to do without the Genoese. Within the republic of Genoa, an influential section of the oligarchy was also opposed to Spanish predominance, and in the course of the seventeenth century made strenuous efforts to emerge from underneath the Spanish umbrella. They never succeeded in doing so.

As it happened, the decisive year 1578 confirmed the need for Philip II to rely yet more on vital outside help in order to keep the empire together.[53] The year had started well, with military successes in the Netherlands, and the birth of a son and heir in the spring. There were, however, harvest problems in the country, and protests against tax increases. When a street prophet in Madrid called Miguel de Piedrola started making dire forecasts, the king asked his officials to 'question him and try to find out from where he gets these prophecies'. A more serious problem arose when on 1 April Philip was awoken with the news that one of his secretaries, Juan de Escobedo, had been murdered in a Madrid street near the royal palace the night before. 'It's all very strange,' he wrote from his bed to his secretary Mateo Vázquez, 'it was very bold for someone to kill so important a person under my very eyes'. The affair very quickly assumed dimensions that clearly implicated one of

Philip's most important secretaries, Antonio Pérez, and subsequently made the king decide to remove him from his post.

Escobedo had been private secretary to Don Juan de Austria, then serving as governor of the Netherlands. In October, Don Juan died suddenly, aged only thirty-one.[54] The king was faced with the pressing need to substitute his leading general in the field, as well as search for a likely minister to replace Pérez. Never before in the monarchy's history had there been so urgent a vacancy in both the military and the political spheres. The crisis was rendered more acute by another event during those months. In mid-August 1578 Philip, then in the Escorial, received news that the foolhardy young king of Portugal, Sebastián, had perished while leading an army against the vastly superior forces of the sultan of Morocco, Abd al-Malik. At the famous battle of al-Qasr al-Kabir, on 4 August, the flower of the Portuguese aristocracy died with their king, and ten thousand men were taken prisoner. The victory of the Sa'did dynasty of Morocco over the Christians closed for the moment a vital chapter in Spain's imperial history, for it excluded Africa as a zone of further expansion. The death of the heirless Sebastián, however, opened up at once the issue of the succession to the throne of Portugal.

Philip II immediately sought help from servants of the monarchy outside Spain, placing his full confidence in a Franche-Comtois and an Italian. To replace Pérez, the king needed a man with experience both of Italy (Pérez's department) and of Flanders. He found him in Cardinal Granvelle, whom we have encountered already as chief minister in Brussels in the 1560s, and who went on to serve as minister in Rome and subsequently as viceroy of Naples. Aged sixty-two when summoned to Spain in 1579, he was the first non-Spaniard ever to assume direction of the affairs of the monarchy. His profound familiarity with every area of interest to the Habsburgs, a dynasty he had served all his working life, and his perfect command of six languages, made him an exceptional phenomenon in the political life of Madrid. A striking aristocratic figure, he was known among ministers as *el barbudo*, 'the bearded one', because of his immensely long, white patriarchal beard. Granvelle was a great humanist, bibliophile, patron of the arts and prince of the Renaissance. He shone in his new environment, which, however, soon disappointed him.

Philip confirmed as new governor in the Netherlands his nephew Alessandro Farnese, prince of Parma (born in 1545), who had been serving there under Don Juan since 1577. Son of Duke Ottavio of Parma

and of Margaret, illegitimate daughter of Charles V, he had been brought up at the Spanish court and taken part in the battle of Lepanto, where he commanded three Genoese galleys. Though Italian in outlook and culture, Farnese was – like his mother – a wholly faithful supporter of the empire and turned out to be a brilliant military commander, perhaps the greatest in Spain's history. His campaigns turned the tide in the Netherlands. Together with his success on the battlefield, he showed a remarkable capacity for negotiation, and moderation in religious matters. Thanks to his efforts, the southern provinces in May 1579 signed a treaty of loyalty (the 'Union of Arras') to the crown. The following month he scored the first of his great military 'successes', the capture of the city of Maastricht.

The siege of Maastricht, which cost the lives of very many besiegers and of even more defenders, was emblematic of the cruel struggle being waged on one of the confines of the empire, and merits some attention. When an entry though the defences was finally secured, on 29 June, Farnese was seriously ill and unable to control events; his lieutenant even wrote to the king that a substitute should be appointed as soon as possible. The triumphant Spanish and German troops poured into the city and began an indiscriminate butchery of all the inhabitants, women and children included. It has been estimated that some ten thousand people, or one third of the population of the city, were massacred.[55] Writing to Philip II from the area six months later, Farnese reported that 'the region where we are is so ravaged and laid waste that not only is there no food but the whole countryside will be a wasteland for many years. So extensive is the mortality of men and cattle, the destruction of dwellings, and the general and universal desolation, that there is no hope of any produce for a long time to come.'[56]

The tragedy of Maastricht was no different in its nature and excesses from many similar horrors that had been occurring in the Netherlands over the preceding twelve years, nor were Spanish troops uniquely responsible for what took place. The case serves, however, to demonstrate that the integrity of Spanish power was being achieved now by 'victories' that were, like Alba's victories, at the expense of the civilian population. It confirmed the provinces of the Union of Arras in their insistence that Spanish troops be withdrawn from the Netherlands. At Easter 1580, as agreed in the terms of the Pacification, the foreign troops were at last sent home. The Germans went back to Germany, the

Spanish tercios began their journey through Lorraine and the Rhineland, reaching Milan in June. Farnese was faced with the task now of recruiting a wholly Belgian army, with few experienced troops and many totally raw recruits. Meanwhile he could also count on the presence of some Italian and Albanian light cavalry. With these he struggled on, scoring amazing successes for two more years, never ceasing to lament that his campaigns would be more satisfactory if he had more foreign troops with him. 'Many already regret the departure of the Spaniards', he informed the king at the end of 1580, 'and realize that without them it is impossible to continue the war.' 'What I need', he wrote a short while later, 'are the Spaniards.'[57]

In the spring of 1582 the southern provinces finally agreed to the return of a limited number of foreign troops, five thousand Spaniards and four thousand Italians. With these tried veterans to count on, Farnese was able to score further successes in the field. He had a good supply of soldiers, sixty thousand men by the summer of 1582. Ypres, Bruges and Ghent surrendered in 1584, and Brussels in March 1585. Finally, in August 1585 he achieved the capitulation of Antwerp.[58] A condition of the surrender was that the Spanish and Italian troops not be allowed within the walls. The king, at the time in Aragon, was in bed when the news arrived. Overjoyed, he burst into his daughter Isabel's room at midnight to wake her. Cardinal Granvelle was present at court to witness his enormous joy: 'Not for the battle of St Quentin nor for Lepanto nor for the conquest of Portugal nor for any other past success, has His Majesty shown such contentment as for this of Antwerp.'

Some years before the recovery of Antwerp, Philip added Portugal to his territories. It is often easily forgotten that the king, with a Flemish father and a Portuguese mother (the Empress Isabella), was not Castilian. He had been brought up in a Portuguese circle at court, his nurse was Portuguese, and Portuguese was perhaps the non-Castilian language he most understood. From the beginning of his reign in Castile his chief confidant was the Portuguese noble Ruy Gómez, Prince of Eboli, a close collaborator of his sister Princess Juana, mother of King Sebastián of Portugal. When young Sebastián perished in the battle of al-Qasr al-Kabir in the North African desert in August 1578, Philip emerged as the candidate with the firmest dynastic claims to the vacant throne. There were, however, obvious international obstacles, since both

France and England would oppose the union of the Iberian crowns. Philip could not therefore count solely on the strong support he already enjoyed within Portugal, and had to consider the possibility of armed intervention in order to assure his candidature. The possession of Portugal was too rich a prize, from every point of view, for him to risk losing it.[59] His peaceful strategy took three forms. First, leading jurists from all over Europe were employed to write in support of his cause, so as to convince not only the Portuguese but other European powers. Second, his representatives in Portugal, most notably his special envoy the Portuguese Cristobal de Moura, attempted to win over individuals as well as cities. Finally, selective bribes were used. Moura orchestrated a brilliant campaign to win support for his master. He talked to nobles and clergy, collected information on Portuguese defences, and distributed money liberally. Despite all these preparations, both the king and his advisers were convinced that the use of an army could not be avoided.

The campaign of Portugal, prepared at a stage when Philip II was notoriously in financial difficulties, was made possible by aid from Italian allies. The king was attempting to escape from the talons of the Genoese financiers. The bills for the war, he instructed early in 1580, were to be sent to the grand duke of Tuscany, Francesco de' Medici.[60] They included invoices for ten thousand arquebuses, two thousand muskets, and bullets for both, all from Italian manufacturers. They also covered the costs of recruiting five thousand German troops, and of recalling four thousand Spanish troops from Flanders via the Milan route; as well as the expenses of the five galleys of the Doria fleet that were to transport both men and munitions to the peninsula. The duke collaborated generously, even to the extent of paying some cash to the disgruntled Spanish tercios who had not yet been paid – such were Philip II's debts – for the previous campaign in which they had served. In Lisbon Philip continued to work with Italian and German financiers, but also collaborated closely with a group of Portuguese merchants who were making their fortunes in Asian commerce.

'I have great hopes', Moura wrote to the king from Lisbon, 'that though the swords are ready there will be no need to draw them.'[61] Philip went ahead with his plans for a possible military and naval intervention. In the spring and summer of 1579 the galleys of Spain were assembled, and a further number of ships brought from Italy under the command of Admiral Doria. The joint force, totalling some sixty galleys,

was assembled off the coast of Andalusia, under the command of the marquis of Santa Cruz. The ships from Italy brought with them detachments of Italian and German soldiers, as well as a force of Spanish tercios, veterans of the war in the Low Countries. Intensive recruitment of Spanish troops took place in Andalusia and the provinces neighbouring Portugal. The cavalry troops were in October put under the command of the Flanders veteran Sancho Dávila. The duke of Medina-Sidonia, seconded by other nobles whose estates bordered Portugal, was to help raise troops for a land invasion. The mobilization was in theory secret, but Philip made sure that the Portuguese knew of it. 'Even if it doesn't come to a use of force', he informed Moura in April, 'it would be all the more helpful to press ahead with negotiations while keeping up the threat of arms.'[62]

Philip already possessed (or had bought) the support of the majority of clergy and nobles in the Portuguese Cortes held at Almeirim in January 1580.[63] But the situation was no longer simple. The Portuguese claimant to the throne, Antonio of Crato, had active support among very many Portuguese, who hoped for help from abroad, particularly from France. The longer the delay, the greater the risk of foreign intervention. Cardinal Granvelle, in control of the administration in Madrid, advised him that the army must be sent in as soon as possible. To this end the 73-year-old duke of Alba, in forced retirement because of a disagreement with the king, was appointed as commander. Philip's advisers were of the unanimous opinion that Alba's reputation as a merciless general was essential to a successful campaign.

In June 1580 the army of invasion, forty-seven thousand strong, was reviewed by the king and Alba at Badajoz in Extremadura. The file-past, which went on all day, left admiring observers almost speechless. 'It is something to see, even as I am writing this', reported one.[64] Half the army consisted of Spanish soldiers and veterans from Flanders, the other half were German and Italian troops.[65] On 27 June the army crossed the frontier in force. There was little effective resistance. Inevitably plunder, outrages and brutality occurred throughout the process of occupation. Setúbal, besieged by land and sea, capitulated on 18 July. The fleet under Santa Cruz sailed in two days later and gave support to the land forces. In Lisbon there was stiff street-by-street resistance, but the city eventually surrendered in the last week of August. On 12 September Philip was proclaimed king in the capital. He recognized that Alba had played a

crucial part in the successful campaign of Portugal. But the veteran soldier did not long survive his last triumph. He was seriously ailing, and died in 1582 in Portugal, in Tomar. The king visited him during his illness and listened to his last words of advice.

The annexation of Portugal was a supreme moment in the history of the monarchy. It was (apart from the virtually effortless occupation of Navarre in 1512) the first, and arguably the last,[66] time that a Spanish army would enter and take over a foreign country. The fact that Portugal's parliament supported Philip's accession served to disarm any accusation of 'aggression', though no one could deny (and Alba tried to avoid) the killings and outrages that took place. For the first time since the days of the Romans, the peninsula was united under a single ruler. In medieval times the term 'the Spains' had sometimes been used as a way of referring to all the states of the peninsula that had formerly been the Roman 'Hispania'. Philip was the first ruler ever to issue (in Lisbon) a decree for 'these realms of Spain', a term in which Portugal was also included. Unity of the peninsula betokened unity of the empire. When the king entered Lisbon in 1581 one of the arches erected for him in the street carried the verse, 'Now will be fulfilled the prophecies of the wise, that you will be sole king and sole shepherd on earth.'

The triumph unleashed among Castilians a flood of jubilation.[67] A poet in Madrid[68] expressed the now commonplace hope of seeing a world with 'un pastor solo y una monarquía' 'one sole shepherd and monarchy'. There was every reason for imperial pride. Peace had come to the Mediterranean: a three-year truce was agreed with the Turks in January 1581. In northern Europe the richest and most populous provinces of the Netherlands had made their peace. The Spaniards were firmly established in the Philippines. Viceroy Toledo had put an end to Inca resistance in Peru, expeditions were moving up from New Spain further into southern North America, and in the south Atlantic the adventurer Juan de Garay had re-founded the city of Buenos Aires on the Río de la Plata. It was in every sense the high tide of Spain's power.[69] With the absorption of Portugal, Philip's authority now extended into India, Indonesia and China. The king's old companion-at-arms, the poet Alonso de Ercilla, who had served with him in the campaign of St Quentin and had then gone to Peru, was during these months in Castile composing his famous narrative poem on the Araucanian war. Looking back to all that had been achieved by Spaniards, he could still

envisage with irrepressible optimism the possibility of further 'conquests in distant lands we have never seen'.

The empire, so extensive as to stagger the imagination, was the biggest ever known in history. Philip's own decision to restrict imperial expansion, in the Ordinance of 1573, seemed now to be of small moment in a scenario where he was to all appearances the most powerful ruler on earth. He was also, it seemed, the richest: he controlled the production of New World silver; his saltpans in Portugal and the Caribbean produced most of the marine salt consumed in the West; through Brazil he controlled most of the sugar available to Europe. Rejecting the term 'monarchy' that Spaniards had always used to refer to their commonwealth of nations, the Castilian writer Pedro Salazar de Mendoza felt that the right term now was 'empire': 'the monarchy of Spain covers one third of the globe. America alone is three times greater than Europe. The empire of Spain is over twenty times greater than that of Rome was.'[70]

The enthusiasm of those months must be seen within their context. Castilians felt that the universe was theirs. It did not mean that they wished for the universe. It has been suggested that Philip II was aiming for 'global mastery', and that he had a 'grand strategy' to that end.[71] He has also been presented as the knight-errant of militant Catholicism in these years.[72] Certainly his many enemies at the time saw him as a powerful antagonist. But the king's own correspondence suggests that his priority was always peace. No imperialist fever reigned at the king's court.

A Venetian observer of around 1584 was impressed by the power of Spain.[73] At that date, he calculated with surprising accuracy, the monarchy had twenty thousand infantry in Spain, sixty thousand in Flanders, twenty-four in Naples and the rest of Italy, and fifteen thousand in Portugal. In an emergency it could raise as many as two hundred thousand infantry throughout the empire. It also had around fifteen thousand cavalry in Spain, two thousand in Sicily, nine thousand in Portugal and two thousand in Flanders. In the Mediterranean it had thirty-four galleys 'of Spain', twenty-six of Naples and Sicily, and eighteen of other Italian princes. Its war fleet in the Atlantic, devoted mainly to protection of the American convoys, consisted of eight large ships and six galleons. There is no doubt that, with the occupation of Portugal, Spain's empire had reached the peak of its success.

The king had the satisfaction of watching from the window of his

palace in Lisbon as the great galleons came in from the ocean. The Spanish fleets to America could now use Lisbon as a departure point. On one occasion, in April 1582, the king actually 'accompanied the fleet out of the harbour' on its first stage to the New World. 'He breakfasted on board his royal galley, and passed the whole day at the mouth of the port.' He took special interest in plans to form a company to organize the trade in pepper from Asia. Asia became a reality. He was proclaimed king in Goa in 1581. To his other titles, at the end of his reign, he was proud to add that of 'king of Ceylon'.[74] Excited by the new dimensions opening up for Christianity, in 1582 he appointed an Indian from Malabar as one of his chaplains. In practice, it was the possibility of finding new sources of income, through Portugal, that absorbed most of his time. He did not have to tax the Portuguese themselves, since overseas commerce brought in good returns. Half of all Portuguese government revenue came from the lucrative trade to Asia, and a third from trade to Europe and America.[75] The Atlantic trade was booming, thanks to the development of Brazil.

In August 1580, only a week after Lisbon capitulated, the king wrote to Alba suggesting that the professional troops, rather than being sent to Italy where most of them were based, be employed in pursuance of what the pope had pressed on him 'insistently many times: the conquest of England'.[76] The ease and success of the Portuguese enterprise stimulated him to believe it could be repeated against Elizabeth. The first requirement both for success against the Dutch and for a possible strike against England, was adequate naval power. But the sea was now drifting out of Spain's control, as could be seen by Drake's successful raids on both sides of the Atlantic in 1585 (Chapter 6). The greatest, the most costly, and the most memorable of Spain's enterprises by sea soon turned into its greatest imperial disaster. This was the Great Armada sent against England in 1588.

'The objective of this Armada', a secretary of the king observed, 'is both the security of the Indies and the reconquest of the Netherlands.'[77] It took about four years to prepare. The most impressive aspect of the naval preparations was the ability of the monarchy to call upon seemingly endless resources in its efforts to crush the insolent English. It was not an exclusively Castilian effort. The shipyards of Naples contributed. The Portuguese vessels and warships made up one-tenth of the entire Armada.[78] Vessels leased from private owners made up the greater part

of the fleet. Castile was unable to supply adequate weapons, and basic supplies for food, cannon and cannonballs had to be imported: copper from Milan, gunpowder from the Germans, biscuit from Naples.[79] The manpower was overwhelmingly peninsular: up to ninety per cent were Spaniards, and ten per cent Portuguese.[80] But there were also soldiers and sailors from Serbia, Germany, Belgium, France, the northern Netherlands and even England. It was perhaps the first great enterprise since the Granada wars, in which so many men from so many states collaborated. The vessels finally put together were evidence of co-operation among the states of the monarchy.

The end product, however, left much to be desired. Possibly two-thirds of the men on the Armada were raw recruits, who had never been to sea or fought in battle.[81] Although the Spanish fleet probably exceeded the English in tonnage, it was less seaworthy, less well-armed, and less well-manned. The ships came from all over Europe, and some (from the Adriatic) were not suitable for the waters of the Channel. In contrast the English had a force of more efficient and speedy warships. The eventual Armada of one hundred and thirty ships that left La Coruña on 22 July 1588 under the command of the duke of Medina-Sidonia carried seven thousand seamen and seventeen thousand soldiers, with instructions to proceed to the Netherlands to pick up the main military force of seventeen thousand from the army of Flanders.

The junction of forces was never made. The English warships, organized in small squadrons under Lord Howard of Effingham, Francis Drake, John Hawkins and Martin Frobisher, began to harass the great ships and force them into the Channel. By 6 August Medina-Sidonia was able to bring most of his vessels intact into the waters off Calais, where he received the first response from the duke of Parma. The Flanders army, the duke wrote, would not be available for boarding for at least six more days. There was a yet more pressing problem. Parma did not have adequate boats to ferry his men out to the galleons. These could not come in further because the waters were too shallow. Parma could not venture out because of the waves and the fleet of Dutch vessels patrolling the coasts. On the night of 7 August the English sent in six small fireships packed with explosive and shot. The anchored galleons cut their cables and fled. At dawn the next day the remaining galleons saw before them the bulk of the now reinforced English fleet, drawn up for battle. A long and fierce engagement of some nine hours took place.

The Spanish ships were at a consistent disadvantage. Few vessels were lost, but the casualties were high. By the end of the day the fleet had to make a run for it, away from Flanders and up into the uninviting waters of the North Sea. The objective of the whole expedition, to take on board an invading force, had failed.

The greater part of the Armada, some hundred and twelve vessels, was still intact. But the wind had carried it beyond any possibility of returning to Flanders or to the battle. By mid-August it was heading into the Atlantic. Off Orkney Scottish fishermen reported seeing 'monstrous great ships, about a hundred in number, running westwards before the wind'. Medina-Sidonia instructed his captains to sail southwest past the Irish coast and thence for Spain. From this point forward the great disasters commenced. Most of the ships perished in the Atlantic storms or on the coast of Ireland, where the natives plundered the wrecks and showed the survivors little mercy.

Not until the third week of September did Medina-Sidonia stagger into Santander with eight of his galleons. Twenty-seven more ships from the fleet made it into other northern ports. Possibly sixty of the one hundred and thirty vessels that had sailed out in May eventually made it home. But some fifteen thousand of the men on board had perished. It was, commented a monk of the Escorial, 'one of the most notable and unhappy disasters ever to have happened in Spain and one to weep over all one's life ... For many months there was nothing but tears and laments throughout Spain.' An officer in the Armada sent a report to a secretary of the king, saying: 'You will now not find anyone who is not saying, "I told you so". We found the enemy with a great advantage in ships, better than ours for battle, better designed, with better artillery, gunners and sailors.'[82]

The failure of the Armada was by no means a mortal blow to Spain, which continued to count on the resources that had made the 1588 expedition possible. The English, however, gained a major advantage in terms of time, and in 1589 a number of London investors backed the expedition that was sent to Portugal under Drake's command with the aim of helping the pretender Antonio of Crato. It was a large fleet, of some 150 vessels, carrying over 10,000 soldiers, but suffered from the defect of having no other objective than looting. 'This army was levied by merchants', a critic stated at the time;[83] and Drake was by mentality a pirate rather than a general. The expedition was destructive, but failed

to dent Spain's power. Another even larger expedition was sent against Cadiz in 1596 and was also destructive, as well as being humiliating to Castilians. But it also achieved nothing. The great fallacy of the naval attacks on the peninsula was the assumption that Spanish power rested there.

The men who gained most in the conflict of those years were the sea-captains who, ignoring the peninsula, attacked the sources of Spain's wealth overseas. In England, merchants and seamen put their investment in joint-stock companies[84] directed towards a combination of trade and plunder. This new business, carried to a peak of perfection by the English, was known as 'privateering', and unleashed on to the seas of Europe and America a flood of small ventures that operated quite legally under the cover of war. Quite often the privateers were single ships, but the most efficient were organized into official companies. They increased the wealth of England through commerce, and above all stimulated the enormous increase in shipbuilding that began in the closing years of the sixteenth century. In this way 'big business' in England managed to profit from the existence of the Spanish empire.

The most outstanding privateering entrepreneur in Elizabethan England was the merchant John Watts, who sent six squadrons to the Caribbean between 1588 and 1597, contributed four ships to Drake's expedition of 1595, and others on diverse occasions.[85] As we have seen (Chapter 6) the foreign corsairs dominated the Caribbean and its trade routes at the end of the sixteenth century. In 1595 the treasurer of Santo Domingo reported that 'corsairs are as numerous and assiduous as though these were ports of their own countries. They lie in wait on all the sailing routes. Coming or going, we always have a corsair in sight. If this continues, either this island will be depopulated or they will compel us to do business with them rather than with Spain.'[86] A Spaniard in London in 1591 reported that though sugar was produced by the Spaniards and Portuguese in America, the amount traded illegally to London was so great that 'sugar is cheaper in London than in Lisbon or the Indies'.[87]

The inauspicious military events in Europe in the closing years of the sixteenth century, the complaints in Castile about heavy taxation and decay of population and agriculture, echoed unfavourably among the subjects of the overseas empire. The king's own secretary informed Philip II in a confidential document that 'the people are full of complaints and many say that things are not going well'.[88] 'I am astonished at what

they tell me about Castile', commented a Spanish resident of faraway Lima in 1590, 'that it is finished, and I believe it from what people say here. Here we go neither hungry nor thirsty, nor do we lack for clothing.' Another, writing from the same city to relatives in Jérez de la Frontera, was alarmed by news of 'the hardship that you suffer in Spain. Since we want for nothing over here, we can hardly believe it.'[89]

Well before his death in 1598, Philip II was coming to terms with the possibility that he could not achieve victory in Western Europe, nor even peace on his own terms alone. For half a century the government had organized a brilliant attempt to harness all the resources of the nations in the empire. But could the effort be continued?

By way of a reaction against the apparent intransigence of Philip II, some ministers of his son and successor Philip III moved explicitly towards a policy that twentieth-century diplomats came to know as 'peaceful coexistence', or living together without compromising ideology. The need had not arisen in the case of peace with France, which was theoretically a Catholic state. But peace with formally Protestant states, such as England and the Dutch provinces, made it impossible to avoid the issue of religion. More crucial was the fact that in the case of both of these states Spain had always insisted on the right of their large Catholic populations to enjoy freedom of worship. Peace could not be made without this essential condition. And if it was essential to respect the beliefs of Catholics, was there not also an argument for respecting the beliefs of non-Catholics? Despite itself the great Spanish monarchy, which had implacably expelled Jews and Muslims from its territories, and persecuted Protestants wherever they appeared, moved forward slowly and reluctantly towards accepting plurality of belief.

The idea appears startling. How could Spain, champion of Catholicism and home of the notorious Inquisition, condone toleration? Yet there can be no doubt of it. Philip II, who had spent many years living among Protestants in Germany, England and the Netherlands, knew what religious coexistence entailed and was not happy about it, but never excluded it as a political alternative.[90] He had accepted the need for it in the case of a successful Spanish invasion of England. In 1591 he was willing to grant toleration 'for a limited time' in the Netherlands if the Dutch submitted to Spanish rule. The thorny issue of coexistence between 'true' and 'erroneous' beliefs became much easier to handle

after the pope gave his unofficial backing to the king of France's Edict of Nantes (1598), which established coexistence of Christian beliefs in that country. The chief Spanish delegate to the peace talks with England, the Constable of Castile, advised his master Philip III that 'Your Majesty is not obliged to make France and England Catholic if they do not wish it', and supported a general policy of what he called 'liberty of conscience' for both Catholics and Protestants.[91]

The conclusion of peace between France and Spain in 1598, the year of the death of Philip II, was a momentous event that appeared to many Spaniards to be a humiliating retreat. The pause, however, could also be seen as a final opportunity to bring to an end the wars in the north. The late king's desperate attempt to achieve peace through a political solution was taken further by his granting of a limited autonomy to the southern Netherlands, which would be ruled over by his daughter Isabel and her husband, Philip II's nephew, the archduke Albert of Austria. Though Spain still had final control of the army in Flanders and of most political decisions, Albert was able to pursue important initiatives that did not always coincide with views in Madrid. Perhaps the most significant of his measures was the decision at the end of 1604 to appoint as commander of the army of Flanders an Italian, the marquis of Spinola.

The most successful general ever to direct Spanish operations in Flanders had also been an Italian, Alessandro Farnese. But there was criticism this time of the appointee's lack of military experience. Ambrogio, Marquis of Spinola, born in 1569, came from the highest aristocracy of Genoa.[92] By profession not a soldier at all but a businessman, he was the epitome of the factors that had helped to create and maintain the empire of Spain. His family was prominent in banking activities both in Genoa and in Seville, and some of its members had been domiciled in Spain since the end of the fifteenth century. They contributed to financing the enterprise of America and developing the commerce and military power of Spain in Europe. Ambrogio's younger brother Federigo had served under Farnese in Flanders, and in 1601 began contracting to supply men and ships to the Spanish authorities there. The collaboration between the Belgians and the Spinolas by sea and by land opened one of the most remarkable, but also typical, phases of Spain's imperial effort. The Madrid government had few of the resources – in money, men, ships or arms – necessary to carry on the war against the Dutch and their allies. It was now the turn of the Belgians to come to the rescue of

Spanish power. Despite constraints that Madrid tried to impose on them, the new rulers of the southern Netherlands were able to act with a remarkable degree of autonomy. 'The Spaniards could not be more sorry', the Venetian ambassador in Madrid reported, 'for they have been left with the cost but not with the control of the government there.'[93]

Flemish corsairs, operating principally from the port of Dunkirk, rendered valuable aid by preying on the shipping of the Dutch and of their allies, England. Drawing on the credit of his family, Federigo raised large sums of money, put together a galley fleet in the Mediterranean, and took it to Flanders to join the Dunkirk ships, where he scored notable successes against the Dutch in the narrow seas.[94] At the same time he financed preparations for a projected invasion of England from the Low Countries. Ambrogio likewise raised an army in Milan at his own expense, and took it down the Rhine valley to join the forces in Belgium in 1602. Federigo died in a military action in 1603 but his work was continued by his brother. The latter scored a spectacular success when in September 1604 his army succeeded in capturing the city of Ostend after previous commanders had failed to do so for three years. The English had just (August 1604) made peace with Spain and no outside help was available for the weary defenders. However, there was little reason for the victors to be satisfied; the siege cost them the lives of over sixty thousand soldiers, a loss no smaller than that sustained by the losers. It was not a comforting outcome for Philip III, who only two years before had apparently given in to his more belligerent advisers and committed himself to make war on the rebels 'with blood and fire, carrying it by sea and land into their very homes, burning and drowning them and laying waste to their fields'.[95]

The unexpected success at Ostend emboldened Albert to appoint Ambrogio, whose career had hitherto been dedicated largely to finance, as commander-in-chief of the army of Flanders. No Spanish nobles suitable for the post could be found, but that was not the main reason for the appointment. The Council of State in Madrid admitted that the financial factor was what weighed most, because Spinola 'with the credit and capital at his disposal can act rapidly to supply everything that is required, such as the wages and provisions of the soldiers'.[96] From this moment his substantial financial resources became the mainstay of Spain's effort in Flanders. The appointment of a foreign banker as its principal general offered the clearest possible evidence of the priority

given to business matters in the running of the empire. For another quarter of a century Spinola exercised the supreme military command in the north, developing into Spain's greatest general of the age. His campaigns helped to push both sides in the Dutch conflict towards the making of peace. When in 1607 the archduchess heard that agreement on a truce was certain she commented with relief that 'it is no small achievement to have attained what everybody thought impossible'.[97]

After the making of peace with France in 1598 and England in 1604, some form of agreement with the Dutch seemed inevitable. Eventually on 9 April 1609 in the townhall at Antwerp the delegates for Spain, Belgium and the United Provinces agreed on conditions for a truce, in the presence of mediators from England and France. The truce was to last for twelve years, during which the military status quo would be preserved and commerce permitted under certain conditions.

In Brussels, where Madrid attempted to pull the strings but where the autonomous government of the archdukes made the effective decisions, there was seldom much doubt about the need for 'peaceful coexistence'. It was a strange truce, in which limited military moves continued to be made, but always with a care not to provoke a war situation. The army of Flanders relied on bases in adjacent German territory, to ensure access to Dutch territory and also to protect the transport of troops down the 'Spanish Road'. As it happened, a number of these bases were in Protestant territory, for the German lands were a complex patchwork of the different Christian faiths. When Spinola's army in the years after 1605 began its campaigns in the area, it successfully occupied several major cities that were wholly Protestant, and had no option but to tolerate the dominant religion. In 1613, for instance, Spinola captured the solidly Calvinist city of Wesel, and granted complete religious freedom in exchange for introducing a garrison of Spaniards and Germans. During this campaign the army of Flanders managed to leave garrisons in over sixty towns, in all of which the free exercise of Calvinism and Lutheranism was conceded. A quarter of a century later, the Protestant faith was still flourishing in them.[98]

It always remained official Spanish policy that the true religion alone had rights. But in practice the empire frequently came to terms with realities. It was not possible, for example, to insist that all troops employed by Spain be Catholic. Like his father before him, Philip II accepted the need to employ Protestant mercenaries. Protestants fought

in the army of Flanders and helped to secure the victory of St Quentin in 1557. In the early seventeenth century the Spanish Council of State advised Spinola not to employ Protestant troops such as Germans and Scots. The general agreed with the idea in principle but felt that it was essential to continue recruiting from all nations regardless of religion, because (as he reported in 1622) 'the number of Spanish and Italian soldiers available is always small'.[99]

Since the Lutheran Reformation the complex maze of German affairs had been the focus of European politics: the Poles, Swedes, Turks, Italians and French had all been vigorously involved in what happened in Central Europe. Charles V had there experienced both triumph and defeat, and lost his good health in the process. The division in 1556 of his inheritance into a Germanic portion, under his brother Ferdinand, and a Hispanic one, under his son Philip, may seem to have created a parting of the ways for the Habsburg family. This, at least, is what has often been assumed. But Philip II was always conscious of the importance of maintaining an active link with his family in Vienna. There were close marriage ties, and he was also host in Spain to his nephews the children of the emperor, one of whom was Archduke Albert, later governor of the Netherlands, and another, Archduke Rudolf, later emperor.

The king also maintained close diplomatic relations with the Austrian Habsburgs, on whom he relied for the recruitment of soldiers for his armies in Italy and the Netherlands. The Spanish empire did not extend to Germany, but it had fundamental interests there that Spanish leaders could not afford to neglect. The lifeline of the Vienna–Madrid connection depended on the continued succession of members of the Habsburg family to the Imperial throne, which was elective and therefore might easily pass out of Habsburg control. This fear was one of the reasons that led to a strengthening of relations through the treaty, signed in March 1617 at Vienna, between the Spanish ambassador Oñate and the heir to the Imperial throne, Archduke Ferdinand of Styria. Ferdinand's untroubled succession to the various territories he was due to inherit from his cousin, the childless emperor Matthias, was from his point of view the main business of the agreement. A further crucial component was Ferdinand's promise to cede to Spain, once he was emperor, the Imperial territory of Alsace, which Spain needed in order to transport its troops down the Rhine.

Spain's renewed interest in Central Europe was a logical consequence of the truce with the Dutch. All the evidence demonstrated that the Dutch and other European powers were profiting from the peace of 1609 by eroding Spanish power throughout the globe. Over much of the Caribbean and in particular the coasts of Tierra Firme, the Spanish presence was so exiguous that non-Spanish settlers normally had little problem establishing themselves. In 1609 and 1619 English settlements were made in Guyana and the Amazon, and in 1626 a company to colonize in these areas was licensed by the English government, with the duke of Buckingham as one of the sponsors. Between 1609 and 1632 the English in the Caribbean settled the Bermudas, the Leeward Islands of Antigua, St Kitts and Nevis, and the island of Barbados. The Dutch in the same period established enduring settlements in Guyana, Curaçao and other islands, while the French were in Cayenne from 1625, and Martinique and Guadeloupe from 1635. These and later colonies were made possible quite simply because there was no Spanish presence in the area.

The English, though not formally involved in the conflict between Spain and the Dutch, played a crucial role in the erosion of Spain's position in the Caribbean and the Pacific. But the Dutch everywhere were the greatest threat. They were in force from the 1590s in the Pacific, where the chief threat to Spain came with the foundation in 1602 of the Dutch East India Company (Vereenigde Oostindische Compagnie, or VOC). Dutch inroads into the Hispano-Portuguese empire were serious enough to form an issue in the talks that attempted to bring peace in the Netherlands. The first significant attack on the Philippines was in 1600, when a Dutch vessel attacked the poorly defended town of Manila and sank a warship that had been rapidly constructed by Antonio de Morga. It was the beginning of a half-century of travails. In August 1614 an expedition sponsored by the VOC, consisting of four vessels and seven hundred men, entered the Pacific by the straits of Magellan. In July 1615 it attacked and destroyed off the coast of Lima the naval force put up by the viceroy; the Spaniards lost two frigates and five hundred men. The incident committed Spain to overhaul defences in the Pacific by fortifying the port of Callao and constructing ships. But little was done for over a century to defend the Pacific coasts adequately.

The most immediate danger to Spanish interests appeared to come from Europe. In May 1618 the Estates of Bohemia, one of the few

kingdoms in Europe to have an elective monarchy, began a revolt that ended in them deposing their Catholic ruler, the Habsburg Archduke Ferdinand of Styria. Ambassador Oñate, who was in Vienna when he received news of the uprising, became deeply concerned and by January 1619 had come round to thinking that only Spain could save the situation. 'It seems to be necessary for your Majesty to consider which will be of greater service to you,' he wrote, 'the loss of these provinces or the despatch of an army of fifteen to twenty thousand men to settle the matter.'[100] The typically chauvinist reaction might have fallen on stony ground but for the predominance in the councils of Spain at that moment of Baltasar de Zúñiga, who had served with distinction in the army and also as ambassador, and now had the ear of Philip III. Thanks to his arguments, aid to Vienna was seen as a necessary part of an overall strategy in Europe of defence against the Dutch (who were giving support to the rebels in Prague). Money was advanced to Spain's friend Ferdinand of Styria, who in the same week that he was removed from the throne of Bohemia was elected unanimously by the German princes as Holy Roman emperor at Frankfurt-on-the-Main.

Meanwhile in the course of the year 1619 the Spaniards gave solid proof of their friendship and of their impressive capacity to raise troops in all parts of the continent. They had already sent a Belgian general, Charles Longueval, count of Bucquoy, to take command of the troops that Ferdinand was raising. In the spring of 1619 a detachment of around seven thousand Belgians and Irish was also sent across from the southern Netherlands. In the summer ten thousand Italians were recruited in Naples under their captains Carlo Spinelli and Guillermo Verdugo, and sent through the Brenner Pass into the Habsburg lands.[101] This time the commitment was more substantial and more lasting than in 1532; it has been estimated that in total the Spaniards were financing half the infantry available to the new emperor.[102] There were few Spaniards, but the soldiers were drawn from all the European territories governed by Spain: there were Castilians, Neapolitans, Belgians, Germans, Florentines. Among the officers in this international force was the Valencian general Baltasar de Marradas, who became one of the supreme commanders of the Imperial army and settled down subsequently in the large complex of estates that he purchased in southern Bohemia. There were extensive military movements on all sides, but as yet no sign of war despite the observation of the English ambassador at The Hague that

'this business of Bohemia is like to put all Christendom in combustion'.[103]

The fateful move to war was made when in August 1619 the Calvinist elector of the Palatinate, Frederick, decided to accept the crown of Bohemia offered to him by the rebels. It was a decision that threatened to overturn the entire political, religious and military order of Germany. In the Spanish Council of State the gloomy ministers foresaw only an 'eternal war' if the Protestants gained control of the Holy Roman Empire. The Catholic powers therefore acted, and decisively. In July 1620 the fifteen thousand troops of the Catholic League headed by Bavaria, marched into the regions of Austria allied with the Czechs, and thence into Bohemia, where they joined the Imperial troops under Bucquoy. On 8 November 1620 they inflicted a shattering defeat on the Czech and German Protestant forces in the battle of the White Mountain, just outside Prague. Only a handful of Spanish troops was involved in the victory, which was achieved in large measure by the Neapolitan infantry and Florentine cavalry.[104] The Bohemian revolt was finished. Frederick fled into exile after having reigned for one short winter (a scornful Europe called him the *Winterkönig*, the Winter King) and peace seemed to return to a Central Europe that had been in turmoil.

In reality, the war was just beginning. The big debate in Spain was not over Bohemia, where everyone agreed on the need to intervene, but over the Dutch. By the middle of 1620 the Dutch had supplied some five thousand men as military assistance to the Estates of Bohemia, and they took part in the White Mountain. Spain was prepared to continue confronting the Dutch wherever they threatened Spanish interests, but was it prepared to renew the war against them after the impending expiry of the Twelve Years Truce in 1621? Zúñiga declared explicitly in the Council of State in April 1619 that the two principal aims of the past conflict – conquering the Dutch provinces, and restoring the Catholic faith by force of arms – were now completely out of the question and unrealizable. His words were uncompromising:

We cannot reduce those provinces to obedience by force of arms. Whoever considers the matter carefully and dispassionately can only be impressed by the great power of the provinces, both by land and by sea. What is more, that state is at the height of its greatness, whereas ours is plunged in confusion. To promise ourselves that we can conquer Holland is to aim for the impossible and delude ourselves.

Both he and other counsellors of Philip III, however, were not quite sure where the bottom line could be drawn in terms of negotiating a renewal of the truce. In the end, the deliberations centred on three main conditions. The first of these concerned obtaining freedom of worship in the United Provinces for the Catholics, who were still a majority of the population. The other two directly affected the survival of the empire as a business concern. They were emphasized in a letter from the king to Archduke Albert in February 1621, explaining that the truce could only be extended if the Dutch ceased trading in the Asian archipelagos, and opened the estuary of the River Scheldt, Antwerp's access to the sea. Otherwise, the renewal of the truce without these conditions 'would result in the complete ruin of these kingdoms', that is, of Spain. There was no mistaking the general preference for war. As the councillors in Madrid stated, 'during the truce Holland has increased its wealth, waged wars in Germany against the Habsburgs, and infested both America and Asia with its shipping, all of them reasons that make it indispensable to redeem religion, honour and justice through resort to arms'. They apparently viewed Spain as a sort of world policeman, 'safeguarding' it against subversion. Philip III died a few days before the expiry of the truce, and was succeeded by his son Philip IV, who was seconded at all times by his special adviser Gaspar de Guzmán, later Count Duke of Olivares. Philip was a sensitive, conscientious ruler, and his long reign of forty-four years was destined to have decisive consequences for the evolution of Spain's empire. But the long shadow of conflict continued to dominate. The drift of opinion in Madrid was still controlled by Zúñiga, and it headed towards war.

In Brussels the Belgians had their own priorities, of which the most important was to defend their territorial integrity against the Dutch and their allies. When the army of the Catholic League had moved into Austria and Bohemia, that of Flanders under Spinola on 5 September crossed the Rhine into Frederick of Bohemia's principality, the Rhine Palatinate. Frederick was far away in Bohemia. His homeland was almost defenceless apart from a small force of two thousand English volunteers who were holding the key fortresses of Frankenthal and Mannheim, while the capital Heidelberg was defended by German and Dutch troops. It became common in Protestant propaganda of the time to present the terrible spectre of Spanish troops marching unimpeded through the defenceless principalities of Western Europe. In reality, Spanish troops

were inconspicuous in the forces that invaded the Palatinate. Spinola's invading army in 1621 included 20,000 infantry and 4,000 cavalry, of which around 40 per cent were Germans, 28 per cent Italians, 12 per cent Belgians, and 10 per cent Spaniards, together with some Portuguese.[105] The principal commanders under Spinola were the Belgians Count Henry van den Bergh and Count Berlaymont. Spinola himself had to return to Brussels (with part of his army) in July 1621 because of the death of Archduke Albert earlier that month, but he left behind some eleven thousand troops under the command of Gonzalo Fernández de Córdoba. They held the greater part of the Palatinate until Imperial troops in 1622 completed the occupation of the territory by capturing Heidelberg and Mannheim; Frankenthal surrendered shortly after.

The Spanish monarchy was now well poised to defend its commitments in Europe. Possession of the Palatinate, though not an absolute necessity, assured the lines of communication between the Alps and the Netherlands. In July 1620 the army of Milan marched into and occupied the strategic route through the Valtelline into the Germanic lands. Meanwhile in the southern Netherlands a major new initiative was under way. The Brussels government in 1620 made an agreement with a Flemish contractor for the building and equipment at Ostend of twelve armed attack vessels. The return of Spinola from the Palatinate shortly after strengthened the army, which was made ready for a possible campaign.

Even while talks between both sides over a renewal went on, the truce between Spain and the Dutch expired officially on 9 April 1621, with majority opinion on both sides resigned to the war. From his position in Brussels, where he could observe at close quarters the situation both in Germany and in the United Provinces, Spinola in the spring of 1621 conveyed to Madrid, through his envoy Carlos Coloma, his inflexible opinion that war was the only sensible option. 'If the truce is extended we condemn ourselves to suffer permanently all the ills of peace and all the risks of war.'[106] The so-called 'peace' had been ruinous, and was costing two million ducats a year just for the army of Flanders. But if war was chosen it must be done properly. All other theatres of war must be shut down. Spain must withdraw from any commitment to Germany or the Palatinate, and must reduce defence measures, currently estimated at two millions a year, in the Pacific. The Dutch, finally, must be attacked where they are strongest, at sea, by supporting the Flemish corsairs and

by maintaining two strong fleets, one in the Atlantic and one in the Mediterranean. Coloma outlined to ministers in Madrid the gains made by the Dutch in Asia: 'they have established now in the East twenty-three trading posts and as many forts; they have seized all the trade in cloves; innumerable ships of theirs have captured or sunk both Castilian vessels in Maluku and the Philippines and Portuguese vessels in India; they have aided and aid all the rulers of the archipelago and coasts who are our enemies; and finally they have acquired there as much power, credit and reputation in twelve years, as the Castilians and Portuguese acquired in one hundred and twenty'.[107]

In July 1621 the king instructed Isabella that a state of war now existed, but for a long time ministers in Madrid, Brussels and The Hague were not reconciled to it and continued, even while the soldiers were on the march, with diplomatic contacts in search of peace.

The Dutch did not intend to be caught unprepared. At the same time as the land army was being restructured by Maurice of Nassau, the overseas enterprise was rejuvenated by the foundation in 1621 of the Dutch West India Company, the WIC (West-Indische Compagnie), which three years later in May 1624 occupied by surprise and with virtually no opposition the chief town of Brazil, Bahia. The substantial Dutch fleet of 26 warships with 3,300 men had as its second in command Vice-Admiral Piet Heyn. The dimensions of the conflict would clearly be intercontinental, extending through all the seas of the world. It was in every sense a world war, with the Dutch and the Spaniards as the main protagonists, and the survival of Spain's empire as the stake. The outbreak of hostilities with England in 1625 (commented on below) further complicated the scene. At war after the 1620s with the world's chief maritime powers, England and the United Provinces, Spain came face to face with the hideous reality of imperial responsibility.

The great worldwide apparatus of Spanish power was now put to the test. And it proved itself remarkably well. Spain faced two main theatres of conflict: in the Netherlands, where it attempted to contain a conflict that had now, thanks to the Thirty Years' War, extended itself to the Germanic lands and Central Europe, and in East Asia, where it was defending the spice trade. Spain itself was unable to produce in sufficient quantity any of the essentials required for maintaining a war: men, armaments, shipping. Its only recourse, on which it now depended entirely, was the business network created by American silver. This was

the most fearsome antagonist of its enemies, who expended all their energies on attempting to destroy or at least undermine it. In addition, Spain counted in Europe on the fundamental input of its two partners, Belgium and Italy, who in the seventeenth century made perhaps their most profound contribution to the survival of the empire. And outside Europe, as we shall see, Spain since the 1580s was in the unprecedented position of being able to count on the Portuguese.

To encourage Spinola in his role as leader of the war effort, Philip IV in 1621 conceded him the Spanish title of marquis of Los Balbases, made him a grandee and granted him the Golden Fleece. The supreme commander continued to be faced with fundamental problems of men and money, especially on the part of Spain, whose participation in the war became progressively smaller. 'There are very few Spanish soldiers to count on', Spinola complained to Madrid in June 1622, at a time when the government there was urging him to depend less on Protestant soldiers from Germany and the British Isles. He pleaded for Italian troops to be sent from Milan. Decisions in Brussels were now tending to be made with minimal reference to Spain. The most significant of them was the decision to besiege the city of Breda. The resolution was made, without the knowledge of or prior consultation with Madrid, by Spinola and a small group of the high command in Brussels in 1624. It was a brilliant move. Breda was garrisoned by Justin of Nassau, natural brother of the Stadholder Maurice. 'The marquis Spinola', the artist Peter Paul Rubens wrote from his home in Antwerp, 'is more and more determined to take the place, and believe me there is no power can save the town, so well is it besieged.'[108] It surrendered finally on 5 June 1625, after a nine-month siege. By coincidence, Maurice himself died shortly before the surrender, asking on his deathbed for news about the siege. Though Spinola stayed on three more years in the Netherlands, it was his last campaign there.

The success at Breda, a largely Belgian–Italian victory financed in part by Spain, which Castilians would always insist on claiming as uniquely their own[109] because of the masterly canvas subsequently painted by Velázquez, was only one of the impressive triad of successes that the monarchy managed to achieve in the memorable year 1625. Just as it could count on the Belgians and Italians to achieve victory at Breda, so it could count on the Portuguese, who were profoundly alarmed by the inroads being made by the Dutch into their overseas

territories. Even while the siege of Breda was in progress, the Portuguese were taking measures to remedy the loss of Bahia. They withdrew men from the North African garrisons in Tangiers and Ceuta, and put together a fleet of twenty-two ships, which they placed at the disposal of the Madrid government.

Early in 1625 an impressive Portuguese–Spanish armada of 56 vessels, carrying 12,500 men (three-quarters of them Spaniards, the remainder Portuguese) and some 1,200 guns, under the command of Fadrique de Toledo, set out from the peninsula. It was the largest European naval force to have crossed the Atlantic, the first of its kind ever dispatched by Spain. The armada appeared before Bahia on 30 March, Easter Eve, and had no difficulty in achieving within four weeks the surrender of the town, garrisoned by 2,300 men under Dutch command. A relief force from Holland arrived at the end of May, only to sail away after seeing the Spanish flag flying above the town and a formidable formation of fifty vessels at anchor in the bay. The recovery was with reason celebrated by Spain, and Olivares commissioned a huge canvas from the artist Juan Bautista Maino, taking care that he should figure prominently in the painting, which was hung in the royal palace of Buen Retiro. Bahia had been made possible by the fruitful collaboration of Portuguese and Spaniards, a superb example of imperial partnership. Particularly extraordinary was the number and the enthusiasm of the higher Portuguese nobility who took part. Possibly not since the ill-fated expedition of King Sebastián in 1578 had so many nobles ventured their lives, and this time with success, on an imperial enterprise.[110]

The satisfaction that year was interrupted by the unwelcome declaration of hostilities by England, where war fever gripped all sections of opinion and a leading politician called for 'peace with all the world but war with Spain'. The English government was angry at the failure of the secret mission to Madrid in 1623 of the Prince of Wales, the future Charles I, to court the Infanta. The Parliament also wished to rescue the Palatinate from occupation by the army of Flanders. In August preparations were being made together with the Dutch for a joint attack on a Spanish port. At the beginning of October 1625 an Anglo-Dutch fleet, consisting of twenty Dutch vessels with ten English warships and seventy transport ships, sailed from Plymouth. Once out at sea the decision was made to attack Cadiz, other alternatives having been rejected. Cadiz was the hub of the American trade, and no doubt mem-

ories were stirred of the highly successful attack on the port in 1596. This time, however, the whole action was botched, and an attempt to seize the silver fleet failed dismally. Four weeks later the expedition commander, Sir Edward Cecil, called off the venture and gave orders to sail for home. While the Spaniards congratulated themselves on their good fortune, it was the turn of the English to lament, in the words of a member of Parliament, that 'our honour is ruined, our ships are sunk, our men perished'. In Brussels, Spinola commented to Rubens that the expedition had been 'utterly foolhardy; the English apparently thought they could take all Spain with twelve thousand infantry and a few horsemen'.[111]

The triple success of 1625, a miraculous year in which Castilians, Portuguese, Belgians and Italians had together demonstrated their ability to stand up to the challenge of war, would not be repeated for a generation. Olivares learned an important lesson from the *annus mira-bilis*. He evolved the idea of a monarchy that could defend itself by using local resources rather than having to call on those of Madrid. The plan was for a Union of Arms, in which each member state would at its own expense raise and maintain a body of troops. Castile and America, for example, would between them recruit forty-four thousand men, Catalonia sixteen thousand, and Milan eight thousand. If all the states co-operated, the empire would be able to dispose of up to 140,000 men. From 1626 the count duke began taking measures to put the idea into effect. Carried along on the same tide of optimism, the king addressed an optimistic message to the Council of Castile:

Our prestige has been immensely improved. We have had all Europe against us but we have not been defeated nor have our allies lost, while our enemies have sued me for peace. The fleet, which consisted of only seven vessels on my accession, rose at one time in 1625 to 108 ships of war at sea, without counting the vessels at Flanders. If we lacked this maritime strength not only would we lose the kingdoms we possess but in Madrid itself religion would perish, which is the principal question we should consider. This very year of 1626 we have had two royal armies in Flanders and one in the Palatinate, and all the power of France, England, Sweden, Venice, Savoy, Denmark, Holland, Brandenburg, and Saxony could not save Breda from our victorious arms.[112]

The speech, packed with half-truths and resonant with chauvinist echoes of victory, was a typical vision of the empire as seen from Madrid. In practice, as subsequent events in that year of 1626 showed, no victory

of any sort was possible without the willing collaboration of allies, who were suspicious of the implications of Olivares's policies. The Union of Arms was immediately recognized for what it really was, an attempt to shift the burden of defence on to the member states of the monarchy. The Catalans refused to have anything to do with it. In Brussels the authorities paid lip-service but murmured privately against it. Rubens remarked angrily that the Union proposed that 'our country must serve as the battlefield', fighting Spain's battles while Spain got off scot-free.[113]

The contribution of Belgium to the defence of empire was, of course, not simply the work of Spinola. His brother Federigo had pioneered the brilliant policy of attacking the enemy by sea, and the archduchess gave her full support to the war effort. Since the death of Archduke Albert in 1621, the southern Netherlands had in theory reverted to full Spanish control. In practice Isabel was very much in control until her death in 1633, and among her first responsibilities was to try and remain on working terms with Philip IV's chief minister Olivares, whose schemes for imperial recovery were already creating tension. She and her advisers had to contend with the presence at Brussels of insistent Spanish officials, among them the ambassador, Alonso de la Cueva, marquis of Bedmar. The Netherlands was crucial to both the naval and the military effort in northern Europe, and Spain had no intention of losing control of decision-making.

It is easy to overlook the tremendous effort made by the people and government of the southern Netherlands in helping to maintain Spanish power in Europe. The military forces stationed there were in the service of Spain, but were only partly paid for by the Spanish, whose troops were always in a minority. Spain continued to make extensive use of the naval, industrial and cultural resources of Belgium, but was seldom able to keep up with its payments. In the year 1627, Rubens expressed the discontent of the government in Brussels at the lack of money. 'We are exhausted', he wrote, 'not so much by the trials of war, as by the perpetual difficulty of obtaining necessary supplies from Spain.' Shortly after, he commented that 'it appears strange that Spain, which provides so little for the needs of this country that it can barely defend it, has an abundance of means to wage an offensive war elsewhere'.[114]

Thanks in part to their linguistic ability, Netherlanders became invaluable members of the imperial diplomatic service, serving Spain in

areas of the continent from which Castilians were excluded by their ignorance of the languages. Among the diplomats was Gabriel de Roy, a noble of Artois who had through extensive travels in every corner of Europe made himself into a superb linguist and a mine of information on all matters. In the years 1602–8 he was in Madrid; subsequently he returned to the Netherlands and worked with Spinola. Other leading Belgian diplomats of the period included Jacques Bruneau, who represented Spain in London, Jean de Croÿ, count of Solre, accredited to Poland, and the artist Peter Paul Rubens. Apart from advice and co-operation, the Southern Netherlands during Isabel's government was the spearhead of a twin military effort, by sea and by land.

The most notable contribution of the Belgians to Spain's war effort was made by the port of Dunkirk, where from 1621, when the truce with the Dutch expired, the authorities gave their support to a campaign of naval privateering directed against the enemy, including the French and English. Around 1600, as we have seen, Federigo Spinola had operated a similar scheme. In 1620 Carlos Coloma in Brussels suggested that the vessels then under construction in Ostend and Dunkirk be used against the enemy 'like pirates'. By 1621 the Spaniards and Belgians were ready to attack the Dutch in their own sphere, the waters of the North Sea. The first engagements were not entirely successful, but as the months advanced the experience of the corsairs improved. Moreover a number of independent merchants also took the opportunity to engage in the officially sanctioned piracy, and made profits from it. At the same time the government in Spain extended the pirate war to all the seas of Europe. The success of the Dunkirkers was impressive, particularly in the *annus mirabilis* 1625. When the archduchess Isabel heard of the proposed English descent on Spain that year she went to Dunkirk to join Spinola and see how the ships were doing. 'The Infanta and the marquis are still in Dunkirk', Rubens reported in October 1625, 'devoting themselves to the building and arming of ships. At the time of my departure I saw in the port of Mardijk a fleet of twenty-one well-armed ships.' 'Our ships from Dunkirk', he added a month later, 'have ruined the herring-fishing [of the Dutch] for this year. They have sent to the bottom a number of fishing-boats, but with the express order of the Infanta to save all the men and treat them well.'[115] The primary target of the Dunkirkers was the Dutch fishing fleet, the basic element in the economy of the United Provinces. In practice, as happened that year, the ferocity

practised on the Dutch fishermen exceeded the limits of civilized conduct, and Isabel was concerned to avoid reprisals by the Dutch.

In the light of the naval successes of 1625 around the seas of the world the king was inspired to claim in his 1626 speech to the council of Castile that 'the war at sea has much advanced the reputation of Spain'. It was true, but a good part of the credit went to the Belgians. The activities of the Dunkirkers in the Channel during 1625–6 cost the British merchant marine the loss of around three hundred vessels, representing up to one-fifth of their entire fleet.[116] The Dutch were under constant pressure: in 1627 the Dunkirk ships captured forty-five Dutch vessels and sank sixty-eight; in the same year the privateers working with them also took forty-nine vessels and sank seventeen.[117] The following year they took even more. 'Who can doubt', commented Olivares, 'that if we continue along the present lines, cutting our enemies' links, their power will decline while that of Spain will increase?'[118] He began to dedicate time and attention to a serious plan to ally with the emperor and establish Spanish naval power on the coast of the Baltic, with the aim of cutting off the Dutch from access to naval supplies and wheat.

But despite successes at sea, the military machine was running into serious trouble. Spinola had seen the impending threat when in January 1627 the Madrid government suspended payment of its debts. He complained from Brussels that the army there, with 68,000 on the payroll though only 47,500 were fighting soldiers, was in peril, and emphasized 'the great risk of losing everything here'.[119] At the end of 1627 he was given permission to go to Madrid and present his case directly to the government. As it happened, Spinola's concerns were not simply for the state of the army. The 1627 suspension, which had serious consequences for Italian financiers, affected him directly as a Genoese banker. He wished to negotiate repayment of his extensive loans to the crown. At the same time he urged a policy of military retrenchment: changing the objectives in the Netherlands in favour of a negotiated solution, and withdrawing from engagements in Italy.

The Spanish empire in Asia had never been in any position to defend itself, and benefited very little from the Twelve Years' Truce. European states tended to take the view that conditions of peace and war in Europe did not affect their overseas territories. The Dutch certainly saw no reason to extend the peace in Europe to the overseas empire. Throughout

the years of truce, therefore, they continued to promote their interests in Asia, regardless of possible conflicts with Spain. The principal victim of this situation turned out to be Portugal, which found itself in the unwelcome position of defender of the Spanish empire in Asia.

On the expiry of the truce in 1621 the VOC, from its base at Batavia and under the leadership of the creator of Dutch power in the east, Jan Pietersz Coen, made serious plans to take over the trading concerns of the Iberians. Manila in 1621 was in the heyday of its Pacific trade but in no condition to present itself as a military power. The Spanish colony no longer thought in terms of the conquest or conversion of Asia. The number of Spaniards on Luzon was inadequate for ambitious enterprises, and commerce had become limited to the vital activity of the annual galleon. For all practical purposes, Manila ceased to be an outpost of the empire. Instead, many of the Spaniards dedicated themselves to their own little undertakings, and the city became a sort of open mart, where Europeans and Asians mixed freely. The Augustinian archbishop of Manila in 1621 complained to the crown that the active men who should have been there to protect the city were scattered through Melaka, Macao, Thailand, Cambodia and Japan, engaged in contraband on their own behalf.[120]

The Dutch took limited action against Manila, attempting for instance to blockade its bay in 1621, but their real effort was directed against the far richer booty to be had from the Portuguese territories. In 1623 Dutch strength in East Asia amounted to some ninety vessels and two thousand men garrisoning forts at Batavia, Amboina and Ternate.[121] With these forces, actions were taken against the Portuguese bases at Goa, Melaka and above all Macao. An ambitious expedition launched against the Portuguese at Macao in 1622 failed, principally because the Chinese helped to repel the invasion. By way of compensation the Dutch were obliged to settle for a base on Taiwan (see Chapter 9), where they soon developed a profitable sugar industry and eventually expelled the few Spaniards that had also managed to establish themselves on the island. Though the aggressions could never be more than piecemeal, in view of the few resources available to the Dutch and the extensive distances involved, the consequences were decidedly depressing for the Portuguese. Their trade was reduced and the viceroy in Goa even contemplated making a separate peace agreement with the Dutch.

There were important repercussions in Madrid, where the council of

Portugal in 1623 advised Philip IV to 'seek an agreement with Holland, since the prospects for war become daily more unrealizable'.[122] One Portuguese minister had already insisted to the government that 'war waged against the rebels in the east will have more useful effects than that now waged in the Netherlands'.[123] What he was asking for, and the Portuguese continued to demand, was that some portion of the vast quantities of silver being poured into the Flanders campaign be diverted to Asia, where the need was no less great and the returns might be more adequate. The Portuguese were equally concerned for the security of Brazil and the Caribbean, where enemy attacks severely affected commerce and resulted periodically in the loss of vessels: the Dutch West India Company claimed to have captured fifty-five Portuguese and Spanish ships during the year 1627.

The successes registered by the empire in 1625 and 1626 had therefore to be set against serious difficulties in areas where the Spanish were exceptionally weak. The dominance of the Dutch by sea was unquestionable. In 1628 they accomplished one of the great feats of the age, an unprecedented blow against Spain's silver lifeline: they captured the entire treasure fleet. That autumn admiral Piet Heyn, on behalf of the Dutch West India Company, sailed for the Caribbean with a fleet of 32 ships armed with 700 cannon and carrying 3,500 men. On 8 September he encountered the New Spain treasure ships as they made for their rendezvous at Havana. The silver fleet, consisting in all of fifteen vessels under the command of Admiral Juan de Benavides, tried to shelter in Matanzas Bay, to the east of Havana. Heyn sailed in and captured all fifteen ships, burning half of them and absorbing the rest into his fleet. The treasure taken, in gold, silver (177,537 pounds), silks and other goods, was valued at some 4.8 million silver pesos. That year the fortunate shareholders of the West India Company received dividends of over seventy-five per cent. Heyn became rich, but not for long; he died the following year in a naval action against the Spaniards in Flanders.

Heyn's exploit provoked anger in Madrid and fury in the government. Such was the division of feelings and opinions among those in power, however, that an outsider who was there got the impression only of immense satisfaction at the disaster. Peter Paul Rubens reported that 'almost everyone here is very glad about it, feeling that this public calamity can be set down as a disgrace to their rulers. So great is the power of hate that they overlook their own ills for the mere pleasure of

vengeance.'[124] The feeling of helplessness in the government was reflected in Philip IV's panic-stricken order to the archduchess in 1629 to send the whole Dunkirk–Ostend fleet, the 'armada of Flanders', to Spain together with three units of Belgian troops, in order to defend the peninsula and reinforce troops in Italy. Nothing was done, for there was no money to pay for the expedition.

The unique success achieved at Matanzas encouraged the Dutch West India Company to look for a more permanent base for its activities, an objective that obviously brought it into full collision with the Spanish empire. It was also looking for more profits for its shareholders. The plans bore fruit in a war fleet it financed, of sixty-seven ships with seven thousand men, which attacked Brazil's northeast coast in February 1630 and occupied the town of Pernambuco. The success was the beginning of a rapid and successful Dutch drive in the Atlantic. Over the next seven years the Dutch took over four of the provinces of northern Brazil, occupied Curaçao and other points in the Caribbean, and finally in 1637 seized the slave fort of São Jorge da Mina on the African coast from the Portuguese.

If we were to judge Spain's actions simply by the exploits of its conquistadors it would be easy to conclude, as American chroniclers like Guaman Poma did, that greed was the overriding inspiration of the newcomers. In reality, the limited military and naval capacity of Spain meant that it could not construct an empire based only on systematic rapine. The conquests had to mature. From the very beginning, there were always men from many nations who were concerned to ensure that their small investments, in land, in mining, in production, in commerce and even in the African slave trade, would perform properly and bring in dividends. Bit by bit, a patchwork of interests was created that brought together European and Asian investors. The problem arose when that investment had to be protected by force of arms, for business does not function adequately without the power to back it up.

It was then that Spaniards, face to face with the inadequacy of their imperial power, began to have doubts about the whole enterprise on which they had embarked.

8

Identities and the Civilizing Mission

Even spirits that are most opposed in the patria, become rec-
onciled when they are outside it, and learn to appreciate each
other. Cristóbal Suárez de Figueroa
(*circa* 1640)

As citizens of the Roman Empire had been taught to look towards Rome,
so citizens of the Spanish territories were encouraged to accept the
culture and values of Spain. All empires are in some measure a process
of acculturation, creating bonds that permeate the entire network of
relations and establish the rudiments of a common identity. In the
nascent empire of Ferdinand and Isabella a common bond was created
by participation in an enterprise that was led and pioneered by Castilians,
who formed four-fifths of the population ruled by the crown in the
peninsula. Castilians logically formed the majority of the troops, gen-
erals, diplomats and clergy. Though sharing with other peoples of the
state a sense of belonging to 'Spain', they felt rightly that their part
in it was foremost and they put their stamp on its actions and its
evolution.

With time, the sense of belonging underwent a subtle change. The
political role of the state, which was called 'Spain', began to grow in
importance. At the same time, the growth of the empire bestowed on
'Spain' a significance, a role and an ethic that helped the peoples of the
peninsula to realize that they now shared a common enterprise which
gave them an unprecedented new identity. Perhaps the most power-
ful influence on this change was warfare. From the wars of Granada
onwards, both soldiers and officers in the army absorbed a war ethic in
which military values transcended the mere level of personal valour, and
were placed at the service of the prince and the state. All soldiers in the

pay of Spain, whether they were Castilians or not, were encouraged to identify themselves directly with the nation. They were told to shout for Spain. The use of a standard battle-cry helped to concentrate the enthusiasm of soldiers. During the Italian wars around the year 1500 all soldiers serving in the tercios were under the obligation to use the battle cry 'Santiago, España!'. Castilian chroniclers reported how the soldiers in battle chanted 'España, España!' and 'España, Santiago!' as they hurled themselves at their enemies. They may not even have been aware what the words meant, but it was a phrase that served to concentrate their ferocity.

Over the next half century the war-cry began to be heard throughout Europe. Italian troops serving in the duchy of Cleves in 1543 shouted 'Santiago, Spagna!', and soldiers of the tercio of Naples, serving at Mühlberg in Germany in 1547, were ordered to cry 'Santiago, España!' Even troops not within Spain's service were known to use the invocation. At Mühlberg the crack Hungarian cavalry in the emperor's army had to choose between the official German or Spanish battle-cries, and in view of their antipathy to Germany had no doubt in opting to cry 'España!' as they charged into battle.[1] Considering that, as we have seen,[2] over half the men in a tercio might be non-Castilian Spaniards, the cohesive effect of this essentially Castilian war-cry was undoubted. All soldiers of the peninsula were encouraged to feel that their cause was the cause of Spain.

It was significant that the battle-cry could not, except in the Granada wars, be used within the peninsula. One could not shout 'Spain!' when fighting a battle against other Spaniards. The proclamation of an identity, of a loyalty to Spain, was always external and associated with imperial enterprise. Just as Basques, Extremadurans and Aragonese might feel they had a common cause against the enemy at Granada, so their joint experience outside the peninsula gave them a common bond. The humanist Juan Ginés de Sepúlveda, who had direct experience of the reign of the emperor and devoted his retirement in the 1560s to writing a life of him, was among the first to originate the image of an empire that had been created by the military effort and heroism of 'Spaniards' alone. Describing the siege of Florence in 1530, when Charles's commander the prince of Orange was unexpectedly killed, Sepúlveda recounted for his Spanish readers how a small handful of Castilians, to cries of 'España!', drove the enemy back and

gave courage to the German troops of the emperor.[3] Long before there was any political reality to the concept within the peninsula, 'Spain' became for the soldiers outside it a vivid reality that determined their aspirations.

The battle-cry of 'España' stirred the emotions of combatants in favour of a 'Spanish nation',[4] phrase employed by a chronicler of 1559. The term 'nation' was not new. It had been used frequently in previous decades to refer to Spaniards and others as a determined group living outside the peninsula (for example, traders living abroad were grouped in their towns of residence as a 'nation'). It was also applied to companies within an army, to define their origins and shared language. The soldiers of the Castilian tercios in Flanders, absent for years from their homes and desperate to identify the cause for which they were sacrificing their youth and their lives, seemed to be using this term 'Spanish nation' in a broader, more collective sense. 'We are from the same nation as you, all Spaniards', wrote the soldiers serving in Holland to the mutineers in the town of Alost in 1576.[5] Absence abroad was a powerful influence in creating sympathy for 'Spain'. The word began to take on echoes of yearning, to refer to the homeland from which all peoples of the peninsula came. The most obvious example was the emigration to the New World. Settlers writing home to their loved ones habitually referred to the peninsula as 'Spain', and even when they were content with their new lives did not cease to long for the things that 'Spain' represented for them.

The majority of emigrants to the empire were from the Crown of Castile, and spoke Castilian. For them, Castile and Spain were perceived as identical. Because of the preponderant part played by Castilians in foreign enterprises, the history of voyage, discovery, conquest and war was written up by official historians in a way that gave all the glory to Castile. In a sense this was not new, for other European nations also were in that same epoch trying to discover their own identity through an exploration of their past. Reading today the stirring historical accounts that have come down to us, it is easy to forget that they were essentially works of propaganda by Castilians who on one hand were delighted by the achievements of their citizens, and on the other were anxious to please their sponsors, who were normally (as were those of Nebrija) the government.

One historian, who in 1559 wrote his account of the wars in Naples

over half a century before, used classical models to invent suitable speeches for his dramatis personae. A military commander trying to mollify four thousand Castilian soldiers of Naples who were mutinying for non-payment of their wages is said to have used the following words to them: 'the whole of that kingdom of Spain, of which we are sons, has its eyes fixed on you'.[6] Hundreds of miles from home, the scattered towns and isolated villages from which the soldiers came, took on the lineaments of a great new identity, the 'kingdom of Spain'. Writing fifty years later, the official historian Antonio de Herrera went so far as to present the entire imperial enterprise, both in Europe and in the New World, as exclusively a history of the deeds of Castilians. In his pages Magellan was transformed into a Castilian, and the Imperial victory at the battle of Pavia became a conflict between French and Spaniards alone, in which the capture of the king of France was a consequence of the victory of the 'Spanish army'.[7]

His contemporary Prudencio de Sandoval, introducing his narrative of the life of Charles V, stated that 'I am going to write about the kingdoms of Castile', a phrase that four lines later became 'this history of Spain'.[8] The part of non-Castilians in the task of discovery and settlement was in no way glossed over by the chroniclers, but they were invariably given an identity, as 'Spaniards', that obscured their nationality and origins. The chroniclers described, for example, the sponsors of Sebastian Cabot's 1525 expedition simply as merchants of Seville, without the detail that they were Genoese.[9] The work of the Castilian historians became perhaps the most powerful tool in the creation of the desired image of empire. Subsequent historians in their turn quoted the earlier writers, and so the notion of Spanish power was born. The contribution of non-Castilian allies was not forgotten, but simply lost to sight.

The warlike deeds of Castilians came to be seen as superhuman and unique. Marcos de Isaba, who had served as a soldier throughout the Mediterranean, wrote proudly in the 1580s that 'I have seen with my own eyes what the valour of the Spanish nation has achieved, and the respect, fear and renown that Spaniards have gained both in the Old World and in the New in these last ninety years. The Germans and the Swiss have admitted that they are outclassed in strength and discipline.' The proof of such a claim, he said, could be found in the famous battle of Pavia, where 'it is both true and accepted that just eight hundred

infantry, musketeers and pikemen, won the victory, shattering the fury of the French cavalry and the greater part of their army'.[10] The re-writing (and, inevitably, distortion) of history was extended to every major encounter in which Castilians participated. At the battle of Nördlingen in 1634 (see Chapter 9), where the Spanish troops constituted one fifth of the Imperial army, an account by a participating Castilian noble makes the German troops after the victory cry out 'Viva España!' and 'Long live the valour of the Spaniards!' in recognition of the outstanding role of the peninsular troops. The same author, with pride, could not avoid the conclusion that 'all-powerful is the Monarchy of Spain, vast its Empire, and its glorious arms pulsate in splendour from the rising of the sun to its setting'.[11] The Germans, who had done most of the fighting at Nördlingen, no doubt had a different viewpoint.

The continuing emphasis on the reality of 'Spain' certainly helped the peoples of the peninsula to become aware of their own role in the making of the empire. From the war of Granada onward, they usually participated together in military enterprises that had a common purpose. But though 'Spain' became a more palpable reality both to Spaniards and to outsiders, very little changed in the immediate perception of daily life in the peninsula, where the loyalties of hearth and home, of local culture and language, maintained their primacy until well into the nineteenth century. From at least the beginning of the sixteenth century there were writers who were using the term 'patria' when they referred to the community – usually the home town – for which people felt an instinctive loyalty.[12] 'Spain', by contrast, remained an abstract entity that seldom penetrated down to the most intimate local level. In the early eighteenth century the Asturian monk and scholar Feijoo affirmed roundly that 'Spain is the authentic object of a Spaniard's love'. But his definition of 'Spain' referred to little more than its existence as an administrative body, 'that body of state where, under a civil government, we are united by the bonds of the same laws'.[13]

A primary consequence of Spain's imperial identity was the diffusion of the Castilian language. Generations of scholars have learnt to accept that the age of empire was also that of the flowering of Castilian language and culture, a visible fulfilment of the intuitions of Talavera and Nebrija. The fact that Castilian is in the twenty-first century the principal language of up to a fifth of the human race, is a source of continuing pride

to Spaniards. At first sight, therefore, it seems evident that the successes of language would not have been possible without the existence of the empire.

Castilian speech was a crucial focus of identity because it became in some measure the language of empire. Spaniards used it everywhere in order to communicate with other Spaniards. It became the medium used by travel writers, clergy, diplomats, and officers in the international armies of the crown. Latin as an imperial language was never a competitor, for few understood it or read it. It was taught in church and village schools, but for most people and even for clergy it was a virtually dead tongue. As a consequence, a powerful tendency among the European élite opposed using it for purposes of communication.[14] The rise of Spanish power, by contrast, favoured the use of Spain's main language. A Navarrese professor at the Portuguese university of Coimbra published a book in 1544 in Castilian, with the comment that 'Castilian is understood now in most Christian nations, whereas few dedicate themselves to reading Latin since they have not studied it.'[15]

Moreover, thanks to the existence of the empire the Castilian tongue enjoyed advantages available to none other in Europe. Printing presses in the two most developed European nations, Italy and the Netherlands, made their resources available to Castilian authors.[16] Unlike the English, who could expect to publish a book in English only in their own country, Castilians had the choice of publishing in any of the realms of the peninsula, as well as in the other states of the monarchy and in France and Portugal. By the 1540s, more books by Spaniards were being published outside than inside the peninsula. They appeared mainly in Antwerp, Venice, Lyons, Toulouse, Paris, Louvain, Cologne, Lisbon and Coimbra.[17] When Philip II in the 1560s wished to print quality books, he published for preference in Antwerp and Venice. The standard of presses outside Spain was much better, and controls were less onerous.[18] The wide diffusion of printed Castilian literature resulted in the rapid transmission to the rest of Europe of the great Castilian writers and also of a genre that soon bred imitations, the *picaro* novel. Needless to say, Castilian literature also crossed the Atlantic, to a continent where the art of writing was unknown, and where it definitively shaped the early American mind.

The literary achievement, of which later generations were justifiably proud, was indubitable. But the success of printed literature obviously

had a very limited impact in a world where very few people read books, illiteracy was overwhelming, and all significant cultural contact was oral rather than written. The situation in the Iberian peninsula was typical. Spanish works might be the best sellers in Barcelona bookshops, but in the streets nearly everyone spoke Catalan. 'In Catalonia', claimed a priest from that principality in 1636, over one hundred years after the beginning of the Habsburg dynasty, 'the common people do not understand Castilian.'[19] The situation could be found elsewhere in the coastal provinces of Spain. As late as 1686 regulations for shipping in Guipúzcoa had to stipulate that vessels carry a Basque-speaking priest, since among the seamen 'the majority do not understand Spanish'.[20] The absence of a common national tongue was, of course, a fairly normal phenomenon in most European states at that time. In Spain it was particularly striking. Castilian was not understood at all by a good part of the natives of Andalusia, Valencia, Catalonia, the Basque country, Navarre, and Galicia.[21] The problem was brought home forcibly to missionaries who tried to communicate with congregations in these parts of the country. In the formerly Muslim areas where Arabic still survived as a spoken tongue, the missionaries tried in vain to learn Arabic and to bring their message home to the people. In Catalonia all the non-Catalan clergy made efforts to learn the local tongue, and the Jesuits, for example, took care to appoint only Catalans to work in the province. Throughout the Habsburg epoch, Castilian was most commonly used but the plurality of languages within the peninsula was necessarily recognized and accepted.

The problem existed throughout the length and breadth of the empire. It is doubtful whether Castilian was spoken as principal language by more than a tenth of the visible population in the colonial New World, where the vast majority of the people continued to maintain their own society, culture and language, and for the most part had no regular contact with Spaniards. Even the black slaves tended to conserve their own African languages rather than speak the alien tongue of the slave masters. The picture was the same in the lands where the Spaniards lived in Asia (Chapter 10).

Nebrija's prediction, therefore, never bore fruit. The Castilian language was spoken by Spaniards wherever they went, and was even used by Basques in northern Mexico as a common lingua franca, although many of course continued to use their own native tongue. On the New

Mexico frontier, pidgin Spanish was employed as a lingua franca among the indigenous peoples, and European words entered their daily vocabulary. But the language of the Spaniards never in colonial times attained universal status, except in administrative matters when it became the only practical one to use. In any other sense, within the empire during the period of Spanish rule more people in the Philippines spoke Chinese than Castilian, within South America more people spoke Quechua (and associated languages) than Castilian, and within Europe the dominant cultures in the Spanish monarchy were as much Italian and French as Castilian.

All civilized empires tend to achieve a universalization of horizons, and Spain's empire was no exception. Like other Western nations, the Spaniards had been in touch with the Renaissance, and some – like Nebrija – went to Italy to drink at the fount of knowledge. Foreign writers, artists and printers also came to seek their fortunes in the peninsula. The first and most famous of them was Peter Martyr d'Anghiera, who was appointed official chronicler of the Indies in 1510 and made Spain his home. The two-way contact promised to drag the peninsula out of its isolation. International expansion did not serve merely to extend peninsular culture. It also aided the entry into Spain of those aspects of culture it lacked. The advent of the cosmopolitan Charles V was followed by the support of many Spaniards for European humanism and the precepts of the Dutch scholar Erasmus.

In the event, two highly important but contradictory developments occurred.

On one hand, Spain firmly resisted much of what the outside world offered. A dynamic culture normally extends its interest to other available horizons. This did not happen in Spain. Throughout the Habsburg centuries the existence of Spanish power fascinated other Europeans, who extended their curiosity also to aspects of Spanish culture. Their attention was highest precisely during epochs of greatest tension, when the wish to learn from the enemy was most acute. By contrast, as the master power Spain showed scant interest in the culture of other peoples, and did not extend to the rest of Europe the profound interest that it had at least evinced for Italian culture and technology. Though there were prominent exceptions, as a class the Spanish elite, nobles and clergy, had little cultural sophistication. An Imperial ambassador to

Madrid in the 1570s commented that when the nobles spoke of certain subjects they did so in the way that a blind man speaks of colours. They travelled out of Spain very seldom, he said, and so had no perspective with which to make judgements.[22]

The question of vernacular literature was the most revealing. Few foreign authors were translated into Castilian. Europeans, however, knew Castilian works. The Germans were no exception. In 1520 they published the *Celestina*, in 1540 the *Amadis of Gaul*, and between 1600 and 1618 nineteen popular Castilian works were issued in German.[23] The Castilians translated nothing from German. The same happened with the English. The peak period for English interest was in the reign of Elizabeth I, when the two nations were in continuous covert or open conflict, and Richard Hakluyt published in 1589 his great compendium of Western (including Spanish) travel literature, *The Principall Navigations*. The interest continued to flourish. Until the mid-seventeenth century at least, Englishmen took an interest in Spain and its literature, translated it and imitated it.[24] The Spaniards translated nothing from English. The Dutch shared an interest in the same literature: exploration, navigation, histories of America and of the Orient, as well as occasional works of literature,[25] such as the famous *Celestina*. In the centuries covered by the present book, private and public libraries in the northern Netherlands stocked over 1,000 editions by Castilian authors, and 130 editions in translation from Castilian. In total, they stocked nearly six thousand editions of works in all languages dealing with Spain.[26] By contrast, in Castile interest was virtually non-existent and limited to the highly specialized theme of the works of Dutch religious mystics, who were very seldom translated. In Switzerland the printers of Basel published 114 editions of works by Spaniards between 1527 and 1564, and a further 70 between 1565 and 1610.[27]

Italy offers perhaps the most striking case of the hermetic element in Spain's intellectual evolution. Spaniards went to Italy in their tens of thousands, lived there and worked there, borrowing all the while from Italian art, music and science. But the movement of literature was overwhelmingly one-way, from Spain to Italy. The Italians translated the *Celestina* in 1506, and the *Amadis* in 1519; in the early sixteenth century 93 Castilian works were translated into Italian, in the later century 724.[28] One of the pioneers of this presentation of Iberian culture to an Italian public was the Italianized Castilian Alfonso

Ulloa, who served as secretary and chronicler to Ferrante Gonzaga, governor of Milan in the mid-sixteenth century. Another case was that of the great Italian collector of travel literature, Giovan Battista Ramusio, who died in 1557; the translations he published from Castilian became the model for the subsequent work of the Englishman Hakluyt. Among the works issued by Ramusio were the *Decades* written (in Spain) by Peter Martyr d'Anghiera, about the discovery of the New World.

The normal Castilian reaction to this outside interest in Spain's activity was to affirm with some reason that Spain had a great deal to offer other nations. The rest of the world could learn from Spain, whereas Spain did not need to learn from anybody else. 'All the world serves her', a proud chronicler of the town of Madrid proclaimed in 1658, 'and she serves nobody.'[29] A French traveller in Madrid in 1666 came to the conclusion that Spain's vision of the world was limited only to that part of it controlled by Spain, 'which in their view is a world apart, and all other nations exist only to serve them'.[30] Castile's own intellectual environment therefore remained (as very many Spaniards were aware) almost impervious to change, even though Spain's place in the world scheme had expanded to an unprecedented degree.

On the other hand, and in virtual contradiction to the tendency we have just noted, some sections of the élite welcomed the new windows into the outside world. Spain had every opportunity to become a centre of universal culture, for there was no closing of frontiers in the imperial age, only an opening. The foreign dynasties that ruled in Spain – the Habsburgs were German, the Bourbons French – stimulated tastes that in time became more widely accepted. In the transfer of specific aspects of culture, including music and in particular art, 'Spain was the recipient, accepting exterior models, making them her own, and adapting them to different circumstances of every type: religious, social, economic and intellectual.'[31] The age of empire was when some Spaniards took maximum advantage of the creative activity of other nations in their orbit. Philip II was perhaps the most outstanding example of this trend.[32] As a passionate collector of the arts he imported to Castile the best that Europe and the New World had to offer. The work of European artists piled up in the royal collections. A subsequent monarch who shared the same passion was Philip IV, friend and patron of Velázquez and Rubens, and zealous purchaser of foreign works of art.[33]

Since the peninsula depended on book imports for much of its litera-

ture in both Spanish and Latin, and many Spanish authors (as we have seen) preferred to publish abroad, there was a considerable and continuous flow of books into the peninsula. In Castile the trader Andrés Ruiz during the years 1557–64 brought in over nine hundred bales of books from Lyon and over one hundred from Paris. By the early seventeenth century there was a virtually free flow of books from French presses into Spain, most of it across the Pyrenees. The holdings in many Barcelona bookshops consisted almost exclusively of imported books, including Spanish authors who had been published abroad. Despite a great deal of bureaucratic interference, most of it on the part of the Inquisition, and a constant vigilance against heretical literature, no significant hindrance to imports took place. From 1559, when a shipment of three thousand books destined for Alcalá was seized on a French vessel in San Sebastián, booksellers in Spain had to put up with wholesale embargoes of their precious imports. However, the shipments were neither confiscated not censored. They were simply delayed until the bureaucracy had decided that no illegal imports were taking place. In 1564 the Inquisition ordered its officials in Bilbao and San Sebastián to send on to booksellers in Medina del Campo 245 bales of books imported from Lyon. Three years later the books were still in the ports. Embargoes apart, books continued to enter freely. 'Every day', the inquisitors of Catalonia reported in 1572, 'books enter both for Spain and for other parts.' The imports were substantial and in no way impeded by censorship.[34]

It would appear, then, that Spain's frontiers were open to the world's culture. In practice, this was not so. Imported books tended to be in Latin, the language of scholars, and dedicated to subjects – theology, medicine, classical history – that appealed to only a tiny élite, whose curiosity seldom extended to the culture of other European states. The few imported works in foreign languages tended to be in Italian during the sixteenth century and in French during the seventeenth and eighteenth; in all cases they were a minute proportion of the books entering Spain. A case in point is the store of the Barcelona bookseller Joan Guardiola, who in 1560 imported ninety per cent of his stock directly from publishers in the French city of Lyon, of which less than one per cent happened to be books in French; virtually all his imports were in Latin.[35] Spain therefore tended to remain open only to cultural contact diffused through the medium of Latin, and then only in a limited

way. A leading expert on literature has come to the conclusion that Spain 'withdrew behind her borders, clinging to the culture pattern that she held dear'.[36] This was strange conduct indeed for a power that controlled the most extensive monarchy on the face of the earth.

The best creativity produced by the imperial experience emanated, it may be argued, less from within Spain than from those writers who, like Miguel Cervantes, went beyond the peninsula and out into the limitless reaches of the monarchy in order to absorb influences and inspiration. The verse, memoirs, narratives, treatises and fiction created during the centuries of Spanish world power were proof that many Castilians, despite the restricted horizons in the peninsula, were capable of responding to the enriching contact with the world outside.

There was one important exception to this picture. While Castilians enjoyed almost unlimited political horizons, they contracted their cultural perspectives by defining in a wholly exclusive sense what it meant to be a 'Spaniard'. Unlike the Roman Empire before them and the British Empire after them, they attempted to exclude from their midst all alternative cultures, beginning with two of the great historic cultures of the peninsula. From the year 1492, which marked the capitulation of Granada and the expulsion of the Jews, both Islam and Judaism were effectively excluded from the Spanish concept of the universe. It was not a sudden move. Hostility to the two cultures was of long standing and the year 1492 was by no means a final date. The few Jews expelled at that moment were allowed back if they changed their religion, and Muslims did not suffer serious constraint until after 1500. The pattern, however, was set, and repression in the peninsula was extended to other parts of the empire. There were important negative consequences of anti-Semitism, not least in the linguistic sphere, where Hebrew and Arabic ceased to form part of the Hispanic heritage. The symbol of this repressive face of empire was the Inquisition, which from its bases in the Iberian peninsula extended its activities to America, Manila and Goa, identifying its enemies always with those who were Jews or Muslims.

As Américo Castro once observed, however, Spain is the only nation capable of verbally maintaining one idea while practising entirely the opposite. Even while the official policy was one of almost fanatical exclusivism directed against Semitic cultures and deviation of belief,

the Spanish empire proved completely incapable of imposing the rigid attitudes it maintained in theory. This arose out of the 'permanent characteristic of the Hispanic condition', as Castro saw it,[37] of creating many laws but observing none of them, a peculiarity still common in the Spain of today. Though Jews were forbidden to reside in Spain after 1492, for example, they lived freely in most territories of the empire long afterwards. The fort of Oran, governed directly by the Spanish crown, was a curious case of this ambivalence. One hundred years after the expulsion of Jews from Spain, there was a small Jewish community in Oran, numbering seventy persons. At the end of the reign of Philip II, his officials seem to have persuaded him to purify his territories of Jews and moves were made to expel them from Oran as well as from the duchy of Milan. In the event nothing happened, and Jews continued to be tolerated in Oran until the end of the seventeenth century. In the same way there were laws forbidding Muslims to be employed in the Spanish army, but it was evident that Oran could not survive without Muslim support, and they were recruited to join the defence force there.[38]

For years, decades and centuries after the so-called expulsion of Jews from the Iberian peninsula, they continued to play a significant role in the evolution of the Spanish empire. The peninsula – Sefarad – was, and would continue to be seen as, their home. The yearning for Sefarad brought a new generation back to the land of their fathers, and families of Jewish origin returned from Portugal and sometimes from France. As we have seen, they were active in business through the converso financiers who placed contacts for the crown and helped to back naval and military expeditions overseas. In 1628 Philip IV granted the Portuguese financiers freedom to trade and settle without restriction, hoping thereby to win back from foreigners a section of the Indies trade. Thanks to this, the New Christians extended their influence to the principal trading channels of Spain and America. They achieved particular success during the decades that the Dutch occupied a portion of Portuguese Brazil. In the Caribbean they managed to set up small communities, composed originally of poor migrants, in the areas taken over by the Dutch and English. In the late seventeenth century Sephardic Jews were resident in territories such as Curaçao, Surinam, Martinique and Jamaica. When they faced problems in Spain, mainly on account of persecution by the Inquisition, many conversos emigrated to one of

their best-known refuges, the city of Amsterdam. Of a sample of around one thousand Jews who married in the city during the seventeenth century, at least one fifth had been born in Spain and two-fifths in Portugal.[39] From their base at Amsterdam the Iberian Jews continued to invest, in a small but by no means insignificant way, in the fortunes of the empire.

The Jews had yet another role to play, one to which they were well accustomed. Ever since the anti-Semitic fervour that culminated in the expulsion of 1492, Spanish religious zealots contemplated with fear and suspicion the presence of Jews outside Spain. The whole imperial enterprise of Castile was considered by one or two imaginative spirits to be under threat of Jewish subversion. As a consequence there was periodic persecution of conversos in the New World and other parts of the empire. Above all, Jews were considered responsible for the fall of Brazil to the Dutch in the early seventeenth century. Both Portuguese and Spaniards were united in believing that Jews were stabbing the empire in the back. A Castilian grandee did not hesitate to claim that Pernambuco had been lost in 1630 'through the Jews'.[40] This was the decade when, partly in reaction against Olivares's patronage of Portuguese converso financiers, anti-Semitic sentiment was rampant in Madrid. Some clergy and intellectuals, notably the poet Francisco de Quevedo, actively propagated the stab-in-the-back theory. If the empire was crumbling, these people claimed, the Jews were to blame, above all the Jews who were backing their long-time enemy the Dutch. 'With the help of Jews', a priest informed the king in 1637, 'the Dutch rebels have prospered.'[41] In practice the anti-Semitic current of opinion, which has continued to be active down to our own day, was always treated with disdain by the politicians who held the reins of power.

The simple logic of numbers converted Spaniards into a minority in their empire. In small colonizing enterprises, settlers could use their numerical superiority to impose their way of life. In extensive empires, such as those of Rome and Great Britain, this was impossible. The limited population of Spain, which began to diminish by the end of the sixteenth century, affected the capacity to project its culture on to other peoples. In the New World, where the indigenous population continued (despite demographic disaster) to dominate the landscape, Spaniards were proportionately always very few, and were moreover soon joined by a

good number of other immigrants. A Portuguese New Christian who lived in Lima in the early seventeenth century reported that the wealthiest merchant in the city was Corsican (the family of the famous Gian Antonio Corso), and that resident foreigners included French, Italians, Germans, Flemings, Greeks, Genoese, English, Chinese and Indians from India.[42] The foreign community numbered around four hundred families, of whom fifty-seven were Corsicans. At the same period the viceroy of New Spain reported – with undoubted exaggeration – that he feared a threat to security from the numerous Flemish, Portuguese, Dutch, French and other non-Spanish Europeans resident in his jurisdiction.[43]

'What was the role of the non-Spaniards,' a leading historian of Latin America has asked, 'the Portuguese, Germans, Flemings, Italians, Greeks and English who went to Spanish America as adventurers, traders, miners or simply settlers?'[44] Though their numbers were limited, foreigners were valued for their expertise. The four Frenchmen licensed to travel from Seville to New Spain in 1538 were required for the quality of their cuisine.[45] Germans could be found everywhere in the mining industry. From the 1590s the authorities in New Spain tolerated the presence of foreigners by inventing a tax, a 'composición', that permitted them to reside there. A French merchant travelling to the Río de la Plata in the 1650s reported that in Buenos Aires there were 'a few Frenchmen, Hollanders and Genoese, but all of them pass for Spaniards'.[46] The contact with Asia also made a crucial contribution to the profile of the New World population. It has been suggested that some six thousand Orientals entered New Spain from Manila during each decade of the early seventeenth century.[47]

Because the Portuguese were in command of a colonial empire that functioned in parallel, it is often forgotten that they too contributed on a major scale to the existence and success of Spanish power. As the pioneers, they invited both imitation and competition. Portuguese experience in shipping, cartography and navigation, as well as in contact with the cultures of Africa and Asia, was exploited with profit by those who came after them. The colonization of the Canaries would have been unrealizable without Portuguese help, and the search for spices in Asia would have been impossible for Spaniards without the existing trade network created by the Portuguese. The Portuguese were also the main suppliers of African slaves, and continued to be so

throughout Spain's imperial history. Well into the eighteenth century, Spanish settlers in South America relied for slaves on suppliers from Brazil. Finally, as subjects of the Spanish crown between 1580 and 1640 the Portuguese were not excluded from participation in Spanish enterprises, though in practice their empire continued to be run as an autonomous entity. By the 1630s, they were, for example, well installed in the viceroyalty of Peru.[48] The consequence of all this was that they played a continuously significant role in the functioning of Spain's territories.

Over and beyond their physical presence the foreigners, like the Spaniards, brought their culture with them. It is a theme that has been little studied, though there can be no doubt of its relevance. Just as they had taken their culture to the Iberian peninsula, so the Netherlanders, for example, also brought it to the New World. The Antwerp artist Simon Pereyns, who arrived in Mexico in 1566, was held to be the best artist in the viceroyalty. In the same period the clergy and élite in New Spain imported tapestries and paintings from the Netherlands, and well into the seventeenth century dozens of Flemish landscapes found their way to Mexican churches and homes.[49] In Peru in the same period the Italian painters Bernardo Bitti and Angelino Medoro made a fundamental contribution to art, and the works of the Netherlander Rubens were as famous in Mexico and Cusco as they were in Madrid.

Spaniards were the people on top, but not always so. Those who emigrated to the colonies enjoyed new opportunities but they also faithfully reproduced their role in the peninsula. Many became rich and successful but others simply fell back into the poverty from which they came. Easy wealth certainly allowed more social mobility than in the home country, but at its core colonial society accepted status barriers and soon became rigidly aristocratic. The experience of being on top first occurred in the occupied kingdom of Granada, which became the testing ground for the attitudes and relationships that went with the exercise of power. Protests by Christian and Muslim members of the cultured élite who appreciated good relations between the races were overruled. After the rebellion of discontented Muslims in 1500, Cardinal Cisneros advised the government that they be enslaved. Many Spanish leaders were less harsh than this, but in general the peoples of Islamic origin within the peninsula continued for the next hundred years to be treated with rigour and

contempt. In their everyday contact with others there was periodic irritation and conflict over dress, speech, customs and above all food. Moriscos slaughtered their animal meat ritually, did not touch pork (the meat most commonly eaten in Spain) or wine, and cooked only with olive oil whereas Christians cooked with butter or lard. They tended also to live apart in separate communities, which could lead to antagonism. In 1567 one of their leaders in Granada protested that 'every day we are mistreated in every way, by both secular officials and clergy'. The conflicts led to rebellion, and then inexorably to the expulsion of the Moriscos in 1609. By then most Castilians had become convinced of their own dominant role.

From the early decades of the sixteenth century, Castilians identified themselves as the 'conquerors'. Many pursued their soldierly career throughout the known world. They passed from one area of war to another, from Granada to Italy, from Italy to Flanders. Veterans were among the Spaniards who looked down for the first time from the great temple at Tenochtitlan on the immense causeways over the lake and the thousands of people thronging the marketplace. 'There were among us', Bernal Díaz recalled, 'some who had been in many parts of the world, in Constantinople, in Rome and all over Italy', and who had never seen anything like that which now met their gaze. One Castilian noble who fought in the Araucanian wars, Alonso de Sotomayor, testified that he had gone to Chile 'with many other valiant soldiers from Flanders, to aid the king in this war'.[50] The memoirs of the heroes of the American frontier were genuine testimony to what Castilians achieved in the New World. But what they achieved was only one part of the military effort made on Spain's behalf by many nations.

Castilians tended not to bear this in mind, and consistently claimed all the credit. Their hubris became proverbial. Seeing it at work in the Netherlands, the humanist Arias Montano, who had been sent there by Philip II, was horrified. 'The arrogance of our Spanish nation here is insupportable', he wrote; many Spaniards 'have begun to call this sort of behaviour "reputation"'. It was an indictment by a Castilian of the developing insolence in Spain's imperial role. In Milan in 1570 an official asserted that 'these Italians, although they are not Indians, have to be treated as such', a curious attitude towards the princes, élites and soldiers who made Spanish power in Italy possible. No less memorable is the observation made by the governor of Milan, Requesens. 'We cannot',

he wrote, 'trust Italy to the Italians.'[51] We now know that this was a common phenomenon in all imperial nations. Initial humility, if and when it occurred, was soon followed by cultural arrogance.

Spaniards in the world empire were proud of and clung to their roots. Like all migrants, they had a basic loyalty to their place of origin. They displayed the debt openly in all the places of America to which they gave names of their home towns: Córdoba, Guadalajara, Laredo. Obeying a rule that has governed all emigration down to our own day, emigrants from the same place of origin tended to head for the same destination and recreate in a new environment the society from which they had come. A striking example is that of emigration from the Castilian town of Brihuega to Puebla, the second largest city of New Spain. During the period 1560–1620 over a thousand people from Brihuega emigrated to Puebla, taking with them much of Brihuega's expertise in textile manufacture. At the same time as they attempted to get on in their new home, they were intent on preserving their identity as natives of Brihuega.[52]

Like the rest of Europe, the Iberian peninsula was one of strong regional ties that extended through all aspects of daily life: family, politics, religion. Those who came from Spain were never simply 'Spaniards': they were primarily people of Jaén, of Cáceres, of Avilés, and tended to remain so. The 'tierra' of origin was the fundamental source of their identity. 'This territory', a settler in Mexico wrote to his wife in Madrid in 1706, 'is made up entirely of people from Spain, and those who are from the same tierra esteem each other even more than if they were relatives.'[53] Prominent among emigrants from the tierras of Spain were the Basques, who played an important role in the push towards northern New Spain, where a province was named New Biscay. Often distinguished from other Spaniards by their language, Basques continued for a long time to maintain a separate profile in their American communities. In the city of Puebla in 1612 a total of 113 Basque merchants and citizens made an independent offer of financial support to the administration.[54] The feeling of separateness might often, even in distant America, lead to conflict between Spaniards. There were cases of tension between Basques and other settlers, especially Andalusians, who were sometimes perceived by them as 'Moriscos'.[55]

Economic realities tended bit by bit to separate the emigrants from their homeland. Those who had now rebuilt their lives successfully could

not go back to the poverty of their origins. The correspondence that survives from early settlers is completely unequivocal about the issue, repeated insistently in letter after letter. America offered more options, more wealth, more mobility of status. Why return to an Old World that offered little? In Peru the rumour was that wars and high taxes were ruining those who lived back home in the peninsula. A settler of Potosí complained in 1577,

Here we get bad news that there in Seville they are seizing all the silver for the king. Many who were on their way to Spain have changed their mind for this reason. And they also relate so many misfortunes of wars and suchlike and many other things, that it clips the wings of those who think of going to Spain. Instead they are buying goods and estates and many are getting married with the idea of not returning to Spain. I don't know what to do. To tell the truth I have no wish to die in this country, but back where I was born.[56]

There in America, wrote a settler from Lima, 'they are interested more in whether you have something than how you got it, and if you have it they shut their mouths and don't ask'. In short, he stated, 'if people over there did as they do here, it would be enough to stay in Spain and not need America; there is work that even beggars would not do in Spain, but which here is highly esteemed'.[57] The New World offered, at least in the post-conquest period, a new ethic based on achievement rather than on inherited status, work rather than idleness. 'My aim has been', a settler wrote from Mexico in 1740 to his daughter in Spain, 'to acquire property by dint of very hard work, in order to keep you as you deserve', so she should come over to join him.[58] The Spanish concepts of honour had little relevance in America, a merchant from Lima wrote indignantly and ironically to a brother in Spain who had mentioned the possession of honour as his chief qualification for coming to America: 'I don't know why you want to come to America; for a man who has so much "honour", why look to gain more?'[59]

Bit by bit, the colonists began to identify themselves more with their new home than with the place where they had been born, the 'patria' of their hometown, their village, their kinfolk, their familiar countryside. When a citizen of Cartagena wrote in 1590 urging his wife to come over and join him, he told her to forget about the pain of leaving her homeland: 'don't keep thinking about your "patria", because the real "patria" is the country that looks after you'.[60] 'I always used to have the deep

349

wish to return to my "patria",' explained a merchant of Mexico City in 1592 to his parents in the Canary Islands, 'and if I had done so I would have been greatly mistaken.'[61] Instead, members of the family should come over to join him. Colonists observed the clear contrast between their life-style in the New World and what they had known in the Old. 'I am not saying to you that I don't wish to go to Spain', a husband wrote from Lima in 1704 to his wife in the peninsula, 'for I really do wish to go.' The problem was, he explained, 'the ruin that is Spain, with so many debts and dues and taxes, none of which we have over here'.[62]

The first generation of settlers in New Spain and Peru thought of themselves as the conquerors, with an inherent right to supremacy in the new lands; by extension, they rejected the pretensions of Spanish officials who continued to come over from Europe. A distinction grew up between those identified with America and who came to be called Creoles (criollos), and those who were from the peninsula, the gachupines. The Creoles felt that they, by their efforts, had created the new America, and that they had a unique right to hold office in their cities. The claim provoked constant tension between the colonial élite and the organs of peninsular control represented by the Audiencia and the viceroy. Already in the 1560s the settlers in southern Chile were resentful of the cost to them of the wars against the Araucanians. 'It was no small grievance to them', a witness reported, 'to see that after they had conquered the country they were still imposed upon, and every day their goods were appropriated in order to pay for the wars, while those who had just arrived from Europe, their hands unsoiled, were granted administrative posts.'[63] After the Pizarro period, however, no major disturbances occurred in America until the revolt of the Creole élite of Mexico in 1624.[64]

The urge to political autonomy was only one aspect of a broader attempt to define the position of the Creoles in the world. Though they continued to retain a pious memory of their roots, the colonizers in time merged into their new environment. The administration of the empire quickly fell into the hands of the colonial élite. From the 1560s, when cash problems became serious, Philip II resorted with frequency to selling offices to officials and their families. In the American colonies, this led to a situation where local élites rather than peninsular Spaniards came to control the administration.

As a consequence of taking control, they assumed a colonial identity

and distanced themselves from their origins. By around 1600, Basques in Mexico had largely ceased to speak Basque.[65] Earlier Creoles had little alternative to identifying themselves with the only historic past they had, that of the native civilizations of the New World. Conquerors frequently married into the Nahua and Inca nobility. They felt therefore that they were part of a new American nobility,[66] and strongly defended the Indian heritage. From the end of the sixteenth century they began to outline an argument based on a mythical vision of the American past, in which both conquerors and Indian peoples were seen to have participated. In Mexico men like Fernando Alva Ixtlilxochitl, descended through his mother from the rulers of Texcoco, and in Spain itself Garcilaso de la Vega 'the Inca', descended from a Spanish conquistador and an Inca princess, wrote histories that claimed for pre-conquest Indian civilization a rightful and even an illustrious part in the character of the evolving Spanish empire.[67] The first generation of settlers, living in lands they had worked and among a native population they appreciated, did not find it too difficult to identify with America, like the successful encomendero in Peru who expressed a paternalistic concern for his Indians:

I treat them as if they were my children, who have helped me to gain a living, and I relieve them of taxes and of anything else I can; they have served me for over thirty years and I owe them a lifetime's debt. I spend most of the year here, it's a habit I cannot shake off, and I have herds of sheep, goats, pigs and I used to have cattle but now I have sold them because they did harm to the Indians.[68]

In the century after the conquest, however, this vision was complicated by the rapid racial changes in the American population. The Indians and their leaders, the curacas and caciques, were now increasingly despised and relegated to a subordinate position in society. Racial mixture, the appearance of a poor mestizo population and even more of those descended from blacks, caused the native peoples to be marginalized in colonial society. Creole theorists could no longer appeal simply to the theme of noble origins.

The need for a new approach was met by the writings of the seventeenth century Mexican scholar Carlos de Sigüenza y Góngora (d. 1700), who defended the nature of what he called in 1681 'our Creole nation'. Because the settlers did not wish to appeal to European antecedents, he elaborated an argument based on the ancient civilizations of the

Americas, whose origins he traced back to the Egyptians and Greeks. Even this elaboration of an historic identity, however, did not prevail, and other writers took up the task again in the later eighteenth century. In the confusion of racial terms that existed in colonial times, labels were not always clear descriptions of identity. All colonial whites were considered 'españoles', and the term 'American' was most commonly used simply as a distinction from European. The words 'mexicano' and 'perulero' tended to be used of both the native and the white population. Words were powerfully emotive, but symbols even more so, as the evolution of the symbol of Guadalupe in New Spain was to demonstrate. In the middle of the sixteenth century in Mexico the Virgin Mary was said to have appeared to an Indian on Mount Tepeyac (site of a previous native devotion to the goddess Tonantzin) and identified herself as the Virgin of Guadalupe (the name of an important shrine in Spain).[69] By the seventeenth century devotion to the Tepeyac Virgin was fully developed, and had become a powerful expression of the autonomous Christianity of Mexico. A great basilica was erected on the site, and in 1648 a Creole priest, Miguel Sánchez, wrote the definitive work proclaiming the glories of the first Virgin of the Creoles, the first Virgin indeed of colonial America.

Once they had crossed the Atlantic and the Pacific, or passed to other lands in Europe, emigrants from the peninsula were able to overcome some of their regional differences and recognize that they came from a common home, for which they still yearned. The Valladolid writer Cristóbal Suárez de Figueroa (d. 1644), who spent half his life in Italy, recognized that 'even spirits that are most opposed in the patria, become reconciled when they are outside it, and learn to appreciate each other'. He expressed forcefully the yearning of those who had left Spain, and with it the 'skies, rivers, fields, friends, family and other pleasures that we look for in vain when we are away'.[70] Thousands, no doubt, found themselves in the position of the settler in Cajamarca who wrote in 1698 that 'though my body is in America, my soul is in Navarre'.[71] For generations of Spaniards, there was a perennial pull between their adopted homeland and the one they had left behind. The persistent longing for home, however, had to compete with and seldom overcame the practical satisfaction that emigrants found in their corner of the worldwide empire.

A settler who passed through alternate phases of enchantment and

disenchantment with America was Diego de Vargas, governor of New Mexico from 1688. Born in 1643 of a noble family of Madrid, he first went to New Spain in 1673. After holding various minor posts, he succeeded in obtaining that of governor, during the period when the count of Galve was viceroy. Sent in 1692 to the Rio Grande on the comfortless assignment of recovering authority over the Pueblo Indians, he lost a large sum of money as well as his health in the task, and eventually died of dysentery in 1704 in a lonely outpost of New Mexico. One of his personal letters home in 1686 has the passage: 'Spain was but a stepmother to me, for she banished me to seek my fortune in strange lands. Here, I do what I could not do there. I have asked for nothing more since I left my homeland.'[72] He was proud of being essentially a self-made man, advancing not because of his merits but because of pushing and striving. Wealth in America, he wrote, 'does not come because silver is plucked from trees or rivers, but because he who does not work ends up without it and without position, as in Spain'. 'The Indies', he wrote in the fall of 1690, 'are good for shopkeepers but not for men of honour who flee the trades; this is a dangerous land.'[73] The reverses in fortune he suffered during his years in the Rio Grande, however, rudely shook his confidence in America. In April 1703, the year before his death, he lamented the 'thirty years that I have lost since I left Spain and my beloved patria, that lovely town of Madrid, the crown of the earth'. Had he remained in Spain, he assured his family, he would have been able to enjoy their company without suffering the 'bottomless pit' of miseries where he was at that moment.[74]

Ironically, the biggest racial category created by the Spanish imperial presence had no wish to claim an identity of its own. The mestizos were a consequence of the inevitable union between Spaniards, who seldom brought their own women with them, and the native women of the empire (see Chapter 6). In the Philippines the shortage of European women contributed to a high degree of race mixture. The same situation prevailed in New Mexico, where the Spaniards who did not bring families over were obliged to marry women of non-Spanish origin. The result was that mestizos played a role that was far more positive than the pure Spaniards would have wished, and facilitated contact between Spanish and indigenous cultures. As we know from the experience of colonial societies in the twentieth century, persons of mixed race are always in an uncomfortable position because they fall between two

worlds. In sixteenth-century America, mestizos were normally classified as belonging to the republic of Spaniards,[75] even though they were gradually excluded from most positions of status in colonial society. In the mid-sixteenth century they took part in all the important Spanish-led expeditions, and played a distinctive role in the foundation of the towns of the New World. The leading authority on the subject has no doubt in affirming that 'the colonization work done by Spain would not have been possible without the mestizos'.[76]

In a law of 1514 King Ferdinand had given his full approval to the intermarriage of Indians and Spaniards: nothing, he insisted, 'should impede marriage between Indians and Spaniards, and all should have complete liberty to marry whomever they please'.[77] From the time of Hernando Cortés, whose children by the Indian Doña Marina were accepted into the colonial nobility, there was no dishonour in inter-marriage between racial élites. 'Though over there you may think it shameful that I have married an Indian woman,' a merchant of Mexico wrote to his family in 1571, 'here it is by no means despised because the Indians are a highly respected people.'[78] Those of élite origin might certainly have been as fortunate as the merchant claimed, but in general the rapid growth of the mestizo sector created problems and provoked active discrimination. People of mixed race in Mexico could not after 1549 inherit encomiendas, nor could they enter the priesthood, and from 1576 they were barred from public office.[79] In 1588 Philip II, possibly under pressure from José de Acosta, decreed that mestizos could become priests, but little progress was made in implementing the decree. Despite the barriers put in their way, however, mestizos came to play a profoundly important role in colonial society.

After Spaniards, the most notable immigrant presence was that of Afri-cans. By 1650, as we have seen, there were more Africans than Spaniards in the New World. At the end of the colonial period, they still had an enormous role to play though there is no reliable information about their numbers. In Lima in 1795, free blacks with slaves made up forty-five per cent of the city's total population. Though they had been brought in simply to work and serve, Africans transformed the society and economy of vast tracts of America, and firmly implanted their race and culture wherever they went.[80] Parallel to the minority identity being created by the élites, therefore, there began to grow up another minority identity

that never became fully Hispanized and that profoundly transformed the culture of the continent. Through their fundamental contribution to virtually every aspect of activity and production, the Africans helped to guarantee the survival of Spanish colonialism.[81] At the same time they not only managed to preserve elements of their culture, but began to evolve a distinctive identity based on their circumstances in the New World.

Africans came from different areas of their own continent, and were bundled together indiscriminately in the distribution of slaves through the New World. They often lost contact with their origins, and had to find new bearings for themselves. The seventeenth-century Jesuit missionary Alonso de Sandoval, one of the few Spaniards to be seriously concerned with the culture of Africans, managed to identify over thirty nations of Africa from which the slaves in Cartagena came. This complexity was clearly a challenge to clergy who wished to understand the languages and concepts of neophytes. Depending on their work situation, Africans frequently managed to overcome the formidable cultural difficulties. An Italian visitor to Hispaniola reported in 1540 that they were divided into national groups, each with an appointed leader.[82] Evidence from later decades, all over Spanish America, indicates that Africans succeeded to some degree in preserving their national grouping, and with it their languages. Where there was no possibility of a common speech, they evolved a lingua franca or pidgin that bore a resemblance to the principal languages among them, and that clergy like Sandoval tried to learn.[83] Sometimes the national grouping would operate under cover of the religious confraternities to which blacks frequently belonged, and to which they contributed distinctively with their music and dances. Seventeenth-century visitors to Caribbean estates testified that they heard slaves singing, in their own language, songs of the West African coast.

Inevitably, however, Africans had to adapt what they preserved and mould it to the necessities of the New World. Many of them, if we go by the evidence of those who took part in rebellions and fled to the mountains, wholly rejected the repressive civilization of the Spaniards. Settled communities of runaway Africans (cimarrones) could be found all over the Caribbean, and from as early as 1513 in the Panama area, where survivors from the wreck of a slave-ship made it ashore.[84] In a continent as vast as America, it was easy to hide in the mountains and

build up an autonomous community. Even in Hispaniola in the 1520s, the mountains were host to groups of escaped slaves. It was estimated in 1545 that the island had over seven thousand cimarrons. Wherever possible, the runaways collaborated with foreigners who penetrated Spanish territory. On the other hand, from an early period the runaway blacks in the Caribbean were often captured and enslaved by the warlike island tribes, the Caribs.[85] Africans therefore had good reason to distance themselves both from Spaniards and from the native Americans.

Spaniards of course feared the possibility of rebellions by the very numerous black community. In 1537 in Mexico the viceroy reported the preparation of a rebellion by the blacks (at that date around twenty thousand in number) in league with the Indians of Mexico and Tlatelolco.[86] Black risings can be identified for instance in 1538 in Cuba, in 1546 in Hispaniola, in 1552 in Venezuela, in 1555 near Panama. Judging by the accounts, it appears that blacks of differing ethnic origin joined together to pursue common aims and live together in a new environment. Their varying roots consequently merged into a shared background inspiration, an 'Africa' to which they would never return but which took on the lineaments of a home. Perhaps the most remarkable of the black cimarron movements was the one active in the mountains near Veracruz in 1609, led by a first-generation Congolese called Yanga, who appears to have been of royal origin and in fact proclaimed his settlement of over five hundred Africans to be a free territory and demanded official recognition from the viceroy. 'They had withdrawn to that place', they announced, 'to free themselves from the cruelty of the Spaniards, who unjustly wished to deprive them of their liberty.'[87] The Spaniards were unable to destroy the settlement and eventually in 1618 recognized the autonomy of the black village of 'San Lorenzo of the Blacks'.[88] Similar settlements of cimarrons came into existence in various parts of America, notably in Venezuela during the seventeenth century.[89]

Other blacks, by contrast, who lived within a more congenial environment, became more Hispanized and merged themselves into the Hispanic world. Their religious roots in Africa had accepted the duality of the universe and the existence of an after-life, so they accepted the forms of Christianity without problems.[90] Many, we should also remember, had been Christians in Africa or in Spanish territory even before arriving in the Americas. Black Christianity as it evolved in the New World became a vital feature of the black identity, because it combined the culture,

beliefs and languages of the places of origin with the context and aspirations of the places of domicile. The nature of some of the practices inevitably led to conflict with the religious authorities, as we can see through the cases prosecuted by the Inquisition in America, which help us to obtain a remarkable picture of Afro-American beliefs and practices. The inquisitors in America interpreted the chants, spells, rites and dances of the Afro-Americans as crafts of the devil, but the black witnesses who gave testimony reveal clearly that woven into the neo-Christian practices of the New World were strong echoes of the religion of Africa. In seventeenth-century Mexico a slave described how a diviner spoke 'through the chest':

Many times this black, Domingo, spoke with some objects and dolls, one dressed as a man, the other as a woman, and the objects spoke with him in everybody's hearing; and we heard them speak in Spanish and in a Congolese language, and they danced the dances of the two nations and sang in the two languages clearly and distinctly, and everyone heard and understood, and later they both asked for food.[91]

Frequently deprived by their masters of any real contact with the official Church and its clergy, scattered in small mixed communities of diverse origin across the entire expanse of the New World, blacks both slave and free conserved what they could of their culture and by this means attempted to give themselves protection against their savage new environment. Millions of black subjects under Spanish rule shared this culture, during the entire period of duration of the empire. It is therefore timely to emphasize the reality of the black identity, as well as its crucial contribution to the culture and society of the colonies. The contribution may appear small, simply because it suffered active persecution and discrimination. Blacks were marginalized and excluded; they were welcomed as Christians but forbidden to take holy orders. Yet with the passage of time their role was slowly recognized. In Costa Rica in 1635, a black woman (mulata) initiated the devotion to the black image of the Virgin Mary that was later adopted as the patroness of the country.[92] Not until 1962, however, with the canonization of the eighteenth-century Peruvian mulatto Martín de Porres, did the official Church attempt to make amends for its indifference to the black race in Latin America.

Despite the extensive sufferings of the blacks, as in Europe they could attain some measure of freedom and enjoy its benefits. There were three

official methods of being legally liberated: a slave could be given a letter of 'manumission', a formal document granted by his master; he could purchase his own freedom; or a third party could buy his freedom.[93] In practice, an almost insignificant proportion of blacks managed to free themselves through these formal processes. Blacks might win the aid of the clergy, as in the well-documented case of the Catalan Jesuit Peter Claver, who spent his active life helping black slaves in Cartagena; but the aid was not designed to free them. The occasional protests of clergy against the practice of slavery, such as that in 1560 by the archbishop of Mexico, Alonso de Montúfar, were never pressed seriously and can be written off as unimportant.

In the long run, blacks had to make their own protracted and agonizing route towards liberty. They worked hard and became rich, like the black farmer whom Thomas Gage met in Guatemala in the 1630s, 'who is held to be very rich, and gives good entertainment to travellers who pass that way. He is rich in cattle, sheep and goats, and from his farm stores [supplies] Guatemala and the people thereabout with the best cheese of all that country.'[94] By the seventeenth century the blacks in New Spain who were for all practical purposes free (though not necessarily so in strictly legal terms) may have represented as much as one third of the entire black population.[95] They worked in the cities as domestic servants and in the minor professions, but also as independent tradesmen. In the countryside they formed essential labour on the great ranches, where they were pioneer 'cowboys' (vaqueros) in charge of the herds of cattle. Organized in gangs, they were regarded with fear by the local population. The inhabitants of Zacatecas said of them, 'their presence is an evil, but their absence is a much greater one'.[96]

The defence of Spanish America outside the major cities was normally in the hands of its non-white citizens. Chagres, the principal barrier to any attack directed against Panama from the Caribbean, was in the 1740s defended by around a hundred men, 'mostly blacks, mulattos and other coloured'. In Panama, 'the militia in the town is made up mostly of mulattos and coloureds'. Even the two or three ships that constituted the Pacific defence squadron, based in Callao, were heavily black in composition. 'It is normal to see on board a ship', reported the officials Juan and Ulloa early in the eighteenth century, 'a Creole sergeant, an Indian quartermaster, a mestizo guard, and a mulatto carpenter or a black shipwright.'[97]

The Spaniards of Spain had long since ceased to have a serious military role in a continent run by its Creole white élite and the immense coloured and mixed population. There was no point in sending out Spanish soldiers, for they deserted as soon as they arrived[98] and vanished into the vastness of America. The only defence solution suggested by Juan and Ulloa was that the government round up every year several hundreds of workless mestizos, transport them to Spain, train them there as soldiers and then send them back to defend America. It was not an unreasonable idea, which would have tackled the permanent problem of a tiny country like Spain trying to run an empire when it had no available military forces. Slowly, and despite the great civil disadvantages they had to endure, the blacks who helped to build and defend America worked their way towards establishing their place in the colonial world.

The indigenous population of America occupied a peculiarly ambiguous place in the Spanish scheme of things. Even while the colonial regime destroyed their villages and culture, the government made efforts to protect them. They were deemed, as we have seen, to be part of a separate Indian society, yet they were also meant to be Hispanized, according to the 1573 Ordinance. While the ruling élite in Spanish America continued to debate about where its loyalties lay, the vast mass of the native population, confused by the disappearance of its previous environment and economy, managed to cling on to vestiges of traditional culture.

A high proportion of natives in America and the Philippines lived outside the confines of the empire, in areas that the Spaniards never penetrated or were unable to settle. They were not directly affected by colonial administration, though they obviously suffered the impact of epidemics and other changes. All other natives, both those on the frontier and those within the range of the empire, were irrevocably affected by the Spanish presence, directly or indirectly. Trade was a fundamental influence. Indians picked up trinkets, tools, foods, and animals that had an impact on their daily lives. Less significantly, they borrowed items of clothing (such as hats) and of language. These changes did not necessarily undermine their culture, and in some measure helped them to survive in a world where the Spanish presence could not be ignored. Even while the Indians rejected the society of the Spaniards,

they both accepted it as a reference point and imitated it. In parts of northern Peru the curacas, in order to emphasize their superiority over their fellow Indians, dressed entirely in the Spanish style, in Spanish hats, stockings, shoes.[99] Though historians have with good reason devoted great attention to the themes of depopulation and the destruction of indigenous culture, only more recently have they emphasized that adaptation and survival were also a fundamental aspect of life in post-conquest territories.

Epidemics, for example, did not always destroy. Natives of inland regions seem to have been less affected by the disastrous fall in population brought about by contact with the outsider. In Peru in 1620, the coastal areas that were the worst affected had only twelve per cent of the Indian population; the substantial remainder that lived inland was more likely to have survived. As the demographic situation stabilized towards the eighteenth century, native culture began to regain confidence and to claim its own identity outside the structure of colonial society. It was, in some areas, a favourable situation. In central Mexico (Oaxaca and Meztitlan) Indians still retained a good proportion of the land; by the end of the eighteenth century communal Indians (de pueblo) far outnumbered Indians who depended on the Spanish hacienda system.[100]

In the process of surviving, the natives retained essential aspects of their identity. Away from the Spanish-dominated cities they were able to develop a parallel society without overt conflict. It was not necessary to reject or rebel against Spanish society; indeed very many natives absorbed Spanish religion and customs without problems. The Nahuas, for example, had never used a clear naming system. In referring to themselves in the early sixteenth century they – or at least those of central Mexico – normally used the phrase 'nican titlaca', 'we people here'.[101] They very quickly took to the Spanish naming system, and by mid-century had adopted it completely. Living at the very heart of the Spanish system, the Nahuas adopted aspects of Spanish culture that could be reconciled with their own, but at the same time preserved their parallel existence and ignored colonial society.[102] At one and the same time, therefore, the post-colonial Nahua people functioned within the imperial system but continued to preserve the framework of their own identity.

Throughout the New World there were others who maintained their identity on the fringes of the system. Very many surviving native popu-

lations were not integrated into the empire, did not speak its language and did not accept its culture. This was almost normal in frontier areas. Among the western Pueblo people on the New Spain frontier, the Hopi tribes were an outstanding example.[103] The missionary programme in their towns began in 1629, and like their neighbours they accepted the Spaniards passively for decades. They gave their support to the Pueblo revolt in 1680 but in like manner accepted the reimposition of Spanish control. From about 1700, finally, the majority of the Hopis refused to accept the missions and reverted exclusively to their own cultural ways, continuing in this manner until the end of Spanish rule.

Another example of cultural independence comes from the Guajiro people of the province of Riohacha in New Granada.[104] Two hundred years after the conquest, they were unconquered. They never accepted the new religion: 'among all the barbarous nations of America', a Jesuit reported in 1750, 'none is more needful of reduction than the Guajiro Indians'. While maintaining their independence, they made free use of the settler population as well as of foreign smugglers in order to ensure their own survival. They sold livestock, hides and tallow to outside buyers, and in return received weapons, manufactures and liquor; in this way they sustained the settler economy without being formally part of it. Their relationship with the empire duplicated that of an untold number of other native peoples. 'What would the whites do without the Indians?', the Guajiros are said to have asked local Spaniards repeatedly and with deliberate irony. There was the same persistent autonomy among the peoples of northern Luzon in the Philippines. They were a variety of different ethnic formations but for simplicity the Spaniards called them all 'Igorots'. For three centuries they successfully resisted assimilation into the Spanish empire. The first missionaries ventured to enter the territory in 1601 but were killed; after the 1630s no further efforts at penetration or evangelization were made.[105]

In addition to natives who maintained their autonomy from colonial culture, there were others who were forced to modify their structures and outlook under the pressure of the advancing Spanish frontier. To a substantial degree, of course, all non-Spaniards had to take stock of their role within the empire. For some, however, there were radical consequences, which recent scholars have categorized under the term of 'ethnogenesis'. The term can be understood as referring to the creative adaptation of certain peoples to the violent changes they suffered in the

period of empire, and the consequent emergence of new identities.[106] The adaptation involved a substantially new definition of every aspect of culture. A remarkable example is that of the Jumano people of the southern plains of Texas. 'Jumano', like 'Pueblo', was a Spanish word used to identify the Plains Indians, who from 1670 were drawn into the Spanish frontier by the founding of missions.[107] As collaborators of the Spaniards, the Jumanos became the target of repeated attacks by the Apaches. The colonial presence, war, drought, all helped to undermine them; by the early eighteenth century they were extinct and the Apaches dominated the plains. That, at any rate, is what appearances suggested. The likelihood, however, is that under pressure the Jumanos simply displaced themselves, moved on and changed their profile, emerging in time as the beginnings of the Kiowa nation.[108]

The rich and complex experience of the peoples under Spanish rule makes it clear that the familiar picture of a powerful colonial regime controlling and dominating a subjected population is no longer convincing and was never in any case plausible. A recent historian has affirmed with justice that 'gone are the images of the colonial state as an iron arm of conquest, erecting caste barriers to create stable, nucleated villages of impoverished Indians'.[109] Nor does it any longer seem credible to present a picture of cultures that collapsed instantly under the shock of confrontation with the superior Spanish world. The demographic catastrophe that afflicted the central regions of the empire in the New World and the Pacific, was by no means the counterpart of a generalized suicide wish. Over large extents of the New World landscape, the Indians survived and maintained their organization, even while accepting the pressures of the Spanish regime.

The contrast of parallel societies is perhaps clearest in the Andean region. Here the big reality in the middle of the sixteenth century was the existence of the inferno of Potosí, where thousands of Indians laboured and died for decades in order to produce silver for the empire. But beyond Potosí, Andean communities built up their own economy and market structure: they worked as artisans, in local trades; they developed lands, in order to promote cash-crop agriculture; they controlled much of the overland transport industry.[110] Both as individuals and as families, and working sometimes independently of the traditional ethnic groupings such as the ayllus, Andeans played an important part in the markets, to which they contributed through their labour and their

landed produce.[111] They maintained, in short, an essential sector of the economy of the New World, and without them Spain's empire would have ground to a halt. The classical image of the Indian as victim continues to be true in many respects, but it was only a section of the role played by the indigenous civilizations of America, where the Indian was no less a creator than a victim. The empire that the Spaniards directed was also influenced and underpinned by the native populations.

There were, inevitably, very many movements of protest and revolt, not only in the Andes or the New Mexico plains but throughout the empire. This is not the place to tell their story. It is common to think of them as uprisings against a firm and dominant imperial structure, whereas the reality was (as in the case of the Araucanians or the Pueblos) that conflict was a permanent aspect of the flabby frontier of the empire. Attacks by Indians against the invader occurred regularly in Apalachee, in New Mexico, in Chile, and everywhere that the white man showed his face. It was a way of expressing a divergent identity, just as silent survival was. In the long run the Indian consciousness of not belonging to the empire was expressed most forcibly through the conviction that though they and the Spaniards were now on parallel paths, in the future those paths would diverge. They might now be sharing the same society and the same religion, but each side had profoundly different perspectives.

Among the earliest high Indian cultures to suffer from religious repression was the Maya. After the ferocious campaign against 'idolatry' carried out by Fray Diego de Landa in 1562, the Mayas consented to the implantation of Christianity, but their leaders conserved details of their history and customs in the compilations known as *The Books of Chilam Balam*. In these writings there is no explicit rejection of the new religion of the Spaniards, but the Christian 'gods' are inserted into the Maya scheme of things.[112] When Christ comes again to rule, say the *Books*, the Maya lords will rule under him. These beliefs suggest that Indian leaders did not accept a syncretic form of belief, in which elements of Maya and Spanish religion were merged together; rather, the two paths remained autonomous, and coincided only for the moment.

When, however, would the paths diverge? Though native beliefs and culture survived, few such beliefs managed to take on the characteristics of a millenarian substitute, in the way that Taki Onqoy did in late sixteenth-century Peru. 'Our Lord "Dios" created the Spaniards and

Castile', claimed the preachers of that movement, 'but the huacas created the Indians and this land, and so they have deprived Our Lord of his omnipotence.' Pizarro had triumphed temporarily over the huacas in Cajamarca, but now the huacas had returned to claim their own land and people, and 'would battle against' the Christian god.[113] The impatient waiting for a future divergence helped to keep alive the sense of a differing identity.

Taki Onqoy was a movement of rejection, an attempt to assert the original identity of the people of the Andes. However, it transformed that identity to a higher plane. 'The said huacas', the preachers claimed, 'no longer enter into stones and trees and streams, as in the time of the Inca; now they enter into the bodies of the Indians and speak through them and that is why they shake, because they have the huacas in their bodies.'[114] It flourished only in the inland regions of Peru, and within about ten years had been largely extirpated. There were other assertions of identity in Peru, of which the best known is the resistance at Vilcabamba, but perhaps the most penetrating comment on the issue was that expressed in the famous *Chronicle* of Guaman Poma.

Guaman Poma was completely unknown to scholars until the manuscript of his *New Chronicle* was discovered in a library in Copenhagen in 1908. It was another three-quarters of a century before his thousand-page text, replete with ingenious line illustrations and long passages in Quechua, was adequately presented to the public. Descended from a line of the Incas, Guaman was a pure Indian whose mind encompassed two worlds. He was proud of his Christian faith and by no means hostile to the rule of the king of Spain, but at the same time he bitterly criticized the injustices of the Spanish conquest, and vindicated absolutely the culture of the Andeans. As the supporters of Taki Onqoy did, Poma viewed the Spanish conquest as a cosmic earthquake, a pachakuti, which had upset the natural order of things. 'After the conquest and the destruction', wrote Poma, 'the world was turned upside down', and all things impossible had come to pass.[115] In the present age of the world, all the vices were triumphant, but the nature of a pachakuti was that it presaged a cyclic change to another epoch, and held out the hope of better times. With this in mind, he was writing his *Chronicle*, which was addressed to Philip III of Spain, who would help to bring about the 'good government' that Peru wanted.

*

A major consequence of the impact of Spanish power in Europe was the creation of regional identities based on opposition to Spain. Peoples who shared little else in common, came together in their common dislike of Spaniards. The empire helped to create nations, in this case nations that were bound together by their resistance to imperialism. In Italy, in England, in the Netherlands, in France, in Germany, writers and statesmen called for a common front against the threat from the enemy, and appealed for a solidarity that transcended internal differences.[116] The Netherlands revolt, the French wars against Spain, the Armada threat to England, the Thirty Years' War in Germany, in each case served to rally sentiment against foreign intervention and create consciousness of a 'national' character. The Spaniards wished, according to a Dutch pamphlet, 'to treat our patria as they have treated the Indies; but they will not find it so easy here'. In Germany one of the first vociferous anti-Spanish writers was Johann Fischart, author of the *Antihispanus* (1590). Legend and propaganda served to promote anti-Spanish hatred, which became a fundamental element of the national myth as it evolved in succeeding generations. Very soon, of course, issues of religion complicated the issue, and fragmented the opposition to Spain. In the Netherlands, in particular, a united front against imperial power was split by sharp religious differences, leading in the end to the creation of two separate states instead of one national state.

Because of its long and intimate relationship with the empire, the case of the Netherlands is particularly interesting. From the beginning of the conflict there, many Spaniards had sympathized with the 'rebels' and were ready to see their point of view. Prominent advisers of Philip II, such as the humanist Benito Arias Montano, were criticized by the king for their inclination towards the side of the Netherlanders. Throughout the years of war, the people in the Netherlands, both north and south, continued to feel that they had more in common with each other than they had with Spain. In any case, the line dividing them was always artificial and always on the move, dependent on military successes. Only the victories of Farnese and the recovery of Antwerp in 1585 imbued the line with a solidity that would turn out to be final.[117] But the finality was not apparent at the time. A Brabant noble writing in 1589 (in Dutch) to the geographer Abraham Ortelius could still refer to his homeland as 'Netherland',[118] a word which when used in the singular applied to the totality of the provinces that outsiders always

preferred to describe as a plurality. As late as 1621 when the famous intellectual Hugo Grotius escaped from his confinement in Amsterdam he was invited to the university of Louvain by a colleague who wrote: 'Come here, this is your fatherland, we also are Netherlanders.'[119] The feeling of a common heritage lingered on, and facilitated – as we shall see – subsequent moves to a *rapprochement* between the Dutch and the Spanish.

It would be superfluous to observe that Spanish power provoked hostility and hatred in every corner of the globe. Spaniards were, in the early days of empire, puzzled and not a little hurt by this reaction. Why, they asked, should there be animosity if they were not posing any threat? By the 1590s they had come to accept the situation. 'There is a general desire in Italy to expel the Spaniards', recognized the Spanish governor of Milan in 1597. In the Southern Netherlands in 1629, at Arras, a parish priest from his pulpit denounced the Spaniards as traitors to the country.[120] Painfully aware of the animosity towards Spain as an imperial power, Spaniards tried to understand why they were hated. 'The name Spaniard', the writer Mateo Alemán admitted in his 1599 work *Guzmán de Alfarache*, 'is now of almost no consequence.'

Alien domination is always detested, and the domination of Castilians was bitterly resented in every corner of the European territories associated with Castile. It is unnecessary to cite the causes of the resentment, for they were many and only too apparent. In the Mediterranean, where the religious issue did not arise, opposition to Castile was no less profound than in northern Europe. Castilian officials were saddened by the hostility. 'I don't know what there is in the nation and empire of Spain', an official in Milan lamented in 1570, 'that none of the peoples in the world subject to it bears it any affection. And this is much more so in Italy than any other part of the world.'[121] Throughout the imperial centuries, Italians did not cease to find fault with Spaniards, their character, their culture, and above all their military presence.[122] Though Italians and Castilians served together in military campaigns in the Italian peninsula from the time of Ferdinand the Catholic, they never got on well, and continuously ended up fighting each other, with considerable loss of life.[123] The humanist Sepúlveda, who lived in Italy during the years about which he wrote, commented that the Spaniards 'during the Italian campaigns tended to despise the Italians, both friends and enemies, as conquerors despise the conquered. The Italians are hostile to the Spani-

ards because of this, and because of the many ills they have suffered at their hands. It is for this reason that Italians always want to attack the Spanish soldiers in Italy.'[124] Rubens saw from his personal experience that in the seventeenth century 'the Italians have little affection for Spain'.[125]

The papacy, essentially an Italian institution, took part in the denigration. It was in some measure a love–hate relationship, for Italians participated wholly in the empire and benefited substantially from it, but when they committed their feelings to paper they conveniently forgot the benefits and saw only the disadvantages. The diplomats of Venice, Rome and other independent Italian states sometimes gave a balanced perspective of what they saw, but just as frequently were capable of gross distortions that have misled many modern historians. Much of the wholly unfavourable image of Spanish rule in Italy rests on uncritical acceptance of the savage portrait painted by anti-Spanish diplomats from other Italian states. The Venetian envoys of the late sixteenth century were notable in this respect. Ambassador Donati called Naples 'the kingdom of the damned', Paolo Tiepolo claimed Milan was suffering 'crimes, oppression and robbery' at the hands of the Spaniards, and Tommaso Contarini stated that Spain's policy was to 'keep the Italian princes disunited'. Spain had ruined all the territories it governed, according to these diplomats. The Tuscan envoy in Naples in 1606, unable to understand why the south was poorer than his native Tuscany, concluded that all was the fault of Spain: 'everywhere there is great despair, ruin and discontent'.[126]

Through all its history, Italy had struggled to free itself from outside invaders, termed universally 'barbarians'. Writers applied the term especially to the French in the early 1500s, but during subsequent centuries it was the Spaniards who had the unique distinction of being considered 'barbarians'. Princes and poets united in clinging to a dream of a country that would be their own, as it had been (so they claimed) in Roman times. 'I would', one prince wrote to the queen of France in the late sixteenth century, 'go so far as to ask for help from the Turk, in order to rescue my fatherland [patria] from the hands of the tyrants who torment and oppress it.' 'Italia, nostra patria', was the stated aspiration of another in 1558.[127] The wish to drive Spaniards from Italy helped to develop the idea of national unity. One of the first writers to see this as a practical proposition was Girolamo Muzio, from Capodistria, who in

1574 called for his country's liberation from 'foreign and barbarian nations'. The key to liberation, he felt, lay in Genoa rejecting the Spaniards. When Genoa regained its freedom, Milan would follow suit, and after that all Italy. The princes should then unite, select a capital for the nation in the middle of Italy, and set up a federal parliament, with its own army and navy.[128] It was a deeply felt aspiration, shared by many sections of the Italian élite, but doomed to frustration because of the very deep divisions among themselves and destined not to be realized for another three hundred years.

Not all Italians, of course, pursued these pipe dreams. Many recognized that the Spanish connection was not inherently negative. An observer in sixteenth-century Milan stated that 'this city is not ill disposed towards the Spaniards'. The expulsion of the French had brought peace to the peninsula. 'Italy', wrote Paolo Paruta, 'has through the great prudence and moderation of Philip II been able to enjoy a long, secure and tranquil peace, to the great satisfaction of its people.'[129] But it was precisely this peace that anti-Spanish writers such as Boccalini in the seventeenth century saw as an obstacle to the liberation of the peninsula.

In 1561 a thirty-two-year-old Dominican took ship at Seville in the company of fifty other friars, all of them with their eyes fixed on the challenge of winning the Indies for the gospel. Francisco de la Cruz, a native of Jaén, had studied in the college of San Gregorio in Valladolid, where he came to know and admire his illustrious colleagues Bartolomé de las Casas and Bartolomé de Carranza. When Carranza was arrested by the Inquisition, Cruz became deeply disillusioned and made for America, where he settled into the Dominican convent in Lima. In 1568 he was sent out to teach in a doctrina of Andeans, but after a year returned to live and teach in Lima. His stay coincided with the early stages of the imposition of crown control in the province. Cruz himself had asked for the crown to take a more active role. He also made a plea to the king in 1566 – the first of a number of strange decisions he was to make – asking for the Inquisition to be established in Peru. A committee in Spain was soon to look into the feasibility of this. The first Jesuits arrived in Lima in 1568, and in 1569 the crown issued decrees for setting up tribunals of the Inquisition in Mexico and Lima. Inquisitors arrived at the end of 1569, the same year as the arrival of the new viceroy,

Francisco de Toledo. The Inquisition did not begin any activity until the summer of 1571. Among its first acts, ironically, was the receipt of a denunciation against Francisco de la Cruz.[130]

After making the normal enquiries, the tribunal arrested Cruz on 25 January 1572. He was interrogated and spoke freely for he felt he had nothing to fear; his answers occupy seven hundred pages of the official record. The statements of witnesses occupy a further seven hundred pages of text. It is a sign of the prestige Cruz enjoyed in Lima as a theologian that his words were taken seriously. Eventually the prosecutors drew up a list of 130 charges, of which the most important concerned his relations with a young Creole seer, María Pizarro; his alleged contact with 'demons' (whom Cruz referred to as 'angels'); an alleged plan to stage an uprising of settlers; and his alarming prophecies relating to 'Gabriel'. Gabriel, or 'Gabrielico', was the son born shortly after Cruz's arrest, to the Lima lady Leonor de Valenzuela, who while her husband was away on active service had developed a relationship with the Dominican preacher. Pizarro, a nervous and hysterical girl of twenty-two, who had built up a following among local Jesuit and Franciscan clergy, was taken into custody in December 1572 but became seriously ill in prison and died there a year later.

The implication of a few notable people in the affair sufficed to give it importance. Cruz never emerged from the cells of the Holy Office. After seven years of examination and interrogation, the Inquisition condemned him as a heretic and he was burnt after a specially imposing auto de fe held in the main square of Lima on 13 April 1578 in the presence of the viceroy and all local dignitaries. José de Acosta, who arrived in Lima the year Cruz was arrested, was present at the burning and said that the accused died unrepentant, with his eyes fixed on the sky. Viceroy Toledo was convinced that the Dominican had led a plot to make Peru independent of the empire, and reported as much to Philip II, who accepted the version unquestioningly. The affair disappeared from sight and from all official histories for nearly four hundred years.[131]

Francisco de la Cruz was a tormented spirit whose visions, imaginings and ravings reflected the torment of the New World with which he identified himself. In his years as preacher and thinker he had acquired a profound enthusiasm for the ideas of his friend Las Casas, just as he later became an ardent defender of the cause of the Indians of Peru. In

his prison cell these and other influences combined to produce a strange cocktail of ideas, fruit of his own mystical reading as well as of the complex reality of the Andean world. He claimed to have had visions in which the angels foretold great things for Gabriel, who was viewed as a future saviour of the realm of Peru. In the end, his dominant vision was probably – if any logic can be given to his ideas – one that sustained the Creole hope of an autonomous regime in Peru.

He maintained,[132] as some thinkers of his own and other mendicant orders had done, that the Church would shortly collapse in the Old World, where it had become corrupt, and would set itself up in the New World. This was a millennial vision that still survived among the clergy working in America, but Cruz gave new twists to it. He asserted that in this new Church the clergy would be allowed to marry, and moreover that intermarriage between Spaniards and Indians would be the basis of the new Andean society. Both these ideas were fairly commonplace, for many Catholic clergy continued to argue against celibacy, and marriage of settlers with women from the Inca élite had been known. However, Cruz was moving in new directions. He reverted to the idea, found in some chroniclers of the time, that the civilized natives of America came from the lost tribes of Israel. On this basis, he arrived at the conclusion that the Indians would become the new Israel, the new People of God. 'One of the reasons why God will punish Spain is because it has not given due care to the succour and salvation of the Indians.'

In this panorama of a new Church and a new chosen people, there was virtually no role for Spain and its empire. Spain would in fact perish, and the peninsular Spaniards and their values would be destroyed. He cited an opinion of Las Casas that most of the Spaniards in America would be damned: 'I remember some words that Las Casas said to me in Spain, in Toledo, when I was coming to this country; he said that all the Spaniards in America are going to hell, except for the friars who are teaching the Indians.' The lust for gold would disappear, according to Cruz, for the silver of Potosí would dry up and vanish. The peoples of Peru would then indeed revert to the Age of Gold spoken of by classical writers, in which 'they will dedicate themselves to agriculture and herding and manual work, and there will be an end to the troubles in the kingdom and to the ill treatment that the Indians receive in the mines'. The disappearance of Spain would lead to liberty for the Creoles: 'the time will come when Peru will be ruled independent of Spain'.[133]

Seven years of rambling and often incoherent declarations, written down and certainly misreported by the secretaries, replete with extravagances that made the inquisitors suspect that the accused was uttering insanities in order to feign madness, cannot be condensed satisfactorily into the few phrases just outlined. We can, however, see in Cruz a sort of prism through which the multiple aspects of the New World identity were filtered and (evidently) distorted. The criticisms, aspirations and doubts of those who lived in that newly emerging society on the shores of the Pacific found in him a voice that converted him into a prophet, an Elijah in the deserts of the Andes.

The empire helped to form the identity of Spaniards, but at the same time it aroused profound and continuous criticism from them. Few of its aspects provoked such controversy as the discovery and conquest of the New World. A persistent current in Spanish opinion viewed America as the cause of all subsequent ills. Easy wealth from the New World, ran this line of thought, undermined the wish to work. 'Our Spain', González de Cellorigo wrote in 1600, 'has looked so much to the Indies trade that its inhabitants have neglected the affairs of these realms, wherefore Spain from its great wealth has attained great poverty.'[134] 'The poverty of Spain', claimed Canon Sancho de Moncada even more firmly and succinctly in 1619, 'has resulted from the discovery of the Indies.'[135] For the next two hundred years there were always commentators to be found who repeated such sentiments as gospel. The opinion was always accompanied by a mordant corollary: foreigners were stealing the wealth of America from Spaniards. Criticism of the role of foreigners in Spanish commerce tended to end up as a raucous expression of Castilian nationalism. What we take from the Indies is ours, writers claimed. Why should others take it away from us?

Criticism of the activity of settlers in America was largely the preserve of the mendicant orders in the first century of the Spanish presence. The relentless campaign of Las Casas, who had support in the very highest quarters, from both Charles V and Philip II, served to keep the issue alive.[136] Not all the criticisms managed to find their way into print. Church writers who insisted on the theme were refused permission by their superiors to air their views. The most notable case was Gerónimo de Mendieta, whose *History of the Church in America* was consulted and used by his colleague Juan de Torquemada, but not published till

1870. Mendieta's criticism was typical. He claimed that the New World was Spain's by virtue of the pope's donation, and not because of any conquest. It followed that America was not discovered 'merely that gold and silver might be shipped from here to Spain. God gave the Indies to Spain in order that she might cultivate a profit from the mines of so many Indian souls.'[137]

There was an important corollary to the argument. Since Spain's role was spiritual, it had no right to dispossess the native rulers, except in special circumstances such as a justifiable conquest because of resistance to the gospel. The friars therefore presented themselves as the defenders of the oppressed Indians and of the natural rights of indigenous chiefs. The contention was obviously not acceptable to the Spanish crown, and Viceroy Toledo in Peru made it his special task (as we have seen in Chapter 4) to vindicate the direct authority of the king and the irrelevance of the papal donation. But the problem would not go away. Many clergy at the end of the sixteenth century continued to make a stand on the papal donation and by implication questioned the authority of the crown. In the faraway Philippines, Dominican friars in the 1590s argued that since the natives had peacefully accepted the gospel, their rulers retained all their natural rights and the king of Spain could not allege that he had conquered them.[138] In October 1596 the council of the Indies in Spain formally debated the issue, and finally in 1597 Philip II issued one of the most extraordinary decrees of his reign. He ordered the governor of the Philippines to give back to the natives any tribute that had been unjustly collected from them in the period when they were not legally under his rule. At the same time, he ordered his officials to go through the islands and obtain formal statements from the natives accepting Spanish rule. For the next two years – a full generation after the arrival of Legazpi – the archipelago was witness to the strange phenomenon of meetings of the chiefs of the barangays in which they ratified before a notary their acceptance of the authority of the king of Spain.

Such controversy over the crown's authority has sometimes been attributed to a peculiar Spanish concern for legality. But it may equally be attributed to their reluctant imperialism. It was a line of thought shared by a broad range of people in Spain including clergy, economists, merchants, political theorists and plain traditionalists who saw little of value beyond the horizon of their local communities, and refused to

accept world power or the responsibilities that went with it. Their ideas surfaced repeatedly in times of crisis, during the rebellion of the Comuneros in Castile, during the wars in the Netherlands and during the invasion of Portugal in 1580. It would be misleading to call the attitude anti-imperialist, for it was very much more. There were also elements of xenophobia, anti-Semitism, anti-capitalism, and a profound concern for 'little Castile', the country which had been their own before it was taken over by the empire. Castile had always been enough for its people, they felt, why grasp for more? In 1565 Luis de Requesens, serving at the time as ambassador to Rome, criticized the view, which he ascribed to 'old men in Castile who believe we were better off when we held no more than that realm'.[139]

Perhaps the most bitter issue was the war in the Netherlands, which provoked among Castilians, from the government downwards, a long-standing debate centred on whether the country should sacrifice its revenues and the lives of its young men in order to win a pointless war far away from home. The passionate words of the Cortes deputy Francisco de Alarcón in 1588 were directed against thirty long years of imperialist war:

My question is: why should we pay a tax on flour here in order to stop heresy there? Will France, Flanders and England be better off if Spain is worse off? The solution adopted for the sinners of Nineveh was not raising taxes in order to go and conquer them, but sending people there to convert them. The Catholic faith and its defence belong to all Christendom, and Castile should not have to bear all the burden while other realms, rulers and states just look on.

Even more angry were the words of a pamphlet that circulated in Madrid just after the death of Philip II, in which the author (who was arrested for his pains) declaimed that 'if two hundred thousand Spaniards, not to mention other nations, have been deliberately led like sheep to the slaughter to be killed in the bogs of Flanders', then the late king was 'worse than Nero'.[140]

The successful occupation of Portugal, as we have seen, gave an enormous boost to Castile's imperialist dream. Among the few dissonant voices was Teresa of Avila. She commented that 'if this matter is pursued through war, I fear great harm'. A leading Jesuit lamented that Christians should be fighting Christians: 'This realm [Castile] is ailing and has little wish to see any growth in His Majesty's power.' The opinions were by

no means anti-imperialist. They reflected, however, a continuous concern over the implications and the possible negative consequences of belligerency. During the transition from the reign of Philip II to that of his son, all the doubts and criticisms came to the surface. One of the reactions was that of Álamos de Barrientos, a friend of Antonio Pérez, who felt in the 1590s that the empire, now barely two generations old, was already falling apart. He divided the realms of the monarchy into two categories. The first were the 'inherited' realms, which for him included Flanders and the Indies. The second were the 'conquered' realms, which for him included Portugal and Naples. None of them had brought any benefit to Spaniards, who were sunk in a 'misery which comes principally from the burden of taxes and from spending all the proceeds on foreign wars'. All the burden of the empire had fallen on Castile alone. 'In other monarchies the limbs contribute to maintain the head, and in ours it is the head that labours so that the limbs are fed and sustained.'[141]

Castilians were suspicious and resentful of foreigners and their preponderant role in the monarchy. Clergy were second to none in their xenophobia. 'Quite lately', claimed Philip II's former tutor and opponent of Las Casas, Sepúlveda, 'I notice that contact with foreigners has introduced opulence to the lifestyle of the nobility.'[142] With writers both great and small, significant and insignificant, the theme was continuous and never failed to come to the surface. Foreigners (including both Jews and Moors) were held responsible for the evils besetting what would have been a perfect empire had it been controlled only by Castilians. As the empire developed, so too did the significance of the word 'foreigner'. In the fifteenth century a Cortes of Madrid raised objections to 'Navarrese and Aragonese and other foreigners'.[143] In political terms, subjects of the different realms of the peninsula were indeed at that time 'foreigners' to each other. A century or more later, distinctions based on language, religion and power had demarcated more clearly what it was to be a foreigner, and Castilians drew quite specific lines separating themselves from others.

Perhaps the most prolific critic of foreign influences was the seventeenth-century poet Francisco de Quevedo, who tirelessly presented fervently nationalist views, attributing to other Europeans all the vices to be found in his own country: 'there is no vice we have that we do not owe to our contact with them'. If there was sodomy in Spain, he

claimed, it had come from Italy; if there was gluttony, it had come from Germany; if there was an Inquisition it was because Calvin and Luther had made it necessary.[144] Continuous wars against France nurtured a specially virulent polemic against that country, right down to the early eighteenth century. Shortly after the War of the Spanish Succession, a pamphlet published in Madrid in 1714 with the title *Reply of a friend to one who asks when there will be an end to our ills*, stated that 'the principal reason for our lament is the innate hostility with which all foreigners have always looked on Spain'.[145]

Though there was much cultural antagonism as a result of the co-existence of races within the empire, many Spaniards were also capable of looking more objectively at the question. The most outstanding early writer on the subject was the Jesuit José de Acosta.[146] He inevitably shared in the prejudices of his time and his religion, but he attempted to define how one should assess the various peoples who composed the empire. During his travels in the New World he had made contact with people of all nations. He accepted the designation of 'barbarian' commonly given to non-Europeans by European thinkers, but attempted (like several other Spaniards of the time) to define what the word implied. It boiled down, he felt, to differences in levels of communication.[147] Three levels of communication, and hence of civilization, could be perceived among the barbarians. The topmost category was occupied by those who possessed civil society, writing and letters, such as the Chinese (whose books Acosta had seen in Mexico) and perhaps also the Japanese and some other Asians. The second level included those who had civil society but lacked formal writing; these included the Mexicas and the Incas. The last level was composed of those who appeared to have no civil society and no written method of communication; into this class fell most of the indigenous tribes of the Americas. Through this type of rational approach, Spanish thinkers attempted to explain to administrators and missionaries how they should approach the task of assimilating other nations into Spain's international commonwealth.

The spiritual endeavours of the Spanish clergy have often, with some justice, been viewed as the crowning glory of the imperial enterprise. Though other aspects of the colonial regime may have failed, it is claimed, the spiritual conquest succeeded and the Catholic identity was Spain's greatest colonial legacy. Bartolomé de las Casas had proclaimed

that the principal purpose of the empire was not oppression but conversion. The missionary effort was certainly a very extensive one, thoroughly documented by those who took part in it. On all parts of the frontier, in old Granada, in Manila, in New Mexico, in the Andes, the old ways of life were substantially affected. Most of the clergy were professional optimists, concerned always to inflate the numbers of natives brought into the Christian fold, and reporting their activities always in the most glowing terms. Theirs is often the only evidence available, but it has to be approached with caution.

Not all missionaries were optimistic. The Franciscan Bernardino de Sahagún commented in the sixteenth century that 'as far as the Catholic faith is concerned, [America] is sterile ground and difficult to cultivate. It seems to me that the Catholic faith will persevere but little in these parts.'[148] It is possible that the Catholic faith survived with greater force than Sahagún perceived. Where it survived, however, the people chose what they wished and rejected the rest, hardly the results that the missionaries had hoped for. It will perhaps always be difficult to arrive at a balanced assessment of whether Spain succeeded in the religious aspect of its imperial venture. Nearly a century after the establishment of the Spaniards in Central America, the English Dominican, Thomas Gage, said of the Indians in his parish in Guatemala that 'as for their religion, they are outwardly such as the Spaniards but inwardly they are slow to believe that which is above sense, nature and the visible sight of the eye. Many of them to this day do incline to worship idols of stocks and stones, and are given to much superstition.'[149]

The harsh campaigns against 'idolatry' among Andean Indians in the seventeenth century drew to an end in the 1660s and may have had some effect, but it was for the most part superficial. Although clergy often used exaggerated language in their evaluations, there is little reason to reject the verdict of a priest in Peru in 1677 that 'the idolatry of the Indians is more solidly rooted today than it was at the beginning of the conversion of these realms'. In Peru the programme of 'extirpation' had to be renewed in 1725, and continued till the end of the eighteenth century. The struggle against the huacas was always an uphill one, doomed to frustration. A bemused Peruvian native in the eighteenth century asked a Jesuit: 'Father, are you tired of taking our idols from us? Take away that mountain if you can, since that is the God I worship!'[150] The animistic beliefs and traditional rites were the central core

of an indigenous identity, and persisted in one form or another all the way through the colonial epoch, even though modified. Natives who accepted Christianity did so at the same time as they continued with their old cultural practices. Those who refused to accept changes maintained a permanent, armed hostility. In 1700 in the peninsula of Darien the Cuna people attempted to ally with a group of Scots who had settled there against the Spaniards. One of their chiefs was captured by the Spaniards and refused to reveal the location of a gold mine even when his captors cut off both his hands. He said: 'God sent devils down upon the earth like a fierce downpour of rain. Thanks to these demons you came to my country and your people occupied my land and ousted me from it.'[151] The Cuna continued to attack the Spanish missions during the eighteenth century.

Two priests, both foreigners in the Spanish mission field, offer interesting though conflicting testimony to the impact of the new religion after a century and a half of Spanish rule. The early hero of the missionary effort in northwestern New Spain was the Tyrolean Jesuit Eusebio Kino.[152] Born Eusebius Kühn near Trent in northeast Italy, he was educated at Ingolstadt, joined the Jesuit order in Bavaria, went to Mexico in 1681 and in 1683 became the first European to reach the Pacific by an overland route. He worked for a quarter of a century in Sonora and then in Arizona among the Pima people and prepared the way for later missionary advances into Lower California. His indefatigable travels, and his revolutionary work as a geographer and explorer of the Colorado valley, distinguish him as one of the great pioneers of the Spanish empire. In 1696, after ten years of labour, he remained wholly optimistic and could still write that he was 'received with all love by the many inhabitants'. It is likely that his lack of obsession with the persistence of 'idolatry' contributed powerfully to his rosy view of success.

On the other hand his contemporary, the Jesuit Josef Neumann, a Belgian of German origin who served for an incredible fifty years, from 1681 to 1732, in the Tarahumara country of the same northwest, had a bleaker perspective. He wrote at the end of his career:

With these people the result does not repay the hard labour. The seed of the gospel does not sprout. We find little eagerness among our new converts. Some only pretend to believe, showing no inclination for spiritual things such as prayers, divine services and Christian doctrine. They show no aversion to sin,

no anxiety about their eternal happiness. They show rather a lazy indifference to everything good, unlimited sensual desire, an irresistible habit of getting drunk, and stubborn silence in regard to hidden paganism. And so we cannot bring them into the fold of Christ.[153]

At almost exactly the same date, in 1730, a Capuchin missionary reported of the Guajiro tribes of New Granada: 'It is impossible to bring forth any fruit among these Indians; they have not given rise to even the slightest hope in all the time that work has been dedicated to their conversion.'[154] This view was expressed in a way that laid emphasis on the refusal of the natives to accept the Catholic religion. A quite different perspective, in that it laid the blame on the clergy, was expressed by the officials Juan and Ulloa shortly afterwards, in the 1740s, when they explained that the parish priests in Peru were guilty of 'total neglect and failure' to convert the Indians in their charge. 'Although the Indians have been Christianized,' they wrote, 'their religious training has been so poor that it would be difficult to discern a difference in them from the time they were conquered to the present day.'

Contradictory and sometimes conflicting religious allegiances, political loyalties, and cultural aspirations, all formed part of the mosaic of identity in the Iberian peninsula on the eve of empire. Spaniards came from a medieval background where there was no unity of creed nor of political affiliation. As a consequence, despite efforts to do so they seldom succeeded in imposing a single exclusive vision on the lands to which they went as rulers or as settlers. Over-zealous clergy were persistently opposed by colonists who put business before salvation, ruthless settlers were opposed by clergy and even more firmly by the indigenous population. Jews, prohibited in Spain after 1492, continued to live freely in every other part of the worldwide empire.

The countries that made up the monarchy enjoyed a richness of contrasts that may surprise those who feel that Spain's subjects laboured under a uniformly heavy hand of tyranny and superstition. In reality, the vastness of the monarchy made it impossible to impose any uniformity of vision. The only common link was the use of a single administrative language – Castilian – which offered members of the empire a shared speech and with it a recognition of the special role played by a far-off mother country, Spain, in the formation of shared traditions. Spain, in

the end, was the *ignis fatuus*, the will o' the wisp, to which people looked when they despaired of making sense of the chaos of the worldwide empire. When the aged Guaman Poma set off from his village in 1614 for Lima, bearing with him the massive manuscript of his *New Chronicle*, and accompanied by his young son, a horse and two dogs, he explicitly recognized that the answer to his aspirations for change in his country lay in Spain. In the same way the Jews of the dispersion continued for centuries to define their identity in terms of the country which had done most to destroy them, the Sefarad of their ancestors, the universal monarchy of Spain.

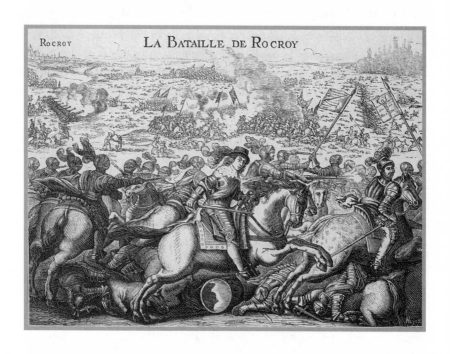

ROCROY LA BATAILLE DE ROCROY

9

Shoring up the Empire (1630–1700)

> If Spain had spent less on war and more on peace it would
> have achieved world domination, but its greatness has made it
> careless, and the riches that would have made it invincible have
> passed to other nations.
>
> Diego Saavedra Fajardo, *Political enterprises* (1640)[1]

Italy continued to be the sheet anchor of Spain's power in Europe
throughout the seventeenth century. Armaments, ships and men from
all over Italy continued to be the essential support for Spanish-led
campaigns in the rest of Europe. Meanwhile ambitious Castilian admin-
istrators (of whom the most notorious was the viceroy of Naples, the
duke of Osuna) attempted by fair means or foul to maintain the initiative
in Italy, where the most direct challenge to Spanish power came from
the Republic of Venice. As in previous decades, the centre of attention
was the army of Lombardy based in Milan. Throughout these years it had
the task of keeping the Alpine passes open, and remaining permanently
vigilant in respect of its three immediate neighbours: Savoy, the Swiss
Confederation, and Venice, states which put their own independence
first but were not above seeking French help in order to maintain it.
'Milan', a Venetian ambassador commented at the time, 'is the true
crucible where all the designs of the Spaniards in Italy are prepared.'[2]
Helped powerfully by the financial resources of its bankers, among them
such leading names as Negrolo, Cusani, Spinola and Doria,[3] the duchy
put its credit, manpower and armaments industry at the service of the
Spaniards. The most belligerent of its governors was the count of
Fuentes, Pedro Henríquez de Azevedo, who in the face of enormous
difficulties was able during his mandate (1600–1610) to confirm and
extend Spain's position. In the long history of Spain's empire, he may

with reason be counted among the most successful of all its military commanders. He consolidated the duchy's access to the Mediterranean by occupying the principalities of Finale (1602), Piombino and Monaco, and took over adjacent fortresses in Novara, Modena, Mirandola and Lunigiana. He also built an imposing fortress, named Fuentes after him, on a rocky hill at the mouth of the River Adda. Its purpose was to control the mountain route – the famous Valtelline – that linked Milan with the Tyrol and the Austrian Habsburgs.

Spain's position, however, was put in jeopardy by the always indepen-dent policy of Savoy, under its duke Carlo Emanuele I, who had become Philip II's son-in-law in 1585 when he married his beautiful daughter the infanta Michaela. In 1612 he disputed control of the adjacent duchy of Montferrat, which he occupied in 1613. The move involved him in war with Spanish Milan, but he had taken care to count on the active support of France (for soldiers) and Venice (for money). The struggle lasted four years, with little profit for Carlo Emanuele, who was defeated by the Milanese forces of the then viceroy Pedro de Toledo, marquis of Francavila. This small conflict had an importance much greater than any of the participants realized. It inspired the duke of Osuna in 1618 to back a conspiracy against Venice, provoked a resurgence of patriotic anti-Spanish sentiment throughout Italy, and brought Savoy to the fore as the one great hope for the liberation of the peninsula from the yoke of Spain.

Some years later, during the Mantuan crisis, Rubens observed with an uncanny prescience that 'I have the feeling that the duke of Savoy will be the brand that sets all Italy afire.'[4] The poet Alessandro Tassoni, in two tracts of 1614 titled *Filippiche contro gli Spagnuoli*, called on Italians to unite against the barbarians: 'no nation in the world could be so base as to allow itself to be endlessly dominated by foreigners'. The poet Fulvio Testo proclaimed that Savoy was the only hope for a free Italy. In the streets of Naples a poster was discovered, addressed to 'Italy' and announcing that it would 'soon be a united state'.[5] With good reason did Rubens comment that 'the hatred of the Italians for Spanish domination outweighs every other consideration'.[6]

The army of Milan was less successful during the subsequent ill-fated war of the Mantuan Succession (1627–31), an apparently small struggle like so many others in which Spain had allowed itself to be involved in the past. In December 1627 the duke of Mantua and Montferrat died

with no direct heir. The strategic importance of the duchies, which included in Montferrat the fortress of Casale, made outside intervention inevitable. Spain laid claim to Mantua, while France supported the claims of Charles de Gonzague, duke of Nevers and a French subject. Olivares recognized that 'the duke of Nevers is the legitimate heir to all the Mantuan estates, and simple justice is undoubtedly on his side'.[7] However, he opted in favour of a rapid conquest of the duchy by the army of Milan. The problem was that the Spaniards soon had to face the intervention of a French army, which forced them to raise the siege of Casale. They also had to deal with the alliance between Carlo Emanuele and France. Unable to hold on, they appealed for help from Germany. In the summer of 1629 units of Wallenstein's army, under the command of the Italian generals Gallas and Piccolomini, entered Italy through the Valtelline and besieged Mantua, while Spinola was sent from Brussels to take over the governorship of Milan and direction of the siege of Casale. The apparently limited and local conflict had become an international war, with the principal armies of France, Spain and the Empire tied down in the north of Italy. It was a scenario that Spain proved unable to dominate.

The death through ill-health at Casale in 1630 of Spinola, last of the great captains of Spain's imperial epoch, was an ominous prelude to the collapse of the military machine in Europe. Through his financial resources, his recruitment abilities, and above all his brilliant generalship, Spinola had held together the entire network of military administration that stretched from Italy through the Rhineland to the Low Countries. In Brussels, according to Rubens, 'he alone is powerful, and possesses more authority than all the others together'.[8] He was, beyond all doubt, Spain's greatest general of the seventeenth century, and richly deserved the honours bestowed on him. But his failure to capture Casale rapidly had been frowned on in Madrid, where they thought a Castilian would serve better. Olivares's ungenerous treatment of the great general was notable. 'Since his intervention in Italy', he complained of Spinola, 'he has been able to achieve nothing more than loss of reputation, so that we are now in danger of defeat both in Italy and Flanders because we paid too much attention to his counsels.'[9] On hearing that he had been replaced by the marquis of Santa Cruz, Spinola was unable to conceal his disgust. He protested to the young papal diplomat, Giulio

Mazarini, who was at the siege trying to negotiate an agreement between both sides, that 'they have dishonoured me'. He took to his sickbed and died in September 1630. Mazarin (as he shortly became known when he entered the service of France) was at his bedside and reported that with his last breath Spinola kept murmuring repeatedly 'honour and reputation, honour and reputation'.[10] Rubens commented sadly that 'Spinola was tired of living. He was disgusted by the hostile feeling shown him in Spain. I have lost one of the greatest friends and patrons I had in the world.'[11] The artist's fine portrait of the resolute, commanding general dates from Spinola's great period of power in the court at Brussels.

Profiting from Spinola's transfer to the Mantuan front, the Dutch succeeded in capturing 's-Hertogenbosch (1629) and so initiated a slow but successful campaign to consolidate their military gains. In Brazil, as we have seen, they succeeded in gaining their first serious hold on the mainland, by the capture of Pernambuco (1630). Olivares had no option but to seek a negotiated settlement in Italy, using the good offices of the papacy to make approaches to France. The result was the treaty of Cherasco (1631), which decided the Mantuan succession in favour of France. It was the first major achievement of the new chief minister of the French royal council, Cardinal Richelieu, who had in 1630 routed his rivals at court and begun his ascent to power.

The success of the Swedish armies in Germany also threatened to destroy the entire chain of alliances on which Spanish security in the north depended. Help came when it was least expected. The Swedish king Gustav Adolf was killed leading a cavalry charge at the battle of Lützen in November 1632. It was a Swedish victory, but the loss of the king was an irreparable blow and changed the entire situation. The generals who succeeded Gustav were unable to command the same support among the German princes, who made moves to distance themselves from the foreign forces in their country. Shortly afterwards there was also a change of leadership in the court at Brussels, where the atmosphere had been anything but favourable to Spaniards. Ambassador Oñate commented at the time that 'anyone who remembers the way the rebellion began will see that we are going through the same stages'. In 1632 a plot in favour of the Dutch and against Spain by the former commander of the army of Flanders, Count Hendrik van den Bergh, was discovered. He was arrested, together with the head of the treasury, the

count of Warfusée.[12] Other nobles were also plotting with Cardinal Richelieu. The obvious threat from France, which had led to the humiliating peace at Cherasco, and the continuing problems in northern Europe, induced Spain to allow the army of Lombardy to take part in the German campaign for, as Olivares commented, 'the answer to everything must come from Germany'.[13]

As a result, Spain made perhaps its most notable intervention in the German theatre of the Thirty Years' War, during the years 1633–4. On the death of Archduchess Isabella in December 1633, Philip IV appointed as her replacement his younger brother the infante Ferdinand, who had been originally destined for the Church and created cardinal, but at the time was serving as governor of Milan. The preceding governor, the duke of Feria, Gómez Suarez de Figueroa, was sent to Germany in August 1633 at the head of an army in order to league up with the forces of the duke of Bavaria and free the Rhineland from the menaces of the French. Feria's force of twelve thousand five hundred men (12 per cent Spaniards, 32 per cent Germans and 56 per cent Italians)[14] entered the Holy Roman Empire through the Valtelline and linked up at Ravensburg with the Bavarian forces under their commander, the Luxemburger general Johann von Aldringen. In October the joint army relieved the key fortress of Breisach from the besieging French. 'I am extremely happy', Feria wrote, 'to have served Your Majesty and in particular to have relieved Breisach, in view of its great importance and because it now opens the road between Italy and Flanders.'[15] The route had to be made safe for the cardinal infante to reach Brussels and take up his post. However, Feria's army was reduced in number and resting in winter quarters; the duke himself fell ill during the bitter cold of the winter, and died in Munich in January 1634. If the cardinal infante wanted to go to Brussels, he would have to recruit an army of his own to accompany him.

Ferdinand had extreme difficulty in raising yet another army, and it took him five months to do so. By then the objectives of his journey had also been modified. His mission was to take up the appointment in Brussels, but his primary assignment was a specifically military one, to take reinforcements to help the Austrian Habsburgs against the still powerful Swedes. He left Milan in June 1634 at the head of an army of eighteen thousand men made up largely of Italian officers and soldiers but with a small contingent – around one fifth of the force – of Spanish

infantry.[16] He took the route through the Valtelline, having agreed in advance with the commander of the Imperial forces, his cousin Ferdinand king of Hungary, to rendezvous with him at the Danube. When they met on 2 September a few miles from the city of Donauwörth, the cousins dismounted from their horses and embraced each other. Ferdinand of Hungary, later emperor as Ferdinand III, was then aged twenty-six years, one year older than the cardinal, to whose sister he was married. Their meeting was a unique moment, never achieved before and never to be repeated, of active military alliance between the two branches of the Habsburg family. The joint retinue of officers and nobles, some eight hundred persons in all, went on to celebrate the meeting with a grand reception.

The king had been besieging the city of Nördlingen since the end of August. A joint Protestant army, commanded by Duke Bernard of Saxe-Weimar and the Swedish marshal Gustav Horn, attempted to relieve it. The joint Imperial army of the two Ferdinands, totalling thirty-three thousand men, was in a commanding position in the wooded countryside before the city. Behind them, beyond the woods, were the Protestants with a force of twenty thousand. Determined to break the Imperial lines, and unaware of his inferiority in numbers, Horn ordered an attack when the first clear rays of the sun came over the hill on 6 September 1634. In the ensuing clash the Swedes suffered a crushing defeat, after five hours of battle and slaughter.[17] Nearly three-quarters of the Protestant army died or were captured in the battle and pursuit. A delighted Olivares promptly hailed it as 'the greatest victory of our times'.[18] The reaction of a Spanish officer who took part in the battle was more sombre: 'you would not believe how the fields were strewn on all sides with weapons, flags, and bodies and dead horses with horrifying wounds'.[19]

Nördlingen was arguably the most important battle of the Thirty Years' War and had decisive consequences for Germany, where it definitively destroyed Swedish power and helped the emperor to bring about an alliance of states in favour of peace. This was achieved by the Treaty of Prague (1635), agreed principally between the emperor and Saxony. An agreement for ending the war was, however, still far away. The successful battle was anything but auspicious for Spain, since it forced the enemy to seek new allies. A German Protestant ruler mused at the time that 'in this extremity we must look to France'.[20] Richelieu received

the news of the battle five days later in Paris, and went to his desk, where he wrote down his thoughts. 'It is certain', he noted, 'that if the Protestants have collapsed the power of the Habsburgs will be directed against France.'[21] He was convinced that the Swedish defeat made it inevitable for France itself to intervene directly against the Imperial forces, instead of – as it had done until then – merely paying others to do the fighting.

In February 1635 the cardinal signed a treaty with the Dutch, which stipulated economic subsidies and even the division of the Southern Netherlands. In March a French army under the Protestant general Rohan invaded the Valtelline and cut the vital line of communication between Milan and the Empire. Finally, France declared war with all the ritual of the Middle Ages: a herald was sent to Brussels, where in the main square on 19 May he formally declared hostilities against Spain on behalf of his master Louis XIII. Unfortunately it was raining and few came to listen to what the lonely herald was reading out in the square.

The declaration of war by France has sometimes been interpreted as a deliberate act of aggression by Cardinal Richelieu. In reality, the interests of France and Spain had already been in conflict for many years, and with particular intensity after the Mantuan war. Already at that date the diplomats feared an inevitable outbreak of hostilities between the two giants of the West. Rubens, whose artistic interests and diplomatic activities gave him access to the major courts of Europe, expressed his thoughts in a comment that echoes down the ages in its blend of sincerity and despondency:

There is fear of a general rupture between France and Spain, which would be a conflagration not easily extinguished. Surely it would be better if these young men who govern the world today were willing to maintain friendly relations with one another instead of throwing all Christendom into unrest by their caprices.[22]

The fact is that Olivares himself had been taking several measures aimed at an undeclared aggression against the neighbour state, and at the beginning of 1635 he expressly informed the Council of State that 'war will be declared against France'. 'Unless they are attacked vigorously,' he declared, 'nothing can prevent the French from becoming masters of the world.'[23] It is true that Olivares was subject to depressions and liable

to see the affairs of the monarchy at times in terms of brilliant optimism, at times in terms of a most profound gloom. But there was no mistaking his reaction to the momentous decision that now pitched the two great powers of Western Europe against each other. 'Everything', he observed in mid-June 1635, 'will come to an end, or Castile will be the leader of the world.'[24]

The outbreak of war between the two great powers of Europe had been awaited with trepidation by many Spaniards. In Madrid a courtier wrote: 'The cure for our ills is even more remote and out of reach.'[25] The poet and diplomat Saavedra y Fajardo was convinced that the objectives of a war policy were unattainable: 'I cannot believe that the whole world should be Spanish.' 'The cost has been high', he wrote in his *Political enterprises* (1640), 'of waging war in unseasonable and distant countries, where our enemies have all the advantages and we have so few that it may be doubted whether we are better off winning rather than losing.'[26] Casting his eye over the dangers faced by Spain throughout the globe, Olivares in February 1635 thought that 'the first and greatest perils are those threatening Lombardy, the Low Countries and Germany. A defeat in any of these three would be fatal for the monarchy, and if the defeat were a big one the rest of the monarchy would collapse, since Germany would be followed by Italy and the Low Countries, and the Low Countries by America.'

The empire, however, was not alone. One of the secrets of its survival had always been the ability to call on help from those who were apparently its enemies but who benefited in a thousand ways from its existence. And it was from the ranks of its enemies that Spain drew one of its greatest defenders, an obscure Dominican friar from Calabria, in the south of Spanish Naples, named Tommaso Campanella. Born in 1568, Campanella entered the Dominican order when he was still very young, in 1582. He proved to be a restless spirit who developed a profound interest in philosophy, Hermetism[27] and the occult. Constantly in conflict with members of his own order, he left Calabria and moved from one convent to another but was persistently harassed by his colleagues in Naples, Rome, Padua and Venice, and accused repeatedly of heresy. He returned in 1597 to Calabria, a marked man. Unperturbed, by 1599 he was preaching sermons that foretold great 'upheavals' and seemed to be fomenting unrest. When a small uprising actually occurred, he was

arrested by the local Inquisition,[28] accused of plotting to overthrow Spanish rule in the realm and transferred with a hundred and fifty other prisoners to the military fortress at Naples. There he was brutally tortured (in part to discover whether the madness he manifested was real) and condemned in 1603 to imprisonment for life. He spent his next twenty-five years moving between various prisons in Naples. 'For eight years', he wrote from prison in 1607 to the king of Spain, 'I have been in a dungeon where I see neither light nor sky, always chained, suffering from bad food and worse sleep, with water oozing from the walls in summer and winter.'[29]

Campanella had already in the 1590s been preparing the draft of a book, the *Monarchy of Spain (Monarchia di Spagna)*, which he began to write in his cell in Naples in 1600. It was an astonishing defence of the empire from one of its notable victims, and reflects clearly the fascination and fear inspired by the power of Spain. But Campanella was not defending the empire that he knew. Rather, his occult imagination conjured up a vision of an even greater and more powerful Spain that, by adopting a more judicious policy, would be capable of covering the earth and bringing universal peace and prosperity. The corrupt and inefficient empire would be replaced by a new, purified world monarchy. A relevant question is why he, an Italian, should see in Spain the great hope for a bright future. The answer lies in his occult imagination and conviction that all the evidence of past and present history and prophecy pointed to God's decision to elevate Spain. 'It is impossible', he warned, 'to resist this monarchy.' The rise of Spain to world status seemed to him nothing less than a miracle, which suggested the hand of God. Spain's empire, he pointed out, 'more than all others is founded upon the occult providence of God and not on either prudence or human force'.[30]

The aspirations, of course, were millenarian dreams rather than subversive or imperialist. But they were also rooted in the reality of how Spaniards actually ran the empire. When Campanella called for a monarchy (i.e. an empire) that would employ citizens of all nations,[31] using Genoese for navigation, Germans for technology and Italians for diplomacy, he was quite simply describing a situation that had already served to create the empire of Spain. The work was smuggled out of his cell and became known through manuscript copies to a wider public. The Spanish writer Juan de Salazar read it at some time before 1619,

but in Italy; it appears to have gone unperceived in Spain. The original text was never published at the time: a German version (with passages added) came out in 1620, a Latin version in 1640 and an English one in 1654.

In the 1620s Campanella's prison conditions in Naples were improved and finally he was released in May 1626. Almost immediately he was arrested again, this time by the Inquisition of Rome, in which city he was confined for eight years. Finally, in October 1634 he was placed secretly by order of the pope on board a ship bound for France. Campanella's fame had preceded him and he was received by Louis XIII and Cardinal Richelieu, who sought his advice on Italian affairs. It was shortly before the outbreak of war between Spain and France in 1635. Campanella was sufficiently aware of the implications of France's entry into the European conflict to change his perspective totally. In 1635 he published three works (as well as a Latin version of his most famous study *The City of the Sun*) in which he argued that the mystical role of Spain as the future world power would be henceforth assumed by France.[32] This universal power, of course, was to be understood not in a territorial but in a spiritual sense. As a philosopher Campanella was seldom taken seriously by his contemporaries (Descartes refused to see him). But his instinctive reasoning over the processes that had made the Spanish empire great and would now precipitate its fall, continues to astonish by its prophetic accuracy.

The large and complex war machine built up by Philip II had at least one grave defect that commentators were not slow to recognize: the inability of Spain to supply enough experienced officers to command its troops. In medieval times the nobles had been the natural leaders of small local forces engaged in defence or warfare. Under Ferdinand and Isabella they had contributed notably to the armies of the Crown, in particular through the vassals and alliances they could summon up. But they always made it clear that their role was voluntary, not obligatory. Increasingly after 1500 they emphasized that their duties lay in defending their own localities, not in going off to fight outside their own lands. The province of Catalonia, for example, produced a few eminent soldiers for imperial service, most notably Philip II's friend Luis de Requesens, who headed the army of Flanders. But the most notable military service rendered by Catalan nobles was always in the defence of their own

frontiers,[33] not in the armies of Castile. They were prominent, for example, in the 1503 Rosselló campaign, and again at the recovery of the fortress of Salses in 1640. Apart from those families that made war their career, a high proportion of Spanish nobles gradually ceased to have practical experience of war. Even fewer had sufficient experience to serve in the navy. A considerable number continued to serve the crown brilliantly, but the government – as in many other European states – became obliged to recruit its officers from outside the ranks of the traditional nobility of the nation.

This was not difficult. All the provinces of the empire had a ruling aristocracy that wished to earn distinction in war, particularly if the war was in their own territory. The nobles in Italy and Flanders felt with good reason that they had the sole right to command the armies based there. Since in practice the crown had few armed forces active outside those two areas, non-Castilian nobles came to dominate the ranks of serving officers. Italians and Belgians distinguished themselves in the service of Spain, and went on with even greater success to serve other masters. During the Thirty Years' War, Belgian generals served with distinction in every corner of the Germanic lands. The practical consequences for the Madrid government were serious. If the majority not only of serving soldiers but of officers in the armies of Spain, was not Spanish, one of the fundamental bonds of cohesion in the army – loyalty – could not be guaranteed. The composition of the army of Flanders in the seventeenth century is an indication of the problem. In 1608, for example, only 17 per cent of its infantry was Spanish, but 45 per cent German, 15 per cent Belgian and 12 per cent Italian.[34] In 1649, the same army had 23 German tercios, 11 Belgian and 4 Italian, against only 6 Spanish.

The problem was present already in the epoch of the Great Captain in Italy. At that time German regiments in the service of Spain mutinied because they had not been paid, but the Castilians under their Castilian officers remained loyal. In Flanders, immediately after the victory of St Quentin non-Castilian regiments mutinied for the same reason, but the Castilians did not. A reliable and professional officer class (as the British discovered two centuries later) was the key to maintaining multinational armies under discipline. Philip II recognized the importance of this, and attempted to appoint Castilians to key positions in all his armies. There were, however, few qualified personnel. Continuous

mutinies in the Army of Flanders from the 1570s demonstrated the gravity of the situation.

The bitter experience of the wars in the north certainly helped to create a reaction in Castile, among both nobles and commoners, against military service. 'Nowadays', was the comment in 1599 of Vargas Machuca, who had been a professional soldier in Italy and the New World, a career in arms 'is looked down upon, everybody laughs at a man who enters the army, and they not only laugh but consider it crazy to do so'.[35] One century later the situation had not changed at all, if we may judge by the report of a Spanish bishop to the king that 'among the nobles there is scarcely one who wishes to serve Your Majesty in the war'.[36] The reaction became a serious problem for recruitment in Castile, which had to supply about one fifth of the men serving in its armies in Europe. Villages, towns, nobles and clergy in Castile constantly made objections that their men were unsuited to war and that taking them would impoverish the community. The city of Madrid in 1636 considered it 'impossible to fulfil this demand to raise and transport one thousand men to the state of Milan, because the money must be available to pay and feed the men and the city does not have it'.[37] If the greatest city of the monarchy could not supply men, it may readily be imagined that lesser towns could not either. Castilian towns consistently obstructed recruiting officers sent to their area. The archbishop of Burgos, explaining why three hundred men could not be raised in his diocese, claimed that 'this is the poorest and most miserable land in all Spain, and the number of needy people consumed by hunger is infinite'. Even when men could be raised, over much of Spain there existed a traditional right, strictly observed in Catalonia but operative also in Castile, that they did not have to serve 'outside Spain'.

Reluctance to serve was also common, as we have noted, among the noble class, and consequently affected the quality of available Spanish officers. The Council of State in 1600 criticized the qualifications of the upper nobility: 'they have little military experience'. It also commented that 'the lack that we now suffer of qualified persons to command in the army is going to get worse'.[38] It is significant that in 1633 not a single regiment in the army of Milan was commanded by a Castilian. In those months, with the prominent exception of the governor of Milan, the duke of Feria, all the military commanders were foreigners, principally Italians and Belgians.[39]

The problem of manpower was no less acute when it came to the navy. All European countries until the eighteenth century had immense difficulties trying to recruit sailors, and Spain was no exception. When in 1641 the royal officials tried to use impressment in the coastal zones of Asturias and Vizcaya, the men in the villages simply absented themselves and refused to appear.[40] In practice, throughout the century warships had to go to sea with only about half the crew they needed. The normal solution was to employ foreign seamen. In 1597 the fleet sent against England was manned mostly by Belgian sailors, with some English and French prisoners to help them. It was a practice that could not be avoided, and the capture of enemy seamen was always welcome. Fadrique de Toledo's victory at Bahia in 1625 was certainly owed to the Portuguese and Spaniards serving under him, but it was the captured Dutch seamen from Brazil who made it possible for his ships to return home.[41] The fleets of Spain, like those of England and France, were completely multinational. Unemployed foreigners readily came to serve under the Spanish flag. This explains why Bosnians and Slovenes could regularly be found in Spanish fleets, and eventually, under the leadership of the Masibradi family from Ragusa, served as an important unit in the Atlantic fleet.[42]

None of this calls in question the outstanding effort made by Spaniards in the 1630s and 1640s to defend the empire. In that decade the nations of the peninsula, among them the Valencians and Basques, sent considerable numbers of men to serve the crown. Aragonese sent more men than ever before to serve abroad in Germany and Italy. 'In over a century', commented the Castilian diarist José Pellicer, 'no one has seen so many Spaniards together on campaign.'[43] He estimated (there is no reason to trust his figures) that around 133,000 Spaniards were serving at that date in the various war zones of the world monarchy.

The global struggle involving Spain became even more acute after 1635. That year, as we have seen, the German leaders tried to bring peace to their own nation. One indirect consequence was the declaration by France of war against Spain. In the same year, in Asia there was a reaction against the Iberians. In Japan the Tokugawa shogun Iemitsu (1623–49) issued a decree prohibiting trade to the south and the east, and his country retreated into a period of isolation (the *sakoku* or 'closed country' era). Ever since the 'expulsion of the Bateren' in 1614,

the Catholic community in Japan and the trading interests connected with them had been under pressure from the Shogunate. The persecution of Christians began in the year that Ieyasu (see Chapter 4) died, 1614, and reached its peak in 1622 with the execution of fifty-five Christians at Nagasaki. The remaining Spaniards were expelled three years later.

The continuing strength of the Christians, however, surfaced during the great Shimabara rebellion of 1637 in Kyushu, in which the rebels marched with banners extolling the Virgin Mary. Their forces, some thirty-seven thousand, were besieged in April 1637 and brutally massacred. The repression was beneficial to the Spaniards, for the size of the uprising forced the Japanese authorities to cancel any ideas about invading Luzon.[44] In 1639 what remained of the Portuguese community in Japan was also driven out. The seriousness of the situation was amply demonstrated by the savage reception given the next year, 1640, to an embassy of merchants sent by the Portuguese of Macao. All the members of the embassy were on their arrival immediately seized and beheaded. By 1644, when *sakoku* was in force, not a single Jesuit, native or foreign, remained in Japan. The indigenous Christians were ferociously persecuted. Some three thousand Japanese Christians were put to death. By 1660 there were virtually no Christians to be found in Japan.

The position of the Spaniards in East Asia had deteriorated rapidly after the entry of the Dutch into those waters. Portugal, which had played so brilliant a role for over a century in exploration, trade and missionary activity, was completely unable to defend its scattered outposts in Asia. The Dutch took over their position in Ceylon in 1630, and in Melaka and Taiwan in 1641. The council of Portugal, the advisory council set up for that realm in Madrid, urged the king to divert more resources to Asia. But the Spaniards were powerless to help.

Their vulnerability in Asia may be seen in the case of Taiwan. The island's key position on trade routes made it the objective of efforts by outsiders – Japanese, Chinese, and Portuguese – to establish bases there. In order to break into the Portuguese trade with Japan, the Dutch in 1624 seized the harbour at Tayovan on the south coast of the island. Two years after they had done so, the Spaniards of Manila landed soldiers at Keelung harbour on the northern tip of Taiwan.[45] On a little island in the harbour they constructed the fort of San Salvador, a useful

base from which to protect the trading route between Manila and Japan. They felt, with an eye on Japan, that it could also serve as a point of departure for Spanish missionaries. Since the isolated fort did not give sufficient protection, in 1628 they sent a unit to occupy the coast of the adjacent tip of Taiwan, at Tan-shui. There they built a mission where a Dominican, Jacinto Esquival, wrote the first 'vocabulary' of the local language. The settlement later developed a school for the children of Taiwanese natives and of Japanese settlers. However, the Taiwan settlements were not economically viable and Manila soon reduced its support. In 1640 the Keelung garrison numbered no more than fifty Spaniards; in addition, thirty Taiwanese, two hundred slaves and one hundred-and-thirty Chinese soldiers brought the total force to around four hundred.[46] It was not difficult for the Dutch, who had been in northern Taiwan since 1626, to capture Keelung in August 1642 and bring the Spanish presence on the island to an end.

The formal entry of France into the war in Europe appeared to pose serious problems for Spain. But for many years the French had already been financing and supplying the enemies of Spain, and the long-expected declaration did not change the real military situation, which continued to be favourable to the Habsburgs. Moreover, a few days after the French declaration of war the leading German Protestant princes agreed with the emperor Ferdinand II (Peace of Prague, 30 May) to cease supporting the Swedes and to withdraw from the conflict. Spain could consequently count firmly on the military support of the emperor. Entry into a state of war with its traditional enemy the French was for Spain a solemn moment, but by no means a disturbing one. French military potential was undeveloped, there was no organized army and few resources were available to wage a sustained war. The Spanish, moreover, were in the unusual situation of enjoying a naval alliance with one of their inveterate enemies, the English. In August 1634 the Spanish ambassador in London, Necolalde, signed a treaty with the government of Charles I which guaranteed English neutrality in any conflict with the Dutch. Olivares was overjoyed to obtain such backing from a nation he considered to be 'masters of the world's trade'. English support, which lasted until the outbreak of the Civil War in that country, turned out to be very useful. Spanish vessels could shelter in English ports from Dutch pirates, Spanish silver could be transported by land

through England, and even Spanish troops could use the same route. A veritable 'English Road' had been created to make up for loss of the 'Spanish Road' through Savoy.

After the victory at Nördlingen, the immediate priority was to restore initiative to the forces in the Southern Netherlands and recover some of the strategic fortresses that had recently been lost to the Dutch, such as Maastricht, Wesel and 's-Hertogenbosch. The position in those provinces was almost immediately and drastically changed by the French declaration of war. A month after it, in June 1635, French and Dutch armies simultaneously invaded the Netherlands. The invasion petered out, and in response the army of Flanders in June the following year, with eighteen thousand men under the cardinal infante and including an Imperial contingent, invaded France. The offensive was not intended to open up a new military front, for Spain's strategy was still at that moment concentrated on the Rhine and against the Dutch.[47] Surprisingly, however, it succeeded. The army pushed southwards up the valley of the Oise and by August had reached the fortress of Corbie, a few miles from Paris, which it took after a week's siege. There was panic in the French capital, and the royal family was evacuated. Just over a month later a Spanish force that had crossed the Basque frontier captured the border town of St Jean-de-Luz.

It was a short-lived success. The French recovered Corbie in November and St Jean-de-Luz a few months later. But the success of the army of Flanders threw into relief the crucial role that Belgium was now playing in the defence of the Spanish empire. In 1628 it was calculated in Madrid that Spain was paying two-thirds of the cost of the war in Flanders, and the southern Netherlands one third. The Flanders' one-third was a high proportion for a country that had been at the centre of conflict for sixty years, had seen its industry ruined and its fields laid waste. This did not seem to deter the Netherlanders. When the cardinal infante took over, he continued the archduchess's tendency to take an independent line. He backed the proposals made in 1636 by a group of Belgian financiers, led by van Hoelbeeck, to take over part of Spain's war financing and in that way avoid having to rely perpetually on the Genoese. The proposals would involve contact also with Dutch financiers. It was a daring idea, which called for secret collaboration with the 'rebels', but it could lead to splitting the Dutch from the French. It would unavoidably mean having to overlook the 'heresy' of the Dutch

collaborators. The cardinal infante was in favour, and in January 1638 wrote to Philip IV suggesting that 'toleration is the lesser evil' and could be a positive way forward. He repeated the idea in several other letters, and unilaterally suspended persecution of Protestants in parts of the Southern Netherlands.[48] The proposals were never put into effect, but they cleared the way for the adoption by Spain of a more pragmatic attitude to the Dutch, one that very soon became reality.

The successes of the cardinal infante were soon checked by the resolve of the Dutch and French to bring an end to the destructive activities of the corsairs operating from Dunkirk. In May 1637 the Stadholder Frederick Henry prepared a large force with the intention of attacking the port, but was unable to embark his men because of unfavourable winds and finally had to abandon the effort. He thereupon changed the objective, and in July gave orders for the army to set out for Breda. The fortress was considered a symbol of power, especially since its capture by Spinola and the army of Flanders twelve years before, since when its defences had been considerably strengthened. With its garrison of four thousand men, it was considered impregnable. Frederick Henry prepared for a difficult siege, and dammed the river in order to flood the country-side around; English and French forces were entrusted with holding the lines to the south. The cardinal infante brought his troops up but could not approach the city, and was forced to attempt diversionary attacks. After a resistance of eleven weeks the fortress, which had been subjected to a massive bombardment and where only half the garrison still survived, capitulated in October 1637.

The subsequent months were anything but successful for the Franco-Dutch troops, for the army of Flanders lived up to its reputation as a fighting force. At this stage, in 1638 the French took the decisive step of invading the Iberian peninsula through the Basque provinces, always an easy target. When the forces under Condé invested the fortress of Fuenterrabía, the government in Madrid made a frantic attempt to round up soldiers from the peninsula. Olivares also ordered the naval forces at La Coruña, then being prepared for Flanders under the command of Admiral Lope de Hoces, to give support by sea. Unfortunately, a French squadron of forty-one vessels commanded by the soldier-archbishop of Bordeaux, Henri, cardinal de Sourdis, trapped Hoces's ships in the bay of Guetaria, near San Sebastián, on 22 August 1638. Of all the Spanish vessels, one galleon managed to escape but eleven were

destroyed including Hoces's own command ship (the admiral had to swim ashore). Only one quarter of the four thousand men on board the fleet survived.[49]

Shortly after this naval disaster the Habsburg cause suffered another major reverse in the land war. Spain had hitherto relied for the security of its troop movements on the protection offered by the Imperial fortress of Breisach, on the Rhine. In August 1638 France's ally Duke Bernard of Saxe-Weimar, commanding a Franco-German army, laid siege to the fortress, which was starved into surrendering in mid-December. Cardinal Richelieu had always considered the taking of Breisach a fundamental prerequisite of the campaign. It commanded not only the traditional 'Spanish Road' taken by Spanish troops coming north from Milan, but also the route followed by troops that made their way to the Rhine through the Holy Roman Empire. With Breisach in French hands, Spain's overland route to the Netherlands was definitively closed. There remained only the sea route through the Channel.

That too was closed the year after.

In September 1639 the Spanish government, resorting as in 1588 to the tactic of irresistible naval force, managed to put together a massive fleet of around a hundred vessels, including some seventy warships and about thirty transport vessels of English and German origin.[50] The warships included twenty-one Belgian vessels, and ships from Lisbon, Naples, Cadiz, Galicia and the Basque country.[51] The fleet, carrying twenty-four thousand sailors and soldiers under the overall command of Admiral Antonio de Oquendo, had instructions to go to the relief of Dunkirk. Oquendo's most outstanding previous action had been as commander of the Portuguese-Spanish armada sent from Lisbon in 1631 to retrieve Pernambuco from the Dutch. For that expedition he had two thousand Portuguese, Italian and Spanish troops on board. In an engagement off the coast of Brazil both Oquendo and the opposing Dutch fleet suffered heavy losses, and only one third of the admiral's men reached shore. It was not a promising precedent.

No sooner had Oquendo entered the Channel in 1639 than he was sighted at nightfall on 15 September by a small group of thirteen ships under the Dutch admiral Tromp. Unwilling to risk anything, Oquendo took shelter off the Downs, along the cliffs between Dover and Deal, where he was kept under observation by a small English squadron, anxious to preserve English neutrality. While Oquendo waited, the

Dutch in their enthusiasm for the expected conflict volunteered ships and men to aid Tromp, who within three weeks found himself at the head of an impressive force of 105 vessels. On 21 October Tromp's fleet entered English waters, thereby violating the neutrality on which Oquendo had relied, and attacked with devastating results. The Spanish admiral attempted, as the Armada had done in 1588, to come to grips with the enemy. Tromp, however, avoided this and kept his ships at artillery range, then at the opportune moment sent in his fireships. Some thirty Spanish galleons were destroyed, together with one quarter of the military force accompanying the fleet.[52] The survivors, including Oquendo, managed to make it to Dunkirk. The battle of the Downs was historic: the Dutch celebrated it as a supreme achievement, and historians have claimed that it marked the end of Spanish pretensions to naval power in Europe. For Olivares it was a calamity that (he said) 'strikes the heart'; it certainly destroyed the reputación of Spain. A Spanish officer who fell into Dutch hands wrote home that the Dutch were 'better sailors' and 'could do with our ships whatever they wanted, just as in 1588'. It was only the first of the naval reverses that occurred during these months. In the early weeks of 1640 a large Portuguese-Spanish fleet that had set out under its commander Da Torre in 1638 with the intention of expelling the Dutch from Brazil, was surprised, defeated and dispersed near Pernambuco by a Dutch squadron less than half its size.

It is possible, according to one estimate, that the Spanish navy between 1638 and 1639 lost close to one hundred warships, ten times the number of ships it was to lose at the battle of Trafalgar in the early nineteenth century.[53] These apparently bleak figures, however, obscure a perspective that is little less than astonishing and sheds enormous light on the nature of Spanish power. In the seventeenth century, Spain could still draw on the resources of the member states of the world monarchy. With extraordinary speed this battered but still persistent nation returned to the fray, refusing to face the realities of its position. News of the disaster at the Downs reached Madrid on 15 November 1639. Immediately the government sent out orders to acquire with all haste ships, cannon and sailors from the four points of the compass.[54] Supplies were demanded from Naples, Sicily, Genoa and Tuscany, and the galleys available in Italy were given orders to bring all that was obtained. The cardinal infante received orders for the purchase of warships from the Dutch (the

enemy!) and from the Hansa. It was the first concrete sign that Spain had decided to come to terms with the Dutch. The kingdom of Naples was asked for six thousand infantry, eighteen galleys and quantities of gunpowder. Early in 1640 Oquendo returned to Spain from Flanders, in a fleet that included four new warships built in Dunkirk shipyards. The capacity of Spain to draw on global resources can only give rise to awe. No other nation on the face of the earth had such potential at its disposal.

At the same time, no other nation was as incapable as the Spanish of recognizing that its power was deceptive, and rested largely on the ability of others to come to its aid. In official circles, defeat was unthinkable. A leaflet issued in Seville shortly after the battle of the Downs celebrated 'the great victory'; and fifty years later Oquendo's grandson was granted a marquisate to honour the 'great naval victory' won by his grandfather. It is obvious, of course, that the Downs was no victory, but neither was it the end of Spanish naval power, which continued (as long as the money did not run out) to rely on the resources of its partners in the empire.

The French invasion of the Spanish peninsula reaped its greatest successes with intervention in Portugal and Catalonia. In 1639 Olivares deliberately chose Catalonia as his main war front and centred attention on the French siege of the border fortress of Salses, which was finally recovered in January 1640 after a late rally by the Catalans. Feeling that the initiative should not be lost, Olivares decided to billet in Catalonia an army of nine thousand men, in preparation for the new campaign. The Catalans had refused to take part in the Union of Arms, and he saw no alternative to relying mainly on Castilian troops. 'With their present attitude', he observed, 'the Catalans are of no help to the monarchy, serving it neither with their persons nor with their goods.'[55] There were clashes between peasants and soldiers throughout the province, and in February the viceroy accused the Catalan governing authority, the Diputació, of 'deliberately stirring up the people and attempting to destroy the army'. A wave of social disorder overtook the principality. On 7 June, the feast of Corpus Christi, a group of Catalan insurgents disguised as reapers entered Barcelona, provoked a riot, drove the viceroy out of his palace and murdered him on the beach as he was trying to escape on a galley. Led by Pau Claris, canon of the see of Urgell, a

section of the Diputació that had no wish to negotiate with Madrid began talks with the French. 'Without any sound reason or justification', lamented the count duke, 'the Catalans have launched a rebellion as complete as that of Holland.' In January 1641 the rebels transferred the title of count of Barcelona from Philip IV to Louis XIII, thereby putting themselves under the crown of France.

Contemplating events in the principality, the historian Gil González Dávila wrote to a friend in Aragon: 'The view of discerning people is that Catalonia will be the Flanders of Spain, putting an end to what little remains of life and substance in it. We had the gout in our lower parts [that is, the Low Countries] and could not get rid of it. Now we have it in the head. When will we be cured?'[56] The next ten years were traumatic ones for Catalonia. In 1642 the French occupied Rosselló. This time it was permanent. The sufferings and expense of war rapidly disillusioned the Catalans. When Juan José de Austria recovered Barcelona in October 1652 they were ready to accept his conditions. The Catalan revolt brought about the fall of Olivares and contributed to the collapse of Spain's military hegemony. Catalonia north of the Pyrenees was lost for ever after the treaty of the Pyrenees in 1659, and the aspiration for unity within the peninsula vanished definitively with the successful revolt of Portugal.

This revolt had little in common with that of Catalonia. The long association of Portugal with the great Spanish empire should in principle have brought considerable benefits. Despite its pioneering role in world exploration and trade, however, the country remained in 1640, after a century and a half of enterprise, a poor and undeveloped land. Many Portuguese found an easy answer for this situation, and blamed the Castilians for all their ills. They lived under the illusion, which happened to be even more prevalent among Castilians, that empire brings wealth and success. When this did not happen, they moralized about the evils of the Habsburg era in their history (1580–1640) and pointed the finger at Spain. Even in the midst of the feeling of triumph engendered by the recovery of Bahia in 1625, the commander of the Portuguese fleet, Manuel de Meneses, complained of 'the hatred of the Castilians for the Portuguese, which they demonstrate in everything, though never publicly'.[57] In reality, Portugal's empire had been not much more than a passing dream of greatness. Asian trade consisted of luxury items that could not stimulate either industry or agriculture at home, and the

profits of the merchant community in Asia were not reinvested in the domestic economy.[58]

On one important point, the inability of Spain to offer protection against the Dutch, the Portuguese were fully justified in their complaints. The return to a state of war between Spain and the Dutch in 1621 emboldened the latter to extend their hostilities very effectively against vulnerable Portuguese interests in Asia and Brazil. In 1605 the Dutch, as we have seen, tried to displace the Spaniards and Portuguese in the Maluku archipelago. They began extending their control of Brazil from the base they had established at Pernambuco, and in 1637 (as we have seen) captured the African slave port of São Jorge da Mina from the Portuguese. In the 1630s the governor of Batavia, Antonie van Diemen, had at his disposal over eighty war vessels, which he used effectively to blockade Portuguese shipping at Melaka and Goa.[59] 'Our blockade', he reported with satisfaction in 1636, 'is undermining the trade of Melaka, and in consequence the trade of Batavia increases daily.' The final coup was given when in 1640 with the help of native allies he mounted a full-scale siege of Melaka, which was obliged to surrender to the Dutch in January 1641.

The union of the crowns seemed to have little to offer to the Portuguese, and war with France raised tensions to a critical point. Olivares's attempt to raise more taxes provoked riots in 1637 in Evora and other cities. When the Catalan revolt broke out the Portuguese nobility were, like the Castilian, asked to serve on the Catalan front. In reply, the Portuguese staged an uprising in Lisbon in December 1640, and proclaimed the duke of Bragança as king under the name of João IV. Active French support, both naval and military, was an immense help; but national energy alone can explain subsequent victories against the Dutch in Brazil and the Spanish in the peninsula. Finally, in 1668 Spain recognized the independence of Portugal. Olivares had observed at the end of 1640 that 'this year can certainly be considered the worst this monarchy has ever experienced'. But there were further shocks to come, and not only from Portugal. There was an attempt at secession in Andalusia in 1641, and a similar plot in Aragon in 1648. They were symptoms of the dissatisfaction of local élites with the policy of Castile, and have their parallel in the revolt in 1647 of Naples, a revolt that threatened to shatter irreparably Spain's empire in the Mediterranean.

*

One of the most fundamental aspects of the empire had been its relationship with the Portuguese. The Portuguese pioneered all the ocean routes and initiated all the colonial economies that the Spaniards later developed; Spanish progress in these areas is therefore almost indistinguishable from the contribution made by them. The cultivation by Portuguese of sugar in the Atlantic islands and then in Brazil, was echoed by Spain's production of sugar in the Caribbean. In the same way the resort to African slavery, later to be used also by the Spanish, gave Portugal an advantage that it never lost. Indeed, even when the slave trade was formally in the hands of others it was the Portuguese who carried off the Spanish American gold and silver to pay for the slaves. It was Portugal that established the European spice trade in East Asia. After the union of the crowns of Portugal and Spain in 1580, therefore, Spain found itself in the difficult position of having to respect Portuguese primacy in major areas of commercial enterprise. Philip II promised the Cortes at Tomar in 1580 that he would scrupulously preserve the independence of his new realm. The monarchy, he stressed, was a union of free and autonomous states that operated separately. There is no doubt that the king did his best to maintain the autonomy of Portugal. In practice, however, the interests of Spain and Portugal became closely intertwined, thanks in good measure to the Portuguese financiers who entered the service of the Spanish crown.

Through their control of the slave trade, the Portuguese made important inroads into the economy of Spanish South America. In 1588 it was reported that in the trade through Buenos Aires, 'every day [not to be taken literally] Portuguese vessels come with blacks and with merchandise', and a few years later a decree stated that 'through the Río de la Plata goods from Brazil enter and foreigners pass through, without anyone bothering to do anything to stop it'.[60] In those years the Portuguese were in fact trading freely throughout the Atlantic coasts of South America, despite theoretical prohibitions.

Like the Spaniards, however, the Portuguese in the new joint empire had to compete with outside finance. Italian financiers had already been prominent in contracts for trade with Asia. When Philip II in 1586 launched a new scheme to import spices from India, he granted the contract to a consortium headed by the German companies Fugger and Welser, with the Italian financier Rovalesca playing a prominent part.[61] Nevertheless the Portuguese financiers managed to hold on to what was

(thanks to the English and Dutch) a declining trade in spices. Many of them became resident in India, in the Portuguese metropolis of Goa. The most prominent of them were New Christians,[62] that is, they were of Jewish origin. Their economic power helped to allay constant suspicions of their religious orthodoxy. Indeed by the end of the sixteenth century they were the financial mainstay of the Crown of Portugal, both at home and in Brazil and Goa. During the truce with the Dutch, which facilitated peaceful commerce in Europe though not outside it, New Christians and their Jewish contacts in Amsterdam extended their control over some sectors of Spain's commerce.[63]

In a memoir sent by them to Philip IV in the 1620s they claimed that they were the chief support of the Spanish-Portuguese monarchy, 'sending to the East Indies countless ships laden with merchandise, whose customs duties maintain the navy and enrich the kingdom; supporting Brazil and producing the machinery to obtain sugar for all Europe; maintaining the trade to Angola, Cape Verde and other colonies from which Your Majesty has obtained so many duties; delivering slaves to the Indies for their service, and journeying and trading from Spain to all the world'.[64] In effect their contribution was important, though impossible to quantify. For a considerable period, from 1626 to 1640, thanks to the patronage of the count duke of Olivares they also managed to obtain a privileged position as bankers of the Spanish crown in its seat at Madrid. The Portuguese penetrated the economies of Peru and New Spain, and in Asia improved their links with the Spanish traders of Manila.[65] They were few in number, and controlled only certain sections of Spain's enterprises, but their activities confirm the dependence of Spaniards on the necessary services of other nations. For three-quarters of a century, until the coming of the Bourbon dynasty, Portuguese financiers of Jewish origin continued to play a crucial role in supplying the capital that helped to run the state tax system and the provisioning of the army and the navy.

In particular, during the key decade 1631–1640 they underwrote Spanish imperial power,[66] sharing with Genoese and German bankers the financing of the armies in northern Europe and the navies in the Atlantic. During the fifteen years from 1626, the year of their first great arrangement with the crown, to 1640, when Portugal declared its independence, the total value of the contracts signed by Portuguese financiers with the crown exceeded forty million ducats.[67] The greater

part of this sum went to other banking centres in Europe to meet government expenses, over forty per cent of it to the city of Antwerp. The financiers were not merely concerned with the official business of the crown. They also participated in all aspects of peninsular trade and the trade to America. In 1640 there were said to be two thousand Portuguese resident in Seville alone, though the richer financiers tended to reside in Madrid, where they had more immediate access to the royal court. There were, moreover, many Portuguese merchants resident in the Spanish territories of South America; both directly and through their contacts they played a prominent role in the trade of the Pacific, the Atlantic and the growing colony in the Río de la Plata.[68] Their wealth and influence in Peru was such that nobody could touch them except the Inquisition, which was used to prosecute them for overtly religious reasons: a bloody auto de fe in Lima in 1639 was the result. In Spain the Inquisition was also used for the same purpose a decade later, though informed opinion knew very well that the real motive was not religious but economic.

The separation of Portugal from Spain in 1640 and the fall from power of Olivares had as one consequence the disgrace of Portuguese financiers in Spain. Many of them left the country, fleeing in some cases from the Inquisition. They also transferred their assets from the peninsula to northern Europe, principally Amsterdam, thus depriving the Spanish crown of their services and resources. There was a reaction against them in New Spain, where they had significant business, and the Inquisition arrested several. In Portugal, to make matters worse, the new regime arrested and in one case executed financiers who were too closely identified with the Habsburg regime. The famous Spanish asiento for supplying African slaves to America had been before 1640 in Portuguese hands. It was now suspended for over twenty years, until 1662.

The Spanish crown, of course, was not interested in victimizing the Portuguese, many of whom had long been resident in the country and continued to offer their services to the state. In 1641 a government official admitted that 'there would be no other bankers to whom one might entrust the provisions [of cash] in Flanders, if it were not for the Portuguese'.[69] Despite their help, the government found it difficult to keep up with its debts, and in 1647 declared yet another suspension of payments. Of the thirty-three financiers mentioned by name in the

decree, three were Genoese, one Florentine, one Belgian, one English and twenty-seven Portuguese, a measure of the international network that backed up the monarchy and of the preponderant role played in it by the Portuguese. However, they were on their way out. Isolated from the new independent Portugal, they also suffered from the steady collapse of Portuguese mercantile interests in Brazil and East Asia. Under the last Habsburg king, Charles II, they maintained their role in public finances, but at a more subdued level. They continued for instance in 1682 to control the slave asiento to America, but had to do it from Cadiz.

Spain's enemies, first the Dutch and then France, did not forget the Mediterranean in their efforts to destabilize the monarchy. The task was not difficult, for after nearly two centuries of Spanish predominance few themes united Italians so much as the desire to rid themselves of their unwanted masters. In Naples and in Sicily the French helped provoke and actively supported two major rebellions against Spanish power. In July 1647 in Naples the fish-vendor Tommaso Aniello, popularly known as Masaniello, led an insurrection that was ignited by rumours of new taxes and that quickly gained wide support. Unlike previous riots of this type, the Masaniello movement managed to build on an anti-Spanish resentment felt by all classes, in both city and countryside. Without adequate means to repress the rising, the viceroy fled the city. The leaders of the revolt, relying on French help, in October declared themselves a republic independent of Spain. But the French, represented by the duke of Guise, failed to live up to their promises, and by April 1648 the Spanish were back in control. The Naples revolt exposed the weakness of Spanish rule and augured the beginning of the end of Spain's power in Italy. It was accompanied in the same year of 1647 by a serious revolt in Palermo that confirmed the alienation of the ruling classes in Sicily. When Vesuvius erupted in 1649, it was taken as a sign from heaven. 'This eruption of Vesuvius', announced a Sicilian friar, Camillo Tutini, 'is a signal for the expulsion of the Spaniards from the kingdom and their total elimination.'[70]

The problems of southern Italy had always been grave, and Spanish rule had not significantly improved matters. There was, however, similar disenchantment in Milan, where the Thirty Years' War dragged the province yet again into war and aggravated discontent. The highest

circles of the patriciate in Lombardy had successfully identified their careers with the Spanish presence, but they did not cease to complain of the cost of the war against the French. Their letters to Madrid in the 1640s affirm explicitly that the worst enemy of the people was the army that served in theory to protect them, whose departure for the front every year was treated as nothing less than a liberation.[71] Quite apart from dissatisfaction in their own territories, the Spaniards had to reckon with the hostility of the major states of the Italian peninsula. Around 1650, according to the Spanish governor of Milan, one had to deal with the scheming of the republic of Venice, the efforts of the papacy in Rome to ensure 'that Spain's monarchy does not expand in Italy or any other part of Europe', the enmity of Savoy, and the unreliability of the states of Cremona, Tuscany and Mantua; of all the Italian princes only the duke of Parma could be trusted.[72]

In November 1641 the cardinal infante died of smallpox at the early age of thirty-nine. During his short career he had done more than any commander since Spinola to maintain the power of Spain in northern Europe. Command of the army of Flanders devolved on to a new governor of the Netherlands, Francisco de Melo, marquis of Tordelaguna, a Portuguese soldier who had served Spain with distinction as viceroy of Sicily, ambassador to Germany, and colleague of the cardinal infante in the government at Brussels. In the spring of 1642 he led his men successfully against the French forces in the south of his territory, defeating them at the battle of Honnecourt, which he described to the king as 'the most signal victory of our times'.

The following spring, 1643, he took the entire army, some twenty-five thousand strong, across the border and laid siege to the French town of Rocroi, in the Ardennes on the road to Champagne. His chief commanders were the count d'Isembourg, the count of Fuentes and the duke of Alburquerque. On 18 May the French army on the Netherlands front, consisting of twenty-three thousand men commanded by the twenty-one-year-old duke d'Enghien (who was substituting at the last minute for Louis XIII, then gravely ill), arrived on the scene and at once attacked. The engagement proved indecisive, and was called off for the night. On receiving information that the enemy would be receiving reinforcements at ten o'clock the following morning, Enghien decided to give battle before dawn the next day, the 19th.

'The armies were large,' reported the French newsletter *Le Mercure françois*, 'the shock of their encounter was great, the stubbornness with which both sides resisted was scarcely credible, the outcome was miraculous.'[73] In the ensuing combat the Flanders army was annihilated, and Melo's infantry were scattered. The last resistance came from the tercios, in which the Italian, Spanish and Belgian units were virtually destroyed; a remaining German tercio arrived too late to be of use. 'Six thousand Spaniards were slain', stated the *Mercure françois*, '5,737 were made prisoner. The booty taken by the French consisted of the baggage of the entire army, twenty cannon, 172 banners, fourteen standards and two pennants. But the French lost two thousand men killed.' Enghien himself was lightly wounded, while on the opposing side the count of Fuentes was killed. For the first time in its history, Europe's most élite military machine had been smashed. The defeat shattered the legend of Spanish invulnerability and brought utter gloom to the government in Brussels. 'The truth is', a depressed Melo reported to Philip IV, 'that we did not take the war seriously enough. But war is real, it makes and breaks empires.'[74] Spain's chief minister commented some months later that 'it is a matter which I never bring to mind without great melancholy'.[75] In perspective, non-Spanish historians tended to see it as the end of Spain's imperial power. This is possibly an over-dramatic interpretation of an event that certainly influenced the campaigns of the next few months in the north, but – like the battle of the Downs – had no significant impact on the resources of the empire.

Rocroi, certainly, gave an initiative to the victorious French forces that they did not lose. The next year Cardinal Mazarin, successor to Cardinal Richelieu, put an even more capable commander at the head of the troops on the Rhine. This was Marshal Turenne, at the time France's most distinguished soldier, and, by a strange irony for Spain, grandson of the hero of Dutch freedom, William of Orange. By September 1644, thanks to the co-operation of two armies led by Enghien and Turenne respectively, the whole left bank of the Rhine from Breisach to Coblenz, a route fundamental to Spain for the movement of troops from Italy, was in French hands. The following year the two generals, again working jointly, defeated the troops of the Emperor at Allerheim, near Nördlingen, on 3 August 1645. Sometimes referred to as the 'second battle of Nördlingen', it could be seen as a revenge for the first one; but it was a pyrrhic victory, for French losses were heavy. Over the same

years France's Dutch allies had also been collaborating in the campaigns. Admiral Tromp's fleet was in effective control of the Channel, cutting off by sea the only other route available for sending troops to the army of Flanders from the Mediterranean. In September 1646 the key port of Dunkirk, which for over a decade had been the centre of the deadly naval attacks directed against the Dutch, surrendered to the French army under Enghien and the Dutch navy under Tromp.

The war in northern Europe and Germany was for all practical purposes over. In reality, overtures for peace had been made long before, throughout the 1630s. In 1641 the French envoy, d'Avaux, proposed that talks be held in two contiguous cities of Westphalia, Münster and Osnabrück; the French would conduct their negotiations in the former, the Swedes in the latter. The congress formally began in July 1643, but the French delegates did not arrive until 1644 and the congress did not begin to function properly until 1645. Talks between Spain and the Dutch United Provinces were held in Münster, where the Spanish delegation arrived in 1645, under the leadership of the count of Peñaranda, Gaspar de Bracamonte. The true brains of the delegation, in reality, was the Franche-Comtois humanist Antoine Brun, who undertook most of the negotiations with other delegates and took charge of the arrangements for signing the peace. The Dutch could not have asked for a better negotiator than Peñaranda, who was of the opinion that concessions to the Dutch would not only gain their friendship but even convert them into powerful allies for the struggle against France. On 8 January 1647 all the Spanish and Dutch delegates, with the sole absence of the representative of the province of Utrecht, signed the peace agreement. The official signing of the treaty took place in the townhall of Münster on 30 January 1648.

The treaty recognized the United Provinces as a sovereign state and accepted the conquests made by the Dutch in the Netherlands. The Dutch gave no guarantees of religious freedom for the Catholics in the Provinces, and were confirmed in possession of the territory they had taken from Portugal in Asia and America. The fate of the River Scheldt, on which the trade of Antwerp depended, was left out of the deliberations; and Dutch trade to Seville and America was implicitly accepted. On every single point in dispute, Spain gave way to the Dutch. In 1646 Antoine Brun was received in The Hague as Spain's first ambassador to the free United Provinces. One year after Westphalia the Spaniards in

Manila, still unaware of the peace, attacked the Dutch post at Ternate. It was the last battle between the two world powers.

The peace agreements at Münster and Osnabrück involved all the parties that had participated in the conflict in Central Europe, and slowly but surely helped to bring peace. Despite the treaties of Westphalia, which made a fundamental impact on the politics of Europe for nearly a century, the war between Spain and France still went on, though in a lower key. France was suddenly removed from the front line of conflict by serious domestic troubles at home, in the shape of the political troubles known as the Fronde, which from 1648 to 1653 engaged the attention of the military forces of the government in the areas of Paris and of Bordeaux. Despite enormous war debts, Spain was able to continue the war effort thanks to its two constant resources: loans from bankers – mainly Italians and Portuguese – and the manpower of the armies of Flanders and Milan. There was, however, inevitably an impact on the government in Madrid, which was faced with spiralling costs it could not control. A grim Philip IV informed the Cortes of Castile in 1655 that in the six years 1649–54 he had spent nearly sixty-seven million escudos on the wars,[76] and that the enemy despite everything refused to come to terms.

In reality the financial position was only one side of the picture, for on the military side there were many reasons for optimism. In October 1652 the Spanish army under Don Juan José of Austria recovered the city of Barcelona. In the same year the army of Milan finally secured the fortress of Casale, and in the Netherlands the army of Flanders, commanded for a while by the most famous general of his day, the prince of Condé (the famous victor of Rocroi, who succeeded later to the family title of Condé and had now been forced into temporary exile by Mazarin), recovered Gravelines, Mardijk and Dunkirk. The event that interrupted these successes and completely turned the balance of power against Spain was the intervention of England in its new role – it had just defeated the Dutch in a short war in 1652 – as a sea power.

Inspired by a 'western design' to dominate the Caribbean and 'to strive with the Spaniard for the mastery of all those seas', the Lord Protector of England, Oliver Cromwell, at the end of 1654 dispatched a small fleet to the West Indies with the aim of seizing Hispaniola. The expedition was a failure, and succeeded only in occupying Jamaica. The

action precipitated a break with Spain, which neither expected nor wished for a further conflict but after much hesitation was obliged in February 1656 to declare war. The main English squadron in Europe, commanded by Admiral Robert Blake, now approached the Mediterranean and threatened Cadiz. A small group of Blake's ships in September successfully seized the two principal vessels, worth two million pesos, of the incoming silver fleet. In April 1657 his main force surprised the remainder of the silver fleet sheltering in the harbour of Santa Cruz in Tenerife, sailed in with the tide and destroyed every vessel. The Spaniards managed to save only part of the treasure. There were no further silver fleets for two years, a calamity for imperial finances. Moreover, England in March 1657 signed a treaty of alliance with France. The result was a series of land campaigns in the Southern Netherlands that climaxed with the historic defeat of the army of Flanders at the battle of the Dunes on 14 June 1658. The victorious general was Turenne, whose army included six thousand Roundheads from Cromwell's New Model Army. It was the swan song of Spain's military power in Europe. The French conquered Gravelines, Oudenarde and Ypres. It was a series of disasters that brought to an end Spanish supremacy in the Southern Netherlands, and forced Philip IV to seek peace.

A truce was agreed in March 1659 and peace talks began. Finally, on 7 November the Peace of the Pyrenees was signed on an island in the river Bidasoa, on the frontier between Spain and France. All Catalan territory north of the Pyrenees was absorbed permanently into France. The most important territorial changes occurred with the Belgian frontier, where France gained a broad belt of forts that extended from Gravelines, on the Channel coast, to Thionville, on the Moselle; at the same time France gave back some conquests in Belgium. A key clause of the treaty arranged for the marriage of the infanta María Teresa, daughter of Philip IV, to Louis XIV of France. The Peace of the Pyrenees marked the end of Spain as a great power in Europe.

There was still unfinished business, principally the war to recover Portugal. But changes in the balance of power in Europe now made that objective impossible. The rebels had the active help of France by land and England by sea; they also received supplies from the Dutch. 'Without strong naval forces the conquest of Portugal cannot be achieved',[77] the government recognized. But the sea was – after the battle of the Downs

– under English control. Moreover, an alliance between Portugal and England had been made in 1661, by which the English agreed to contribute two thousand infantry and a thousand cavalry until Portugal achieved its freedom. The Portuguese defeated Spain's land forces at the battle of Villaviçosa (17 June 1665), and in 1668 the government finally and formally recognized their independence.

The remaining decades of the century confirmed the growing power of France, which continued to eat away at the territory of states allied to Spain. It was a long history of wars, battles, annexations, and peace treaties that confirmed the piecemeal dismemberment of the once proud Spanish empire. And yet, despite everything, the empire stubbornly survived. It did so in great measure because it could, once again, count on the support of those who had done most to destroy it.

The least expected consequence of French aggression was an alliance between Spain and the United Provinces.[78] A *rapprochement* between the two antagonists had been developing for a long time. The Dutch were by no means friends of the Spaniards; on the other hand, they never ceased to be aware that ties of blood, language and economy bound them close to the Southern Netherlands. In the year of the great Armada, 1588, traders from Amsterdam were reported to be selling naval supplies to Brussels; at the end of the century Dutch ships were acquired for Spain's navy; during the years of war Dutch armaments were sold to the army of Flanders.[79] No sooner had the Treaty of Münster been agreed in 1648 between the Dutch and Spain than both sides found they had several interests in common besides the peace.

Throughout the eighty years of struggle, and despite the obvious points of conflict, a great many Spaniards had come to know and respect the Dutch people.[80] Officials and ministers in Brussels encouraged the *rapprochement.* A section of the Dutch leadership looked for trade advantages, while the Spaniards counted on help against the Portuguese, who were in rebellion against the Spanish crown and also intent on expelling the Dutch from Brazil. Spain valued Dutch naval expertise: immediately after the signing of peace in 1648, construction began at Amsterdam of twelve frigates for the Spanish navy.[81] The contact between both sides became closer when in the 1650s they found themselves at war against the England of Oliver Cromwell. In 1653 Peñaranda summarized what in his view were the relative merits of the two Prot-

estant powers: 'if I were to be asked which is the stronger and more solid power I would reply England under its Parliament; but if I were asked which is the better as friend, and offers both benefits and confidence, I would always reply Holland'. From 1656, when Don Juan José of Austria as governor of the Southern Netherlands opened negotiations with The Hague, the two former enemies drifted into a working alliance. A Dutch representative was in Madrid from 1656.[82] No sooner had France and Spain made peace in the Treaty of the Pyrenees in 1659 than the States General of the United Provinces sent a special diplomatic delegation to talk business with Madrid. One week before Christmas 1660, the Dutch ambassadors paid their respects to the Catholic majesty of Philip IV at the palace of Buen Retiro, addressing him in French while the king replied in Castilian. In that act, nearly one hundred years of conflict and mistrust between the two nations was undone.

The talks, however, were less about accords than about commerce. In effect, the United Provinces needed the support of the Spanish empire in order to maintain their own economy and protect themselves against the encroaching interests of the English and the French. And the Spanish reciprocated. Antoine Brun informed the Dutch Estates General in 1651 that 'nowhere in the world have your merchants and commerce received better welcome than in the territories of my master'.[83] From the 1650s Dutch commerce with the peninsula increased, and developed into a profitable trade to the Mediterranean.[84] They brought grain, fish, timber and naval stores from the north; in return they collected from the peninsula silver and more silver, with some wool, olive oil, wine and occasionally salt. They gained an advantage from Spain's wars against England in 1655–60 and against France in subsequent years, stepping in to trade in goods that were forbidden to nationals of these two countries. Dutch vessels carried most Spanish wool exports to northern Europe or to Italy. In subsequent decades the Dutch made available the capital required for financing the slave trade to America.[85] The Spanish empire, in its turn, benefited from the military protection of what was still the world's biggest maritime power. Dutch vessels escorted Spanish trading ships around the coasts to protect them against the enemy. The appearance in 1657 of sixteen Dutch warships at anchor in the bay of Alicante, Spain's largest Mediterranean port, was a sight that soon became familiar in the major ports of southern Spain. Spanish

merchants were happy to trade with their former enemies. 'All the English merchants upon the coast', reported an English official visiting Spain in the 1660s, 'complain of the Spanish partiality towards the Dutch.'[86]

In 1670 Spain confirmed its intention of reaching an understanding with the Dutch, who were now the chief guarantors of the integrity of the Southern Netherlands. In Madrid Peñaranda stuck firmly by the alliance, driving the English ambassador to observe that 'here they all desire extremely to assist the Dutch, and would do it without any hesitation even though the French were yet more powerful than they are'.[87] Unfortunately for the Dutch, their friendship with Spain was soon called upon. In 1672 two enormous French armies (some eighty thousand men under the command of Louis XIV and Turenne, and another thirty thousand under Condé) advanced from Charleroi and Sedan respectively and descended on the Provinces following the line of the Meuse. The French invasion, which had carefully avoided touching Belgian territory, helped to bring the Dutch and Spanish closer together, a policy which had been taken yet further in those years by Spain's ambassador in The Hague from 1671 to 1679, the brilliant diplomat and thinker Manuel de Lira. The desperate situation of the Dutch and the evident threat to the Spanish forced both to come at last to a formal agreement, which took the form of the Treaty of The Hague (30 August 1673).[88] True to its accord, Spain instructed its governor in Belgium, the count of Monterrey, to declare war on France that same month.

Though the Spanish government recognized that its presence in the Southern Netherlands was essential if it were to maintain its status as a European power, it had few resources in men or money with which to uphold that status. In 1664, when the number of effective Spanish troops garrisoned there barely exceeded six thousand, the new Spanish commander on his arrival was horrified to find that the men were (in his opinion) 'unclothed, unshod, dirty and begging'.[89] Thanks to the need for collaboration against a common enemy, the United Provinces managed to secure from Spain a concession that it considered absolutely necessary to its own survival. A limited number of Dutch troops were allowed to garrison select fortresses on the frontier between the Southern Netherlands and France. The defence of the most conflictive territory in the great Catholic monarchy was therefore, after the 1670s, left in the

hands of heretics and ex-rebels. At the same time, Spain's principal naval force in the Mediterranean was, as we shall see, entrusted to the supreme command of a Dutch admiral. It was perhaps the most astonishing development in the entire saga of the empire, which was now underpinned by the resources of nations that in former times had been its most bitter enemies. Dutch Protestant generals now commanded Spanish troops, and Dutch Protestant admirals directed the Spanish navy. In the Netherlands Spain put all its troops under the command of the prince of Orange, who declared that 'the foremost of my concerns is to find out how to prevent the Spanish Netherlands falling into the power of France'. In November 1673 the prince at the head of an army of Dutch and Spanish troops captured the Rhine fortress of Bonn, forcing the French to withdraw from Belgian territory. His forces then went on to distinguish themselves against the French at the battle of Seneff in August 1674.

Events in the Mediterranean were, however, uniformly disastrous for the Spaniards. In 1674 the city of Messina rose in revolt against Spanish rule.[90] Spain sent a fleet of thirty vessels to deal with the rebels, who were able to count on the support of France. A French fleet of twenty ships was sent to encounter the Spaniards, who on 11 February 1675 were defeated in an engagement off Lipari. The Dutch immediately despatched a naval force of eighteen warships under Admiral Martijn de Ruyter, their most prominent commander. They were not the best ships available, and De Ruyter was by no means happy with the commission. The French admiral Duquesne sailed from Toulon with twenty ships of the line and encountered the Dutch in January 1676 off Stromboli, forcing them to withdraw. Then on 22 April 1676 Duquesne engaged the joint Dutch and Spanish forces off Agosta in Sicily. In the ensuing action De Ruyter was mortally wounded and died four days later. The defeated Dutch-Spanish fleet withdrew for shelter to Palermo, but on 2 June the French sailed in and inflicted heavy losses on them. Twelve warships were destroyed, and both the Dutch commander Vice-Admiral De Haan and the Spanish commander Diego de Ibarra were killed in the action. The Dutch bitterly criticized the inadequacy of the Spanish navy, which they accused of having 'few ships, and those poorly manned'.[91] The decisive naval defeats converted the western Mediterranean into a French lake.

Alliance with the Dutch was of undeniable benefit to Spain but could

not stop the might of the French military machine, now the biggest in Europe. At the peace of Nijmegen (September 1678) which ended the war, Spain recovered some of its fortresses in the Netherlands but ceded to France Franche-Comté, Artois and several major cities including Cambrai. The loss of Franche-Comté, all that remained to the empire of the territory of medieval Burgundy, was a profound blow. The next two decades were ones of unremitting disaster. A short war in 1683–4 ended with the invasion of Catalonia and the cession to France at the Peace of Ratisbon (1684) of the duchy of Luxembourg. The subsequent major conflict, the Nine Years' War of 1689–97, was brought to an end by the Treaty of Rijswijk, in which Haiti (the other half of the island of Hispaniola) was ceded to France. In Europe, fortunately for Spain, the terms of the peace allowed Dutch troops to occupy and protect vital Belgian fortresses, such as Namur, against the danger of French invasion. The Catholic empire, wilting under the attacks of Europe's leading military power, took shelter under Protestant protection.

At the end of Philip III's reign, a naval officer urged the king to 'adapt to the practices of the English and the Dutch because though they are men of less valour than the Spanish they have been victorious over Your Majesty's armadas'.[92] The defeat of the Armada in 1588 encouraged the government to solve problems that were by no means the fault of Spain. Originally a sea power based on the galleys of the Mediterranean, Spain had had to adjust to the open oceans and build ships that were useful both for trade and for defence. It was an uphill task.[93] On one hand, naval advisers were aware that the Dutch and English had ship designs that were more effective in those seas and should be imitated; on the other, they were convinced that nothing could beat a powerful, well-armed galleon of the traditional type. For the next century or so, therefore, the Spaniards continued a dual policy of imitating (or buying from) their enemies, and pressing ahead with their own shipbuilding. In practice, more and more they were compelled to buy ships from their enemies.

After the naval defeat at the Downs, the Spanish empire – it seems reasonable to conclude – for all practical purposes lost control of the oceans on which its very survival had depended. This by no means implied that the Spanish were powerless. The Basques and Cantabrians had established Spain's naval reputation long before the discovery of

America, and continued their modest activity throughout subsequent centuries. The activity of the Belgian corsairs also continued to be of vital importance in the north but had a very limited impact within the context of the world empire. Despite some efficiency at a local level, in global terms Spanish naval power evaporated. The French were increasing their naval resources, but the true masters of the oceans in the west were now the English and the Dutch.

The government's own figures for the year 1630 suggest that it disposed in all of some forty warships, of which ten were the property of the state and the rest under contract.[94] It was hardly a basis on which to defend a worldwide empire. Foreign shipyards, moreover, now built the greater part of the ships required by the monarchy. Spain's vessels were constructed in Hamburg, Lübeck, Bremen and Gdańsk.[95] In the Mediterranean the three principal arsenals for royal galleys were at Naples, Messina and Barcelona. The last of these suspended production for the quarter of a century after the rebellion against Spain, and in 1661 the king was informed that to replace what had been constructed in Barcelona 'all new galleys have been built in Genoa'.[96] The construction of ocean-going ships also decayed. The Basque shipyards were seriously damaged in the French invasion of 1638. Shortage of government finance was, however, the biggest obstacle. In 1648 a project was begun to construct twelve galleons in Vizcaya for the Indies route, but not one of the ships was ever built. Olivares, fully aware of the importance of sea power, resorted to a policy of contracting vessels from other nations. Though Philip IV felt that this was the wrong solution, it proved to be the best way out for acquiring warships. In the 1630s Spain made regular purchases from the Belgian shipyards. In the 1660s, one of the principal tasks occupying the Spanish ambassador in The Hague was the construction by Dutch shipyards of warships for Spain. At that period, all four warships protecting Spain's Atlantic shipping had been built by Spain's former enemy Holland.[97]

The southern countries of Europe had always depended to a certain extent on the north, especially the Baltic, for supply of materials such as pitch, canvas and masts. From the seventeenth century Spain found it necessary also to import the experts for shipping and its support industries. In 1617 seventy families of engineers from Liège, employees of the armaments magnate Jean Curtius, were brought in to install the first major ironworks in northern Spain, in the province of Santander. It

flourished until the battle of the Downs drastically reduced the demand for armaments. In order to keep up with the technical advances being made by the English and Dutch, the government found it necessary in subsequent years to engage in industrial espionage, purchase ships abroad, and place contracts with foreign companies for war materials.[98] It was the only way to cling on to the status of world power. English and Belgian pilots were hired for new vessels, and it was common to recruit sailors among the people of the Southern Netherlands. In the early decades of the seventeenth century no Spanish pilots could be found to guide vessels round Cape Horn into the Pacific, and they had to be brought in from Flanders.[99]

Precisely because of its inability to finance a powerful state navy, the Spanish government decided from the 1620s to back private enterprise and license privateers in the North Sea, the Baltic and the Atlantic, directed principally against the Dutch.[100] The challenge was taken up with alacrity, principally among the Basques and notably in the port of San Sebastián, which put to sea over four hundred licensed corsair ships in the period between 1622 and 1697.[101] In those years the ports on the northern coast of Spain harboured some 740 vessels licensed and armed for private war, operating within a maximum radius of 300 nautical miles. Once again international help was not lacking: foreigners, mainly French and Irish, ran one in eight of the ships based in San Sebastián. The financing in general came from local traders, who hoped to recoup the investment through the captures made. The effort was by no means wasted. It has been estimated that in the last three-quarters of the century the privateers captured at least 2,700 vessels, or around 42 a year.[102] At the same time, the private-enterprise corsairs served in other capacities, such as carrying mail between the peninsula and the Netherlands, or giving support to Spanish fishing vessels.

The impotence of Spain before the naval power of France, demonstrated clearly in the death of De Ruyter, was confirmed at the end of the century in the summer of 1691, during the last war waged by Louis XIV against Spain.[103] In July the French fleet based at Toulon appeared off Barcelona and began a bombardment of the effectively defenceless city that lasted for two days. Some eight hundred bombs were used, and over three hundred houses levelled. To the Spaniards it was a barbarous and gratuitous attack on a civilian population, and a thrill of horror ran through the country. The fleet then sailed on to Alicante, where it fired

over 3,500 bombs and left only one-tenth of the buildings untouched. It was a new style of war, comparable to the aerial bombing of the twentieth century, and provoked protests of outrage at what the city of Alicante described as 'barbarous inhumanity'. These were the last days of the Habsburg dynasty, when it was difficult to find allies on whom to depend for military supplies. In Catalonia the army defending the principality against the French consisted largely of Germans, Belgians and Neapolitans. The Spaniards were unable to defend themselves adequately either by land or by sea. The great strength of the French by contrast lay in their naval artillery, which amply demonstrated its abilities in the memorable siege of Barcelona during the summer of 1697, when the city was obliged to surrender. A Barcelona official reported to the government: 'This siege has witnessed more blood and fire than any seen in our time. The bombs ruined a great part of the city.'

During all these years of storm and strife in Europe, in the waters of the Pacific the Manila galleon continued to pursue its remarkable career. Spanish officials who travelled from Mexico to the Philippines to take up their turn of office would entertain themselves occasionally by stopping off at islands on their route and formally 'discovering' or 'claiming' them in the name of the king of Spain. A group of islands that entered European history in this way were the 'Ladrones', called such by Magellan during his visit in 1521 as a mordant comment on the thieving character of the inhabitants whenever they boarded his ships. Some 1,500 miles east of the Philippines, the Ladrones are a group of 15 volcanic islands. The Manila galleon and other ships stopped there periodically during the Pacific run; around one hundred vessels called at the islands in the century after Legazpi. The Spaniards, however, made no attempt to settle until a zealous Jesuit, Diego de San Vitores, who had visited the area in 1662, applied to the queen regent of Spain, Mariana, for permission to found a mission. He sailed with his group from Acapulco and reached the largest island, Guam, in June 1668. On his arrival he renamed the archipelago the Marianas in honour of his sponsor. San Vitores was a conscientious missionary who achieved several conversions and composed a grammar and catechism in the language of the Chamorro inhabitants. He was killed in 1672 by a small group of hostile natives, an event that began some ten years of sporadic conflict between the Chamorros and the few Spaniards in the island. By

1685 all organized resistance ended, and the 'Spaniards' (mostly Filipinos from Luzon) imposed a presence that lasted to 1898. It was the first substantial appearance of the Spanish empire in the Polynesian Pacific.

The impact of empire on exotic islands is illustrated to perfection in the case of Guam, whose history was changed as radically as that of the Canary Islands had been a century and a half before. The collision of cultures was merciless. Outsiders came in carrying bacteria that devastated the indigenous population. An estimated population in Guam in 1668 of around twenty-eight thousand declined to less than eight thousand in 1690.[104] Little or no part in this disaster was played by skirmishes between invaders and the natives. The Spaniards had no policy of extermination, and their own casualties in those years did not exceed a hundred and twenty, among them twelve Jesuits. Relentlessly, however, as natives fled and the demographic fertility of those who remained fell, Guam became depopulated. The Spaniards resorted (as they had done in the Caribbean over a century before) to a policy of forced transportation of natives from other islands, which as a consequence became in their turn uninhabited. By 1700 the Chamorro population was almost entirely concentrated only in the three islands of Guam, Rota and Saipan. By the same date the staple products of Guam were (apart from native crops) tobacco and sugar, neither of them known to the islands before the coming of the Spaniards.[105]

In 1686 Francisco de Lezcano named another group of islands the Carolinas, in honour of Charles II of Spain; ten years later the islands were formally put under the control of the governor of the Marianas. In reality, none of these occupations of islands in the Pacific was undertaken seriously. The Marianas were useful mainly as a supply post for the trade between the Philippines and Acapulco, and the few Spaniards in residence probably helped contribute to the rapid decline of the native population. By the mid-eighteenth century only the islands of Guam and Rota were inhabited. The Carolinas were even more of a phantom colony. No official steps to settle them were taken until the year 1885. The slow disappearance of the Spanish presence from the Pacific could be seen by the situation of Manila which, despite its rich commerce (now largely controlled by Asians) 'vegetated in inglorious obscurity'.[106] When Portugal separated from Spain it immediately shifted to an alliance with the English, thereby removing the richer of the two partners

in the Asiatic trades. The Philippine Islands, with the unique exception of Luzon, were no longer adequately defended and pirates roamed at will among them. The seas around Mindanao and the Visayas were almost completely under the control of the Moros who lived in the area.[107]

Spain's continuing loss of security in the oceans could be measured by the activities of two adventurers, one Chinese and one English. The master of the South China Sea in these years was the Chinese admiral Coxinga, a young and dynamic warlord whose fleet by 1655 totalled some two thousand vessels, supported by a hundred thousand soldiers and with the additional help of western cannon and weapons.[108] In 1661 Coxinga drove the Dutch out of Taiwan and then turned his attention to Manila. The Spaniards hastily withdrew their small garrisons from Mindanao and from Maluku – to which they never again returned – and prepared for a last-ditch resistance. They were opportunely saved by the death of the admiral, aged only thirty-seven, in June 1662.

The other scourge of the Spaniards was the English buccaneer William Dampier. Famous later in life for his scientific exploration, Dampier was both intellectual and an adventurer. He was active in buccaneer groups in the Caribbean from 1680 onwards, and spent the second half of the year 1686 with them on the island of Mindanao, where he explored the islands and dreamed of finding a 'Terra Australis'. After eight years of this roving life he returned to England and published a successful narrative of his voyages. The prestige he obtained from it was such that in 1703 he was supplied with two fighting ships and ordered to look for the Manila galleon, which he encountered at the end of 1704 just off Acapulco but failed to take.[109]

Both the Dutch and the British infiltrated the Manila trade. The British first made a direct trading voyage in 1644, from their base at Surat, in India. They then switched to the more discreet policy of trading through third parties. In the 1670s this trade was conducted on behalf of the British by the sultan of Bantam (north Mataram, Indonesia). After 1682, when the British were driven out of Bantam by the Dutch, they traded from Madras, in India, but still through the agency of local Hindu or Muslim traders. Several notable members of the British East India Company also conducted to Manila on their own behalf what has been called a 'country trade', that is, a private and unofficial commerce from

which the profits went to themselves and not to their Company.[110] In 1700 the governor of the East India Company was the personal owner of four vessels that traded on his behalf to Manila. In this way Spain's distant outpost in the Pacific was maintained by the trade of other Europeans who would eventually take an interest in occupying the Philippines. Its commerce, as measured by the income from customs duties, actually expanded after 1680,[111] in contrast to Spain's own crumbling control over the economy of its Pacific empire.

In North America the missionaries were the main standard-bearers of the Spanish presence, bringing religion, cattle, horses and agricultural methods to the tribes that wished to receive them. By the mid-seventeenth century the frontier was represented by the provinces of New León and New Biscay; further expansion was prevented by the hostility of the Indians in the region beyond the Rio Grande. The significant step of crossing the Rio Grande was made only in 1670, as part of the missionary endeavour of the Franciscan friar Juan Larios. The gradual winning over of reluctant tribes made it possible for the Spaniards in 1674 to found the province of Coahuila, or New Extremadura, which theoretically covered the territory up to the Rio Grande. The following year, 1675, an important reconnaissance was made across the Rio Grande into Indian territory by the Franciscans, who reported back to Mexico that the tribes were keen to receive Christian instruction. It is possible to read between the lines to understand the motives of the tribes. 'These Indians', reported friar Fernando del Bosque in 1675, 'have said that they wished to be Christians, and that all wish it; and they wish that aid be given to *each one separately and not together*.'[112] The permanent quarrels between tribes made them look to the Spaniards for help against each other.

Contact between Indians and the few Spanish settlers in northern New Spain was sporadic. By contrast the missionaries had made efforts to establish a permanent presence in the area. The several tribes of the Rio Grande valley were known collectively as Pueblos, from the Spanish word for the settlements that the missionaries directed. In reality they included the Hopis (of eastern Arizona), the Zunis (of New Mexico), the Tewas, the Towas and several other peoples. In the twenty years after the founding of the town of Santa Fe in 1610, churches were built in all the villages of the Pueblo Indians. By 1630 there were fifty

Franciscans in twenty-five missions, and the priests claimed to have converted sixty thousand Indians.

These apparent successes were undermined by profound conflicts between settlers and clergy that effectively destabilized the frontier.[113] The missionaries objected to settlers and officials levying tribute on the natives, and denounced the continuing use of the encomienda. Officials, on the other hand, claimed that the missions were the chief problem. The clergy, they said, had virtually enslaved the Indians, were monopolizing their labour, treating them brutally and sexually misusing them. Specific evidence to back up the allegations was, obviously, available; the charges reflect a situation to be found in every part of the empire. A notable incident, denounced by the Hopi people, was that of the Franciscan who in 1655, to punish an Indian for 'idolatry', whipped him publicly in the public square and inside the church, then covered him in turpentine and set light to him with the inevitable consequence that he died. Clerical violence against 'idolatry' eventually proved, for Indians, to be the most intolerable of their burdens. As we have seen from Peru, missionaries termed 'idolatry' a broad range of cultural practices that the natives deemed essential to their way of life and quite compatible with the Christian religion. In most New World societies, masks were used by natives during celebrations and rites, and had multiple meanings. Among the Pueblos, masked dances were traditional, but the friars suspected them to be rites of idolatry. In 1661 the Franciscans prohibited all ceremonial masks, collected all they could find and burnt them. In 1675 they rounded up forty-seven Pueblo leaders on the charge of idolatry and had them publicly whipped. The deliberate humiliation proved to be the last straw, provoking local leaders to prepare the great revolt of 1680.

The revolt, directed principally against the Christian religion, brought about an unprecedented unity among the scattered villages and gave them liberty for over a decade. The chief instigator was a medicine man called Popé, who persuaded the chiefs of several villages to unite together against the Spaniards. On the eve of the rebellion there were around 17,000 Indians in the Pueblo communities, with no more than 170 Spanish soldiers to protect the missions. The uprising began on 10 August 1680 and was directed principally against the mission clergy: wherever the rebels went they sought out the priests.[114] Twenty-one out of thirty-four missionaries were killed, churches were

burnt and all records of Pueblo Christianity were destroyed; the total dead among the settlers was estimated at three hundred and eighty by a local official but the real number may have been much smaller. The small garrison at Santa Fe was unable to cope with the scale of the rising, and all Spaniards, together with those Indians who remained faithful to them, were evacuated to El Paso. The frontier was rolled back for over a decade.

Many Indians, however, were happy to limit their rebellion simply to the removal of Christianity. They objected to the more radical rebels who attempted to destroy horses, plants, trees and all other evidence of Spanish civilization. In 1683 some tribes invited the Spaniards back, mainly to help them against the Apaches. The expedition that was sent out in response in 1684, under Captain Juan Domínguez de Mendoza, on the excuse of penetrating into the lands of the Tejas Indians, was greeted by a triumphal gathering of thousands of Indians who were counting on Spanish support against their enemies.[115] The contrasting situations in which the Spaniards found themselves, of complete rejection on one hand and of eager acclaim on the other, illustrate the constant ambivalence of life on the unstable frontier.

From September 1692 a Spanish detachment under Governor Diego de Vargas set out to clean up what remained of the Pueblo revolt. He was able to muster no more than forty soldiers, backed up by fifty Indian allies.[116] Fortunately for him, a number of the tribes had decided to stop the violence. Santa Fe and various other towns passed into his control with little effort. The Mexican writer Carlos Sigüenza y Góngora ingenuously commented at the time that 'an entire realm was restored to the king without wasting an ounce of powder or unsheathing a sword'. When at the end of 1693 Vargas decided to strengthen the Spanish presence by bringing in more settlers and cattle, many tribes returned to their previous hostility, and the conflict resumed. There was a further small revolt in 1696 but it was quickly suppressed. The villages after that date decided to accept the Spanish presence, for it was – as we shall see (Chapter 10) – in their interest to do so.

The Pueblo revolt was only one example of the permanent restlessness of indigenous cultures within the orbit of Spanish authority. Another example can be found in the messianic revolt of the Tzeltal Indians in the province of Chiapas in central America.[117] Though the Indians of North America failed in the short term to liberate themselves from the

Spaniards, in the long run they were bound to succeed, thanks to the intervention of a new factor: the establishment on the Atlantic coast during the seventeenth century of French and English settlements. In the later seventeenth century Spanish Franciscans were the only mainstay of the dwindling Spanish presence in the north of Florida. From their mission centres in the Apalachee they attempted in the 1680s to expand towards Carolina across the Chattahoochee and Savannah rivers. This was now doubly dangerous territory, not only for possible hostility of Indians but even more surely because of a challenge from English colonists. From 1670, when the English settled permanently in Charleston, they made it their policy to ally with local Indians against the Spaniards. At the same time they launched fierce attacks against St Augustine. During the period known in American history as Queen Anne's War (in Europe, the War of the Spanish Succession), the greater part of the Indians of Apalachee, towards the Gulf of Mexico, and of the north Atlantic coast of Florida, had deserted the Spanish cause.

Indians rejected the Spanish for their oppressive methods in religion and in levying labour. They chose the English not only for liberty but also for material goods and ammunition.[118] Spain by the end of the war remained in control of St Augustine and Pensacola, but had lost the support of the native population, and without that it could not for long continue its hold. An English pamphlet printed in London in 1710 reported that

There remains not now so much as one village with ten houses in it, in all Florida that is subject to the Spaniards; nor have they any houses or cattle left but such as they can protect by the guns of their Castle of St Augustine, that alone being now in their hands, and which is continually infested by the perpetual incursions of the Indians.[119]

The French, meanwhile, had begun to take a serious interest in the Gulf coast. The great name in French exploration at this time was René Cavelier, Sieur de La Salle, who in 1682 made a pioneering journey down the Mississippi from Canada to the Gulf. He returned the following year to France, where he obtained the support of Louis XIV for an expedition to attack Mexico through bases on the north coast of the Gulf. All his plans, and his ultimate disaster, derived from his mistaken belief that the Mississippi emerged into the Gulf right next to New Spain. He set out from France with four ships and a small crew in 1684, but once in

the Gulf of Mexico was unable to locate the mouth of the great river. He finally decided to establish a base on the very west of the Gulf; and inland from what is now Matagorda bay, north of the San Antonio river, he began to construct what he called 'Fort St Louis'. Word eventually reached the Spaniards in New Spain that a Frenchman had penetrated what they claimed as their territory. From 1686 they sent out several coastal and land expeditions to try and locate him.

The expeditions were working with no adequate cartographic knowledge of the coast and no solid information of La Salle's whereabouts. They all failed to find any trace of the intruders. Not until three years later, in the spring of 1689, did the governor of Coahuila finally find Fort St Louis, or what remained of it. It had been destroyed by hostile Indians, and its defenders killed. From two French survivors who were living nearby among Indians, the Spaniards learnt that La Salle's ships had been destroyed, and that when La Salle proposed to his men a prolonged trek to Canada by way of the Mississippi they had murdered him. That had been two years before, in March 1687.

The unfortunate history of La Salle turned out to have decisive consequences for the Spaniards in North America. It spurred them to new bursts of exploration, both in order to eliminate the French presence and in order to establish their own frontiers. The result was the most extensive effort of exploration ever carried out by Spaniards in the Gulf of Mexico.[120] Among the achievements was the first complete circumnavigation of the Gulf by the Rivas-Iriarte voyage of 1686–7. Even the lore of pirates, who because of their profession knew every creek and cranny of the Gulf, was put to use: the pilot of the Rivas-Iriarte team was a pirate. The La Salle episode had another important sequel: it advanced the timetable for Spanish occupation of eastern Texas and Pensacola Bay.[121]

In the later 1680s several expeditions made their way into Texas territory and the Mississippi area. Four left by sea from Veracruz and Florida, five made their way by land from New Spain. The land expeditions, between 1686 and 1690, were all made by Alonso de León, who in 1687 was made governor of Coahuila and captain of the fort at Monclova. It was León who led the group that found the remains of Fort St Louis in 1689. The 1690 expedition, which took ninety men ('for the most part tailors, shoemakers, masons and miners from Zacatecas'[122]), two hundred cows and four hundred horses, set up among the

Tejas Indians two missions that became the first Spanish settlements in the future province of Texas. In 1691 the province was officially created, and a governor appointed. The Spaniards soon found it impossible to maintain an area so far away from New Spain and so difficult to supply, and in 1693 withdrew all their men and missionaries. But it was not the complete end of Spanish efforts in the region. Spanish military detachments that had fortunately decided to occupy and fortify the site of Pensacola from 1698 were able to maintain their presence in the northern Gulf. The apparent threat from other European powers proved to be a positive stimulus to an empire that had long passed its period of expansion.

By 1700 the French were not only poised to strike into Spanish North America; they were also positioned in the Caribbean, where since the peace of Rijswijk in 1697 they had obtained from Spain possession of Saint-Domingue (modern Haiti), the western half of the island of Hispaniola. During the second half of the seventeenth century, in which Spain's inability to defend its empire became obvious, the European powers struggled with each other for control of the Caribbean Islands as bases for economic expansion. Key points of the area were now firmly in non-Spanish hands. The British had occupied the islands of St Kitts (1624), Barbados (1625), Nevis (1628), Montserrat and Antigua (1632), and Jamaica. The French took Martinique and Guadaloupe in 1635, and Saint-Domingue in 1697. In the period 1630–1640 the Dutch occupied St Eustace and Curaçao. The Danes took St Thomas in 1672. The demography, economy and culture of the Caribbean changed within a generation. Efficient new businesses were implanted by the other European settlements. An English government committee reported that in 1625 'Barbados shipped out of that island as many goods in tunnage yearly as the Spaniards do out of the two famous empires of Mexico and Peru.'[123]

From the island bases, unlicensed traders operated throughout the area. Some of them were clearly 'pirates', preying not only on Spanish vessels but on shipping of all nations. They came to be known as 'buccaneers' (*boucaniers* in French) from their outdoors life-style, grilling meat from wild cattle over a *boucan* or grill placed over an open fire. After the English capture of Jamaica they made their unofficial haven on British soil, at Port Royal in Jamaica, and on the French islands

of Tortuga and Saint-Domingue (Hispaniola). The most dreaded of the buccaneers was the Welshman Henry Morgan, who captured Portobelo with four hundred men in 1668 and Panama with four hundred and seventy men in 1671.[124] In the latter attack the pirates came ashore from three ships, and destroyed the fort of San Lorenzo at the mouth of the River Chagres, with considerable loss of Spanish lives. Morgan and his men then sailed up the River Chagres and trekked overland until they reached an unprepared Panama. The town surrendered after one hour and was then accidentally set ablaze and burnt to the ground. It ceased to exist for two years. In 1673 a new Panama City was founded but on a different and more secure site, and construction began after 1677.[125]

The English buccaneers also entered the Pacific. Like Morgan, they relied less on naval force than on human numbers, backed up by small arms and small boats, which gave them more mobility and allowed them to avoid completely the official Spanish defences, which always consisted of cannon that pointed seaward and galleons that patrolled the sea. Alarmed by what had happened at Panama the viceroy of Peru in 1671 informed his government that 'the Indies are lost, since there is no defence in the ports of this realm'.[126] With only two hundred and fifty men the buccaneers, led by the Englishman Bartholomew Sharp, came overland and sacked the town of Portobelo again in February 1680. Emboldened by success, they once again threatened the (new) city of Panama in the spring of 1680, after making their way across the isthmus of Darien from the Caribbean, and floating downstream in canoes supplied by the Indians. The expedition was a complete success, going on to indulge in wholly unprecedented pirate activity on the Pacific coast during sixteen months before the men eventually returned to England in the spring of 1682.[127] In their last big action they seized a merchant ship *en route* from Callao to Panama, and were startled to find among the passengers what one of the Englishmen described as 'the most beautiful woman that I ever saw in the South Sea', a comely young Spanish lady of eighteen. In 1684 a subsequent group of buccaneers, both French and English, again attacked coastal settlements on the Pacific, captured half the vessels of Spanish merchants trading to the isthmus from Peru, paralysed the celebration of the trade fair at Portobelo in 1685, and committed extensive damage during the four years that they were there.[128] Every aspect of life along the Pacific coast was dislocated.

The days of the buccaneers, however, were numbered. Their decline came about not because of Spanish intervention but precisely because the Spaniards were unable to control them. The English, French and Dutch, who now held key areas of the Caribbean, realized that they would have to take measures of their own against piracy and would, in effect, have to protect the Spanish empire. The lieutenant governor of Jamaica in 1686 pointed out that the interruption of Spanish trade at Portobelo and suspension of silver shipments from Peru would affect the whole Caribbean and Europe as well: 'this damage will not onely befall ye Spaniards but all Europe that are concerned in ye trade of these seas'.[129] That very year, the crisis obliged the Spaniards to reduce their trade with Jamaica. When proposals were made for collaboration with England to reduce the buccaneer threat, however, the council of the Indies objected strongly on the grounds that any such action would ruin the trade controlled by Spain. It was a typical bureaucratic attitude that would continue to prevail in Spain for another half century.

At the same time some hesitant steps were made to improve local defences. The viceroy of Peru in 1685 passed on to the government a letter from a local correspondent which claimed that 'not only is there no one in the entire kingdom who has ever built a warship, there is nobody who has ever seen one'.[130] There were no regular militia soldiers available, for nobody bothered to pay their wages and therefore they all deserted. Nor were any qualified sailors to be found. At the Pacific port of Trujillo they eventually managed to get hold of an Italian engineer, Giuseppe Formento, who supervised the construction of a defensive wall during the years 1687–90. At Lima earlier plans for a wall by a Belgian engineer were not implemented until 1684. These and other measures provoked a steep rise in defence costs in Peru, and a corresponding fall in the amount of silver available for sending to Spain.

A key activity of the Spanish system had been the supply of African slaves to the Caribbean. By the seventeenth century the greater part of slave supplies in the region was controlled by other European powers that needed to supplement the labour force in islands they controlled. The English had been regular slavers since the sixteenth century; the Dutch on the other hand did not slave regularly until the foundation of their West India Company in 1621. From around that date the greater part of slave imports from Africa was directed to the non-Spanish

territories, where in the absence of indigenous labour the new plantations were worked exclusively by blacks. The factor that most stimulated Dutch participation in the trade was their conquest of northern Brazil in 1630, with the corresponding need for suitable labour in their sugar plantations.[131] The WIC took a crucial step forward with the occupation in 1634 of the island of Curaçao, which was turned into a station for the transport of black slaves.

Even the Spanish part of the slave trade was no longer – if it had ever been – in Spanish hands. After a twelve-year period when the asiento was suspended, the Genoese financiers Domenico Grillo and Ambrogio Lomellino took it over in 1662. They were not in a position to import slaves directly from Africa, as the contract stipulated, since the Portuguese, who had previously managed this side of the business, were now enemies of the Spanish crown. It became unavoidable to purchase slaves from the English or the Dutch, who by their superior naval power were now in total control of the commerce. The chief places of export in West Africa were in non-Spanish hands: the French were at the mouth of the Senegal, the British at the mouth of the Gambia, and the Dutch were well distributed along the whole coast. After the Genoese the contract was conceded in 1674 to a Portuguese financier in Seville, Antonio Garcia, who was in reality front man for the Dutch financier Balthasar Coymans. The contract was taken over directly by the Consulado of Seville when Garcia went bankrupt, but it was then granted to the Genoese financiers Giovanni Barroso and Niccolò Porcio in 1679. Through all these years the Dutch, trading from the island of Curaçao, continued to supply the Spaniards with slaves whom they had imported directly from Africa. The incapacity of Spain to procure its own slaves was utterly astonishing. 'No Spaniard could be found willing to take over the asiento', complained the council of the Indies.[132]

The fact is that since the inception of the slave trade in the early sixteenth century Spaniards had never been in a financial position to manage it. Because of their incapacity, in 1685 the asiento was for the first time formally and openly contracted to a Protestant trader, Coymans. The move was in line with the general tendency towards a political and military alliance with the Dutch. But it could not fail to shock religious susceptibilities in Spain. Since the Spaniards were unable to supply any shipping to back up the asiento trade, Coymans was granted permission to use ships built in Holland, and have two

Dutch warships to escort him on trading runs. The only firm condition made was that he must take ten Capuchin friars from Spain to minister to the needs of the slaves. This contented the Inquisition, which stated that it saw no danger to the faith in the contract. Coymans died in November 1686 but the contract was continued with his successors until 1689.

An important sector of the Spanish economy in the Caribbean, still heavily dependent on black labour, was in this way maintained and underwritten by the Protestant English and Dutch. The Western European powers were agreed on one point: the Spanish empire must survive, for they lived off it. No sooner had Grillo agreed the asiento of 1662 than his agent, the Englishman Richard White, went to London to arrange contracts with English merchants for the supply of five thousand slaves to be collected by the Spanish at Jamaica and Barbados.[133] The Catholic duke of York, heir to the English throne, was asked to secure permission for Spain's agents to live in these English territories. The English, of course, were in direct competition with the Dutch for supplying slaves. In 1664 the English in Jamaica complained that at that time the Spanish were buying most of their slaves from Curaçao, on which 'cursed little barren island [the Dutch] have now fifteen hundred or two thousand'. The report was not exaggerated. Between 1658 and 1729, it has been calculated, the Dutch shipped a total of approximately ninety-seven thousand slaves to the ports of Portobelo, Cartagena and Veracruz, mostly by the route through Curaçao.[134] But the British were by no means behind. In the early years of the eighteenth century the island of Jamaica alone exported to the Spanish colonies over eighteen thousand black slaves brought in from Africa, and it has been estimated that between 1700 and 1714 the number of slaves supplied by the British to the Spaniards varied between one thousand five hundred and three thousand a year.[135]

The Spanish empire was an international enterprise in which many peoples participated, and the first effective example of a 'globalized' economy. The globalization had two main features. In the first place, Spain through its expenditure on defence and trade provided the payments that sustained the economy of half the globe. The Iberian peninsula had few resources of its own, either in men or materials. The empire therefore used its American silver in order to purchase goods

and contract the services of foreign specialists. In the second place, when the political hostility of specific nations threatened the stability of the empire, other foreign interests were the first to rally to the defence of Spain. They could not afford to lose their share in an enterprise that contributed to their own well-being and which they in some measure already controlled.

The consequence of this situation was that Spain's apparent enemies were those who strove most to conserve the empire.

This fascinating situation could be found already in the later sixteenth century. In the England of Elizabeth I there was a solid body of opposition to the anti-Spanish strategy of the government. The English merchants who maintained an active trade in Bilbao and Seville protested against Drake's marauding adventures. 'The merchants make the greatest outcry against it,' ambassador Mendoza reported with satisfaction from London in 1580, 'saying that because two or three of the principal courtiers send ships out to plunder in this way, their prosperity must be imperilled and the country ruined.'[136] Though there was war in subsequent years, the foreign trade of England continued to rely on Spain. English merchants who traded to the Baltic and Russia in 1604 were buying goods 'most vendible in Spain and needful for the West Indies'. Those who traded to Turkey relied on Spanish bullion to finance their projects.[137]

English merchants who did not trade directly to the peninsula relied on the West Indies for their profits. It is a common error to view the European powers in the Caribbean as dedicated to undermining Spain's power. They were in practice its firmest backers. The English authorities in Barbados, in an attempt to justify the 1662 agreement to supply slaves to Peru even though such trade was formally illegal, pointed out that it was impossible to refuse an offer that 'filled the island with money'.[138] American silver continued to turn the wheels of empire, and the vast American market lay wide open to the world's merchants. The English pressed home their chance of good trade in the Caribbean by agreeing on the Treaty of Madrid in July 1670. There were many political obstacles, but trade continued to flourish. In 1680 an Englishman, agent for the Spanish government, appeared in Jamaica with a commission to buy black slaves. The governor, no less a person than the ex-pirate Henry Morgan, wrote: 'It is confidently reported that we shall shortly have free trade with Spain. This will speedily make this island very

considerable, for all the current cash that we now have is brought here by private trade with them.'[139] There were objections in Jamaica, principally from plantation owners who did not wish to lose slaves to the Spanish. Eventually in February 1690 the English government gave formal permission for both Barbados and Jamaica to trade in blacks with the Spanish. By the end of the seventeenth century the British were in the comfortable position of having penetrated the Spanish commercial system so extensively that it was in their interest to maintain it unimpaired. As the duke of Marlborough wrote to the Dutch leader Heinsius in 1706: 'As a good Englishman I must be of the opinion of my country, that both by treaty and interest we are obliged to preserve the monarchy of Spaine entire.'[140]

The same picture applied to the former Dutch rebels. The financing of war was an international business that always worked to the detriment of the belligerent country, but Spain had no option. In sending bullion to the Low Countries, it was in effect helping the Dutch rebels, who benefited from the boost to their trading system. 'By the commerce with Spain that the rebels have had in the past twenty-two years', stated a report made to Philip III in 1607, 'they have received in their towns and provinces quantities of silver and gold in exchange for cheese, wheat, butter, fish, meat, beer, and other products of the Baltic, and thereby have obtained much greater treasures than they could have got with their fisheries and their trade.'[141] This astonishing but inevitable trade between the Dutch and the Spaniards continued throughout the years of war, and accelerated during the twelve years of truce from 1609 to 1621.

There were three main routes for the flow of bullion to the Dutch. First, there was the direct trade with Seville and Cadiz, conducted through agents resident in Spain or through third parties who disguised their affiliation with the rebels. Throughout the later years of the century, large quantities of the bullion arriving from America were destined for bankers in Amsterdam. The English ambassador reported in 1662 that at least a third of the treasure arriving in the ships that year would go to the Dutch, and the proportion continued to be roughly the same with every fleet arrival.[142] Second, there were bankers and traders – mainly Genoese between 1577 and 1627, and Portuguese between 1627 and 1647 – whose trade with Spain was paid for with bullion that immediately found its way to the Dutch market with which the same bankers

also traded.[143] For example, an English merchant in Livorno in 1666 reported that a large part of the American silver going to Genoa and Livorno was in fact the property of agents for the Dutch in those cities.[144] A policy of embargo on trade with the Dutch after 1621 did not appreciably reduce the flow of bullion to the rebels. Finally, there were the direct imports of precious metal by the Spanish authorities, to pay their costs; it has been calculated that 'between 1566 and 1654 the military treasury in the Netherlands received a minimum of 218 million ducats from Castile',[145] of which a good proportion found its way to the Dutch. All these three routes made use of the international trade system, so that in a sense Spain needed the existence of the Dutch market in order to conduct its financial transactions, a situation that has been correctly described as 'mutual economic dependence'.[146] Even within the Iberian peninsula, Spain recognized that it was irremediably in tow to its Dutch enemies for two fundamental necessities: raw materials for shipbuilding, and wheat for the Spanish consumer.[147]

The shoring-up of the universal monarchy by its enemies was recognized by many observers, among them the marquis of Varinas, a distinguished Spanish colonial administrator, who observed in 1687 that 'the French, English and Dutch, who see that nothing suits them better than that the Indies remain with Spain, so they can exploit them more cheaply thanks to the lack of application by Spaniards',[148] were the main defenders of the existing colonial system. Each European power knew that if the Spaniards were displaced other Europeans would move in to take their place. The most convenient arrangement was for Spain to remain in control.

The collaboration of friend and foe alike in the task of supporting the Spanish empire paid off handsomely. The thirty-five years' reign (1665– 1700) of the last Habsburg king of Spain, the desperately ill Charles II, seemed to many to be the lowest point reached by the once-great world empire.[149] Foreign observers saw only decay. 'The ancient valour of Spaniards has perished', a Venetian ambassador claimed in 1678. Another reported: 'There are no navies at sea, no armies on land, the fortresses dismantled and unguarded, everything exposed, nothing protected. It is incomprehensible how this monarchy survives.' The French ambassador in 1689 was equally damning. 'Informed people agree', he said, 'that the House of Austria is leading them to total ruin.'

Yet the monarchy soldiered on as it had always done, and it did so with the help of all those its money could buy. In the prolonged border war within the peninsula against the rebel Portuguese, some two-thirds of the infantry in the Spanish army were foreign.

France, which by its military aggression was doing most to undermine Spain's power in the Western world, was at the same time the nation that most underwrote Spain's economy. Lord Godolphin, who was English minister in Madrid, reported in 1675 that 'of all others the French are the greatest gainers by the Spanish trade'. Every year thousands of French workers passed into the peninsula to help with the harvest and to perform other tasks. In Andalusia, according to a French visitor, 'their employment was carrying water to the houses, selling coal, oil and vinegar in the street, serving in hostels, ploughing the soil, harvesting and tending vines'. Most of the French returned home after a while, their pockets full of Spanish coin. 'They live humbly while they are here', an indignant Aragonese politician claimed, 'but put on fine and sumptuous clothes on returning to their own country.' Over and above their role in the labour force, the French controlled most of Spain's foreign trade. They supplied one third of the imports into Andalusia, nearly forty per cent of the imports into Valencia, and the virtual totality of imports into the kingdom of Aragon. Between them, English and French merchants controlled the foreign trade of Spain's chief Mediterranean port, Alicante.

And all the while the riches of the New World came pouring in. Spain's bullion imports in the great era of its power had dazzled contemporaries. Those imports now multiplied, to a degree that historians had seldom realized before new research was done in the 1980s.[150] The apparently supine empire was producing unprecedented riches, as the American mines picked up on production. At Potosí in Bolivia, at Parral and Zacatecas in northern New Spain, output rose. In the 1590s, commonly thought to have been the period when most silver was sent, bullion imports into Seville had peaked at an average seven million pesos a year. Between 1670 and 1700, by contrast, the average rose to around eight millions a year. Since the fleets from America came very infrequently, sometimes at intervals of five years, the actual totals per voyage were in reality much higher than this average. The French consul in Cadiz calculated that the galleons from the isthmus of Panama brought home twenty-four millions with each shipment. He concluded with good

reason that 'the trade in this port is the greatest and most flourishing in Europe'.

And the trade, of course, belonged to everybody, not just to the Spaniards. In order to preserve face (as well as avoid taxes) the Spanish commercial agents tended to doctor their documentation, so that the norms of the official monopoly could be seen to be observed. Most of the cargo statements drawn up by officials and carefully preserved in the archives at Seville, where they continue to mislead diligent researchers, took pains to disguise the truth. The foreign consuls in Spain, on the other hand, carefully noted what was really happening. A French consul noted in 1691 that ninety-five per cent of the goods traded to America in the fleet that year were non-Spanish. By the same token, the bulk of the silver coming to Europe really belonged to foreigners. It was money they owned not only because of the direct trade from the peninsula, but also because of payments due to them from the Spanish government for military costs throughout the monarchy.

When the great ships sailed in from the Atlantic they hovered outside the bay of Cadiz as though preparing themselves for the obligatory inspection by the authorities. While they did so, they would unload surreptitiously on to foreign vessels a good part of the silver they were carrying. The French consul documented how in March 1670 fifty per cent of the silver on board the recently arrived fleet from New Spain was taken away in foreign vessels bound for Genoa, France, London, Hamburg and Amsterdam. Another French consul in 1682 reported how the Panama galleons that year, carrying twenty-one million pesos in silver, unloaded two-thirds of this cargo on to vessels that sailed away to France, England, the United Provinces and Genoa.

'What use is it', a Castilian writer protested in the 1650s, 'to bring over so many millions worth of merchandise, silver and gold in the galleons, at so much cost and risk, if it comes only for the French and Genoese?'[151] The indignation was misplaced. Since the days of the emperor, if not before, Spain had been able to exploit its limited resources precisely because it was drawn into a global network that supplied essential services – credit, recruitment, communication, shipping, armaments – which allowed the empire to function. The silver had to work outside the country, otherwise it would have been useless. Till the end of the Habsburg dynasty, Spaniards stubbornly refused to recognize that their wealth had to be shared in order to be productive. Only under a

new regime, that of the Bourbons in the eighteenth century, did it become possible to break with the old way of looking at the empire, and turn towards new perspectives.

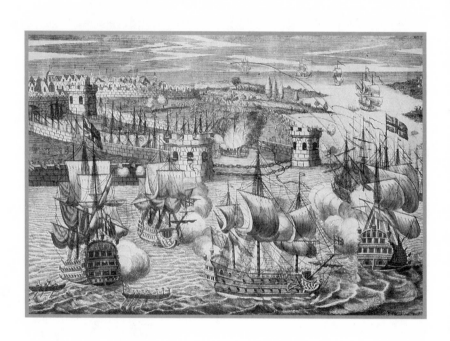

10

Under New Management

At the same time that we are pursuing these goals for the greater
glory of God, we are also promoting the welfare of the Spanish
nation because of the great wealth that can be taken from those
areas. Jorge Juan and Antonio Ulloa,
Confidential report on America

Childless and chronically sick, just before he died in November 1700
the last Spanish ruler of the Habsburg dynasty, Charles II, named as his
successor the grandson of Louis XIV of France. The new king, Philip
Duke of Anjou, succeeded to the throne as Philip V, and arrived in
Madrid the following April. Both in Spain and in France the succession
of the Bourbon dynasty was greeted with enthusiasm, as offering hope
for the recovery of an empire that was universally viewed as being in
decay. 'The present state of the realm', the marquis of Villena, sub-
sequently founder of the Royal Academy of Language, wrote to Louis,
'is the saddest in the world.'

Philip was barely seventeen, little more than the age at which his most
illustrious predecessor, Charles V, had also succeeded to the throne.
Like Charles, the young Philip spoke no Spanish and had no personal
experience of the Iberian peninsula. He therefore came accompanied, as
Charles had been, by a host of foreign officials and advisers. The French
were fully aware of the reaction that had taken place in Castile against
Charles's Flemish court, and had strict instructions not to interfere in
affairs. But the international situation in 1700 was not comparable to
that in 1500. Louis XIV's acceptance of the Spanish inheritance threat-
ened to lead to a war with all the principal European powers, which
over preceding decades had arrived at agreements to prevent the vast
Spanish empire falling into the hands of any single dynasty, whether of

France or of Austria. As soon as the French succession took place, there was agitated diplomacy in the other courts, with Britain and Austria taking the lead in forming an alliance against Louis XIV. Louis strengthened France's northern borders by agreeing with Spain to assume the defence of the Southern Netherlands, where French soldiers took over the main fortresses. He also sent his forces into Milan to occupy the Italian fortresses controlled by Spain, but had to contend with an opposing Imperial army under the command of Prince Eugene of Savoy. In September 1701 a military alliance was agreed at The Hague between England, the United Provinces and the emperor, and official hostilities followed soon after. On 15 May 1702 the powers simultaneously declared war on France and Spain, and were able to count from May 1703 on the alliance of Portugal. Their formal aim was to replace Philip V with a Habsburg candidate, the emperor's younger son Archduke Charles.

The war came, for Spain, at a particularly vulnerable moment. The empire at the beginning of the Bourbon dynasty was nearly two centuries old, and had shown a remarkable capacity for survival. But it had also become heavily dependent on the protection of others. Support that it enjoyed from the Dutch and English in the later seventeenth century was now followed by that from the French, who found to their dismay that the Spanish inheritance was both bankrupt and defenceless. The control exercised by foreign nations could not easily be dislodged. Even while war waged in the peninsula the French ambassador Amelot was urging his government to allow the enemy powers to continue trading with Spain. 'It is absolutely necessary', he wrote, 'for the king of Spain to issue passports to the English and Dutch to come and fetch wool, otherwise the flocks cannot be maintained.'[1]

The perspective that greeted the French was almost exactly that which greeted Philip II when he returned home in 1559. In 1701, as in 1559, the country had virtually no naval forces and was completely exposed at sea. There were no royal warships in the Mediterranean, only a handful of galleys; in the Atlantic and America there were in theory twenty warships, four of which were reserved for protection of American shipping. The fortresses of the peninsula were badly fortified and poorly manned. In the whole of Spain the crown had at its disposal just over ten thousand infantry soldiers and five thousand cavalry, but both infantry and cavalry lacked adequate armament and were therefore not

equipped to fight. The meagre dimensions of Spain's forces may be contrasted with those of France, which was estimated at the same date to have a total army of over half a million men.[2]

From Madrid Louis XIV's ambassadors advised him that it was essential to take over the machinery of government, which functioned in a way that the French could neither understand nor tolerate. Already in 1689 one diplomat had reported that 'what is needed is a complete revolution before establishing good order in this state. Such a revolution can be found only by changing the form of government.'[3] Writing to his ambassador in 1702, Louis concurred: 'it is to be wished that one could carry out a general reform in all the different states of the monarchy. But as this idea is too vast, he [the ambassador] must try as far as possible to remedy the most pressing evils and think principally of enabling the king of Spain to contribute in some way to the war that the king [of France] is preparing to endure.'[4] A whole team of French administrative experts and military officers descended on Madrid. With the support of a small number of Castilian officials (and the opposition of a great many more) France prepared to change the system that had operated, for better or worse, throughout the period of Habsburg rule. Fresh management was in control.

Rapidly and efficiently, the new masters moved in to manage their inheritance. It was a sea change in the constitution of the world monarchy. In the Spanish Netherlands, control was handed over to administrators who overturned the whole structure of the government, the army and the tax system. The provinces had in practice ceased to be Spanish since July 1690, when France defeated the united Spanish-Dutch army commanded by the general in Dutch employ, Georg Friedrich, Count of Waldeck, at the battle of Fleurus. Since that memorable defeat, the last field battle fought by Spain in defence of the Southern Netherlands, the provinces had been under Bavarian administration. In Spain itself there were fundamental changes in the court, the administration, and the army; and the aristocracy was excluded from any significant part in government. The much-prized slave trade to America was adjudicated to a French consortium, the Guinea Company. As may be imagined, none of the changes was greeted with enthusiasm by those who had controlled the machinery of state. There were intrigues and conspiracies against the new regime in all the realms, from Castile to Naples, followed by arrests and detentions.

Philip's advisers were discovering to their horror that Spain did not have the resources to wage a war of any sort. Louis XIV sent to Madrid a French official, Jean Orry, to check on the state of Spain's finances. Orry confirmed that in 1704 only three and a half million escudos a year were available for the war, when perhaps twelve million were needed.[5] He found that the government of Castile could count on only half the money that it normally collected in taxes (the other half went to creditors); that the treasury received virtually no silver from America, because the bullion went to creditors of the government; that the soldiers of Spain had outdated military equipment and no uniforms; and that 'the king of Spain received almost no gunpowder from the realm'. 'Spain is entirely your responsibility', the head of Philip V's household wrote to the French war minister, 'without troops, without money, without a navy, in a word lacking in everything that pertains to the defence of a monarchy as extensive as this.' In consequence, the Madrid government was persuaded to change its entire military system and adopt the French one, particularly since military supplies could only be obtained from France. Spain abolished all its antiquated weapons (the arquebus, the pike) and adopted the French flintlock with bayonet; in September 1704 the old tercios were abolished and substituted by 'regiments'; and for the first time, an order was made in 1703 for all soldiers to wear a standard French-style military uniform. The war effort, effectively, was put into French hands.

The War of the Succession, which commenced in 1702 and went on for some twelve years, developed into a virtual world war, with military and economic repercussions that stretched from Russia to Peru. The combatants on both sides swore that they were moved by the wholly unselfish intention of preserving for the Spaniards an empire that the other side was trying to destroy. In the English colonies of North America, where the conflict against contiguous Spanish colonies took on serious proportions, it was known as 'Queen Anne's War' (see Chapter 9). When the French began to suffer military reverses, it became obvious that the task of establishing the Bourbon dynasty was going to be an uphill one. In Milan, the French army found itself at a stalemate against the Imperial forces under Prince Eugene.

One of the first acts of Louis XIV during his grandson's reign was to order a detachment of French warships, under Admiral Châteaurenaud, to escort the annual convoy of the Spanish treasure fleet across the

Atlantic from Cuba. The vessels made a safe entry into the port of Vigo, but were not prepared for a state of war in Europe. Shortly after their arrival at the end of September 1702 they were attacked in the inner reaches of the bay by a joint Anglo-Dutch fleet. The French and Spanish vessels were wiped out: all, save half-a-dozen seized as prizes, were destroyed and sunk. Finally, during 1704 the conflict reached into the peninsula itself, when the Portuguese attempted an invasion by land and in August a British fleet under Admirals Rooke and Byng captured the fort of Gibraltar. For the first time in history the Iberian peninsula was invaded by tens of thousands of foreign troops, half of them Protestant, with the specific aim of overthrowing the ruling dynasty. There was no way for Spain to defend itself adequately. Because of the country's constitutional system there was no national army for defence purposes, nor any navy.

From this point onwards, the role of Spaniards in the defence of their empire became wholly secondary. During two centuries of Habsburg rule, Spain had been able to display an astonishing ability to conjure up men, munitions and ships from all parts of the world monarchy. From the beginning of the eighteenth century, by contrast, it was cut off from access to all its sources of supply outside the peninsula, and quickly found that its own resources were not sufficient to maintain the struggle. The main obstacle was the British, whose superiority at sea was responsible for the disaster at Vigo, the capture of Gibraltar and subsequently of the principal cities on the Mediterranean coast, above all Barcelona. At no stage during the conflict did the French navy attempt seriously to engage them, and as a result Spain was effectively isolated from any contact with its traditional lifeline, the Italian states. A persistent historical tradition has claimed that Spain's helpless situation was now one of 'decline'. The claim is, put simply, meaningless. Spain was no worse off in 1700 than it had been in 1600 or in 1500; indeed, its economy and population were now in better shape than ever. The difference was that its success as an imperial power had depended on the collaboration, both as allies and as enemies, of the major states of the West. The War of Succession changed all that fundamentally.

Philip V now remained entirely dependent on one power alone, France, for his tenure of the crown and the prosecution of the war. The first detachments of French troops sent to help the king entered the

peninsula in February 1704, under the command of the duke of Berwick. They helped Philip to launch the first real military campaign to be undertaken within Spain for half a century, against the allied army of twenty-one thousand men which invaded from Portugal. Deficiencies in Spanish supplies soon showed. 'I see such great shortages among the troops', Philip reported in 1704, 'because of lack of bread and non-payment of wages, that troops are deserting on all sides.' Supplies, munitions, guns, tents and uniforms were ordered in their tens of thousands from France. The entire war machine of Castile was put into the hands of the French, who came to a country that had been accustomed for two centuries to fight its wars abroad rather than at home. The commanders now appointed to direct the war in the peninsula were for the most part French. The leading generals of Philip V – the marquis of Bay, the count del Valle, the prince of T'Serclaes Tilly, the marquis of Castelrodrigo, the duke of Popoli – were all foreigners, and their superiors were – like the dukes of Vendôme, Berwick and Orléans – always French. Only French control could make it possible to co-ordinate military and naval strategy, in a theatre where support from the sea was of immense importance. Spanish armies benefited from foreign advice, which rationalized their methods of recruitment, organiz-ation and equipment. French manufacturers supplied the war material needed to fill the enormous gaps in Spanish equipment and resources.[6] The French, above all, secured for Philip V one of the most resounding military victories in the history of the empire: the battle of Almansa.

The years 1705–6 were particularly unfortunate for the Franco-Spanish forces in the peninsula. At the end of 1705 the British navy made possible the capture of the cities of Barcelona and Valencia, then in the summer of 1706 the Portuguese army occupied Madrid. It was a moment of triumph for the Portuguese soldiers, who could hardly believe that they had overthrown the great Spanish monarchy. Fearing the worst, in February 1706 Louis XIV made Berwick a marshal of France and sent him to Spain once again to conduct the campaign against the Portuguese; a year later he sent a further quantity of French troops, under his nephew the duke of Orléans.

James FitzJames, first duke of Berwick, was the illegitimate son of the last Catholic king of England, James II, and of the sister of the duke of Marlborough. Now aged thirty-four, he had been in the service of France as a general since 1693. In the spring of 1707 he found himself at the

head of the united French forces in the peninsula, in a campaign intended to recover the city of Valencia. He was challenged by the British and Portuguese forces led by the earl of Galway and the marquis das Minas. At daybreak on the morning of 25 April, Berwick had drawn up his army on high ground overlooking the plain before the town of Almansa.[7] It was noon before Galway's forces reached the plain and aligned themselves about a mile from the Bourbon position. The Franco-Spanish forces, commanded by Berwick, Popoli and d'Asfeld, amounted to somewhat over twenty-five thousand men; half were French, there was also an Irish regiment, and the rest were Spanish. Galway and Minas had a considerably smaller force of about fifteen thousand five hundred men, of whom half were Portuguese, one-third English, and the rest Dutch, Huguenot and German; there were no Spaniards. The battle, which began early in the afternoon and went on for two hours, resulted in the total defeat of Galway's forces. The allies lost at least four thousand killed (mostly English, Dutch and Huguenots) and three thousand prisoners. The losses would have been higher but for the flight of most of the Portuguese at an early stage of the battle. Berwick's total casualties in dead and wounded were also substantial, about five thousand men.[8] Orléans arrived the day after the victory, too late to share its glory. Berwick, who always felt himself to be English and avoided fighting Englishmen wherever possible, invited the captured enemy officers to a large banquet which he held in their honour two days later.

The importance of Almansa, the one decisive battle of the War of the Succession in the peninsula, is beyond dispute. By it, Valencia was permanently recovered for Philip V, the principal allied army was shattered, vital moral initiative was regained, and the archduke was compelled to rely solely on the resources of his Catalan supporters. At Almansa, the marshal duke of Berwick saved the Bourbon succession. Years later, Frederick the Great of Prussia described it as the most impressive battle of the century. The most important internal consequence of the victory was the revocation of the fueros (or autonomous laws) of the realms of Aragon and Valencia. The recovery of the rest of the eastern part of the peninsula was completed several years later with the capture in 1714 of Barcelona.

In those same weeks of the year 1707, the tide of events outside the peninsula was not so favourable. Italy, which had long aspired to be free of Spain, seized the opportunity of the war with alacrity. The military

balance was swung in favour of the Austrians when Prince Eugene in 1706 returned from a three-year absence in Vienna. He brought with him an army that joined the forces of the duke of Savoy and decisively defeated the numerically superior army of the French outside Turin on 7 September. The victory sealed the fate of Spanish power. France withdrew most of its troops and in March 1707, by the Convention of Milan, agreed to abandon the whole of northern Italy. From this date Savoy, which since the seventeenth century had been the focus of Italian nationalist aspirations, began to emerge as the dominant power in the north. The peninsula lay open to the Austrian army, which under the command of Field Marshal Daun swept triumphantly southwards and occupied Naples in July 1707. The campaign was made to pay for itself: former Spanish allies such as Genoa, Parma, Tuscany and Lucca were forced to contribute huge sums of money to sustain the troops. In their new territories the Austrians settled down to enjoy their gains and profit from the Mediterranean sunshine. Like the Spaniards before them, they made few changes in government, confirmed the existing élites in power, and invited Italian intellectuals and musicians to go to the north and teach them about culture.[9]

The military operations in Europe determined the future shape of the Spanish empire. But Spain had no part whatever in the decisions taken. When negotiations for peace with the Allies were opened, they were conducted by France alone. Philip V busied himself sending agents to talk to the opposite side but had no plenipotentiaries at the peace conference. The other great contender for the crown of Spain, the archduke Charles, had now succeeded to the Imperial throne as the Emperor Charles VI. He managed to have his representatives at the peace talks, but his demands were not accepted by the other powers and in the end he did not sign the peace treaty. In August 1712 hostilities between Great Britain, the United Provinces, Portugal, France and Spain were suspended. On 11 April 1713 the Treaty of Utrecht (in reality there were several treaties signed on that date and in later weeks, but they are normally referred to as though they were one) was formally concluded. It was certainly the most important accord in the entire history of the empire, whose shape it altered radically for the first time since the early sixteenth century.

By the terms of the peace agreed between France and Great Britain, Spain and the Indies were guaranteed to Philip V who, in turn, reaffirmed

the renunciation of all his rights to the French throne. A treaty between Spain and Britain was not in fact concluded till 13 July, when Philip's plenipotentiaries at last took part. By this agreement, Spain ceded to Great Britain the fort of Gibraltar and the island (captured by the British in 1708) of Minorca; gave up the kingdom of Sicily to the duke of Savoy; and granted to Britain the asiento for the slave trade to America as well as the right to send one ship a year to trade legally with the colonies. The peace treaty between France and the Dutch provided, among other things, for the eventual transfer of the southern Netherlands from Bavaria, which had controlled it for over a decade, to the Emperor. Louis XIV had long been aware of the need to make concessions, but his problem had been to try and convince his grandson. As early as October 1706 he was warning Amelot that 'the king of Spain must be prepared for great dismemberments of the monarchy'. Even more forcibly, in 1711, when Philip was refusing to accept the loss of Gibraltar and Minorca, Louis told his grandson directly that 'there are occasions when one must know how to lose'. Spain made peace with the Dutch in June 1713, with the British and Savoy in July the same year, and with Portugal in February 1715.

The concessions of territory made in 1713 were painful ones. Gibraltar had been captured in August 1704 by an Anglo-Dutch expeditionary force, and its loss was a bitter pill that the Spanish government always refused to accept, for it wounded national dignity. Never since the medieval Arab invasions had the Spaniards ceded a fortress on their own territory to a foreign power. On the other hand the British had spent effort and lives in capturing the town and later in resisting the various sieges that took place during the war. Though it had no strategic or commercial value, Gibraltar became a symbol of victory that no British government would contemplate relinquishing. The loss of Minorca was of a different order. The island was invaded in September 1708 by General Stanhope and Vice-Admiral Leake, and reduced after just over a week. Its importance was immediately recognized by Stanhope, who wrote to his government that 'England ought never to part with this island, which will give the law to the Mediterranean both in time of war and of peace.'[10] These were the only losses of metropolitan territory, but they were enduring. Minorca flourished quietly under British rule and was given back to Spain a century later; Gibraltar remains British.

The dismemberment of the European empire continued after Utrecht,

and was fated to be total. Sicily, a kingdom that had been an integral part of the Crown of Aragon since before the days of Ferdinand the Catholic, was at Utrecht ceded to the duke of Savoy. But the other Mediterranean possessions remained to be disposed of. Their arbiter was the Emperor Charles VI, who had refused to accede to the Peace of Utrecht and was therefore not only still at war with Spain (and France) but also in effective occupation of all Spanish territory in Italy. The year after Utrecht, therefore, on 7 March 1714 France and the Empire agreed on conditions for peace in a treaty signed at Rastatt, on the right bank of the Rhine just north of Strasbourg. The actual treaty of peace between the two was not signed until 7 September, at Baden in Switzerland. The French agreed to transfer to the emperor all Spanish territory in Italy, including Naples, Sardinia, Milan and the fortresses of Tuscany; the Spanish Netherlands were ceded to him at the same time. With Minorca and Gibraltar in English hands, and Italy under Austrian control, Spain found itself deprived at one blow of its control of the western Mediterranean. Utrecht and Rastatt opened a new era in Spanish history, leaving the peninsular monarchy utterly alone in Europe and subordinated to the dictates of the two emergent world powers, France and Britain.

The conditions imposed at Utrecht were to remain in force for nearly a century, and in theory regulated the relations between the great powers. But it was a system that had been imposed by force on Spain, which therefore made repeated attempts to overturn it. The Treaty at Baden did not include peace between the Empire and Spain, leaving the latter free to question the new arrangements in the Mediterranean. Over the next half-century the two powers, still formally at war, continued to fight for control of Italy.

Supported from 1700 by the protecting hand of France, the Spanish crown was able to take stock of its position in the world, and did not like what it saw. The great commercial empires of Britain and the United Provinces had seized every advantage afforded them by their naval supremacy. Was it possible to salvage what remained of the world empire?

The mines of New Spain were now increasing their production of silver, thanks to receipts of Spanish mercury from Almadén. Production figures of five million pesos a year at the opening of the century doubled by the 1720s, and remained at that level during the reign of Philip V. By

contrast, in the viceroyalty of Peru both population and production declined. The great silver mining centre of Potosí in Bolivia lost over two-thirds of its population in the century after 1650. The city of Lima in the same period lost half its population. No small role was played by the earthquake which in 1687 destroyed a good part of the city and provoked a tidal wave that wiped out the port of Callao. America still continued to feed its wealth into the European market, where the Iberian peninsula acted as an essential link in the trading system. A Nantes merchant resident in Cadiz in 1726 saw American silver as 'the public and common treasure of all nations'.[11] From 1700, bullion that came to Cadiz from the Spanish colonies (including gold from the increased production in New Granada) was supplemented by substantial quantities of gold that came to Lisbon from Brazil.[12] Spain continued to be the centre of an international market, but its role in respect of colonial wealth had changed radically: it now became a centre for the re-export of precious metals. From 1640 to 1763, almost all the bullion reaching the peninsula was re-exported to other European countries and to Asia.[13]

Aware that American produce, whether in goods or in bullion, was going largely to non-Spanish markets, the new management in Madrid looked closely at possible solutions. In American ports, vendors inevitably sold their produce to ships from other nations if there were no Spanish vessels to make the purchase. In the opening years of the eighteenth century over two-thirds of the goods traded from Peru went to France, mainly to the port of St-Malo.[14] The immense 'contraband' trade was of long standing and impossible to control. An attempt to revive the old fleet system failed to produce results.

After Utrecht the Bourbon government set itself two clear priorities: to reclaim initiative for the state in matters of war finance; and to recover control of exterior trade. Both questions were related, for they involved sources of revenue. The loss of the Italian territories delivered a mortal blow to the international network that had previously enabled Spain to conduct its imperial business in Europe. In return, of course, the loss also reduced the enormous costs that maintenance of the European empire had caused till then. In effect, the new government wrote off that part of the state debt that went to foreign financiers. Working from zero, and with the help of a new bureaucracy organized on the French pattern, Philip V's government achieved a spectacular rise in tax income, derived almost entirely from national rather than overseas sources.[15] Spain by

the mid-eighteenth century had reached the curious position of being an imperial power whose strength no longer lay in the empire but in its own internal assets. Spain had for all practical purposes liberated itself from its empire.

Perhaps the most startling development in this unusual scenario was the creation of a new military capacity. The Treaties of Utrecht and Rastatt had stripped proud Spain not only of its European empire but of segments of its metropolitan territory, and during the war years it had completely lost its foothold in North Africa. Despite these reverses, the War of Succession enabled the government to bring into existence an autonomous war machine that it had never before possessed. The integration of the eastern provinces into a national state gave Spain's administration, for the first time in its history, the material resources to pursue the belligerent policies favoured by Philip and his advisers. There were three main consequences: treasury receipts rose, administrative control increased, and a new army and navy were created.

All the reforms had been made possible thanks to measures initiated by the French during the War of Succession. Subsequently, from around the year 1715, the king's chief ministers – who happened to be Italians, Cardinal Giulio Alberoni from Piacenza and José Patiño from Milan – dreamed, with the active encouragement of the king, of restoring Spain's power on the international scene. In 1715 the British representative in Madrid, George Bubb, was of the opinion that 'the revenues of Philip V exceed by one third those of his predecessors, and his expenses do not come to one half'. The government's own confidential figures suggest that this assessment was correct.

The creation of a new army and navy was an impressive achievement. During the centuries of world predominance the nation, like others in Europe, had no permanent military forces and recruited armies only when required. Now, for the first time in its history, it began to maintain a powerful standing army. The new Bourbon army, recruited with great difficulty because of the objections everywhere (especially in the Crown of Aragon) to military service, inevitably involved important administrative and fiscal reforms. We have seen that the poor condition of the Spanish forces in the War of Succession made it necessary at every stage to have the support of foreign troops and foreign generals. Philip had decreed a few limited reforms during the war, mainly in order to obtain recruits. But the problem of securing a good standing army remained

unresolved. Fortunately, many of the foreign soldiers and officers who had served in the war continued their career under the Spanish crown. As a result, in the 1720s up to one third of the infantry of Spain consisted of foreigners who chose to continue the old tradition of serving the Spanish crown. In 1734 there were thirty thousand foreigners in service, mainly Belgians, followed in number by Swiss and then by Irish.[16] In effect, the astonishing number of Belgians serving in the Spanish army meant that the famous Army of Flanders had reconstituted itself in the peninsula. The annual cost of the army in 1725 was nearly five and a half million escudos, a massive sum that had no precedent in the history of the Spanish treasury.[17] Of this, three-fifths went to finance the army in Catalonia.

The need to garrison the fortresses of the peninsula adequately, to maintain security in the provinces of the peninsula that had lost their fueros, and to contribute towards external military expeditions, all served to make it essential that Spain have a permanent force. There is no reliable calculation of the army's size. Official figures suggest that it reached its peak in 1734, when it had thirty thousand men; but the British representative in Madrid, Sir Benjamin Keene, reported at around the same date that it actually totalled seventy thousand. A few years later he put the total even higher. 'The king of Spain', he reported, 'has upon paper and in his imagination one hundred and fifty thousand men, of which thirty thousand are militia. His regular troops I believe may be computed at seventy thousand effective men, of which about nineteen battalions are in the garrisons of Oran and Ceuta.'[18]

The navy owed its existence manly to José Patiño. As we have seen, at the beginning of the century the naval resources of the Spanish crown were severely limited. During the War of Succession, the country was totally dependent in naval matters on the protecting hand of France. Not a single Spanish warship took part in any of the naval actions of the war. Successive Spanish failures at key points of the campaign can be explained largely in terms of France's inability to overcome the naval supremacy of the British and Dutch. The count of Bergeyck, a Belgian who became chief minister of Spain in 1711, was the first to be seriously concerned with naval recovery. In his correspondence with the French Navy minister Pontchartrain, he proposed an ambitious plan that would draw on French resources. Philip took a close interest in the subject. 'I have revealed the plan only to the king', wrote Bergeyck in 1713, 'It has

been necessary to keep it secret because of the jealous attitude of the English ministry.' In February 1714 Philip created a new naval officer corps, and abolished all the old profusion of titles by which commanders of the various fleets were known, instituting in their place a standard superior rank of 'Captain General of the Sea'.

Bergeyck's plan was never put into effect. The real creation of the navy may be dated to Patiño's appointment as intendant of Cadiz in 1717. From that period, the amount of money set aside by the government for the navy rose spectacularly. In 1705 only 79,000 escudos was spent on the navy, by 1713 the figure had risen eighteen times, to more than 1,485,000 escudos. And the cost kept rising. In his first year in charge of the navy, 1717, Patiño spent three times more than had been spent in 1713. He also held the posts of president of the House of Trade (the Casa de la Contratación) of Seville, and intendant of the area, so he had virtually total powers over policy. He used them wisely to found dockyards and to promote shipbuilding. 'Ever since I returned to this country', Keene wrote in 1728, 'I observed with the greatest concern the progress Patiño was making towards a powerful marine. That idea is so strong in him, that neither the subsidies paid to the emperor nor the misery of the Spanish troops nor the poverty of the household and tribunals can divert him from it.' Patiño paid for the building of ships in Biscay and Cadiz, promoted support industries, and reformed naval administration. At the time of his death the navy totalled thirty-four warships, nine frigates and sixteen smaller vessels. Without these ships neither the great expeditions of Alberoni nor the king's enterprise of Oran would have been possible.

However, there continued to be major defects that affected future events in the history of Spain's navy. Keene observed in 1731 that 'their naval officers do not deserve that name'. It was a long time before efficient officers and pilots could be trained. Though vessels were being built in Catalonia, Andalusia and Vizcaya, most of the ships used in naval expeditions tended to be purchased from France or hired from private owners. For example, the fleets that took part in the Mediterranean expeditions of 1717 and 1718 were not for the most part constructed in Spain. Thanks principally to the contracts that the government made with French captains,[19] Spain was able to convert itself overnight into a major naval power. Quick solutions turned out to be the most practical ones. They gave the country the appearance of

strength, but little more. In practice, Spanish ships turned out to be excellent as transport vessels but disastrous as a fighting force.

Early in 1717 preparations were being made in Barcelona for a naval expedition that Alberoni claimed was being directed against the Turks. Patiño, who was in charge of the military preparations, strongly advised the king that no action against a distant objective such as Naples was advisable. In July 1717, Philip and Queen Elizabeth Farnese (whom he had married in 1715 after the death of his first wife) signed instructions for the fleet to set out for the occupation of Sardinia.[20] There was no doubting the strength of the force that sailed. About one hundred vessels, among them 9 ships of the line and 6 frigates, transported 8,500 infantry and 500 cavalry under the command of the marquis of Lède, a Belgian general who in subsequent years also commanded many of Spain's expeditionary forces. The vessels sailed in detachments from mid-August. By the end of September, the island was under Spanish control.

The success of the venture seems to have converted Alberoni to the selective use of force. Spain, thanks to the work of Alberoni and Patiño over the last few years, now disposed of a valuable instrument that the emperor lacked totally: naval power. In June 1718 the cardinal wrote to a correspondent in Italy that 'there can be no system of security in Italy without tranquillity. A good war is necessary, until the last German has been driven out.'[21] No sooner had the European powers recovered from the surprise of the Sardinia expedition, than yet another fleet was launched from Barcelona in June 1718. Twelve ships of the line, seventeen frigates, seven galleys, two fireships and two hundred and seventy-six transports, transported thirty thousand men and eight thousand cavalry across to Sardinia, where provisions were taken on board. The fleet then made for Sicily, where the forces landed near Palermo on 1 July.

Spain's return to an imperial role under the Bourbons was deceptive, fragile and in the long run disastrous. No better evidence of it can be found than in the famous incident at Cape Passaro. The naked Spanish aggression in Sardinia and Sicily in 1718 greatly alarmed the European powers that had agreed upon, and now wished to preserve, the conditions of the Treaty of Utrecht. In August 1718 Britain, France, the Empire and Savoy formed a Quadruple Alliance against Spain. A British fleet of twenty-one warships under Admiral Sir George Byng was sent to

Naples to protect the interests of the emperor against the Spanish naval expedition. The British ambassador in Madrid warned the government to call off its venture. A defiant Alberoni shrugged off the warning and said, 'Do what you wish!' On the morning of 11 August Byng located the Spanish fleet, twelve newly constructed warships, and seventeen frigates under the command of Antonio de Gastañeta, off the east coast of Sicily, at Cape Passaro. The British vessels began to engage the Spanish ships one by one. By nightfall the Spanish fleet had ceased to exist. Of its twenty-nine vessels, nine were captured and six sunk; only fourteen escaped. Gastañeta and his admirals were captured and later set ashore at Catania.[22]

Declarations of war followed, by Britain in December and by France in January 1719. The duke of Berwick headed an army of twenty thousand men that crossed the Basque frontier in April 1719. The general appointed to lead the Spanish forces was the Italian general the Príncipe Pio, marquis of Castelrodrigo, who was summoned from his post as governor in Barcelona. The bulk of the Spanish forces was concentrated in Pamplona, while the king and the Príncipe Pio headed a detachment that attempted to relieve the besieged fortress of Fuenterrabía. With very little effort, the French occupied Fuenterrabía (18 June) and San Sebastián (17 August), and by the end of August were in possession of the three Basque provinces of Vizcaya, Guipúzcoa and Álava. The startled Basques, on finding that they had been occupied by the man who abolished the liberties of Catalonia, hastened to make their peace and even negotiated conditions for a hypothetical integration of their provinces into the French state. They would accept becoming French, they said, provided their fueros were preserved. Berwick, however, had received no instructions about such an eventuality, and ignored the offer, which if accepted would have fundamentally changed the course of Spain's entire subsequent history.

The British meanwhile in August made an expedition by sea to the shipyards at Santoña, on the northern coast, where they took pains to destroy all the vessels under construction. They also invaded Galicia in a campaign that was clearly punitive – like the French invasions – with no intention of conquest. At the end of September they captured the port of Ribadeo, landed five thousand men and went on to occupy Vigo, Pontevedra and other towns.[23] They stayed only four days in Ribadeo, but remained in Vigo for four weeks. A defenceless Galicia suffered severe damage to property and crops, and no attempt was made by

English officers to prevent looting. The conflict, which came to an end the following year, was a sham war with little other purpose than to demonstrate to Spain that it could operate as a military power only with the permission of the French or the British. Spain was forced to join the Quadruple Alliance in February 1720 and take part in the peace talks that began informally at Cambrai in 1722 but did not officially begin until 1724. In August 1722 Fuenterrabía and San Sebastián were formally returned. The arrangement laid down by the Alliance at Cambrai (1724) was intended to bring peace to the Mediterranean. Philip was to return Sardinia and renounce the conquest of former Spanish territories, the emperor was to abandon his claim to the Spanish Crown, and Spain's claim to the succession in the duchies of Parma and Tuscany would be recognized.

No sooner had his forces put into effect their withdrawal from Sicily in the summer of 1720, than Philip used other available forces from the peninsula to mount another rapid expedition. The objective this time was the North African fortress of Ceuta, Spanish territory that had been besieged since the year 1694 by the sultan of Morocco, Muley Ismael. Ceuta had an exceptional symbolical value, as the only territory still held by Spain in North Africa (Oran had been lost during the War of Succession). It also had a very substantial material value, for without Ceuta the crown would (technically) cease to be able to collect the income from the famous 'bull of the Crusade', one of its biggest sources of revenue.[24] A force of sixteen thousand men, commanded by the marquis of Lède, was organized by Patiño to sail from Cadiz. It landed near Ceuta early in November, and began a military operation designed to drive back the sultan's forces. The Ceuta garrison was strengthened, and the men returned safely to Spain.

Several years later, in 1732, a similar campaign was directed against Orán. The king's eldest son by Elizabeth Farnese, the Infante Charles, had just been successfully installed by international agreement as ruler of the Italian duchies of Parma and Piacenza. Encouraged by the event, the king proceeded with a plan that he had been considering even before his son's departure to Italy. He intended to recover the African fortress of Oran, lost to the Muslims as a result of the defection of the commander of the Spanish galleys during the war of Succession. His admiral the marquis of Mari was instructed to take three warships to Genoa and pick up two million pesos deposited with banks there in the

king's name. The money was to be used to hire vessels for the Orán fleet. The expedition was put into the hands of Patiño, who as usual carried it out with scrupulous efficiency. A military force of thirty thousand men on twelve warships, seven galleys and a large number of transport vessels, under the command of the count of Montemar, José Carrillo de Albornoz, sailed from Alicante on 15 June 1732 and crossed the straits to Africa. Information about its objective was kept secret until the moment of sailing, when Philip issued a decree in Seville confirming the operation. Resistance in Oran was minimal; both the fortress and the neighbouring town of Mers-el-Kebir were occupied after a period of six days. News of the success arrived in Seville on 8 July, and gave rise to the inevitable festivities: the whole cathedral tower was decorated with fireworks. But Benjamin Keene was suspicious of the possible threat to British interests in Gibraltar and the Mediterranean, and doubted whether the campaign had really been successful, since the loss of Spanish lives was (he reported) as high as three thousand men.

The rapid expeditions to Africa, which reclaimed outposts that had been Spanish over twenty years before, were intended to enhance security at the entrance to the Mediterranean and make up for the loss of Gibraltar. But they also set in motion once again a distant dream of the Spanish imperial imagination. By securing Oran, as he had secured Ceuta twelve years before, Philip V gave new life to one of the most permanent dreams of the Spanish political élite: the maintenance of an empire in North Africa. The vision of a southern frontier had obsessed Cardinal Cisneros and it continued to obsess many Spaniards. Frustrated in the attempt at maintaining world hegemony, the ruling élite realized suddenly that there were imperial possibilities nearer at hand. As a politician declaimed over a century later in the Cortes in Madrid: 'Africa, in the testament of Isabella the Catholic; Africa, with Cisneros in Oran; Africa, with Charles V in Tunis; Africa, a dream in which the whole peninsula joins, from Lisbon to Cadiz, from Cadiz to Barcelona!'[25]

Bit by bit, it seemed, the lost heritage would be regained. And the opportunities did not cease to present themselves. The scenario became yet more complex when in the following year, 1733, Spain was dragged into a war over the succession to the throne of Poland. French diplomacy, which had in the past worked hard to maintain the peace, now worked equally hard to persuade Spain to go to war against Austria, whose candidate was in possession of the Polish throne, contested also by a

candidate of France. In a ceremony at the Escorial in November 1733, a so-called Family Pact was signed between the Bourbons of France and Spain. In February Philip V sent Spanish troops to northern Italy to back up the French troops which had invaded the Austrian territories there. Charles, now aged eighteen, was made nominal commander of the Spanish forces.

Seeing that the French were in control of the situation in northern Italy, Philip V decided to change his plans. The troops under the count of Montemar were now ordered to go south and occupy the formerly Spanish territories of Naples and Sicily. From its naval bases in the western Mediterranean, Spain had little difficulty in backing up the military expedition. A large fleet of twenty Spanish warships, accompanying a force of sixteen thousand men, sailed from Barcelona for Italy. It was a rapid and wholly successful campaign. Most of the inhabitants of the south had never accepted Austrian rule and greeted the Spaniards with enthusiasm. As soon as he reached Neapolitan territory, Charles in March 1734 issued a general pardon to all citizens of the kingdom, confirmed their laws and privileges, and promised to remove all taxes imposed by the Austrians. The bulk of the Imperial forces saw that fighting would be hopeless, and refrained from offering resistance.

On 9 May, even before Charles had arrived in the capital, representatives of the city of Naples came to offer him their obedience. Charles made his solemn entry into the city the next day and was proclaimed king. An Austrian force that invaded from the Adriatic was defeated by Montemar later that month. The Sicilians waited with expectation to be liberated from Imperial rule. In August a force under Montemar sailed from Naples for Sicily, and on 1 September entered Palermo and proclaimed Charles king. The Sicilians rose all over the island in support. Charles crossed over to visit them during the first six months of 1735. The Spanish Bourbons were now in control of all southern Italy as well as Tuscany. It was an astonishing achievement carried out with remarkable speed and very little loss of life. Philip V's forces had recovered all the Italian territories lost at Utrecht, with the exception of Milan. In Naples, the Bourbons initiated a great new dynastic epoch.

In theory the Castilian élite should have been overjoyed at the recovery of the old Habsburg empire. But the change of dynasty and the thirty years of war that followed it had profoundly affected the outlook of all the participants in the story. The Castilian historical image, carefully

cultivated over the centuries, was of a kingdom of Naples that had been conquered gloriously by the Spanish troops of the Great Captain, annexed to the Spanish Crown and ruled over by Spaniards. That image had nothing to do with the new conquest of Naples, organized only by Italians and Frenchmen. To make matters worse, Philip V refused to integrate Naples ('the kingdom of the Two Sicilies', as it was now called) into the Spanish monarchy, and instead recognized his son Charles as ruler of a wholly independent kingdom. The decision infuriated the Castilians. When news arrived in Madrid that Charles had been proclaimed king in Naples, only two grandees, both of them Italians, went to the royal palace of La Granja to congratulate Philip on the achievement.

The succession of the Bourbons in Spain provoked a radical critique of the empire as it had been managed for two hundred years by the Habsburg dynasty. No longer constrained by the need to flatter and fawn in order to conserve their position, a few intellectuals of the new regime delivered mortal broadsides against the policies that, in their view, had brought the empire to the pass in which it found itself. Spanish economists of the period who compared the condition of their country with that of Holland, England or France experienced a deep sense of 'backwardness, inferiority and resentment'.[26]

One of the most striking of the new critics was José del Campillo, a brilliant administrator whom Philip V intended to make his chief minister but whose career was cut short by an early death. In his *New System of economic government for America*, which circulated among colleagues but remained unpublished until the end of the century, Campillo denounced the opportunities that Spain had lost in the New World.[27] Instead of enjoying a flourishing commerce in America, he said, Spain earned less in trade from the whole continent than France earned from the island of Martinique alone. Spain had wasted its efforts pursuing 'conquest', when it should have been creating wealth by developing the resources of the New World. Above all, Spain had neglected the biggest resource at its disposal: the native population of America, which could have been drawn into productive schemes instead of being oppressed and exploited. Campillo, like other commentators of the early Enlightenment in Spain, did not fail to underline the contrast between the failures of the Spanish empire and the growing successes of the other

West European nations, particularly the British. Always with an eye on the British formula for success, they had no hesitation in supporting a system of free trade (above all, with America) as the only way in which Spain's hidden potential might be developed.

In reality, the critics were only one side of the picture. There were also others who looked back on the past with nostalgia and feared the outcome of the changes that appeared to be happening all round them. In Italy, the passing of the Spanish crown to a French dynasty in 1700 threatened to break the long-standing links between the ruling nobility and the Spanish crown. Those who had benefited from Spanish rule were justifiably concerned. The Venetian envoy reported from Milan in 1700 that 'the Milanese fear passing under a rule that they describe as tyranny, and losing the liberty that they enjoyed under the present [Habsburg] government'.[28] For over a century Milan had not (unlike Naples) experienced famines or riots or conspiracies. For the élite, empire had been a time of collaboration and success, not of oppression.

But in other parts of peninsular Italy there was a sigh of relief at the disappearance of Spanish rule. In Naples during the eighteenth century the political economists Paolo Mattia Doria and Antonio Genovesi presented a reasoned indictment of the impact of Spanish domination. Their views set out a perspective that would become widely accepted among Italians, for whom the 'problem of the south' would be blamed largely on the negative effects of Spanish rule. It was a view that received its definitive form earlier in the same century in the writings of the lawyer and historian of Naples, Pietro Giannone, whose *Civil History of the kingdom of Naples* was published in 1723. The work was burnt publicly in Rome in 1726 and earned the author papal excommunication and exile. Giannone died far from home, in a Turin prison. But his book was as music to the ears of the Austrians, and the author had the honour of being able to present a copy of his study to the Emperor Charles VI in Vienna in 1723.[29]

Neapolitan intellectuals, in effect, were criticizing not the Habsburg dynasty but rather the rule of Spain. 'This country', wrote Genovesi, referring to the two hundred years of Spanish control, 'became a province of Spain. It was no longer governed by those who were familiar with the inhabitants, but by foreigners, nearly all of them transients and with their hearts elsewhere.'[30] In his *Maxims of the government of Spain*, written shortly after the Austrians had occupied Naples, Doria subjected

the whole period of Spanish rule to a devastating criticism. The Spaniards, he said, had deprived Neapolitans of 'virtue and wealth and introduced instead ignorance, villany, disunion and unhappiness'. They had destroyed the roots of civilized society and introduced a tyranny that had undermined the virtue of citizens. 'The Indies', he claimed, invoking a standard image of the annihilation of peoples by the Spaniards, 'are not those in America; the true Indies are here in the kingdom of Naples.'[31]

In contrast to what was happening in Europe, the War of Succession seemed to have a limited effect on the Spanish empire in the New World, where Spain's friends and enemies were both well ensconced and there were few gains to be made. One of the foreign Jesuits working in the Caribbean reported that 'although there is a war in Europe between the Spaniards and the Dutch, there is no sign of it in America'.[32] The appearances were deceptive. In the vast land mass of America changes seemed less notable but were no less decisive. The anti-Bourbon nations concentrated their efforts less on territory than on trade and on disrupting the commerce of Spain and France. On the North American mainland they took advantage of the hostilities in order to ally with native Indians against what remained of the Spanish missions.

The war offered a good opportunity for foreign vessels to enter the Pacific. Because Spaniards did not and could not control the passage round Cape Horn, they inevitably allowed other nations an unimpeded entry. The merchants of Bristol seized the chance for illicit trade and financed the sending of two well-armed frigates under the command of Captain Woodes Rogers, with a motley crew that included the irrepressible William Dampier. They rounded Cape Horn early in January 1709. On approaching the archipelago of Juan Fernández, off the coast of Chile, Rogers noticed a fire at night on one of the islands and sent a boat to investigate. The sailors, he reported, 'returned from the shore and brought an abundance of cray-fish, with a man cloathed in goat-skins'. The wild man, whose story Rogers related in an account that was subsequently immortalized by Daniel Defoe in *Robinson Crusoe* (1719), was Alexander Selkirk, who had been stranded on the uninhabited island over four years earlier by the captain of his vessel. Selkirk had fortunately been left with most essentials, including clothes, bedding, a gun with bullets, a knife, and books. He managed to survive in the face of

incredible difficulties, learning to eat without salt, and obtaining meat from wild goats, whose skins also served as clothing when his own apparel wore out.

Rogers's own fame rests on his harassing of Spanish territory in the Pacific. He held the port of Guayaquil to ransom, and augmented his fleet with captured Spanish vessels. On the advice of Dampier they lay in wait for the Manila galleon off the coast of New Spain. After cruising about for some weeks by Lower California, Rogers's ship *The Duke* spied a galleon, the *Nuestra Señora de la Encarnación*, which had been separated from its larger companion ship, and after a short struggle captured it single-handed. Four days later, on Christmas Day 1709, Rogers and his other vessels attempted to engage the companion Manila vessel, a powerful galleon called the *Begoña*, but failed to capture it. The English then returned to Europe across the Pacific, stocking up for the voyage in Guam, where the Spaniards were friendly and the governor invited them to a sixty-course dinner. The captured ship was displayed to an eager public in London: it was the first Manila galleon to be brought back entire. The Bristol merchants had spent less than £14,000 financing the expedition; their profits were estimated at up to £800,000.[33]

Secure in their naval and commercial superiority,[34] the French took advantage of the war in order to trade to the Caribbean and the Pacific. The council of the Indies reported in 1702 that 'the French continue trading considerable amounts of clothing throughout America, and especially in Veracruz, Santa Marta, Cartagena and Portobelo. In Havana the French have been buying and dealing in almost all the sugar in the island.' The French ambassador in Madrid, Amelot, commented on 'the abundance of European goods which French traders have taken to the Indies via the South Sea'.[35] In 1712 the viceroy of Peru accepted without opposition the entry of French trading vessels into Callao. His explanation to the government was that 'at present the treasury is so empty that there is no way it can finance an armada in the Pacific; in view of the present state of defence of this city of Callao I gave the necessary orders permitting the French vessels currently on this coast, numbering around twelve or fourteen, to come to Callao'.[36] As on many previous occasions, the entry of foreign vessels served to preserve rather than to undermine the empire, by supplying the colonies and maintaining contacts with the peninsula. A government official in Fontainebleau

commented that 'it is not surprising that the Americans have received our ships in their ports. They have brought them several things from Europe that they badly needed and which were of great value. Our ships have traded to them in the same way that the English and Dutch have traded in the Caribbean.'[37]

From 1698 the Spaniards began building a small pine-log fort at Pensacola, a site which an official expedition that included the writer Carlos de Sigüenza y Góngora had pronounced to be 'the finest jewel' possessed by the crown.[38] The wild and beautiful northern coast of the Gulf of Mexico was, however, also the object of intense French interest. Despite La Salle's failure, France's minister of marine Louis Pontchartrain was in reach of a much greater prize. Early in 1699 a small French force of five ships commanded by Pierre Le Moyne, Sieur d'Iberville, became the first European contingent ever to enter the mouth of the Mississippi from the Gulf. They built (1700) a small fort near the river mouth, about thirty miles downstream from the site of what is now New Orleans. Hardly aware of the significance of what they were doing, they had taken possession of the entrance to the greatest waterway in North America, which gave access to the interior of the continent and linked up with French possessions in Canada. The Spaniards never succeeded in identifying the correct entrance to the great river. Moreover, lack of manpower and resources made it difficult for them to take effective control of the rest of the eastern coast of the Gulf, from Tampico to Apalachee. Ventures inland were also undertaken half-heartedly: there was little motivation for moving into Texas territory, and the missions planted there among the Hasinai were short-lived. In practice, Spain's only hold on the vast central mass of the North American continent was, by 1700, the post at Pensacola. Across from them, the French were firmly entrenched at Mobile and the coast to the west.

The establishment of the French at Fort Mississippi occurred just as France converted itself into the ally and protector of Spain. The outbreak of war shortly after made the two countries combine their resources to keep the English and Dutch out of America. French help was invaluable. French forces were put at the disposal of harassed Spanish settlements: in both Pensacola and St Augustine the survival of the Spaniards was made possible by French reinforcements. But the French also made use of their unprecedented position as imperial partners, in order to advance

their own interests, with little fear of retribution from Spain. From the mouth of the Mississippi and their base further to the east at Mobile, French traders worked their way inland and made contact with interior tribes such as the Choctaws and Chickasaws. By working towards an understanding with these tribes Iberville, as French governor of the area, was doing the Spaniards a signal favour, for the alliance helped to block the relentless advance of the English colonists.

In 1712 a new governor was appointed for French Louisiana in the person of Antoine de La Mothe Cadillac, who had been serving in the north of the continent, where he founded the town of Detroit in 1701. In 1713 there came into his hands a letter (sent from Coahuila province, on the New Spain side of the Rio Grande, over two years previously in January 1711!) from a Franciscan friar, Francisco Hidalgo, asking for help in sending missions to the Tejas Indians in northern New Spain. Cadillac felt it was an ideal opportunity to use the current alliance with the Spaniards in order to promote French interests. He sent a Canadian lieutenant, Louis de Saint-Denis, to Mexico City to offer help to the Spaniards and their missions. As a result, in 1716 a small party of seventy Spaniards (including eight Franciscans) led by St Denis crossed the Rio Grande and eventually during the summer, at a spot between the Trinity and Neches rivers, set up a fort (in Spanish 'presidio') and four mission centres among the Hasinai Indians.[39] The area was ideal, for it was only a short distance away from the French fort at Natchitoches, on the Red River. Relying on Spanish support, the French could trade, which was their principal intention. The Spaniards, in their turn, had decidedly returned to east Texas, a development made possible only by French protection. Once again, as in 1691, a 'governor' was appointed.

Over the next few years a handful of French traders and agents managed to extend into the north the area of their operations. In doing so, however, they also stimulated the New Spain authorities to resist French influence by setting up posts and missions deep into Tejas territory. It was there that in 1718 the defence post of San Antonio, and its mission (later known as the Alamo), was set up by the new Spanish governor. Despite the unremitting rivalry between France and Spain, the two nations coexisted side by side for a while in North America while they extended their imperial frontiers.[40] The normally good relations between the Bourbon rulers of France and Spain protected the territories

of both in America. The French in Louisiana were tolerated by the Spaniards, who had no means with which to dislodge them, and therefore survived without problems. In 1718 a settlement called New Orleans, after the Regent of France (the duke of Orléans), was founded on the shores of the Mississippi near the Gulf and became the capital of the territory which the French called Louisiana.

A break in this peaceful coexistence, however, occurred suddenly in 1719, when events in Europe dictated that the French and Spaniards were now officially enemies. The French troops in Louisiana without any effort seized Pensacola in May 1719. The comic dimensions of the 'war' in these territories may be judged by the 'attack' made by the French detachment at Natchitoches on the Spanish settlement of Los Adaes. Seven French soldiers with their officer presented themselves one day in the town and informed the sole defending soldier that they were taking over. When the viceroy in Mexico City was apprised of the state of war, he sent off a troop of eighty-four men to strengthen the Spaniards in San Antonio. A more serious and substantial force took twelve months more to raise, for volunteers were difficult to find. Consisting of five hundred men and led by the marquis of Aguayo, it left Mexico City in October 1720 and reached San Antonio after seven months. It then continued eastward and reached the missions at the River Neches. In all this time there was no sign of the French. By the time that Aguayo and his force reached the Neches in June 1721, they were informed by the French (whose postal system was more rapid) that peace had been made in Europe.

The Aguayo expedition was not as useless as may appear. Though it seemed to have failed in its purpose of expelling the French, it succeeded in something more substantial: affirming the presence of Spaniards, however fragile, on the Texas frontier. When he retired from Texas, it has been pointed out,[41] Aguayo left behind him 10 missions where there had been 7, 4 forts where there had been 2, and 268 soldiers (whom he dropped off at each fort on the journey back) where there had been only 60 in the whole province.

In reality, the Spanish frontier in North America continued to be little more than a number of small, isolated forts with an insecure existence because they were both undermanned and vulnerable to the attacks of hostile Indians, who were usually organized by other Europeans. The main post in Texas, for example, was that of Los Adaes, dignified with

the status of capital of the Spanish province. Throughout its existence the post was wholly dependent on the French in Louisiana for supplies and armaments.[42] Indeed, the entire Spanish frontier from New Spain to the Atlantic owed its continued existence to the protection of other Europeans, who used the Spanish posts to further their own trade and communication lines. Spanish Pensacola supplied itself from the French in Mobile, and Spanish St Augustine bought its arms from the English in Carolina. Without the presence of other Europeans as suppliers, the Spaniards would have been unable to survive. Attempts to encourage settlers to immigrate from Spain failed. In one instance, the settlement at San Antonio was maintained only by bringing fifteen Canary Islander families overland from Veracruz.[43] There were occasional ambitious expeditions into the interior by missionaries and soldiers, but with few positive results.

The situation of the North American territories in the first half of the eighteenth century was unpropitious, so much so that in 1720 Spain even offered to give Florida to the English in exchange for Gibraltar, which had been seized during the War of Succession. In substance, the same defencelessness was to be found in every corner of the empire, but it was not caused by any deterioration of Spain's capacities, which had always been exiguous. The decisive new factor, not found in the sixteenth century, was the acquisition by other Europeans of permanent territories in the Atlantic and the Pacific, which they used at will as bases for trade and expansion.

The trading presence of Europeans was complemented by substantial immigration, especially on the part of the British. The number of Britons on the north Atlantic coastline increased nearly twentyfold between 1660 and 1760, and the English-speaking frontier was already in place in Florida and the Gulf coast. By the mid-eighteenth century, there were ten times more Europeans in South Carolina alone than there were Spaniards in the whole of Spanish Florida.[44] Logically, local native tribes chose to ally with the stronger side, and Spaniards found their last foothold on the Atlantic coast vanishing. The establishment in these years of the new British colony of Georgia, with its base at Savannah, produced further pressure on beleaguered St Augustine.

The disappearance of Spanish control can be seen through the experience of the indigenous peoples of northern Florida, where the Franciscans valiantly continued to maintain a string of missions through the

forests and lakes that were home to the Apalachee and Timucuan peoples. From the end of the seventeenth century the British in Carolina teamed up with the Yamasee Indians to the east and the Creek Indians to the west, in order to make raids into Apalachee territory. The decisive blow came during the War of the Spanish Succession, when in the winter of 1703–1704 a British force backed by Creeks attacked and destroyed what remained of the Apalachee. A local French official reported that 'the Apalachee have been entirely destroyed by the English and the savages. They made prisoner thirty-two Spaniards, who formed a garrison there, besides which they had seventeen burnt including three Franciscan fathers,[45] have killed and made prisoner six or seven thousand Apalachee, and killed more than six thousand head of cattle. The Spaniards have all retired to St Augustine.'[46] Not surprisingly, when Florida later passed under British rule many Indians chose to evacuate with the Spaniards who had been their protectors. After the impact of epidemic and wars, there were few Indians left. 'By the 1760s the indigenous population of Florida, once numbered in the hundreds of thousands, was reduced to almost nothing.'[47]

Changes in the relative role of the Europeans, meanwhile, were slowly being superseded by a much greater change that affected the native populations of the North American continent and worked against the interests of Spain's empire. By the early eighteenth century the entry of European horses, armaments and supplies was beginning permanently to change the environment of many Indian tribes. In Texas the French traders freed the tribes of dependence on Spaniards for outside goods. 'The French', a Franciscan missionary complained, 'are giving hundreds of guns to the Indians.'[48] Comanches and Apaches on the plains of Texas found that they had the means and, by now, the experience to attack and destroy Spanish outposts and missions. The situation was the same in northern Florida, where the British gave guns to the Yamasee and Creeks, while the mission Indians remained without their own weapons. The new firepower of the nomadic Indians was inevitably also directed against other Indians whose lands they desired. This fortunately helped the Spaniards in some areas. In the Pueblo country, the villages from 1704 onwards consistently united with available Spaniards against the raids of their enemies, especially the Apaches. In 1714 expeditions sent out to fight the Navajos consisted of around fifty Spanish soldiers but

also of up to two hundred Pueblo Indians. In 1719 an expedition against the Comanches had sixty soldiers but nearly five hundred Pueblos.[49]

In other areas it was not so easy to profit from an essentially unfavourable predicament. Deprived of their previous monopoly of armaments, the Spanish clergy were left vulnerable and unable to impose discipline by the force that had been their chief recourse. The missions crumbled, as we have seen, in Apalachee. In 1727 a visitor in eastern Texas reported that 'there were no Indians in the missions'. The coming of the horse, brought in from Europe by the Spaniards, revolutionized the life of the Plains Indians. Though the tribes at first used the animal for meat, they gradually learned that it served also for transport, hunting and attack. By the eighteenth century Spanish outposts were being subjected to repeated attacks from tribes that had mastered the horse and used it to extend their hunting grounds against other tribes. The Indians of the Great Plains – the Sioux, Blackfoot, Comanche and Crow tribes – were 'off on horseback on one of the most spectacular adventures that any people has ever known'.[50] The missions continued to import and breed horses, and the pioneer priests always travelled with their regular quantity of horses, mules and cattle, without which the spread of Christianity would have been literally impossible.

The situation was aggravated, from the Spanish point of view, by the entry into the heartland of the continent by French traders moving southwards from the Great Lakes and northwards from the Gulf. In 1719 evidence from Comanche sources reached officials in New Mexico, that Frenchmen trading for hides had sold guns to the Pawnees further north. It was the period of war between France and Spain, and Governor Valverde felt that it was worth going out to reconnoitre for information about the situation in the Plains. The Franciscans grasped eagerly at the chance to extend the mission frontier. In June 1720 a force of forty-two soldiers supported by sixty Indian allies set out from Santa Fe and two months later were in the region of Nebraska. They failed to find evidence of any French, however, and were attacked and virtually wiped out by the Pawnees. A few survivors straggled back to arrive in Santa Fe in September. In practice the Spaniards were unable to impede the French, who distributed arms to their Indian allies and thereby disturbed the balance of power among the Plains tribes. The main sufferers were the Spaniards, who were too thin on the ground to resist any further pressure on their undermanned forts and missions. The Apaches had become by

the eighteenth century the principal threat to the Spanish frontier, but an effort was made in the 1750s to construct missions among them to the north of San Antonio. They failed, in part because of devastating raids by the bitter enemies of the Apaches, the Comanches.

It was a situation that faced the Spaniards throughout the North American continent. To survive they were forced to rely on help from local peoples, not only Pueblos but also Utes, Navajos and even Comanches. Despite all efforts, the frontier not only came to a decisive halt, it also drew back. The missions, lacking security, gave up and left. In all Florida by mid-century only ten friars remained.[51] By the 1760s all attempts to Christianize the northern plains of Texas had been abandoned. In that decade the immensely long northern frontier from the Pacific to Texas was guarded by a total of a mere nine hundred soldiers distributed through twenty-two scattered presidios.[52]

There remained only one last horizon: California. The non-Spanish clergy who came to the missions in the north of New Spain at the end of the seventeenth century made a decisive contribution to the thrust towards the Pacific. In the mid-sixteenth century Cabrilho had discovered San Diego bay and after him the Basque Vizcaíno had explored the northern coast. But Spaniards continued to be baffled by the Gulf of California, which seemed to indicate clearly that Baja California was an island. Only the extensive travels and cartographic work of the Tyrolean Father Kino in the 1690s opened up the reality that Baja was not an island but a peninsula joined to the continent near the Gila and the Colorado rivers.[53] Kino, whom we have had occasion to mention already, was the great pioneer of the Jesuit enterprise in northern New Spain and the exploration of the land route to California. Based from 1687 in his mission a hundred miles south of modern Tucson, he spent twenty-four years dedicating himself to missionary work, exploration and writing. He twice descended the Colorado river, and crossed once into California and the Gulf. Writing in 1710, he estimated that 'with all these missions which have been made to a distance of two hundred leagues in these twenty-one years, there have been brought to the desire of receiving our holy Catholic faith more than thirty thousand souls, there being sixteen thousand of Pimas alone'.[54] But his dream of the conversion and conquest of Upper California was not carried out in any significant degree until the expeditions of the rival order of Franciscans, and with them Fray Junipero Serra, in the later eighteenth century.

After Kino's death in 1711 the vision of a route to the north and the Pacific did not fade, but the main missionary thrust was in Baja. By the mid-eighteenth century a high proportion of the Jesuits working on the frontier were Central Europeans. Among them was the Bavarian Jacob Sedelmayr, who became in the 1740s the great explorer of Arizona, crossed the Gila and went northwards to the Colorado.[55] The northwest was now no longer of interest exclusively to Spain.

A sign of this was what happened after the publication in Spain in 1757 by the Jesuits, of the *Noticia de la California* (*News from California*). Its main purpose was to defend the Jesuit order, which was already under attack in Europe for a variety of reasons. But it was soon after published in London in English (1759), and was followed by translations in Dutch, French and German. The English were moving westwards through Canada, and, perhaps most threatening of all, the Russians were moving southwards down the Pacific coast. In 1728 Vitus Bering, a Dane in the service of the tsar, explored the eastern limits of Siberia and discovered the strait that bears his name. In 1741 he organized an expedition across the Pacific which bypassed the Aleutian Islands and made landfall on the northern California coast, sixty miles south of Sitka. California, the outer rim of the American empire, was about to constitute a completely new chapter in Spain's experience. An early warning was given by the work *I moscoviti nella California (The Muscovites in California)*, published at Rome in 1759 by a Spanish Franciscan who had lived in the Philippines and Mexico. Two years later the Spanish ambassador in St Petersburg, the marquis of Almodóvar, sent a detailed report of Bering's activities to Madrid, but discounted any danger from the Russians.[56] It was not the first time that diplomats proved to be mistaken.

Through good and bad years, through war and peace, there was one constant comfort for the government and merchants of Spain: the arrival of silver from America. It was the fuel that had created the mechanism of empire, and it still continued to fire imperial hopes. Hand in hand with the flow of silver went the flow of merchandise. So long as the process continued, Spain could feel that it was the centre of the universe. Spanish trade was largely in the hands of foreign merchants, but that did not detract from its importance.[57] The very Western powers with the biggest control over Spain's silver remained anxious to preserve the

integrity of the empire. In the late seventeenth century the Dutch had come to Spain's help, in the early eighteenth century the French had done so. In the mid-eighteenth century, however, it was the turn of the English to emerge not as protectors but as a serious threat. Spain's relationship with Britain was being put to the test by several small conflicts in the Americas. A quarter of a century of disputes, centring on Gibraltar, the asiento and illegal English trade to America, fuelled Spanish grievances.

The main problem was the superior naval and commercial power of Britain and France. Foreign shipping accounted for three-quarters of all the vessels taking part in the American trade, and foreign merchandise represented the bulk of the goods traded to the New World. When Spanish vessels reached the ports of America, they found that foreign vessels had been there before them and flooded the market with produce that they had imported directly, without going through the monopoly system that operated from the peninsula. It was the same story no matter what the merchandise. The merchants of Lima reported in 1706 that 'holding the fair at Portobelo will be more of a hindrance than a help', since the viceroyalty had enough goods, all supplied by the French.

One of the most lucrative businesses was the slave trade, operated (as we have seen) through a trading company registered in Spain, with an 'asiento' to send a fixed number of African slaves to the American market. During the War of Succession the French had operated the asiento. With the peace of Utrecht in 1713, the asiento passed to the British, together with the right to send one ship a year to the trade fair at Portobelo. The British operated their privilege through their South Sea Company, which established a network of points throughout the Caribbean at which they could pick up and distribute blacks. In reality, the Company was little more than a clearing agency, and a high proportion of supply and distribution was carried out by licensed independent small traders and ships' captains, all British. The Company also had to supervise distribution in the interior of the continent of South America. In 1725, they were given formal permission by the Spanish government to transport slaves inland from Buenos Aires, to markets in Chile, Bolivia and Peru.

The official (and unofficial) activities of the British did not supersede the activity of other nations, which continued to supply slaves not only to their own territories but also to the Spanish. In around 1720, the French were supplying hundreds of slaves illegally to Havana, Portobelo

and Cartagena, and the Dutch (at Curaçao) and Portuguese (at Buenos Aires) were equally active. There was no effective way to limit the illegal supply, which in practice benefited the Spanish settlers. In 1716 the Company complained to George Bubb, British minister at Madrid, that 'the introduction of great quantities of blacks is winked at by persons in power [in America], and seems to be tolerated by them'. In Cuba in 1733, 'the inhabitants live, as it were, exempt of Spain's government, and as those people are very numerous and all alike guilty, their numbers protect them against any attempt to seize either their illicit blacks or their goods'.[58]

Extra-official trade, in blacks and in all other items, was the rule. At the last trade fairs ever to be held at Portobelo, in 1721, 1726 and 1731, the Company's annual ship *The Royal George*, together with its back-up vessels, dominated sales. In Spain there was an impression that the British were making huge profits as a result of their control of the asiento, and that foreigners were promoting contraband in America. It was an issue, as we shall see, that led to many disputes and eventually to war. In fact, the British found it difficult to make good profits out of a trade system that was in total chaos. In the period up to 1732 they managed to supply only two-thirds of the contracted slaves, and sent only forty per cent of the annual ships.[59] But when they made profits, they made good profits. At the Portobelo fair of 1731 the merchants of Peru spent half their money exclusively on the goods carried by the annual ship of the British South Sea Company.

It is easy to fall into the error of accepting the Spanish view (repeated faithfully by historians) that foreigners were ruining the economy of the colonies and destroying the Atlantic trade. The constant practice of contraband by interlopers would seem to confirm the picture. At the end of the seventeenth century an official in New Granada reported seeing a fleet of ten vessels laden with contraband sail for Europe; it was reported that the British and Dutch were taking gold, silver, pearls and emeralds from the coast. The fact, however, is that by their unofficial trade the foreigners were making (as we have already had occasion to comment) an invaluable contribution to the colonial economy. There is nothing more revealing than a listing of the items for which British traders risked their fortunes and their lives to transport across the Atlantic to America: drinking glasses, cups, teapots, plates, pots and pans, knives, wax candles, locks, cases, desks, writing paper, soap, medicines, books.[60] It

is unnecessary to add that the items most in demand were guns and weapons of every sort. The incapacity of the official Spanish trade system to minister to the needs of the empire was both flagrant and notorious. Without smuggling the Spanish colonies would have collapsed. During the War of the Succession, when conditions of warfare made life even more uncomfortable for settlers, the colonies survived precisely because the English and Dutch brought supplies.[61]

The evolution of an 'informal economy' of smuggling was a logical consequence of the inexistence – it would be pointless to call it a 'breakdown' for it had never reached the point of functioning properly – of the official trade system, through which Spain had hoped to claim the whole of the New World as a closed market for its products. By the early eighteenth century the metropolis was no longer serving the needs of its colonists. In the case of New Granada (modern Venezuela), within the half-century between 1713 and 1763 only four galleon fleets visited the port of Cartagena. The population was inevitably forced to buy goods from any other available suppliers. And there were very many of them. Within those years foreign traders brought to New Granada textiles (silks and linens), food (wheat flour, oil, wine, spices), manufactures (razors, scissors, mirrors), and slaves.[62] They took in return silver, emeralds, pearls, hides, cacao and dyes. It is easy (and also correct) to conclude that the 'informal economy' was in reality the normal economy, for smuggling became necessary in order to survive. The local authorities realized this to the extent of levying taxes on the smuggled goods that they could identify. In the province of Santa Marta, the revenue from taxes on contraband yielded twice as much as from licit commerce.[63] Since the greater part of contraband tended to escape detection, the dimensions of the informal economy may be imagined. An official of Cartagena in 1737 stated the situation of trade in New Granada succinctly. 'The king', he said, 'has the usufruct in name only; foreigners are its real owners.'[64]

In these circumstances we may throw overboard the idea that the trade system operating in the New World consisted of a dominant official trade and a secondary informal one consisting of contraband. The unofficial trade was in reality the dominant and therefore the official trade.[65] From the triangle represented by Curaçao, St Eustace and Guyana the Dutch, and particularly the diligent and growing Dutch Jewish trading community,[66] conducted an active commerce that was

not only formal but also legally sanctioned by the terms of the Treaty of Utrecht. A visitor to the area reported that 'the Dutch of Curaçao introduce, export, trade in, and do whatever they have a mind to on that coast', with the support of the settlers, the Indians and the royal officials. The crown and the Spanish missionaries might object, but the Dutch were in control. There was no point to repression or investigation, because neither worked. An official writing from Cartagena in 1718 informed the Spanish government that 'here anything that is untrue is presented as though it were the unvarnished truth; but demonstrating otherwise is impossible because nobody says or wishes to say anything, or does not dare to, either from fear or from intention or because they don't wish to get involved'.[67]

The English, like the Dutch,[68] complained of obstruction of their legitimate trade, and of harassment by the guardacostas, ships licensed by the Spaniards to act against informal trading. In practice, many of the guardacostas were licensed pirates who attacked and robbed whatever they liked, and did not restrict themselves only to foreign traders.[69] They were, in the opinion of an agent of the South Sea Company, 'the most abominable robbers of mankind'. Between 1713 and 1731 more than 180 English trading ships had been illegally confiscated or robbed by guardacostas, according to the British government. The most notorious case was that of Captain Robert Jenkins, who stated in the House of Commons in 1738 that seven years before, in 1731, the Spaniards in America had pillaged his ship and he had been bound to the mast and had his ear cut off. As proof, he showed the House a bottle with his ear preserved in it. When asked what he did then, he stated that he 'committed his soul to God and his cause to his country'. His speech stirred patriotic sentiments in England and convinced the Commons that war with Spain was the only solution. In April 1738 Benjamin Keene in Madrid was instructed by his government to demand compensation for the damage done to English shipping. Talks over the amount of compensation resulted in the Convention of the Pardo in January 1739, negotiated by Keene with the Spanish ministers. The Convention in reality settled none of the major points in dispute, and the amount of compensation that Spain agreed to pay was offset by money that Spain also demanded for the sinking of its fleet at Passaro.

The resentment against Spain among both politicians and traders in

England after the failure of the Pardo negotiation made war inevitable. The prime minister, Sir Robert Walpole, tried to explain to an angry House of Commons that it was in Britain's interest to support Spain. 'The preservation of the Spanish monarchy in America entire and undiminished has, for almost an age past, seemed to be the general inclination of all the powers in Europe. At present there is scarce any nation in Europe who has not a larger property in her plate ships and galleons than Spain herself has. It is true all that treasure is brought home in Spanish names, but Spain herself is no more than the canal through which all these treasures are conveyed all over the rest of Europe.'[70] His argument was that an attack on Spain's empire was really an attack on Britain's own interests, for Britain profited from the empire. It takes little effort to demonstrate that the British were effectively in control of many Spanish markets. Direct trade by the British to Spain itself fluctuated periodically because of outbreaks of war, but was always substantial; trade to the Mediterranean territories formerly under Spanish control did not cease to grow. By the 1730s the Mediterranean was the chief market for three-quarters of London's total European exports.[71]

Walpole could not prevail against rampant war hysteria, and his government was pushed into action. Admiral Edward Vernon was sent out in July 1739 to the Caribbean, to reinforce Jamaica and to take aggressive action against Spanish positions. War was declared in London in October, with the ringing of church bells and rejoicing in the streets. 'It is your war', the reluctant Walpole wrote to one of his ministers, 'and I wish you joy of it.' He had previously condemned any action against Spain as 'unjust and dishonourable'. Shortly afterwards he resigned. And the 'War of Jenkins' Ear' went on.

Vernon's ships concentrated their attack on the principal Spanish ports. They invested Portobelo with 6 warships and up to 4,000 men, who included 2,500 whites and 500 black auxiliaries. The small and poorly defended town surrendered in November 1739. Vernon returned the following spring to destroy the coastal fortress of San Lorenzo de Chagres and attack Cartagena. The main objective of British attacks was the port of Havana, the focus of all Spanish navigation in the Caribbean. Aware of the threat, Philip V in the summer of 1740 ordered a fleet of fourteen ships and two thousand men with armament to leave El Ferrol for Cuba. The detachment was battered by bad weather and disease and forced to take refuge in the harbour of Cartagena in October

that year. At the same time, Philip's ally France sent instructions to its colonies to block the British.

Eventually in January 1741 Vernon assembled in the harbour of Port Royal what has been called 'the most formidable force ever assembled in the Caribbean'.[72] The fleet totalled thirty ships of the line, in addition to one hundred transports carrying more than eleven thousand troops. But its bark was worse than its bite. The fleet besieged Cartagena in the spring of 1741 then withdrew because of fears that reinforcements had arrived to help the city. It next seized Guantánamo Bay in Cuba but was unable to turn the capture to any advantage. Finally, it tried to capture Panama, but failed there also. It was a naval campaign with confused objectives, for there was never any intention of occupying Spanish territory, merely (as with the corresponding attacks on the Iberian peninsula) of humiliating the empire. By contrast the Spaniards knew that they had to defend Havana, and did so successfully. Throughout the months of war, the bullion shipments continued to arrive safely in Spain.

The British also sent a small squadron under Commodore George Anson into the Pacific. With six ships of the line, two supply vessels and fifteen hundred soldiers, the force looked promising but suffered devastating weather for three months, from March to May 1741, on its route through Le Maire Strait into the Pacific. Eventually only three ships, with half their original crew, made it to Juan Fernández Island, where they rested for three months. The ships then sacked the port of Paita on their way north, their intention being to link up with Vernon at the isthmus and take Panama. On hearing of Vernon's failure in the Caribbean, Anson changed his objective and lay in wait instead for the Manila galleon off Acapulco. That too escaped his grasp, so the commander set out across the Pacific and reached Macao in November 1742. He left the port in April, his mind still fixed on the galleon. Cruising off the Philippines, he eventually sighted his prize in May 1743: the galleon *Covadonga*, fresh out from Manila, commanded by the Portuguese captain Jerónimo Monteiro. In a short action which cost the British one man dead and the Spaniards seventy, Anson captured the galleon, with some 1.5 million pesos on board.[73] The vessel was taken to Macao, where the Spanish sailors were released and the hulk sold.

The naval wars and commercial rivalries made, as Robert Walpole had seen clearly, little sense. The intervention of other European nations

in Spain's commerce had by the 1720s completely undermined the official 'monopoly'. Even the section of the monopoly that was legally in foreign hands – the annual British ship to Portobelo – was no longer profitable. The Navarrese political economist Jerónimo de Uztáriz, in his *Theory and Practice of Trade* (1724), was the first to unleash a tide of controversy over how to find a way out of the chaos. The activities of Vernon in the Caribbean and Anson in the Pacific served finally to convince those in authority on both sides of the Atlantic that the old monopoly system was gone forever. Bit by bit a strategy of open trade across the Atlantic was put into practice, and eventually in 1778 a royal decree established a system of Free Trade, which gradually took all of Spanish America into its orbit. From those years the monopoly of Cadiz was abolished, and a growing number of peninsular and American ports was integrated into a network of open trade.

French influence was decisive in dragging Spain into the era of new ideas. Since the mid-seventeenth century foreign writers were being read in French translation in a few cultured circles in the peninsula. Access to the Spanish empire gave French scientists the opportunity to make explorations that Spaniards themselves had not made. During the early war years of the reign of Philip V, Father Louis Feuillée made the first truly scientific expedition to South America. His voyage, which lasted from 1707 to 1711, resulted in the publication of his *Journal des observations physiques* (*Journal of physical observations*) (1714). The scientist Amadée Frézier also obtained permission from Philip V to sail to the Pacific, in 1712. His two ships sailed from St Malo, entered the Pacific through Tierra del Fuego and reached as far as Lima. They returned to Marseille in August 1714, convinced that stories about a continent of Australia were a chimera. Frézier published his observations as *Relation du voyage de la Mer du Sud* (*Narrative of a voyage to the Pacific*) (1716).

The sponsorship of the French Academy of Sciences was responsible for the most important scientific voyage of the reign, led by the young aristocrat Charles-Marie de La Condamine, mathematician and friend of Voltaire.[74] In question was nothing less than the shape of the earth. Scientists in Europe had been divided over whether the earth was an oblate spheroid (slightly flatter at the poles) as the English authority Isaac Newton maintained, or a prolate spheroid (narrower at the equator and longer at the poles) as some French experts believed. If Newton was

correct, a degree of latitude would increase slightly towards the poles, information of fundamental value for the preparation of accurate navigational charts. To settle the controversy, the French in 1735 prepared two scientific teams, one to make observations in Lapland (Sweden), and one under La Condamine and Louis Godin to do the same in the province of Quito (Peru). As Spanish observers to accompany La Condamine, Philip V sent two young cadets from the Naval Academy in Cadiz, Jorge Juan, twenty-two years of age, and Antonio de Ulloa, nineteen years old.

The Spanish authorities had little idea of the controversy over the shape of the earth nor were they familiar with Newton's work,[75] but they were keen to send token representatives. Juan and Ulloa were given a crash course in physics, geometry and French, promoted to officer rank and sent off to meet the French scientists in Cartagena de Indias. These unpromising beginnings were to prove far more fruitful than anyone could have imagined. From the moment they left Cadiz in two separate ships in May 1735, Juan and Ulloa set to work making scientific observations of every conceivable type, about marine navigation and even about the society of the exotic world that unrolled itself before their eyes in America. From June, when they arrived in the Caribbean, to November when they joined the French party in Cartagena de Indias, Juan and Ulloa made notes on everything they saw. The two young Spaniards, reported by Condamine to be 'charming gentlemen, extremely sympathetic in character and very sociable',[76] in mid-December accompanied the French experts across the isthmus to Panama. From here a month later they all took ship southward for their destination, the city and province of Quito. An optimistic Voltaire celebrated the expedition by publishing his play *Alzire, or The Americans* (1736), and explained to a friend: 'the setting is Peru: La Condamine is measuring the country, the Spaniards are exploiting it, and I sing of it'.[77]

The French-directed expedition was the first major contribution of the Spanish empire to the observational science of the Enlightenment. The members split into two groups for the ascent to Quito. One, with Juan and Ulloa and most of the scientific instruments, took the mountain route from Guayaquil. The other, under La Condamine, went first up the coast then inland towards Quito, buffeted all the while by torrential rain but enjoying the invaluable assistance of local Indian tribes that helped carry their instruments. It was on this journey that La Condamine

observed the properties of the substance later known as rubber, and became the first man to bring samples of it to Europe. He also discovered a new metal (which scientists very much later decided was platinum) and experimented with quinine. Meanwhile Juan and Ulloa dedicated themselves to recording every visible aspect of the society, biology and economy of the Quito region.

The members then began their principal task, for which they required a large and level area sufficient to establish base lines, as a prelude to a rigorous triangulation of as large an area as possible. They found the base area in the windy desert of the plain of Yaruquí, then had to split into three widely separated groups in order to carry out the triangulation, based on observations ranging over three hundred miles of mountains and valleys. It was a long, slow and arduous task, which they eventually completed eight years later. In March 1743 Condamine and his colleague Bouguer made their final simultaneous observations, two hundred miles apart. Their readings confirmed – six years after their colleagues in Lapland had done so – Newton's position. During their stay in America the scientists also made extensive observations of social customs and culture of both natives and Creoles, of animal and plant life, climate, diseases and medicines, earthquakes, winds and tides, and in the course of their work drew up numerous maps and charts. La Condamine, for example, was the first to map the great watershed of the Amazon.

Their lengthy experience in South America matured Juan and Ulloa, and changed them from raw recruits into emblematic figures of Spain's empire in the age of Enlightenment. Though they showed little interest for the indigenous peoples of the continent, whom they regarded as little more than savages, they were driven by their contact with the vestiges of pre-Hispanic culture to admire the achievements of the ancient empires in the Andes and to regret Spanish neglect of Inca monuments. 'What remains testifies to the greatness of their achievement, and the ruins are evidence of the their neglect by the Spaniards who established themselves in the empire of the Incas.' In the final months of 1740 Vice-Admiral Anson's fleet entered the Pacific and Juan and Ulloa were summoned urgently to Lima to help organize coastal defences against the English. It was the first consequence in the Pacific of the War of Jenkins' Ear. They found to their surprise that there were almost no weapons in Peru, and that the principal means of defence were wooden spears tipped with iron heads. When they returned to Quito some

months later, they found to their disgust that La Condamine had constructed small pyramids at the ends of the base line on the plain of Yaruquí, crowned by the French royal emblem of a fleur-de-lys and with a Latin inscription commemorating the measurement of the area by the French. Juan objected strongly to the omission of any reference to Spain or to the help given by himself and Ulloa. The dispute was taken to the Audiencia at Lima, which a year later decreed that the pyramids could remain, but with the addition of the names of Juan and Ulloa and the removal of the fleur-de-lys. Five years later, in 1747, the council of the Indies ordered (against the wishes of Juan and Ulloa) the demolition of the pyramids. They were duly levelled the next year, but rebuilt in 1836 by the Republic of Ecuador.

After Condamine concluded his calculations of longitude, he and the Frenchmen continued their work on other schemes. The two Spaniards, meanwhile, were fated to spend three more years on the Pacific coast revising naval defences. Ulloa finally returned to Europe in 1744 in a French vessel, which was captured at sea by a British ship. He was taken to London, treated with great honour by the Royal Society, and sent back to Spain with all his papers. Juan returned without incident in a different French ship, was made a corresponding member of the Academy of Sciences in Paris, and was eventually reunited with Ulloa in Madrid. They had been absent from Spain eleven long years. La Condamine returned to Paris in 1745, ten years since his departure. Both the Frenchmen and the Spaniards were fortunate enough to miss by a few months the cataclysmic earthquake that destroyed most of the city of Lima on 28 October 1746 in the space of three minutes. The same quake wiped out the port of Callao with a tidal wave in which ninety-five per cent of its population drowned.

In Madrid in 1748 Juan and Ulloa published a formal report on their work, in the shape of a *Historical Relation of a voyage to South America*, accompanied by a volume of *Astronomical Observations*. There was some doubt about the feasibility of publishing the books, since Spain did not have suitable paper, nor experienced printers and draughtsmen, nor the correct copper plates for printing. All these obstacles were overcome by importing Dutch plates, imitating French paper, and driving the draughtsmen like slaves.[78] Eventually five magnificent volumes were printed. It was a great coup, for the French scientists had not yet published their results. The Spanish government was therefore able to

present the Condamine expedition as a great national achievement of Spain, in which Juan and Ulloa had played a decisive part. The extensive confidential report on the colonies drawn up by the two men, known subsequently as the *Confidential report on America*, was, however, made available only to ministers and not published until an English printer got hold of the text and issued it (in Spanish) in 1826 in London.

The apotheosis of Juan and Ulloa was a classic example of the most developed form of the myth cultivated by Spaniards about their empire. Their participation in the French expedition was presented as evidence of the great achievements of Spanish science, and their research was exploited for frankly imperial purposes;[79] but inconvenient information, as contained in the *Confidential report*, was quietly set aside. The official attitude of imperial pride, however, was curiously counterpoised by the tasks that the government shortly entrusted to their two scientific heroes. Juan was sent to England in 1748 to act as a spy in the dockyards and to recruit shipbuilders and sailors for Spain, while Ulloa was sent to France and the United Provinces the following year to carry out a similar mission. The practice of industrial espionage was by then so widely put to use in Europe as to be almost respectable. The United Provinces and England were the chief countries to which experts from all over Europe came, openly or surreptitiously, to gather information about industry and technology.[80] Spain had always benefited from foreign technology, especially from the Netherlands, and had consistently since around the year 1600 collected information about Dutch techniques in finance and shipbuilding.[81] The government now made available large sums of money for the purchase of the latest foreign warships, and the contracting of technicians from England, France and Holland.

The policy was a clear recognition of Spain's inferiority in the competition for empire. The foreign contribution to the naval reforms was fundamental; without it little could have been achieved. Impressed by the achievements of the British navy, which had dictated the course of the War of Succession in the peninsula and continued to dominate the western Mediterranean during the century, the Spanish authorities made a special effort to import English naval artisans and imitate English achievements in shipping and navigation.[82] The archival records give the names of around one hundred British workers who were contracted secretly by the Spanish government in the mid-eighteenth century,[83] evidence that the enterprise was being taken seriously. Spain's inferiority,

Jorge Juan explained in 1751 in a revealing report to the prime minister, the marquis de la Ensenada, was patent: its navy 'has had no armaments, regulations, method or discipline'. But that did not mean that the situation should be accepted.

It would be madness to propose that Your Majesty have land forces equal to those of France or sea forces equal to those of England, for Spain has neither the population nor the finances to meet such an outlay; but not to propose a bigger army or a decent navy would be to leave Spain subordinate to France by land and to England by sea.[84]

*

One of the most crucial conflicts of European history, the Seven Years War from 1756 to 1763, known in North America as the 'French and Indian War', had a decisive impact on the distribution of Spain's territories outside Europe. The primary conflict was between Britain and France, not only for the system of alliances in Europe but also for their colonial interests in India and Canada. France began with successful campaigns in Europe but was then bested by superior British naval power, and effectively lost the initiative in both North America and India. In August 1761 Spain promised to enter the war on France's side before the following spring.[85] In reality, the country entered the conflict a bit earlier, in January 1762. It was an unfortunate decision because the war ended with sweeping French losses. The British in North America drove the French back decisively, taking what remained of French Canada (and Quebec, which fell in 1759), and occupying Martinique in 1761. At the peace of Paris of 10 February 1763, France ceded Canada to the British, as well as a number of West Indian islands, but retained Martinique and Guadeloupe.

The war also exposed the total vulnerability of Spain's possessions, as British forces moved in to occupy Havana and Manila, the two most vital ports in the Spanish imperial system. Havana, the central rendezvous for the New World fleets before they set out across the Atlantic, was protected by a supposedly impregnable fort, the only one that served as protection for all Spain's possessions in North America and the outer Caribbean. Its defences had been improved in the 1720s by Patiño, who sent out French and Italian engineers because he did not consider there were any Spanish engineers capable of doing the job.[86] With a garrison of two thousand men, the fort was reasonably well equipped to resist attack. The British fleet, commanded by Admiral Sir

George Pocock, made its rendezvous at Martinique in May 1762, and mustered twenty ships of the line, five frigates and around two hundred support vessels with eleven thousand troops.[87] Their arrival off Havana on 6 June startled the Spanish officials, who did not know that a state of war existed, since the British had previously seized their mail ship. The complex layout of the bay made it impossible to carry out a direct attack, and the British were obliged to besiege the city for two months until 11 August, the date on which Havana surrendered. Two days later the Spaniards signed the terms of capitulation. Together with the fort, they handed over a squadron of twelve warships and around one hundred merchant vessels. But the British casualties were very high, virtually all from gastric disorder and an epidemic of yellow fever; the outbreaks accounted for 87 per cent of the 5,366 soldiers who died and 95 per cent of the 1,300 sailors who died.[88] On hearing the news in London, Dr Johnson exclaimed, 'May my country be never cursed with such another conquest!'

In 1762 a British fleet of eight ships of the line, three frigates and two merchant vessels, under Admiral Cornish as naval commander and General Sir William Draper as head of the troops, left Madras with the specific aim of capturing Manila. The expedition was financed by the East India Company, which had convinced the government in London that the effort was worthwhile. One third of the 1,700 men under Draper consisted of British infantry, the rest were sepoys and (in Draper's own words) 'such Banditti as were never assembled since the time of Spartacus'.[89] The journey from India took eight weeks and the fleet arrived on 23 September in Manila Bay, where it proceeded to disembark just over a thousand men. To defend itself the city had around five hundred soldiers, recruited in Mexico, and an indeterminate number of local volunteers. Resistance was ineffectual, and Manila surrendered on 10 October, after skirmishes in which the attacking force suffered 26 dead and the besieged soldiers 178 dead and wounded. The surrender included 'all the twenty or so provinces of the islands with their forts and citadels'; and a special condition was attached that the Spaniards should pay four million pesos for the costs incurred by the British.

This last condition was the crucial one, for the East India Company had to cover the costs of the expedition, which amounted to nearly a quarter of a million pounds. In the event, they managed to put together barely one quarter of the sum, for the Spaniards refused to admit the

validity of the ransom demand. The conquerors were sorely disappointed with what they had secured at so much expense. Expecting a rich prize, they found only a drab run-down colony with no resources of its own. General Draper commented: 'It may appear wonderful that so many islands, so excellent in situation, should yield so little.' Another Englishman observed the same year, that 'the British public absurdly imagined that Manila must be a place of great wealth. They were seduced into a belief in this mischievous fantasy, by the millions of dollars sent annually from America.'[90] The Philippines did not remain in enemy hands more than a short while, and were returned to Spain a year and ten months later in accordance with the Treaty of Paris. The fleet sailed out on 11 June 1764. British attempts at control had never in reality been effective, and their limited troops barely managed to patrol more than a portion of the 120 miles circumference of Manila Bay.

Few regretted the return to Spanish rule more than the Filipinos did. The native population had rarely expressed its grievances against the colonial authority, preferring normally to vent its anger on the Sangleys. In the years 1660–1 one of the few major rebellions against Spaniards took place on Luzon, mainly in the provinces of Pampanga and Pangasinan. There were further agrarian disturbances in 1745 in the Tagalog provinces.[91] When the British took control in 1762, the native population rejoiced that there would be 'no more king, priest or governor'.[92] A resident of the city also noted in his diary that 'the great number of Sangleys resident in the Parian and in the provinces sided with the English'.[93] The British invasion provided the occasion for Diego Silang to emerge as the head of a Filipino movement for native autonomy. He set up his own alternative government in 1762 in the nearby town of Vigan, but was assassinated later in the year at the instance of local clergy. The most notable gain made by the British during their short stay was not the city, described by the triumphant General Draper as 'one of the richest in the world', but the famous Manila galleon, which had shortly before set sail for Mexico.[94]

The *Santísima Trinidad*, the largest recorded galleon in the long history of the Manila run, with cargo worth three million pesos in her hold, was captured off the islands in October 1762. 'She lay like a mountain in the water', reported an admiring English observer, and in two hours' fierce resistance cost the British seventy-two killed to her own losses of twenty-eight men. But she had already been severely

damaged by a tropical storm shortly after leaving Manila, and was forced to yield. The mighty galleon was taken back to Manila for refitting, and then to Madras. When it transpired that she had little future there, in 1764 she was taken back round the Cape to England, where she ended her days, captive but still tall and proud, as a tourist attraction in Plymouth harbour.[95]

For Spain the most significant consequence of the Peace of Paris was an obligation to abandon all American territory east of the Mississippi. To sweeten the pill, France agreed to cede to Spain the colony of Louisiana, which Charles III and his ministers insisted they must have as a barrier against British expansionism. The Treaty accordingly arrived, with British approval, at a historic division of the French territories in North America. All the lands to the west of the Mississippi, down to and including the mouth of that river and the town of New Orleans, passed to Spain, which conserved for them the name of Louisiana. The preliminary act of cession of Louisiana was made at Fontainebleau on 3 November 1762, and confirmed at the final Peace in February 1763.[96]

The lands to the east of the Mississippi were conceded to Great Britain, automatically giving the British unimpeded access to all the territory between the Atlantic and the Gulf of Mexico. The Treaty also gave Britain possession of the whole of Florida, in exchange for returning Havana to Spain. The entire Spanish colony in St Augustine, some three thousand people, and the colony in Pensacola, some seven hundred, emigrated to Cuba and to Mexico respectively. Confident that they had the right to determine the ownership of distant lands that had barely been explored or settled by the white man, European diplomats achieved a revolutionary change in the political map. Britain was confirmed in possession of the territories of Grenada, Dominica, St Vincent and Tobago. In possession of Canada, half of what would be the United States, as well as the Florida peninsula, together with key islands in the Caribbean, Great Britain for the next generation dominated the northern half of the American continent.

The new Spanish governor in the capital of Spanish Louisiana, New Orleans, arrived in March 1766. He was Antonio de Ulloa, who after his pioneering research days with Jorge Juan had become a colonial administrator and been governor in Peru. His immediate problem was trying to coexist with the resident French population, who did not

emigrate at the change of masters and instead maintained their homes, culture and trading habits. He had strict instructions to respect existing French laws, and did so even to the extent of not raising the Spanish flag over the town. It proved impossible, however, to reconcile the Spanish trading system with the free trade that the French merchants had maintained. In 1768 the French traders provoked riots against Ulloa, taking as their theme the good wine of their home country. They ranged through the streets shouting 'Vive le roi, vive le bon vin de Bordeaux', protesting that they would never 'subject themselves to drinking the wretched wine of Catalonia'.[97] Ulloa was forced to abandon the city rapidly; since no seaworthy Spanish vessel was available, he was escorted to Cuba on a French ship. The Spaniards eventually asserted themselves in Louisiana, but never succeeded in altering the French character and language of the settlers.

The North American empire remained thereafter a frail possession in Spanish hands. Louisiana was subsequently in 1801 returned to France, which two years later sold it to the United States for the sum of fifteen million dollars. Perhaps the most fragile part of what remained of Spanish North America was the Pacific coast and California, where, as we have seen, the threat of Russian expansion began to seem very real. An optimistic committee presided over by the viceroy in Mexico City in 1768 suggested that if adequate measures were taken to protect the northern Pacific, the result might 'in a few years constitute a new empire equal to or better than this one of Mexico'.[98] The proposal was the beginning of a new dream and a new frontier, that took the Spaniards north towards Monterey and up to Vancouver Island, where the Spanish flag was planted at Nootka Sound. It proved to be the last great challenge faced by a universal empire on which for over two centuries the sun had never ceased to shine and which now, appropriately, faced a reckoning in the lands of the setting sun.[99]

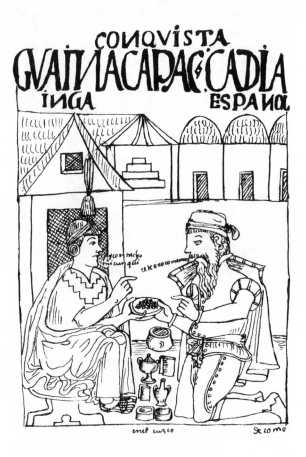

CONQVISTA
GVAINACAPAC, CADIA
INGA ESPAÑOL

enel cuzco delomo

II

Conclusion: The Silence of Pizarro

None of us understands the words they speak.

Christopher Columbus, 1492

One of the most genial commentators of the Europe of 1600 was Pierre de Bourdeille, lord of Brantôme, a French noble who had travelled around the Mediterranean, including Spain, and was willing to recognize the impressive achievements of Spaniards.

They have conquered the Indies, East and West, a whole New World. They have beaten us and chased us out of Naples and Milan. They have passed to Flanders and to France itself, taken our towns and beaten us in battle. They have beaten the Germans, which no Roman emperor could do since Julius Caesar. They have crossed the seas and taken Africa. Through little groups of men in citadels, rocks and castles, they have given laws to the rulers of Italy and the estates of Flanders.

But the achievement, as his own experience showed, was not exclusively Spanish. He had served under the Spanish, and taken part in the capture of the Peñón de Vélez in 1564. On retiring to the lands of the countryside abbey from which he derived his title, like other Renaissance gentlemen of France he put to paper his reflections on the great persons of his time. The elegant lords and ladies of Western Europe live on through his memorable pages, as he recalled the great Flemish, Italian, Castilian, German and even French commanders who established the power of Spain in Europe.

The Spanish world empire described by Brantôme was evidently one of the greatest known to history. Yet it is no accident that some recent studies of global powers virtually ignore its existence.[1] Its capacity as a naval force has been seriously called in question.[2] Spanish power was

never at any time based exclusively on its own resources or its own contribution, nor did Spain ever possess an 'innovational advantage'[3] that gave it the edge over other nations. The Castilians, like all peoples throughout history, were eager to affirm their own merits and prowess. Through enthusiasm, courage and perseverance they and other peoples of Spain took part in an extraordinary enterprise that pushed the nation to the forefront of world attention. But their successes were wholly dependent on the collaboration of others, and without it they were vulnerable.

They were reluctant imperialists, disinclined to expand their territorial or cultural horizons. Almost from the beginning there were Castilians who suggested that the imperial role was not one that Spain should have taken on. The expeditions to the Canaries and North Africa were limited ones with no ambitious horizon in sight, and the Spanish presence in Naples arose out of dynastic interest rather than expansionism. Under King Ferdinand there were many fantasies about power, but neither the means nor the money to convert them into reality. Thereafter a series of small but, in the long run, earth-shaking events took place. A Genoese sailor announced in Barcelona that he had discovered China and Japan by sailing westward; a Flemish prince with a fallen jaw arrived in Valladolid and was acclaimed as king, then left the peninsula hurriedly because a group of German princes wished to make him their emperor; and even before he left a Portuguese sea-captain set out from Cadiz with three ships and headed southwards across the Atlantic. What did all this activity on the part of all these foreigners really mean? The Castilian Comuneros in 1520 were among those, along with the emperor Montezuma in faraway Mexico at the same date, who did not understand what was going on and tried to call a halt to it. But the making of empire was a vast process that transcended the boundaries of Castile or the federation of the Mexicas. It was not the consequence of any deliberate will-to-power on the part of Spaniards, who were – to their great surprise – pushed into the role of empire-makers.

Spain's power was created not by force of arms alone but by profound changes in the technology, biology, demography and economy of the territories drawn into the process. The small handfuls of Castilian adventurers who braved the tropical jungles with the desperate illusion that they could survive and become rich, became mere instruments in the hands of those who followed and laid the foundations of a more perma-

nent enterprise. Their efforts were the catalyst that enabled other interests to contribute to the creation of empire. Without the help of allies, the Spaniards would have had neither the soldiers nor the ships nor the money to achieve what they did. In that sense, it is meaningless to imagine Spain alone as a great power, for its power was neither more nor less than the sum of the capacities of its collaborators. For a brief century, from 1560 when it cut free of the Vienna Habsburgs to about 1660 when England, France and the Dutch marshalled greater resources, Spain had the satisfaction of believing that it had reached the peak of success. When the period passed, Castilian writers (and subsequent historians) lamented that the empire was now in decline.

The truth was that Spain was a poor country that made the leap into empire because it was aided at every turn by the capital and expertise and manpower of other associated peoples. It is a story that has never been fully told, and some day the historians will get round to doing it. Who were the Portuguese, from a nation with one of the smallest populations in Europe but with the greatest familiarity with the ocean, who backed the Castilians in the Canaries, in the Caribbean, in the Maluku archipelago, and who piloted their ships across the Pacific?[4] Who were the Genoese whose fleets and finances anchored the Spanish presence in the Mediterranean? Who were the Africans who created the economy of the Caribbean, and defended Havana, Portobelo and Callao against the depredations of foreigners? Who were the Chinese who ran the economy of Manila, built its ships and directed its trade? The traditional image of a world empire that one day was securely in the control of Spaniards and the next had slipped out of its control, is little more than fantasy born out of intellectual lethargy. Spain never controlled the waters of the Caribbean, and even less the Pacific. In a military situation in which the decisive factor was always foreign help (the Belgian troops at St Quentin, the Italian vessels at Lepanto, the French army at Almansa) the dreams of imperial power based purely on Castilian resources were self-delusion.

A long historical tradition, initiated by official Castilian scholars such as Nebrija, who earned their salaries from the Castilian crown, never ceased to extol the martial glory of Castile as the creator of empire. Writing in a period when doubts about the empire were most pressing, a friar in 1629 took comfort in a vision that completely re-wrote the past. For Fray Benito de Peñalosa, the power of Charles V had been

constructed only by the Spaniards, who were the 'strength and support of his armies'; the emperor's expenses, likewise, had been paid by the 'riches of Spain'. There were no soldiers to match those of Spain: 'we witness every day how with only a few Spaniards among the tercios of Germans, Italians and other nations, all achieve wonders, but if the valorous Spaniards were absent they would achieve nothing'. Above all, the Spaniards were invincible in Asia: 'just four Spaniards fighting with or leading an army of Asiatics, can overcome and crush an infinite multitude of others'.[5]

This image fails to accord with the reality that Castilians were more than happy to let others build the empire for them. We have seen that in the 1540s when no Castilians could be found willing to go out and colonize the Río de La Plata, the authorities were anxious to recruit foreigners as well as Moriscos. When colonists could not be found for the young settlement at New Orleans, they were sent for from the Canary Islands. When Spaniards could not be found to defend Spain itself, foreigners were brought in. 'For the coming campaign', wrote a Castilian commentator in 1645, prior to a campaign inside Aragon, 'we will assemble a great army of the nations, because our own men value their home life more than duty and glory.' In the same year the king himself could not refrain from commenting on the unwillingness of Aragonese to defend their own territory: 'I am amazed at the fact that these people do not seem to feel their homes are any more at risk than if the enemy were in the Philippines.'[6]

As we have seen (Chapter 9), Spaniards were in fact during those years making a bigger effort than ever before to defend the monarchy. But non-Castilian help to the peninsula was by 1640 impressively extensive. Castilians were sometimes only a minority even in the army within Spain.[7] Philip IV's army of 24,000 men in Aragon in August 1643 included 4,000 Aragonese, 2,000 Valencians, 2,500 veterans from the tercios who had fought at Rocroi, 4,000 Neapolitans, 1,500 Belgians, 1,000 Franche-Comtois and 2,000 Andalusians. In the same way, therefore, that 'a great army of the nations' had been the effective instrument in Italy, Germany, Portugal and the Netherlands, so now in Lleida in 1645 soldiers came from the four points of the compass to defend the Spaniards in the peninsula against French invasion forces. Neapolitans, Germans, Irish and Belgians headed for Catalonia to defend the empire in its homeland. In the same decade the best warships from the Dunkirk

fleet were ordered to come to the peninsula to defend Spain. In 1641 the Belgians sailed out into the Atlantic from their base at Cadiz and brought the silver-laden fleet from America safely home. In 1643 they performed a similar duty, escorting the America-bound ships safely out as far as the Canaries. They were active on the Catalan coast against the French in Rosas and Perpignan, and in 1647 took part in the fleet that sailed under Don Juan José of Austria to repress the rebellion in Naples.[8]

Empires were transnational organizations that aimed to mobilize the resources available not only within their areas, but outside them as well.[9] Whatever their origins, they owed their existence and their unity to the broad network of connections that they managed to establish. Empires managed to survive when they adequately organized and maintained this international web of connections. In an extensive power structure such as the Spanish, the transaction costs involved could be formidable and unprecedented. To move an army from one zone to another could involve prolonged diplomacy, expensive recruitment, organization of substantial transport and supplies, and a search for satisfactory financial backing. In practice, the lack of central control in an early modern empire meant that a high proportion of costs was at an initial stage borne by small entrepreneurs, notably the adelantados who in the Canary Islands, the Caribbean and mainland America accepted all the risk in return for guaranteed profits in the shape of lands and titles.

When the government took over the risk, however, it had to oversee a much broader business than that which individual adelantados had handled. Those who invested in the enterprises of the government, namely the bankers who themselves had to insure against risk by reaching agreements with other European colleagues, were also unwilling to throw their money away on badly managed adventures. The banking families – the Fugger, the Welser, the Spinola – dedicated themselves to ensuring that their business investment was run efficiently. When possible, as with the Welsers in Venezuela, they participated directly in the enterprise. It became necessary to create with government sponsorship an interconnected conglomerate, that is a business called 'empire', which could increase the flow of resources, rationalize costs, and regulate the disputed rights to property.

For empires were very much about property. All the concepts to be found in the traditional view of empire involve property: conquest, colonization, settlement. These concepts involved claims by some people

over the property of others. It had not been a problem in the local communities of traditional Europe,[10] or in the Philippines or in Inca Peru; in all these places, people customarily continued to share property rather than seize that of others. From the moment it confronted the notion of 'conquest', however, the Spanish empire had to think seriously about the rights of property. Many Spaniards, relying on Roman precedents, tended to take the view that the empire was one of dominion, in which property of the conquered passed into the hands of the conquerors. Others, like the political theorist Vitoria or like Philip II, tended to think rather that the empire was a commonwealth in which the subjected peoples retained their rights and property provided they did not forfeit them by rebellion.

The concern of the Dominican professors at Salamanca university about property rights, a concern shared by many Renaissance intellectuals including Charles V, made them develop a number of ideas that have since been accepted as a pioneering contribution to the theory of international law.[11] Their highly important work, transmitted in part through the well-known labours of Las Casas has too often been configured in a way that stands on its head the solemn reality of what took place in the period of empire.[12] A number of professors, missionaries and administrators were indeed concerned to make Spanish imperialism function according to ethical and European rules. But the 'theory of empire', even though it served to guide legislators (such as Philip II in his Ordinance of 1573), had small influence on the real world. The different views over property had little effect on practical politics, for they did not touch or alter the basic conviction that the empire existed in order to make a profit. The inherent property rights of a black man, for example, were recognized and often respected, but did not modify the institution of black slavery. When slavery was essential to make the business prosper, it was used. Throughout Spanish America, slavery of the native Indian through the institution known as the encomienda continued to be practised long after it had been theoretically abolished. In the same way the notion that the supra-national empire should be rationally organized in economic terms, was constantly undermined by the essentially predatory policies of the central government in Madrid.

In the pre-industrial world, property took the form above all of land. Wherever the Spanish empire established itself, it searched inevitably for wealth – that is, gold or silver – but even more surely it searched for

land, land on which to live, and from which to provide the necessities of life and the basis for commerce. Cortés is famous for having declared in Cuba that 'I came here to get rich, not to till the soil like a peasant.' But five years after making the statement he was already the biggest landowner in the Western hemisphere, with thousands of Indians available to till the soil for him. Transformation of the soil was far and away the most direct impact of the coming of empire. By the peak of empire in the early eighteenth century the richest cultivable lands of America were in the hands of strangers. This may have been of small concern at a time of falling population, but when the population expanded during that century the Indians had to reconcile themselves to being landless. In the twenty-first century the plight of the landless native continues to be the primary social problem in the empire that the Spaniards once ruled.

Above all, access to bullion helped to create the empire and allowed it to survive. Sir Walter Ralegh, one of the great humanists of his day, whose life was cut short because the Spanish ambassador asked for his head, wrote an account of his expedition to the Orinoco in 1595 with the title of *The Large, Rich and Bewtiful Empyre of Guiana*. In it he saw clearly that the Spanish empire's 'abilities rise not from the trades of sackes and civil Orenges. It is his Indian Golde that indaungereth and disturbeth all the nations of Europe.' The gold and silver of the colonies was beyond all doubt the sheet anchor of Spain's power, even though Spaniards quickly recognized that its benefits were two-edged.

It is common to accuse Spain of frittering away its advantages. A distinguished historian has written that 'for two centuries Spain squandered its wealth and manpower'.[13] If the present book has indicated anything, it is that Spain had very little of either, and would have been hard put to squander what little it had. Castilians were very certain that if they really had wealth they would spend it wisely. But from the beginning of the imperial experience they saw themselves being plunged into a scenario where the profits were in fact being managed by others. The wealth and the manpower belonged in great measure to non-Spaniards, who invested it in the ongoing business of empire and reaped the appropriate rewards. Spaniards, particularly Castilians, Basques and Andalusians, made their own distinctive contribution, and enjoyed the honour of being managers of the enterprise. But the enterprise itself belonged to all.

*

One of the fundamental problems of Spanish power, an element of the problem of contact between Castilians and the outside world, can to some degree be subsumed in the problem of communication. In an attitude that had been common among medieval conquerors, such as the English in Ireland,[14] Castilians assumed that they were superior and insisted that the imposition of order had to be done through their language, which was the only means of communication they accepted. They left the learning of the autochthonous languages to a select few, such as missionaries. As Talavera had hinted to Queen Isabella, language would be a means of domination. The Castilian speech carried to the empire was a language in continuous evolution which contained within itself elements of the speech of all the peninsular provinces, including Portuguese. Eventually, the strains that most dominated in the New World were those of Toledo and Madrid, which were the centres of administration, and that of Seville, the centre of emigration to the colonies.

The predicament for Spaniards was how to communicate easily with the polyglot nations they wished to dominate. The Castilian élite during the great age of empire found it difficult to cope with the problem of languages. This profoundly affected its relationship with all the peoples it encountered. In the century or more that Castilian policy dictated the political and military life of the Netherlands, it is rare indeed to find any Castilian noble with knowledge of the Dutch language. By contrast, very many cultured members of the Netherlands élite had a perfect grasp of Castilian. No Spanish ambassador to the England of Elizabeth I could speak English; conversely the queen, riding out one day with the ambassador, was able to speak to him in Castilian, 'showing me [reported the ambassador] great pleasure both in the horse and in the language'.[15] Several kings of France (notably Henry IV) spoke Spanish perfectly; no king of Spain spoke French.

As the empire extended its ambit and power, its ability to make contact directly with its peoples decreased. The language barrier came to affect residents of the peninsula, where knowledge of Hebrew and Arabic rapidly disappeared in the wake of the expulsion of the relevant minorities in 1492 and 1609. When officials of the Spanish Inquisition occasionally discovered suspicious books written in these tongues, they were unable to read them. This had serious consequences for government policy, diplomacy and culture. Philip II put together for the Escorial the

largest collection of Arabic manuscripts of that time, yet nobody could read them and he had to call on the services of a Morisco. The prohibition of books in Arabic had formed part of the repression of Morisco culture, and when the Moriscos disappeared so too did the residue of the Arabic tongue. The pretensions to disseminate the Catholic faith among the Muslims of North Africa vanished before the reality that there was no way to communicate with them. In 1535 the governor of Oran wrote to Charles V that 'in the whole town of Oran there is not a single priest who is able to expound in their language a single word of our faith'.[16] Other languages also suffered at the hands of official policy. From the 1560s the Inquisition in Catalonia ceased to accept judicial evidence given in Catalan or French. The scribes used by the inquisitors were ignorant of Latin, so that all other languages had to be translated into Castilian, with the corresponding danger (as the Catalan authorities pointed out) of distortion of meaning.[17] An imperial power in this way found itself unable to communicate with or understand the peoples of the empire, save through the mediation of interpreters. This created an enormous and insuperable obstacle. When at a key moment in Netherlands affairs in 1577 a document written in French arrived in Madrid, none of the ministers could read it and it had to be set aside until someone could be found to translate it.[18] Rulers and ruled moved effectively in separate universes that failed to understand each other; the rulers cut themselves off from the people they governed.

Castilians dismissed the problem as a false one, ostentating instead their great pride that their tongue had now attained universal status and that everyone spoke it. It had become, as we have seen (Chapter 6), 'the language of empire', used everywhere in the administration. It was a valid point of view but also an erroneous one, for non-Castilians used the language only when Castilians were unable to use theirs. Because Castilian diplomats, for example, were normally unfamiliar with foreign languages, others had to speak theirs. In Charles V's privy council in 1527 the count of Nassau, Gattinara and the emperor himself, spoke in Castilian for the benefit of the Castilian members, otherwise they would have spoken French, their own language. In the emperor's day the humanist élite often spoke several tongues: Charles himself spoke German acceptably even though, as he confessed once (in German) to the Polish ambassador, 'I do not speak it very well.'[19]

When the Spanish empire came into being, however, it was more

difficult to find qualified diplomats with a knowledge of tongues. In the early sixteenth century the common diplomatic language of Europe was Latin, but already by mid-century the language was little known in Spain. In 1574, when the government was searching for a high-ranking noble with knowledge of German to serve as ambassador in Vienna, it could find none. Nor could it find anyone who could speak Latin, the necessary alternative to German.[20] By contrast, Austrian ambassadors to Madrid were uniformly fluent in Castilian. For generations, Spain conducted diplomatic relations with its principal protagonist in the Mediterranean, the Ottoman empire, through third parties and not through its own officials, because of the language barrier. From the time of Ferdinand the Catholic the leaders of the Jewish community in Oran served as chief interpreters to the Crown for negotiations with Arab states, and were used in this capacity by both Philip II and Olivares.[21] The solution, in short, was to employ in the diplomatic service persons who came from areas where it was normal to speak more than one language. As a consequence, citizens of the Netherlands and Franche-Comté figured prominently as diplomatic spokesmen for Spain in foreign courts such as Warsaw, The Hague and London. In the seventeenth century the Spanish ambassador in Vienna, Castañeda, communicated with his German allies through the good services of a Belgian noble, Jean-Henri de Samrée.[22] The problem continued in force throughout the age of empire. The Spanish negotiators at the Peace of Westphalia, for example, could not speak the languages of their opposing numbers, and had to employ Franche-Comtois agents. Occasionally, of course, there were diplomats who proved to be competent in Italian and French; in the seventeenth century some even became devotees of French language and culture.[23] It is particularly notable that in the early eighteenth century foreigners played a predominant role in the diplomatic service. Over half of Philip V's ambassadors were foreign: among them were four Englishmen, two Dutchmen, one Belgian, and fifteen Italians.[24]

In this difficult scenario, which all imperial powers down to our own day have had to confront, there were a few bright moments that illuminated succinctly the nature of the problem. Let us consider one. The protagonist was Esteban de Gamarra, Spain's second ambassador to the United Provinces, who took up his post at The Hague in 1655.[25] His predecessor, the Franche-Comtois Antoine Brun, had been appointed

in part because of his mastery of French and Dutch, and Gamarra exceptionally also had a good grasp of these languages. At a time when France and Spain were vying for influence with the Dutch, Gamarra in the summer of 1657 happened to have a public dispute with the French ambassador De Thou in the streets of The Hague, before a crowd of Dutch passers-by who looked on with curiosity and interest. De Thou did not speak Dutch, and his words in French fell on deaf ears. Gamarra, by contrast, spoke also in Dutch, with (as he wrote back to the chief minister Luis de Haro in Madrid) extraordinary consequences:

Over three hundred person followed me, crying out 'The Spanish ambassador has won!'. The incident drives me to say to Your Excellency that it would be of the greatest service to His Majesty if my successor could speak Dutch, and if he were Spanish so much the better, for they are best won over if they hear their language. The citizens were saying, 'We can speak to this one and understand him, but with the other we have no idea what he is grunting'. The crowd was so much in my favour that everybody was surprised. Yesterday the Pensionary of Holland[26] told me that his father came to his house to visit that night, and said to him with astonishment, 'What is this, my son? Who would ever have thought such a turnaround possible? The people, in favour of Spain?'

It was an unusual moment of triumph, with very few parallels in the history of the empire. When the Jesuit Alonso de Sandoval, who lived during those decades in America, heard Spaniards criticizing their black slaves as 'beasts' for not being able to speak in Castilian, he retorted that 'our people would be the same if they were captured by Arabs or by the English'.[27] He tried to study the languages the blacks spoke. Other Spaniards made no such attempt.

The failure of Spain to create an imperial discourse, that is, to create an understanding among its peoples based on shared interests, communication and language, may be termed 'the silence of Pizarro'. In a piece of modern Quechua theatre that draws on old oral traditions and continues to be performed in various versions in Peru and Bolivia, the action centres on the capture and death of the Inca Atahualpa. When the Inca in the town square of Cajamarca demands that Pizarro and his men leave the country, Pizarro is unable to find the words and 'only moves his lips'; the interpreter Felipillo has to speak for him because of his silence.[28] The interpreter also addresses the following words on behalf of Almagro:

It is impossible for me
To understand your obscure language.

To which a nephew of the Inca replies:

I do not know what you are saying,
There is no way I can make it out.

When in addition the priest Valverde offers the Inca his breviary, Atahualpa brushes it aside because it says nothing to him. The theme of non-comprehension between the Spaniards and the Indians was a constant of post-conquest tradition among the subjected peoples.

For the Indians it may have been a conviction of the superiority of their oral culture over the non-spoken, written culture of the invaders.[29] Spoken language was seen as power, the inability to speak was an absence of power, and the reliance on a mute written language even more so. In one version of the Quechua theatre, Almagro presents the Indians with a written sheet, and the Indians comment to the Inca on what it might be. 'This way, it looks like a nest of ants. This other way, like the claw marks of birds on the river bank. This way, like deer, but upside down. No, no, my lord, it is impossible to make it out.'[30] The notion of the primacy of a spoken over a written tongue was also to be encountered at this period among the Guaraní, whose myths spoke only of the *sound* of language being brought into existence at the creation of the world. For them their culture began to suffer barbarization when at the time of the Spanish conquest a written language began to be imposed. Centuries after the conquest, in Paraguay the two universes of a spoken and of a written culture continued to remain inherently distinct.[31] Indian chroniclers who, like Guaman Poma attempted to bridge the gap between the two universes, ended up using a form of discourse that both sides found difficult to comprehend.[32]

The barrier of language was seldom crossed. The ritual of the requerimiento, read out by Felipillo to the uncomprehending Inca warriors assembled in Cajamarca, was a parable of the impenetrable screen separating Europeans and the colonial peoples. When the first Franciscans came to preach in Mexico among the conquered Nahuas, they like Pizarro spoke in silence. Fray Gerónimo de Mendieta in 1525 described how the friars just after their arrival in Mexico decided to instruct the Nahuas in Latin because they were unable to speak Nahuatl.

And 'in so far as they could, like dumb men they used signs in order to make themselves understood'.[33] It was a silence that proved difficult to overcome. Half a century after the conquest of Mexico, the Spanish judge Alonso de Zorita asked an Indian leader from Mexico City why the Indians were so prone to evil ways, 'and he said to me, "Because you don't understand us, and we don't understand you and don't know what you want. You have deprived us of our good order and system of government, that is why there is such great confusion and disorder." '[34] 'The older Indians say that with the entrance of the Spaniards all was turned upside down', Zorita reported. It was almost the same response, word for word, that the peoples of Peru subsequently gave during the years of Taki Onqoy.

At some points of the colonial world, the written word did indeed penetrate with success. This occurred in Mexico thanks to the abilities of the Indian nobles who studied at the College of Santa Cruz of Tlatelolco, where they helped to standardize the written form of Nahuatl. Thanks to them, the friars were able to use Nahuatl in their religious work and European literature began to penetrate the indigenous world.[35] But the fusion of cultures through the written word was always more apparent than real. Beyond the written word, the real world for the natives of America consisted of the sounds, colours and presences that remained beyond the reach of the perceptions of Spaniards.[36] It was a universe quite alien to the Europeans, who failed to understand it and rejected it as pagan.

At the level of culture, the intuition of Nebrija that Castilian should become the 'language of empire', that is, that Castilian culture should predominate, never quite succeeded. A Castilian writer boasted forcefully in 1580 that 'we have seen the majesty of the Spanish language extended to the furthest provinces wherever the victorious flags of our armies have gone'.[37] Seventy years later Baltasar Gracián claimed that there were two universal languages, Latin and Spanish, 'which today are the keys of the world'.[38] It was good imperialist rhetoric, but it was not true.

During the period covered by this book the most notable world empire was that of Spain, with settlements and fortresses in every continent of the globe. Yet in Europe the only language with any pretensions to cultural universality was Italian, soon to be succeeded from the seventeenth century by French. Italian was, after Latin, the most common

language used by diplomats in Renaissance Europe.[39] It was used, read, studied and spoken by élites from London and Brussels to Vienna and Warsaw. The famous Castilian speech of Charles V in Rome in 1536 was seen on all sides, and particularly within its Italian context, as innovatory and aggressive. The emperor did not repeat the performance, and thereafter limited himself to speaking the appropriate language within the appropriate context. As we have seen, after his speech he spoke in Italian to the French ambassador. At this early period, there were in reality few serious objections to the use of Castilian, for Castilians had not yet become a hated imperial power. But the revolt of the Netherlands a generation later changed the situation considerably. When Alessandro Farnese became governor there, he encountered a great tide of hostility to things Spanish. As a consequence, he took care to present himself as an Italian, and his public discourse was always in Italian or in bad French, never in Spanish.[40]

There were many admirers of Spain and of Spanish literature in Europe. One of them was Johann Ulrich von Eggenberg (d.1634), a Bohemian noble whose love for Spain began during a visit in 1600–1 and who collected the works of Cervantes and Lope de Vega. He also supported the Habsburgs during the Battle of the White Mountain. Today his rich collection of books is preserved in the beautiful but half-empty[41] castle library of Český Krumlov in the mountains outside Prague. In the years that he bought foreign works he collected 28 items in Spanish, but he also collected 24 in French and the overwhelming bulk of his purchases was in Italian, 126 books.[42] The Latin culture that penetrated central Europe was, despite Spain's power and influence, predominantly Italian. When the Austrian nobility of this period wished to broaden their cultural horizons they went to study at Padua, Bologna and Siena, rather than to Spain. When they bought foreign books, they preferred works by Italians.[43] The same happened in France, where the marriage in 1614 of King Louis XIII to a Spanish princess, Anne of Austria, stimulated a great vogue for things Spanish. It was a fashion that lasted little more than a decade. From mid-century the vogue returned to Italian culture, which had never lost its predominant position.[44]

The Valencian scholar Gregorio Mayans, a fervent admirer of Italian culture, admitted in 1734 to Spain's chief minister, the Italian Jose Patiño, that Spain had failed to extend the influence of its language.

'One of the things that a nation should take particular care to achieve', he wrote, 'is that its language become universal.' That had only happened, according to him, in the great days of Philip II, when Spanish had reached the furthest corners of the earth. Now, by contrast, it had been superseded by English and French, whose literature, science and languages were supreme in the world. 'The fault', he said, 'is ours, through our inadequacy.'[45] It was no doubt comforting to Mayans to believe that at some unidentified stage in the age of Philip II 'the Spanish language became universal', but the truth was somewhat different.

In Asia, during the age of early European commerce, the accepted lingua franca was Portuguese,[46] spoken even by Asian traders to each other and adopted perforce by Spaniards if they wished to communicate with Asians. Hindu rulers in Ceylon and Muslim rulers in Macassar spoke and wrote Portuguese.[47] To communicate with other Europeans the non-Portuguese missionaries habitually spoke Portuguese, with the consequence that some began to lose fluency in their own language.[48] The Navarrese Jesuit Francisco Xavier used the language as his main medium of communication in Asia. As late as the eighteenth century, officials of the British East India Company in India had to learn to communicate with their employees in it.

But in what language could Spaniards communicate to the peoples of their empire the message of imperial power and eternal salvation? It was little more than an *ignis fatuus* to imagine that the Castilian tongue could take root as the universal language of the empire, for few natives of America in the colonial period managed to speak more than a pidgin version of the language of the conqueror. When Guaman Poma wrote his *Chronicle*, he depicted a confrontation between Indian and Spaniard where the inability to communicate was total. Poma saw the Spaniards as interested neither in the country nor the people of America but only in their gold: 'driven by greed, many priests and Spaniards and ladies and merchants took ship for Peru, all was Peru and more Peru, and more and more gold and silver, gold, silver from this land'. In one of the most telling of the drawings in Poma's *Chronicle*, the Inca Huayna Capac addresses a conquistador and asks: 'cay coritacho micunqui' [Do you eat this gold?]. To this the Spaniard replies, not in Quechua, which he does not understand, but in Spanish: 'este oro comemos' (We eat this gold).[49] The irony is that the communication barrier was overcome by a commodity, gold, that made all communication superfluous. Garcilaso

de la Vega, who wrote his monumental *Commentaries* in Spain, observed the lamentable inadequacy of many Spaniards in matters of language and the consequent gap of comprehension between cultures. The Indians, he wrote, 'do not dare to give an account of things with the proper meaning and explanation, seeing that Christian Spaniards abominate everything they see'. Even the learned Spanish missionaries confused basic terms in Quechua.[50]

In a colony such as Manila where Spaniards were a tiny minority, Castilian had a slim chance of survival. The earliest Spanish missionaries came face to face with the phenomenon of Chinese preponderance. The first books to be turned out in the islands were printed by Sangleys, who used their experience from the Chinese continent to introduce block printing and pioneer the necessary typography. Books were, of course, on the Christian religion and written by Dominicans. But they were printed in the native tongues, at a time when the government in Spain was officially trying to discourage native tongues in favour of Castilian. The first known printed work, in 1593, was in Chinese and written by a Dominican. The second, a *Christian Doctrine* or catechism published that same year, had facing pages in Castilian and Tagalog. In a *Memorial on the life of a Christian* published in 1606 in Chinese, Fray Domingo de Nieva explained (in Chinese) that 'when religion does not use language it is obstructed, when faith is explained in an unknown script it will not be recognized'.[51] Like many of his fellow missionaries on the American mainland, he had come to the conclusion that the Castilian language was, in reality, an obstacle to empire. Unless and until Castilian could overcome the language barrier, no proper communication was possible. He and his colleagues patiently devoted themselves to Chinese studies, less because of the Sangleys that were awaiting the gospel in the Philippines than because of the mighty Chinese empire that lay beyond them and, in their eyes, awaited conversion.

The achievement of the clergy in language studies was of fundamental value, since in many cases they rescued dialects from probable oblivion and opened bridges to communication. The Franciscan Francisco de Pareja in 1612 produced the first word-book, designed for the confessional, of the Timucuan dialects used in northern Florida. It was the first time that the language appeared in printed form. But it was also for all practical purposes the last, since both the Timucuan Indians and their language very soon became extinct. The efforts at ethnology were

admirable, but usually served little. Many religious orders, among them the Franciscans, very soon gave up the attempt to teach Indians in local dialects and limited themselves to teaching only in Castilian. In the peninsula, they gave up the attempt to learn Arabic. The consequence was an exclusive reliance on Castilian, with all the attendant consequences. In 1642 a Portuguese writer commented that during the years of their presence in his country 'the Castilians permitted use of their language alone, and treated the Portuguese language worse than if it were Greek'.[52] Chauvinism in matters of language was common to all empires. It eventually gave rise to a misapprehension that the Castilians had in some way suppressed and destroyed local languages. The truth was that those who most cared about communication, namely the clergy, made extensive efforts to keep alive the dialogue between their own tongue and that of their parishioners. But the policy seldom worked. Well into the eighteenth century parish priests in the Andes would preach their sermons in Castilian while the uncomprehending natives would listen in polite silence.

Some clergy in Manila, like the Dominican Domingo de Navarrete in the mid-seventeenth century, assiduously learnt Tagalog, Mandarin and Fukien. The first grammar of the Tagalog language was the achievement of Francisco Blancas, *Art and rules of the Tagalog language* (1610).[53] All these pioneering works had a single purpose: to enable the European to understand, speak and write the native language. They therefore adopted an exclusively one-way process of the transfer of meaning: the Castilian language was translated into native terms. By contrast, little attempt was made to translate native concepts into Spanish. By grasping at perceived words and actions and freezing them within a recognizable vocabulary, the colonial missionaries brought into existence something that was defined according to Castilian concepts alone. The result was an often-neglected aspect of the impact of empire: its failure to understand the way that subject peoples really thought.[54] Missionaries lived with native Americans and Asians for decades and claimed to be able to speak their language and even write it, but at certain moments of conflict they suddenly realized that they had no real comprehension of the way the people thought. Conquerors and conquered appeared to be speaking the same language, but they were really living in two different worlds of meaning.[55]

*

Despite the universality of its imperial experience, Spain appeared to many outsiders to be a closed world, divorced from European reality. Spaniards were to be found in every corner of the world, certainly the most-travelled people of any in Europe, yet at home they appeared reluctant to let the world in. The testimony of foreign visitors was impressive. They 'are not naturally friendly to foreigners', commented the Florentine ambassador Guicciardini in 1513.[56] Italians commented repeatedly on the apparent hostility towards them in the peninsula. Worse still was the fate of the French, who were disliked everywhere in Spain and with particular ferocity in Aragon, Valencia and Catalonia, where the large number of French residents provoked animosity and violence. The reluctance of foreigners to visit Spain may explain the surprise expressed by natives at seeing them. When Francis Willughby visited Castile in the 1660s he commented that people were 'uncivil to strangers, asking them, What do you come into our Countrey for? We do not go into yours.'[57]

With time, of course, people of peninsular origin immersed themselves in the culture of the lands to which they went, and learnt to identify with their environment while still conserving their memory of Spain. By contrast, metropolitan Spain itself seemed to remain aloof from the cultural interchange. In the pioneering report drawn up by Juan and Ulloa after their return from South America, they expressed their astonishment at the almost total ignorance about the New World prevailing in Spain two hundred years after the birth of empire. The authors pointed out, as others had done before, that the lure of easy wealth in gold and silver had blinded Spaniards to the possibility of exploiting the immense cultural resources of the empire.

Curiously, Castilians were reluctant to let the empire penetrate their own homes in the peninsula. We have already seen (Chapter 6) that the rest of Europe was eager to learn from Spain, and translated its literature eagerly. But Spaniards were not so keen to find out about the rest of the world. In the time of Philip II the Jesuit Ribadeneira went so far as to accuse Castilians of being 'arrogant and unwilling to learn'.[58] It was an age when the exotic tastes and extraordinary experiences of the outside world came to influence and modify much Western culture.[59] But after three hundred years of direct contact with America, the Philippines and Mediterranean Europe, Spain tended to remain impervious to change. It is curious, for example, that the Spaniards appear never to have shown

much interest in the rich and exotic *non-profitable* produce to be found in the overseas territories. They took very quickly to tobacco, first described to them by a Seville physician, Monardes, in 1569. It became, and has remained, an essential component of the Spanish way of life. But the detailed reports sent back home by the historian Oviedo and by others, about plants, fruits and flora, fell on stony ground. It was left to the British, Dutch and French to publish the first comprehensive surveys of New World botany.[60] The first published drawings of New World maize, for instance, came out in Strasbourg in 1539 and Basel in 1542. The pioneering botanical work of Francisco Hernández, done in the 1570s during his travels in the Caribbean and Mexico, lay gathering dust in the library of the Escorial and did not see the light of day until a group of Italian intellectuals sponsored its publication in Rome in 1651. Non-European foods, among them the tomato and the bean, penetrated only very slowly into the Spanish diet. Indifference to the world outside was also reflected in the absence of guidebooks. Tens of thousands of Spaniards had been to the far ends of the earth and seen unprecedented marvels, yet they never came to develop a literature of travel. Their most common travel book in the sixteenth century remained the one written by the Piedmontese Giovanni Botero.

The poor reputation of Spain in matters of courtesy, culture and lodging (the peninsula was considered to have the worst inns in Europe) excluded it automatically from the itinerary taken by European gentlemen doing the Grand Tour in the seventeenth and early eighteenth centuries. Many visitors to the country were open-minded enough to recognize its pleasures and attractions, but the prevailing sentiment was that of the Englishman John Holles in the early seventeenth century, that 'Spain is to be passed through, not to be dwelt in.'[61] Europeans were not impressed by the state of culture in Spain. French, English and Italian intellectuals who visited the peninsula all took the same view. The nation had made little attempt to absorb European culture, and as a result the rest of Europe despised it. 'The ignorance is immense and the sciences are held in horror', an Italian nobleman commented on a journey through the peninsula in 1668, and in the same years an English traveller, Willughby, concluded that 'in all kinds of learning the Spaniards are behind the rest of Europe'.[62] They would have been comforted to learn that many educated Spaniards shared their views. 'How sad and shameful it is', a young Valencian doctor, Juan de Cabriada, exclaimed in

1687, 'that like savages we have to be the last to receive the innovations and knowledge that the rest of Europe already has!'[63] Spain remained prominent by its absence from the European intellectual and scientific scene. When the Royal Society of London in the 1660s began to organize its scientific links with European intellectuals, Spaniards did not feature. The puzzle, which still eludes any easy explanation, is why the most universal society of the globe was unable, after centuries of imperial experience, to discourse on equal terms with other European nations that shared the same background.[64]

The silence of Pizarro was not a local phenomenon restricted to a momentary confrontation in the Andes. It was a silence that encompassed continents. Even a reactionary clergyman like Philip II's adviser Villavicencio felt that it was important to warn the king that Spaniards had no future in the Netherlands 'for they neither know the language nor understand the laws and customs'.[65] The failure of empire to overcome the cultural divide was nothing short of astonishing. The Greek and Roman empires had in some measure been predicated on a conscious superiority over the nations with which they collided. By contrast, the nations with whom Spaniards came into contact always insisted that their own cultures were superior. Spain's discourse with them was, as a consequence, normally conducted from a position of inferiority. This evoked from Castilians, who felt that their position as masters entitled them to deference, the logical reactions of anger, frustration, pride and even stupor. Northern Italian intellectuals, reconciled by now to the fact that they were always being invaded by barbarians, continued to perceive Spaniards as culturally beneath them. In Brussels the Spaniards were scarcely better treated. The worst treatment of all was reserved for them in the New World, where the Creole élites, even while recognizing their European roots, preferred to express their pride rather in the great American civilizations that had preceded the 'conquest'. In the early eighteenth century the Peruvian marquis of Valleumbroso despised the peninsular Spaniards and claimed instead to be descended from the Inca; he wore Inca-style clothes, had himself addressed as 'apu' instead of 'señor', and preferred to speak Quechua.[66]

During the Napoleonic Wars, when the empire was on the verge of political collapse because of events in Europe and the threat of rebellion in America, Spaniards in the peninsula attempted desperately to claim

that there existed a great cultural unity – what later politicians would come to call 'Hispanidad', 'Spanishness' – that bound together all the peoples of the imperial commonwealth. The governing body in war-torn Spain, the Junta Central, wrote to the city council of Bogotá in 1809, in the following terms:

There exists a union between the two hemispheres, between the Spaniards of Europe and America, a union that can never be destroyed, because it is grounded upon the most solid bases that tie men together: a common origin, the same language, laws, customs, religion, honour, sentiments, relations and interests. These are the ties that unite us.

When steps were taken to summon a Cortes of all free Spaniards in 1810, it was proposed that representatives of the provinces of America and of Asia should also be convoked.[67] It was suggested that there be two deputies for the Philippines, and up to twenty-four for all the American territories. The proposal did not, evidently, recognize any rights to autonomy of the overseas territories, but simply intended to identify them with the cause of 'all true Spaniards' who were fighting against the French in the peninsula. This new version of imperial mythology found little acceptance among élite Americans. The Junta in Spain, anxious to obtain their support, proclaimed that the overseas territories were not colonies but 'an essential and integral part of the Spanish monarchy', and that Spanish Americans were 'free men', 'equal in rights' (to quote a decree of the Cortes of Cadiz in October 1810) 'to those of this peninsula'.[68] At last, three hundred years after the foundation of the city of Santo Domingo in Hispaniola, the Spaniards needed the empire, just as eighty years later (as they were losing it to the Americans) they were also to feel that they needed Cuba. And they needed the empire because the empire had in effect created Spain.

Castile and the Spanish realms had risen to prominence because of their impressive capacity to harness the resources of others: the Neapolitans, the Genoese, the Franche-Comtois, the Flemings, the Nahuas, the peoples of Tawantinsuyu, the Chinese. And, thanks to the voluntary collaboration of élites everywhere, the effort paid off. The trade of the Mediterranean, the silver of Potosí, converted Seville into the metropolis of the West, stimulated economic growth, shipbuilding, and commerce, attracted the merchants of Christendom, and encouraged the emigration

of small groups of Spaniards to all points of the globe. This great co-operative enterprise brought Spaniards together and began to give them a common purpose. Whether gathered before the walls of Granada or assembled on the banks of the Danube, Castilian nobles felt a justifiable pride in the amazing series of events that had bestowed on them a measure of world leadership.

Unfortunately, the very extent of international collaboration undermined Spain's ability to innovate technologically. Portugal supplied the early expertise in navigation, ships and pilots; Italy supplied the ships, manpower and weaponry in the Mediterranean; Germans and Netherlanders provided soldiers and technology; Genoese, Flemings and Portuguese provided financial expertise. Castilians demonstrated that they were perfectly capable of learning from the technologies they encountered,[69] but their achievements never passed beyond the level of borrowing. Depending in every detail on their allies, they deprived themselves of the means to subsist on their own. This, of course, was no immediate problem. The empire was never without friends. As the War of Succession showed, none of the European powers was going to let the profits of empire fall into the hands of anyone else, and by the time of the Treaty of Paris in 1763 Spain was in theoretical control of a larger extent of the world's surface than it had ever before possessed.

Many scholars, including the present writer, have habitually argued that the cost of running this enormous empire crippled Spain. It is easy to document the conclusion from the words of Spaniards themselves. The opinion, however, is based on a mistaken view of the costs involved. The Castilian treasury was always in debt, from the time of Ferdinand and Isabella onwards, yet it managed for two centuries to stave off collapse. This was only in part because of the enormous advantage of wealth from the New World. The real secret of the empire, as in the case of any good multinational, was the successful integration of regional businesses and an effective 'autonomy of cost', paying for each enterprise on the spot rather than from the centre. Disaster at specific points in the business structure brought laments from the directors in Madrid but seldom affected the viability of the company. A battle lost, a fleet sunk, a shipment that did not arrive, were major hazards that seemed to portend calamity; but so long as the investors did not rebel or lose confidence the business survived. It consequently makes little sense to talk of shortage of men or money. The empire never lacked men: its

armies down to 1763 were always predominantly foreign armies. And it never lacked money: foreign traders and financiers – and even foreign pirates – continued to underwrite the empire's regional economies even while they were trying to undermine the extent of control from Madrid.

When empire comes to an end, it is habitually seen as the cause of all the residual ills. No empire has, at any time, been viewed in retrospect as a success. It is this acute consciousness of failure, unfortunately, that helps to launch the endless mythologies associated with the history of Spain's world dominion. Spaniards blamed everybody else, and everybody else blamed Spain: they were the two perennial faces of imperial confrontation.

A good example of Spaniards blaming others can be found in the writings of the soldier Marcos de Isaba, who served Philip II faithfully but in the 1580s at the end of his career questioned (after barely one generation of the empire's existence!) whether the effort had been worthwhile. 'In all the time', he wrote, 'that I have spent outside Spain, travelling, speaking to Italians, French, Dutch, Walloons, Franche-Comtois, Turks and Arabs', the only consequence he could see was 'that our nation is hated and detested by everybody'. Fiercely nationalist in attitude, he saw good only in Castile and bad everywhere else. His comments merit quotation:

These nations outside Spain that are subjects, friends or allies of His Majesty, are by nature inconstant, unreliable, restive and seditious. The greatness of our king and the blessed name of Spaniard have few friends. In the past Spaniards were well loved by all peoples, but for the last ninety years we are hated and detested and all because of the wars. Envy is a worm that does not rest, it is the cause of the resentment and hatred shown to us by Turks, Arabs, Jews, French, Italians, Germans, Czechs, English and Scots, who are all enemies of Spaniards. Even in the New World there is hatred and detestation for the valorous arms of this nation.[70]

Like Americans and Russians of the twentieth century, the Spaniards had to learn to live with universal hatred. 'The hatred for Spaniards', a Spanish official in Brussels reported to Philip IV in 1632, 'is unbelievable.'[71] Protected by their own view of how the world should be run, most Spaniards were incapable of seeing that there was a price to be paid for their imperial role. 'I don't know what there is in the nation

and empire of Spain', an official in Milan lamented in 1570, 'that none of the peoples in the world subject to it bears it any affection.'[72]

On the other hand, a classic case of how the others blamed Spain can be found in the experience of Naples. As we have seen (Chapter 10), Italians never ceased to claim that Spaniards had ruined the south of the Italian peninsula. The philosopher and historian Benedetto Croce was the first to question this dogma. When contemplating the problems of the Mezzogiorno and the 'lack of a national political life' in nineteenth-century Naples, Croce was inspired to analyse the writings of an economist writing in 1613, Antonio Serra, who pointed out that if Naples was poor it was really because it had not been any help to itself. It was not the Spaniards who were to blame, but the Neapolitans themselves. If foreign (that is, Genoese and Venetian) capitalists got rich in the Mezzogiorno it was because of 'the industries which they, in default of the natives, promoted'.[73] As a consequence of Croce's writing, no serious historian thinks that Italy's problems were exclusively the fault of Spanish imperial rule. The impact of imperialism was always ambiguous. In Italy the kingdom of Naples failed to overcome its problems, but Milan by contrast benefited from the economic activity generated by Spain's military presence.[74] After the years of devastation and destruction caused by the Eighty Years' War against Spain, the northern Netherlands could look back with satisfaction on the economic benefits they had reaped. Viewed in perspective, domination by a foreign power did not necessarily lead to disaster.[75]

Spaniards themselves were not sure whether their imperial adventure had been a success. International power, the moralists (as well as many taxpayers) never ceased to point out, had not made the country better. A handful of intellectuals stretched out their hands to complain to their allies in the empire that things were not going well. 'We wish to be seen as champions of what is good', the Aragonese historian Argensola wrote in 1602 to the Flemish scholar Justus Lipsius, 'but at the very most we are ghosts and apparitions.' The poet Francisco de Quevedo commented mordantly in a letter in 1604 to the same: 'there [in Belgium] we consume our soldiers and money, here we consume ourselves'.[76] In the high tide of empire thousands of Spaniards had escaped with alacrity from the poverty of Spain – 'that wretched Spain where no amount of work can wipe out misery'[77] – to the rich promise of the Caribbean, the New World, and Asia. But the promise, many of them felt, was a false one,

like the ghosts and apparitions spoken of by Argensola. 'Don't be deceived, don't listen to what they say about America,' a disillusioned colonist wrote home from New Spain in 1593, 'would to God I did not live where I live, God knows how things are'.[78]

Imperial enterprise would always be an ambiguous experience, reason for pride of achievement but also for shame. And the pride and shame were shared in equal measure by all those peoples, from every continent of the globe, without whose resources the creation of the worldwide empire would have been, quite simply, impossible. The price paid for global dominion was always high. 'Our country', observed Peter Paul Rubens as he pondered the part of Belgium in the war arrangements of Spain, 'must serve as the battlefield and the theatre of the tragedy.'[79] At every level, the tragedy was immense. The spreading of the gospel in the missions of California, for example, brought no temporal salvation to the Indians, whose numbers plummeted. 'They live well when they are free', lamented a Franciscan missionary, 'but as soon as we reduce them to a Christian and community life they sicken and die.'[80] And there were costs that were impossible to measure, in which Spaniards also assumed a crucial role: the hundreds of thousands who perished in the wars, the tens of thousands who died in battles and shipwrecks at sea. Castilians died far from home. Generations of mothers and wives would remember the fields of Flanders as the 'cemetery of Spaniards'. Very many died spectacularly and meaninglessly, like the four thousand soldiers who were sent to the New World in 1619 and a few days out to sea perished in a storm in the Atlantic; it was a disaster twice as great as that of the *Titanic*. 'The loss is very great and much felt here,' the English ambassador reported from Madrid, 'yet they make show as if they would instantly repair all.'[81]

And they were only a tiny fraction of the cost. The real cost in the Netherlands, more than the twelve hundred executed by Alba, were the tens of thousands of Belgians and Dutch who died defending their homes. Brutalities perpetrated during the age of world power were very often the responsibility of Spaniards. 'We killed eight thousand men in about two hours and a half', a young Basque who took part in the capture of Atahualpa proudly wrote home to his father, 'and we took much gold and clothing.'[82] The deaths formed part of the setting of world power, and had many counterparts. On 4 November 1576, the memorable day of the Spanish Fury, the mutinous Spanish tercios sacked

and burned the rich trading metropolis of Antwerp, leaving eight thousand people dead.[83] The toll in lives was, however, no less the responsibility of those who helped to sustain Spanish power. The Tlaxcalan confederates of Cortés who helped to slay and destroy at Tenochtitlan, the German regiments that slaughtered without mercy at St Quentin in 1557 and at Mechelen in October 1572, were part of the same apparatus of military savagery. Outside Europe, the cost was the thousands of Africans who rotted and died every year in Portuguese, English and Dutch slaving ships in the long passage across the Atlantic; the millions of indigenous peoples whose lands were invaded by pathogens, plants and animals of the Old World. It was beyond all doubt an immense saga of glory for many, but for very many others it was one of almost unrelieved desolation.

Glossary

adelantado governor of a frontier province, or leader of an expedition

asiento a contract, especially contracts of financiers with the crown, or contract to supply slaves

Audiencia in the Spanish colonies, the highest administrative and judicial tribunal, under the viceroy; by extension, the area governed by it

auto de fe public ceremony held by the Spanish Inquisition

barangay in the Philippines, a social unit of settlement; used by the Spaniards to mean 'a village'

black in this book for purposes of simplicity the word 'black' is used indifferently to apply to all people of African origin, and also to those whose origins were primarily African (such as 'mulattoes')

cacique in New Spain, an Indian chief or official

calpulli in Mexico, territorial unit or group of families composing it

cédula royal order

cimarron runaway; used mainly of black slaves, and of cattle

Comuneros rebels who took part in the 1520–21 revolt against Charles V

conquistador description applied to the Spanish military pioneers in America

Consulado the Consulado in Seville and other Spanish cities was the corporation of merchants trading there

Creole New World settler of white, Spanish descent

Cruzada special tax created by papacy and granted to Spanish government

curaca in Inca Peru, an Indian chief or official

daimyo Japanese warlord

datu in the Philippines, a native chieftain

doctrina a Church parish area

ducat originally a gold coin but later simply a monetary unit of account

encomienda	grant of Indians, for labour or for tribute; the holder of an encomienda was the 'encomendero'
escudo	Castilian coin
galleon	large Spanish ocean-going warship
galley	open-oared vessel, used in coastal traffic and in the Mediterranean
Hermandades	medieval urban police in Castile
huaca	in the Peruvian Andes, a sacred object or place
Infante/Infanta	title applied to son/daughter of the Spanish royal family
juro	annuity from state income, repaying loans made to the crown
maravedí	traditional Spanish unit of account; a small coin
mestizo	person of mixed Spanish-Indian parentage
mita	in Peru, system of native forced labour
Padroado Real	privileges of the Portuguese crown in Church affairs
Patronato Real	privileges of the Spanish crown in Church affairs
peso	unit of value in which American treasure was expressed; there were also silver and gold coins bearing the name 'peso'
quintal	Spanish measure of weight, approximate to hundredweight
repartimiento	system of Indian draft labour
samurai	Japanese warrior
sepoy	in the British East India Company, a native soldier in their service
situado	annual subsidy received by the Philippines from the treasury of New Spain
tercio	infantry regiment in Spanish armies up to the eighteenth century

List of Abbreviations

AGS:E	Archivo General de Simancas, section Estado
AEA	*Anuario de Estudios Americanos*
AHR	*The American Historical Review*
BL	The British Library
BRAE	*Boletín de la Real Academia Española*
CODOIN	*Colección de Documentos Inéditos para la Historia de España*
EconHR	*The Economic History Review*
HAHR	*The Hispanic American Historical Review*
JEEH	*The Journal of European Economic History*
OP	Order of Preachers
P&P	*Past and Present*
PHR	*The Pacific Historical Review*
PS	*Philippine Studies*
RABM	*Revista de Archivos, Bibliotecas y Museos*
REJ	*Revue des Etudes Juives*
SCJ	*The Sixteenth Century Journal*
SJ	Society of Jesus
TRHS	*Transactions of the Royal Historical Society*

Notes

Preface

1. Castro, p.571.

2. Analysed, for example, by Felipe Fernández-Armesto, *The Spanish Armada*, Oxford 1988.

3. Quoted in Parker 1998, p.xix.

4. Francisco Mallari SJ, 'The Spanish navy in the Philippines, 1589–1787', *PS*, 37, 1989, p.413.

5. Raymond E. Dumett, ed., *Gentlemanly imperialism and British imperialism. The new debate on empire*, London 1999, p.13.

6. P. J. Cain and A. G. Hopkins, 'The theory and practice of British imperialism', in Dumett, p.198.

7. Arthur O'Shaughnessy, 'Ode'.

8. For one contribution to the debate, see Henry Kamen, 'The decline of Spain: an historical myth?', *P&P*, 81 (1978), 24–50; for a general discussion, J. K. J. Thompson, *Decline in history. The European experience*, Cambridge 1998.

9. Fernand Braudel, *Autour de la Méditerranée*, Paris 1996, p.283.

10. Ellis, p.105.

11. Castro, p.580.

12. Santiago Ramón y Cajal, *Reglas y consejos sobre investigación científica (Los tónicos de la voluntad)*, 6th edn Madrid 1923, cited in Ramón Tamames, *Estructura económica de España*, Madrid 1960, pp.198–199.

13. The study that stimulated most discussion on this topic was by E. L. Jones, *The European miracle*, Cambridge 1981. My views on it were presented in an unpublished paper, 'Early modern Europe, Eric Jones and the world economy', Economic History seminar, St Antony's College, University of Oxford, spring 1987.

14. Cf. Tracy, pp.142, 195.

Chapter 1: Foundations

1. M. L. López-Vidriero and P. Cátedra, 'La imprenta y su impacto en Castilla', in A. García Símon, ed., *Historia de una cultura*, Valladolid 1995, I, 472.

2. Cited in Luis Gil Fernández, *Panorama social del humanismo español (1500–1800)*, Madrid 1981, p.565. Aldus was the great Italian printer Aldus Manutius, Froben the Swiss printer Hieronymus Froben.

3. Hillgarth, pp.243–249. Weiditz's *Tractenbuch* was the first comprehensive artist's survey of life in the peninsula.

4. For a recent general perspective, Amancio Labandeira, 'Repertorios tipo-bibliográficos de Hispanoamérica y Filipinas', *Cuadernos de Investigación Histórica*, 18, Madrid 2001, p.200.

5. Gil Fernández, p.573.

6. *Ibid.*, pp.565 following.

7. For a brief assessment of Nebrija, see Jeremy Lawrance, in A. Goodman and A. MacKay, *The impact of humanism on western Europe*, London 1990, pp.240–246.

8. Cf. Carande, I, 167, and the subsequent pages.

9. What follows is a summary of the presentation in my *Spain 1469–1714. A society of conflict*, London 1991, Chapter 1.

10. The bachiller Palma, quoted in J. N. Hillgarth, *The Spanish kingdoms 1250–1516. Vol.II 1410–1516*, Oxford 1978, p.364.

11. Relevant quotations may be found in Arco y Garay, pp.119–121.

12. Cf. Eduardo Aznar Vallejo, 'The conquests of the Canary Islands', in Schwartz 1994, pp.148–51.

13. This information, and what follows, is derived from L. A. Anaya Hernández, 'Los aborígenes canarios y los estatutos de limpieza', *El museo canario*, xlix (1994). I thank the author for giving me a copy of his article.

14. Grove, p.29.

15. Fernández-Armesto, p.13.

16. Otte 1996, p.215.

17. Fernández-Armesto, p.21.

18. *Ibid.*, pp.15–21.

19. David E. Vassberg, *The village and the outside world in Golden Age Castile*, Cambridge 1996, pp.67, 129, 174.

20. Olesa Muñido, I, 360–1, mentions no naval actions.

21. What follows is based on the essay by Eloy Benito Ruano, 'La participación extranjera en la guerra de Granada', *RABM*, 80, no.4, Oct–Dec 1977.

22. Quoted by Benito Ruano, 'Participación', p.689.

23. M. J. Viguera Molins, 'El ejército', in *El reino nazarí de Granada (1232–1492)*, Madrid 2000, p.447.

24. M. A. Ladero Quesada, *Castilla y la Conquista del reino de Granada*, Valladolid 1967, p.201.

25. Otte 1996, pp.187, 190.

26. Isaba, p.226.

27. John Edwards, *The Spain of the Catholic Monarchs 1474–1520*, Oxford 2000, pp.124–127.

28. M. J. Viguera Molins, 'El ejército', in *El reino nazarí de Granada (1232–1492)*, Madrid 2000, pp.444–445.

29. Benito Ruano, 'Participación', p.688.

30. Letter of Aug. 1489, in Epistolario de Pedro Martir de Anglería, *CODOIN*, vol.IX, Madrid 1953, p.123.

31. Quoted in L. P. Harvey, *Islamic Spain 1250 to 1500*, Chicago 1990, p.278.

32. The finest account of the siege of Málaga is in Prescott 1841, chap.XIII.

33. Harvey, p.304.

34. *Ibid.*, p.305.

35. Cf. M. A. Ladero Quesada, *Granada. Historia de un país islámico (1232–1571)*, Madrid 1969, p.150.

36. A. Fernández de Madrid, *Vida de Fray Fernando de Talavera*, ed. Granada 1992.

37. Cisneros to the chapter of Toledo, 3 Feb 1500, in Ladero Quesada 1988, p.427.

38. Cited in Ladero Quesada 1988, p.305 n.66.

39. Royal letter of 12 Oct 1501, in Ladero Quesada 1988, p.478.

40. Quoted by L. P. Harvey, in *Legacy of Muslim Spain*, p.219.

41. For a recent survey, Kamen 1998.

42. For a fuller discussion of the background to the expulsion, see Kamen 1998, chap.2.

43. Joseph Ha Cohen and Rabbi Capsali, in David Raphael, *The Expulsion 1492 Chronicles*, Hollywood 1992, pp.17, 106.

44. Cf. Mark D. Meyerson, 'Religious change, regionalism, and royal power in the Spain of Fernando and Isabel', in L. J. Simon, ed., *Iberia and the Mediterranean World of the Middle Ages*, vol.I, Leiden 1995, pp.101–2.

45. Cf. G. V. Scammell, *The world encompassed. The first European maritime empires c.800–1650*, London 1981, p.336: 'No more than that of Portugal was Spanish expansion the outcome of precocious nautical skills.'

46. Interestingly, in a recent study where the authors present naval power as a prerequisite of imperial power, they omit the Spanish and concentrate only on the Portuguese and the Dutch: Karen A. Rasler and William R. Thompson, *The Great Powers and global struggle 1490–1990*, Lexington 1994, pp.6, 16, 18.

47. Cf. the presentation in Carande, I, 351, 363–4.

48. He hit his head on the lintel of a low doorway.

49. José M. Doussinague, *La política internacional de Fernando el Católico*, Madrid 1944, p.97.

50. He lived at Xàtiva, and in 1526 married Germaine de Foix (formerly the wife of Ferdinand the Catholic) and was appointed titular viceroy of Valencia; he died in 1559.

51. Brantôme, I, 35.

52. See the study by Raffaele Puddu, *Il soldato gentilhuomo*, Bologna 1982.

53. The Navarrese general (1460–1528) was not ransomed by King Ferdinand, and in revenge he renounced his estates and his allegiance to the king and took service with France. In a subsequent campaign in Italy, however, he was captured by the Spaniards and imprisoned at Naples, where he died.

54. Manglano, II, 209.

55. Prescott 1841, p.670.

56. J. Vicens i Vives, *Ferran II i la ciutat de Barcelona 1479–1516*, 3 vols, Barcelona 1936–7, II, 332.

57. Cf. Taylor, pp.41, 46, 58–59.

58. Tercios were not formally created until 1536; see Chapter 4 below.

59. 'All the evidence for radical military change', writes a leading expert, 'came from Spain, Italy, the Netherlands and France': Parker 1988, p.24. I confess that I cannot see the reasons for including Spain in this list.

60. Juan de Narváez, quoted in Green, III, 99.

61. Quoted in Eric Cochrane, *Historians and historiography in the Italian Renaissance*, Chicago 1981, p.193.

62. *Crónicas del Gran Capitán*, p.xxxv.

63. Cf. Galasso, p.19. The point is an important one, but many historians ignore it; even Merriman, II, 307, claims that Naples was 'added to the domains of the Spanish Empire'.

64. Cf. Carlos José Hernando Sánchez, *El reino de Nápoles en el Imperio de Carlos V*, Madrid 2001, pp.48–50.

65. Cf. Ladero Quesada 1988, pp.201–203.

66. A useful summary with reference to recent research is by Beatriz Alonso Acero, 'Las ciudades norteafricanas de la monarquía hispánica en los siglos XVI y XVII', *Torre de los Lujanes*, 45, Oct. 2001, pp.123–143.

67. Doussinague, p.134.

68. *Ibid.*, p.135.

69. Quoted in Ricardo del Arco y Garay, *Fernando el Católico*, Saragossa 1939, p.270.

70. Doussinague, p.198.

71. *Ibid.*, p.194.

72. Vilar and Lourido, pp.46–47.

73. Arco y Garay, p.646.

74. Pierre Boissonnade, *Histoire de la réunion de la Navarre à la Castille*, Paris 1893, p.322.

75. All figures are from Boissonnade, p.325.

76. Father of García de Toledo and grandfather of Philip II's duke of Alba.

77. Mario García-Zúñiga, 'Privilegios fiscales y política tributaria en el reino de Navarra (siglos XVI–XVII)', in A. M. Bernal *et al.*, *El gobierno de la economía en el imperio español*, Seville 2000, p.368.

78. G. Schurhammer, *Francis Xavier, vol.I: Europe*, Rome 1973, p.49.

79. Cited in Arco y Garay, p.104.

80. Cf. Thomas Brady's opinion, citing other scholars, that 'there is growing agreement that the most important agent of [the pursuit of empire abroad] was the European nation state', in Tracy, p.120. The conclusion cannot be applied to the most important of early modern colonial empires, the Spanish. The insistence on European political power as a prerequisite of European expansionist capacity forms part of the standard Marxist paradigm about the so-called transition from feudalism to capitalism.

81. Juan de Mariana, *De rege*, Madrid 1872, Biblioteca de Autores Españoles, vol.xxxi, p.475.

82. Ochoa, IV, 48–55.

83. Garrett Mattingly, *Renaissance diplomacy*, London and Boston 1955; Charles H. Carter, *The Western European powers 1500–1700*, London 1971, p.24.

84. Epistolario de Pedro Mártir, *CODOIN*, IX, 162.

85. Ochoa, IV, 402.

86. Manglano, II, 206.

87. As we have noted, the real victors at Ravenna were the French, who withdrew because of heavy losses.

88. In Ochoa, IV, 421.

89. Manglano, II, 79.

90. For a summary of the situation, see Kamen 1991, p.49.

91. Cited in Ruth Pike, *Enterprise and adventure. The Genoese in Seville and the Opening of the New World*, Ithaca 1966, p.192.

92. *Crónicas del Gran Capitán*, p.xxx.

93. Ochoa, IV, 450–452.

94. Otte 1996, p.35.

95. *Ibid.*, p.186.

96. *Ibid.*, p.119.

97. Hillgarth, p.16.

98. Otte 1996, pp.212–213.

99. Carande, I, 440.

100. Manglano, II, 42.

101. Cf. Bernal, p.100.

102. Sauer, p.24.

103. *Ibid.*, p.32.

104. Cf. Sauer, p.65.

105. Sauer, p.100.

106. Peter Martyr d'Anghiera, *De Orbe Novo*, trans. by F. A. MacNutt, 2 vols, New York 1912, I, 262.

107. Sauer, pp.96–99.

108. Cook 1998, p.207.

109. 'Charles VIII invaded Italy in the grip of millenarian fantasies': R. Finlay, 'The Immortal Republic: the Myth of Venice during the Italian Wars', *SCJ*, xxx, 4, 1999, p.939. Cf. Samuel Kraus, 'Le roi de France Charles VIII et les espérances messianiques', *REJ*, 51, 1906.

110. On Columbus, see the brilliant study by Milhou 1983, p.199.

111. Leonard, p.24.

112. See Kamen 1993, pp.82–93.

113. The picture of a revitalized and crusading Church in Spain, too frequently transmitted by popular writers, has no basis in reality. Changes came, but they were two generations later, in the 1560s.

114. Milhou 1983, p.381.

115. See the stimulating essay by Sanjay Subrahmanyam, 'Du Tage au Gange au XVIe siècle: une conjoncture millénariste à l'echelle eurasiatique', *Annales ESC*, 56, no.1, 2001.

Chapter 2: The Early Western Empire

1. Vargas Machuca, I, 51.

2. The best survey is still C. R. Boxer, *The Portuguese Seaborne Empire 1415–1825*, Harmondsworth 1973.

3. Jover 1963, pp.44–48. Jover's analysis is based on the rich collection of letters from Isabel to Charles, published in M. Carmen Mazarío Coleto, *Isabel de Portugal*, Madrid 1951.

4. The fundamental study is by Hayward Keniston, *Francisco de los Cobos, secretary of the Emperor Charles V*, Pittsburgh 1960.

5. Juan Sanchez Montes, *Franceses, protestantes, turcos. Los españoles ante la política internacional de Carlos V*, Pamplona 1951, p.102.

6. John M. Headley, 'The Habsburg world empire and the revival of Ghibellinism', in Armitage, p.66.

7. Arco y Garay, p.127.

8. The document, discovered by Brandi, is printed in Carande, III, 521.

9. My argument coincides to some extent with that presented by Douglass C. North in a recent essay, 'Institutions, transaction costs, and the rise of merchant empires', in James D. Tracy; see esp. p.27 of the essay. However, I have preferred to place the third of his three factors, namely the acceptance of risk, within the context not of insurances but of state debt.

10. Ruiz Martín 1975, p.733.

11. M. Montañez Matilla, *El Correo en la España de los Austrias*, Madrid 1953, p.61.

12. Cf. the names given in Ochoa, V, 572–575.

13. Ochoa, V, 73.

14. *Ibid.*, 92.

15. Brantôme, I, 58.

16. Galasso, p.63.

17. J. M. Jover, *Carlos V y los españoles*, Madrid 1987 edn, p.307.

18. Cf. H. V. Bowen, *Elites, enterprise and the making of the British overseas empire 1688–1775*, London and New York 1996, especially Chapter 3.

19. Carande, III, 77.

20. Jover 1963, p.123.

21. Quoted in Merriman, III, 223.

22. Quoted in *ibid.*, 122.

23. Quoted in Solnon, p.54.

24. I follow the details given by an officer who was in the battle: García Cerezeda, I, 113.

25. The action of the three Castilians is verified by Eloy Benito Ruano in 'Los aprehensores de Francisco I de Francia en Pavía', *Hispania*, XVIII, 1958, p.547.

26. Taylor, p.127, does not emphasize the arquebuses, but agrees on the role of the Germans and the tactics of Pescara's light infantry.

27. Brantôme, I, 93.

28. There are many books on this famous episode. Vicente de Cadenas y Vicent, *El Saco de Roma de 1527*, Madrid 1974, contains good contemporary documentation.

29. Vicente de Cadenas y Vicent, *El protectorado de Carlos V en Génova. La 'condotta' de Andrea Doria*, Madrid 1977, pp.50–91.

30. Arturo Pacini, *La Genova di Andrea Doria nell' Impero di Carlo V*, Florence 1999, p.154.

31. Green, III, 105.

32. Merriman, III, 296.

33. Vicente de Cadenas y Vicent, *Doble coronación de Carlos V en Bolonia*, Madrid 1985.

34. Jover 1963, p.97.

35. Vicente de Cadenas y Vicent, *Dos años en la vida del emperador Carlos V (1546–1547)*, Madrid 1988, p.93.

36. Galasso and Migliorini, p.48.

37. Vasto was Affonso d'Avalos d'Aquino, Doria had the title of principe di Melfi, and Gonzaga had the title of principe di Molfetta.

38. Otte 1996, pp.184–193.

39. Cited in Jover 1963, p.84.

40. Jover 1963, p.90.

41. *Ibid.*, p.398.

42. García Cerezeda, III, 247.

43. Merriman, III, 209.

44. Hernando, pp.398–404.

45. The fundamental work is Ruth Pike, *Enterprise and Adventure. The Genoese in Seville and the Opening of the New World*, Ithaca 1966, esp. chap.III.

46. Bernal, pp.166–169.

47. Among the very many studies on Genoese entrepreneurs, see in particular Felipe Ruiz Martín, 'Los hombres de negocios genoveses', in Kellenbenz.

48. Kirk, p.409.

49. Quoted in Galasso and Migliorini, p.141.

50. Quoted in Pike, p.8.

51. See the excellent survey by Àngel Casals, 'Esperanza y frustración. La defensa mediterránea de la Corona de Aragón en la primera mitad del siglo XVI', in *L'Orde de Malta, el regne de Mallorca i la Mediterrània*, Palma de Mallorca 2001, p.181.

52. Cited Carande, III, 96.

53. García Cerezeda, I, 309.

54. Cited in Green, III, 100. 'Spaniards, Spaniards, the whole world fears you!'

55. Carande, III, 108.

56. García Cerezeda, I, 464.

57. Carande, III, 175–6.

58. Figures for both ships and men are based on García Cerezeda, II, 21.

59. Solnon, p.55.

60. García Cerezeda, II, 51.

61. Jover 1963, p.137.

62. Manglano, II, 95.

63. Jover 1963, p.151.

64. *Ibid.*, p.176.

65. Merriman, III, 323–329.

66. Carande, III, 218.

67. There are several accounts of the disaster; I follow the documents cited in Carande, III, 219–223.

68. Merriman, III, 339.

69. The best short essay on this theme is by Werner Thomas and Eddy Stols, 'La integración de Flandes en la Monarquía Hispánica', in Werner and Verdonk, chap.I.

70. The phrase is from Merriman, III, 225; he follows Pirenne and others.

71. L. P. Gachard, ed., *Relation des Troubles de Gand*, Brussels 1846, printed in H. H. Rowen, *The Low Countries in Early Modern Times*, New York 1972, p.23.

72. Raymond Fagel, *De Hispano-Vlaamse wereld. De contacten tussen Spanjaarden en Nederlanders 1496–1555*, Brussels 1996, pp.383–385.

73. Cf. Merriman, III, 258, 266.

74. The figures are those of the Venetian ambassador in the Empire, Alvise Mocenigo, in his account of the battle printed in Cadenas y Vicent, *Dos añōs en la vida del emperador*, pp.146–148.

75. The duchy of Saxony had in 1485 been divided between brothers of the same Wettin family into an 'electoral' and a 'ducal' territory. The conflicts of the Reformation era sharpened the differences between the two Saxonies.

76. The Venetian ambassador says that an Italian noble, Hippolito da Porto, captured the duke.

77. Avila y Zúñiga, p.28.

78. Gómara appears to be the main source for Merriman (III, 258) claiming that 'it was largely with Spaniards that Charles won the battle of Mühlberg'.

79. Cadenas y Vicent, *Dos años en la vida del emperador*, p.148.

80. J. M. Jover, *Carlos V y los españoles*, Madrid 1987 edn, p.307.

81. Both quoted in Merriman, III, 371.

82. See Kamen 1997, chap.2, for the paragraph that follows and the quotations in it.

83. *Historia general de las Indias*, Zaragoza 1553, I, 4.

84. Cf. Lockhart, in James Lockhart and Stuart B. Schwarz, eds, *Early Latin America*, Cambridge 1983, p.78: 'in the Caribbean one did not speak of conquest'.

85. Sauer, pp.23–28.

86. *Ibid.*, pp.162–174.

87. Quoted in *ibid.*, p.207.

88. Cf. Merriman, III, 536.

89. Pike, p.129.

90. Kellenbenz, p.287; Carande, III, 516–518.

91. Friede, pp.90–91.

92. Sauer, p.236.

93. Cited in *ibid.*, p.235.

94. Cited in Sauer, p.248 [from *CODOIN*, 37, 181].

95. Jover 1963, p.202.
96. García Cerezeda, I, 134.
97. Cross, p.401.
98. Carande, III, 18.
99. Jover 1963, p.422.
100. Carande, I, 159.
101. Cited in *ibid.*, 248. The seizures of bullion are detailed in Carande, III, 168 and following.
102. Carande, I, 263.
103. Carande, III, 21.
104. *Ibid.*, 382, 398.
105. Cited in *ibid.*, 446.
106. Quoted in Merriman, III, 384.
107. Sandoval, p.479.
108. Quoted in Parker 1998, p.3.

Chapter 3: A New World

1. Cf. examples in Chile in the 1550s, in Jara, p.29.
2. Later conquistadors, and theorists in Spain itself, soon abandoned the notion that their title rested on the will of the pope, and returned to the idea that America had been won by right of 'conquest'.
3. Cited in Carande, I, 479.
4. Sauer, p.249.
5. Bernal Díaz del Castillo, *The Conquest of New Spain*, trans. J. M. Cohen, Harmondsworth 1963, p.250.
6. Bernal Díaz, p.88.
7. The following quotations are taken from the Spanish text of Sahagún's Florentine Codex, in Lockhart 1993.
8. Lockhart 1993, p.112. This passage, like some others cited here, is given in the Codex only in Nahuatl, the translation here is Lockhart's.
9. The date is that given by Bernal Díaz, and before him by Gómara; but the time interval seems inordinately long, and it is more likely that the Noche Triste took place a few days earlier on 30 June: cf. Hernando Cortés, *Letters from Mexico*, ed. A. R. Pagden, London 1972, p.479 n.92.
10. Lockhart 1993, p.166.
11. The few lines devoted here to one of the most famous events in world history are obviously an inadequate summary. A recent monumental narrative is that of Hugh Thomas, *Conquest, Montezuma, Cortes and the Fall of Old Mexico*, New York 1993.

12. Fernando de Alva Ixtlilxochitl, *Ally of Cortes*, trans. by Douglass K. Ballentine, El Paso 1969, p.23.

13. Bernard Grunberg, *L'univers des conquistadores. Les hommes et leurs conquête dans le Mexique du XVIe siècle*, Paris 1993, gives a fascinating analysis, based on the details of around 58 per cent (or 1,212 individuals) of the conquistadors. He estimates that in total nearly 2,000 Spaniards were directly associated with the fall of the Mexica capital.

14. Grunberg, p.41.

15. *Ibid.*, p.77.

16. *Ibid.*, p.104.

17. His brothers, both illegitimate like himself, were Gonzalo and Juan; his half-brother, legitimate, was Hernando; another, Francisco Martín, was his mother's son by a different father, and his young cousin was Pedro.

18. There are very many accounts of these events in English, notably that by John Hemming, *The conquest of the Incas*, New York 1970. My short summary is based on the classic account by Prescott, written in 1847 and used by me in the 1901 edition.

19. Pedro de Cieza de León, *Obras completas*, 2 vols, ed. Carmelo Saenz de Santa Maria, Madrid 1984, I, 276.

20. 'Since the Indians had no weapons it was easy to crush them without any risk', in Prescott, *Peru*, p.432.

21. Cieza de León, *Obras completas*, I, 278.

22. 'It was something to see a valley four or five leagues long, overflowing with people', from the extract in Prescott, *Peru*, p.431.

23. Lockhart and Otte, p.5.

24. Lockhart 1972, pp.18, 32, 38.

25. During his imprisonment, Atahualpa sent out orders for the execution of Huascar.

26. This is the probable date; most historians had previously accepted the date of 29 August. See Adám Szászdi Nagy, 'Algo más sobre la fecha de la muerte de Atahuallpa', *Historiografía y bibliografía americanistas*, 30 (2), Seville 1986, p.76.

27. Carande, III, 530.

28. Hemming, *The conquest of the Incas*, p.201.

29. As I write, in February 2002, archaeologists have announced the discovery of the ruins of Vilcabamba, in the mountains some eighty kms from the site of the ancient ruins of Machu Picchu.

30. This is the vision offered in the well-known book of Miguel León-Portilla, *The broken spears: the Aztec account of the conquest of Mexico*, Boston 1962.

31. Cieza de León, *Obras completas*, I, 2.

32. Vargas Machuca, I, 102.

33. Cf. also the presentation in Chapter 6 below.

34. Alva Ixtlilxochitl, p.67.

35. Quoted by Karen Spalding, 'The crises and transformations of invaded societies: Andean area', in *Cambridge History of the Native Peoples of the Americas*, III, 1, p.928.

36. Lockhart 1993, p.291.

37. *Ibid.* 1993, p.259.

38. Cited in Jara, p.81.

39. Lockhart 1993, p.265, from the 'Annals of Tlatelolco'.

40. Jones, p.17.

41. Jara, p.86.

42. Quoted in Millones, p.392.

43. Restall, pp.87, 89–90. I have altered Restall's word 'foreigners' to 'strangers', and '*cah*' to 'community'.

44. Restall, p.121.

45. *Ibid.*, p.44.

46. *Ibid.* p.73.

47. Cited in Jara, p.38.

48. Otte 1998, p.432.

49. Bray, p.16.

50. Leonard, p.34.

51. Bray, p.16.

52. Konetzke, p.9.

53. See the *Historia General de la emigración española a Iberoamerica*, 2 vols, Madrid 1992, I, 53. Since America did not have households of the style of Spain, the size of each American household should probably be estimated at around three persons. López de Velasco's figures coincide with other estimates of the time: cf. Rosenblat, I, 83–88.

54. Steve J. Stern, 'The rise and fall of Indian–White alliances: a regional view of "conquest" history', *HAHR*, 61, iii, 1981, p.471.

55. Otte 1998, p.555.

56. *Ibid.* 1988, p.316.

57. Cited in Jara, p.45.

58. Richard Konetzke, 'La esclavitud de los indios como elemento en la estructuración social de Hispanoamérica', *Estudios de Historia Social de España*, 1, 1949, pp.441–79.

59. MacLeod, p.52.

60. Quoted in Cook 1998, p.4.

61. Restall, p.14.

62. *Ibid.*, p.124.

63. Janusz Tazbir, 'Los conquistadores en opinión de los polacos de los siglos XVI–XVIII', *Ibero-Americana Pragensia*, año III, 1969, p.175.

64. Cf. Cook 1998, p.17.

65. Cf. Russell Thornton, *American Indian holocaust and survival. A population history since 1492*, Norman, OK 1987, pp.40, 44.

66. Cf. Ann F. Ramenofsky, *Vectors of death. The archaeology of European contact*, Albuquerque 1987, pp.1–6.

67. For a biting and entertaining commentary on the inflation of figures, see David Henige, *Numbers from Nowhere. The American Indian contact population debate*, Norman, OK 1998.

68. Reff, p.275.

69. Cook 1998, pp.202–204.

70. Cf. Ramenofsky, p.173.

71. Linda A. Newson, 'Old World epidemics in early colonial Ecuador', in Noble D. Cook and W. George Lovell, eds, *Secret Judgments of God. Old World disease in colonial Spanish America*, Norman, OK 1991, p.109.

72. Hanns J. Prem, 'Disease outbreaks in central Mexico during the sixteenth century', in Cook and Lovell, pp.33–34.

73. Otte 1998, p.97.

74. Cook 1998, p.206.

75. Thornton, p.14.

76. Otte 1998, p.240.

77. *Ibid.*, pp.45, 327.

78. *Ibid.*, p.248.

79. *Ibid.*, p.161.

80. Ida Altman and James Horn, *'To make America'. European emigration in the early modern period*, Berkeley 1992, p.3.

81. Auke P. Jacobs gives a good summary of a convincing argument in 'Las migraciones españolas a América dentro de una perspectiva europea, 1500–1700', in Jan Lechner, ed., *España y Holanda*, Amsterdam and Atlanta 1995.

82. Otte 1998, p.236.

83. *Ibid.*, p.284.

84. *Ibid.*, pp.186, 338.

85. *Ibid.*, p.144.

86. *Ibid.*, p.376.

87. *Ibid.*, p.130. The italics are mine.

88. *Ibid.*, p.454.

89. Leonard, p.136.

90. Otte 1998, p.120.

91. Konetzke, p.37.

92. Otte 1988, pp.187, 110.

93. *Ibid.*, p.281.

94. *Ibid.*, p.349.

95. *Ibid.*, p.496.

96. *Ibid.*, p.467.

97. *Ibid.*, p.207.

98. *Ibid.*, p.415.

99. *Ibid.*, p.534.

100. *Ibid.*, p.524.

101. Ward, p.34.

102. Quoted in Friede, p.47.

103. Quoted in *ibid.*, p.48.

104. Francisco Morales Padrón, 'Colonos canarios en Indias', *AEA*, 8, 1951, 399–441.

105. Francesco D'Esposito, 'Portuguese settlers in Santo Domingo in the sixteenth century (1492–1580)', *JEEH*, 27, ii, Fall 1998, pp.321–322.

106. Milhou 1976, p.17 n.69.

107. Eduardo R. Saguier, 'The social impact of a middleman minority in a divided host society: the case of the Portuguese in early seventeenth century Buenos Aires', *HAHR* 65:3, 1985, p.480.

108. Enriqueta Vila Vilar, *Hispanoamérica y el comercio de esclavos*, Seville 1977, pp.101–102.

109. Francesco d'Esposito, 'Presenza italiana tra i "conquistadores" ed i primi colonizzatori del Nuovo Mondo (1492–1560)', *Presencia italiana en Andalucia, siglos XIV–XVII*, Seville 1989, pp.493–533.

110. Andrews 1978, p.39.

111. Thornton, pp.72–97.

112. A good general survey is Rolando Mellafe, *La esclavitud en Hispanoamérica*, Buenos Aires 1964.

113. Magalhães, IV, 195.

114. Friede, p.121; Georges Scelle, *La Traite Négrière aux Indes de Castille*, 2 vols, 1906.

115. Mercado, *Suma de Tratos*, chap.20.

116. Thornton, p.118, where his bases of calculation are given.

117. Bowser, p.72.

118. Slightly lower totals are given by Philip Curtin; the ones I give approximate to those of Paul Lovejoy, 'The volume of the Atlantic slave trade: a synthesis', in Manning, p.61; some detailed figures for the Spanish ports are offered by Enriqueta Vila, 1977, cited above, n.108.

119. Patrick Manning, 'Migrations of Africans to the Americas: the impact on Africans, Africa and the New World', in Manning, p.66.

120. The ship was English: Palmer 1981, p.45.

121. Cf. sources cited in Rout, p.71.

122. Milhou 1976, p.35.

123. Quoted Palmer 1981, p.135.

124. Bowser, p.75.

125. Cited by Rolando Mellafe, *La introduction de la esclavitud negra en Chile*, Santiago de Chile 1959.

126. Ward, pp.34–5.

127. Rout, p.75.

128. Jean-Pierre Tardieu, *Noirs et Indiens au Pérou (XVIe–XVIIe siècles)*, Paris 1990, pp.27, 29.

129. Rout, p.150.

130. The pioneering study was that of José Antonio Saco, *Historia de la esclavitud de la raza africana en el Nuevo Mundo*, 2 vols, Barcelona 1879.

131. Bray, p.61.

132. Bowser, p.301.

133. Pérez-Mallaína and Torres Ramírez, p.106.

134. Rout, p.79.

135. For the identity of the black in Spanish America, see Chapter 8 below.

136. The pioneering researches of Francisco Morales Padrón and Enriqueta Vila Vilar have helped to reorientate peninsular historiography on the subject.

137. Vargas Machuca, II, 59.

138. Altman, pp.252–253.

139. Lyon, pp.121–127.

140. Lillian E. Fisher, *Viceregal administration in the Spanish-American colonies*, Berkeley 1926.

141. For further discussion of imperial control, see Chapter 4 below.

142. Otte 1988, p.291.

143. What follows is drawn from Charles Gibson, *Tlaxcala in the sixteenth century*, New Haven 1952.

144. Carande, I, 251.

145. Lechner, p.7.

146. The classic study is Robert Ricard, *La 'Conquête spirituelle' du Mexique*, Paris 1933.

147. Mendieta, *Historia eclesiástica indiana*, Mexico 1997, p.344.

148. Guaman Poma, I, 284.

149. Spanish and Indian views of the Atahualpa incident are considered in Patricia Seed, 'Failing to marvel: Atahualpa's encounter with the word', *Latin American Research Review*, 26 (1), 1991, pp.7–32.

150. Cf. for example López-Baralt, pp.396–7. López-Baralt's book is an excellent exposition of the semiotic content of the message presented by Poma. My own presentation in this book limits itself to the question of verbal communication.

151. See below Chapter 11, Conclusion.

152. MacCormack, pp.263, 316.

153. For some aspects of the problem as seen by missionaries, Pagden 1982, pp.179–189.

154. Mendieta, *Historia eclesiástica indiana*, Mexico 1997, p.373.

155. Fernando de Armas Medina, *Cristianización del Perú (1532–1600)*, Seville 1953, p.88.

156. Pagden 1982, p.158.

157. Cf. the comment of J. Jorge Klor de Alva that 'from the time of the fall of Tenochtitlán the primary requirement was tactical and ethnographic knowledge', in 'Colonizing souls: the failure of the Indian Inquisition', in M. E. Perry and A. J. Cruz, *Cultural encounters*, Berkeley 1991, p.10.

158. Jesús Bustamante García, 'Francisco Hernández, Plinio del Nuevo Mundo', in B. Ares and Serge Gruzinski, eds, *Entre dos mundos. Fronteras culturales y agentes mediadores*, Seville 1997, p.266.

159. In what follows, I lean in part on Lockhart 1993, pp.27–46.

160. *Historia eclesiástica*, p.120.

161. Inga Clendinnen, *Ambivalent conquests. Maya and Spaniard in Yucatan, 1517–1570*, Cambridge 1987, pp.70, 116.

162. Clendinnen, p.85.

163. Letter of Motolinía to Charles V, 2 Jan. 1555.

Chapter 4: Creating a World Power

1. *Política para Corregidores*, II, 571.

2. Much of what follows is drawn, without citing sources, from Kamen 1997.

3. The account that follows is based largely on Philip's original military dispatches, in the British Library (BL), MS. Add.28264.

4. The structure of the Netherlands is explained above in Chapter 2. In the present chapter the word 'Flanders' (and its adjective, 'Flemish') will be used frequently for the whole Netherlands even though it was only one constituent province, because that was common usage at the time in Spain. When talking only of the southern Netherlands, I sometimes use the terms 'Belgium' and 'Belgian'.

5. For a detailed account, see Kamen 1997, pp.66–70.

6. Philip to Charles, Nov. 16, 1554, AGS:E leg.808 f.54.

7. Such as the philosopher Fox Morcillo (Arco y Garay, pp.138–9) or the bureaucrat Vázquez de Menchaca (Pagden 1995, pp.56–62).

8. Granvelle obtained his cardinalate in 1561.

9. Charles Weiss, *Papiers d'État du Cardinal de Granvelle*, 9 vols, Paris 1841–52, V, 643, 672.

10. Philip II to Council of State, 1565, AGS:E leg.98.

11. Cf. Kamen 1991, pp.98–111, 168–171.

12. Braudel, II, 973–987.

13. Brantôme, I, 105.

14. Jeremy Black, *Warfare, Renaissance to Revolution 1492–1792*, Cambridge 1996, p.27.

15. For two differing views, see Goodman 1997, p.31; and Thompson 1976, *passim*.

16. Cf. the comments of Thompson 1976, pp.282–3.

17. Henri Lapeyre, *Simon Ruiz et les Asientos de Philippe II*, Paris 1953, p.14.

18. Braudel, I, 374.

19. Cf. Parker 1998, pp.50–55.

20. Cf. Anthony F. Buccini, 'Swannekens Ende Wilden: Linguistic attitudes and communication strategies among the Dutch and Indians in New Netherland', in J. C. Prins and others, eds, *The Low Countries and the New World*, Lanham, MD 2000, pp.16–17.

21. Cf. the final chapter of this book.

22. John Goss, *The mapmaker's art*, New York 1993, p.89; G. Parker, 'Maps and Ministers: the Spanish Habsburgs', in David Buisseret, ed., *Monarchs, Ministers and Maps*, Chicago 1993.

23. For this and related matters, there is a good outline in Parker 1998, pp.59–65.

24. Parker 1998, p.69.

25. Edited by Richard L. Kagan, *Spanish cities of the Golden Age. The views of Anton van den Wyngaerde*, Berkeley 1989. In the same years Joris Hoefnagel also prepared a series of sketches of Spanish towns for a work he published in 1572.

26. Philip D. Burden, *The mapping of North America*, Rickmansworth 1996, pp.xxvi, xxxi.

27. *Ibid.*, p.xxix–xxx.

28. Goodman 1988, pp.68–71, gives a useful brief summary. See also H. Cline, 'The *Relaciones Geográficas* of the Spanish Indies', *HAHR*, 44, 1964.

29. As in Naples and Sicily: See Koenigsberger, p.50.

30. 'The Catalans are not very diligent in serving the crown', an official reported to Philip II in 1562: cited in Joan Lluís Palos, *Catalunya a l'Imperi dels Àustria*, Lleida 1994, p.41.

31. Joseph Rübsam, *Johann Baptista von Taxis*, Freiburg 1889, p.32.

32. *Ibid.*, p.32.

33. Quatrefages, p.113.

34. *Ibid.*, pp.295–298.

35. *Ibid.*, p.47. Two outstanding exceptions were the war in Granada in 1570 and the invasion of Portugal in 1580, for which tercios were raised in order to fight in the peninsula.

36. Brantôme, I, 122.

37. The best discussion is in Thompson 1976, pp.103–107.

38. Parker 1979, p.186.

39. J. Albi de la Cuesta, *De Pavia a Rocroi. Los tercios de infantería española en los siglos XVI y XVII*, Madrid 1999, p.380.

40. Parker, in Thomas and Verdonk, p.277.

41. James B. Wood, *The King's Army. Warfare, Soldiers and Society during the Wars of Religion in France, 1562–76*, Cambridge 1996, p.233.

42. J. R. Hale, 'Armies, navies and the art of war', in *The New Cambridge Modern History, vol.III*, Cambridge 1968, p.181. The exception to the rule was Sweden, which already in the mid-sixteenth century had an army composed only of Swedes, 'the first truly national army of modern times' (Michael Roberts, *Gustavus Adolphus*, 2 vols, London 1953–58, II, 191). During the Thirty Years War, however, the Swedish army also included foreign troops.

43. Parker 1984, p.192.

44. See Figure 4 in Parker 1972, p.28.

45. Friedrich Edelmayer, 'Soldados del Sacro Imperio en el Mediterraneo en la epoca de Felipe II', in Bruno Anatra and Francesco Manconi, *Sardegna, Spagna e Stati italiani nell'età di Filippo II*, Cagliari 1999, p.94.

46. Quoted by Mario Rizzo, 'Milano e le forze del principe. Agenti, relazioni e risorse per la difesa dell'impero di Filippo II', in *Felipe II (1527–1598). Europa y la Monarquía Católica*, 4 vols, Madrid 1998, II, 736.

47. Quoted by Croce, p.105.

48. Cited in Calabria, p.90 n.21.

49. Gráinne Henry, *The Irish military community in Spanish Flanders, 1586–1621*, Dublin 1992, p.20.

50. Karin Schüller, *Die Beziehungen zwischen Spanien und Irland im 16. und 17. Jahrhundert*, Munster 1999, p.123.

51. R. A. Stradling, *The Spanish monarchy and Irish mercenaries*, Dublin 1994, p.139.

52. *Ibid.*, p.25.

53. *Ibid.*, p.266.

54. Parker 1972, p.44.

55. Stradling 1994, p.266.

56. Thompson 1976, p.126.

57. Castillo de Bobadilla, II, 571, 579.

58. Jerónimo de Urrea, *Diálogo de la verdadera honra militar*, Venice 1566, cited in Arco y Garay, p.327.

59. Andrés Ponce de León to Philip II, Apr. 1575, cited in Thompson 1976, p.22.

60. Thompson 1976, p.25.

61. *Ibid.*, pp.235-7.
62. Quatrefages, p.194.
63. Thompson 1976, p.26.
64. Isaba, p.215.
65. Goodman 1988, pp.110-117, 121, 127.
66. Thompson 1976, p.167.
67. Haring, p.207.
68. Botero 1605, II, iv, 134.
69. See Chapter 7 below.
70. J. Leitch Wright Jr., *Anglo-Spanish rivalry in North America*, Athens, GA 1971, p.7.
71. *Cambridge History*, I, i, 340.
72. Goodman 1997, p.261.
73. Goodman 1988, p.78.
74. For reforms in the training of pilots in the eighteenth century, see M. E. Sellés and Antonio Lafuente, 'La formación de los pilotos en la España del siglo XVIII', in the composite work *La ciencia moderna y el Nuevo Mundo*, Madrid 1985.
75. Goodman 1988, p.80.
76. Konetzke, p.31.
77. *Ibid.*, p.36.
78. Goodman 1997, pp.215–220.
79. Michel Fontenay, 'The Mediterranean 1500 to 1800', in Victor Mallia-Milanes, ed., *Venice and Hospitaller Malta 1530–1798*, Malta 1992, p.29.
80. A good outline of the units in the fleet is given by Olesa Muñido, I, 504–516.
81. Cf. the comment by Galasso, p.30: 'The Italian realms had in the context of the empire an importance that is difficult to exaggerate.'
82. Ruiz Martín 1965, p.xviii.
83. AGS:SP leg.984, documents of Nov 11, 1589.
84. Koenigsberger, p.57.
85. *Ibid.*, pp.105, 139.
86. Tommaso Astarita, *The continuity of feudal power*, Cambridge 1992, pp.203–204.
87. Manuel Rivero, 'Poder y clientelas en la fundación del Consejo de Italia', *Cheiron*, 17–18, 1992.
88. Cf. Galasso, pp.37–41.
89. D. Frigo, ' "Per ben negociare" in Spagna', *Cheiron*, 17–18, 1992, p.291.
90. Above, Chapter 2.
91. Mario Rizzo, 'Lo stato di Milano nell'età di Filippo II', in Elena Brambilla and Giovanni Muto, *La Lombardia spagnola*, Milan 1997, p.374.
92. Cited by Koenigsberger, p.81.

93. Antonio de Herrera, *Comentarios de los Hechos de los Castellanos . . . en Italia*, Madrid 1624, p.467.

94. Cf. Luigi de Rosa, 'Economic crisis in the kingdom of Naples in the days of Philip II', *JEEH*, vol.28, no.3, 1999.

95. Roberto Mantelli, *Il pubblico impiego nell'economia del Regno di Napoli*, Naples 1986, p.102.

96. Croce, p.130.

97. Mario Rizzo, 'Lo stato di Milano', p.380.

98. Domenico Sella and Carlo Capra, *Il Ducato di Milano dal 1535 al 1796*, Turin 1984, p.9.

99. Calabria, pp.89–90.

100. Quoted in Galasso, p.183.

101. Quoted in Essen 1933, I, 139.

102. Brantôme, I, 29.

103. At the siege of Berg-op-Zoom by the tercios in 1622, the number of camp followers was estimated by a witness as being greater than that of the army itself.

104. Kamen 1997, p.126.

105. *CODOIN*, XXXVII, 42–70. Villavicencio was, despite his apparently liberal advice, a fervent enemy of the cause of the Netherlands.

106. Cf. Braudel, II, 1068.

107. In Jan. 1570, for example, the army received 414 cases of armament from Milan: AGS:E leg.152 f.76. In 1572 it ordered 250 field guns: AGS:E leg.154 f.106.

108. Don Juan to Ruy Gómez, Nov 5, 1570, *CODOIN*, XXXVIII, 156.

109. All the available sources give slightly varying figures for both vessels and soldiers. I have followed in general the figures suggested by Cayetano Rosell, *Historia del combate naval de Lepanto*, Madrid 1853, p.79; José M. Martínez-Hidalgo, *Lepanto*, Barcelona 1971, p.15; and I. A. A. Thompson and Geoffrey Parker, 'Lepanto (1571): the costs of victory', in Thompson 1992.

110. The best short account of Lepanto is still that by Braudel, II, 1102–1103.

111. John F. Guilmartin, 'The tactics of the battle of Lepanto clarified', in Craig L. Symonds, ed., *New aspects of naval history*, Annapolis 1981, p.44.

112. Martínez-Hidalgo (cited in n.107), p.35.

113. Eric Cochrane, *Historians and Historiography in the Italian Renaissance*, Chicago 1981, p.205.

114. Ruiz Martín 1975, p.739.

115. March, J. M., *Don Luis de Requeséns en el gobierno de Milán*, Madrid 1943, p.57.

116. García Hernán, p.231.

117. Cited in *ibid.*, p.228.

118. Cf. Milhou 1983, pp.361–5.

119. Vilar and Lourido, p.66.

120. Notes by king in AGS:Eleg. 2842.

121. *CODOIN*, LXXV, 135.

122. Secretary Prats to king, Nov 1572, *CODOIN*, LXXV, 129.

123. The appointment was in fact made early in 1572, but Requesens did not go to the Netherlands until the end of 1573.

124. AGS:E leg.156 ff.105, 141.

125. 'Lo que Su Magd manda que se platique', AGS:E leg.568 f.51.

126. Quoted by Parker in Thomas and Verdonk, p.281.

127. Parker 1979, p.33.

128. Cited in A. Morel-Fatio, *L'Espagne au XVIe et au XVIIe siècle*, Heilbronn 1878, p.112.

129. The standard life is William S. Maltby, *Alba; a biography of Fernando Alvarez de Toledo, Third Duke of Alba, 1507–1582*, Berkeley 1983.

130. Brantôme, I, 31.

131. Duque de Alba, *Epistolario del III duque de Alba, Don Fernando Álvarez de Toledo*, 3 vols, Madrid 1952, I, 110, 118.

132. Alba, *Epistolario*, I, 349, 370.

133. *Ibid.*, 390, 447. Alba's letter states that 3,000 tercios were lost at sea; this seems improbable. Since he also mentions they formed three companies, I have corrected the total to 1,000 men.

134. On some views about banks in the Mediterranean, see Martin H. Körner, *Solidarités financières suisses au seizième siècle*, Lausanne 1980, p.332.

135. José Manuel Pérez Prendes, *La monarquía indiana y el estado de derecho*, Valencia 1989, p.150.

136. Guaman Poma, I, 334.

137. *Ibid.*, 340.

138. Spanish theorists of 'empire' tended to write about an imagined rather than a realistic notion. A good discussion of the theme, written a generation ago, is that by Mario Góngora, *Studies in the colonial history of Spanish America*, Cambridge 1975.

139. Quoted in Lewis Hanke, *The Spanish struggle for Justice in the Conquest of America*, Philadelphia 1949, p.167.

Chapter 5: The Pearl of the Orient

1. Quoted in Schurz 1939, p.26.

2. What follows is based on Goodman 1988, pp.53–65.

3. Leonard Andaya, in Tarling, p.354.

4. Montserrat León Guerrero, 'El hallazgo del tornaviaje de las Filipinas por el Pacífico', *XIII Coloquio*, p.1032.

5. Nicholas D. Pisano, *The Spanish pacification of the Philippines 1565–1600*, Kansas 1992, pp.289–303.

6. Morga, p.14.

7. Pisano, pp.332–333.

8. Leslie E. Bauzon, *Deficit government. Mexico and the Philippine situado, 1606–1804*, Tokyo 1981, p.2.

9. Quoted in Nicholas P. Cushner, *Spain in the Philippines*, Quezon City 1971, p.4.

10. Morga, pp.238, 269.

11. Otte 1988, p.89.

12. Cf. Phelan 1959, chap.VIII.

13. Only in the twentieth century have Asians greatly extended the cultivation of maize.

14. Schurz 1939, p.29.

15. *Ibid.*, p.23.

16. Otte 1988, p.89.

17. Schurz 1939, p.26.

18. *Ibid.*, p.70.

19. Anthony Reid, in Tarling, p.477.

20. Reed, p.33.

21. Phelan, p.11.

22. Gungwu, p.59.

23. Morga, p.224.

24. Schurz 1939, p.92.

25. Cf. Reed, p.56.

26. Morga, p.154.

27. Gungwu, p.62.

28. Morga, p.14.

29. *Ibid.*, p.249.

30. Reed, p.34.

31. Quoted in *ibid.*, p.33.

32. Schurz 1939, chap.6.

33. O. H. K. Spate, *The Spanish lake*, London 1979, pp.106–109.

34. Cook 1973, p.16.

35. *The Cambridge History of the Pacific islanders*, Cambridge 1997, pp.122–124.

36. Schurz 1939, p.262.

37. Otte 1988, p.116.

38. Schurz 1939, pp.256, 259.

39. *Ibid.*, p.15.

40. Cook 1973, pp.5–6.

41. For a recent bibliographical sketch, P. Pérez Herrero, 'El galeón de Manila. Relaciones comerciales entre el Extremo Oriente y América', in *El Extremo Oriente Ibérico*, Madrid 1989, p.445.

42. Leonard Andaya, in Tarling, p.357.

43. Crosby, p.199.

44. A. Kobata, 'The production and uses of gold and silver in 16th and 17th century Japan', *EconHR*, XVIII, 2, 1965, p.255.

45. Leonard Andaya, in Tarling, p.351. Some Japanese scholars put the figures very much higher: see William S. Atwell, 'International bullion flows and the Chinese economy circa 1530–1650', *P&P*, 95, May 1982, p.71.

46. Adapted from the quotation in Vera Valdés Lakowsky, *De las minas al mar. Historia de la plata mexicana en Asia: 1586–1834*, Mexico 1987, p.119.

47. Meilink-Roelofsz, p.265.

48. J. Kathirithamby-Wells, in Tarling, p.607.

49. Meilink-Roelofsz, p.264.

50. Scott, p.9.

51. Quoted in Schurz 1939, p.42.

52. Schurz 1939, p.41.

53. Leonard Andaya, in Tarling, p.347.

54. Gil, p.62.

55. Hall, p.62.

56. Boxer 1967, p.169.

57. Hall, pp.363–364.

58. Gil, p.110.

59. *Ibid.*, p.121.

60. Quoted in Schurz 1939, p.99.

61. W. Michael Mathes, *Sebastián Vizcaíno y la expansión española en el océano Pacífico, 1580–1630*, Mexico 1973, pp.99–115.

62. Gil, pp.309–385, has the contemporary text relating Vizcaíno's visit.

63. Ohashi Yukihiro, 'New perspectives on the Tokugawa persecution', p.50, in J. Breen and M. Williams, *Japan and Christianity*, London 1996.

64. Schurz 1939, p.195.

65. Gil, p.191. The official was Rodrigo de Vivero, who in 1608–1609 was interim governor of the Philippines.

66. Boxer 1959, pp.111, 135.

67. Schurz 1939, p.81.

68. *España y el Pacífico*, Madrid 1990, p.36, a summary of the 1586 memorial.

69. Bauzon, *Deficit government*, p.14.

70. Scott, p.6.

71. Cf. Merle Ricklefs, 'Balance and military innovation in 17th-century Java',

in Douglas M. Peers, ed., *Warfare and Empires. Contact and conflict between European and non-European military and maritime forces and cultures*, Aldershot 1997, p.101.

72. Leonard Andaya, in Tarling, p.387.

73. Reid, p.229.

74. G.V. Scammell, 'Indigenous assistance in the establishment of Portuguese power in Asia', in *Ships, oceans and empire*, Aldershot 1995, chap.XI, p.8.

75. Furber, p.100.

76. Botero 1605, II, iv, 140.

77. Boxer 1969, pp.133–134.

78. Argensola's *Conquista de las Islas Malucas* was published in 1609; see Green, IV, 49–50.

79. John Villiers, 'Manila and Maluku: trade and warfare in the eastern archipelago 1580–1640', *PS*, 34, 1986, p.152.

80. Schurz 1939, p.140.

81. *Ibid.*, p.141.

82. Quoted in Valdés Lakowsky, p.100.

83. Boxer 1969, p.123.

84. Gil, p.31 n.19.

85. Goodman 1988, p.63.

86. John M. Headley, 'Spain's Asian presence, 1565–1590: structures and aspirations', *HAHR* 75:4, 1995, p.640.

87. *Ibid.*, p.641.

88. Rodao, p.14.

89. *Ibid.*, p.23.

90. *Ibid.*, p.28.

91. Irving A. Leonard, *Los libros del Conquistador*, Mexico 1953, p.48.

92. Cook 1973, p.3.

93. Spate, *The Spanish lake*, p.229.

94. Quoted in Andrews 1984, p.132.

95. Quoted in Bradley, p.26.

96. Andrews 1984, pp.144–158.

97. Cf. Pérez-Mallaína and Torres Ramírez, pp.4, 86.

98. Cook 1973, p.11.

99. Bolton 1908, pp.123–132.

100. Cook 1973, p.18.

101. Boxer 1978, p.134 n.43.

102. Boxer 1959, p.200.

103. Cf. Anthony Reid, 'Islamization and Christianization in Southeast Asia: the critical phase, 1550–1650', pp.158–160, in Anthony Reid, ed., *Southeast Asia in the early modern era: Trade, power and belief*, Ithaca 1993.

104. Olwer, p.121.
105. Boxer 1978, p.112.
106. Phelan 1959, p.18.
107. *Ibid.*, p.131.
108. *Ibid.*, p.88.
109. Boxer 1978, p.61.
110. Schurz 1939, p.52.
111. *Ibid.*, p.288.

Chapter 6: The Frontier

1. Otte 1988, p.325.
2. For the frontier, see Silvio Zavala, 'The frontiers of Hispanic America', in W. D. Wyman and C. B. Kroeber, eds, *The frontier in perspective*, Madison 1965; and Frederick Jackson Turner, 'The significance of the frontier in American history', reprinted several times.
3. A pioneering and little recognized contribution to the subject is the chapter in Schurz 1956, chap. VIII.
4. Leonard, p.46.
5. *Ibid.*, p.61.
6. Rosenblat, II, 24–26.
7. Otte, 'La mujer', p.1497.
8. Adapted from the text in James Lockhart and Enrique Otte, *Letters and people of the Spanish Indies. Sixteenth century*, Cambridge 1976, pp.15–17.
9. Ángela Pereda López, 'La mujer burgalesa en la América del siglo XVI', *XIII Coloquio*, p.1152.
10. Maria Angeles Gálvez Ruiz, 'Mujeres y "maridos ausentes" en Indias', *XIII Coloquio*, p.1166.
11. Otte 1998, pp.222, 162.
12. *Ibid.*, p.379.
13. *Ibid.*, p.303.
14. Pereda López, p.1156.
15. Enrique Otte, 'La mujer de Indias en el siglo XVI', *XIII Coloquio*, p.1495.
16. Otte, 'La mujer', p.1497.
17. Knaut, p.29.
18. Cited in Weber, p.49.
19. Wachtel, p.293. He suggests figures of between ten thousand and sixty thousand for the Indians.
20. Bannon, p.27.
21. Lyon, p.5.

22. Full details of the events of 1565 are in Lyon, pp.171–188.

23. *Ibid.*, p.xix.

24. Otte 1988, p.212.

25. Powell, p.158.

26. Bannon, p.36.

27. Knaut, p.42.

28. See Weber, p.86.

29. Bannon, p.39.

30. Bolton, pp.234–238.

31. Knaut, p.196.

32. *Cambridge History*, I, i, 359.

33. Ovando, president of the committee that prepared the law, had the Las Casas manuscripts brought to Madrid for study: Lewis Hanke, *Aristotle and the American Indians*, London 1959, pp.86–7.

34. Miguel Angel de Bunes Ibarra, 'Felipe II y el Mediterráneo: la frontera olvidada y la frontera presente', in *Felipe II (1527–1598): Europa y la Monarquía Católica*, 4 vols, Madrid 1998, I, i, 100–102.

35. For the concept of the mission on the frontier, the seminal study is that of Herbert Bolton, 'The mission as a frontier institution in the Spanish American colonies', *AHR*, xxiii, 1917–18. There are excellent comments on the Spanish situation in Weber, pp.11–13.

36. Jara, pp.94, 99.

37. *Ibid.*, pp.124–5.

38. Cited by J. Israel, 'Spanish imperial strategy in northern New Spain', *El Hispanismo anglonorteamericano*, 2 vols, Córdoba 2001, I, 522.

39. Powell, p.169.

40. Lane, p.18.

41. Otte 1988, p.581.

42. Milhou 1976, p.14.

43. Hoffman, Paul E., *The Spanish crown and the defense of the Caribbean, 1535–1585*, Baton Rouge 1980, p.12.

44. For its activity, see Hoffman, *Defense*, pp.130, 134, 187.

45. Andrews 1984, p.129.

46. R. D. Hussey, 'Spanish reaction to foreign aggression in the Caribbean to about 1680', *HAHR*, 4, 1929, 286–302.

47. Goodman 1988, p.127.

48. Andrews 1984, p.283.

49. Andrews 1978, p.159.

50. Engel Sluiter, 'Dutch maritime power and the colonial status quo, 1585–1641', *PHR*, xi, 1942, p.32.

51. Peter Gerhard, *Pirates on the west coast of New Spain 1575–1742*, Glendale 1960, p.239.

52. Pérez-Mallaína and Torres Ramírez, p.218.

53. Bradley, p.19.

54. *Ibid.*, p.40.

55. Gerhard, *Pirates*, p.124; Bradley, pp.52–63.

56. Bradley, p.28.

57. In Lima the available civil defence in the late seventeenth century could count on three coloured residents to every Spaniard available: see Bradley, p.183.

58. Cited by A. Pérotin-Dumon, in Tracy, p.211.

59. Cf. *ibid.*, p.223.

60. Cf. Andrews 1978, p.79.

61. The Portuguese Crown had a similar privilege, the *padroado*.

62. Figures from Pedro Borges, *El envío de misioneros a América durante la época española*, Salamanca 1977.

63. Gerónimo de Mendieta, *Historia eclesiástica indiana*, Mexico 1997, pp.36–37.

64. Cf. Francisco Javier Alegre SJ, *Historia de la Provincia de la Compañia de Jesús de Nueva España*, vol. IV (1676–1766), Rome 1960.

65. Cutter and Engstrand, pp.144–164.

66. Phelan 1956, pp.60, 69.

67. Cf. Adriaan C. Van Oss, *Catholic colonialism. A parish history of Guatemala 1524–1821*, Cambridge 1986, pp.57–8.

68. Weber, p.95.

69. For the beginnings of the Counter Reformation in Spain, see Kamen 1993.

70. Bolton, p.309 n.2.

71. An excellent description in Spicer, pp.288–298.

72. *Ibid.*, p.324.

73. Quoted by Monique Mustapha, 'L'évangile par la force? Le clergé colonial vu par Acosta', in J.-P. Duviols and A. Molinié-Bertrand, *La violence en Espagne et en Amérique (XVe-XIXe siècles)*, Paris 1997, p.179.

74. Knaut, p.78.

75. Van Oss (cited above, n.67), pp.143–144.

76. I cite the translation in Weber, p.106.

77. Cf. Weber, pp.130–133.

78. Weber, p.105.

79. On strategies, see the excellent section in *ibid.*, pp.107–121.

80. Knaut, p.69.

81. Sauer, p.189.

82. Crosby, p.88.
83. Fisher, p.35.
84. Cited in Crosby, p.84.
85. Wachtel, pp.279, 226.
86. Laverne H. Clark, *They sang for horses. The impact of the horse on Navajo and Apache folklore*, Tucson 1966, p.29.
87. As explained brilliantly by Melville, p.6.
88. The phrase appears to have been originated by Alfred W. Crosby; see his *Ecological imperialism: the biological expansion of Europe, 900–1900*, New York 1986.
89. Reff, p.276.
90. Spicer, p.166.
91. Melville, p.47.
92. *Ibid.*, p.79.
93. Alvaro Huerga, 'La pre-Inquisición hispanoamericana', in J. Pérez Villa-nueva and B. Escandell Bonet, *Historia de la Inquisición en España y América*, vol.I, Madrid 1984, p.662.
94. *Ibid.*, p.679.
95. *Ibid.*, p.680.
96. Cf. Richard Greenleaf, *Zumarraga and the Mexican Inquisition*, Washington 1961.
97. When the clergy used Quechua, they used the term 'Dios' to refer to God, since there was no adequate Quechua equivalent; so that for the Indians 'Dios' was simply another god, the god of the Christians.
98. Millones, p.143.
99. Louis Baudin, *Daily life in Peru under the last Incas*, London 1961, p.148.
100. Rafael Varón, 'El Taki Onqoy: las raíces andinas de un fenómeno colonial', in Millones, pp.356–366. Varón defines *taki* as 'cantar histórico', for which I choose the English form ballad rather than chant or song.
101. Millones, pp.343, 345.
102. *Ibid.*, p.409.
103. Cf. Iris Gareis, 'Repression and cultural change: the extirpation of idolatry in colonial Peru', in Griffiths and Cervantes, p.237.
104. The fascinating material on these years is conveniently printed in Pierre Duviols, *Cultura andina y represión. Procesos y visitas de idolatrías y hechi-cerías: Cajatambo siglo XVII*, Cusco 1986.
105. Weber, p.114.
106. Magnus Mörner, *The political and economic activities of the Jesuits in the La Plata region*, Stockholm 1953, is the authoritative study.
107. Caraman, pp.27, 36.
108. *Ibid.*, p.121.

109. *Ibid.*, p.104.
110. Chevalier, p.249.
111. Bannon, pp.61–64.
112. Nicholas P. Cushner, *Lords of the land. Sugar, wine and Jesuit estates of coastal Peru, 1600–1767*, Albany 1980.
113. Cushner, *Lords of the land*, p.69.

Chapter 7: The Business of World Power

1. Quoted in Pagden 1990, p.50.
2. Quoted in MacLeod, p.56.
3. Or perhaps from Italy: see Carlos Serrano Bravo, 'Intercambio tecnológico en la amalgamación', in M. Castillo Martos, ed., *Minería y metalurgia. Intercambio tecnológico y cultural entre América y Europa*, Seville 1994, p.409.
4. Cross, p.405.
5. Otte 1988, p.526.
6. *Ibid.*, p.525.
7. Cf. the summary in Steve J. Stern, 'Feudalism, capitalism and the world system in the perspective of Latin America and the Caribbean', *AHR*, vol.93, no.4, Oct. 1988, p.850.
8. Cross, p.404.
9. Otte 1988, p.526.
10. *Ibid.*, p.474.
11. *Ibid.*, p.409.
12. Arco y Garay, p.328.
13. Cf. C. R. and W. D. Phillips, *Spain's Golden Fleece*, Baltimore 1997, pp.168–76.
14. See Michel Mollat, 'Le role international des marchands espagnols dans les ports de l'Europe occidental à l'époque des Rois Catholiques', *Congreso para la Historia de la Corona de Aragón*, Zaragoza 1952; also Constance J. Mathers, 'Merchants from Burgos in England and France, 1470–1570', reprinted in Douglas A. Irwin, *Trade in the pre-modern era, 1400–1700*, 2 vols, Cheltenham 1996, pp.67–97.
15. Pike, p.10.
16. Guillermo Lohmann Villena, *Les Espinosa. Une famille d'hommes d'affaires en Espagne et aux Indes à l'époque de la colonisation*, Paris 1968, pp.14–15.
17. Mercado, p.314.
18. *Ibid.*, p.315.
19. Bernal, p.142.

20. *Ibid.*, pp.154–155.

21. *Ibid.*, pp.162–165.

22. See Woodrow Borah, *Early colonial trade and navigation between Mexico and Peru*, Berkeley 1954.

23. Vila Vilar, p.294.

24. Boxer 1959, p.170.

25. Reid, p.26.

26. The silver/gold bimetallic ratio in New Spain around 1600 was 15:1, in China it was 8:1: Cross, p.399.

27. For a general survey see Om Prakash, 'Precious metal flows in Asia and world economic integration in the seventeenth century', in Wolfram Fischer *et al.*, eds, *The emergence of a world economy 1500–1914*, 2 vols, Wiesbaden 1986, vol.I.

28. Hernán Asdrúbal Silva, 'Marginalidad rioplatense y relaciones comerciales con el Brasil en épocas de Felipe II', *XIII Coloquio*, p.970.

29. Cf. Lapeyre, chap. IV, 'Les foires de Castille'.

30. Mercado, pp.414–15.

31. Report by the financier Simón Ruiz, in Lapeyre, p.485.

32. Ruiz Martín 1965, p.xxix.

33. Lewes Roberts, *The Merchants Mappe of Commerce*, London 1636, quoted in Haring 1918, p.178 n.1.

34. Felipe Ruiz Martín, 'Los hombres de negocios genoveses de España durante el siglo XVI', in Kellenbenz, p.85.

35. Ruiz Martín 1965, chap.III.

36. *Ibid.*, p.xxxvi–xxxvii.

37. *Ibid.*, pp.xxxvii–xxxviii, xl.

38. Phillips, *Golden Fleece*, p.180.

39. Ruiz Martín 1965, p.xl.

40. Lapeyre, p.118.

41. Professional scholars will recognize that this is my principal difference with the excellent Marxist analyses of André Gunder Frank and Emmanuel Wallerstein, both of whom accept unquestioningly the primacy of Spanish capitalism in the colonial period.

42. Ruiz Martín 1965, p.xlix.

43. Enriqueta Vila Vilar, 'La liquidación de un imperio mercantil a fines del s.XVI', *XIII Coloquio*, p.987. Also, by the same, 'Descendencia y vinculaciones sevillanas de un procer italiano: Juan Antonio Corzo Vicentelo', in *Presencia italiana en Andalucia, siglos XIV–XVII*, Seville 1989, pp.411–426. There is a fuller study in her *Los Corzo y los Mañara: tipos y arquetipos del mercader con América*, Seville 1991.

44. Vila Vilar, 'Descendencia y vinculaciones', p.423.

45. Estimates of Boyajian 1993, p.42.

46. Cf. Pike, p.144.

47. Calabria, pp.5, 19.

48. Cf. Nicolas Broens, *Monarquía y capital mercantil: Felipe IV y las redes comerciales portugueses (1627–1635)*, Madrid 1989, p.30.

49. Eddy Stols, *De Spaanse Brabanders of de Handelsbetrekkingen der Zuidelijke Nederlanden met de Iberische Wereld 1598–1648*, 2 vols, Brussels 1971, I, 98–113; II, 1–73.

50. Hermann Kellenbenz, 'Mercaderes extranjeros en América del Sur a comienzos del siglo XVII', *AEA*, XXVIII, 1971, p.395.

51. Vila Vilar, 1982, p.300.

52. Quoted in Kirk, p.413. The quotation is of the year 1623.

53. For what follows, see Kamen 1997, pp.158–168, and references given there.

54. According to Brantôme, I, 133, 'some said that he picked up the pox from the Marquise d'Avré', but others thought he had been poisoned by Antonio Pérez. Neither of these allegations is true.

55. Essen 1933, II, 188.

56. *Ibid.*, II, 256.

57. *Ibid.*, II, 299; III, 21.

58. *Ibid.*, IV, 134.

59. Fernando Bouza, *Portugal en la monarquía hispánica (1580–1640)*, Madrid 1987, 2 vols, I, 65–95.

60. Ruiz Martín 1965, pp.lvii–lviii.

61. Moura to king, Feb. 7, 1579, *CODOIN*, VI, 110.

62. Philip to Osuna and Moura, Apr 14, 1579, *CODOIN*, VI, 350.

63. Cf. Bouza, I, 209–280.

64. *CODOIN*, VII, 295.

65. Muster of April 1580, *CODOIN*, XXXII, 27–9. Alba disliked Italian soldiers. 'Italians, for the love of God', he wrote, 'Your Majesty must not bring any more, it's money wasted; but as for Germans, bring another five thousand': *ibid.* p.15.

66. The occupation of Naples under Philip V took place with the support of the population.

67. What follows is adapted from Kamen 1997, pp.242–3.

68. Juan Rufo.

69. Otte 1988, p.11: 'in 1580 the Spanish colonization of America began its maturity'.

70. Arco y Garay, p.226.

71. This is the central argument of the fascinating study by Parker 1998; see e.g. p.166 where he writes of the Portugal campaign as 'a vital step on Spain's road to global mastery'. My own dissenting view is that not a single phrase can be cited from any Spanish politician or general in favour of global mastery.

72. E.g. by Braudel, who felt that religious zeal in the 1580s 'turned the Spanish king into the champion of Catholicism': Braudel, II, 677.

73. Cited in E. García Hernán, *La Armada española en la monarquía de Felipe II y la defensa del Mediterráneo*, Madrid 1995, p.19.

74. Merriman, IV, 381.

75. P. T. Rooney, 'Habsburg fiscal policies in Portugal 1580–1640', *JEEH*, vol.23, no.3, winter 1994, p.546.

76. Philip to Alba, Badajoz, Aug 31, 1580, *CODOIN*, XXXII, 507.

77. Kamen 1997, p.264.

78. The ships are listed in Colin Martin and Geoffrey Parker, *The Spanish Armada*, London 1988, pp.34–35.

79. The best survey of the preparation for the Armada is by Thompson 1992, chapters VIII and IX.

80. Carlos Selvagem, *Portugal militar*, Lisbon 1931, p.356, puts the Portuguese total at over five thousand soldiers and one thousand sailors.

81. Thompson 1992, chap.VIII p.12.

82. Cited in *ibid.*, chap.VIII, p.17.

83. Andrews 1984, p.238.

84. *Ibid.*, p.246.

85. Andrews 1978, p.162.

86. *Ibid.*, p.168.

87. *Ibid.*, p.187.

88. Kamen 1997, p.283.

89. Otte 1998, pp.442, 444.

90. Cf. Kamen 1997, pp.233, 295.

91. Henry Kamen, 'Toleration and dissent in sixteenth-century Spain', *SCJ*, no.19, Spring 1988, p.22.

92. The best survey of his career is by Rodríguez Villa, but there is a vast amount of unpublished documentation out of which a new and comprehensive life could be written.

93. Rodríguez Villa, p.39.

94. Cf. Stradling 1992, p.13.

95. Cf. Paul C. Allen, *Philip III and the pax hispanica 1598–1621*, New Haven, CT and London, p.139.

96. Rodríguez Villa, p.71.

97. *Ibid.*, p.663.

98. Israel 1997, pp.33–4.

99. Rodríguez Villa, p.414.

100. Quoted in Parker 1984, p.49.

101. Polišenský 1971, p.124.

102. Polišenský 1978, pp.79–84.

103. Quoted in Parker 1984, p.55.

104. Polišenský 1971, p.125.

105. Rodríguez Villa, p.354.

106. *Ibid.*, p.387.

107. *Ibid.*, p.385.

108. Rubens, p.102.

109. It is exceptional to find a recent Spanish art critic admit that 'the truth is that Spinola was Genoese and the greater part of the officers and men he commanded at the taking of Breda was foreign', Francisco Calvo Serraller, in the collective work *Velázquez*, Barcelona 1999, p.136.

110. Schwartz 1991, pp.740–745.

111. Reported by Rubens, p.124.

112. I follow in part the English version given in Lynch, p.103.

113. Rubens, p.207.

114. *Ibid.*, pp.179, 206.

115. *Ibid.*, pp.118–119.

116. Stradling 1992, p.59.

117. *Ibid.*, p.255.

118. Memorandum of 1628, cited Stradling 1992, p.63.

119. Rodríguez Villa, p.480.

120. Cited in Rodao, p.43.

121. Israel 1982, p.117.

122. *Ibid.*, p.122. I have re-phrased the quotation.

123. *Ibid.*, 1982, p.121.

124. Rubens, p.295.

Chapter 8: Identities and the Civilizing Mission

1. Avila y Zúñiga, p.66v.

2. Chapter 3, above.

3. Sepúlveda, II, 95.

4. Cited in Puddu, p.63.

5. Cited in Quatrefages, p.282.

6. *Crónicas del Gran Capitán*, p.375.

7. Herrera, pp.6, 265.

8. Sandoval, I, 20.

9. Pike, p.195.

10. Isaba, pp.66–67.

11. Aedo y Gallart, pp.130, 195.

12. Maravall, I, 464, 475.

13. Cited by Antonio Mestre, 'La historiografía española del siglo XVIII', *Coloquio Internacional Carlos III y su siglo. Actas, tomo I*, Madrid 1990, p. 39.

14. Cf. Kamen 1993, pp.354–357.

15. Cited in Kamen 1993, p.355.

16. Cf the diagram of Castilian books published abroad, in Kamen 1993, p.404.

17. Henry Thomas, 'The output of Spanish books in the sixteenth century', *The Library*, 1, 1920, p.30.

18. Jaime Moll, 'Problemas bibliográficas del libro del Siglo de Oro', *BRAE*, 59, 1979; also his 'Valoración de la industria editorial española del siglo XVI', in *Livre et lecture en Espagne et en France sous l'Ancien Régime*, Paris 1981.

19. Dr Diego Cisteller, cited in Kamen 1993, p.365.

20. Otero Lana, p.109.

21. My wife remembers how her grandmother, in the days when television first arrived in Catalonia, used to watch the screen happily for hours even though she did not understand a word of the language (Castilian) being spoken.

22. Ambassador Khevenhüller, cited in Friedrich Edelmayer, 'Aspectos del trabajo de los embajadores de la casa de Austria en la segunda mitad del siglo XVI', *Pedralbes* (Barcelona), no.9, 1989, p.47.

23. Arturo Farinelli, *Die Beziehungen zwischen Spanien und Deutschland in der Litteratur der beiden Länder*, Berlin 1892, p.27.

24. Cf. Dale B. J. Randall, *The Golden Tapestry. A critical survey of non-chivalric Spanish fiction in English translation (1543–1657)*, Durham, NC, 1963.

25. Lechner, p.10.

26. Jan Lechner, *Repertorio de obras de autores españoles en bibliotecas holandesas hasta comienzos del siglo XVIII*, Utrecht 2001, p.309. I am grateful to Dr Lechner for making this very useful work available to me.

27. Carlos Gilly, *Spanien und der Basler Buchdruck bis 1600*, Basel 1985, pp.155–273.

28. Franco Meregalli, *Presenza della letteratura spagnola in Italia*, Florence 1974, p.17.

29. A. Núñez de Castro, *Sólo Madrid es Corte*, Madrid 1658.

30. Jean Muret, *Lettres écrites de Madrid en 1666 et 1667*, Paris 1879, p.75.

31. Jonathan Brown, 'La antigua monarquía española como área cultural', in *Los Siglos*, p.22.

32. For a fuller discussion see Kamen 1997, chap.7.

33. Some 200 paintings bought by Spanish agents from England were the subject of the exhibition on 'The Sale of the Century: Artistic Relations between Spain and Great Britain 1604–1655', held in the Prado in 2002.

34. For a survey of the problem of censorship and the Inquisition, see Kamen 1998, chap.6.

35. Kamen 1993, p.411.

36. Green, IV, 59.

37. Castro, p.583.

38. Beatriz Alonso Acero, 'Judíos y musulmanes en la España de Felipe II: los presidios norteafricanos, paradigma de la sociedad de frontera', in *Felipe II (1527–1598): Europa y la Monarquía Católica*, 4 vols, Madrid 1998, II, 22.

39. Daniel M. Swetschinski, *Reluctant cosmopolitans: the Portuguese Jews of seventeenth-century Amsterdam*, Littman Library, 2000.

40. Schwartz 1991, p.753.

41. Jonathan Israel, *Empires and entrepots. The Dutch, the Spanish monarchy and the Jews 1585–1713*, London 1990, p.356.

42. Cited in Schurz 1956, p.348.

43. Israel 1997, p.xxi.

44. Friede, p.47.

45. Schurz 1956, p.203.

46. *Ibid.*, p.204.

47. Israel 1975, p.76.

48. L. F. Thomaz, in Tracy, p.305.

49. Serge Gruzinski, *Images at war*, Durham, NC 2001, p.112.

50. Quoted in Jara, p.95.

51. Kamen 1997, p.241.

52. Ida Altman, *Transatlantic ties in the Spanish empire*, Stanford 2000, p.185.

53. Macías and Morales Padrón, p.65.

54. Israel 1975, p.112.

55. *Ibid.*, p.115.

56. Otte 1988, p.526.

57. *Ibid.*, p.435.

58. Macías and Morales Padrón, p.87.

59. Otte 1988, p.384.

60. *Ibid.*, p.307.

61. *Ibid.*, p.124.

62. Macías and Morales Padrón, p.187.

63. Chronicle of Mariño de Lovera, cited in Jara, p.92.

64. Israel 1975, p.136.

65. *Ibid.*, p.115.

66. Pagden, 'Identity formation in Spanish America', in Canny and Pagden, pp.67–8.

67. There is an excellent summary of these and other writers in Brading, part 2, 'Strangers in their own land'.

68. Otte 1998, p.470.

69. Jacques Lafaye, *Quetzalcoatl et Guadalupe. La formation de la conscience nationale au Méxique (1531–1813)*, Paris 1974, p.281.

70. Maravall, I, 472, 478.

71. Tamar Herzog, 'Private organizations as global networks in early modern Spain and Spanish America', in L. Roniger and T. Herzog, *The collective and the public in Latin America. Cultural identities and political order*, Brighton 2000, p.121.

72. John L. Kessell, ed., *Remote beyond compare. Letters of don Diego de Vargas to his family from New Spain and New Mexico, 1675–1706*, Albuquerque 1989, p.333.

73. *Ibid.*, pp.333, 353.

74. *Ibid.*, p.446.

75. Olivia Harris, 'Ethnic identity and market relations: Indians and mestizos in the Andes', in Larson and Harris, p.358.

76. Rosenblat, II, 30.

77. *Ibid.*, 19.

78. Otte 1988, p.61.

79. Schwartz and Salomon, 'New people and new kinds of people', in *Cambridge History*, III, 2, p.485.

80. Thornton, pp.129–30.

81. See above, chap.3.

82. Benzoni, cited Thornton, p.202.

83. Cf. Thornton, pp.213–17.

84. Carlos Guillot, *Negros rebeldes y negros cimarrones*, Buenos Aires 1961, p.42.

85. See Thornton, pp.288–90.

86. Palmer 1976, p.133.

87. Guillot, pp.126–7.

88. David Davidson, 'Negro slave control and resistance in colonial Mexico, 1519–1650', *HAHR*, 46, 1966.

89. Miguel Acosta Saignes, *Vida de los esclavos negros en Venezuela*, Caracas 1967, pp.259–261.

90. On the transition from African to Christian religion, see Thornton, chap.9.

91. Palmer 1976, p.164.

92. Cited in Thornton, p.267.

93. Cf the discussion in Palmer 1976, pp.172–184; also the article by Frederick Bowser in Stanley L. Engerman and Eugene D. Genovese, eds, *Race and slavery in the western hemisphere*, Stanford 1975.

94. Gage, p.197.

95. Cf. the comments of Palmer 1976, p.178.

96. Chevalier, p.113.

97. Juan and Ulloa, I, 134, 133, 101.

98. Juan and Ulloa, I, 164.

99. Wachtel, p.224.

100. Erwin P. Grieshaber, 'Hacienda-Indian community relations and Indian acculturation', in Foster, I, 82–83.

101. Lockhart 1992, p.115.

102. *Ibid.*, pp.443–444.

103. Spicer, pp.189–191.

104. Grahn, pp.38–41.

105. Scott, pp.2, 10.

106. I borrow the definition by Jonathan Hill in Hill, pp.1–2.

107. Gary C. Anderson, *The Indian southwest, 1580–1830. Ethnogenesis and reinvention*, Norman, OK, 1999, p.34.

108. Nancy P. Hickerson, 'Ethnogenesis in the south plains', in Hill, p.74.

109. Larson and Harris, p.27.

110. *Ibid.*, p.25.

111. Steve J. Stern, 'The variety and ambiguity of native Andean intervention in European colonial markets', in Larson and Harris, p.77.

112. Inga Clendinnen, 'Landscape and world view: the survival of Yucatec Maya culture under Spanish conquest', in Foster, p.445.

113. Rafael Varon, 'El Taki Onqoy: las raíces andinas de un fenómeno colonial', in Millones, pp.339–40.

114. Millones, p.178.

115. López-Baralt, p.302.

116. The literature for each of the countries named is substantial, but marginal to the present book.

117. Léon van der Essen and G. J. Hoogewerff, *Le sentiment national dans les Pays-Bas*, Brussels 1944, p.38.

118. *Ibid.*, p.81.

119. *Ibid.*, p.45.

120. Kamen 1997, pp.309, 318; Rodríguez Villa, p.570.

121. Kamen 1997, p.241.

122. The classic study for the sixteenth century is Sverker Arnoldsson; for some aspects of the later period see Hillgarth, chap.7.

123. Numerous cases detailed in García Cerezeda, *passim.*

124. Sepúlveda, II, 96.

125. Rubens, p.258.

126. Tocco, pp.32–34, 68.

127. *Ibid.*, pp.9–10.

128. *Ibid.*, pp.34–40.

129. *Ibid.*, pp.17, 25.

130. The best survey of the Cruz affair is Alvaro Huerga, whose exposition I follow.

131. The effective rediscovery of Cruz was made by Marcel Bataillon in his *Erasme et l'Espagne*, Paris 1937.

132. My outline follows some of the points in Huerga, pp.272–295.

133. Quoted in *ibid.*, p.292.

134. Martín González de Cellorigo, *Memorial de la política necesaria y útil restauración a la república de España*, Valladolid 1600, p.15.

135. Sancho de Moncada, *Restauración politica de España*, Madrid 1619, p.22.

136. The immense literature on Las Casas can be conveniently approached through the writings of Lewis Hanke.

137. Phelan 1956, p.82.

138. J. Gayo Aragon, OP, 'The controversy over justification of Spanish rule in the Philippines', in Gerald H. Anderson, ed., *Studies in Philippine Church history*, Ithaca 1969, pp.18–19.

139. Quoted in Parker 1998, p.284.

140. Iñigo Ibáñez de Santa Cruz, 'El ignorante y confuso gobierno', BL Cott. Vespasian C.XIII, ff.375–87. Another version in BL Eg.329 f.16 onwards.

141. 'Discurso al Rey nuestro Señor del estado que tienen sus reynos'; the text has recently been published (Madrid 1990).

142. Sepúlveda, III, 65.

143. Maravall, I, 501.

144. Sáinz Rodríguez, p.82.

145. Cited in Kamen 1969, p.392.

146. For what follows, see Pagden 1982, chap.7.

147. Pagden 1982, p.162.

148. Olwer, p.121. This is a translation of a work published in Spanish in Mexico in 1952.

149. Gage, p.234.

150. Nicholas Griffiths, *The cross and the serpent. Religious repression and resurgence in colonial Peru*, Norman, OK 1996, p.263.

151. Lance Grahn, ' "Chicha in the chalice": spiritual conflict in Spanish American mission culture', in Griffiths and Cervantes, p.261.

152. Cutter and Engstrand, pp.122–132. The standard study is Herbert E. Bolton, *Ruin of Christendom. A biography of Eusebio Francisco Kino*, Tucson 1984 (repr. of 1936 edn).

153. Quoted in Spicer, p.310.

154. Grahn, ' "Chicha in the chalice" ', p.268.

Chapter 9: Shoring up the Empire (1630–1700)

1. Cited in J. M. Jover, *1635. Historia de una polémica y semblanza de una generación*, Madrid 1949, p.401 n. 26.

2. Galasso, p.325.

3. There is a brilliant summary of the importance of the Milanese financiers by Giuseppe De Luca, 'Hombres de negocios milaneses al servicio de la Monarquía Hispánica', *Torre de Lujanes*, 46 (2002), pp.117–131.

4. Rubens, p.260, in a letter of 1628.

5. Tocco, pp.99, 103, 124.

6. A comment of 1628, in Rubens, p.258.

7. Cited in Stradling 1994, p.101.

8. Rubens, p.142.

9. Stradling 1994, p.275.

10. Rodríguez Villa, p.593.

11. Rubens, p.368.

12. Essen 1944, pp.23–24; Henri Pirenne, *Histoire de Belgique*, 3rd edn, Brussels 1927, vol.IV, pp.260–266.

13. Stradling 1994, p.107.

14. Essen 1944, p.112.

15. *Ibid.*, p.185.

16. Aedo y Gallart, pp.87, 98. The cavalry was Italian and Flemish; Germans and Italians made up 80 per cent of the infantry. The army was augmented, before Nördlingen, by detachments of Belgian infantry and cavalry from Brussels: Essen 1944, p.414.

17. The most accessible summary of the battle in English is in C. V. Wedgwood, *The Thirty Years' War*, Harmondsworth 1957, pp.327–335.

18. The image of the victory as a Spanish one is transmitted in many Spanish historical works, where the crucial role of the Imperial troops is ignored, and the fact that 90 per cent of the army was non-Spanish is not mentioned.

19. Aedo y Gallart, p.128.

20. Quoted in Parker 1984, p.141.

21. Georges Pagès, *La Guerre de Trente Ans*, Paris 1949, p.181.

22. Written at Brussels, Feb. 1626: Rubens, p.130.

23. Stradling 1994, pp.109–117.

24. *Ibid.*, p.118.

25. Matías de Novoa, cited in Arco y Garay, p.546.

26. Cited in J. M. Jover (cited above, n.1), p.408 n.51.

27. 'Hermetism' was in Late Renaissance times an occult philosophy that claimed to find knowledge in pre-Christian sources.

28. The Inquisition in Naples was an autonomous section of the Italian body of that name, and not connected with the Spanish Inquisition.

29. Headley, p.52.

30. Quoted in Pagden 1990, p.51.

31. Headley, p.214.

32. Pagden 1990, p.44.

33. J. L. Palos, *Catalunya a l'Imperi dels Àustria*, Lleida 1994, pp.105–109.

34. Rodríguez Villa, pp.700–704.

35. Vargas Machuca, I, 61.

36. Report by bishop of Solsona, 15 Oct 1694, printed in Antonio Valladares de Sotomayor, *Semanario Erudito*, 34 vols, Madrid 1788, vol.30, p.267.

37. Ruth Mackay, *The limits of royal authority*, Cambridge 1999, p.69.

38. Rodríguez Villa, p.42.

39. Essen 1944, p.121.

40. Goodman 1997, pp.202–205.

41. *Ibid.*, p.207.

42. *Ibid.*, p.208.

43. Quoted in Thompson 1992, chap.IV pp.9–11.

44. Boxer 1967, pp.375–382.

45. John R. Shepherd, *Statecraft and political economy on the Taiwan frontier 1600–1800*, Stanford 1993, p.56.

46. *Ibid.*, p.58.

47. I agree with the view of Israel, in Israel 1997, chap.4, that Spain did not intend to substitute the offensive against the Dutch for one against France.

48. M. A. Echevarría, *Flandes y la monarquía hispánica 1500–1713*, Madrid 1998, p.312.

49. Alcalá Zamora, p.399.

50. These figures come from *ibid.*, pp.429–33.

51. Israel 1982, p.268.

52. My estimates follow Stradling 1992, p.107.

53. Alcalá Zamora, p.459.

54. *Ibid.*, p.458.

55. This and other quotations in these pages are taken from my chapter, 'La política exterior', in vol.VIII of the *Historia general de España y América: La crisis de la hegemonía española, siglo XVII*, Ediciones Rialp, Madrid 1986.

56. Ricardo del Arco y Garay, *La erudición española en el siglo XVII y el cronista de Aragón Andrés de Uztarroz*, 2 vols, Madrid 1950, I, 259.

57. Quoted in Schwartz 1991, p.749.

58. Cf. the excellent discussion in Boyajian 1993, pp.167–72.

59. Israel 1982, p.277.

60. Hernán Asdrúbal Silva, 'Marginalidad rioplatense', p.968.

61. Boyajian 1993, p.21.

62. *Ibid.*, p.33.

63. *Ibid.*, p.13.

64. Elkan Adler, 'Documents sur les Marranes d'Espagne et de Portugal sous Philippe IV', *REJ*, 49, 1904.

65. Cited in S. Subrahmanyam and Luís Thomaz, 'The Portuguese in the Indian Ocean', in Tracy, p.305.

66. Boyajian 1983, chap.3.

67. *Ibid.*, p.44.

68. *Ibid.*, pp.121–5.

69. Quoted in Boyajian 1983, p.139.

70. Tocco, p.263.

71. G. Signorotto, 'Il Marchese di Caracena al governo di Milano', in *Cheiron*, 17–18, 1992, p.149.

72. *Ibid.*, pp.164–66.

73. My account of the battle of Rocroi is based on the *Mercure françois* for that week, as given in Geoffrey Symcox, *War, diplomacy and imperialism, 1618–1763*, New York 1974, p.135.

74. From a letter of Melo to the king in 1643, quoted by Geoffrey Parker in Thomas and Verdonk, p.283.

75. Stradling 1994, p.288.

76. Domínguez Ortiz, p.74.

77. Goodman 1997, p.29.

78. This book was completed when I learnt of the publication of the fine thesis by Manuel Herrero Sánchez, *El acercamiento hispano-neerlandés (1648–1678)*, Madrid 2000. His study covers in detail the diplomatic side of the argument presented here.

79. Barbour, pp.32–33, 35

80. The theme has been little studied; but see J. C. M. Boeijen, 'Een bijzondere Vijand. Spaanse kroniekschrijvers van de Tachtigjarige Oorlog', in *Tussen twee culturen. De Nederlanden en de Iberische wereld 1550–1800*, Nijmegen 1991.

81. Israel 1997, p.209. Herrero Sánchez, p.53 n.58 states the number as eight.

82. Herrero Sánchez, p.63.

83. Quoted by *ibid.*, p.82.

84. Israel 1982, pp.418–427.

85. Barbour, p.110.

86. *Ibid.*, p.101.

87. Quoted in R. A. Stradling, *Europe and the decline of Spain*, London 1981, p.161.

88. Herrero Sánchez, p.195.

89. *Ibid.*, p.158.

90. The best study, based principally on French sources, is by Emile Laloy, *La révolte de Messine, l'expédition de Sicile et la politique française en Italie (1674–1678)*, 3 vols, Paris 1929–1931.

91. David Salinas, *La diplomacia española en las relaciones con Holanda durante el reinado de Carlos II (1665–1700)*, Madrid 1989, p.54.

92. Goodman 1997, p.6.

93. *Ibid.*, pp.114–124.

94. Otero Lana, p.267. I have excluded small vessels (pataches) from these figures.

95. Alcalá Zamora, p.52.

96. Goodman 1997, p.134.

97. B. Torres Ramírez, *La Armada de Barlovento*, Seville 1981, p.75.

98. Alcalá Zamora, pp.68–9.

99. Pérez-Mallaína and Torres Ramírez, p.215.

100. Otero Lana, pp.259–260.

101. *Ibid.*, p.56. The author distinguishes between categories of 'armed ships' and 'corsairs'; I have added both together.

102. Otero Lana, p.225.

103. Details in Kamen 1980, p.381.

104. Richard J. Shell, 'The Marianas population decline: seventeenth-century estimates', *The Journal of Pacific History*, 34 (3), 1999, p.304.

105. Robert F. Rogers, *Destiny's Landfall. A History of Guam*, Honolulu 1995, p.72.

106. Schurz 1939, p.49.

107. Francisco Mallari SJ, 'Muslim raids in Bicol 1580–1792', *PS*, 34, 1986, p.264.

108. Parker 1988, p.112.

109. Schurz 1939, p.321.

110. Furber, pp.271–2.

111. Pierre Chaunu, *Les Philippines et le Pacifique des Ibériques*, Paris 1960, p.255.

112. My italics; in Bolton, p.308.

113. Spicer, pp.159–160.

114. Cf. Henry W. Bowden, *American Indians and Christian missions. Studies in cultural conflict*, Chicago 1981, p.55. There is an excellent summary of the revolt in Cutter & Engstrand, pp.91–117.

115. Bolton, pp.338–339.

116. Bannon, p.86.

117. Murdo J. MacLeod, 'Dominican explanations for revolts and their suppression in colonial Chiapas 1545–1715', in Susan E. Ramírez, ed., *Indian-Religious relations in colonial Spanish America*, Syracuse 1989, p.46.

118. Weber, p.143.
119. Quoted in Verner W. Crane, *The southern frontier 1670–1732*, Westport 1956, p.81.
120. Weddle, p.82.
121. *Ibid.*, p.83.
122. Letter of Fray Damián Massanet to Carlos de Sigüenza, in Bolton, p.369.
123. Quoted in Ellis, p.107.
124. Lane, pp.114–125.
125. Ward, p.173.
126. Bradley, p.105.
127. Pérez-Mallaína and Torres Ramírez, pp.295–299.
128. Bradley, pp.129–156.
129. Quoted in Bradley, p.160.
130. Bradley, p.163.
131. Postma, p.14.
132. Quoted in Donnan, I, 348.
133. Donnan, I, 108.
134. Postma, p.55.
135. Palmer 1981, p.98.
136. Pauline Croft, *The Spanish Company*, London 1973, p.xxiii.
137. Croft, p.xlix.
138. Donnan, I, 110.
139. Donnan, I, 116.
140. Padfield II, p.180.
141. Cited Attman 1983, p.32.
142. Barbour, p.50.
143. Attman 1983, p.33.
144. Barbour, p.51.
145. Parker 1979, p.188.
146. The phrase is by Attman 1983, p.33.
147. Cf. Stradling 1992, p.18: 'The hegemonic empire had arrived at the bizarre situation of dependence for consumer materials on its main adversary.'
148. Quoted in Herrero Sánchez, p.364.
149. All details in the following section, come from Kamen 1980.
150. New figures for bullion imports were given in *ibid.*, pp.131–140; and in Michel Morineau, *Incroyables gazettes et trésors merveilleux*, London 1985.
151. Francisco Martínez de Mata, *Memoriales*, ed. Gonzalo Anés, Madrid 1971, pp.149–150.

Chapter 10: Under New Management

1. Kamen 1969, p.133.
2. The *Histoire militaire de la France: vol.I: des origines à 1715*, ed. Philippe Contamine, Paris 1992, p.389, estimates the total military manpower of France in the 1690s at 600,000.
3. Cited in Kamen 1969, p.26.
4. A. Morel-Fatio and H. Léonardon, eds, *Recueil des Instructions données aux ambassadeurs*, vol.12, *Espagne*, Paris 1898, p.8.
5. The following paragraphs draw on material in my *Philip V of Spain. The king who reigned twice*, New Haven, CT and London 2001.
6. Details in Kamen 1969, chap.4.
7. For the battle, Arthur Parnell, *The War of the Succession in Spain during the reign of Queen Anne 1702–1711*, London 1905, pp.210–222.
8. The figures cited here are based on the careful study by Parnell, chap.XXIV. There are numerous other estimates, made by officers who were present, that offer much higher figures.
9. J. W. Stoye, in *The New Cambridge Modern History*, vol.VI, Cambridge 1970, p.597.
10. Cited in Parnell, p.257.
11. Quoted in Bernal, p.315.
12. Attman 1983, p.30.
13. Ct. the discussion in Attman 1986, pp.30–33.
14. Quoted in Bernal, p.299.
15. See figures in Kamen, *Philip V*, pp.241–242.
16. Cristina Borreguero, 'Extranjeros al servicio del ejército español del siglo XVIII', in *Coloquio Internacional Carlos III y su siglo. Actas*, 2 vols, Madrid 1990, II, 78–79.
17. AGS Guerra Moderna leg.2362, 'Gastos generales de los ejércitos'.
18. Cited in Lynch, p.125.
19. For example, the contracts cited by Joan Mercader, *Felip V i Catalunya*, Barcelona 1968, pp.217–32. Cf. Geoffrey J. Walker, *Spanish politics and imperial trade 1700–1789*, London 1979, p.96.
20. Cf. M. A. Alonso Aguilera, *La conquista y el dominio español de Sardinia (1717–1720)*, Valladolid 1977, pp.49–56.
21. Cited by D. Ozanam, in *Historia de España Menéndez Pidal*, Madrid 2000, vol.XXIX, i, 589.
22. Padfield II, p.184. Micaela Mata, *Menorca Británica, vol.I. 1712–1727*, Mahon 1994, p.138.
23. A. Meijide Pardo, *La invasión inglesa de Galicia en 1719*, Santiago 1970.

24. 'Il est de l'intérêt des Espagnols de la [Ceuta] bien défendre, car sans elle le prétexte de la Bulle de la Croissade cesserait et avec elle le profit immense qu'elle rapporte au Roi' [It is in the interest of Spaniards to defend Ceuta, for without it they would not have the excuse to raise the Crusade tax, an immense source of profit to the King]: *Voyage du Père Labat en Espagne 1705–6*, Paris 1927, p.232.

25. Cited in Arco y Garay, p.646.

26. Stein and Stein, p.149.

27. There is no surviving original manuscript of the work, which was written around 1740. It has been attributed to Campillo, and as such discussed in Pagden 1995, pp.120–21. It has also quite plausibly been attributed to Melchor de Macanaz, and under that authorship has been analysed by Stein and Stein, pp.221–226.

28. Cited by C. Mozzarelli, 'Patrizi e governatore nello stato di Milano', in *Cheiron*, 17–18, 1992, p.130.

29. Franco Venturi, 'L'Italia fuori d'Italia', *Storia d'Italia, III: Dal primo Settecento all'Unità*, Turin 1973, p.1019.

30. Pagden 1990, p.68.

31. *Ibid.*, p.86.

32. Arauz, p.138.

33. Schurz 1939, p.329.

34. Cf. Pérez-Mallaína and Torres Ramírez, p.230.

35. Kamen 1969, pp.146, 152.

36. Quoted in Pérez-Mallaína and Torres Ramírez, p.232.

37. E. W. Dahlgren, *Les relations commerciales et maritimes entre la France et les côtes de l'Océan Pacifique*, Paris 1909, p.633.

38. Weber, p.155.

39. Bannon, p.114.

40. A point made by Weber, p.163.

41. Quoted in Bannon, p.122.

42. Weber, p.174.

43. Weddle, p.302.

44. Cited in Weber, p.179.

45. According to an eyewitness, prisoners were bound helpless and then set alight to burn to death.

46. David Hurst Thomas, ed., *Ethnology of the Indians of Spanish Florida*, New York 1991, p.123.

47. Jerald T. Milanich, *Florida Indians and the Invasion from Europe*, Gainesville 1995, p.230.

48. Weber, p.186.

49. Jones, pp.65–98.

50. Crosby, p.104.

51. Cited in Weber, p.182.

52. Jones, p.8.

53. It is worth noting that Ortelius had already, one hundred years before, in his 1589 map of the Pacific shown Baja California as a peninsula.

54. Relation of Father Kino, in Bolton, p.450.

55. Bannon, p.150.

56. Cook, p.46.

57. For foreign merchants active in Spain, see Wilhelm von den Driesch, *Die ausländischen Kaufleute während des 18. Jahrhunderts in Spanien und ihre Beteiligung am Kolonialhandel*, Cologne 1972.

58. Palmer 1981, pp.87–88.

59. Cited in Lynch, p.150.

60. Hector R. Feliciano, *El contrabando inglés en el Caribe y el Golfo de México (1748-1778)*, Seville 1990, pp.238–240.

61. Arauz, I, 149.

62. Grahn, p.27.

63. *Ibid.*, p.96.

64. *Ibid.*, p.122.

65. Enriqueta Vila Vilar, p.311.

66. Arauz, I, 46–66.

67. *Ibid.*, 260.

68. Arauz, II, 55–69.

69. Arauz, I, 286.

70. Quoted in Padfield II, p.195.

71. Christopher J. French, 'London's overseas trade with Europe 1700–1775', *JEEH*, 23, iii, Winter 1994, p.492.

72. J. C. M. Ogelsby, 'Spain's Havana squadron and the preservation of the balance of power in the Caribbean, 1740–1748', *HAHR*, 69:3, 1969, p.479.

73. Schurz 1939, p.337.

74. The following draws heavily on Goodman 1972, chap.XI.

75. Lafuente and Mazuecos, p.195.

76. *Ibid.*, p.98.

77. *Ibid.*, p.68.

78. *Ibid.*, pp.221–222.

79. See the informative chapter on 'La gloria nacional', in *ibid.*, pp.195–235.

80. Cf. Karel Davids, 'Openness or secrecy? Industrial espionage in the Dutch Republic', *JEEH*, 24, ii, Fall 1995.

81. M. A. Echevarría, *La diplomacia secreta en Flandes 1598-1643*, Leioa 1984; cf. Stradling 1992, p.21 n.13.

82. José P. Merino Navarro, *La Armada española en el siglo XVIII*, Madrid 1981, pp.49–53, 68–71.

83. *Ibid.*, pp.100–102.

84. Quoted in Lafuente and Mazuecos, p.232.

85. Folmer, p.307.

86. J. R. McNeill, *Atlantic empires of France and Spain. Louisbourg and Havana, 1700–1763*, Chapel Hill 1985, p.245 n.123.

87. David Syrett, ed., *The siege and capture of Havana 1762*, London 1970, p.xix.

88. J. R. McNeill, p.104; Syrett, p.xxxv.

89. Nicholas Tracy, *Manila ransomed. The British assault on Manila in the Seven Years War*, Exeter 1995, p.17.

90. Schurz 1939, pp.37, 42.

91. Phelan 1959, pp.145–147.

92. J. Kathirithamby-Wells, in Tarling, p.561.

93. Nicholas P. Cusher, *Documents illustrating the British conquest of Manila 1762–1763*, London 1971, p.118.

94. Schurz 1939, pp.339–40.

95. David F. Marley, 'The Great Galleon: the Santisima Trinidad (1750–65)', *PS*, 41 (1993).

96. Folmer, p.310.

97. Weber, p.201.

98. Cook 1973, p.49.

99. The Nootka incident (1789) marked a crucial moment in the history of the Russian, Spanish and Anglo-Saxon empires, but takes us beyond the limits set to the present story.

Chapter 11: Conclusion: The Silence of Pizarro

1. Rasler and Thompson, *The Great Powers* (cited in chap.1, n.46), p.6, admit only four empires to the status of 'pre-eminent states': those of Portugal, the Netherlands, Britain and the United States.

2. George Modelski and William R. Thompson, *Seapower in global politics, 1494–1993*, London 1988, pp.56, 174, 267.

3. Rasler and Thompson, p.7.

4. In reality the Portuguese and their empire both in the New World and in Asia have been brilliantly and exhaustively studied by a host of distinguished historians from Vitorino Magalhães Godinho and Charles Boxer onwards. It is the role of the Portuguese *within* the Spanish empire that has received less attention.

5. Arco y Garay, pp.38–40.

6. Both quoted in Stradling 1994, pp.253–254.

7. Thompson 1992, chap.IV p.13.

8. Stradling 1992, pp.120–127.

9. This is a paraphrase of the summarized argument in Hopkins, 'Back to the future', p.205.

10. For communalism in early modern Europe, see my *Early modern European society*, London 2000, pp.9–14.

11. Cf the perceptive presentation in Chapter 1 of Pagden 1990.

12. The excessive attention paid to the cult figure of Las Casas, in particular, has tended to distort our vision of what the Spaniards really said and did in America.

13. Richard Herr, in *New York Times, Book Review*, 1 July 2001, p.21.

14. R. R. Davies, 'Language and historical mythology', *TRHS*, 6 ser., VII, p.15.

15. Cited by M. Fernández Álvarez, *Tres embajadores de Felipe II en Inglaterra*, Madrid 1951, p.143.

16. Fernand Braudel, *Autour de la Méditerranée*, Paris 1996, p.71.

17. Kamen 1993, p.218.

18. Kamen 1997, p.221.

19. Ochoa, V, 610.

20. Kamen 1997, p.220.

21. Cf. J. Israel, 'The Jews of Spanish Oran', in Israel 1997, pp.221–224.

22. Essen 1944, p.141.

23. Gutiérrez, pp.195–206, gives one example out of many that can be cited.

24. Didier Ozanam, 'La diplomacia de los primeros Borbones (1714–1759)', *Cuadernos de Investigación Histórica*, no.6, p.182.

25. The incident that follows is related in Herrero Sánchez, p.163.

26. The Pensionary was the Chief Executive of the province of Holland.

27. Alonso de Sandoval, *De Instaurando Aethiopum salute*, Seville 1627, in a modern edition by Enriqueta Vila Vilar, as *Un tratado sobre la esclavitud*, Madrid 1987, p.381.

28. Wachtel, p.71.

29. Cf. the essay by J. Goody and I. Watt, 'The consequences of literacy', first published in 1962 and reprinted in P. P. Giglioli, ed., *Language and social conflict*, Harmondsworth 1972.

30. Wachtel, p.73.

31. Milagros Ezquerro, 'L'identité paraguayenne au peril du bilinguisme espagnol-guarani', in Milagros Ezquerro, ed., *Identité et altérité*, Caen 1994, p.90.

32. Cf. Frank Salomon, 'Chronicles of the impossible', in Rolena Adorno, ed., *From oral to written expression: native Andean chronicles of the early colonial period*, Syracuse 1982, p.32: Guaman, he says, 'tries to speak through two qualitatively different systems of thought at the same time'.

33. Cited by Manuel Alvar, 'Lengua, imágenes y cambio cultural en América', *Torre de Lujanes*, 42, Oct 2000, p.84.

34. Alonso de Zorita, *The Lords of New Spain*, ed. Benjamin Keen, Rutgers 1963, p.125.

35. Serge Gruzinski, *The Conquest of Mexico. The incorporation of Indian societies into the western world, 16th to 18th centuries*, Cambridge 1993, p.59.

36. Gruzinski, p.91.

37. Quoted in Pagden 1990, p.58.

38. Cited in Green, III, 84.

39. Cf. Ochoa, IV, 502.

40. Essen 1933, II, 36.

41. At least, it was half-empty when I visited it some years ago.

42. Polišenský 1978, p.32.

43. See the pioneering study by Otto Brunner, *Neue Wege der Sozialgeschichte*, Göttingen 1956.

44. *L'Age d'Or de l'Influence espagnole. La France et l'Espagne à l'époque d'Anne d'Autriche 1615–1666*, Paris 1991, p.51.

45. M. J. Martinez Alcalde, *Las ideas lingüísticas de Gregorio Mayáns*, Valencia 1992, pp.243–244.

46. Furber, p.298.

47 C. R. Boxer, *The Portuguese Seaborne Empire 1415–1825*, Harmondsworth 1973, p.128.

48. J. S. Cummins, *A question of rites. Friar Domingo Navarrete and the Jesuits in China*, Aldershot 1993, p.210.

49. López-Baralt, p.303. The illustration is reproduced at the head of this chapter.

50. MacCormack, p.348.

51. P. Van der Loon, 'The Manila incunabula and early Hokkien studies', *Asia Major*, XII, 1966, p.30.

52. Quoted in Edward Glaser, *Estudios Hispano-Portugueses. Relaciones literarias del Siglo de Oro*, Madrid 1957, pp.v–vii.

53. Vicente L. Rafael, *Contracting colonialism. Translation and Christian conversion in Tagalog society under early Spanish rule*, Ithaca 1988, p.26.

54. The study by Vicente Rafael is a brilliant exposition along these lines.

55. Cf. MacCormack, p.407. My experience of life in British India was comparable. The British learnt to speak a pidgin language, called Hindustani, that established a basic communication but little more.

56. Hillgarth, p.48.

57. Kamen 1980, p.8.

58. Gutiérrez, p.182.

59. As explored in the rich volumes of Donald Lach, *Asia in the making of Europe*, 3 vols, Chicago 1965–1993.

60. Cf. Jonathan D. Sauer, 'Changing perception and exploitation of New World

plants in Europe, 1492–1800', in F. Chiapelli, ed., *First images of America: the impact of the New World on the Old*, 2 vols, Berkeley 1976, II, 813–832.

61. Hillgarth, p.73.

62. Kamen 1980, pp.313, 319.

63. *Ibid.*, p.322.

64. A persistent strategy has been to shift the blame for Spain's cultural isolation on to the Inquisition.

65. See Chapter 4 above.

66. Mannheim, p.71.

67. Federico Suarez, *El proceso de la convocatoria a Cortes (1808–1810)*, Pamplona 1982, p.410.

68. For all these quotations, Timothy E. Anna, 'Spain and the breakdown of the Imperial Ethos', in Armitage, pp.326, 328.

69. Cf. J. M. López Piñero *et al.*, *Materiales para la historia de las ciencias en España, s.XVI–XVII*, Valencia 1976.

70. Isaba, pp.216–217.

71. Quoted in Henri Lonchay, *La rivalité de la France et de l'Espagne aux Pays-Bas 1635–1700*, Brussels 1896, p.26.

72. BL Add.28399 ff.7–9.

73. Croce, p.145. Serra's views seem to have relevance also to the current debate over 'globalization'.

74. Mario Rizzo, 'Lo Stato di Milano nell'eta di Filippo II', in Elena Brambilla and Giovanni Muto, *La Lombardia spagnola*, Milan 1997, p.381. See also Romano Canosa, *Milano nel Seicento. Grandezza e miseria nell' Italia spagnola*, Milan 1993: 'It is no longer acceptable to make a contrast between a pure Italian spirit (good) and the dominance of a Spanish culture (bad).'

75. Cf. the comments of Bartolome Yun, 'La economia castellana en el sistema político imperial en el siglo XVI', in Aurelio Musi, ed., *Nel sistema imperiale: l'Italia spagnola*, Naples 1994, pp.217–219.

76. Alejandro Ramírez, *Epistolario de Justo Lipsio y los españoles (1577–1606)*, St Louis 1967, pp.337, 402.

77. Otte 1988, p.57.

78. *Ibid.*, p.562.

79. Rubens, p.207.

80. Weber, p.263.

81. Quoted in Stradling 1994, p.204.

82. Lockhart and Otte, p.6. The figure of 8,000 was, of course, exaggerated. But even half that figure would have amounted to the number of people whom terrorists murdered in the same interval of time in New York on 11 September 2001.

83. Nearly three times as many as died in the massacre of St Bartolomew in Paris four years previously: cf. Motley, p.640.

Select Bibliography

This bibliography is limited to items of general relevance or cited in more than one chapter; other items appear in the footnotes to each chapter.

Aedo y Gallart, D., *Viage, successos y guerras del Infante Cardenal Don Fernando de Austria*, Madrid 1637

Alcalá Zamora y Queipo de Llano, José, *España, Flandes y el Mar del Norte (1618–1639)*, Barcelona 1975

Altman, Ida, *Emigrantes y sociedad. Extremadura y América en el siglo XVI*, Madrid 1992

Andrews, Kenneth R., *The Spanish Caribbean. Trade and plunder 1530–1630*, New Haven, CT 1978

Andrews, Kenneth R., *Trade, plunder and settlement. Maritime enterprise and the genesis of the British Empire, 1480–1630*, Cambridge 1984

Arauz, Celestino A., *El contrabando holandés en el Caribe durante la primera mitad del siglo XVIII*, 2 vols, Caracas 1984

Arco y Garay, Ricardo del, *La idea de imperio en la política y la literatura españolas*, Madrid 1944

Armitage, David, ed., *Theories of Empire, 1450–1800*, Aldershot 1998

Attman, Artur, *American Bullion in the European World Trade 1600–1800*, Göteborg 1986

Attman, Artur, *Dutch Enterprise in the World Bullion Trade 1550–1800*, Göteborg 1983

Avila y Zúñiga, Luis de, *Comentarios de la Guerra de Alemania hecha de Carlo V*, Antwerp 1549

Bannon, J. F., *The Spanish Borderlands frontier 1513–1821*, New York 1970

Barbour, Violet, *Capitalism in Amsterdam in the 17th century*, Ann Arbor 1963

Bernal, Antonio-Miguel, *La financiación de la Carrera de Indias*, Seville 1992

Bolton, H. E., *Spanish exploration in the Southwest 1542–1706*, New York 1908

Botero, Giovanni, *Le Relationi universali*, Venice 1605

Bowser, Frederick P., *The African slave in colonial Peru 1524–1650*, Stanford 1974

Boxer, C. R., *The great ship from Amacon. Annals of Macao and the old Japan trade, 1555–1640*, Lisbon 1959

Boxer, C. R., *The Christian Century in Japan 1549–1650*, Berkeley 1967

Boxer, C. R., 'Portuguese and Spanish projects for the conquest of southeast Asia, 1580–1600', *Journal of Asian History*, III, 1969

Boxer, C. R., *The Church militant and Iberian expansion 1440–1770*, Baltimore 1978

Boyajian, James C., *Portuguese bankers at the court of Spain, 1626–1650*, New Brunswick 1983

Boyajian, James C., *Portuguese trade in Asia under the Habsburgs, 1580–1640*, Baltimore 1993

Brading, D. A., *The first America. The Spanish monarchy, Creole patriots and the Liberal state 1492–1867*, Cambridge 1991

Bradley, Peter T., *The lure of Peru. Maritime intrusion into the South Sea 1598–1701*, London 1989

Brantôme, Pierre de Bourdeille, abbé de, *Oeuvres complètes*, 2 vols, Paris 1898

Braudel, Fernand, *The Mediterranean and the Mediterranean World in the Age of Philip II*, 2 vols, London 1973

Bray, Warwick, *The gold of El Dorado*, London 1978

Calabria, Antonio, *The Cost of Empire. The finances of the kingdom of Naples in the time of Spanish rule*, Cambridge 1991

Cambridge History of the Native Peoples of the Americas: vol. I, North America, part 1, ed. B. G. Trigger and W. E. Washburn, Cambridge 1996; *vol. III, South America, parts 1 and 2*, ed. Frank Salomon and Stuart B. Schwarz, Cambridge 1999

Canny, Nicholas and Pagden, Anthony, *Colonial Identity in the Atlantic World, 1500–1800*, Princeton 1987.

Caraman, Philip, *The lost paradise. An account of the Jesuits in Paraguay 1607–1768*, London 1975

Carande, Ramón, *Carlos V y sus banqueros*, 3 vols, 2nd ed. Madrid 1965–1967

Castillo de Bobadilla, Jerónimo, *Política para corregidores*, 2 vols, Madrid 1597

Castro, Américo, *España en su historia*, Barcelona 1983 (orig. Buenos Aires 1948)

Chevalier, François, *Land and society in colonial Mexico*, Berkeley 1963

Cook, Noble David, *Born to die. Disease and New World conquest, 1492–1650*, Cambridge 1998

Colloquio, XIII: see end of bibliography

Cook, Warren L., *Flood tide of empire. Spain and the Pacific Northwest, 1543–1819*, New Haven, CT 1973

Croce, Benedetto, *History of the Kingdom of Naples*, Chicago 1970

Crónicas del Gran Capitán, ed. Antonio Rodríguez Villa, Madrid 1908 (Nueva Biblioteca de Autores Españoles, vol.10)

Crosby, Alfred W., *The Columbian exchange. Biological and cultural consequences of 1492*, Westport, CT 1972

Cross, Harry, 'South American bullion production and export 1550–1750', in J. F. Richards, ed., *Precious metals in the later medieval and early modern worlds*, Durham, NC 1983

Cutter, Donald, and Engstrand, Iris, *Quest for empire. Spanish settlement and the Southwest*, Golden, CO 1996

Domínguez Ortiz, Antonio, *Política y Hacienda de Felipe IV*, Madrid 1960

Donnan, Elizabeth, *Documents illustrative of the history of the slave trade to America*, 3 vols, Washington 1930

Ellis, David, 'The slave economies of the Caribbean', in Franklin W. Knight, *General History of the Caribbean. Vol.II: The slave societies of the Caribbean*, London 1997

Essen, Alfred van der, *Le Cardinal-Infant et la politique européenne de l'Espagne 1609–1641*, Brussels 1944

Essen, Léon van der, *Alexandre Farnèse, prince de Parme, gouverneur général des Pays Bas (1545–1592)*, 5 vols, Brussels 1933

Fernández-Armesto, Felipe, *The Canary Islands after the conquest*, Oxford 1982

Fisher, John R., *The economic aspects of Spanish imperialism in America, 1492–1810*, Liverpool 1997

Folmer, Henry, *Franco-Spanish rivalry in North America 1524–1763*, Glendale 1953

Foster, Robert, ed., *European and non-European societies, 1450–1800*, 2 vols, Aldershot 1997

Friede, Juan, *Los Welser en la conquista de Venezuela*, Caracas 1961

Furber, Holden, *Rival empires of trade in the Orient 1600–1800*, Minneapolis 1976

Galasso, Giuseppe, *Alla periferia dell'Impero. Il Regno di Napoli nel periodo spagnolo (secoli XVI–XVII)*, Turin 1994

Galasso, Giuseppe and Migliorini, Luigi, *L'Italia moderna e l'unità nazionale*, Turin 1998

García Cerezeda, Martín, *Tratado de las campañas de los ejércitos del emperador Carlos V desde 1521 hasta 1545*, 3 vols, Madrid 1873

García Hernán, Enrique, *La acción diplomática de Francisco de Borja al servicio del Pontificado 1571–1572*, Valencia 2000

Gil, Juan, *Hidalgos y samurais. España y Japón en los siglos XVI y XVII*, Madrid 1991

Goodman, David C., *Power and Penury. Government, technology and science in Philip II's Spain*, Cambridge 1988

Goodman, David C., *Spanish naval power, 1589–1665*, Cambridge 1997

Goodman, Edward J., *The explorers of South America*, New York 1972

Grahn, Lance, *The political economy of smuggling. Regional informal economies in early Bourbon New Granada*, Boulder 1997

Green, Otis H., *Spain and the western tradition. The Castilian mind in literature from El Cid to Calderón*, 4 vols, Madison 1968

Griffiths, Nicholas, and Cervantes, Fernando, eds, *Spiritual encounters. Interactions between Christianity and native religions in colonial America*, Lincoln 1999

Grove, Richard H., *Green imperialism. Colonial expansion, tropical island Edens and the origins of environmentalism, 1600–1860*, Cambridge 1995

Guaman Poma de Ayala, Felipe, *Nueva Coronica y Buen Gobierno*, 2 vols, ed. Franklin Pease, Caracas 1980

Gungwu, Wang, 'Merchants with empire: the Hokkien sojourning communities', in Sanjay Subrahmanyam, ed., *Merchant networks in the early modern world*, Aldershot 1996

Gutiérrez, Asensio, *La France et les français dans la littérature espagnole. Un aspect de la xénophobie en Espagne (1598–1665)*, St-Étienne 1977

Hall, John W., ed., *The Cambridge History of Japan. Vol.4: Early modern Japan*, Cambridge 1991

Haring, Clarence H., *Trade and Navigation between Spain and the Indies in the Time of the Hapsburgs*, Boston 1918

Headley, John M., *Tommaso Campanella and the transformation of the world*, Princeton 1997

Hernando, Carlos José, *Castilla y Nápoles en el siglo XVI. El Virrey Pedro de Toledo*, Salamanca 1994

Herrera, Antonio de, *Historia General de los Hechos de los Castellanos*, Madrid 1601

Herrero Sánchez, Manuel, *El acercamiento hispano-neerlandés (1648–1678)*, Madrid 2000

Hill, Jonathan D., *History, power and identity. Ethnogenesis in the Americas, 1492–1992*, Iowa 1996

Hillgarth, J. N., *The mirror of Spain, 1500–1700*, Ann Arbor 2000

Hopkins, A. G., 'Back to the future: from national history to imperial history', *P&P*, 164, Aug. 1999

Huerga, Alvaro, *Historia de los alumbrados (1570–1630). Vol.III: Los alumbrados de Hispanoamerica (1570–1605)*, Madrid 1986

Isaba, Marcos de, *Cuerpo enfermo de la milicia española*, Madrid 1594, modern edition 1991

Israel, Jonathan I., *Race, class and politics in colonial Mexico 1610–1670*, Oxford 1975

Israel, Jonathan I., *The Dutch Republic and the Hispanic World 1606–1661*, Oxford 1982

Israel, Jonathan I., *Conflicts of empires. Spain, the Low Countries and the struggle for world supremacy 1585–1713*, London 1997

Jara, Alvaro, *Guerre et société au Chili. Essai de sociologie coloniale*, Paris 1961

Jones, Oakah L., *Pueblo warriors and Spanish conquest*, Norman, OK 1966

Jover, José María, *Carlos V y los españoles*, Madrid 1963

Juan, Jorge and Ulloa, Antonio de, *Noticias secretas de América*, 2 vols, Madrid 1982 (facsimile of the London 1826 edn)

Kamen, Henry, *The War of Succession in Spain 1700–1715*, London and Bloomington 1969

Kamen, Henry, *Spain in the later seventeenth century, 1665–1700*, London 1980

Kamen, Henry, *Spain 1469–1714. A society of conflict*, London and New York 1991

Kamen, Henry, *The Phoenix and the Flame. Catalonia and the Counter Reformation*, New Haven, CT and London 1993

Kamen, Henry, *Philip of Spain*, New Haven and London 1997

Kamen, Henry, *The Spanish Inquisition. A historical revision*, New Haven, CT and London 1998

Kellenbenz, Hermann, ed., *Fremde Kaufleute auf der iberischen Halbinsel*, Cologne 1970

Kirk, Thomas, 'A little country in a world of empires: Genoese attempts to penetrate the maritime trading empires of the seventeenth century', *JEEH*, vol.25, no.2, fall 1996

Knaut, Andrew L., *The Pueblo revolt of 1680*, Norman, OK 1995

Koenigsberger, Helmut, *The government of Sicily under Philip II of Spain*, London 1951

Konetzke, Richard, 'La emigración española al río de La Plata durante el siglo XVI', in *Miscelanea americanista*, vol.III, Madrid 1952

Ladero Quesada, M. A, *Granada después de la conquista*, Granada 1988

Lafuente, Antonio and Mazuecos, Antonio, *Los caballeros del punto fijo. Ciencia, política y aventura en la expedicíon geodésica hispanofrancesa al virreinato del Perú en el siglo XVIII*, Madrid 1987

Lane, Kris E., *Pillaging the empire. Piracy in the Americas 1500–1750*, New York 1998

Lapeyre, Henri, *Une famille de marchands: les Ruiz*, Paris 1955

Larson, Brooke and Harris, Olivia, *Ethnicity, markets and immigration in the Andes*, Durham, NC 1995

Lechner, Jan, 'Contactos culturales entre España y Holanda durante los siglos XVI y XVII', *Boletín del Instituto Cervantes de Utrecht*, spring 2000

Leonard, Irving A., *Los libros del Conquistador*, Mexico 1953

Lockhart, James, and Otte, Enrique, *Letters and people of the Spanish Indies*, Cambridge 1976

Lockhart, James, *The Men of Cajamarca*, Austin 1972

Lockhart, James, *The Nahua after the Conquest*, Stanford 1992

Lockhart, James, *We people here: Nahuatl accounts of the conquest of Mexico*, Berkeley 1993

López-Baralt, Mercedes, *Icono y conquista: Guamán Poma de Ayala*, Madrid 1988

Los Siglos de Oro en los Virreinatos de América 1550–1700, Madrid 1999, catalogue of an exhibition in the Museo de América

Lynch, John, *The Hispanic world in crisis and change 1598–1700*, Oxford 1992

Lyon, Eugene, ed., *Pedro Menéndez de Avilés*, New York 1995

MacCormack, Sabine, *Religion in the Andes: vision and imagination in early colonial Peru*, Princeton 1991

MacLeod, Murdo J., *Spanish Central America. A socioeconomic history 1520–1720*, Berkeley 1973

Macías, Isabelo and Morales Padrón, Francisco, *Cartas desde América 1700–1800*, Seville 1991

Magalhães Godinho, Vitorino, *Os descobrimentos e a economia mundial*, 2nd edn, 4 vols, Lisbon 1983

Manglano y Cucaló de Montull, baron de Terrateig, Juan, *Política en Italia del Rey Católico (1507–1516)*, 2 vols, Madrid 1963

Mannheim, Bruce, *The language of the Inka since the European invasion*, Austin 1991

Manning, Patrick, ed., *Slave trades 1500–1800: globalization of forced labour*, Aldershot 1996

Maravall, José Antonio, *Estado moderno y mentalidad social, siglos XV a XVII*, 2 vols, Madrid 1972

Meilink-Roelofsz, M. A. P., *Asian trade and European influence in the Indonesian archipelago between 1500 and about 1630*, The Hague 1962

Melville, Elinor G. K., *A plague of sheep. Environmental consequences of the conquest of Mexico*, Cambridge 1994

Mercado, Tomás de, *Suma de Tratos y Contratos*, Madrid 1975 (1571 edn)

Merriman, Roger Bigelow, *The rise of the Spanish empire in the Old World and in the New*, 4 vols, New York 1918, repr. 1962

Milhou, Alain, 'Las Casas frente a las reivindicaciones de los colonos de la isla Española (1554–1561)', *Historiografía y Bibliografía americanistas*, Seville 1976, vols XIX–XX

Milhou, Alain, *Colón y su mentalidad mesiánica*, Valladolid 1983

Millones, Luis, ed., *El retorno de las huacas*, Lima 1990

Morga, Antonio de, *Sucesos de las Islas Filipinas*, ed. W. E. Retana, Madrid 1909

Motley, John L., *The rise of the Dutch republic*, London 1912 edn

Ochoa Brun, Miguel Angel, *Historia de la diplomacia española*, 6 vols, Madrid 1999

Olesa Muñido, Francisco-Felipe, *La organización naval de los estados mediterráneos y en especial de España durante los siglos XVI y XVII*, 2 vols, Madrid 1968

Olwer, Luis Nicolau d', *Fray Bernardino de Sahagún (1499–1590)*, Salt Lake City 1987

Otero Lana, Enrique, *Los corsarios españoles durante la decadencia de los Austrias*, Madrid 1992

Otte, Enrique, *Cartas privadas de emigrantes a Indias 1540–1616*, Seville 1988

Otte, Enrique, *Sevilla y sus mercaderes a fines de la Edad Media*, Seville 1996

Padfield, Peter, *Tide of Empire. Decisive naval campaigns in the rise of the West*, 2 vols, London 1982

Pagden, Anthony, *The fall of natural man. The American Indian and the origins of comparative ethnology*, Cambridge 1982

Pagden, Anthony, *Spanish Imperialism and the Political Imagination*, New Haven, CT and London 1990

Pagden, Anthony, *Lords of all the World. Ideologies of Empire in Spain, Britain and France c.1500–c.1800*, New Haven, CT and London 1995

Palmer, Colin A., *Human cargoes. The British slave trade to Spanish America, 1700–1739*, Urbana 1981

Palmer, Colin A., *Slaves of the White God. Blacks in Mexico, 1570–1650*, Harvard 1976

Parker, Geoffrey, *The Army of Flanders and the Spanish Road 1567–1659*, Cambridge 1972

Parker, Geoffrey, *Spain and the Netherlands 1559–1659*, London 1979

Parker, Geoffrey, ed., *The Thirty Years' War*, London 1984

Parker, Geoffrey, *The military revolution. Military innovation and the rise of the west 1500–1800*, Cambridge 1988

Parker, Geoffrey, *The grand strategy of Philip II*, New Haven, CT and London 1998

Parnell, Arthur, *The War of the Succession in Spain during the reign of Queen Anne 1702–1711*, London 1905

Parry, J. H., *The Spanish Seaborne Empire*, Harmondsworth 1973
Pérez-Mallaína, P. E., and B. Torres Ramírez, B., *La armada del Mar del Sur*, Seville 1987
Phelan, John L., *The millennial kingdom of the Franciscans in the New World*, Berkeley 1956
Phelan, John L., *The Hispanization of the Philippines. Spanish aims and Filipino responses 1565–1700*, Madison 1959
Polišenský, Josef V., *The Thirty Years War*, London 1971
Polišenský, Josef V., *War and Society in Europe 1618–1648*, Cambridge 1978
Postma, Johannes M., *The Dutch in the Atlantic slave trade 1600–1815*, Cambridge 1990
Powell, Philip W., *Soldiers, Indians and silver. The northward advance of New Spain, 1550–1600*, Berkeley 1952
Prescott, William H., *History of the reign of Ferdinand and Isabella*, London 1841
Prescott, William H., *History of the Conquest of Mexico*, London 1901 edn.
Prescott, William H., *History of the Conquest of Peru*, London 1901 edn.
Quatrefages, René, *Los tercios españoles (1567–77)*, Madrid 1979
Reed, Robert R., *Colonial Manila. The context of Hispanic urbanism and process of morphogenesis*, Berkeley 1978
Reff, Daniel, *Disease, depopulation and culture change in northwestern New Spain, 1518–1764*, Salt Lake City 1991
Reid, Anthony, *Southeast Asia in the Age of Commerce 1450–1680. Vol.II: Expansion and crisis*, New Haven, CT 1993
Restall, Matthew, *Maya conquistador*, Boston 1998
Rodao, Florentino, *Españoles en Siam (1540–1939)*, Madrid 1997
Rodríguez Villa, Antonio, *Ambrosio Spinola*, Madrid 1904
Rosenblat, Angel, *La población indígena y el mestizaje en América*, 2 vols, Buenos Aires 1954
Rout Jr, Leslie B., *The African experience in Spanish America*, Cambridge 1976
Rubens, Peter Paul, *The letters of Peter Paul Rubens*, trans. and ed. by Ruth Saunders Magurn, Cambridge, MA 1955
Ruiz Martín, Felipe, ed., *Lettres marchandes échangées entre Florence et Medina del Campo*, Paris 1965
Ruiz Martín, Felipe, 'Credito y banca, comercio y transportes en la etapa del capitalismo mercantil', in *Actas de las I jornadas de método aplicado de las ciencias históricas. Vol.III: Historia Moderna*, Santiago 1975
Sáinz Rodríguez, Pedro, *Evolución de las ideas sobre la decadencia española*, Madrid 1962
Sandoval, Prudencio de, *Historia de la Vida y Hechos del Emperador Carlos V*, Biblioteca de Autores Españōles, vol.LXXX, Madrid 1955

Sauer, Carl Ortwin, *The early Spanish Main*, Berkeley 1992

Schurz, William Lytle, *The Manila Galleon*, New York 1939

Schurz, William Lytle, *This New World*, London 1956

Schwartz, Stuart B., 'The voyage of vassals', *AHR*, vol.96, no.3, June 1991

Schwartz, Stuart B., ed., *Implicit Understandings. Observing, reporting and reflecting on the encounters between Europeans and other peoples in the early modern era*, Cambridge 1994

Scott, William H., *The discovery of the Igorots. Spanish contacts with the pagans of northern Luzon*, Quezon City 1974

Sepúlveda, Juan Ginés de, *Obras Completas*, 4 vols, Pozoblanco 1995–2000

Solnon, Jean-François, *Quand la Franche-Comté était espagnole*, Paris 1983

Spicer, Edward H., *Cycles of Conquest. The impact of Spain, Mexico and the United States on the Indians of the Southwest 1533–1960*, Tucson 1962

Stein, Stanley J. and Stein, Barbara H., *Silver, Trade and War. Spain and America in the making of early modern Europe*, Baltimore 2000

Stradling, R. A., *The Armada of Flanders. Spanish Maritime Policy and European War, 1568–1668*, Cambridge 1992

Stradling, R. A., *Spain's struggle for Europe 1598–1668*, London 1994

Tarling, Nicholas, ed., *The Cambridge History of Southeast Asia. Vol.I: From early times to c.1800*, Cambridge 1992

Taylor, F. L., *The art of war in Italy 1494–1529*, London 1921, repr. 1993

Thomas, Werner and Verdonk, Robert A., eds, *Encuentros en Flandes. Relaciones e intercambios hispanoflamencos a inicios de la Edad Moderna*, Leuven 2000

Thompson, I. A. A., *War and Government in Habsburg Spain 1560–1620*, London 1976

Thompson, I. A. A., *War and Society in Habsburg Spain*, Aldershot 1992

Thornton, John, *Africa and Africans in the making of the Atlantic world, 1400–1680*, Cambridge 1992

Tocco, Vittorio di, *Ideali di indipendenza in Italia durante la preponderanza spagnuola*, Messina 1926

Tracy, James D., ed., *The Political Economy of Merchant Empires. State power and world trade 1350–1750*, Cambridge 1991

Vargas Machuca, Bernardo de, *Milicia y descripción de las Indias*, Madrid 1599 (2 vols, Madrid 1892)

Vila Vilar, Enriqueta, 'Las ferias de Portobelo: apariencia y realidad del comercio con Indias', *AEA*, xxxix, 1982

Vilar, Juan Bautista, and Lourido, Ramon, *Relaciones entre Espana y el Magreb, siglos XVII y XVIII*, Madrid 1994

Wachtel, Nathan, *Los vencidos. Los indios del Perú frente a la conquista española (1530–1570)*, Madrid 1976

Ward, Christopher, *Imperial Panama. Commerce and conflict in Isthmian America, 1550–1800*, Albuquerque 1993

Weber, David J., *The Spanish Frontier in North America*, New Haven, CT and London 1992

Weddle, Robert S., *The French thorn. Rival explorers in the Spanish sea, 1682–1762*, College Station 1991

XIII Coloquio de Historia Canario-Americana (1998), Grand Canary 2000

Index